Pin-Up Grrrls

Pin-Up Grrrls

FEMINISM, SEXUALITY,

POPULAR CULTURE

Maria Elena Buszek

Duke University Press Durham and London

2006

© 2006 Duke University Press

All rights reserved

Printed in the United States of

America on acid-free paper ∞

Designed by C. H. Westmoreland

Typeset in Bembo

by Tseng Information Systems, Inc.

Library of Congress Cataloging-in-

Publication Data appear on the last

printed page of this book.

A mis padres, con cariño

CONTENTS

Acknowledgments ix

Introduction: Defining/Defending the "Feminist Pin-Up" 1

1 Representing "Awarishness": The Theatrical Origins of the
 Feminist Pin-Up Girl 27

2 New Women for the New Century: Feminism and the Pin-Up
 at the Fin de Siècle 69

3 The Return of Theatrical Feminism: Early-Twentieth-Century
 Pin-Ups on the Stage, Street, and Screen 115

4 Celebrating the "Kind of Girl Who Dominates": Film Fanzines
 and the Feminist Pin-Up 142

5 New Frontiers: Sex, Women, and World War II 185

6 Pop Goes the Pin-Up: New Roles and Readings in the Postwar
 Era 232

7 Our Bodies/Ourselves: Pin-Ups in the Wake of Women's
 Liberation 268

8 From Womyn to Grrrls: The Postmodern Feminist Pin-Up 311

Conclusion/Commencement 355

Notes 365

Bibliography 403

Index 437

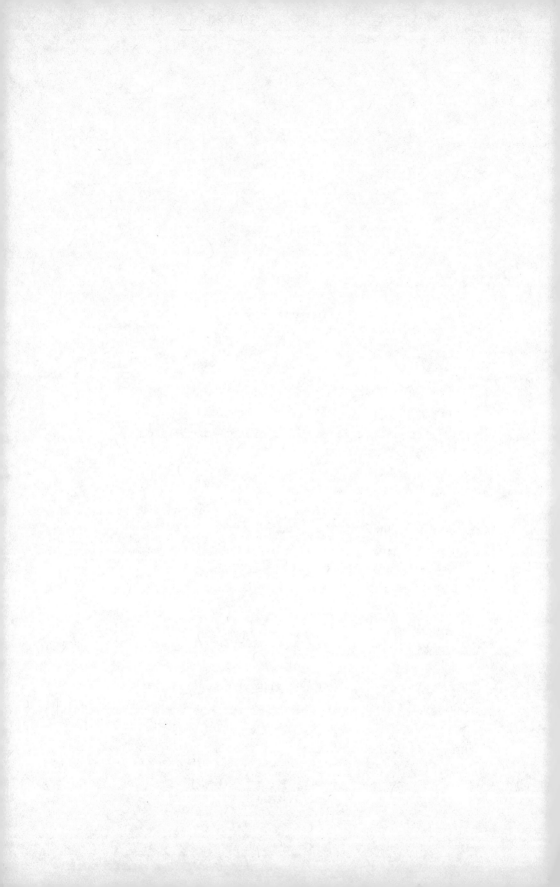

ACKNOWLEDGMENTS

I owe many people thanks for seeing this book from the graduate seminar to press. First, however, I would like to thank my editor and good friend Ken Wissoker, whose enthusiasm for and support of this book from the very start more than made up for the years of baffled responses with which the project was met while in progress. Needless to say, I hit the jackpot when I stumbled into an editor with whom I could talk Pierre Bourdieu, Chuck D., and Susie Bright in one sitting. I would also like to thank Duke University Press editors Christine Dahlin, Courtney Berger, and Justin Faerber for absorbing my frequent freak-outs over the workaday details, and the press's anonymous readers for their amazingly insightful suggestions for the manuscript's revision.

This book began as my doctoral thesis at the University of Kansas's Kress Foundation Department of the History of Art, and although it has been through myriad changes since I first subjected it to the cruel margin ruler of KU's Graduate School secretary, even in this transformed version it is indebted to the mentorship and patience of my dissertation committee members: John Pultz, Ann Schofield, Marilyn Stokstad, Patrick Frank, and especially Joanna Frueh, whose thoughtful readings and criticism of each original chapter and whose love and encouragement of my person immeasurably shaped this project. The students and faculty at KU's history of art, women's studies, and

American studies departments also influenced my research tremendously, particularly Elissa Anderson, Temma Balducci, Erin Barnett, Bradley Carter, David Cateforis, Sarah Crawford-Parker, Tracy Floreani, Steve Goddard, Randall Griffey, Heather Jensen, Angel Kwolek-Folland, Janet Rose, Cotten Seiler, Barry Shank, Scott Shields, Linda Stone-Ferrier, Jill Vessely, Katie Vinz, Robert Vodicka, and Deborah Whaley. My professional colleagues at Santa Monica College and the Kansas City Art Institute also provided me with both support and the resources as I revised my dissertation into the book that you hold today. I am particularly indebted to the members of the KCAI Faculty Development Committee, whose generous Faculty Development Grant allowed me to obtain and reproduce most of the book's images.

None of this nurturance, however, would have been toward any good without the true support of every scholar: librarians and archivists. I have had the opportunity to personally tell many of you the following, but to those I missed, let me say that I sincerely believe you belong to the noblest and most generous race on earth—it is through the assistance of each and every one on whose coat I pulled that this volume was built. First credit must go to my first resources: the University of Kansas's Murphy Art and Architecture Library, particularly Susan Craig and the late Jan Altenbernd; the entire staff of KU's Watson Library; and especially the curators and staff at the Spencer Museum of Art. My research outside of KU's holdings was conducted in large part through the generosity of the Kress Foundation Department of the History of Art's Murphy Travel Fund, through which I was awarded several travel grants that allowed me to conduct research and interviews across the country. Many of the individuals and institutions I visited were extremely generous in helping me not only research but also reproduce the images in this volume: in particular, I would like to thank the curators and staff at the Museum of Modern Art Research Library and MoMA Film Library, especially Mary Corliss and Terry Geesken; the librarians at the New York Public Library's Billy Rose Theater Collection; Fredric Wilson and Kathleen Coleman at the Harvard Theatre Collection; James P. Quigel Jr. and the staff at Pennsylvania State University's Special Collections Library; Lauren Buisson at the UCLA Arts Library Special Collections; the entire staff of the Getty Research Institute in Los Angeles; the British Film Institute, especially Simone Pot-

ter; Alexis Curry and Deborah Barlow Smedstad at the Los Angeles County Museum of Art Library; Brett Stolle at the United States Air Force Museum; Martha Wilson and Michael Katchen at the Franklin Furnace; Ann Powers and Jen Wolfe at the Experience Music Project; Marianne Boesky and the staff at the Marianne Boesky Gallery; Ronald Feldman Fine Arts, especially Laura Muggeo; the staff at Metro Pictures; Teresa Roussin, Lisa Joyce, and the Brown and Bigelow calendar company; and the Alan Cristea Gallery, London, especially Sally Higgens. And, all these institutional finds would have meant little without the help of my amazing research assistants Cortney Andrews, Christopher Bell, and Heather Gutierrez, who put in countless hours sifting through them for gold.

Not surprisingly, for a topic about which so little has been written, perhaps the most valuable resources I discovered were the individuals whose own experience, ideas, research, art collections, and encouragement led me to new places. As such, the work and insights of the following individuals have informed my research and writing immeasurably: Elizabeth Adan, Shonagh Adelman, Robert Allen, Jack Banning, Jennifer Baumgardner, Susie Bright, Veronica Cross, Katy Deepwell, Faye Dudden, Ilene Fort, Lorraine Gamman, Susan A. Glenn, Maureen Honey, Amelia Jones, Despina Kakoudaki, Joyce Kozloff, Elizabeth Lee, Ann Magnuson, Karal Ann Marling, Marlene McCarty, Liz McQuiston, Louis Meisel and Charles Martignette, Marsha Meskimmon, Joanne Meyerowitz, Técha Noble, Linda Nochlin, Helena Reckitt, Amy Richards, Lynn Rideout, Mary Louise Roberts, Rebecca Schneider, Renee Sentilles, Alexis Smith, Ali Smith, Abigail Solomon-Godeau, Annie Sprinkle, Janet Staiger, Shelley Stamp, Gaylyn Studlar, Debbie Stoller, Robert Swanson, Linda Williams, and Lisa Yuskavage.

Much of this book is also indebted to conference coordinators, participants, and respondents who have seen it through several drafts presented at Bowling Green State University; SUNY, New Paltz; the American Studies Association; and the College Art Association. I am also grateful to readers and editors who offered criticism as well as accolades, particularly *TDR: The Journal of Performance Studies*, which published an early version of chapter 1 in *TDR* 43, no. 4 (1999): 141–62, and recognized the piece with its Student Essay Contest prize. Different versions of chapter 5 were published in the electronic edition of *n.paradoxa* 6 (March

1998), and the online catalog for the University of Kansas's Spencer Museum of Art exhibition *Alberto Vargas: The Esquire Years*.

Finally, as any long-worked-out project comes to a close, one truly begins to appreciate the important role that the support and encouragement of one's family and closest friends plays in seeing things through. As such, I am naturally indebted to my parents, Maria Josefa and Jerome Buszek, my brothers Jerry John and Joseph Buszek, and my dear friends Renée and Bill Hoover, Timothy McEvoy, and Brigitte McQueen, all of whom made sure that I remembered both the diversions and resources of the world outside of the academy. Meanwhile, Laura Berman, Rebecca Dolan, Daven Gee, Mara Gibson, Anne Pearce, Brett Reif, Ann-Marie Rounkle, DeAnna Skedel, and Dianne Stannish were among my few close friends to join me in alternating pressing ears against the ivory tower and the ground. But above all I am grateful for the love, support, and mental-health services of Torry Akins, upon whose goodness and strength I could rely even when it was simply to hang my anxieties somewhere. What follows would have been impossible without him.

INTRODUCTION

Defining/Defending the "Feminist Pin-Up"

In 2000, I attended a lecture at the Los Angeles County Museum of Art in which the legendary art historian Linda Nochlin addressed the issue of the nude. She approached the subject through her life experience as both a scholar and a feminist, which has informed her tastes in and fascination with its representation. Reading from her essay "Offbeat and Naked," Nochlin said: "I like any nude that isn't classical, any naked body that doesn't look like Michelangelo's *David* or the *Apollo Belvedere*. For me, as for the poet-critic, Baudelaire in the 19th century, the classical nude is dead, and deathly. What is alive? The offbeat, the ugly, the other, the excessive."[1] Her perspective intrigued me: at work on this book, investigating the feminist history of the pin-up, I felt that my fascination with the genre came from a similar place. Afterward, I asked Nochlin where, if anywhere, she felt the pin-up genre belonged in this aesthetic of the offbeat. To the surprise of the audience, and without hesitation, she began an impromptu paean to perhaps the most famous pin-up in the history of the genre — Alberto Vargas's "Varga Girl" (fig. 1). Nochlin recounted how, as a child during the Second World War, she would rifle through her uncles' *Esquire* magazines to marvel at the grotesque beau-

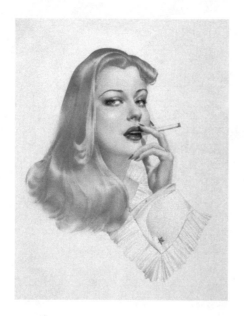

1: Alberto Vargas, water-color painting published as the January calendar girl, *Esquire* 1942 Calendar. (The Spencer Museum of Art, The University of Kansas, Gift of Esquire, Inc.)

2: Ali Smith, portrait of Janeane Garofalo, from the book *Laws of the Bandit Queens*. (© Ali Smith, 2000, courtesy of the artist)

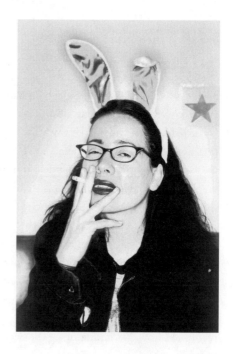

ties within. Those endless legs! Those bowed feet! Those fetish fashions! Absolute freaks of nature!, she enthused with a mischievous grin.[2]

The pin-up continues to impress young feminists with her aggressive sexuality, imperious attitude, and frightening physique—an ideal that Joanna Frueh has appropriately dubbed "monster/beauty": "Monster/beauty is a condition, and it can also describe an individual. Because extremity is immoderation—deviation from convention in behavior, appearance, or representation—and starkly different from standard cultural expectations for particular groups of people, monster/beauty departs radically from normative, ideal representations of beauty. . . . Monster/beauty is artifice, pleasure/discipline, cultural invention, and it is extravagant and generous."[3] As such, the similarities between photographer Ali Smith's recent portrait of a popular young feminist icon, comedian Janeane Garofalo, and a 1942 Vargas pin-up should come as unsurprising (fig. 2). Posed in the reversed but otherwise exact manner of a 1942 Vargas *Esquire* calendar girl, the portrait manifests many of the complex issues surrounding the feminist appropriation of the pin-up genre. The irony is palpable as the militant antiglamour girl Garofalo poses with the sultry come-hither stare of the classic pin-up. Of Garofalo's pose and most prominent accessory—a comical pair of satin ears one instantly associates with *Esquire*'s post–World War II cheesecake successor, *Playboy*—photographer Smith said: "I envisioned that perhaps she had knocked a *Playboy* bunny down, stolen her ears, and was smoking a cigarette in victory." Yet, it can also be argued that Garofalo has never looked so sexy, so confident, or so intimidating, which Smith acknowledged when she elaborated on her choice to photograph Garofalo because "she is a beautiful woman in a very real, cool, un-Hollywood way, [who has] managed to help punch a hole in standards of Hollywood beauty. . . . her sexuality in [this] picture is based on her exuding confidence, which is more traditionally why men are considered sexy. Her sexuality comes across to me as totally in her control and that is the key."[4] Although her rumpled garb and hairdo counter the Varga Girl's polished femininity, Garofalo's candy-apple-red lipstick and suggestively handled cigarette reflect not only those same superficial aspects of the original, but also its sense of audacity, artifice, and control. Young feminists may poke fun at the pin-up, but they do so in ways that betray affinities with, even affection for the genre itself.

To those who view the feminist movement as a cadre of humorless harpies, repelled to a one by sex, pleasure, and pop culture, feminist thinkers' interest in the pin-up must seem surprising, if not completely implausible. But this limited view ignores several facts about the long history of the women's movement. First, as feminism has always been premised on fighting for equality between the sexes, the role of sexuality in sexual inequality has inevitably been addressed by all generations of the movement. Second, although feminist thinkers have consistently drawn upon women's sexuality as a site of oppression, so too have they posited the nurturance of women's sexual freedom and pleasure as an antidote to the same. Third, as a movement driven by the need to reach, educate, and persuade the masses, popular culture has not been viewed by feminists solely as a reserve of conservative messages to rage against, but also as a powerful tool for offering progressive alternatives to these very messages. For all these reasons, alongside the protectionist and anti-pornography feminist voices who have rightfully challenged men's historical dominance over and access to women's sexuality, anticensorship and prosex voices have existed in the women's movement since its origins to posit women's agency over and right to express their own sexuality as a different kind of challenge to male supremacy. Although many shades of opinion and a range of activist positions exist between the antipornography and "sex radical" stances in contemporary feminism, all these positions in today's debate existed long before the second wave of the feminist movement visibly dragged them into academic, political, and popular discourses in the 1960s and 1970s. Although this generation's use of and impact upon popular culture led to the very interpretive and appropriative strategies of feminists like Nochlin, which in turn led to uses of the pin-up by younger feminists like Smith, the fact is that feminist uses of the genre long predate the popular women's liberation movement. Alas, no thoroughgoing survey exists to track the history and evolution of feminist uses of the sexualized woman in popular culture to both reflect and affect the larger fight for women's rights. This book is an effort to fill that void.

Contrary to the popular belief—held by many within, outside of, and even against the movement—that a "feminist pin-up" is an oxymoron, it is no more so than "feminist painting" or "feminist sculpture," or "feminist porn" for that matter: these are all media and genres historically

used and appreciated primarily by men, about which nothing is inherently sexist, but which have all been both kept from women and used to create images that inscribe, normalize, or bolster notions of women as inferior to men. While this fact has been recognized by many feminist thinkers—indeed, many such media and genres have been *avoided* by certain feminist artists for these very reasons—few would deny that the same have been and may be strategically used by women to subvert the sexism with which they have historically been associated. Yet the pin-up—because of its simultaneous ubiquity and invisibility, prurient appeal and prudery, artistry and commercialism—has not been so readily granted a feminist interpretation. The genre is a slippery one: it doesn't represent sex so much as suggest it, and these politely suggestive qualities have as a result always lent it to a commercial culture of which feminists have justifiably been wary for its need to cultivate the kind of desire and dissatisfaction that leads to consumption.

But the feminist movement itself has historically been dedicated to the cultivation of desire and dissatisfaction—in its own case, leading to dissent. As such, we should be unsurprised that both the visibility and persuasiveness of the pin-up might be used by a feminist movement that has always sought to inspire broad cultural change. As a genre associated almost exclusively with women—due, of course, to its creation and prominence in cultures where women's rather than men's sexuality is considered acceptable for scrutiny—the pin-up has, no less than (indeed, perhaps more than) any other cultural representation of women, reflected women's roles in the cultures and subcultures in which it is created. Because the pin-up is always a sexualized woman whose image is not only mass-reproduced, but mass-reproduced because intended for wide display, the genre is an interesting barometer for Western cultural responses to women's sexuality in popular arts since the Industrial Revolution, as well as feminist responses to the same. Indeed, the pin-up seems an excellent place to track the history of both heated disagreements and remarkable similarities within and between feminist generations precisely because of its longevity, prominence, and mixed meanings in pop culture since the rise of the feminist movement. When feminist history is viewed through the lens of the popular pin-up, what emerges is a picture of the myriad ways in which women have defined, politicized, and represented their own sexuality in the public eye. And

when the pin-up's popularity is viewed through the lens of feminist history, what emerges is a picture of the myriad ways in which feminist thought has profoundly affected women's sexuality both within and beyond the women's movement.

> Women are no longer to be considered little tootsey wootseys who have nothing to do but look pretty. They are determined to take an active part in the community and look pretty too.
> —Lydia Commander, 1909

> We can be feminine
> And still knock boots.
> —Salt 'n' Pepa, NAACP Awards, 1996

Few issues have caused more debate within feminism's history than the sexualized representation of women. The arguments that bookend this debate generally hold that the identification/representation of woman as a sexual subject and sexual object either coexist or operate independently of one another. Feminist activists and scholars have long tangled with the issue of whether images liberate women from or enforce traditional patriarchal notions of female sexuality. From Laura Mulvey's psychoanalytical construction of the "masculine gaze" to Andrea Dworkin and Catharine MacKinnon's longstanding appeals to broaden both cultural and legal definitions of pornography, there is a wide and influential range of contemporary feminist discourse on the ways in which women are manipulated and victimized through various cultural representations. These have led to a popular stereotype of the "feminist view" (if there ever were such a monolith) of the sexualized woman as a consistently negative one. However, the history and evolution of the women's movement problematizes this stereotype, as women have actively demanded the right to act as free and discerning sexual subjects even as they may be interpreted or serve as another's object of desire. As the decades that yawn between the statements of Lydia Commander and Salt 'n' Pepa demonstrate, this position has been complicated and consistent in modern women's history.

Frueh has articulated this desire succinctly in her writing on the rele-

vance of sexuality to the feminist movement: "As long as I am an erotic subject, I am not averse to being an erotic object."[5] The problem with this conflation of subject/object is in constructing and representing a feminist identity that is both subversive and alluring (as well as accommodating to what is by nature the highly individualized yet powerful realm of sexual pleasure). As bell hooks puts this conundrum: "It has been a simple task for women to describe and criticize negative aspects of sexuality as it has been socially constructed in sexist society; to expose male objectification and dehumanization of women; to denounce rape, pornography, sexualized violence, incest, etc. It has been a far more difficult task for women to envision new sexual paradigms, to change the norms of sexuality."[6] Part of this challenge has been the drive toward creating representations that disrupt the patriarchal subjugation of women yet retain the right to use familiar conventions of representing women's beauty and desirability to make this disruption more accessible.

Contemporary artists as varied as Judy Chicago and Renée Cox, Cindy Sherman and Lisa Yuskavage have appropriated icons, objects, and stereotypes that speak to traditions of representing women as sexual creatures. However, all these artists effectively subvert these methods and image types to assert the pleasure and power feminist women may find in them—a clever bait-and-switch process perhaps best described by art historian Kate Linker as "seduce, then intercept."[7] Naturally, finding visual languages that perform this task as it relates to women's sexuality and pleasure has been difficult. Historical constructions of female sexuality in both the art world and popular culture have frequently represented womanhood according to patriarchal myths that feminism has sought to deny. Yet many feminist constructs of female sexuality—in a desire to depart from sexist constructs—have resulted in a visual language pointedly hostile to both sexual desire and women for whom a radical denial of traditional feminine signifiers is itself oppressive. Surely echoing the frustration of many feminists in this position, artist Barbara Kruger asks: "How do I as a woman and an artist work against the marketplace of the spectacle while residing within it?"[8]

As a ubiquitous signifier for the sexualized female in contemporary visual culture, the pin-up provides us with a starting point through which to study feminist attempts to answer this question. On the one

hand, the (not entirely correct) assumption that the genre exists as a catalyst for heterosexual male desire has made it a kind of visual short-hand for the desirable female. On the other, the genre also has a history of representing and accepting seemingly contradictory elements—traditional as well as transgressive female sexualities—by imaging ordinarily taboo behaviors in a fashion acceptable to mass cultural consumption and display. While many pin-ups are indeed silly caricatures of women that mean to construct their humiliation and passivity as turn-ons, the genre has also represented the sexualized woman as self-aware, assertive, strong, and independent. As such, it should come as no surprise that in their search for a mediating image between the roles of subject and object, and the languages of transgression and tradition, many contemporary feminist artists have looked to this genre as a mode of self-expression.

> **pin-up** (pin'up) *U.S. Colloq*. n. That which is affixed to a board or wall for scrutiny or perusal; specifically, a clipping or photograph, usually of an attractive young woman.—adj. Designating a photograph, clipping, or drawing used in this manner, or a person who models such picture.

According to the recent *Webster's* definition—little-changed since it first appeared in the dictionary in 1941—the pin-up is an image of an individual meant for display and concentrated observation. Implied in the dictionary's almost humorously formal description is that the image also generally represents a woman as the subject of such public "scrutiny." This idea reflects the popular understanding of such representations' association with women, as a sort of publicly displayed and consumed genre of feminine portraiture (regardless of the scores of advertising and Hollywood-generated male pin-ups that would seem to indicate otherwise).[9] While this definition is indeed accurate in its description of the now-universal understanding of this fairly modern genre, its representational form actually originated much earlier than its contemporary definition implies.

Pin-up connoisseur Mark Gabor locates the genre's origins alongside the development of Western print media in the fifteenth century.

The circulation of print imagery allowed for the creation of images that could be mass-produced, distributed, and displayed among publics larger than those with the means to afford singular imagery, such as sculpture or painting, for display and perusal.[10] From the earliest widely circulated prints and advertisements of the Renaissance, the images reproduced or reflected the period's "high art" conventions of depicting the female nude: generally mythological or allegorical representations of women, or women in various states of undress engaged in subtly sexualized poses or narratives. Gabor astutely locates the pin-up's origins in the proliferation of popular prints, through which the genre's traditional distinction from the realm of the fine arts is articulated and which made it accessible to lower-to-middle-class audiences. But these "pin-ups" from the fifteenth to the early nineteenth century generally lack the contemporaneity, ubiquity, and display-worthy modesty that define the modern genre. It would not be until the Industrial Revolution—with its explosion of mass-reproductive print technology and the rise of a formidable middle class in America and Europe to purchase them—that a "true" pin-up genre would emerge to both negotiate a space for itself between the fine and popular arts and define itself through the representation of a pointedly contemporary female sexuality.

Writer and cultural historian Casey Finch has observed that as the near-obsessive representation of the solitary female in European painting of the nineteenth century rose in visibility and popularity, so too did technological developments in print media, allowing such works to be reproduced and distributed widely and cheaply. As these fine-art images came to be copied, circulated, and popularized in prints and illustrations, the easily obtained knock-offs became the ideal for what would become the pin-up genre.[11] This fact calls into question the notion that the modern pin-up's origins lie entirely outside of the realm of art history, lending logic not just to its conflicted reception by audiences in the nineteenth century, but to the later fine-art appropriations that will be addressed here. In Edith Wharton's novel *The Age of Innocence*, the narrator's appalled description of an unabashedly sexual and tenuously historicized Adolphe-William Bouguereau nude on a prominent wall of the nouveau-riche Beaufort family's salon re-

minds us why deluxe chromolithographic reproductions of the period's academic nymphs also hung behind bartenders at Victorian and Edwardian saloons. Moreover, Wharton's description of generations-old New York families taking offense at the painting's blatant display in a public room of the house is used as a sign of the Beaufort's "vulgar" bourgeois tastes, unrefined by old-money modesty, which are exposed in their patronage of such a fashionably naughty contemporary work—exposing in turn the designations of class that both the Industrial Revolution and the pin-up would problematize.[12]

Art historian Abigail Solomon-Godeau more succinctly articulates Finch's linking of the academic nude and the pin-up. She also draws stronger parallels between the pin-up's defining conflation of "high" and "low" cultures and consumption practices in the nineteenth century. In this period, she argues, photographic and illustrated prints in Europe and the United States reflected more than just the expanding spectrum of what both "art" and "class" meant in Western society; they also reflected a new spectrum of sexual moralities between earlier binaries as well as the establishment of a "fully evolved commodity culture" that often blurred the lines between the classes.[13] Simultaneously, developments in the work of the period's avant-garde increasingly posited the female body as the ultimate signifier of modernity, an understanding of which was imperative to the tastes of both fine-art and mass-cultural audiences.

Solomon-Godeau asserts: "Once this equivalence was secured, at a historical moment already consumed by the Baudelairean 'cult of images,' it was at least doubly determined that the distinctive forms of modern mass consumer culture would adapt the image of feminine desirability as its most powerful icon."[14] Reflecting both the period's avant-garde obsession with the female body and its consumer-culture obsession with up-to-the-minute contemporaneity, the pin-up by the mid–nineteenth century had developed as an image of modern female sexuality that was instantly recognizable, culturally acceptable, and eminently purchasable. Solomon-Godeau defines the resulting genre as "an image type that could be relatively deluxe or relatively crude, but in either case was predicated on the relative isolation of its feminine motif through the reduction or outright elimination of narrative, literary, or mythological allusion . . . [and a] decontextualization, reduction, or dis-

tillation of the image of femininity to a [representational] subject in and of itself."[15]

Let us not confuse the pin-up girl with the pornographic or erotic imagery that dates from the dark backward and abysm of time. The pin-up girl is a specific erotic phenomenon, both as to form and function.
—Andre Bazin

Solomon-Godeau's research on the pin-up also suggests a separation of the genre from pornography by definition—a separation that reflects the contemporary (and slippery) delineation between soft-core and hard-core sexual imagery. From its birth as a representational genre, the pin-up has served as an image that pointedly eliminates the explicit representation of a sexual *act* by both eliminating the presence of men (and, generally, other women) and strategically covering the genital area of the female subject.[16] With its high-minded, art-historical precedents, general focus upon the lone female figure, and allusion to (as opposed to demonstration of) sexual activity, the self-consciously controlled pin-up differs greatly from the pointedly explicit and transgressive representation of sexual organs and sexual acts that comprise the basic elements of legal definitions of pornographic imagery since the nineteenth century.[17] As Finch writes, whereas "hard core seeks to document the supposedly raw truth of the body's sexual mechanics . . . [the pin-up] is concerned to package and purvey a very different brand of myth."[18] Thus, what Finch calls the pin-up's "double movement" between the intellectual/contemplative and the physical/active allows the genre to negotiate a space that oscillates between portraiture and pornography.[19]

It is the subtlety of this "double movement"—couching unseemly sexual truths in a more appropriately covert (literally, covered) formal language—that has allowed the pin-up to slip so widely into public visibility and, thus, popular culture, serving as what historian Joanne Meyerowitz dubs "borderline material."[20] This double movement defines not only the pin-up's formal qualities, but also the accessibility and display-ready nature that gave the genre its name. The pin-up is a genre associated with mass reproduction, distribution, and consumption, meant for (at least limited) visibility to more than one viewer. As

an image where explicitly contemporary femininity and implicit sexuality are both synthesized and intended for wide circulation and public display, the pin-up itself is an interesting paradox. It represents a space in which a self-possessed female sexuality is not only imaged but also deemed appropriate for exhibition. Yet Western mores have, since the rise of the pin-up, preserved the subject and display of self-aware, contemporary female sexuality as one for consumption that is private and guarded, if not downright threatening and therefore taboo. Is it possible, then, that the very representation of female sexuality can be interpreted not only as subordinate to oppressive cultural mores but also as potentially subversive?

In much the same way that Judith Butler has argued that drag cross-dressing can mime, rework, and resignify the external signs and stability of gender ideals, so too will we see the pin-up mime, rework, and resignify the signs and stability of specifically female sexual ideals.[21] Also like Butler's reading of drag and its history, in my attribution of these potentially subversive powers to the pin-up, I do not intend to argue that the genre can always or should invariably be read in this way.[22] Quite often drag, like the pin-up, lends itself to readings that Butler astutely concedes serve to reidealize and reinforce dominant gender norms: not all pin-ups are created equal. However, paralleling Brian McNair's appraisal of women's authorship in postmodern pornography, this book finds within the pin-up genre's entire history women assimilating this visual language largely constructed by men, but "adapting and stretching it to accommodate an expanded range of subversive meanings and messages."[23] In my analyses of pin-up history from its origins to the present, I hope to reveal moments in which the pin-up has presented women with models for expressing and finding pleasure in their sexual subjectivity. Moreover, by using this popular signifier for desirable womanhood toward a feminist expression of subversive sexual agency, I will explore the ways in which these pin-ups not only image and provoke desire but also, by penetrating and influencing the cultures of fashion and consumption, succeed in the feminist aim of changing the rigid, patriarchal terms by which desire has historically been framed.

Pin-Up and Paradox: The History, Evolution,
and Persistence of Feminist Sexuality

In recent years, many feminists have viewed explicit pornographic imagery as what M. G. Lord calls "an unruly force that promises to unsettle social conventions, and . . . [serve as] a radical political act."[24] However, the pin-up's historical association with the representation of women alone, its implicit nature through an insistence on the strategic selection of physical exposure, and the performative quality that results from such artificial constructions of sexual display make it a more subtle and publicly visible statement of female sexuality than legally defined pornographic imagery.[25] It should be unsurprising, then, that though the pin-up is, in creation and consumption, often assumed as a privileged image for men, it also has a history of consumption, interpretation, and appropriation by women.

This, however, has not happened without incident. As a movement dedicated to upending limitations on and stereotypes of women, the issue of sexuality has proven itself an extremely divisive one within feminism. The most obvious problem with representing sexuality is the fact that sexualized representations of women have—like female sexuality itself—historically been used to limit women's growth and opportunities as nonsexual beings. This makes it tempting for any representation of female sexuality to be read as symbolic of women's sexual oppression. However, this reaction neglects another, more nuanced fact of women's history, related succinctly by anthropologist Muriel Dimen: "On the one hand, since women have been traditionally seen as sex objects, feminism demands that society no longer focus on their erotic attributes, which, in turn, feminism downplays. . . . On the other hand, because women have been traditionally defined as being uninterested in sex, they have been deprived of pleasure and a sense of autonomous at-one-ness, both of which are necessary to self-esteem."[26] Dimen notes that this tension results in a situation in which "judgments about the correct path [toward a feminist sexuality] are as contradictory as the situation which gave rise to the feminist critique in the first place."[27]

Thankfully, many feminist artists see in this problem a challenge

that has led to their own attempts to represent the very contradiction of feminist sexuality in their work. Indeed, the paradoxical nature of the issue has forced feminist thinkers to approach feminism itself as a political paradox: not as a singular *feminism* but as multiple *feminisms*, which are, like sexuality itself, simultaneously individual and (like the "communities" they produce), inevitably somehow common. As theorized by feminist scholar Donna Haraway, this organizational strategy for feminism does not deify movement-killing individualism above women's mobilization. Indeed, art historian Katy Deepwell has appropriated Haraway's use of the parasite *mixotricha paradoxa* as a creative metaphor for feminism's *growth* through diversity.[28] Deepwell argues, via Haraway's research, that this creature, like feminism itself, "has paradoxical and unexpected habits of survival and reproduction. . . . it survives by attracting others to live on it [and] it reproduces by division."[29] In other words, each of these contemporary scholars promotes the logic to be found in both paradox and division in ways that feminist thinkers have been exploring since the nineteenth century, which this book will track through the convenient "case study" of the pin-up.

The pin-up in all the feminist contexts addressed here is constructed as an icon of the paradoxical that also stands for the pleasurable. Joanna Frueh's pin-up self-portraits, frequently published alongside her own essays and art criticism, reference the complexities of both feminist history and sexuality that I hope this book helps to illuminate. The original photographs published in her 1996 book *Erotic Faculties*, made in collaboration with artist Russell Dudley, depict Frueh as a fierce, midlife female whose selective, self-aware construction of the erotic intellectual defines the "feminist pin-up." The images illustrate Frueh's bold and inspirational proclamation therein: "As long as I am an erotic subject, I am not averse to being an erotic object."[30] In my favorite visual moment from the book (fig. 3), Frueh creates a clear link between her very contemporary, explicitly feminist pin-up and the popular pin-ups of the past that on the surface seem so removed from women's liberation. A wordless, two-page layout opens to juxtapose a 1950s pin-up playing card of a carefree, nude young woman on a flower-strewn swing; a formal photograph of Frueh as a child, striking a thoughtful pose, arms crossed on a table before her with a pensive, faraway look on her face; and Joanna as a grown woman, naked and with her head thrown back

3: Joanna Frueh and Russell Dudley, "pin-up" layout from *Erotic Faculties*, 1996 (Courtesy of the artists)

ecstatically, reclining in a dramatic pose amid the eclectic décor of her own living room.[31]

Five years after *Erotic Faculties*, in her book *Monster/Beauty: Building the Body of Love*, Frueh may have revealed the biographical connection between these seemingly unconnected images when she wrote of her memories of the first grade:

> I drew pictures of pinups from a deck of playing cards owned by the older brother of my friend Joyce. The drawings must have been funny because of their naïve execution, but her brother wanted them. I'd sit in class some-times thinking about the pinups, which interested me far more than did Dick, Jane, and Spot.
>
> I didn't like Joyce's brother. His sexuality nauseated me, as if it emitted an evil odor. I sensed that he liked the pinup bodies differently than I did, that his soul-and-mind-inseparable-from-body worked on them from vio-

lation; for though I gave him some of the drawings, I felt dubious when I did so. His masturbation would shame the female body, whereas mine enveloped it in love. I imagined being the pinup women, but not for him.

Already instructed in wanting to be what my feminist generation would fiercely critique, woman as sex object. Already aware that a female soul-and-mind-inseparable-from-body could perform for its own pleasure.[32]

A trio of images in conversation: young Joanna appearing to meditate upon the beauty of the laminated-cardboard pin-up floating in her dreamy line of vision, liberated from the sweaty palms of Joyce's brother just as her future self would be liberated from the "instruction" that would unsuccessfully attempt to keep her young self from her own pleasure. This conversation serves as a visual diagram of Frueh's feelings on the contradictions and powers of feminism—as if to illustrate how the loving gaze of her young self had the power to ward away the violating gaze from this smiling, guileless pin-up's sexuality as the two become one in the grown-up author's pin-up self-portrait. Frueh's strategies exemplify those of feminists throughout history who have used the pin-up to simultaneously exploit and challenge its popular acceptance as a marker of unstable and multiplicitous but eminently desirable and pleasurable female sexuality.

In her revolutionary and highly influential "Cyborg Manifesto," Haraway calls for this paradoxical image of feminism to be tempered by the sense of self-awareness with which the movement first encouraged women to approach their lives and choices. Haraway's call "for *pleasure* in the confusion of boundaries and for *responsibility* in their construction" reflects a new way of considering the popular feminist rallying cry of "the personal is the political" that explicitly takes into account the issues of pleasure, diversity, and agency.[33] In *Pin-Up Grrrls*, I hope to show how contemporary feminism's embrace of the paradoxical has led to different ideas of feminism's potential, as well as different ways of expressing the same. However, I will begin my study by tracing this approach to the very origins of the organized feminist movement in the mid–nineteenth century—during which time the pin-up genre also first emerged.

Waving, Not Drowning:
On the Problematic Resiliency of Feminism

Because of my choice to address this historical sweep of the feminist pin-up, rather than zero in on a single period or movement, I have also chosen to historicize the pin-up's evolution through feminism's own—an evolution historians of the modern women's movement generally address as three "waves" of feminist expression and organizing that have emerged since the late eighteenth century. However, because in both cultural studies and art history feminism is used almost exclusively as an ahistorical interpretive tool rather than addressed as an activist history, perhaps a brief description of these historical markers and their contemporary significance is in order. The wave metaphor has been frequently applied to Western feminist history for its ability to simultaneously define surges in the organized women's movement around specific issues and experiences, even as it suggests the presence of differing voices, debates, and even generations within them. The first wave of feminism is by far the most nebulous, in large part because for nearly 150 years its myriad participants were almost uniformly involved in the one battle that tended to connect them: enfranchisement in democratic societies. As such, feminism's first wave encompasses individuals and movements as separated by time and approach as Mary Wollstonecraft—whose 1792 *A Vindication of the Rights of Woman* was published in the wake of the American and French revolutions to contrast women's universal powerlessness against the self-congratulatory, democratic zeal of revolutionary philosophers—and Simone de Beauvoir—whose groundbreaking 1949 book *The Second Sex* was begun shortly after French women first gained the vote in 1945.

However, the first-wave period between roughly 1920 and 1960 is marked by feminist activity ebbing as women in Europe and North America sorted out the limits of enfranchisement that they had won and applied throughout these years. In this period feminism was also actively fought within these same cultures, a backlash against both women's gains to date and the world-upside-down that they threatened to many —a period that Shulamith Firestone would in 1970 call history's "first

counteroffensive" against the women's movement. Firestone, however, would be among the firebrands of feminism's second wave, born largely of the labor and civil rights movements of the post–World War II era, which in the 1960s sought to take inventory of and fight against on-going sexism that voting rights alone had been clearly incapable of un-doing. Generally referred to, then as now, as the "women's liberation movement," feminism's second wave used strategies of the progressive movements from which its leaders sprung, similarly initiating and pass-ing equal-rights legislation—concerning everything from reproductive rights to gender-specific classified ads—as well as producing feminist memoirs, theory, and collectives that raised consciousness concerning more insidious examples of sexism ingrained and normalized in every-day life. While this era is often discussed as not just popularizing but institutionalizing feminism—both *as* an "institution" with certain com-mon goals and practices, and *within* institutions ranging from national governments to organized religion—the fact is that the second wave was far more diverse and contentious than it is (or was) generally ac-knowledged to be, leading to visible fissures from the start of this era's feminist resurgence. Feminists of color and working-class women called attention to the middle-to-upper-class Eurocentrism of second wave leaders, straight and lesbian feminists debated the "proper" sexual posi-tioning of the movement's members, and sex-radical and anticensorship feminists declared their right to sexual self-expression in the midst of antipornography activism.

This expanding discourse—and the heated debates that it inspired—resulted in a diverse and increasingly individualistic feminism that, as the evolving movement both shaped and responded to postmodern theory, would by the 1980s give way to what many have begun to both recognize and theorize as a third wave of feminism in our present day. As reflected in the feminist practices of Generations X and Y—who, for better or for worse, are generally the most reported-upon and self-identifying members of our contemporary third wave—our era is cur-rently defined less by a single-minded focus on organization and activ-ism (which, it is frequently argued, excluded as much as served women who did not meet certain leaders' "standards" for the same) than on the study of identity-formation, leading women to theorize and practice

an individual feminist politics expressed more subtly in everyday-life actions.

I appreciate the feminist wave model because, as Judith Roof puts it, it allows one to address feminism's evolution without resorting to the tempting mother/daughter framework in which age-based generations are pitted against one another, which privileges "a kind of family history that organizes generations where they don't exist, ignores intragenerational differences and intergenerational commonalities, and thrives on a paradigm of oppositional change."[34] As Jane Gallop has both articulated this problem and explained its ubiquity: "Difference produces great anxiety. Polarization, which is a theatrical representation of difference, tames and binds that anxiety."[35] As such, literary scholar Astrid Henry argues, "the metaphor of the wave seems to offer an alternative model for describing feminist generations."[36] The wave structure also allows for feminist scholarship to "flow," as it were, toward individuals, movements, and practices that may not in their own day have been recognized by—indeed, may even have been fought by—the period's dominant feminist culture, recuperating them as preexisting models for subsequent generations.

However, like Henry, I also recognize a crucial problem in applying this seemingly fluid structure in our present moment of feminist history in that the "emergence of feminism's third wave seems to profoundly alter our use of the metaphor of the wave. Given the early mapping of 'mother' and 'daughter' onto 'second wave' and 'third wave,' the wave metaphor and the mother-daughter relationship increasingly have become synonymous within feminist discourse. While initially offering a generational model located outside the family, then, the wave metaphor has come to resemble the familial structure with its understanding of generations based on the human life cycle."[37] As such, this binary construction of recent feminist history often lends itself to the very polarizing positioning that Gallop rightly cautions against. Moreover, it forces women who came to the movement in the late 1970s and early 1980s to choose either one side or the other in this illusory divide—or worse: "As they can be understood as neither 'mothers' nor 'daughters' within feminism's imagined family structure, such feminists [find themselves] frequently absent from recent discourse on feminism's (seemingly two)

generations."[38] In other words, as Diane Elam has put it: While most debates on the issue posit "senior," second-wave feminists against their "juniors" in the third wave, in reality "most feminists find themselves to be both a senior and a junior at the same time."[39]

However, I have chosen to structure this history of the pin-up using the wave metaphor nonetheless, because I maintain that, in addition to presenting the most straightforward chronology of dominant issues and ideas in the long history of the movement, a discussion of feminism's various waves provides the best available metaphor for precisely the paradoxes that have sustained the movement itself. The wave model respects the fluidity and resiliency of the women's movement but also respects the significance of difference and even conflict therein—which I believe many feminists who reject the wave metaphor wish to sweep under the rug in favor of a unity—just as illusory as a generation-based feminism—that threatens to prove fatal. Nancy Whittier has compellingly argued that "the presence and strength of conflicts over what it means to be a feminist and over appropriate feminist behavior and goals signify the continued vitality of the movement. A movement remains alive as long as there is struggle over its collective identity, or as long as calling oneself or one's organization 'feminist' means something."[40] This struggle has historically forced the question succinctly articulated by Elam: "Is feminism a *tradition* handed down by powerful ancestors, or is it a *progress* in which the latecomers, however dwarf-like, are always standing on the shoulders of those who came before, seeing farther, knowing more?"[41] While efforts to pose this question have perhaps inevitably resulted in the very polarization within the movement that this book attempts to track, as we will also see, nuanced efforts to answer it have resulted in a productive paradox that this book attempts to champion: of course, the reality of feminism is that both answers are correct—a fact that instigates tension but also understanding across generations, as a balance is necessarily struck between tradition and progress.

Indeed, I will argue that the pin-up itself, which has always struck a balance between tradition and transgression, makes it a useful case study for an investigation of not just feminist sexuality, but feminism itself. While the pin-up genre has been associated with the art practices of younger feminists of the third wave, I hope that by tracking both the pin-up and the debates it inspired back to the earliest years of the

movement, in exposing the pin-up's "secret" feminist history, I might contribute to the growing pool of feminist scholarship calling for an embrace of paradox in contemporary feminism by revealing its consistent presence in feminist history. For this reason, I address feminism's various "waves" less to mark (or privilege) age-based feminist generations so much as periodize feminism itself. Granted, I agree with Whittier's contention that "activists have long taken for granted [that] what it means to call oneself 'feminist' varies greatly over time, often leading to conflict over movement goals, values, ideology, strategy, or individual behavior. In other words, coming of political age at different times gives people different perspectives."[42] But, while it may be helpful for us to identify ourselves according to the shared experiences of the generation in which we were born, it is equally instructive for us to understand that we live through certain waves together, and waves are, by definition, fluid. Beside their nebulous beginning and end, they also flow into one another.

Both feminists and feminism itself exist, live through, and define the third wave—an evolving, malleable present, not a fixed, generational label—which is as much built upon as it is a challenge to the waves that came before. We are all invested in contributing to and vigilantly looking out for what is made of feminist practice as the tide continues to roll. This book responds to Henry's call for "the public exposure of the differences and diversity" within feminism's history, in the hopes that in presenting feminism—past and present—"as contested ground, it appears both alive and lively, open and eager for a new generation to engage with it."[43] I hope that by historicizing both these differences and their persistence in feminist visual culture, this book contributes to larger efforts to facilitate intergenerational dialogue as these new generations continue to emerge—particularly my own field of art history and criticism, where such dialogues are markedly polarized. I hope that my choice of the popular pin-up will encourage this discourse as it relates to both activist and academic feminists, popular and privileged imagery, across not only generations but also cultures and classes.

In chapter 1, I investigate the origins of the popular pin-up genre alongside the concurrent invention and popularization of photography as well as the emergence of both a rapidly growing middle class and an organized feminist movement in industrialized nations during the

mid–nineteenth century. This period's shifting ideals of female sexuality were literally embodied by female stage performers, whose ordinarily taboo expression of the female sexual agency and self-awareness many contemporary feminists were promoting was viewed as acceptable under the rubric of burlesque theatricals—which, like photography, were becoming increasingly popular among both male and female bourgeois patrons. I will address the ways in which, by juxtaposing and manipulating these concurrent trends in bourgeois culture, female burlesque performers used photography both to invent the pin-up girl and to imbue the genre with the same subversive, expressive sexuality that period feminists would increasingly view as an essential part of modern women's emancipation.

Chapter 2 tracks the pin-up's move into the twentieth century, during which time—reflecting the chaotic climate of fin de siècle culture —the genre grew to add an emerging feminist model known as the New Woman to a slowly growing cast of popular images of sexualized womanhood. As embodied by Charles Dana Gibson's illustrated "Gibson Girl" pin-ups, the New Woman, like the burlesque pin-up that preceded her, was a paradoxical, modern sexual ideal—however, unlike her clearly transgressive burlesque predecessors, the subversive edges of both the New Woman's feminism and sexuality were tempered by her familiarity. Like the feminist movement itself, the frightening openness of the New Woman was precisely her appeal: she might be native or immigrant, working- or upper-class, bride or "bachelor girl," even—as demonstrated in the photography of Frances Benjamin Johnston modeled after Gibson's illustrated types—straight or lesbian. One thing that the New Woman always was, however, was Anglo, and this chapter addresses the limits of celebrating this era of rapidly changing roles for women—in both their personal and professional lives—by drawing attention to the ways in which progressive views concerning feminist sexuality did not extend to either "Oriental" or African American women. Indeed, even white actresses—the presumed decadence of their profession thrown into high relief next to the well-scrubbed New Woman—were generally lumped into this period's "Othering" of certain female sexualities as feminist self-expression became more and more acceptably bourgeois.

This, however, would change in the earliest decades of the twentieth

century, as Western feminists moved toward an unprecedented, international unity through the dominance and agitation of the suffrage movement. While this period is marked by new activism in the form of well-organized and even violent suffrage protests, chapter 3 explores how the increasingly public and demanding feminist movement would also find it prudent to counter its radical new image by holding up popular female stage performers as icons of the movement. In these years the success and independence, even the eccentricities and sex appeal we see in the popular pin-up imagery of actresses such as Sarah Bernhardt and Ethel Barrymore—marveled at and admired by legions of fans across cultures and classes—were held up by suffragists as models of the myriad freedoms that enfranchisement would offer women. In this period, suffragists also came to appreciate theatricality itself as an activist strategy, and younger suffragists would embrace the self-conscious stylish image and performative feminism of the actress as tools through which suffrage protests might be turned into persuasive "parades." The result would not only broaden the strategies and reception of the period's feminist activism but also help make feminism fashionable among younger women who began to view the now decades-old suffrage movement as one that spoke to and for their generation as well.

Indeed, the "fashionable feminist" that emerged in the years bracketing the passage of the Nineteenth Amendment in the United States would be so popular as to provide the country's rapidly growing movie industry with a convenient symbol for the very type of transgressive, modern female characters on which the young industry's fortunes would be built. Whether in the form of serial daredevils, adventurous heiresses, or what the cinema scholar Lori Landay calls the "kinaesthetic" flapper, Hollywood recognized that women whose behavior pushed boundaries of traditional femininity guaranteed a box-office blitz. In addition to creating female characters to whom the period's overwhelmingly female audiences could both relate and aspire, the movie industry discovered that using the socially progressive language of the women's movement lent a political or educational "moral" to their otherwise sensationalist films. Perhaps unsurprisingly, in these years the dominant organizations of the American suffrage movement created their own popular films—built around real-life causes fought for by the films' fictional heroines—to exploit the industry's own exploitation of the

movement. In the midst of this revolution in popular culture, the film "fanzine" was born to report upon, analyze, and promote cinema and the modern culture that it championed, primarily to the young women whose lifestyles it allegedly reflected and whose pocketbooks were financing the burgeoning industry. Chapter 4 addresses the ways in which pin-ups presented in fanzines like *Photoplay* around the years of late woman suffrage give us a clear sense of how the turn-of-the-century New Woman evolved through its construction, reception, and emulation in a film culture much invested in feminist culture.

Alas, as the sensational modern woman depicted in Hollywood films gave rise to the creation and enforcement of the movie industry's Hays Code in the early 1930s, industry efforts to avoid the ire of censors would tame her into submission. The demise of these early feminist models in the cinema also reflected the period's overwhelming anti-feminist backlash after the successes of the international suffrage movement took away the single rallying point of organized feminist activism, and the economic depression that affected most of the nations affected by suffrage encouraged a dim view of women who agitated for gender equality when many argued more pressing problems needed to take priority. However, when "pressed" further by the unique cultural challenges arising from America's involvement in World War II, the pin-up once again came to idealize a subversive model of female sexuality with its explosive popularity during the war. Focusing on the phenomenon of illustrator Alberto Vargas's "Varga Girl," chapter 5 addresses his pin-ups as exemplary of the period's feminine ideals. The Varga Girl presented the American public with a heretofore unheard of combination of conventional beauty, blatant sexuality, professional independence, and wholesome patriotism that resembled the similar, contradictory cocktail of attributes cultivated by young women of the period. With the entire country focused on (even pandering to) youth as their strength and stamina were needed to lead the country into war, young Americans' fascination with the pin-up became the country's, and the Varga Girl a subversive icon for the sweeping changes in gender roles and sexual mores that developed during World War II.

Such developments toward the creation of a feminist ideal embraced by popular culture would rapidly change at the war's end. Thus began the era of the "feminine mystique" so succinctly addressed in Betty Friedan's

study of the systematic postwar repression of women's earlier feminist gains. However—as Friedan's own life as a mother, wife, journalist, and activist demonstrated—many women circumvented antifeminist postwar ideals in ways that would logically evolve into the full-blown second wave of the women's movement in the 1960s. In chapter 6 I track ways in which the pin-up genre reflected these changes in ways both subtle and explicit, and to audiences both underground and popular. Indeed, with the pin-up's increasing absorption for analysis by both the burgeoning civil-rights movement and the art-world avant-garde of the postwar era, the political meanings of the pin-up, so covert in previous generations, were acknowledged and amplified. These countercultural movements' approaching the pin-up as a subject of their progressive, yet critical view of the role of beauty and sexuality in contemporary culture gave license to pop artists, who would begin to recycle the image of the now nostalgic pin-up with meanings that fit the period's heady climate of political, cultural, and sexual revolution.

This legacy would prove both influential and problematic to feminism in the late 1960s and 1970s. On the one hand, the rise of a second wave of feminist activism led to a women's liberation movement that would kick open doors to sexual freedoms previously shut tight for women. On the other, many recognized that these "free" sexual practices often reflected the very power structures they had sought to overturn—the revolutionary aspect of encouraging women's sexual freedom had in reality exacerbated the oppressive, conventional demand for women's sexual availability to men. In chapter 7, I discuss the pin-up's appropriation by feminist artists as reflective of the period's rapidly changing and expanding second-wave discourse, when issues of sexuality were addressed with particular urgency, ultimately leading to a splintering of the women's liberation movement that reached a heated crescendo in the "sex wars" of the early 1980s.

This fragmentation of the feminist movement, while certainly using its debates on the representation of sexuality as a focal point, in fact reflected the much larger tendency toward multiplicity and an identity-based activism that marked the concurrent definition and discussion of an emergent postmodern era. Embracing the postmodern concept of the potential and "ownership" of one's unique politics and self-expression, as well as the redefinitions of "community" that inevitably

followed, feminism's current and third wave also emerged from this culture to stress the multiple feminisms within the now-sprawling and truly international feminist community. Chapter 8 is dedicated to both periodizing and problematizing the third wave through feminist appropriations of the pin-ups since the early 1980s. In the twenty-some-odd years since Barnard College's groundbreaking "The Scholar and the Feminist: Toward a Politics of Sexuality" conference proposed the subject of sexuality as reason for and a way toward a thoughtful, plural feminist culture, at least one generation of young feminists has come of age to internalize and apply this proposal as a matter of course, rather than a point of violent debate. This chapter addresses the proliferation of contemporary feminist artists using the pin-up to simultaneously connect to and disavow earlier feminist practices and ponders the pin-up's legacy in the midst of the intergenerational battles over the same in contemporary art criticism.

1

REPRESENTING "AWARISHNESS"

The Theatrical Origins of the Feminist

Pin-Up Girl

Faye E. Dudden's *Women in the American Theatre* begins with an anec-
dote about the author's grandmother, who once told Dudden, "with
an air of considerable importance, that *she had seen Ellen Terry*."[1]
Whether her grandmother had witnessed a performance by the legend-
ary nineteenth-century Shakespearean performer or had simply caught
a glimpse of the actress in the street, Dudden could not tell. What
the author did understand, however, was that the awe with which her
grandmother regarded the actress revealed something of the curious
status which women of the stage possessed in the early decades of the
industrial revolution—an age in which society generally indexed white
women at one of two poles of existence: the idealized domestic "true
woman" or the vilified "public woman." Women's dissatisfaction over
this binary existence would ultimately lead to the emergence of the
first wave of feminism in Europe and the United States, which would
battle for recognition of the actual (and growing) spectrum of realities
for women in between. But before these "New Women" were able to
articulate and project their demand to transcend the binary order by

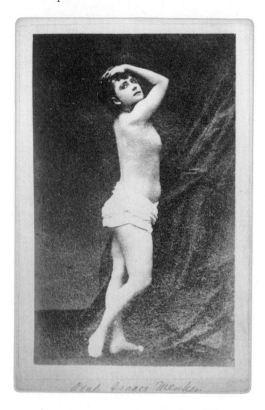

4: Photographer
unknown, Adah
Isaacs Menken,
ca. 1865 (Harvard
Theatre Collection,
The Houghton
Library)

which female identity was indexed in society, in the theater the presen-
tation of the multiplicitous, shifting, even unstable womanhood of the
actress was not only an acceptable but a celebrated identity for women.

While female performers like Ellen Terry pursued careers in the per-
formance of theatrical classics—Shakespeare, Greek tragedy, and ro-
mantic drama—a great many more, such as the sensational Adah Isaacs
Menken (fig. 4), thrived in contemporary musical comedies and melo-
dramatic spectacles that demanded comparably physical and sexually-
suggestive performances. By the mid–nineteenth century it was ac-
ceptable for women to act out not only these multiple female but also
multiple male roles without fear of reproach in an age where, we shall
see, the mere presence, much less voice, of women in the public sphere
was considered an aberration. Moreover, as actresses' talents came to
afford them a certain celebrity status, the "performance" of off-stage
personae became increasingly acceptable, even when they performed

real-life roles considered taboo for ordinary women. Dudden concludes that, for all these reasons, to a woman like her grandmother the actress "stood for pecuniary independence, authenticity, or the possibility of self-transformation; perhaps she was simply beautiful, famous and desirable. Perhaps, indeed, she was both."[2]

Among the stage performers of the early burlesque era, we find interesting connections not only between these actresses and the goals of the slowly emerging "women's rights" movement, but also between these women and the continuing goals of feminist artists today. Then, as now, the construction, fluidity, and politics of sexuality was a focus of their work and identity. Most striking is how much these women's photographic imagery—when created to represent and promote these sexualized theatrical identities *outside* of the contained space of the theater—was created, circulated, and made visible in ways that would be used and debated by feminist thinkers for decades to come. As we will see, early *carte de visite* photographs of bawdy burlesque actresses represented not only the earliest examples of pin-up imagery but also a space in which these stage performers could construct, control, and promote what one nineteenth-century burlesque performer would call a feminist ideal of sexual "awarishness" in an era of both great oppression and great strides for women.[3]

Sex and Sphere

To understand both the complicated identity and the subversive nature of the nineteenth-century actress, one must also understand that the era's views on women's potential were inextricably tied to their sexuality, which in turn was tied to their level of visibility in the public sphere: regardless of race, class, or background, it was generally assumed that the more public the woman, the more "public," or available, her sexuality. As the middle class exploded in the mid–to–late nineteenth century, not only making up its own codes of conduct but also affecting those previously thought stable (and even genetic) in populations both "above" and "below" the bourgeoisie, middle-class morality held sway over more than just its own members as its numbers and influence grew in the early years of the industrial revolution. In their monumen-

tal study of sexuality in American culture, *Intimate Matters*, historians
John d'Emilio and Estelle B. Freedman assert that influential literature
from this period (both scientific and otherwise) reversed earlier beliefs
in the inherent Eve-like carnality of white women, suggesting rather
that woman is a passionless creature, whose "maternal instincts . . .
were stronger than her sexual desires." This supposedly natural asexu-
ality would inevitably lead these women to disdain any sort of public
life, where the passions and vices of men ruled and corrupted. D'Emilio
and Freedman also note that this "new ideal of sexually pure woman-
hood created an antithetical model: the so-called fallen woman who
defied nature or failed to resist men's advances."[4] Exemplary of this era's
fallen woman were the Caucasian, working-class women of Western
urban centers, caricatured as the flamboyant "Bowery Gals" of New York
City's low-rent and theater districts or the seductive *filles publiques* of
Paris.[5] Although some of these women might have supported them-
selves through prostitution, many simply indulged in the sensual and
commercial pleasures of these districts with wages earned from the new
labor opportunities available to them outside of the home—jobs cre-
ated directly (like mining and factory work) or indirectly (like sales and
service positions) by the industrial revolution.

But, as feminist historian Jean H. Baker notes, one also found deter-
mined, educated women from both bourgeois and upper-class back-
grounds living increasingly public lives alongside the working classes:
women from families headed by fathers working in the rapidly expand-
ing managerial class whose families not only enjoyed more money and
leisure time than their predecessors but also felt it increasingly appro-
priate to educate their daughters in a manner similar to their sons. Like
their working-class sisters, these women felt similarly entitled to their
own professional and personal lives and would increasingly come to
consider political enfranchisement an obvious and tardy entitlement
as well.[6] While the ramifications of such changes in the education of
women would not reach critical proportions until the fin de siècle—the
consequences of which will be explored in the following chapter—by
midcentury one nonetheless finds the stirrings of what would eventu-
ally become a formidable, if diverse and contentious, movement advo-
cating the greater influence of women in the public sphere. With radi-
cal antislavery, free-love communitarians, and socialist "wild women"

arguing for equal rights regardless of gender, race, or class at one end of the spectrum, and Victorian "true women" (subscribing to the feminine ideal of "four cardinal virtues: piety, purity, submissiveness and domesticity")[7] arguing for the necessity of woman's innate nurturing instincts in determining government policy on the other, these women found that they had little choice but to make their lives increasingly public in order to obtain a political voice.[8] Whereas "proper" upper- and middle-class women began the nineteenth century cloistered in the family home and engaged in strictly private courtship and marital relations, as the century wore on more women, and more kinds of women, would find reasons to become familiar with and comfortable in the public sphere, openly pursuing the social, political, and even sexual pleasures available there.

The female stage performer existed in the same urban centers where all these women proliferated but, as Tracy C. Davis wrote, enjoyed a unique status there: "Actresses were symbols of women's self-sufficiency and independence, but as such they were doubly threatening: like the middle classes generally, they advocated and embodied hard work, education, culture and family ties, yet unlike prostitutes they were regarded as 'proper' vessels of physical and sexual beauty and legitimately moved in society as attractive and desirable beings."[9] As such, by the mid-nineteenth century, female performers were among the first women to negotiate a rare gray area between the two poles of the period's societal binary for their sex. They were proof that there existed alternative, unstable, and powerful roles for women in the modern public sphere—transgressive identities that were not only made visible but even celebrated in the theater and its promotional imagery.

Like the stage identities they were meant to represent, these photographs—among the earliest modern pin-ups—call into question the ability to define women according to a binary structure while marking the spectrum of unstable and taboo identities imagined and imaged between these poles as acceptable and even desirable. Moreover, these early pin-ups served to create a popular awareness of these transgressive identities—sexual, certainly, but also professional and even intellectual—through media more readily controlled than and separate from the theater. Such uses of the pin-up genre resulted in a decontainment of their subjects' unstable performances from a specific physical site. In this

way, the period's theatrical cartes de visite aided in the pin-up's establishment at its origins as a genre defined by the ways in which its media and viewers were manipulated by the will of its subjects. As representations of female performers who pointedly explored roles (both on- and offstage) in the interstices of the period's binary construction of femininity, their pin-ups can also be read alongside the larger activist culture of the nascent women's rights movement that would blossom in the years following the burlesque boom.

Photography, Women, and Burlesque in
the Realm of "Democracy"

The invention of photography was shared by several individuals working independently in France and England in the late 1830s, but the patenting of the positive metal-plate process daguerreotype is credited to French photographer Louis Daguerre. By the 1850s, however, negative-positive methods were invented, lending the photograph—heretofore a singular and unreproducible image—to mass production. In 1854, A. A. E. Disdéri patented the carte de visite (or "calling card") process, through which a multiple-exposure camera recorded up to eight images on one negative. These images were then mass-produced and distributed by the photographed subject (if a private patron) or the photographer (if the subject was a celebrity), and prints sold for pennies apiece.[10] Cartes de visite, generally six by nine centimeters, were mounted on the reverse of the conventional calling cards that the European aristocracy had used to identify and document their presence upon visits to other persons of rank since the sixteenth century. As Elizabeth Anne McCauley notes in her study of Disdéri and the carte de visite, from its inception the portrait taken and circulated of the card carrier using this photographic process—like the calling card from which the process took its name—served as "a legitimization of identity and proof of a certain social standing, even if the claims and titles printed on the card were bogus."[11] The novel, inexpensive cartes were aimed at attracting, and mainly consumed by, the expanding middle classes of Europe and the United States, eager to demonstrate materially their social and cultural clout.

McCauley also notes that such "commercial photography grew out of the popular Boulevard de Crime circus and vaudeville entertainments"—and the population in which both aristocratic pretensions and vaudeville vulgarity frequently intermingled was the bourgeoisie.[12] The growing middle classes of the nineteenth century, with more money to spend and a proliferation of popular theaters at which to spend it, demonstrated a demand for imagery of theatrical celebrities, a familiarity with whom the bourgeoisie asserted their modernity. As one critic of the period noted: "The private supply of cartes de visite is nothing to the deluge of portraits of public characters which are thrown upon the market, piled up by the bushel in print stores, offered by the gross at the book stands, and thrust upon our attention everywhere. These collections contain all sorts of people, eminent generals, ballet dancers, pugilists, members of Congress, Doctors of Divinity, politicians, pretty actresses, circus riders and negro minstrels."[13] The *American Journal of Photography* spoke to the democratic and even educational potential that exposure to the various careers and classes represented in cartes de visite could offer a collector, writing that viewers "might take no harm from associations which now they could regard with sentiments of aversion and even of horror; indeed, much of mutual benefit might be derived from very many persons coming into contact with one another, who now stand sternly apart; and certainly, very many persons might confer most important benefits, even though they received within more than a fresh lesson in experience with both classes of individuals that are now absolutely unknown to them."[14]

Capitalizing upon the period's breathtakingly optimistic views of photography's potential, McCauley asserts that "Disdéri's cartes de visite, which had been conceived as inexpensive portraits for the bourgeoisie, became a means of advertising or propaganda for the rich or talented."[15] The images were snapped up by middle-class consumers at photo studios, cigar shops, book and print stores, and theatrical venues, and displayed in albums alongside cartes of friends and relatives.[16] Because of cartes de visites' associations with both professional and social "calling cards," they were collected by women as well as men—indeed, because carte albums often served to document the familial and social connections of the families that owned them, many women went to great lengths to create impressive volumes of imagery for display

in their homes. By 1870, carte-de-visite albums were such a ubiqui-
tous accessory of bourgeois women's lives that even dolls' "trousseaus"
included them—complete with miniature cartes of other dolls pur-
chasable through the manufacturer.[17] A technology aimed at bourgeois
consumption and social "upclassing," this sneaky commercial ploy dem-
onstrates how quickly the early photographic medium was exploited
from the outset for both its identification with the middle class and its
propagandistic potential.[18] French emperor Napoléon III and England's
Queen Victoria used the new technology to construct and promote the
imperial families as dignified and fashionable, yet unpretentiously mod-
ern and accessible. However, as we will see, the leveling quality of the
carte de visite was used rather toward upwardly mobile motives of the
"pretty actresses" of the demimonde—the shadowy, yet exciting "second
society" of artists, performers, and courtesans—who used the medium
to advertise and elevate the perceived status of their professions as enter-
tainers.

For decades after their invention, cartes de visite of bourgeois female
subjects followed the earliest precedents set by its aristocratic sitters—
the understated images of Napoléon III's beautiful Spanish wife, Em-
press Eugénie, exemplifying the era's feminine ideal in photographic
portraiture (fig. 5). A carte de visite of 1860 is highly representative of
her photographic portraiture of the period. The empress stands, arms
crossed in a stiffly "casual" pose, against the back of a thronelike arm-
chair. She wears a fashionably modest, full-skirted, dark satin dress
with minimal and monochromatic ruffled edging and embroidery, and
she gazes off-camera with a look of dreamy repose in a tilted, three-
quarter profile. A model of quietly virtuous, contemporary woman-
hood, Eugénie's cartes de visite also reflect the extent to which middle-
to-upper-class female subjects were influenced by fashion plates of the
period—popular illustrations in, among other sources, ladies' journals—
with photographic subjects imitating the sweet and courtly illustrated
ideal of the "steel-engraving lady."[19] The passive and unengaged de-
meanor of the fashion plate, reflected in popular images such as Em-
press Eugénie's, came to be the ideal for women across Europe and the
United States, and the power of the steel-engraving lady as an icon of
"true womanhood" in the popular imagination would last well into the
twentieth century. Such standardization of appearances for women—

5: S. L. Levitsky,
Empress Eugénie,
1860 (William Culp
Darrah Collection,
courtesy of Histori-
cal Collections and
Labor Archives, Spe-
cial Collections, The
Pennsylvania State
University)

notably lesser for men in both the imagery and magazine suggestions
of the day—also reflects a more subtle issue: the period's desire to rep-
resent the individual woman as the timeless and essential definition of
woman.[20] In other words, carte-de-visite photography strove to represent
women as representational subjects whose personality (like their photo-
graphed demeanor) was constant and indexical. Burlesque performers
approached the medium with radically different ideals and motives.

What would become known in the United States as the burlesque
"leg show" in the nineteenth century is a theatrical performance gen-
erally based textually upon (or parodying) a historical or romantic fan-
tasy drama. In it, the show's focal point was not the drama itself, but
the performances of scandalously scantily clad actresses and coryphées.
In early burlesque shows, women frequently performed both the male
and female roles, often using the historical texts as frameworks to either
"send up" or juxtapose the venerable texts themselves and contempo-

rary events, manners, and fashions.[21] From the 1830s, elements of the leg show had been both prominent and a popular draw for theatergoers in France, Italy, and England, as were the actresses and ballerinas who used the brief costumes of Romantic ballet to draw attention to their figures.[22] The leg show offered a space in which women were not only the visual draw, but frequently the sole actors, comedians, and writers of the material, and soon evolved into the theatrical staging of a Victorian world upside-down, raising what historian Robert C. Allen calls "troubling questions about how a woman should be 'allowed' to act on stage, about how femininity should and could be represented, and about the relationship of women onstage to women in the outside, 'real' world."[23]

Burlesque, interestingly enough, is credited as being brought to legitimate theatrical spaces in the United States in 1860 by a woman: Laura Keene, a savvy playwright and theater manager who sought to draw larger male audiences to her "women's plays," and away from the working-class dance halls and concert saloons of New York City. In these venues, prostitutes often served as both performers and servers, entertaining the all-male audiences in outfits that bared shoulders, cleavage, and legs. As a result, the identity of the female performer in the United States had, since the eighteenth century, fit neatly into the category of the "public woman": a literal or de facto prostitute. In fact, it was not until late in the first half of the nineteenth century that actresses came to gain recognition as either performers or theater consumers, largely due to lingering associations of the actress with prostitution.

While the status of the theater was elevated considerably during the Enlightenment, along with other popular art forms, even the era's most celebrated thinker, Jean-Jacques Rousseau, continued the centuries-old argument that its very nature was suspect. Rousseau's 1758 *Lettre à d'Alembert sur les spectacles* held that actors were guilty of "trafficking in the self," a position that remained a highly influential one in the following century.[24] In Europe, the mere theatrical display of female performers—whether dancers or actresses—was associated with the same display and commercial "exchange" of the prostitute, a profession in which many women in the theater dabbled, if not took on as a primary source of income. In fact, as Abigail Solomon-Godeau has pointed out, even when the stereotype of the actress/courtesan became increasingly confused and disseminated among a growing spectrum of female iden-

tities later in the nineteenth century, the theater nonetheless served as a site in which "society women, marriageable daughters, and courtesans [still] participated in intricate rituals of exhibition and display."[25] This association of the theater with the prostitute was arguably even firmer in the United States, where the nation's puritanical origins held sway over the perception of performance in general, and the immorality it implied. As Allen notes in his analysis of the puritanical influence on American theater reception: "Whereas the actor's mimetic abilities linked the theater with the sin of blasphemy and the crimes of fraud and bearing false witness, his showing off connected it with the sin of idolatry and the crimes of exhibitionism and prostitution."[26] So strong, in fact, were American associations of the theater with the sexual display and dissipation of women—both on the stage and in the audience— that well into the nineteenth century the third tier of boxes in American theaters were reserved for prostitutes and their clients to conduct business.

Such typical associations of women in the public sphere with sexual exchange both limited the range of women's professional roles there and were frequently used to defend their lack of representation in politics— a fact that women after the industrial revolution grew to realize affected not only the public sphere, where they were accustomed to limited access, but also the domestic sphere over which they allegedly reigned. However, many women would use their place in this domain—and the traditional idea that strong families and morals were formed there—to begin challenging the period's politics. Capitalizing on this fact, the burgeoning women's rights movement of the nineteenth century would, paradoxically, first begin to thrust women into the public sphere based on the particularly "feminine" wisdom they allegedly brought from the domestic. (This is a strategy reflected in perhaps the earliest collective effort to articulate goals for a modern women's movement, the 1848 "Declaration of Sentiments" written at the famous Seneca Falls Convention organized by Lucretia Mott and Elizabeth Cady Stanton.)

This paradox did not go unnoted. As feminist historian Alison M. Parker notes of the period's female activists, no matter how righteous the cause, their activities would inevitably lead to "charges that they were engaging in an unwomanly meddling in politics. Criticism often focused on the right of women to speak in public," where the same

mores that affected female performers' public display as entertainers af-
fected not just suffragists but even evangelical, temperance, and anti-
slavery campaigners whose causes were otherwise supported by the very
men who led the movements.[27] When the fame of women abolitionists
like Sarah and Angela Grimké grew, in 1837 the Council of Congre-
gationalist Ministers of Massachusetts issued a strong condemnation of
women's participation in public, stating: "The power of woman is her
dependence. . . . But when she assumes the place and tone of man as a
public reformer . . . she yields the power which God has given her for
her protection, and her character becomes unnatural."[28] The following
year, when Quaker abolitionist Abby Kelley gave her first public speech,
rioters were moved to such violence by the headlining female lecturer
that by the end of the conference they had succeeded in destroying the
building in which it took place.[29] And when in 1850 former slave So-
journer Truth drew crowds to a series of lectures in Indiana, the force
of her rhetoric and personality led an incredulous audience there to de-
mand she prove that she was not a man—culminating in her famously
revealing her breast to the audience as indisputable proof of her sex.[30]
So suspicious was the public woman of the period that it was argued that
a woman simply presenting herself in a public forum like the meeting-
house or polling booth would compromise her femininity.

So it was that both Laura Keene's professional ambition and her strate-
gies for expanding women's participation in the theater were subver-
sive. On the one hand, Keene was among many of the period's theatrical
managers who sought to establish a space in which live performance
could be "elevated" as a virtuous and viable entertainment for a middle-
class audience. In this way, her attitude reflected a general drive toward
the segmentation of American theaters as an increasingly diverse Ameri-
can theatergoing public grew. Class antagonisms had been clear since
the institutionalization of live entertainment in the United States, and
growing as the expanding middle classes were problematizing centuries-
old breakdowns of social status. The different mores regarding inter-
action between the lower-class "elements" of the pit and third tier and
the upper-class patrons of the private boxes—both with the perfor-
mance itself and between one another—had historically been a con-
siderable source of tension among audience members and performers.

But after a riot erupted in and claimed the lives of twenty audience members in the ensuing police row at New York's Astor Place Theater in 1849, American theaters became increasingly particular in the audiences that their respective management courted, and to which their styles of performances catered. The Laura Keene Theatre had a respectable location along the upscale Broadway strip, featured no discount sections and certainly no third-tier business, and charged high ticket prices compared to other middle-to-upper-class theaters.

On the other hand, Keene's theater sought to cultivate a unique niche within the middle-class market in that it had no bar (a staple at even the most expensive locales) and courted the patronage of not just female audiences, but in particular the very "true women" of genteel society whose unwillingness to participate in such popular entertainments had been a sign of their virtue. In addition to her dry theater's implicit nod to the temperance movement, Keene's reputation of personal involvement in charitable societies and her writing and staging of plays dedicated to "women's themes"—which revolved around sympathetic (and often contemporary) female lead characters—aided in her goal. Staged in 1860, Keene's play *The Seven Sisters* is frequently credited as the first production to bring elements of the concert saloon's feminized spectacles to a "legitimate" American theatrical space. In line with the conventions of the romantic ballet, Keene's play incorporated the European, short-petticoated corps into her narrative about a daughter of the god Pluto who visits contemporary New York City and falls in love with a young playwright.

It was not, however, Keene's clever premise, but what one period critic noted as the show's "hundred miscellaneous legs in flesh-colored tights," that most impressed the audiences.[31] The woman-centered spectacle was a sensation among Keene's audiences, and the play went on to a run of two hundred performances. Keene's move to displace the as-yet-unnamed leg show from the visibility of an all-male, working-class audience and into a middle-to-upper-class theater for the pointed consumption of women and their families helped instigate what would soon become a boom of leg show productions and performers in the United States. Seeking to capitalize on Keene's success came a flood of ballet- and burlesque-based performance in "legitimate" American the-

aters, as most notoriously demonstrated in the successes of actress Adah Isaacs Menken, the production of *The Black Crook*, and Lydia Thompson's British Blondes comedy troupe.

In 1861, Adah Isaacs Menken took the title role in a production of Lord Byron's *Mazeppa* at New York City's Broadway Theatre, at what appeared to be the end of an unsuccessful run. The male role of Ivan Mazeppa required an equestrian scene in which the lead (or, rather, a dummy or double) was exiled into the wilderness, stripped naked, and tied to a charging steed, which served as the Broadway Theatre's heretofore weak spectacle draw for the show. Taking control of the drag "britches role," Menken insisted on performing the stunt herself—clothed, moreover, in nothing more than the coryphée's pink body stocking and a brief tunic, which would appear in a blur to the audience as a naked woman bound to a horse. With Menken in the lead role, the ailing production was reborn due to her use of this leg show gimmick and ran for another eight months. This Broadway success resulted in a West Coast revival, for which the actress reportedly earned over $100,000[32]—a blockbuster Mark Twain thought important enough to attend and describe in 1863 while serving as a critic and correspondent in San Francisco. (Twain cheekily described Menken's minimal costume as a "thin, tight, white linen [garment] of unimportant dimensions; I forget the name of the article, but it is indispensable to infants of tender age.")[33] This theatrical style of "clothed nudity" that Menken helped usher into the show—be it Mazeppa's flesh-colored tights (fig. 6) or, later, form-fitting male drag—would soon become a staple of the burlesque spectacle, as would the audacious star image that she built for herself.[34]

Following Menken's successes, in 1866 another important production influenced by Keene's synthesis of legitimate theatrical conventions and contemporary, feminized spectacle rose in the form of a production of *The Black Crook* at Niblo's Garden. Known for its luxurious and large-capacity seating, up-to-the-minute set technology, and spectacularly staged productions, Niblo's was regarded by many as the finest theater in America, and its staging of *The Black Crook* brought Keene's conventions to an even more upscale and less gender-specific audience.[35] Combining the traditions of fantastic melodrama, romantic ballet, and the contemporary leg show, the play is often credited with the distinc-

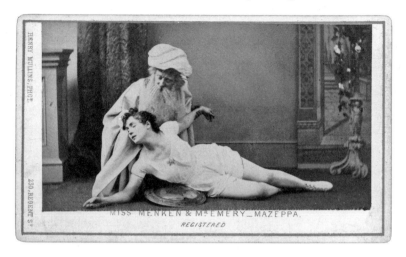

6: Henry Mullins, Adah Isaacs Menken, and Sam Emery in *Mazeppa*, ca. 1865 (Harvard Theatre Collection, The Houghton Library)

tion of being both the first modern Broadway musical and the first true leg show. Using the already acceptable premise of the abbreviated ballerina costume as its focal point, *The Black Crook* featured dancers in what Twain would describe in another of his theatrical reviews as elaborate "half-costumes."[36]

The play ran for an unprecedented fifteen months, closing (in the same way it opened) to packed houses, and instigating an astounding amount of both praise and criticism during its run for what was viewed as the production's social and moral transgressions—particularly before the "respectable" audiences that frequented Niblo's. Many critics lauded *The Black Crook*'s ability to draw wide audiences with its novel, spectacular elements. A year into its initial run the *New York Tribune*'s drama critic enthused: "Children cry for it. Countrymen coming to town clamor for it, and will not be comforted until they see it. The rural visitor, in fact, divides his time between Niblo's Garden and Trinity Church, and he certainly sees a good deal of both places."[37] Many others, however, saw the popular crossing-over of the leg show from the confines of the working-class concert saloons (and the delectation of their all-male audiences) and into a reputable playhouse as a threat to the bourgeois social order. As the city's entertainment review, the *New York Clipper*,

wrote on the issue: "We question whether this introduction of such un-dressed performers at a first-class theater like Niblo's will not injure the heretofore excellent character of that house. . . . why not take [its] im-ported nudities and exhibit them in some place more suited to such exhibitions than Niblo's Garden?"[38]

Much to the dismay of its critics, however, the popular interest in such performances continued to grow in the New York theater district. Two months after the closing of *The Black Crook* at Niblo's, Lydia Thomp-son's burlesque troupe, the British Blondes, arrived in New York in 1868, hoping to capitalize on the American popularity of the leg show with productions and performers that they had made popular in England. Thompson had been a child star of the British stage and grew up to lead her own troupe of performers—four women and one man, each of whom had gained fame in the London theatrical community be-fore joining her—through performances at venues as prestigious as the Prince of Wales and Strand Theatres. Shortly after arrival in the United States, the British Blondes secured dates at Wood's Theatre and, even-tually, Niblo's itself. The biggest surprise of the Blondes' success was the fact that the troupe used not the highbrow pretense of drama or ballet for their "leg show," but bawdy humor and satire as the framework for their largely all-female performances. They lampooned classical litera-ture and contemporary culture alike (and sometimes simultaneously), as well as the very notion of the melodramatic and sentimental contempo-rary female that the ideal nineteenth-century "true woman" supposedly represented—an ideal that previous leg show practitioners, to a certain degree, maintained in their reliance upon classical or allegorical allusions in their performances. Their choice of stage attire was equally brazen. Whether adapting togas or male garb, their costumes always empha-sized the performers' forms according to the very contemporary ideals of charismatic sexuality that actresses like Menken had already popu-larized.

What Thompson and her Blondes made manifest was what dramatic actor and essayist Olive Logan would vehemently criticize less than a year after the Blondes' arrival as the leg show performer's subversive ten-dency to be "always peculiarly and emphatically herself—the woman, that is, whose name is on the bills in large letters, and who considers her-self an object of admiration to the spectators."[39] It was not their sexual

display that Logan found objectionable—for that had been a residual effect of the art of actors and dancers for generations—but the acknowledgment and flaunting of their capacity for agency and pleasure, both professionally and sexually. For Logan, as for many social critics of the late nineteenth century, women's ability to provoke sexual desire was an unfortunate fact of their existence, inevitably hindering women's ability to function in the public sphere. However, for women to actually invite, control, and relish the same was another, more dangerous issue entirely. It was also an issue that many burlesque actresses sought to explore and idealize in their professional and personal lives alike. Blurring the borders between character and actress, performance and reality, the birth of burlesque had created an unusual new role for its already unusual female performers: not just a charismatic public ideal for women, but an openly sexualized ideal of what Thompson herself referred to as modern women very much aware of their "own awarishness."[40]

Audacity and Ambition: The Pin-Up Is Born

It was with this sense of "awarishness" that burlesque performers approached the new medium of photography in their efforts to promote both their productions and themselves as celebrity figures. As Logan rightfully noted in her criticism of these women, they were unsettling not simply because they were on the stage, but also because of their conscious contemporaneity and sexual self-awareness. Worse yet was the fact of their willingness to exploit both to advance their careers. All of these traits of the burlesque actress culminated in their cartes de visite, the display of which, Logan lamented, could scarcely be escaped: "You can go to almost any green-room of this period, and find their business cards stuck about in the frames of the looking-glasses, in the joints of the gas-burners, and sometimes lying on the top of the sacred cast-case itself."[41] The simultaneous emergence and popularity of both the leg show and the carte de visite guaranteed that the marriage of the two would be a shrewd promotional device for burlesque performers. More important, it was a manner in which their transgressive, self-constructed identities could be made visible outside of the contained world of the theater itself—in ways that would contribute to

7: A. A. E. Disdéri, Adelaide Ristori as Medea, ca. 1858 (Harvard Theatre Collection, The Houghton Library)

overturning conventions of both women's place and women's potential in the public sphere.

In line with her lifelong tendency toward what one contemporary historian dubs "Barnumesque tactics" in self-promotion, Adah Isaacs Menken was among the first actresses to use carte-de-visite technology for both publicity and posterity.[42] Successful precedents had proven that easily reproducible promotional portraiture could be manipulated to construct a favorable image of a performer's talents. P. T. Barnum's own widespread campaign of print imagery in 1850 had helped create the craze that surrounded Jenny Lind's first performances in the United States.[43] Later, Disdéri's portraits of Italian actress Adelaide Ristori as Medea (fig. 7) had helped to herald and promote her performances— and to establish her reputation as an actress worthy of such widely cir-

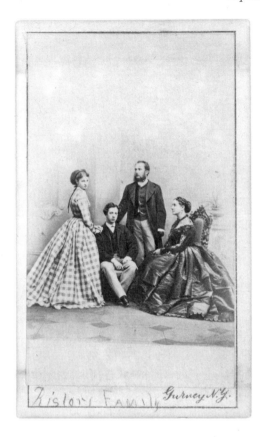

8: J. Gurney,
Ristori Family,
ca. 1860 (Harvard
Theatre Collection,
The Houghton
Library)

culated imagery.[44] What Lind and Ristori represented—in their promotional imagery as in their on- and off-screen star images—was an image of the actress in accord with an ideal of the virtuous female performer. These actresses clearly rejected the unseemly theatrical tradition of the actress-courtesan by thoroughly denying any sexualization of their star identity. Their identities asserted the potential of the true woman to exist in the sphere of the theater as in the home, making them a type of actress lauded by Logan as a woman "of tender feelings, holy passions, such as every author loves to paint."[45] Like Queen Victoria, Ristori even circulated celebrity photos of herself with her real husband and children (fig. 8), lest admirers doubt the "true womanhood" of these two public figures.

Menken's photographs, however, tended to highlight the scanty or

masculine costuming of her performances, and her very contempo-
rary and scandalous sense of personal style. A published poet and es-
sayist, lecturer for the political causes of the women's rights movement,
and self-described bohemian, Menken smoked cigarettes, wore her dark
curly hair short in homage to Byron, married and divorced four times,
and openly took lovers. Sexually and racially ambiguous (she variously
claimed and conflated French, African American, and Spanish roots),
a passionate convert to and scholar of Judaism who would baptize her
only (illegitimate) son in the Catholic Church, and a southerner who
claimed allegiances to both Union and Confederate causes (depending
on that night's audience), Menken's true history remains obscured by
the constantly changing tales she told about her past and the contra-
dictory personae she presented to friends, lovers, and the press.[46] She
sought to capitalize on these transgressive qualities by constructing her-
self, in carte-de-visite pin-ups as on the stage, as a new and wildly para-
doxical model of contemporary womanhood. Menken's negotiation of
a space between virtue and vice in her acknowledgment and represen-
tation of a self-aware feminine sexuality—as well as her fluctuations
between races, religions, sexual preferences and political associations—
would come to fascinate the period's permissive bourgeois theatergoers.
Menken's precedent also set the standard for many female performers
who came after her, as the word *Mazeppa* became synonymous with the
wild behavior and unstable identity of contemporary actresses.[47]

Menken's cartes de visite presented her in a manner quite unlike the
charming portraiture of Lind (the very epitome of the true woman).
They also differed from the *tableau vivant* style of Ristori's various and
dramatic family portraiture, all of which read as maternal performance
"stills," whether she was posing as the tragic, antique (and modestly at-
tired) Greek mother, or a bourgeois, contemporary variation of the
same. In Menken's cartes de visite in the role of Mazeppa, the actress
posed in both the veiled "clothed nudity" and the embroidered breeches
costume of her stage character. In either case, the photograph's focus was
upon Menken's contemporary looks, voluptuous physique, and charis-
matic sexuality.[48]

Known to be conscious and controlling of her star image, Menken's
exacting approach to the medium and its representation of her image
was recalled by American photographer Napoleon Sarony, who first

9: Photographer unknown, Adah Isaacs Menken in *The French Spy*, ca. 1860 (Harvard Theatre Collection, The Houghton Library)

photographed the actress in 1865 in a variety of "street dresses" and costumes. As a condition of his commission, Sarony had to agree with the actress's demand for control over her own poses, and she instructed her agents to make available the photos of her choosing for sale at every city she played.[49] In Sarony's photographs of Menken in costumes from the play *Children of the Sun*,[50] the actress is clothed in gypsy-styled drag, with a plunging neckline and leg-baring breeches, and reclining in a pose simultaneously suggestive of heroic death and sexual invitation. In yet another Sarony photograph, however, Menken is posed in a chaste style much closer to that of classical actresses such as Ristori, portraying a moment of theatrical, tragic reflection. In Sarony and other photographers' cartes de visite for her popular breeches roles in plays like *Black Ey'd Susan* and *The French Spy* (fig. 9), Menken was photographed as a glamorous feminine beauty "passing" in remarkably convincing male

drag, posing with a butch swagger that predated Marlene Dietrich's similar vamping in *Morocco* by nearly eighty years. As a clever form of bait-and-switch promotion, Menken even constructed cartes de visite of herself (see fig. 4) in shocking topless costumes that she never attempted on the stage yet surely assumed would tantalize theatergoers to attend performances with hopes of witnessing the display that the pin-up seemed to advertise.[51]

Lind had counteracted the unstable identity of the female performer with extratheatrical acts such as donating proceeds from her concerts to local charities, thus cultivating a national reputation "as one of the most admirable and saintly women in the world."[52] Menken instead reveled in her financial success and professional ability to disrupt conventional feminine ideals from her first press conference, where she flouted conventions of femininity with style and pleasure. After her debut performance as Mazeppa, the Menken (as she would come to be known) was reported to have accepted members of the press at her upscale hotel while "reclining on a tiger-skin, sipping champagne, feeding bonbons to a French poodle," and wearing an open-collar blouse over a "daringly short skirt . . . [with] a total absence of petticoats."[53] Appalled by the lack of education most women received and unapologetic about her disdain for the contemporary ideal of domestic womanhood (as well as adamant that it was her lot to reject the same), Menken's views on women's "place" resemble those of predecessors such as Mary Wollstonecraft and Frances Wright and look forward to much-debated essays on marriage by the generation of New Women who followed her, when late in her short life Menken wrote:

> I don't believe in women being married. Somehow they all sink into nonentities after this epoch of their existence. That is the fault of female education. They are taught from their cradles to look upon marriage as the one event of their lives. That accomplished nothing remains. However, Byron might have been right after all: "Man's love is of his life a thing apart, it is a woman's whole existence." If this is true we do not wonder to find so many stupid wives. . . . Good women are rarely clever, and clever women are rarely good wives.[54]

She refused, however, to be treated with the disrespect given the prostitute, regardless of her flouting of convention. Pinched in the thigh dur-

ing the course of a performance by a male member of *Mazeppa*'s British touring cast (for improvised comic effect), the actress soundly chastised the perpetrator with a blow from her prop whip—an event delightedly reported upon and widely illustrated in the British and American press.

Menken's use of the carte de visite—much like her choice of stage roles—denied a binary identity in the roles of women both on and off the stage. Blurring the line between life and performance, Menken circulated imagery of herself in both stage and street clothes, performing her "real" identities with the same dramatic flourish and plurality as her theatrical characters. Among the hundreds of photos Menken commissioned by various photographers, there are as many examples of her offstage roles as her stage performances. In a pair of Sarony images (figs. 10 and 11), apparently shot in the same studio session, we get a sense of both Menken's unconventional beauty and the different molds in which she chose to cast it. In both images she is presented as a fashionable, female counterpart to the male poets with whom she associated in New York City. (Among her friends, supporters, and wards were the Broadway bohemian set that congregated at Pfaff's Tavern—including Walt Whitman, Edwin Booth, and Ada Clare—and the English pre-Raphaelites Dante Gabriel Rossetti and Algernon Charles Swinburne.)[55] Sporting tightly curled, close-cropped tresses and dressed in a military-style jacket over an open, slightly disheveled blouse and skirt, in one image from this session Menken smiles shyly up at the viewer, eyes peering through her eyelashes from her slightly downcast face. Appearing as if caught momentarily exposing her face from beneath the ornate fan that rests lightly against its right side, the notorious Menken successfully represents herself in the role of a shy and submissive object of desire— the thinking-man's crumpet, perhaps, but empty calories nonetheless.

In the other image from this session, however, Menken does not pose as the Menken—flirtatious sex symbol who courted and even supported the male literary figures with whom she sought favor—but more closely resembles the melancholy and misunderstood Infelix, the name with which she often signed letters and poems. In this carte de visite Menken sits at a desk in the same garb as the previous image, her gaze downcast. Rather than finding the sitter in a moment of submission or flirtation, however, we find her in a moment of activity and concentration. Left hand at her furrowed brow in a gesture of deep thought, she pauses with

10: Napoleon Sarony, Adah Isaacs Menken, ca. 1864 (Harvard Theatre Collection, The Houghton Library)

11: Napoleon Sarony, Adah Isaacs Menken, ca. 1864 (Harvard Theatre Collection, The Houghton Library)

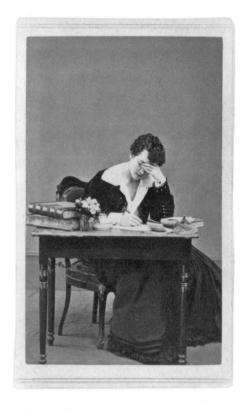

a pen in her right hand over sheets of paper, writing in one of the several deluxe folios before her. In another, presumably later Sarony photograph (fig. 12) she presents a similar persona, but with a grim spin on the more "proper" feminine pose of Empress Eugénie. Hunched forward against the back of an ornate velvet chair, and dressed in a flamboyantly ornamented brocade jacket, Menken seems to be playing the brooding "masculine" genius trapped in the voluptuous body of a woman.

In other cartes de visite, audiences were surely confounded as to where the onstage Menken left off and the offstage Menken began. In one, the actress poses in her filmy *Mazeppa* veils alongside an aging female friend, who is clothed in very modern and conservative feminine street dress.[56] The visual pairing of the leg-show actress as historical literary character and her "properly" feminine contemporary in an informal and warm embrace calls into question the safe containment of Menken's personae within the confines of the theater. (This jarring juxtaposition of the lady and the vamp would surely have [dis]placed the existence of the theatrical woman into the reality of modern life in the same way a photo of Hillary Clinton similarly embracing a Las Vegas showgirl in full plumage would our notions of the real/theatrical today.) Menken's delight in constructing and promoting a shockingly contradictory star image reached its most infamous level when she posed for and circulated other cartes de visite of herself in embraces with the elderly romantic writer Alexandre Dumas père, with whom she was rumored to have had an affair during her 1866 Parisian theatrical engagements (fig. 13). The session's photographer sold hundreds of these images, prints and caricatures of which soon appeared in the French press. This scandal would repeat itself shortly after she left Paris for London, when she posed for similarly intimate cartes de visite with Swinburne that were reproduced and mocked in the English popular press after they began circulating in the cartes market.[57]

As Reneé Sentilles wrote of Menken's use of photography, through her cartes de visite the performer at turns "charmed, challenged, reassured and titillated. Which was the real Menken? A viewer could choose among any of several images to give evidence of what he or she *wanted* to see."[58] These myriad personae were nonetheless cooked up and doled out under Menken's strict control, demonstrating the lengths to which she was able to go—before the age of the image-making (and

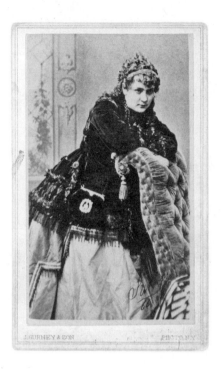

12: Napoleon Sarony,
Adah Isaacs Menken, 1866
(Harvard Theatre Collection,
The Houghton Library)

13: A. Liebert, Adah Isaacs
Menken and Alexandre
Dumas père, 1866
(Harvard Theatre Col-
lection, The Houghton
Library)

image-breaking) paparazzi—in selectively constructing and disseminating her star image. A juxtaposition of all the cartes above also underscores the way in which her selection of promotional imagery thwarted the potential of that image to become static, easily definable, or entirely separate from her stage personae.

Lydia Thompson also understood the power of photographic images to promote her shows and the Blondes' celebrity, and the troupe members posed for many promotional cartes de visite. While the Blondes' photographs did feature the actresses in revealing garments, the level of parody involved in both the costumes and poses differed greatly from Menken's. Unlike the sheer shock value of seminakedness and straight male drag that were prominent in Menken's pin-ups, in their own cartes de visite the Blondes drew upon the *comical* stage texts and gender conflations of their stage productions. In cartes de visite the Blondes usually addressed the viewer with an even gaze and smirking expression that reflected the attitude of their satirical stage send-ups. They dressed in comically contemporary versions of antique costumes and feminine adaptations of male garb, underscoring both the comedy and the sex appeal of the burlesque. Pauline Markham, recalled by an early burlesque historian as "the most beautifully formed woman who had ever appeared on the stage," served as the glamour draw of the Blondes' performances.[59] In both Markham's street-dress and her character cartes (fig. 14), the poses and outfits always underscored her voluptuous figure and smoldering sensuality, even when she was wrapped in a comically amended version of male garb.

Lydia Thompson's cartes, however, more closely resembled Menken's in their character diversity and subversive quality. On the one hand, Thompson played up her reputation as a revered star of the British stage through street-dress cartes that reflected those of grandes dames such as Ristori; in these, without exception, she was represented in elegant contemporary dress and a proper feminine pose (fig. 15). The conventional quality of Thompson's street-dress cartes make her wildly unconventional character cartes seem all the more shocking. In these, Thompson played Robinson Crusoe as a dandy in tailored sheepskins (fig. 16), legendary seaman Sinbad as an effeminate sailor boy, and the tragic Greek king Ixion in a scandalously short, fringed tunic. These (always corseted) britches-role costumes parodied the feminine frills of modern

14: Photographer unknown, Pauline Markham, ca. 1865 (Harvard Theatre Collection, The Houghton Library)

15: Photographer unknown, Lydia Thompson ca. 1866 (Harvard Theatre Collection, The Houghton Library)

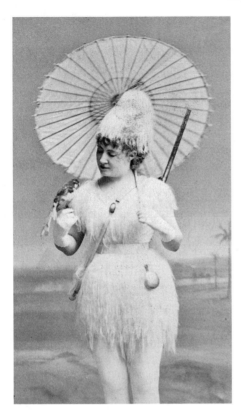

16: Photographer unknown, Lydia Thompson as Robinson Crusoe, ca. 1870 (Billy Rose Theatre Collection, The New York Library for the Performing Arts, Astor Lenox, and Tilden Foundations)

men's fashions and the self-conscious, mannered demeanor of genteel bourgeois, upper-class, and historical masculinity, and reflected the gendered world-upside-down of the troupe's performances.

In Thompson's "Girl of the Period" character, the actress even mocked her own public identity as an ostentatiously modern girl, posing in man-tailored women's wear, complete with a riding crop and stuffed-squirrel hat (fig. 17). As irreverent as were Thompson's send-ups of the heroic modern male, this satirical take on contemporary young womanhood perhaps packed the most critical punch—particularly in how intricately it weaved together commentary on period manners and morals, and the stake of women such as herself in both. Thompson's character was a parody of Eliza Lynn Linton's highly influential and much-debated London *Saturday Review* critique of what Linton saw as the various ills plaguing Victorian womanhood. In this 1868 essay, "The Girl of the Period,"

Linton named and attacked what she viewed as the emergence of a ma-
nipulative, self-consciously sexual young woman in England, who imi-
tated the style and behavior of famous actresses and dancers. She be-
moaned the rapid extinction of the well-bred (and, likely upper-class)
Anglo-Saxon girl of "innate purity and dignity . . . neither bold in bear-
ing nor masculine in mind; a girl who, when she married, could be
her husband's friend and companion, but never his rival . . . a tender
mother, an industrious house-keeper, a judicious mistress." In her place
Linton found an expanding bourgeois culture in which figures of the
theatrical demimonde led its girls "to slang, bold talk and fastness; to
the love of pleasure and indifference to duty . . . to uselessness at home,
dissatisfaction with the monotony of ordinary life, and horror of all
useful work."[60] These middle-class "girls of the period" dressed in flashy,
body-conscious garments and strolled the avenues and entertainment
centers unchaperoned, admiring and imitating the generally working-
class women of the theater whose behavior Linton apparently thought
women from better homes had no business emulating.

Novelist and critic Henry James, in a review of Linton's collected
essays on modern womanhood—popular on both sides of the Atlan-
tic—saw in American women a similar attitude, reflective of the stage
personalities of the burlesque: "Accustomed to walk alone in the streets
of a great city, and to be looked at by all sorts of people, she has acquired
an unshrinking directness of gaze. She is the least bit *hard*."[61] Thomp-
son's Girl of the Period cartes present an extreme vision of Linton's and
James's reviled subject that is at once silly, sexy, and subversive—much
like her troupe's performances. In one of these cartes (fig. 18), Thompson
stands at three-quarter pose, saucily jutting out her hip in the direction
of her leather riding crop. In her right hand she dramatically displays a
lit cigarette, beneath which dangles an ostentatiously long and ribboned
braid, falling parallel to a chain that holds a large monocle. Thompson's
mocking grin plays to the dual meaning of the image—this girl is both
a gag and a challenge, a caricature and a self-portrait. Thompson and her
Blondes, it seemed, were the very epitome of the "unshrinking" and ir-
reverent modern woman whose existence, influence, and thrill-seeking
pleasures were feared by critics like Linton and James. Not surprisingly,
it was in this very character's onstage monologue that Thompson coined

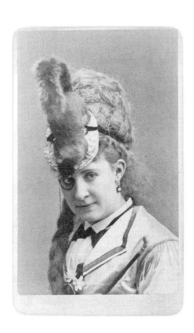

17: J. Gurney Studios (?), Lydia
Thompson as the Girl of the Period,
ca. 1868 (Harvard Theatre Collec-
tion, The Houghton Library)

below **18**: J. Gurney Studios (?),
Lydia Thompson as the Girl of the
Period, ca. 1868 (Billy Rose Theatre
Collection, The New York Library
for the Performing Arts, Astor
Lenox, and Tilden Foundations)

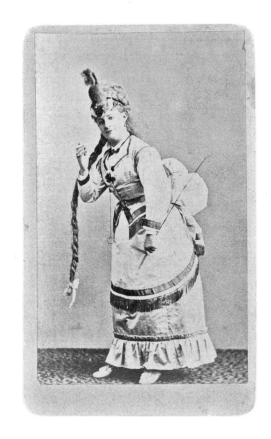

the term *awarishness* to celebrate the social and sexual audacity in modern young women that Linton denounced.

Contemporary moralists had reason to be concerned with the influence that such performers had over young women. Not only were these actresses' performances well-attended and pin-ups purchased and admired by star-struck women as well as love-struck fans, but the speed and thrift with which the era's producers and salespeople could study, make, and sell knock-offs of these women's costumes and accessories meant that one could not only look *at*, but look *like* these idols. Lois Banner's scholarship on the commercial beauty culture of the mid-nineteenth century demonstrates how a burgeoning culture of "dressmakers, department store owners, hairdressers, and cosmeticians" capitalized on the popularity of actresses by creating or imitating their "look" in these thriving new businesses. In fact, popular actresses were valuable enough to these businesses that performers would be hired or provided free products by many in order to claim that performer's style as their own in advertisements, where dressmakers like "Madame Marguerite" could proudly announce themselves as "dressmaker to Miss Adah Isaacs Menken."[62] Linton's "Girl of the Period" essay lamented the speed with which these trends translated from stage to parlor: "If some fashionable *dévergondée en evidence* is reported to have come out with her dress below her shoulder-blades, and a gold strap for all the sleeve thought necessary, the girl of the period follows suit the next day."[63] Not only did industrial revolution technology make these styles easier to represent, report, recreate, and disseminate, but because increasing numbers of young women were actually earning spending money from precisely the manufacturing and sales jobs upon which this culture depended, they were easier for many women to obtain. As such, it should come as no surprise that this girl of the period was so audacious, ubiquitous, or threatening.

As symbolized in the Girl of the Period character—as performed both on the stage by Thompson and on the street by the young women who imitated her—the British Blondes took the precedent of the independent and brazenly sexual *bohemienne* established by Menken's ever-oscillating, dramatic persona and adapted it for the purpose of a female-based parody and critique of modern society. And, also like Menken, the Blondes took seriously attacks on their virtue: after a series of per-

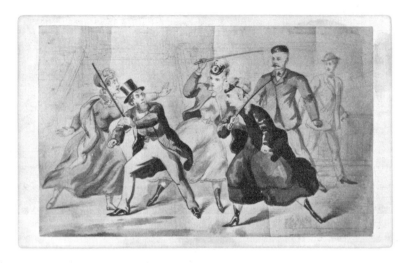

19: Artist unknown, carte-de-visite illustration of the "Chicago Cow-hiding" incident, ca. 1869 (Harvard Theatre Collection, The Houghton Library)

sonal attacks on Thompson published in 1869 by *Chicago Times* editor Wilbur F. Storey, she and fellow "Blonde" Pauline Markham ambushed and horsewhipped the journalist outside his home. After being chastised and fined in court, Thompson took to the stage and defended her actions to her audience. In a monologue meant to protest not only the critic's attack of her troupe in particular, but more broadly the social and political sexism that oppressed all women, Thompson stated: "The persistent and personally vindictive assault in the *Times* upon my reputation left me only one mode of redress. . . . They were women whom he attacked. It was by women he was castigated. . . . We did what the law would not do for us."[64]

Word of the Blondes' revenge spread quickly and apparently inspired enough interest—whether comical or sexual, one can only speculate—that fantasy illustrations of Thompson and Markham angrily whipping Storey in the streets of Chicago were created and sold in carte-de-visite form (fig. 19). The story was also good enough for the troupe's business that an "anonymously published" broadside titled "The Literature of the Lash"—instigated if not written by Thompson—was published.

The broadside was likely circulated in cities on the troupe's schedules by "advance men" as an advertisement for new performances, reproducing Chicago press clippings from the arrest and trial and featuring an introductory essay that asserted: "Every blow that fell lightly or heavily upon this man's person was a protest in the name of women and of decency against outrages upon women."[65] While they were willing to flout convention, the Blondes also reminded the public that they allowed neither women's professional nor sexual identities to be categorized or criticized as easily as their detractors might like. Better yet, Thompson was savvy enough to capitalize on the sensation inspired by such transgressive, real-life "performances," using them to draw larger audiences to witness those they put on the stage. That the public would revel in the details of these women's revenge—"a protest in the name of women," no less!—seems outrageous considering that the freedom with which these women acted in the public sphere threatened the sex roles that many felt held up nothing short of the entire social order.

Faye Dudden argues of this phenomenon, "Linton's ['Girl of the Period'] essay became enormously popular because it addressed male fears about independent women, and Thompson's burlesque seems to have done the same."[66] Yet, though they mocked the girl of the period, perhaps easing the threat her presence in the world posed to a binary construction of womanhood, the British Blondes nonetheless embodied this same unstable, threatening persona. As critic William Dean Howells wrote in 1869 of the disturbing appeal of the Thompsonian burlesque actress: "Though they were not like men, [they] were in most things as unlike women, and seemed creatures of a kind of alien sex, parodying both. It was certainly a shocking thing to look at them with their horrible prettiness."[67] Returning to Thompson's Girl of the Period cartes de visite, it is easy to appreciate how this "horrible prettiness" was being played out in the visual economy of the burlesque pin-up. In a confident pose, grinning knowingly at the viewer, the lovely Thompson speaks at once to the traditional ideals of female beauty and, draped in the accoutrements of vilified and unfeminine modern womanhood, its opposite. The delicate hand that holds the horsewhip belongs to none other than the infamous "Chicago Cowhider" herself. Her amused smile also speaks to the fact of these actresses' personae that made both their

critics most anxious and their fans most enamored—the sincere pleasure that these women seemed to take in their own audacity, and the allure that they held for regular young women inspired by their precedent. In the "horrible," yet sexually alluring pin-up representations of their "alien sex," the British Blondes—like Menken—used the genre as a key medium toward the insertion of their complex and multiplicitous theatrical identities into the environment and discourse of extra-theatrical life.

Naturally, scores of other actresses saw reproducible photo technology's considerable potential for constructing and promoting an identity for themselves—particularly if the imagery (like the shows from which the actresses generally came) was titillating. Photographers also saw the benefits of creating and selling these women's cartes. For actresses, the sale and circulation of their photographs meant the potential success of their shows and name recognition associated with their images. For both the actress and the photographer, there was also the potential of great profit from the commercial sales of the images. Photographers such as Sarony were reputed to pay thousands of dollars for the privilege of capturing the image (and owning the negatives) of the most popular stars, and actresses were well aware of the financial benefits of capitalizing on the popularity of their stage personae through the sale and circulation of cartes. Even antiburlesque Olive Logan herself discussed the necessity of the carte de visite in theatrical promotion and her own experiences with the process in a chapter from her 1869 book, *Apropos of Women and Theatre*. From the discomfort of the photographer's headrests (used to aid in keeping the head still for the relatively long exposures needed for the cartes) to that of the gallery's walk-up ("what carriage can mount a half a dozen flights of stairs? . . . Mazeppa's may, but I am not Mazeppa"), Logan found the experience a trial, suffered only because "the sale of these photographs is immense . . . [and] people buy cartes de visite of well-known persons for as many reasons as other people resort to the convivial tumbler."[68] In addition to their sales at studios and stores, photographers and barkers sold the pin-up carte-de-visite portraits of famous performers in the streets of the theater districts just as deluxe programs and tour paraphernalia are sold at concerts today—a commercialization of the theatrical arts that Logan

herself found in scandalously poor taste and claims led to her personal boycott of the medium.[69] (Her commission, five years later, of cartes advertising her status as "The Best Dressed Woman in the World," reflecting the polite and reserved bourgeois Empress Eugénie ideal, indicates that the "boycott" was short-lived.)[70]

Performers also recognized that the circulation of cartes de visite had the potential to extend far beyond their individual purchase and consumption. Long fascinated with representations of both the theatrical and off-stage exploits of actresses—particularly burlesque performers— popular tabloids such as *Punch* and the *National Police Gazette* commissioned prints made after the cartes de visite of the performers its writers fancied, from local chorus girls to venerable international performers such as Sarah Bernhardt. As reproductive techniques improved in the popular press, and photographs became easier and easier to reproduce, a provocative pin-up portrait increasingly meant the possibility of not only a place in a bourgeois collector's photo album, but also a headline in the papers. Moreover, the undifferentiated use of the photographic imagery of both the lowly coryphées and the more respectable grandes dames of the theatrical community in such a manner served to blur the once distinct roles of female performers and the nature of the theatrical roles they embodied—a fact that likely helped determine the disdain with which actresses such as Logan came to approach the medium of photography. As far as Logan was concerned, the phenomenon sullied the name of every actress—for with the blurring of the boundaries between the Ristoris and the Menkens, the Linds and the Markhams, the burlesque would "involve in the obloquy which falls on them hundreds of good and pure women [of the stage]."[71]

Another factor in the transformational appeal of the carte de visite was paradoxically due to a popular perception of photography that ran counter to both the subjects' willful and the media's unwitting manipulation of the medium: the period's belief in the truthful and objective nature of photography. While many treatises on the art of photography complained of the medium's difficulty in capturing a "natural"— or even flattering—image of the subject, there were nonetheless a great many more that hailed the medium's ability to capture not only the physical but the emotional and intellectual likeness of the sitter. Writing in the *Atlantic Monthly*, famed doctor, poet, and essayist Oliver Wendell

Holmes Sr. articulated the period's physiognomic approach to photography:

> The picture tells no lie. . . . There is no use in [one's] putting on airs; the make-believe gentleman and lady cannot look like the genuine article. Mediocrity shows itself for what it's worth, no matter what temporary name it may have acquired. Ill-temper cannot hide itself under the simper of assumed amiability. The Querulousness of incompetent complaining natures confesses itself almost as much as in the tones of the voice. The anxiety which strives to smooth its forehead cannot get rid of the telltale furrow. The weakness which belongs to the infirm of purpose and vacuous of thought is hardly to be disguised.[72]

Photography was as easily manipulated as the stage performances which were their trade, yet photographs were scrutinized by the public as scientific and objective proof of one's essential personality. To this end, the carte de visite as constructed by its female burlesque patrons held the potential of not only decontaining their diverse character identities, but *concretizing* them—every one of them—as a fact, rather than a theatrical fiction.

The Pin-Up and Feminism: Edging toward a New Century

The new range of roles for women in legitimate theatrical spaces—manager, performer, and viewer alike—resulted in what Abigail Solomon-Godeau identifies as a "shifting, unsecured meaning of the sexualized women drifting between the sturdy fixities of *femme honnête* and *fille publique* . . . confound[ing] the social need to define that is an inseparable component of the power to name, regulate, survey, and control" female identity and sexuality.[73] In the theater as in the market for the carte de visite, the presence of a bourgeois audience had helped in both the creation and the decontainment of these pluralistic new roles for women. As Allen writes of this phenomenon:

> Ironically, it was the presence of respectable, middle-class women and men in the audience that made burlesque so problematic, and it was only in relation to what the bourgeois theater had become since the Astor Place riot

that burlesque seemed so transgressive. . . . Just when sexuality in the audience had been stifled, the third tier evacuated, and the concert saloon closed, the "leg business" put the issue of female sexuality on center stage. . . . Theater had once again become unpredictable.[74]

Formerly associating the presence of female performers with prostitution, the increased bourgeois involvement and consumption of the burlesque spectacles in which women's participation was integral further problematized the once-stable identity of these performers solely by virtue of their profession. Middle-class patronage in the rise of the burlesque "leg show" within changing trends in the theater had actually assisted in not only its upclassing, but its very construction and acceptance—and by extension its representation of unstable models of femininity to heretofore unprecedented audiences. Fluctuating variously between the behavioral signifiers of prostitution (through their trade in physical exhibition, flaunting of self-aware sexuality, and public visibility) and "true womanhood" (through their beauty, desirability, and struggles for respectability), the burlesque performer effectively disrupted the binary that had named and controlled female sexuality in the nineteenth century—particularly that of the white bourgeois women who became her newest admirers.

The carte-de-visite pin-up threatened to break down yet further not just this distinction between the "proper" and the "public" woman, but also the literal containment of the transgressive female within the walls of the theatrical space. Individuals who had never stepped foot in a theater could read accounts of the productions and see the highly individuated and realistic photo images of burlesque actresses taken directly from life—a reality that the performer could manipulate and control to her specifications. This reality, in turn, had a good chance of being read as a scientifically rendered truth of her essential nature—a "nature" disrupted by the proliferation of guises and personalities which the performers' multiple-role cartes conveyed. The novelty and status of these cartes de visite as markers and objects of bourgeois culture also meant that even the most scandalously attired showgirl—and the unstable feminine identity she embodied—could likely be contemplated alongside one's aunt or political figures in a collector's album.

The combined upclassing of the medium and the unprecedented visi-

bility and bourgeois acceptance of the formerly demonized female per-
formers that the burlesque produced (and the pin-ups reproduced) led
to a widespread questioning of the binary social and sexual identities
available to women of the period. Indeed, the bourgeois audiences of
these women's performances and pin-ups not only had a hand in prob-
lematizing the once-stable identity of the female stage performer, they
went so far—as Linton's and James's essays make clear—as to desire and
emulate women like them outside of the theater. As the fashions and
ideals of bourgeois female beauty grew closer and closer to the look
of stage performers, so would these performers' ambition and indepen-
dence eventually become embraced as less superficial qualities to admire
and imitate.[75] As such, Allen observes that the "awarish" identity of the
burlesque pin-up "provoked desire and at the same time disturbed the
ground of that desire by confusing the [binary] distinctions on which
desire depended."[76]

By the 1870s, however, the burlesque slowly backtracked from its
popularity among the bourgeois and returned to its marginalized form
of working-class entertainment. Allen notes that chief among the fac-
tors of its decline were the vocal campaigns of critics who made note
of the very "corrupting" influence of the genre that we today applaud
for its progressivism:

> If burlesque was an epidemic of "flaxen scrofula," then its patrons were,
> by extension, its infected victims. If burlesque impudently ridiculed what
> should have been above ridicule, then its patrons abetted in this anarchic
> transgression. If burlesque was tantamount to prostitution, its patrons were
> consorts. Furthermore, it is possible that the discursive construction of bur-
> lesque and its audience helped to change the social constitution of bur-
> lesque's "real" audience, making it more difficult for "respectable" (read:
> middle-class) women to attend without stigma.[77]

The success of burlesque performers' mockery of gender and sexual
binaries would gradually succeed in convincing bourgeois audiences
that burlesque subject matter was too base an inversion of its principles
to be defended as mere entertainment. Anxiety over the *new* freedoms
and pleasures that the growing community of "awarish" young women
both on and off the stage could conceivably begin demanding led to

the inevitable backlash against this complex model of femininity. In the end, the very cross-class, cross-gender appeal that led to the rise of the burlesque would eventually contribute to its demise. As its star waned with bourgeois audiences in the 1880s, maintaining only its lower-class audiences, burlesque would come to merge with vaudeville and carnival circuits and become relegated to its own theatrical venues. With the exception of burlesque performers like Mae West—who wrote and performed most of her suggestive stage and screenplays in the original tradition of the genre—the female performer was during this time reduced to nothing but physicality.[78] Satirical performances would be relegated to men, and dancing and striptease to women—all but obliterating the subversive voice and influence of the original burlesque woman.

However, the ideal of the appealingly "awarish" burlesque performer had irrevocably defined the pin-up, even as it became appropriated by new entertainments and new authors. The actress in the mid- to late nineteenth century made visible—to audiences of unprecedented number—the possibility of an existence and acceptance of the same plural female identity we will see increasingly sought by the nascent first wave of the feminist movement in Europe and the United States as the century wore on. When the pin-up genre was born through the residual visual imagery of these theatrical identities, a medium was found through which their unstable, yet desirable, constructions could be further controlled by their subjects and witnessed by audiences both within and outside of the theatrical world. In other words, the pin-up genre developed as part of a theatrical discourse in which the onstage identities that emerged and oscillated between the period's binary of domestic/public womanhood found a way to exist beyond the confines of the theater, assisting in a *discursive* expansion of the broader extratheatrical identities that these images suggested were possible.

"Always peculiarly and emphatically herself," the nineteenth-century burlesque pin-up left a legacy for the genre in the acknowledgment and performance of her own power for agency on many different levels. Representing its beautiful/beautified subjects as not only self-aware sexual and professional beings, but beings whose identities were self-constructed, self-controlled, and ever-changing, the pin-up both represented and marked as desirable a spectrum of female identities possible between the period's established poles of acceptably "feminine" behav-

ior. Moreover, the burlesque pin-up had the power not only to image and provoke desire but, by penetrating and influencing the culture of bourgeois fashion and consumption, to change the rigid terms by which desire had been framed in the industrial world. With the expansion of both the mass media and first-wave feminist rhetoric that led to these particular pin-ups in the mid–nineteenth century, we will see how each would aid in the pin-up's evolution as it moved into the twentieth.

By the fin de siècle, the carte de visite had grown out of fashion with middle-to-upper-class consumers of photography. Larger and more expensive imagery developed in the late nineteenth century soon became the media of choice for bourgeois photographic portraiture.[79] Although several renowned performers created promotional material with such deluxe media, the less expensive carte de visite remained a more affordable and efficient method of easily reproduced photography for most stage performers, as well as for the lower classes. As such, the pin-up went underground, where until the turn of the century it was created specifically for the delectation of heterosexual male audiences that could cheaply buy and view the imagery in a covert fashion. The burlesque carte-de-visite pin-up of mid-nineteenth-century family albums and scrapbooks by the turn of the century had become the "cigarette card girl," or the more racy "French postcard lady," marketed exclusively toward male consumers and sold in tobacco shops.[80] Illustrated nineteenth-century magazines and "pulp" tabloids, such as *La Vie Parisienne* and the *National Police Gazette* continued to publish images and stories of transgressive stage performers and demimondaines into the twentieth century, but they had always been targeted almost exclusively toward a male audience. These publications often used sexualized images of women to illustrate their lurid, "true-confession" tales of the titillating exploits of everyday female players in the drama of an increasingly gender-segregated urban society.

Such product packaging and magazines served as distributive media by which producers could market the pin-up to all-male audiences. However, women certainly remained aware of, and likely fascinated by, the pin-up's existence and its appeal to the men in their lives. In her autobiography, pioneering sexual- and reproductive-freedom activist Margaret Sanger recalled these "days when every pack of cigarettes carried a bonus in the shape of a pictured actress, plump and well-

formed." Although she was just a teenager, Sanger and her girlfriends secretly idolized these actresses and "compared [their own] sizes with these beauties."[81] Like the burlesque, the pin-up's visibility and subversive style no longer enjoyed the broad audiences it had in the nineteenth century. However, the genre nonetheless managed to remain in the public imagination, if not the public eye, and would go on to regain its popular appeal in the first half of the twentieth century, when, with the pin-up's associations with the New Woman in the popular press, it would begin to reclaim the feminist appeal it held in its earlier incarnation.

2

NEW WOMEN FOR THE NEW CENTURY

Feminism and the Pin-Up at the Fin de Siècle

Perhaps no performer better represents the conditions surrounding the unfortunate demise of the original burlesque pin-up than the mysterious "hootchy-kootchy" dancer of Chicago's 1893 World's Columbian Exposition, Little Egypt. The exposition of 1893 was the fifteenth world's fair and the second such international exposition in the United States. Because of the timing, President Benjamin Harrison and the U.S. Congress decided to use the commemoration of Columbus' "discovery" of America four hundred years earlier as the fair's unifying theme. The 633-acre fairground, called the White City, was built on the shores of Lake Michigan and constructed to look like an industrial revolution Venice, complete with miles of canals, islands, and broad thoroughfares that led to hundreds of exhibition buildings. Although most histories of the fair focus upon its cluster of Great Buildings—monumental edifices dedicated to equally monumental subjects of importance to the industrialized world, such as manufacture and liberal arts, mines and mining, and machinery—few dwell too long upon the equally popular but considerably humbler attractions of the auxiliary buildings that were grouped on the Midway Plaisance. The mile-long midway was not considered part of the fair itself; consisting of private vendors and entertainers, its

"pleasures" were organized by New York theatrical promoter Sol Bloom and offered solely as a commercial venture through which the tapped-out fair organizers might turn a profit. Its ragtag group of attractions included athletic competitions, concerts of popular music, a mock military battle, the world's first Ferris wheel and, interestingly, many of the fair's international exhibits. It was here, in a theater built as part of the midway's recreation "A Street in Cairo," that Little Egypt performed her *danse de ventre*—the French colonial name for what would come to be known in the American vernacular as the "belly dance"—for twenty-five cents a show. (Ticket buyers had already shelled out half of the admission for entry to the fair itself.) In his first-hand account of the performance's reception by fairgoers, writer Halsey C. Ives reported in *The Dream City* that no "ordinary woman looked on these performances with anything but horror, and at one time it was a matter of serious debate in the councils of the Exposition whether the customs of Cairo should be faithfully reproduced, or the morals of the public faithfully protected."[1] Needless to say, "A Street in Cairo" went on to become one of the most profitable attractions on the Midway, and pin-up postcards of its performers sold like hotcakes as some 27 million visitors passed through the fairgrounds.[2]

In fact, it was precisely such souvenir items that helped make the midway so profitable, and the social vision that the fair promoted so widespread. The fair had its own photography division, led—or, rather, monopolized—by Charles Dudley Arnold, who strictly controlled the photographers allowed on the fairgrounds, and whose own photographs were the only ones allowed for purchase at and even reproduction in guidebooks, postcards, and articles about the fair.[3] This level of control in the image presented by the fair is consistent with its goals as a whole. In her account of the images on display and for purchase at the exposition—paintings, engravings, lithographs, souvenir handkerchiefs and programs, and of course photographs—Margaretta Lovell argues that the fair they record was not simply the celebratory snapshot of the future that its organizers heralded: "What they intend is celebration; what they achieve—by selection, by omission, by reiteration, by framing, and by point of view—is a curious commentary on the fair's utopic ideology."[4] Naturally, that ideology placed an emphasis on the inevitability of a technological—and specifically Anglo-American—future, but it also

shed "anthropological" light on the past in such a way that evolution both produced and indexed dominant races and sexes in which Western manhood naturally came out on top. Indeed, Lovell argues, a "narrative of Darwinian survival (figured at the fair as triumph)—itself recently emerged from decades of embittered controversy—dominated both micro and macro visions of the fair,"[5] a fact revealed in the pin-up imagery sold at and reproduced from the fair.

Ives's above account of "A Street in Cairo" is itself taken from one of these "macro-visions" of the fair—a souvenir program titled *The Dream City: A Portfolio of Photographic Views of the World's Columbian Exposition*—and not surprisingly draws upon a particularly interesting pair of pin-up-style photographs by Arnold (fig. 20) to make precisely this point about the triumph of Eurocentric culture. (In fact, Ives's commentary exists to illuminate the program's primary purpose of compiling the "photographic views" of the title.) It is abundantly clear throughout that Ives found each of the non-Western entertainments of the Midway "begging," sniffing: "All Asiatic, African and some Muscovite dances resembled one another." The Far Eastern entertainments of "A Street in Cairo," however, were singled out for their unique ability to drive "away the 'Christian,' and [keep] him at a wise distance." Underscoring not just the present but historical threat that the *dance du ventre* performers in particular constituted to the Christian world, Ives could recommend the spectacle only so that "Western people might see how the head of St. John Baptist was lost to Herodias." He sought to draw this history up to the present, however, in juxtaposing Arnold's souvenir images of an Egyptian dancer from "A Street in Cairo" with one from the Midway's Hungarian Concert Pavilion. Noting the ironic parallels between the burlesque and the belly dance—the latter "undoubtedly the style in Cairo, where our own Western *Black Crook* amazons would be instantly suppressed"—Ives felt it instructive to compare this "study of the Cairo girl and her frightful tambours" to the ways in which the Hungarian pin-up's embodiment of "Listz's [*sic*] music and Western beauty and grace, is the greatest that could be furnished by feminine youth," adding: "Only Darwin could expatiate impartially on these variations of taste in the human kind."[6]

From the vantage of the twenty-first century, it seems ridiculous that these two figures could be held up as evidence of such a Darwinian

leap in human evolution. Yet from her pelvic performance to her two-piece costume (interestingly, worn modestly over a long-sleeved blouse that covers the same amount of skin as her Hungarian counterpart conceals), Little Egypt was held up as not only an "Oriental" answer to the banished burlesque, but a reminder of its devolutionary influence on modern culture. What is most interesting about the legend of Little Egypt is the fact that no single such performer actually existed at the fair. Though she certainly exists in photographic records like this one, there is in none of the primary sources related to the Columbian Exposition any mention of a Little Egypt. However, countless books, articles, and photographs from the late nineteenth century forward bear her name and trace her provenance directly to the 1893 fair—even though many of these images (fig. 21) and accounts clearly depict her as a Western woman using jury-rigged contemporary clothing to approximate the effect of Middle Eastern dance costumes. As dancer Donna Carlton would discover conducting the research that led to her book *Looking for Little Egypt*, this is because in the generalized character of Little Egypt—a caricature of the actual Middle Eastern folk dancers at the Exposition adopted by scores of American women performers who appeared in the vaudeville circuit for decades afterward[7]—Western audiences invented a convenient repository for the repressed sexual feelings that mass culture found great profit in stimulating. The lust that Little Egypt inspired—because mingled with revulsion over her identity as a dark, primitive Oriental—was acceptable in that the "base" nature of the sentiment was projected upon an anonymous and equally base "Other."[8]

Considering the encouragement of such backward perceptions in the utopic world of the appropriately nicknamed White City, it seems almost unbelievable that the fair would simultaneously champion the progressive evolution of woman in its scheme. Yet not only on exhibit but even holding a coveted spot among the Great Buildings was the Woman's Building, dedicated to just this subject. Designed by the recent (and first female) MIT architecture graduate Sophia Hayden, the building's Italianate style pointedly blended into the bland, academic architecture that dominated the fairground. However, its exhibits and program furthered a much more progressive agenda than its polite exterior suggested. The Woman's Building included a collection of 4,000 books written by women, displays and artwork that tracked the inventions and

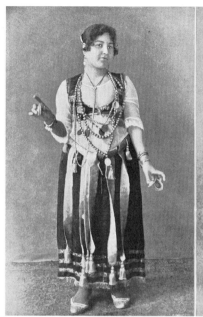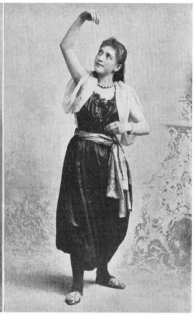

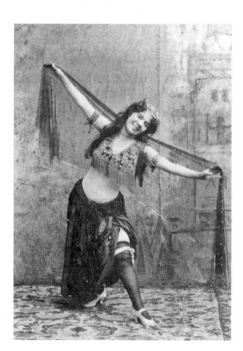

above **20**: Charles Dudley Arnold, images of Egyptian and Hungarian performers from the 1893 Columbian World Exposition, reproduced side by side in Halsey C. Ives's *The Dream City*, 1893–94

left **21**: Photographer unknown, "Little Egypt" postcard, ca. 1900

work of women from the ancient times to the present, restaurants and a model kitchen, and a professionally run "Model Day Nursery" in which visitors were invited to leave children while they toured the building. In addition to the sixty women's organizations whose booths crammed the hall—walls ultimately had to be ripped out of the original design to fit them all into the building—invited speakers included suffragists such as Susan B. Anthony and Elizabeth Cady Stanton (busts of whom also sat in the Gallery of Honor), African American activists Ida B. Wells and Fannie Barrier Williams, and international feminists whose participation underscored the role of women's progress in the fair's global scope.[9]

Indeed, this global scope was accommodated in surprising ways considering the Eurocentrism of the fair as a whole. In addition to inviting such speakers, the creative exhibits at the Woman's Building were the only ones to include the work of marginalized, colonized, and other non-Western peoples alongside the products of Americans and Europeans.[10] But, as with many activist movements led by white progressives of the period, such gestures at the Woman's Building had their limits. The president of the exposition's Congress-appointed Board of Lady Managers, the midlife Chicago socialite Bertha Honoré Palmer, rejected appeals to name black representatives to her managing body; although she eventually appointed a Secretary for Colored Interests, this was a position of little authority. It was also notable that, unlike work from any other nation, the art of Africa was isolated and treated "ethnographically" rather than as part of an international "fine arts" continuum.[11] Yet, even as this very fine arts tradition was adopted relatively uncritically by the Board of Lady Managers, it would ironically be challenged by its most conservative members when Augustus Saint-Gaudens's monumental nude sculpture of the goddess Diana—which was offered to and rejected by most of the fair's Great Buildings, not just for its state of nudity but for the highly naturalistic modeling of its female figure—was offered a place of honor atop the Woman's Building by Palmer. A passionate patron of then-cutting-edge impressionist and postimpressionist work from Europe, Palmer probably found the academic sculpture relatively conventional. However, Palmer's influence was no match for Woman's Building participants from the Women's Temperance Union, who vigorously denounced the work's inclusion in the exposition at all.[12] Although the work was ultimately left off of the Woman's Build-

ing because of its lack of an appropriate outdoor pinnacle on which to
place it, the oppositional attitudes of Palmer and the Women's Temper-
ance Union reflect the contentious nature of the sexualized woman not
only in popular culture at the turn of the century, but also within the
expanding women's rights movement, of which the Woman's Building
was something of a microcosm. (Unsurprisingly, as Ives gloats in *The
Dream City*, the Board of Lady Managers led the futile protests over the
inclusion of "A Street in Cairo" 's female performers at the midway.)[13]

The enormous Gallery of Honor mural by the American impression-
ist Mary Cassatt exemplifies the manner with which contributors to
the Woman's Building sought to both draw upon and transform famil-
iar images of women for activist ends in this contentious environment.
Cassatt herself was a midlife suffragist who used her work and connec-
tions to the art world to further the cause, and she seized upon Palmer's
commission to paint an allegorical mural, *Modern Woman*, as an oppor-
tunity to contribute a subtle feminist statement to its overall program.
In it, she played brilliantly upon Mary Fairfield MacMonnies's opposing
mural *Primitive Woman* in the central gallery by contrasting and connect-
ing the women in the historical continuum that the murals bookended.
In Cassatt's three-panel mural, she slyly reclaimed and transformed the
myth of Judeo-Christianity's original "primitive woman," Eve, by rep-
resenting an orchard full of contemporary women happily plucking
apples from the central panel's Tree of Knowledge and sharing the (lit-
eral) fruits of their labor not with Adam but with each other.[14] But,
hardly the temptress of ages past, Cassatt's multigenerational Eves were
domestic darlings to a one; robust and pink-cheeked like peasants, they
were nonetheless clothed in the "proper," full-skirted, limb-covering
dresses of the middle-class true woman.[15] (Cassatt had quite specifically
ordered the dresses for her sitters from a posh clothier in Paris.) In a let-
ter to Palmer written while the work was in progress, Cassatt revealed
the predicament that she faced as an artist seeking to impart a feminist
message to a broad audience, and how it affected the work, when she
wrote of the responsibility she felt to represent "the charm of woman-
hood" alongside the charge of womanhood: "If I have not conveyed
some sense of that charm, in one word, if I have not been absolutely
feminine, then I have failed."[16]

As Norma Broude has written, while Cassatt's mural "speaks boldly,

albeit metaphorically, of the passing of knowledge from woman to woman—the feminist insistence on empowering modern woman by giving her a public voice"—the work nonetheless succumbs to the period's "notions of femininity and woman's place." Ultimately, Broude argues, Cassatt's contribution to the Exposition reflects the broader strategy at work in feminist visual culture at the fin de siècle: "an important and widespread pattern of resistance on the one hand and simultaneous complicity on the other, a pattern typical of many Euro-American women artists and intellectuals who achieved fairly notable positions during the nineteenth century."[17] Cassatt's suggestion that the true woman could possess the intellect and ambition of her opposite— the public woman—was a radical one. But by focusing on the "absolute" charm and femininity of contemporary womanhood, derived from the domestic model of the upper classes, she simultaneously confirmed the same Victorian clichés of women's "essential" nature and proper sphere that limited the scope of their ambitions. Key to maintaining this charm was, of course, avoiding any trace of the transgressive ambition, desire, and sexuality that so marked Eve in the first place.

The different images that Little Egypt and Cassatt's new Eve presented at the World's Columbian Exposition reflect the ways in which both sexuality and race would divide early feminists as the women's movement grew in the late nineteenth century. Indeed, the earliest splits in the women's movement came when pursuing such growth, as evidenced in the first famous splintering of the U.S. suffrage movement, resulting in the National Woman Suffrage Association (NWSA) and the American Woman Suffrage Association (AWSA). The coordinators of the Seneca Falls convention, Elizabeth Cady Stanton and Susan B. Anthony, had founded NWSA in New York in 1869 to push for a rewording of the impending Fifteenth Amendment to include women as well as freedmen. Although many suffragists in both the United States and Europe first came to activism through antislavery campaigns, the NWSA's rhetoric revealed the latent racism of many activists when faced with continued disenfranchisement in the face of the Fifteenth Amendment. Stanton, in a keynote speech delivered to the Equal Rights Association at the nation's capital the same year as the NWSA was founded, called universal manhood suffrage an "appalling question" when one considered "the dregs of China, Germany, England, Ireland, and Africa," who

would be making laws for women like herself.[18] In 1878, NWSA's executive committee chair Matilda Joslyn Gage wrote articles railing against the fact that American Indians, former slaves, and naturalized immigrants were afforded the vote, while the white woman, "educated, enlightened, Christian, in vain begs for the crumbs cast contemptuously aside by savages."[19] Anthony infamously asked Frederick Douglass—an active supporter of women's rights since the Seneca Falls convention—to stay away from the NWSA's 1895 convention for fear of alienating supporters.[20]

In Boston, Lucy Stone and her husband Henry Blackwell, both antislavery activists before the Civil War and both appalled by the NWSA's racial attacks, created the American Woman Suffrage Association in Boston in an effort to coax women to support the amendment as it was written, to not endanger black men's vote. They were joined by outspoken African American suffragists such as Sojourner Truth and Frances Watkins Harper—respectively, a former slave and live-in domestic worker, and a highly educated, middle-class woman born free—who not only argued for the importance of women of color in the suffrage movement but stood as a study in contrasts that defied white culture's stereotypes of what it meant to *be* "colored."[21] However, the AWSA's formation was as much the result of suffragists' splintering on the role of sexuality in the women's movement as it was upon race: Stone was critical of Stanton's support of more lenient divorce laws, as well as with the NWSA's brief alliance with legendary free-love socialist Victoria Woodhull during her self-nominated run for president in 1872, and Stone felt that the group's association with such obvious departures from "true-womanly" ideals would bring shame to the suffrage movement.[22] Even after the unification of the two groups into the powerful North American Woman Suffrage Association (NAWSA) in 1890, not only would the subjects of race and sexuality divide its members, but so too would generational issues, as younger women joined the group and began to offer new ideas on such subjects with a youthful optimism, liberalism, and sense of entitlement that many of their elders found naive at best, and downright destructive at worst. After this new generation led the vote to dissociate the group from NAWSA leader Stanton's radical 1892 tome *The Woman's Bible*, she fumed: "Our younger coadjutors seem to be too satisfied with painting in the brightest colors of the successes of the woman move-

ment, while leaving in the background the long line of wrongs which we still deplore."[23]

<div align="center">

Sex, Suffrage, and the "New Woman"

</div>

Such early splits in the suffrage movement were harbingers of things to come: as the women's rights movement grew and diversified toward the turn of the century, such splits became more and more common. Many women were coming to the realization that the single-mindedness of suffragists—dedicated to the cause for, at this point, decades—often reflected their tunnel vision as much as their doggedness. As such, feminist thinkers became increasingly interested in articulating the possibilities of a multiplicitous women's movement beyond simply obtaining the vote. In 1894, the English writer Sarah Grand would help feed this sensibility in an essay that sought to broaden the horizons of the suffrage movement and would consequently contribute a new term to the international lexicon: "New Woman." The term has, in its own time as today, been used as a catchall to describe every type of vaguely rebellious womanhood—from suffragists to anarchists to flappers—that emerged in industrialized nations between the fin de siècle and the Great Depression. Indeed, a part of its appeal to feminists and antifeminists alike in this broad sweep of history was precisely its openness. However, in her analysis of the New Woman in American painting, Ellen Wiley Todd has noted that, though varied, all these types in fact shared the distinction of exemplifying "women's increasing engagement with social spaces that were public, urban, and modern."[24]

Although the glamorously "awarish" stars of the burlesque who helped initiate this engagement were weeded out of the popular theater and public eye as the century came to a close, their behavior, attitude, and image would be reborn in the New Woman—the politicized, fin de siècle daughter of the Girl of the Period. Unlike her exceptional and plainly transgressive predecessor from the theatrical realm, the New Woman was identified instead by her accessibility and ubiquity as growing numbers of middle- and working-class women began embracing new roles in the public sphere—a fact that led to both the appeal and the vilification of the New Woman. Related to but not synonymous

with the "suffragette," she emerged as the nebulous women's rights movement of the early to mid–nineteenth century simultaneously co-alesced into the formidable, international suffrage movement and splin-tered into the diverse factions of New Womanhood around it. These varied groups of like-minded thinkers generally supported women's en-franchisement but saw this as just one issue among many that merited change. This breadth of new ideas about what not just women, but femi-nists "could" be at the turn of the century would, in turn, result in a breadth of images representing these same ideas. Many popular images of the New Woman reflected cultural anxieties over this new—and newly politicized—strategy by which ordinary women were expand-ing their roles in society. But many others plainly suggested that such changes were intriguing, even appealing. In any case, as feminist scholar Martha Banta's research on the subject has made abundantly clear, the result was that at the fin de siècle Western popular culture offered images of women that "were not only varied to the point of potential self-contradiction, they were all-pervasive."[25] The pin-up would both re-spond and contribute to this proliferation of imagery as it applied to the increasingly politicized and sexualized image of the New Woman.

The term *New Woman* was first put into popular usage in 1894, after a published debate in the *North American Review* between Grand and Ouida (Marie Louise de la Ramée) instigated an international firestorm over the rightful place of women at the threshold of a new century. While debates on the subject of suffrage had been circulating in the popular press for decades, Grand's essay, "The New Aspect of the Woman Ques-tion," sought to track both what kind of modern culture these debates had helped to create and where this culture might lead women beyond the vote. In it, she identified and defended a "new woman . . . [who has] solved the problem and proclaimed for herself what was wrong with Home-is-the-Woman's-Sphere, and prescribed the remedy": full par-ticipation in public life and a "new man" who would respect and even emulate her.[26] Grand's New Woman was as well educated as her male counterpart, independent, and rebelled against limiting her experience to the homosocial environs to which women had been relegated for most of the nineteenth century.[27]

Countering this position in the same journal two months later, Ouida argued that the woman Grand celebrated had "no possible title or ca-

pacity to demand the place or the privilege of man." She recognized in this so-called New Woman nothing new at all: indeed, in them she saw "the beings so justly abhorred of Mrs. Lynn Linton."[28] Ouida spoke for a generation brought up with the feminine ideal of the steel-engraving lady, appalled that the familiar—dare one say, "awarish"—figure of the New Woman seemed on its way to becoming not a popular and socially acceptable ideal for their own daughters in the next. Had women not learned the error of bourgeois culture's fascination with the Girl of the Period's world upside-down? Was her anarchic sexual persona not better relegated to and silenced in the clubs and saloons of men's "private" public sphere, where she belonged?

Alas, what moralists at the end of the nineteenth century had not anticipated the degree to which the Girl of the Period had infiltrated and affected women's culture. Unanticipated as well was the style with which her audacious model would be less imitated than reinterpreted and refocused by not only the performers who invented it but also the "decent" young ladies of the bourgeoisie who idolized them. As we will see, the precedent of the midcentury actress would inspire a subsequent generation of middle-class women toward successes beyond the stage, and the "radical" precedent of the Girl of the Period would give way to the more "rational" expressions of the New Woman. Working-class women, too, grew to seize new opportunities and power at the turn of the century: by the 1880s, there was a surge in women's trade-union membership in England and the United States, which not only led to the increased political awareness of many working-class women but also forged bonds between these women and the "philanthropic" women of the upper classes who had previously viewed their relationship to these laborers as protective rather than egalitarian.[29] Increasingly, class and sex struggles became intertwined in the view of many feminists, as well as some of their detractors. (Indeed, Ouida begins her essay "The New Woman" by conflating—and deflating—the goals of "The Workingman" and "The New Woman," linking them in the sense that "both he and she want to have their values artificially raised and rated, and a status given to them by a favor in lieu of desert.")[30]

The politicization of the New Woman—or, as this "North American" debate gained currency internationally over the following decade, the *Femme Nouvelle* and *Neue Frau*—was indicative of the continuous

growth and interactions of many different kinds of women in the public sphere since the "public woman's" vilification in the mid–nineteenth century. John D'Emilio and Estelle B. Freeman summarize the reasons for the growing public presence of women at the end of the nineteenth century:

> By the end of the century, more and more daughters of the prosperous classes were attending college and pursuing careers in the professions after graduation. Meanwhile, for young working-class women . . . factory, office, and retail jobs grew at a rapid pace, while the number of working women expanded far faster than the growth of the female population . . . with the result that the sex-segregated world of the nineteenth century became less descriptive of their experience.[31]

This phenomenon influenced not only Western women's intellectual and economic growth, but their sexual development as well. In both Europe and the United States, women of the upper classes increasingly entered clubs and white-collar professions, and working-class women joined factories and family businesses, all of which brought them into contact with both the freedoms and the people of the opposite sex.[32] Simultaneously, youth of all classes enjoyed public and private gatherings in which both sexes were allowed to wander unchaperoned, often with spending money that they themselves had earned. In this environment, "young men and women mingled easily, flirted with one another, made dates, and stole time together."[33] At school and in the parlor, they would learn of new scientific and societal approaches to sexuality: Darwinian advocates wrote of the "naturalness" of women's sexual drives, Sigmund Freud inscribed human neuroses and family relations with sexual foundations, and sexologists Havelock Ellis and Ellen Key optimistically heralded a new era of mutual desire and sexual expression—and such ideas were debated in the university, bohemian salons, and the pages of popular magazines alike.[34]

Like their midcentury predecessors, feminists in the age of New Womanhood debated the "proper" role of sexuality in progressive women's lives. However, because of the increasing openness of fin de siècle culture to the discussion of sexual issues, the subject was addressed with a frequency and political edge unprecedented in the movement to date. Radical feminists like Woodhull, Olive Schreiner, and Eleanor

Marx, who followed evolutionist or socialist models, challenged the double standard, arguing for the "natural" role of sex and pleasure in human relations and a plurality in expression of the same.[35] At the other end of the spectrum, "social purist" feminists subscribed to evangelical Christian ideas that women's sexuality held to a higher moral standard than men's and should be aspired toward by both sexes. But, interestingly, as Jean V. Matthews has noted in her analysis of the period's purity campaigns, even these otherwise conservative arguments often "slid easily into attacks on the sexual double standard."[36] Indeed, although she herself sided with the social purists on the subject of sexuality, in "The New Aspect of the Woman Question," Sarah Grand directly mocked both this double standard and the period's "true woman/public woman," binary—referring to these terms as the equivalent of "cow woman" and "scum woman"—and argued that, whether portrayed as a domestic breeder or a sexual receptacle, women's realities were both broader than these caricatures suggested and dishonored when labeled as either.[37] Regardless of the various positions that women took between these poles of feminist sexuality at the fin de siècle, the undeniable existence and visibility of this very spectrum—in which ordinary women, rather than either exemplary or "aberrant" ones, were both the subjects and authors of this expanding sexual discourse—indicated that the Victorian sexual binary for women was slowly disintegrating as the century came to a close.

Because the New Woman was symbolic of new ideas about her sex, it was inevitable that she would also come to symbolize new ideas about *sexuality*—although, regardless of the breadth of ideas on the matter that the period's feminists espoused, in popular culture the New Woman was generally depicted as extreme in all matters sexual. Indeed, in an ironic inversion of the still-powerful true woman/public woman ideal, the mere fact of her interest in sexuality meant that the New Woman was consistently vilified as being either under- or over-sexed in precisely the way that women were frequently (and acceptably) painted. This parody of the New Woman as a new sexual binary is demonstrated in a typical caricature in the English illustrated journal *Punch*, which was among many of the period's popular magazines that reveled in her comic possibilities. Published just as Ouida's response to Grand first appeared in the *North American Review*, and debates surrounding the New Woman began

to explode, the magazine's imagined meeting of two "Passionate Female Literary Types" makes clear the sexual extremes with which women like Grand and Ouida were identified. Moreover, this exchange makes clear how the sexuality of women in the public eye—even those women like Ouida who defended the status quo—was conveniently conjured as a method of defusing the explosive matters they were debating.

> Miss Waly (Author of "Boots and Spurs and a Baritone Voice!"): "Honestly, Lucilla, have you ever met the Man you couldn't love?"
> Miss Thrump (who wrote "Oh, the Meeting of the Lips!") "No, Clarissa! Have you?"
> Miss Waly, "Oh, never, *never*! And I earnestly trust that I *never shall*!"[38]

It is easy to read into the man-crazy Miss Thrump echoes of Sarah Grand—whose frank discussion of sex from a woman's perspective in her best-selling 1893 novel *The Heavenly Twins* was viewed by many as pornographic—and the prudish "Miss Waly" as a stand-in for moralizing, conservative, and contradictory feminist apologists like Ouida—who defended the superiority of male genius by (ironically) arguing with great skill and passion about women's inherent lack of precisely these "masculine" traits. The fact that *Punch* has emphasized the single status of these women—note that they are both referred to as "Miss"—suggests that each woman's sexual identity is undesirable to men who might court them.

It is also easy to read a lesbian subtext into Miss Waly's side of this exchange, which reveals a further cause for anxiety about the sexualized figure of the New Woman. Like the Girl of the Period before her, she caused alarm as readily as she did lust with her "mannish" behavior and dress and her ability to identify simultaneously with qualities that had been safely indexed as either masculine or feminine in the slowly eroding separate-spheres ideology of the Victorian era. Granted, the homosocial environments of the nineteenth century's separate spheres often fostered homosexual relationships, which took place in the secrecy of (and with the often-intense intimacy that marked) each sphere. However, at the turn of the century, both scientific analyses of homosexuality and the increasingly public lives of women as well as men found what we might today call as queer subcultures growing and visible in ways that began to build toward those we take for granted in the twenty-

first century.[39] Gay men and lesbians sought each other out both in the public sphere and in reflections of themselves and their communities in the period's popular culture—which would lead to greater cultural efforts to identify and stop those reflections (perhaps most infamously, the Labouchère Amendment to England's Criminal Law Amendment Act of 1885, leading to the trials and public humiliation of Oscar Wilde ten years later). Because she publicly demonstrated "masculine" traits by gravitating toward the professions and power associated with the opposite sex, while at the same time being almost completely woman-centered in advocating on behalf of her sex, the queer undertones of the New Woman's sexuality posed a distinct threat to the heterosexual order.

By the end of the nineteenth century, the subject of sexuality was becoming increasingly acceptable among the bourgeoisie and, wherever she stood within it, it was clear that the New Woman helped to initiate and further this very dialogue. While many early feminists—surprisingly, Sarah Grand among them—argued passionately for the "natural" passionlessness of the true woman as a model toward which members of *both* sexes should aspire, many others promoted the new pleasures increasingly available to them in the public sphere and sought to incorporate them into the expanding discourse of the women's rights movement. As a result, the New Woman contributed to the sense of "sexual anarchy" that Elaine Showalter has famously argued dominated at the fin de siècle. Showalter documents the rush with which popular journals across the Western world created caricatures of the New Woman—such as *Punch*'s "Miss Waly" and "Miss Thrump"—as cautionary figures, which suggested that when "women sought opportunities for self-development outside of marriage . . . such ambitions would lead to sickness, freakishness, sterility, and racial degeneration."[40]

But, as Patricia Marks has noted in her own study of the New Woman in the period's press, it was also true that—like the Girl of the Period before her—the New Woman was occasionally championed for her new sexual ideals. This was, perhaps, because she was simply inescapable. In her groundbreaking study *Women and Labor*, Olive Schreiner wrote of the ubiquitous presence and complex identity of the New Woman at the turn of the century: "Much is said at the present day on the subject of the 'New Woman': . . . It cannot truly be said that her attitude finds a lack of

social attention. On every hand she is examined, praised, blamed, mistaken for her counterfeit, ridiculed or deified—but nowhere can it be said, that the phenomenon of her existence is overlooked."[41] Because it was undeniable that the New Woman was a real, increasingly common, and even inevitable fixture in modern life, there were those that recognized her existence in day-to-day life and acknowledged her influence at the dawn of a new century. Moreover, because the "real" New Woman out in the world was not only ubiquitous but almost invariably young, often beautiful, and possibly sexually available, she was often a subject of fascination and even admiration in the same bourgeois culture that simultaneously feared the consequences of being seduced by her charms. Marks argues that, in particular, American magazines tended to treat the New Woman more sympathetically than did the press in countries like England and France—reflecting a "belief that American women, fostered by the atmosphere of liberty and progress in their native land, were capable of doing anything."[42] In this environment, the glamorization of the New Woman would bring the feminist pin-up into the twentieth century with *Life* magazine's introduction of the Gibson Girl.

Resistance Is Futile:
The Dangerous Allure of the Gibson Girl

Like many late-nineteenth-century American magazines, the original *Life* magazine, founded in 1883, was marketed as a family publication but had a progressive edge. In Marks's study of popular magazines at the turn of the century, she argues that while its enormous readership suggests its mass appeal, *Life* stood out among its often conservative competitors because it claimed to represent "the middle-class reader with a variety of interests in art, music, drama, and politics; its audience was generally well-read and *au courant*."[43] Like many popular publications, *Life* was packed with artwork that illustrated as well as built upon the writing on contemporary life that comprised much of its content. *Life* also shared with its competitors a fascination with that most curious of contemporary phenomena: the New Woman. In 1886 the magazine began publishing Charles Dana Gibson's illustrations of fictional women based on this new type being lampooned in the popular press. However,

22: Charles Dana Gibson, "Her First Appearance in This New Costume," 1893

unlike many of his contemporaries, Gibson depicted the New Woman as a romantic ideal: so lovely and prevalent that the artist once marveled, "Wherever I looked I saw those beautiful girls, and who was I to resist."[44] Gibson's character studies presented her as neither an oversexed nor an undersexed creature, but a healthy balance of "natural" passions tempered by an understanding of bourgeois manners. The Gibson Girls— as they would come to be known—went on to become a staple of *Life* for twenty years, where they served as the feminine embodiment of *Life* magazine's progressive American spirit, and as icons of the lifestyles to which its readers aspired.

The Gibson Girl began as just one of many contemporary "types" that *Life* celebrated and satirized in its illustrations: she often appeared in either comical or moralizing scenarios with captions that elaborated upon the narrative at hand. One typical early Gibson illustration in the magazine is an 1893 piece titled "Her First Appearance in This New Costume" (fig. 22), in which a young woman tugs self-consciously at her abbreviated black bathing suit in the foreground of a sprawling beach scene. Although the narrative presents Gibson the opportunity to depict several young ladies in the closest thing to the altogether allowed

in public at the turn of the century, the artist also takes advantage of the situation to comment positively on the increasingly public lives of women. While the woman of the title is obviously the butt of the joke — as its subtitle makes clear that "she feels more at home in a ball dress" than her bathing gear — the comedy derives from how unreasonable Gibson suggests we should find her embarrassment in light of the scene around her.[45] As the eye moves around the landscape, one finds that the beach is packed with both women and men in costumes appropriate to their activities there. In addition to the bathers in suits, strollers and diners sport outfits ranging from casual separates to full, showy dress; all mill about, breezily greeting and flirting with one another.

From the different styles and qualities of dress presented, it also appears as if this modest, presumably upper-class young woman (not only does her suit appear to be beautifully tailored, her hair appears to have just been carefully, professionally arranged in a tight chignon) may be as worried about the different classes mingling on this public beach as she is about the different sexes. In any case, the woman's hesitation to either present herself in public in a way perfectly appropriate to her activities there or submit herself to engagement with classes "beneath" her are part of the piece's humor — a laugh that Gibson clearly asks us to share with the young woman to the left of the central female figure, who gently coaxes her shier counterpart to cast off the conventions of "ballroom" society and join in the democratic pleasures of this new environment. In Gibson's drawings, this new environment didn't consist just of leisurely locales like the beach, golf course, and theater but included the street, office, and government institution: the narratives in which the Gibson Girls appeared took place on packed boulevards, government buildings, and even elevated trains. And, in all these scenes they engaged with — and, in all cases, made an impression upon — men and women of the working and upper classes alike.

Gibson's moralizing, however, generally focused on sexuality and romance, which seemed the primary areas in which the artist felt women's power lay — clearly indicated in another early *Life* illustration, "A Modern Daniel," where a den of "lions" in the form of beautiful young women threaten a stoic, chained cupid playing "Daniel," resigned to his fate.[46] However, even in such contexts Gibson was perfectly comfortable suggesting intersections between traditional notions of women's

romantic power and their very new, subversive power in the contemporary public sphere. Such intersections connected his otherwise conventional romantic narratives to the politicized New Woman, pointedly presenting such unusual combinations as appealing ones. An 1896 series of *Life* illustrations loosely based around "the coming age" of the next century demonstrates this strategy in ways that, while comical, nonetheless suggested to popular audiences the positive evolution of women's changing roles, which the series imagined on the horizon. In the series Gibson envisioned such progress as all-woman war councils, ambassador's balls, presidential cabinets, and even Christian clergy. Only one work in the series approaches a cautionary narrative: regal depictions of a female judge and admiral stand at each side of an "abandoned" cupid—cup in hand, alms note hanging from his neck—and a caption asks viewers, "In the days to come, who will look after this boy?" This suggestion of the demise of romance with women's rise in professions is the only such warning in the series—indeed, these formidable, handsome (and, unusually, middle-aged) women seem to indicate that the trade-off might be worthwhile—and it makes clear that this demise would result from women's new professional distractions rather than the loss of their womanly appeal.

In the entire "coming age" series, the women depicted are elegant, animated, and seem completely at ease in these new roles, representing the New Woman's future as an enticing, if radical change from the Victorian age that readers, like the Gibson Girls, were leaving behind. Among these future visions, however, none quite capture what was surely their shock appeal than "The Coming Game: Yale versus Vassar" (fig. 23) in which Gibson depicts a fantasy football game between the venerable men's and women's colleges. In it, Vassar's team has successfully tackled all of Yale's players, save the man with the ball at far right who is about to be cut off at the pass by the woman who spies him at far left. Although the potential for sexual humor in his depiction of the tackled players trapped beneath the women surely must have occurred to him, Gibson plays it straight: although gorgeous to a one, these women are trained on athletic, not sexual victory—clearly indicated by not only the determined looks on the ladies' faces, but the dark expression on the last man standing.[47]

Gibson did not, however, shy away from associating the athleticism

23: Charles Dana Gibson, "The Coming Game: Yale vs. Vassar," 1896

of the Gibson Girl with her sexual prowess in other images, and he delighted in depicting her in the pages of *Life* in both romantic clinches and disputes that suggested the New Woman's expressive physicality was as logical and attractive in private as it was in public—particularly since it was always depicted in heterosexual relationships. This is not to say that the works were devoid of the dangerous charge that this distinctly aggressive sexuality carried. Drawing attention to *Life* images like "In the Swim: Dedicated to Extravagant Women"—in which the literally unattainable Gibson Girl smirks cruelly as she watches a suitor drown the minute he comes within her reach—Martha Banta rightfully asserts that few popular illustrators of the period "strained after darker visions . . . [or] came near an expression of the physical passion of which Gibson's art was sometimes capable." [18]

To get a sense of how subversive Gibson's representation of the New Woman truly was in its own time, compare the Gibson Girl's New Womanhood with her more typical, less attractive contemporaries in the popular press. Particularly mean-spirited images of the New Woman could be found in English journals that, like many popular magazines in both continental Europe and the United States, tended to underscore either the folly or the evil of her goals. However, in England the New Woman was additionally viewed as devoid of the age-old morals that

"the colonies" may have shaken off, but which many Britons counted among the last vestiges of their cultural identity as the century came to a close.[49] Typical of this approach were the images of *Punch* magazine, whose oft-cited New Woman caricature in its 1894 "Donna Quixote" illustration depicted her as a bespectacled, mannish spinster with her nose in a book (and surrounded by presumably just-read volumes by Tolstoy, Henrik Ibsen, and Mona Caird) from whose imagination spews dreams of "tyrant man" beheaded, the dragon "decorum" slain, and "marriage laws"—in the form of a distant windmill—ready to be lanced by an equestrian "Donna" riding (horrors!) astride rather than side-saddle.[50]

Occasionally, *Punch* would recognize the at least superficial appeal of the New Woman—her youth, beauty, and preference for relatively re-vealing clothing based on form-fitting masculine dress—only to make sport of her vanity or incompetence. An excellent example of this type —and a compare-contrast study with what *Punch* seems to posit as her ideal and opposite—is found in an 1894 comic illustration of "A New Woman" (fig. 24), in which the titular character is paired with "The Vicar's Wife," as if the two have met by chance on a country path. The latter, swathed head-to-toe (even her hands are hidden by gloves) in a heavy, ruffled outfit, has encountered the former, who is on her way back from the hunt. Demurely approaching the New Woman—who, naturally, wears man-tailored hunting gear, complete with jaunty cap and boutonniere poking out of her lapel, and carries a rifle at her side— The Vicar's Wife politely asks her, wide-eyed: "And have you had good sport, Miss Goldenberg?" Miss G. (again, pointedly identified as single), her head tossed back imperiously, breezily responds: "Oh, rippin'! I only shot one rabbit, but I managed to injure quite a dozen more!"[51] Al-though both women are represented as young, slim, and beautiful, it is clear which of the two women *Punch* feels is the feminine ideal of her age—not only in the way that the New Woman's folly is mocked, but in the undignified form that she cuts next to her elegant, composed, and modest contemporary.

Gibson, on the other hand, dreamed of the "coming age" when women would become the vicar as opposed to the vicar's wife—even daring to suggest that, if such a development were to come to pass, "Churches May Be Fuller."[52] In his narratives, the "lady" is chided for her

24: "A New Woman,"
Punch magazine, 1894

passivity and modesty in a world where women's action and audacity are the order of the day. Whereas *Punch*'s New Woman was grotesquely, perversely oversexed when sexualized at all, the Gibson Girl was held up as not just an actively desiring, but an abundantly *desired* sexual subject— a fact that would inevitably lead to her gradual evolution from illustration to pin-up. Although arguably closer to genre prints than true "pin-ups," Gibson's full-page illustrations were easily torn and displayed as well as reproduced and sold as single-sheet prints—all of which lent the imagery to pin-up display. As early as 1895, Gibson's friend and frequent collaborator, writer Richard Harding Davis documented as much when he reported seeing the Gibson Girl "pinned up in as far distant and various places as the dressing room of a theatre in Fort Worth, Tex., and in a students' club at Oxford."[53] As the popularity of these mininarratives grew, so did the visibility of Gibson's work: by 1900, his illustrations appeared not only in *Life*, but also in *Scribner's, Harper's Monthly*, and the *Century*. In 1903 he accepted a contract from *Collier's Weekly* that paid him $100,000 for one hundred illustrations over four years, making him the highest-paid illustrator of his day.[54] Gibson's imagery

25: Charles Dana Gibson, frontispiece of "A Big American Girl," from *Pictures of People*, 1896

was not only cut out and displayed but illustrated (and knocked off) in countless books by contemporary authors—although the most popular of his published volumes were those in which his previously published magazine work was compiled and reproduced in deluxe monographs. These were collected and admired by individuals and families in precisely the same way as carte-de-visite albums had been by a previous generation—amusing, even titillating, but ultimately "educational" compilations of imagery that attested to the modernity and sophistication of the owner. During this time, the Gibson Girl shifted from illustration to icon, in need of neither narrative nor backstory. Increasingly, she became the subject of single-panel images that make this iconicity clear, foregrounding her New Womanhood as a modern sexual ideal in a manner similar to the burlesque actresses that preceded her.

Such a pin-up-styled image opened Gibson's 1896 book, *Pictures of People* (fig. 25), a volume that compiled illustrations previously published in *Life* and *Scribner's* as well as works like this one, which were derived from his sketchbooks and offered purchasers the promise of

new Gibson Girl "characters" to discover alongside old favorites. This sketch appeared next to the book's cryptic dedication "To a big American girl"—but, published the year after his marriage to Irene Langhorne (herself precisely the type of woman he was so fond of representing),[55] one can assume that this "big American girl" relates not only to the Amazonian women he was already famous for depicting, but the ideal woman he just landed. In either case, unlike many of Gibson's contemporaries who satirized the "big," bold New Woman, the image and accompanying inscription make clear that the artist saw this ideal as both real and desirable. Slim and athletic yet impeccably dressed and coiffed, her coat, scarf, and muff indicate that she not only journeys out of doors, but does so unchaperoned. She looks, almost disapprovingly, down her nose to meet the viewer's gaze, striding forward with poise and confidence. Although her tall hat and furry muff suggest a certain wealth, and even frivolity, the relative simplicity of her coat, lack of stiff petticoats, and tendrils of her loosely piled hair blowing in the breeze all speak to the "mannish" informality of her image.

This appealing juxtaposition of traditionally vilified masculine attributes with clearly attractive qualities of conventional feminine beauty is elaborated upon in an 1899 image from Gibson's satirical *Life* series, *The Education of Mr. Pipp*. The series follows the dimwitted-but-wealthy Mr. Pipp as he travels with his wife and comely daughters through Europe. Much of the narrative revolves around the wit and ambition of Pipp's daughters, who gently guide their coarse, nouveau-riche father through European society and toward social affairs in which they might meet and woo handsome young bachelors—who are uniformly delighted by the young women's directness, athleticism, and of course beauty.[56] As in many such series, Gibson occasionally halts the narrative so that the viewer might steal a moment alone with one of these young women. In a striking, pin-up style image, one of Pipp's daughters is rendered lovingly on an otherwise blank page, pausing momentarily in a round of golf to admire her own shot as it sails into the distance. Not only is this Gibson Girl dressed again in a slim skirt, she tops it with a man-tailored shirtwaist and bow tie, shading her gaze with a hand tilting the brow of her jaunty straw hat. The following year, he elaborated upon this image and sentiment in a drawing for *Life* that has since become among the most iconic of Gibson's images, ac-

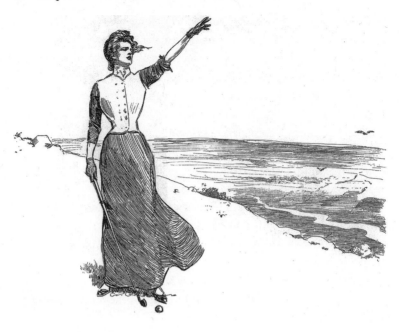

26: Charles Dana Gibson, "Fore! The American Girl to All the World," 1900

companied by the exclamatory caption: "Fore!" (fig. 26). Subtitled "The American Girl to All the World," the work invites viewers to admire the Gibson Girl's charismatic sexuality while asserting that—like her sporting warning—the aggressive allure of American New Womanhood projects across the ocean.

Such studies, isolated from any direct narrative but clearly constructing a modern and self-aware sexualized "character," invite admiration in the same manner of earlier burlesque pin-ups: as an object of desire presented for the viewers' delectation. But, also like these earlier works, the women's desirability is derived in no small part from the unconventional yet composed manner with which they conduct themselves. The Gibson Girl's contribution to the continuum of the feminist pin-up is the fact that her subversive behavior is made appealing by its appearance in the figure of an otherwise ordinary bourgeois young woman. In this way, the Gibson Girl was an interesting and unique new image of the sexualized woman. The contradictory traits of the New Woman that caused anxiety when presented in real women—signifiers of both mas-

culinity and femininity, the working and upper classes, conventionality and unconventionality—were in the Gibson Girl presented in a positive light. While these opposites had been brought together in the mid-nineteenth century by the remarkable figure of the actress, what stood out about the Gibson Girl was the "ordinariness" Gibson suggested in these otherwise extraordinary characters. Perhaps this was the result of the fact that, unlike the photographed personae of actresses a generation earlier, the fantasy nature of the Gibson Girl—whose various manifestations were safely found on the page and not as documents captured from "real life"—gave the artist leeway in constructing her in as plural and shocking a fashion as he would like: while she was drawn from "types" of women Gibson observed in life, there was no real woman to bear the repercussions of the daring behavior that she displayed. As scholar Carolyn Kitch recently noted in her analysis of the Gibson Girl in the context of feminist history, at a moment when real women's struggles for independence were met with outrage and thwarted at every turn, in "magazines, the Gibson Girl was bold, confident, and free to do as she pleased."[57]

Although it is a mark of the period's fear of precisely such women that this was true, it makes Gibson's imagery and popularity no less remarkable. More so, perhaps, when considering that the subversiveness of the Gibson Girl hardly resembled the intentions of her creator. Gibson addressed his women as modern romantic figures and was personally unsympathetic to issues of women's rights and suffrage—indeed, in the rare illustration where he directly addressed suffrage, the cause was represented as either the pure folly of women or dangerously emasculating for men.[58] Reflecting Chris Willis's analysis of the Gibson Girls' literary equivalents in the period's popular New Woman fiction, they were generally portrayed as "attractive, independent, highly intelligent young women entering a range of professions before (almost invariably) falling in love . . . [and] almost sure to come to a bad end unless she abandons her socio-political and intellectual activities in favor of a conventional wifely role."[59] The heroism and danger of Gibson's women was presented as exciting in youth, but those who exhibited similar characteristics into middle age and beyond were almost invariably represented as vain, decadent, or pathetic. One particularly instructive image is his 1900 *Life* illustration depicting "A Spinster's Reverie." In it, the "spinster"

of the title is represented napping alone in an upright chair, dreaming of a past in which she sat in that same room with a handsome suitor, who literally kneels before her beautiful, younger self, presumably begging for her hand. The young woman's sly grin and imperious glance at the poor man impart that—like many a Gibson Girl—she intends to reject another smitten young man in order to maintain her freedom and independence. However, the result of her decision is clear in the juxtaposition and title: this cautionary tale suggests that the allure of the New Woman is a temporary one, good only until she has attracted a heterosexual mate and channeled her "new" strengths into the age-old roles of wife and mother. The work contrasts Gibson's view of the different behaviors acceptable in young and older women—after all, in contrast to his less popular Gibson Man, she was never a Gibson Woman—and reminds us of the romantic as opposed to political ends that he believed his subversively sexual New Women should work toward.

Regardless, it is difficult to look back at Gibson's illustrations in myriad publications of the day and not be amazed at the power, freedom, and passion with which he imbued his women. More amazing is the fact that, during an era in which the New Woman struck fear in the hearts of many, the public delighted in the Gibson Girl's exploits. Gibson's success as an illustrator is but one indicator of his creation's phenomenal popularity at the turn of the century. She not only sold magazines and books; by 1904 *Collier's* reported: "We find the Girl burnt on leather, printed on plates, stenciled on hardwood easels, woven in silk handkerchiefs, exploited in the cast of vaudeville shows, and giving her name to a variety of shirtwaist, a pompadour, and a riding stock."[60] She was an attractive ideal for male fantasy and a willful model for women to emulate; her general ability to stay within (or at least return to) the bounds of acceptable feminine behavior made her a reassuring model of modern womanhood to guardians protecting the morality of either sex. As such, while modeled on young women whose appeal represented a radical departure from popular ideals of the same, the Gibson Girl presented an acceptable and even attainable sexual ideal from this otherwise objectionable model. As Banta succinctly puts the reflective glow that the fantastic Gibson Girl cast upon real women: "Once Gibson created the sign of the Girl, young American women were associated with the grace and glamour he gave to his drawings."[61]

While she was invariably Anglo, and generally of the genteel upper classes, the Gibson Girl's "Americanness" was important in an age where the United States was as synonymous with immigration as it was with democracy—in fact, the "leveling" quality of both was occasionally addressed in his illustrations. As *Collier's* approvingly reported in a feature on the artist, in such images Gibson represented "not only beautiful women in gorgeous raiment, but all types of women in all classes":[62] in her various manifestations she might appear corseted in feminine gowns at society balls, visiting her tenement-dwelling family to share the rewards of her stage career, or lounging in a scandalously modern bathing suit, shoulder-to-shoulder with all manner of person at the popular, cross-class public beaches of the day. Even Gibson's upper-class American women were often presented as something of a mutt, cobbled together as the chimerical product of a young country reinventing traditional notions of race, class, nationality—and, in turn, femininity. In fact, her distinctly unaristocratic scrappiness was contrasted positively against the excessive femininity of not just the European woman (most clearly presented in his drawings for Davis's fictional 1895 "travel journal" *About Paris*),[63] but the European man as well. Indeed, this point is made abundantly clear in Gibson's "Warning to Noblemen: Treat Your American Wife with Kindness," a 1900 illustration in *Life* wherein precisely such a nobleman cowers as a ballgown-clad Gibson Girl strikes a double-fisted, pugilistic pose, having just overturned a chair in her rush to avenge what we are to presume is a cruel comment her husband has foolishly dispensed in the course of dinner.

As Gibson's friend Davis himself noted, because the Gibson Girl could be myriad young women, she would be imitated by "countless young women"—the fact to which he attributed her international popularity.[64] Though the ideal she represented—from her patrician beauty to her bold behavior—was perhaps easier rendered in art than in life, her fictional nature and diverse characteristics also made it easy for women to project themselves onto the Gibson Girl: her appeal derived from the familiarity of her iconic character, regardless of the specificity and limitations of her physical and racial characteristics. This fact was not inherently liberating, of course: according to the biographer (and great-great-granddaughter) of Madam C. J. Walker, the first hair-straightening products marketed in the early 1900s by the African

American entrepreneur were developed precisely so that black women could look like Gibson Girls.[65] (Interestingly—at the height of the Little Egypt craze—the closest thing to a Gibson-Girl-of-color that the artist produced were his quasi-ethnographic studies of young North African women published in Gibson's 1899 travelogue *Sketches in Egypt*.)[66] And, like the "success" of Walker's customers in obtaining this ideal look— or even the success of Walker herself as a businesswoman who made her fortune arguably on the racial insecurities of her people—the success of the Gibson Girl as an early feminist icon in this age of casual chauvin- ism and racism is problematic. The Gibson Girl's beauty and generally inoffensive exploits ensured that her image as an icon of New Woman- hood could be circulated among wide audiences without fear of dis- rupting either bourgeois morals or the white supremacy that even the period's feminist culture was guilty of perpetuating.

But the Gibson Girl nonetheless celebrated the dramatic shifts occur- ring in women's culture at the fin de siècle, when even these superfi- cial signifiers of independence were ordinarily looked upon with great anxiety—an anxiety that led many to suspect that beneath the Gibson Girl's romantic appeal lurked myriad dangers. Indeed, although in- tended as a comical series, Gibson's own ironically titled series *The Weaker Sex*—first published in *Collier's Weekly*, but quickly bound and sold as part of a stand-alone volume of the same name—seems cause for alarm as much as laughter by illustrating members of said "weaker sex" turning the tables on men. Without doubt the most powerful image from the 1903 series, "The Weaker Sex II" (fig. 26), depicts a group of Gibson Girls assembled for the purpose of "scientifically" scrutiniz- ing—with magnifying glass and dissecting instrument—a tiny, pleading man, at whom they poke with cool detachment. On the one hand, the series' presentation of this world upside-down conforms to the age-old, comical scenario in which the manipulation of heterosexual men's sex drives is demonstrated as the one area in which women are permitted to exercise any degree of power. On the other hand, the dramatic dif- ferences between the lovely giantesses and their buglike captive, as well as the manner with which the former scrutinize and torment the latter, clearly associate the beauty, self-awareness and—considering the me- thodical, even scholarly method of her entomological scrutiny—intel- ligence of the Gibson Girl with both danger and power. As Gibson's

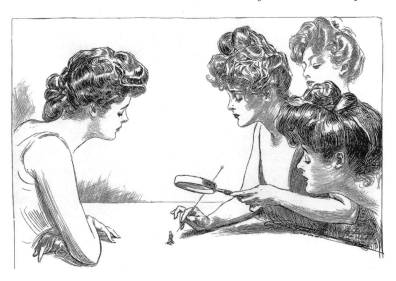

27: Charles Dana Gibson, "The Weaker Sex II," 1903

own sister (and one of his favorite models) Josephine Gibson Knowlton asserted, regardless of her brother's feelings on the matter, the Gibson Girl "carved out a new type of femininity suggestive of emancipation."[67] Considering the period's suspicions concerning the New Woman's real-life struggles for freedom, it is perhaps unsurprising to find that there were women eager to claim both the feminist potential and enormous popularity of such images for their own ends.

Queering the New Woman:
Frances Benjamin Johnston's "Pin-Up" Portraits

The fact that fictional New Woman characters were often used to trivialize the very real debates affecting very real women in society and politics at the turn of the century was of great concern to the period's activists, who felt that such representations undermined their cause. But in 1895 a feminist author who sought to reclaim the New Woman in verse summarizes a counterstrategy with which many other feminists would approach her image in popular culture:

As "New Woman" she is known.
'Tis her enemies have baptized her,
But she gladly claims the name;
Hers it is to make a glory,
What was meant should be a shame.[68]

In this spirit, as Richardson and Willis argue, many writers associated with the women's movement created appealing, sympathetic New Woman characters by appropriating figures that could be interpreted as such from popular culture "as a means of advancing sexual and social change . . . [by] bringing debates on femininity to a wider audience."[69]

Similarly, while feminist illustrators like American suffragist Nina Allender and the collective artists of the English Suffrage Atelier attempted to counter unsympathetic caricatures of progressive women with "types" that instead presented feminists as reasonable, beautiful, and even glamorous, others appropriated already popular figures such as the Gibson Girls toward a strategy of promoting the fact that positive images of the New Women were already in their midst.[70] As such, while she was favored for her beauty and panache by many admirers, the Gibson Girl was among the period's feminine ideals admired by others as an appealing model of New Womanhood: one that might convince the doubtful—as Charlotte Perkins Gilman would attempt to do in her revolutionary 1898 study of *Women and Economics*—that were the Gibson Girl held up next to her genteel, Victorian predecessors, the New Woman's detractors might grow to find her "braver, stronger, more healthful and skillful and able and free, more human in all ways."[71]

Photographer Frances Benjamin Johnston—who, incidentally, snapped Gilman's best-known portrait in 1900—is another turn-of-the-century firebrand who appropriated the popular pin-up as a symbol of New Womanhood. This association is clear in an 1895 self-portrait of Johnston within her Washington, D.C., studio, where she is surrounded by examples of the same (fig. 28). In this image, Johnston poses at her photo-strewn corner desk—smoking a cigarette and reading papers with a pointedly pensive expression—surrounded by illustrations for and advertisements from popular magazines, almost all of which feature images of New Womanhood in its various manifestations. Although they paper the room in the haphazard manner befitting an artist's "wall

28: Frances Benjamin Johnston, self-portrait in the artist's studio, 1895 (Library of Congress, Prints and Photographs Division)

of inspiration," Johnston's choices were hardly random: she was a poster collector whose collection was renowned and centered upon works featuring precisely such popular imagery of young women.[72] The works on display in her studio when this particular photo was taken feature mostly current, pin-up style images that include striking advertisements for popular magazines, such as the postimpressionist posters of Edward Penfield for *Harper's Monthly*, and J. J. Gould and William L. Carqueville for *Lippincott's*; William H. Bradley's arts-and-crafts-inspired posters for his literary journal *Chap-book* (which itself promoted posters as a modern art form); and even a *National Police Gazette* poster featuring a burlesque carte-de-visite reproduction. In the midst of this collection—on the wall before the artist's desk, in fact—are two Gibson Girl posters promoting *Scribner's* magazine for that year.[73]

Considering her association with contemporary young women like Johnston, it is unsurprising that the photographer would meditate upon the Gibson Girl's image alongside the other images of the New Woman —even such historical precedents as Joan of Arc—that we see strewn around the room. In fact, the Gibson Girl's presence alongside myriad

29: Mills Thompson, Handbill for Frances Benjamin Johnston's studio, 1895 (Library of Congress, Prints and Photographs Division)

glamorous examples of New Womanhood from the popular press reminds us of the wealth of such models that would become increasingly available for women's contemplation by the turn of the century. Perhaps more interesting than Johnston's contemplation of these illustrations, however, is her appropriation of them: the photographer would comfortably project her professional image onto such models, as evidenced in a handbill advertisement from Johnston's archive at the Library of Congress, created for Johnston by her friend, artist Mills Thompson, the same year as her in-studio self-portrait was taken (fig. 29). Something of a pastiche of the different styles of illustration we see on Johnston's walls, Thompson's work advertises both Johnston's burgeoning photography studio—where she was fast becoming a popular portraitist for both the society women and the bohemian set in and around Washington, D.C.—and her services as a writer. (The daughter of one of the city's renowned women journalists, Johnston's photography career had, in fact, grown out of her family's connections to the local press.) In Thompson's illustration, Johnston is dressed in a manner strikingly similar to the bicycling Gibson Girl we so clearly see in the *Scribner's* poster to the right of the studio's desk (fig. 30), striding away from

30: Charles Dana Gibson, *Scribner's* poster, 1895 (Library of Congress, Prints and Photographs Division)

the viewer toward the sunrise with the same purposefulness as Gibson's figure rides toward the viewer. Both wear the man-tailored, sporting "rational" separates and flat-brimmed hat often associated with the New Woman—but, in Johnston's case, accompanied not by a trendy modern bicycle, but by her tripod and camera box. In both images, however, the metaphor of travel is drawn upon, and it is not incidental to the meaning of either. Bicycling, for example, was a loaded activity clearly associated with feminism at the turn of the century: from the unfussy dress that the sport required—often including the "split skirts" and bloomers that still scandalized the public at the turn of the century—to the sexual connotations of the machine itself, young women riders were seen as advertising their progressivism. Historians Richardson and Willis convincingly argue that in images like Gibson's, "cycling and rational dress provided visual emblems of the social, sexual, and political disquiet caused by women's demand for equality," emblems that Johnston undoubtedly recognized in such pin-up images, whose symbolic "mobility" the photographer and her peers likely associated with Johnston's own particular and even professional mobility that we see in images of the photographer.[74]

Such easy associations between the fictional and actual New Woman exemplify the manner in which illustrated pin-up imagery was accessed and appropriated by progressive women at the turn of the century. It also

helps explain why these women might be drawn to such constructs for practical as well as political reasons: as iconic stand-ins for real women in the public sphere, they tempered the sharp edges of the potentially subversive activities that independent women like Johnston not only performed, but needed the acceptance of a somewhat broad audience to continue performing. It is interesting that Johnston so eagerly used an illustration rather than a photograph of herself specifically for the purpose of advertising her photography studio—she herself wrote approvingly on the reverse of this very handbill by Thompson (which she kept for her files) that it "brought me many friends and customers."[75] One cannot help but wonder if Johnston realized that to potential patrons the generalized and charming image of a "Miss Frances Benjamin Johnston" might prove more appealing than the real woman, whose formidable presence was far more intimidating than Thompson's plucky pen-and-ink portrait suggests.

This, of course, is not to say that Johnston did not take great pleasure in her unconventional ability to intimidate, in person or in photographs—as demonstrated in her *Self-Portrait as New Woman* (fig. 31), taken around the same time as her studio self-portrait. Sitting before the fireplace in the reception area of the same studio seen in her poster-strewn self-portrait, Johnston here presents not a professional but a playful side of her personality—one that seems equal parts portrait and parody, and another pastiche of different iconic elements of the New Woman. Her pose is the confrontationally casual stance of a seated barroom bachelor: slouching forward with elbows akimbo as if deep in a drunken philosophical conversation, an attitude embellished by the cigarette she holds before her and the beer stein she holds at her hip. The open, cross-legged way in which she is seated is also distinctly masculine, although revealed by Johnston's hiking up the full-length skirt of a fashionably feminine outfit in a manner that shows off her lacy underskirt and shapely legs. Such juxtapositions of conventional masculine and feminine attributes are echoed in her own features—her striking profile draws attention to the prominence and angularity of her nose and cheekbones, yet her deep-set eyes, full lower lip, and daintily upswept hairdo are precisely the feminine attributes Charles Dana Gibson fixated upon in his ideal women of the period. The image is so theatrical, so extreme that it arguably more closely resembles the theatrical cartes

31: Frances Benjamin Johnston, *Self-Portrait as New Woman*, ca. 1895 (Library of Congress, Prints and Photographs Division)

de visite of burlesque actresses some decades earlier than the mannered New Woman illustrations that covered the walls of the same studio in which Johnston poses.

Perhaps theater did, indirectly, enter into the image's conception. Personal photographs from her archive include shots of the elaborate costume parties that Johnston often hosted at her studio, attesting to the fondness with which she and both the men and the women of her social set approached role-playing and masquerade.[76] In fact, this same archive includes photographs of Mills Thompson performing different roles in the same kinds of theatrical, if makeshift, costumes and make-up as one finds her partygoers—playing an exasperated old man, a minstrel, an African villager—but meticulously staged and framed in Johnston's

studio. In these images, Thompson acts out different ages, races, and genders—notably, in a drag photograph where he has been dressed and made up as an art nouveau nymph. Draped in white fabric, the sheer veil over his head held in place by blossoming branches, Thompson grins broadly but does not mug—he seems to earnestly enjoy his dramatic gender transformation in a way that obscures whether that pleasure is derived from the sitter's sense of humor or sense of joy.[77] Similarly, Johnston's fireside self-portrait might seem a theatrical mockery of the New Woman it depicts, were it not for the fact of both Johnston's own, well-documented enjoyment of the "masculine" vices of which she partakes—from her letters and household budgets, it is abundantly clear that she regularly indulged in both tobacco and liquor[78]—and the simultaneous, unambiguously "feminine" manner in which she has sexualized this same performance staged for her own camera.

The extremes of gender performance that Johnston brings together in her "New Woman" self-portrait are found elsewhere and in isolation in Johnston's self-portraiture. One particular pair of images (figs. 32 and 33) clearly elaborates on precisely these sexual extremes that Johnston seems to have both identified within herself and sought to represent in pin-up imagery. In one of these photographs, Johnston appears on a beach in the same type of abbreviated, modern bathing suit seen in Gibson's beach scenes of the period: edging into the sea, she looks out toward the water and strikes a studiously "candid" pose, with one hand grazing the edge of her skirt, the other resting on the bough of the small wooden boat behind her. While her pose suggests activity, her choice to not only stand before (rather than behind or inside) the boat, but with a graceful and flattering twist of her torso, leads one to believe that this image is primarily a glamorous one meant to draw attention to the very feminine allure she projects. An equal-but-opposite effect is found in the other image, in which Johnston poses indoors next to an old bicycle in full male drag—complete with painted-on moustache. Again, Johnston's pose is studied in its casual effect: looking away from the camera and over the handlebars that she firmly grips with both hands, were it not for the fact that she appears to be in someone's parlor one might assume that she were about to leap astride the bike and take off. Although these are very different images, it is interesting that they were likely taken not only around the same time, but in the context of festive

32: Frances Benjamin
Johnston, self-portrait,
ca. 1890–1900 (Library of
Congress, Prints and
Photographs Division)

below **33**: Frances Benjamin
Johnston, self-portrait,
ca. 1890–1900 (Library of
Congress, Prints and
Photographs Division)

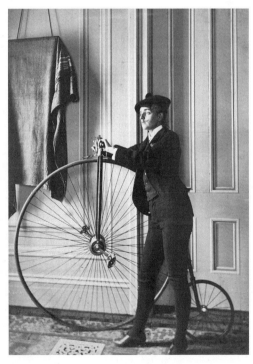

gatherings: photographs by Johnston of her extended family posed on a beach in the same attire and atmospheric conditions as her bathing-suit image appear elsewhere in Johnston's archive, as do images of Johnston posing in this same male drag and setting with another woman and a man, each in the drag of their opposite sex as well. (In fact, in another photograph from Johnston's archive, this same trio in this same room also appears in what seems to be their own street clothes having tea together on that same day.)

Although Johnston was primarily a camera for hire, such photographs constitute a handful of personal photographs suggestive of themes that may have reverberated with her sexual identity—which all existing evidence indicates was as complex as these self-portraits would seem to indicate. While intensely secretive about her romantic life, Johnston's personal letters reveal at least one long-term romantic relationship with a woman (her studio assistant Mattie Edwards Hewitt) as well as flirtations with members of the opposite sex; and during her years living and working in both D.C. and New York's Greenwich Village, she was associated with social groups of which both feminist and queer subcultures were a part. However, because Johnston is today best known for her photojournalism on the subjects of professions and education (such as her much-debated images of Native Americans and African Americans at the Hampton and the Tuskegee Institutes),[79] these well-known images have been used to paint the artist as a product of her genteel, privileged upbringing. To be sure, as a doted-upon, only child born to a comfortable Anglo-Protestant family with two working parents, Johnston never appeared to feel that her professional ambitions were particularly unusual or political, nor did she feel compelled to actively support the women's movement.[80] However, images like these from early in her career suggest that this sense of entitlement took a different—and comparatively transgressive—turn in her curiosity about and confidence in representing sexuality from what can be read as both a feminist and a queer perspective.

Such confidence, in fact, led to a brief scandal in 1898, when Johnston was sued by the father of a young friend of hers who had commissioned and sat for a series of seductive nudes by Johnston. The patron, a single and adventurous society lady named Alice Berry, already had a

reputation as a troublemaker and had been recently arrested at a dog-fight. Although it was reported that Berry herself had enthusiastically "exhibited several of the photographs to girl friends," the father held Johnston responsible for not only the images' circulation, but the resulting "besmirching" of his daughter's reputation that occurred when D.C. society caught wind of the ladies' photo session.[81] The Alice Berry incident is instructive to the degree that it gives contemporary viewers a sense of both the transgressive nature of Johnston's sexualized imagery and its relationship to the subcultures of which she was a part. Yet it is interesting to note that it appears as if most of her own pin-up masquerades were staged for and before audiences comprised of not only friends from within these subcultures, but even her family—suggesting a relationship between the popular acceptance of fictional pin-ups like the Gibson Girls and the growing acceptance of women's sexual self-expression in the real world. Indeed, while Johnston's pin-up self-portraiture might reasonably be viewed as private documentation from and for the transgressive-but-intimate queer circles in which she ran, there exist in her commissioned, formal portraits myriad, if subtler reflections of the New Woman's sexual audacity in the way she photographed her unconventional contemporaries—particularly insofar as one finds echoes of the period's pin-ups within them as well. Many of Johnston's subjects were precisely the kind of New Women idealized in popular imagery like Gibson's—rebellious, but safely bourgeois young women like poet Helen Hay Whitney, muckraking journalist Ida Tarbell, and Johnston's most consistent patron, Theodore Roosevelt's feisty daughter Alice Roosevelt Longworth.

In fact, in one of Roosevelt's best-known portraits (fig. 34) taken by Johnston in 1902, the "first daughter" strikes a pose that undeniably bears the mark of Gibson's influence: standing before a tree on the grounds before the White House, wearing a sporty but feminine printed-cotton dress, hair piled loosely atop her handsome head, Roosevelt looks down her nose at the photographer in a three-quarter pose, jutting out a hip and crossing her arms before her chest in a gesture of defiance. Johnston's image perfectly captures the spirit of this young woman dubbed "Princess Alice" in the press, who was arguably the most visible and talked-about embodiment of the Gibson Girl in the United States: attractive

34: Frances Benjamin Johnston, Alice Roosevelt, 1902 (Library of Congress, Prints and Photographs Division)

but tomboyish, she smoked and drank, was fond of betting on horses, bragged about setting speed records in her friend's automobile on an unchaperoned road trip, and was once likened to a puffing locomotive as she rhythmically blew cigarette smoke while dancing wildly at a White House ball.[82] Admonished by a visiting official for the president's unwillingness to chastise her constant interruptions of his meetings, the legendarily scrappy Theodore Roosevelt responded with uncharacteristic resignation: "I can do one of two things. I can be President of the United States, or I can control Alice. I cannot do both."[83]

Whether compared to her photographs of socialites like Alice Pike Barney or now-elderly suffragists like Susan B. Anthony—whom she photographed in the flattering-but-reserved manner of painted portraits by the likes of John Singer Sargent—Johnston's pin-up representations of not only herself but her youthful and notable contemporaries suggest many interesting developments in the pin-up's feminist history. First, they indicate the shift that occurred in cultural perspectives on the role

of women's sexual self-expression as the "public woman" became more visible, diverse and, subsequently, less easily defined by her sexuality alone. This inability to define women's sexual lives by their public lives would lead to greater freedoms in both areas—leading, further, to the growth and plurality of a Western women's movement that similarly sought emancipation in ways both personal and political. And while the New Woman that emerged from this culture would initially contribute to the panic-inducing "sexual anarchy" of the late nineteenth century— and, correspondingly, to great concern within the women's movement as to the role of sexuality in its politics—the early twentieth century would see greater acceptance of both the New Woman and the self-aware sexuality that she symbolized. However, unlike a previous generation's similar acceptance of the same in the star image of the unruly but exceptional burlesque performer—a sexual ideal rejected when her phenomenon was embraced and emulated by the women of the bourgeoisie—it was precisely the bourgeois nature (or, at least manner) of pin-ups such as the Gibson Girl at the turn of the century that would break down cultural resistance to both the feminism and the sexuality of the New Woman.

The Lingering Threat of the "Public Character"

Whether they are compared with Johnston's Washington debutantes or juxtaposed with her own queer self-portraiture, it is difficult for contemporary eyes to see the fashionably (and fully) clothed, utterly feminine figure of pin-ups like the Gibson Girl as models of first-wave feminism, much less feminist sexuality. However, all these images of young women at the fin de siècle not only transcended the boundaries of feminine sexual ideals set forth and regulated in the previous century, they did so in a manner that would establish new ideals in the next—a possibility that was immediately apparent to many social critics. And tellingly, in much the same way that the charming Girl of the Period was used to vilify the women who both inspired and emulated her, the iconic Gibson Girl was conjured by those who felt the behavior she symbolized was leading young women down a troubling path—all the more troubling in that this influence threatened to affect the foundation of

a new century. Essayist Caroline Ticknor's imagined conversation be-
tween "The Steel-Engraving Lady and the Gibson Girl" in the *Atlantic
Monthly* exemplifies the general anxieties over the feminist model that
the period's celebrated pin-up represented to many.

In her 1901 essay, Ticknor imagines a meeting of these different gen-
erations of fantasy female from the popular press, instigated when the
Gibson Girl, golf club in hand, pays a call on the Steel-Engraving
Lady. The Gibson Girl wears an ankle-exposing skirt over comfortable,
square-toed shoes, and bounds into the house with a "heavy step on
the stair" so strident and masculine that the Steel-Engraving Lady at
first breathlessly mistakes it for that of her anticipated beloved, Regi-
nald. After exchanging polite insults over the other's vestments and de-
meanor, the modern girl gets down to the business of educating her Vic-
torian predecessor as to the developments in women's culture that the
latter has obviously missed, and that the former admits to personifying:

> "[I] very likely [seem] odd to you," the [Gibson Girl] continued, "who are
> so far behind the times; but we are so imbued with modern thought that
> we have done away with all the oversensitiveness and overwhelming mod-
> esty in which you are enveloped. We have progressed in every way. When
> a man approaches, we do not tremble and droop our eyelids, or gaze ador-
> ingly while he lays down the law. We meet him on a ground of perfect
> fellowship, and converse freely on every topic."
>
> The Steel-Engraving Lady caught her breath. "And does he like this
> method?" she queried.
>
> "Whether he *likes* it or not makes little difference; *he* is no longer the one
> whose pleasure is to be consulted. The question now is, not "What does
> man like?" but "What does woman prefer?" You see, I've had a liberal edu-
> cation. I can do everything my brothers do; and do it rather better, I fancy. I
> am an athlete and a college graduate, with a wide, universal outlook. My
> point of view is free from narrow influences, and quite outside of the home
> boundaries."[84]

Besides the obvious differences between the two women's approaches
to men and education outlined above, they also square off on the sub-
ject of professions, with the Steel-Engraving Lady jumping to a telling
assumption on the matter:

"I am prepared to enter a profession," the [Gibson Girl] announced. "I believe thoroughly in every woman's having a distinct vocation. . . . In my profession I shall be brought in contact with universal problems."

"A public character! Perhaps you're going on the stage?"[85]

The New Woman proceeds to share with her old-fashioned predecessor the news that for her generation, all the world is a stage:

"Oh, no. I'm to become a lawyer. . . . We cannot sit down to be admired; we must be 'up and doing'; we must leave 'footprints on the sands of time.'"

[Unimpressed, the Steel-Engraving Lady] glanced speculatively at her companion's shoes. "Ah, but such great big footprints!" she gasped; "they make me shudder."[86]

Lest the winner of this mannered debate go unnoticed by the reader, Ticknor ends the essay with one final contrast after the two women part ways. The Steel-Engraving Lady is rewarded for her "grace and dignity" upon dear Reginald's return to the home: "He dropped upon one knee, as if to pay due homage to his fair one, and, raising her white hand to his lips, whispered, 'My queen, my lady love,'" after which she serenades her "fond lover" romantically (but chastely) with a "quaint old ballad." The Gibson Girl, in contrast, spends the evening with a jocular young man who calls her "Joe," leaves her to walk herself home, and warns that he will likely break their golfing date the following day in order to hang out with his buddies—all of which leads Ticknor to her emphatic concluding remarks: "Hail the new woman—behold she comes apace! WOMAN, ONCE MAN'S SUPERIOR, NOW HIS EQUAL!"[87] Reviving the logic of the nineteenth century's separate-sphere rhetoric, Ticknor holds up the Steel-Engraving Lady as not only a cultural but even evolutionary ideal—one who had evolved into her rightful place in the home, where she was worshipped as the "superior" specimen of humanity—and posits the Gibson Girl/New Woman as her frightening devolution toward the baseness of the masculine public sphere that she aspires to affect. Worse still, whereas the genealogy of her predecessor in the form of the Girl of the Period could be safely traced to (and sent *back* to) the contained spaces of the theatrical realm, the Gibson Girl makes clear that the New Woman she represents has no intentions to limit herself to this "appropriate" Victorian space for female rebellion—that the same

"great big footprints" that so appalled her predecessor were trained on sites beyond the footlights. And, as went the New Woman's professional life, so went her private life; in the twentieth century the public would have to contend with the increasingly "public character" of both.

But this is not to say that women of the stage were actively excluded from the community of New Women—far from it. Indeed—as the presence of Ibsen's work in the feminist triumvirate of *Punch*'s "Donna Quixote" demonstrates—the theater at the fin de siècle not only witnessed, but was instrumental in contributing to the culture and growth of feminism. The problem for many theatrical New Women, however, had been refuting the stigma of sexual "exchange" associated with the stage—and as such, the clearest route for most actresses was to reject the representation of sexuality and pleasure in their work and imagery, in favor of creating more explicitly intellectual or political personae. However, we will see that as both the "legitimate" theater and feminist activists came to new conclusions about the potential of women's sexualized performance, and new practices of creating and viewing these performances rose with the phenomenon of the moving picture, actresses would re-emerge in the pin-up's feminist history to once again use the genre for its "awarish" potential.

3

THE RETURN OF

THEATRICAL FEMINISM

Early-Twentieth-Century Pin-Ups

on the Stage, Street, and Screen

Frances Benjamin Johnston's photograph of Alice Roosevelt's friend and frequent partner in crime, the Countess Marguerite Cassini (fig. 35), is symbolic in the feminist history of the pin-up. Its existence reminds us of the role that sexual self-expression increasingly played in the lives of this generation of women as the Victorian sexual binary began to erode at the turn of the century. However, the image also symbolizes the consequent erosion of cultural anxieties surrounding the sexualized figure of the actress: although Cassini's "performance" takes place in the safe space of her home, it was a recreation of a tableau she put on for guests at the Russian Embassy. It is not difficult to imagine the reasons why an audience likely composed of older, male ambassadors would thrill to this beautiful young woman's spontaneous performance of what she herself would refer to as a "dramatic and sultry Judith"—followed by a *katchouka* in full Russian costume, no less![1] But, the scandal of female

35: Frances Benjamin Johnston, Countess Marguerite de Cassini, ca. 1904 (Library of Congress, Prints and Photographs Division)

performance in the countess's own family just one generation earlier throws into high relief the cultural changes that needed to pass before such an exemplary young lady could savor "curtain call after curtain call" in polite company.[2] When the countess first arrived in Washington, D.C., as a child, it was with her ambassador father, the Count de Cassini, and her beautiful governess Mme. Scheck. Scheck, however, was no mere caretaker: she had begun her professional life as the continental stage performer Stefanie van Betz. It would be years before another secret of Mme. Scheck/van Betz was discovered: she was, in fact, not only the wife of the ambassador but the mother of his child—her "ward"—the Countess Marguerite. She was secretly married to Betz in 1880, two years before the child's birth. The count was so fearful of the scandal that his wife's professional history might cause his own political career that the family lived a very private kind of theater that al-

lowed them to keep up appearances in the last decades of the nineteenth century.

The radically different reception that the dramatic proclivities of mother and daughter Cassini enjoyed before and after the turn of the century demonstrate the cultural shifts that pin-up-style imagery such as Countess Marguerite's portrait by Frances Benjamin Johnston documents. While Marguerite's status as a white aristocrat in an increasingly open, high society perhaps gave her wider berth than most women in Western culture received, the freedom that this privileged young woman was allowed nonetheless shows the ways that cultural acceptance of sexual expression, feminism, and performance was changing. Yet, though sexualized and alluring New Women in the form of pin-up illustrations like the Gibson Girl, or even character studies in popular New Woman fiction like that penned by Sarah Grand, provided women with not just sympathetic but even attractive models of feminism at the fin de siècle, they were ironically lacking in the realm of popular performance from which such models first emerged—but not for a lack of women on the stage. The U.S. Census is an excellent indicator of the exponentially growing popularity of performance as a career for working women since the heyday of the burlesque, revealing that from 1870 to 1880 the number of women working as actors rose from 780 to 4,652. By 1910, that number would more than triple to 15,436.[3]

In these years that the sassy and sexualized burlesque woman saw her star wane, dramatic actresses thrived, gaining popular acceptance by cultivating precisely the "tender," asexual star image defined and promoted by antiburlesque feminist predecessors like Olive Logan. However, a small but significant group of dramatic actresses in this period—which included now-legendary performers like Ethel Barrymore and Sarah Bernhardt—would break with this convention to capitalize upon the same sexual audacity previously associated with the burlesque, but "elevate" it through its expression in "legitimate" theatrical drama. Such women's careers remind us that complex female roles and performers did exist at the fin de siècle, and they were expressed in visual culture. As with the visual culture of the burlesque, the pin-up in the hands of particularly shrewd actresses would help not only to carry on and redefine the subversively sexualized identities created by their burlesque predecessors, but to pass this torch further—to a generation of "per-

formers" who would influence women's culture from the street and the screen rather than the stage in the late years of the suffrage movement.

The New Woman on the Stage and on the Streets

Interestingly enough, Ethel Barrymore—granddaughter of the famous Philadelphia actress/theater manager Louisa Lane Drew, whose own theatrical ancestry extended back to the Elizabethan age and continues to the present day with actress Drew Barrymore—first came to prominence less for performing any single character on the stage than for performing a character from the *page*, promoted as she was in the press and her photographs as the living embodiment of the Gibson Girl (fig. 36).[4] While the veracity of assertions that she was a model for Charles Dana Gibson's creations is debatable, there is no doubt that—because of her physical resemblance to both the Gibson "type" and the contemporary young women modeled after them that she first came to prominence playing in romantic comedies on the New York stage in the late 1890s— Barrymore would come to represent the same type of New Womanhood to theatergoers in both the United States and Europe by the turn of the century. And, in the same way that the fictional Gibson Girl encouraged an acceptance of the New Woman in everyday life, so did the emergence of actresses like Barrymore give rise to an acceptance of the New Woman on the stage. The key to Barrymore's popularity, like that of the Gibson Girl, was her familiarity and malleability in the popular imagination; as a columnist of the period summarized the allure of "Our Ethel," "the beautiful Miss Barrymore is Ethel to us because she is the daughter of every parent in America, the beloved charge of every household. . . . Miss Barrymore was born to be 'daughter of the American stage,' but she has made herself 'daughter of the American people.' "[5] This perspective on Barrymore's appeal is striking for how it marks popular shifts in the embrace of the sexualized woman and the actress, as well as the New Woman, written as it was just one year after the actress's startling choice of dramatic debut in the New York theater as Nora Helmer in *A Doll's House* in 1905.[6]

Henrik Ibsen's plays, particularly *A Doll's House*, were infamous in their own time for bringing the New Woman—particularly the sexu-

36: Burr McIntosh
Studios, Ethel
Barrymore, ca. 1901
(Library of Congress,
Prints and Photographs
Division)

ally expressive New Woman—to the stage as neither a monstrous nor a
comical caricature at the turn of the century.[7] In addition to his plays'
finely drawn studies of the frustrations and desires of progressive mod-
ern women, Ibsen was also renowned for stressing the collaborative na-
ture of performance, wherein the playwright and actor are equally re-
sponsible for the life of the character—a fact that was empowering for
actresses seeking to assert the artistry and autonomy of their work in a
theatrical world still dominated behind the scenes by men.[8] Powerful,
popular performers Mary Shaw and Elizabeth Robins were among the
first champions of Ibsen's work and among the earliest dramatic actresses
on the "legitimate" stage to align themselves with the suffrage move-
ment. Both women performed early English translations in the United
States and England in the 1890s in the hopes of using Ibsen's complicated,
sympathetic characters on the stage to instigate changes in women's lives
offstage as the suffrage movement was slowly gaining momentum in
both countries. Both women also wrote theatrical correspondence and
criticism and spoke publicly on the actress's art in an effort to bring at-
tention to the stage as another platform for suggesting women's poten-

tial beyond the theater—but both were also looked upon by the general public as either "high art" fringe figures or outright propagandists for the suffrage movement.⁹ The fact that by 1905 as popular and beloved an actress as Barrymore would choose Nora as her first "adult" dramatic role speaks volumes about the inroads that the New Woman had made in popular culture within the first decade of the twentieth century.

Though Barrymore's interests and ambitions were impossible to pin down, rather than fret over her contradictions, the press (and, presumably, her legions of fans) delighted in them: articles juxtaposed the facts of her conservative convent education and her taste in avant-garde European art and literature; the veritable dynasty of actors from which she emerged and her rung-by-rung climb from bit player to Broadway phenomenon; and later the fact that at the very moment that she married and gave birth to her first child, she began attending suffrage meetings.¹⁰ She was, perhaps unsurprisingly, among the friends of that other contradictory "daughter of the American people," Alice Roosevelt. As different as were the details of these young women's lives, their common, independent spirit was held up as a model for young women everywhere at the start of the twentieth century. When the young women were spied riding together one day, a reporter for the *Toledo Blade* assured her readers that "It is a strong healthy ideal these girls illustrate."¹¹

But another actress's feminist appeal preceded and led the way to that of turn-of-the-century actresses like Barrymore. Although Sarah Bernhardt both shunned the work of Ibsen (she famously dismissed its tortured realism as "la norderie") and was ambivalent on the subject of the women's rights movement (she alternately scorned and supported suffrage, depending on the audience), her audacious model and decades-spanning career was by the early twentieth century held up across the globe as symbolic of the New Woman's success. In the feminist history of the pin-up, Bernhardt's relevance is particularly important in that, unlike the "healthy" bourgeois sexual ideal of younger contemporaries like Barrymore—who swapped the unruly sexuality of burlesque performers before her for the relatively well-scrubbed appeal of the Gibson Girl—Bernhardt was uniquely able to directly and successfully translate the working-class audacity and dangerous sexuality of the demimonde into the legitimate theater. Indeed, Bernhardt was one of

the few renowned actresses to directly problematize the clear barriers many theatrical managers attempted to throw up between the burlesque and legitimate theatricals after the 1870s, staging her touring performances in spaces, and sometimes even on bills, shared with burlesque performers: her 1879 London debut was launched at the Gaiety Theatre (home of the naughty Gaiety Girls), and in the United States she frequently appeared as part of vaudeville variety shows.[12] Her choices were likely driven by her bank account rather than any sense of camaraderie with her sisters in the burlesque. (In the United States, for example, Bernhardt discovered that vaudeville appearances paid two to three times what she earned in Broadway productions: in her first vaudeville run, the actress earned an astonishing $7,000 a week — in an era when the average weekly wage for female workers was $5–$15.)[13] However, Bernhardt was also more comfortable with both her sexuality and its representation on the stage than most dramatic actresses of her stature and, as we shall see, had no problem capitalizing upon either in ways that fit easily with burlesque spectacles — a fact that distinguishes Bernhardt's career from those of her contemporaries.

As Gail Marshall succinctly states, whereas the asexuality cultivated by most fin de siècle "dramatic actresses could be absorbed more easily into the middle-class society critics and audiences would have them bolster . . . burlesque actresses signified much more blatantly than did their colleagues the underlying, and perhaps indelicate, terms of [all] their work and audiences' reception of it."[14] As such, successful dramatic actresses of the period — Ellen Terry, Mary Anderson, Eleanora Duse — were careful to the point of obsession to present themselves both on and off the stage as sentimental, transparent, vulnerable, and above all chaste models of femininity very much in line with the ideal of "true womanhood." These qualities were praised not only for reflecting positively upon the morality of the actress herself, but for how they contributed to the actress's ability to "submit" to the roles she performed.[15] Bernhardt, however, rejected the dramatic actress's disavowal of both her own agency and sexuality. She instead infused historical and modern characters alike with not only the sex appeal inherent in her famous, uniquely physical style of acting, but also the blatantly contemporary and personal sex appeal heretofore associated with the burlesque.

This fact was noted by her many detractors, who leveled at Bernhardt

all variations on Olive Logan's earlier critique of the burlesque actress's tendency to be "always peculiarly and emphatically herself": the eccentric, publicity-savvy celebrity who—like predecessors such as Menken and Thompson—always lurked beneath the veneer of the characters she played. George Bernard Shaw would be among the most vehement and articulate of Bernhardt's critics for this very reason, comparing what he saw as the pure emotional authenticity of Eleanora Duse with Bernhardt's "personal fascination . . . which the actress can put off and on like a garment."[16] Elsewhere, he would elaborate: "The dress, the title of the play, the order of the words may vary; but the woman is always the same. She does not enter into the leading character: she substitutes herself for it."[17] No less a contemporary than Anton Chekhov shared Shaw's view, complaining after her 1881 performances in Moscow that she "remakes her heroine into exactly the same sort of unusual woman she is herself . . . the ultra-clever, ultra-sensational Sarah Bernhardt."[18] This clear construction of characters bent to the will of the actress that conjured them—rather than vice versa—was threatening to many in this period of theater history, who preferred their dramatic actress's complete submission to not only the character she played, but also by extension the (overwhelmingly male) playwrights from which they originated. As Henry James would write of this threat in *The Tragic Muse*—describing his Bernhardt-inspired character Miriam—such a woman was "a real producer . . . whose production is her own person."[19]

This power of production would lead feminists of the period—regardless of Bernhardt's ambivalence toward the women's rights movement—to celebrate the actress as one of their own. Susan A. Glenn has interpreted Bernhardt's appeal to New Women of the period: "Bernhardt took what was then the revolutionary step of encouraging audiences to believe that what they saw on stage was not an actress playing a character, but a woman using that character to reveal herself to the spectators."[20] At a moment when progressive women in the theater sought to legitimize contemporary women's struggles with their realistic portrayal on the stage, Bernhardt's insinuation of a contemporary femininity and charismatic sexuality both in modern plays (often written specifically for her) and in the roles of historical characters ranging from Medea to Lady Macbeth to St. Teresa of Avila was undoubtedly looked upon as a subversive gesture—one, as we have seen, with origins in the

burlesque. In fact, Bernhardt was famously fond of another subversive strategy with origins in the burlesque: drag performance in "breeches roles." By 1900, the actress had incorporated the male leads from *Loren-zaccio, L'Aiglon,* and *Hamlet* into her repertoire, and she chose to recreate her performance as Shakespeare's tragic Dane for her film debut that same year.[21] Historian Martha Vicinus writes that, like her burlesque predecessors' drag performances, Bernhardt's "heroes must have raised awkward questions about not only the impotence and folly of masculine heroics, but also about feminine guile"—particularly in an era when feminist thought was moving from a marginal to central position in Western women's culture.[22]

This contemporaneity—and how it reflected back upon other contemporary women—endeared the actress to the *Femmes Nouvelles* of her native France, where the feminist daily newspaper *La Fronde* (founded by former actress Marguerite Durand) breathlessly reported upon her every move: in response to criticism over Bernhardt's Hamlet, *frondeuse* Elise Nora celebrated the fact that, regardless of either the character or gender she was performing, Bernhardt always "remained the great woman that she is down to her very bones."[23] With her first English tour in 1879 and first American tour the following year, Bernhardt also earned the admiration of English-speaking New Women who (regardless of the fact that she always performed in French) held up the actress as symbolic of the success, freedom, and respectability for which they were fighting—so much so, in fact, that in Willis J. Abbott's 1913 biography *Notable Women in History*, Bernhardt is represented as the culmination of the feminist history he documents.[24] And Bernhardt was known to return such compliments. In the popular press the actress defended French women's demands to "keep their individuality and make it felt,"[25] and of American women she rhapsodized: "Woman reigns and reigns so absolutely. She comes and goes. She orders, wills, exacts, instructs, spends money recklessly, and gives no thanks. This shocks some people, but it only charms me."[26] As Mary Louise Roberts has asserted in her study of Bernhardt's influence on feminists at the fin de siècle, the actress represented "the links between 'acting' and 'acting up' [that] lay at the heart of gender transformation in this period—a key to the process by which the new woman challenged conventional womanhood and shaped a 'personality' beyond domesticity."[27]

Unsurprisingly, Bernhardt's "acting up" extended beyond the stage. Like Adah Isaacs Menken before her, Bernhardt wished to be viewed as a "bohemian" Renaissance woman and followed her success as an actress into several career paths that flouted convention: she was a writer and a gifted artist as well as a theater manager and, with her famous world tours and cinematic performances, fashioned herself into an international brand name synonymous with great drama. Also like Menken, Bernhardt understood the potential of exploiting her eccentricities both on- and offstage through shrewd self-promotion that, naturally, included pin-up imagery. Bernhardt commissioned deluxe lithographic posters from artist Alphonse Mucha (fig. 37) that served as a French theatrical response to the kind of iconic New Women appearing in the American and English poster advertisements collected by Frances Benjamin Johnston. Mucha's poster pin-ups of Bernhardt both stand out from and speak to the work of his best-known contemporaries in the realm of theatrical posters. Since the 1870s, the style of lithographer Jules Cheret had set the standard in France for eye-catching theatrical posters that—as the medium became less and less expensive, and the buildings and kiosks of the recently Hausmannized city made Paris more and more ad-friendly—were a ubiquitous part of the city's urban life. Not only did Cheret's gaudy, masterfully applied color combinations draw attention to the posters, so did his representations of scantily clad performers from the burlesque spectacles that they frequently advertised—appropriately anonymous, fantasy composites of the period's recently muted burlesque bodies of the French stage, who themselves became so popular as illustrated ideals that they became identified collectively as *Chérettes*.[28] Henri de Toulouse-Lautrec would simultaneously draw upon and critique both the work and the women of Cheret with his minimalist lithographic posters of avant-garde celebrities like Yvette Guilbert, whose "vulgar" cabaret performances were derived in equal parts from the old burlesque and the brothel salon.[29] Rather than following the lead of either model, Mucha appropriately drew upon elements of each in his posters for Bernhardt; on the one hand, he emphasized and idealized the actress's beauty and often represented her "floating" in an ethereal void, in the manner of the *Chérettes*. On the other hand, Bernhardt's physicality and features were rendered in a flat, abstracted manner, and with the same exaggerated, angular gestures as Toulouse-

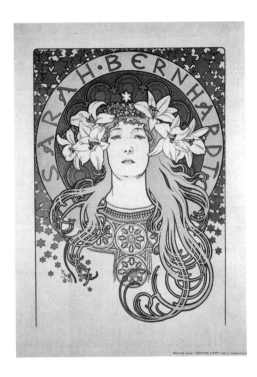

37: Alphonse Mucha,
Sarah Bernhardt poster,
1896

below **38**: Jules Cheret,
advertising poster for
La Diaphane face
powder, 1890

Lautrec's self-consciously modern style represented his self-consciously modern women. The result was an illustrated pin-up of Bernhardt so iconic as to appear Byzantine—a modern "sex goddess" whose unapproachable appeal is clear when compared to Cheret's own, very different illustrated interpretation of Bernhardt (fig. 38), created to advertise a face powder to which she licensed her name.

At the other end of the spectrum from Mucha's apotheosizing ads one finds Bernhardt's highly individuated and often intimate pin-up photographs. Like her burlesque predecessors, Bernhardt recognized the multitasking potential of the pin-up photo: they were cheap to produce (indeed, she was often lavishly paid for her sittings), easy to circulate, and could be both sold as souvenirs that "connected" the star and fan, and shared with the press as all-purpose promotional tools.[30] (Because of Bernhardt's broad appeal, she would share her photographs with outlets from progressive papers like *La Fronde* to illustrated "pulp" tabloids like the *National Police Gazette*.) Moreover, a frequently reproduced nude portrait of the very young Bernhardt in the 1860s—likely still a student at the Paris Conservatory of Music and Drama—demonstrates that from the earliest stages of her career she both was comfortable with expressing her sexuality and recognized the value of its representation in photographs; years later, in the chaste theatrical culture before the fin de siècle, she continued to exploit these facts through her pin-up photography. By the end of her life, it was alleged that Bernhardt's photographs were numerous enough for a computational expert to decree that, if brought together and placed in a pile, they would add up to exactly the height of the Eiffel Tower.[31]

Bernhardt was a fan and subject of Menken's favorite American photographer, Napoleon Sarony, and sat for him on many different occasions at his New York studio. An 1891 cabinet photograph of Bernhardt from one of these sessions (fig. 39) represents the actress in the role of Cleopatra, leveling a smoldering gaze at the viewer as she lounges seductively on a chaise in a body-skimming, art nouveau gown. Much like Sarony's images of Menken made over twenty years earlier, Bernhardt's image seems constructed less to reveal the narrative of the performance from which the historical character comes than to provide the viewer an opportunity to feast upon the sight of an underdressed, beautiful contemporary woman. Naturally, imagery of her drag characterizations

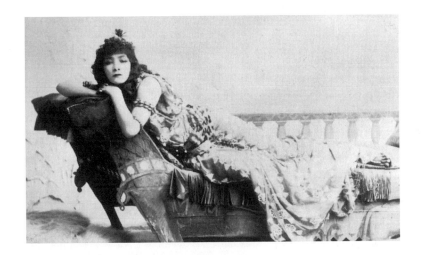

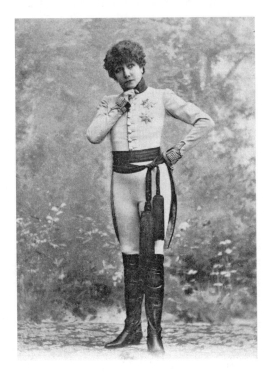

39: Napoleon Sarony, Sarah Bernhardt as Cleopatra, 1891 (Harvard Theatre Collection, The Houghton Library)

40: Photographer unknown, Sarah Bernhardt as L'Aiglon, 1900 (Collection of the author)

also conjures memories of Menken's burlesque photographs, as all of the male roles Bernhardt chose to perform were "tights" roles—the effect of which is demonstrated particularly well in postcard images she created in 1900 to promote her performance as the Duc de Reichstadt in *L'Aiglon* (fig. 40). In these—remarkable in their resemblance to Menken's cartes de visite from her own modern drag roles like *The French Spy*—Bernhardt's performance as the relatively contemporary (and doomed) son of Napoléon Bonaparte allowed the actress to flaunt not only her willingness to usurp and perform an over-the-top, brooding masculinity, but also her excellent feminine figure—a figure going strong and flaunted well into midlife—when her postcards for *L'Aiglon* were created, the actress was fifty-six years old.

Also like her burlesque predecessors, Bernhardt constructed pin-ups that invited viewers into her intimate personal life as another staged spectacle. Nowhere is this more apparent than in Bernhardt's infamous 1873 portrait by the Parisian photographer Melandri,[32] where the actress is posed "asleep"—arms crossed as if laid to her final rest—in the satin-lined coffin that she kept for macabre effect in her Paris flat (along with an inscribed skull given to her by Victor Hugo and an anatomical skeleton that she nonchalantly addressed as Lazarus) and allegedly schlepped across the globe with her as a "creature comfort" from home while on tour. The photograph, for which Bernhardt received a hefty fee, and which allegedly made its creator a small fortune in cabinet-card reproductions, naturally instigated gossip surrounding the coffin's origin and purpose in the actress's bedroom and bolstered Bernhardt's reputation as a gothic sexual adventuress.[33] But her offstage photographs reflected her larger interest in blurring the boundaries between star and fan, stage and street beyond simply opening her boudoir to photographers; again like Menken, she used photography to present herself as more than "mere" actress, but also as an artist and intellectual. In a manner strikingly similar to Menken's use of photography to construct her offstage self as a writer, Bernhardt presented herself in a series of photos by Melandri as both painter and sculptor in meticulously staged photographs that likewise balance the actress's "masculine" endeavors with a fetchingly feminine sense of style. (So fetching, in fact, as to be inappropriate. While the impressive artworks in this series of photographs are indeed by Bernhardt's hand, the spotless white Pierrot costume she wears while

hovering over her creations—an ensemble embellished with lacy cuffs and collar, boutonnière, and kitten-heel shoes veritably exploding with ornamental ribbons—was surely not part of her actual studio routine.)

While Bernhardt was internationally renowned and widely revered, she was anomalous in both the professional and personal liberties she was allowed by theater fans in this relatively conservative era of stage history. As Roberts proposes, and the artificiality of photographs like these document, Bernhardt's extreme eccentricity was seen by the general public as somehow safe—as if the amusement the public gained from her outrageous behavior and the unlikely chance that it was even possible for her model to be imitated by other women outweighed the threat of her influence. As Roberts and many others have also argued, her Jewish ancestry surely further aided the public's acceptance of Bernhardt's professional ambition and sexual audacity in that many believed both were marks of the "Oriental" race that her behavior revealed—that Bernhardt represented to many little more than an upscale Little Egypt.[34] However, to women actively fighting for the right to live the kind of life Bernhardt seemed to enjoy and to those for whom the actress simply seemed a glamorous alternative to "ordinary" life, Sarah Bernhardt, her eccentricities, and the overwhelming cultural acceptance of both would represent what Roberts calls a "fantasy of transcendence"—a fantasy "of overcoming gender differences altogether. As [Ibsen's] Nora put it, she was the image of humanity—both more and less than a man."[35]

"We Glory That We Are Theatrical!": The Sexualized Strategies of Late Suffrage

Following Bernhardt's model, early-twentieth-century stage actresses would begin to demand the respect the New Woman commanded in the same way that the "ordinary" women in the heyday of the burlesque sought to command the respect of the actress. New Women would grow to recognize the power of the theater—particularly as the activities of the suffrage movement heated up after the turn of the century. Indeed, from the earliest recognition of an organized women's movement in the mid–nineteenth century, the suffragist not only negotiated her own kind of "public womanhood" that linked her to the actress in the eyes

of many, she was as a result often referred to as a "platform woman" who used theatrical strategies to promote her own opinions on the issue of women's rights.[36] As activists of the upper classes who dominated the movement grew to realize the incompatibility of women's rights with the principles of "true womanhood," increasingly aligning themselves with working-class women in the ongoing struggle for suffrage, so feminist activists became more open to embracing not only the actress in all her manifestations, but her attention-getting theatricality—in all *its* manifestations.

After the turn of the century, feminist activists had few doubts about either the inevitability or the necessity of women's presence in the public sphere, making the "public" nature of the actress something to embrace rather than reject. But, the women's movement had changed not only its image but its activities since the New Woman first rose, in ways that made the actress additionally appealing. After 1907, international suffrage organizations, both emboldened by the increasingly public presence of women since the turn of the century and discouraged by women's lack of a corresponding political influence, turned to more and more public forms of protest in hopes of winning the vote. The charge was led by British feminists, applying radical methods such as street protests and hunger strikes as well as arson and rioting. Such civil disobedience successfully shook up the period's public sphere, which seemed willing to tolerate women so long as they were seen and not heard.[37] While such strategies earned suffragists many enemies—the popular press presented such activities as nothing short of terrorism—activists viewed them as a necessary last resort in not just a century-long struggle for women's enfranchisement, but a centuries-long struggle for woman's very humanity. If society would prevent woman from stepping off her pedestal, she would apparently have to kick it out from under herself, and the violent agitation of the late suffrage movement would present the desperation of the situation in no uncertain terms. Charlotte Perkins Gilman heralded this new breed of New Woman: "Here she comes, running, out of prison and off pedestal; chains off, crown off, halo off, just a live woman."[38]

As the years went on, suffragists would come to embrace such acting up as not just a method of protest but a method of conversion. Yet while the violent protests of the suffrage movement drew attention

to the desperation of the cause, they did little to positively promote the movement to those unconvinced of its merits. Enter the actress: *her* "acting up," even when interpreted as shocking or immoral, had been for decades one of the few culturally acceptable modes of performing femininity beyond the limits imposed upon women offstage —performances that, as we have seen, actresses were often indulged in their real lives as well—and provided men as well as women with an entertaining and even alluring image of the woman as "actor" in many senses of the word. Moreover, because actresses were frequently rewarded—both financially and professionally—for their transgressive behavior, they themselves were often both living and drawn to supporting the goals of the larger women's rights movement. The result, as articulated in her book *Female Spectacle: The Theatrical Roots of Modern Feminism*, was what Susan A. Glenn describes as a "crucial epoch of historical upheaval, [when] female performers became agents and metaphors of changing gender relations," and suffragists actively forged alliances with them for the good of the movement.[39]

That such alliances were perhaps inevitable is suggested in Harriot Stanton Blatch's 1909 *American Suffragette* manifesto—which articulated the basic terms of militant feminism in the United States—in which she proclaimed: "We . . . believe in standing on street corners and fighting our way to recognition, forcing the men to think about us. We glory . . . that we are theatrical."[40] This fight for recognition would be theatrical indeed: in the ten years between the *American Suffragette* manifesto and the U.S. Senate's introduction and passage of the Nineteenth Amendment, suffragists coordinated sprawling parades, protests, and public lectures that directly contributed to both the growth and the success of the movement—creating spectacles that the press would almost be forced to report upon, while carefully planning the staging of these spectacles in a way that allowed these women to counter stereotypes and even outright lies perpetuated about the movement and its participants.[41] As Blatch herself asserted: "As this is an advertising age, leaders of any movement do well to study . . . the methods of the [theatrical] press agent."[42]

Like the press agent, Blatch and her contemporaries understood that sex could sell the movement to men and women alike—indeed, Glenn notes that as younger women who grew up with the existence of the New Woman as an ever-present model in popular culture were drawn

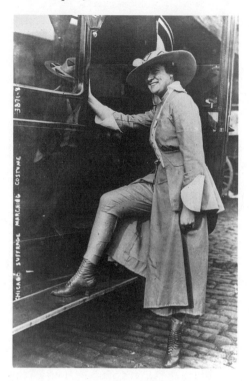

41: Photographer unknown, Chicago suffragist in marching costume, 1916 (Library of Congress, Prints and Photographs Division)

to suffrage, the movement increasingly stressed that "physical allure and stylishness were perfectly compatible with political commitments . . . [and] worked to recast the woman citizen variously as mother, worker, consumer, 'municipal housekeeper,' womanly woman, and modern girl —feminine, stylish, fashionable, and pretty."[43] Suffragists' new interest in theatrically flaunting their numbers and demands would lead to organized protests and parades in which participants wore "uniforms" of matching colors in styles that corresponded to the range of women involved—conservatively modest to eye-catchingly revealing. In these spectacles, which borrowed their choreography and costuming from the theater, participants often struck provocative poses for press photographers (fig. 41) that were clearly modeled after theatrical pin-ups. Glenn notes that even the most militant of American suffrage groups, Alice Paul's Congressional Union for Woman Suffrage—renowned for its use of the most extreme tactics of English suffragists Christobel and Emmeline Pankhurst, alongside whom Paul protested during her PhD studies

at London's School of Economics and Political Science [44]—was careful to choose "its public speakers on the basis of their ability to project an image of beauty, youth, and intelligence."[45]

While it is tempting to argue that such tactics simply pandered to traditional and even compulsory standards of beauty for young women rather than making an effort to challenge them, one must consider not only how much the image of a "beautiful suffragette"—an oxymoron in the context of the day's popular culture—itself leveled such a challenge, but also, as Lisa Tickner has written of these tactics, how powerfully this notion would strike an "Edwardian public [that] expected to see the virtues and vices of femininity *written on the body*."[46] With such efforts, it was hoped the line that separated both the activities and the image of the actress and suffragist might become blurred in the popular imagination, leading the existing acceptance and success of actresses in the professional sphere to the acceptance and success of the suffragist's demands. As such, in the very same year as Blatch "gloried" in the spectacle that the *American Suffragette* would promote, suffrage supporter Israel Zangwill would write optimistically, "As far as feminine fascination is concerned [the suffragist] is becoming indistinguishable from the typical actress."[47]

For all these reasons, the actress became an important figure for suffragists to relate to, hold up, and even recruit as the 1910s wore on—indeed, at the decade's start, a group calling themselves the Joan of Arc Suffrage League decided to begin at the top by coordinating a welcoming committee of a hundred banner-and-flower-bearing women to receive Sarah Bernhardt at the dock in New York City at the start of her 1910 American tour. American suffragists' dedication to Bernhardt was sufficiently moving to the actress that on her subsequent tour of the United States—arriving as she did in New York on the very day of a scheduled suffrage parade there in 1912—she actually took the opportunity to speak directly in favor of the cause.[48] But Bernhardt's support was purely symbolic; by the time of her "conversion" high-profile actresses were lending more than just their blessings to the suffrage movement. As early as 1908, English suffrage recognized the Actresses' Franchise League among its supporters; its members used their knowledge of public speaking to promote and raise funds for the movement, while teaching fellow activists how to do the same.[49] By 1912 the num-

ber of actresses actively contributing to the movement in New York City was great enough that the city's Women's Political Union actually formed an Actress's Committee (which included none other than Ethel Barrymore) to give them appropriate voice in the union. Like their English predecessors, actress/suffragists were utilized as experienced public speakers, familiar public figures, and of course as models of desirable femininity for the movement to hold up as contradicting the stereotype of the shrieking, unsexed, undesirable militant. By 1915, actresses were visible enough representatives of the movement that actress Lillian Russell—whose own mother was a suffragist and socialist and had followed Victoria Woodhull's footsteps by running for public office before women had the vote as a publicity stunt and protest—offered herself as a suffrage candidate for mayor of New York.[50]

New Women, Terms, and Technology: Feminist Sexuality in Early Film History

By the time Russell proposed her candidacy, the issue of women's rights had been taken on by a new generation of suffragists but also a new generation of actresses—known by their work not on the stage, but on the screen. Indeed, that very same year, screen "vamp" Theda Bara famously aligned herself with feminism to defend the soul-sucking sexuality on which she based her star image, and by extension the pleasure women derived from screen idols such as herself, when in 1915 she told a female reporter: "Believe me, for every woman vampire, there are ten men of the same type—men who take everything from women—love, devotion, beauty, youth, and give nothing in return! V stands for Vampire and it stands for Vengeance, too. The vampire that I play is the vengeance of my sex upon its exploiters. You see, . . . I have the face of a vampire, perhaps, but the heart of a 'feministe.'"[51] That Bara would frame what we might call the actress's cinematic activism in terms of its sexual nature using the term *feministe* was not coincidental. Derived from a French term for women's rights activists in use since the 1880s, the English word *feminist* would by the mid-1910s become the moniker of choice for the growing numbers of women for whom the increasingly visible and appealing suffrage movement inevitably led to ever-

broader definitions of the rights they were demanding—and, for some, to lament the movement's single-mindedness in focusing upon the vote before all else. While this tunnel vision was precisely the reason the New Woman had emerged as the broader-minded counterpart to the "suffragette" at the fin de siècle, once suffrage itself had lost the stigma attached to it in earlier decades, those *supportive* of the movement sought new ways to identify with the changes it sought to usher in—particularly insofar as these changes might affect their personal, professional, and political power. The New York City–based women's group Heterodoxy was among the first to advertise the term *feminist* as a catch-all for acknowledging the varied perspectives increasingly held and debated by women with ties to the suffrage movement. The group included Charlotte Perkins Gilman, IWW organizer Elizabeth Gurley Flynn, public health worker Dr. Josephine Baker, NAACP activist Grace Nail Johnson, arts advocate Mable Dodge, and suffrage leader Inez Milholland.[52] As suggested by the group's moniker, at Heterodoxy meetings and lectures stage actors like Mary Shaw, Ida Rauh, and Fola La Folette spoke alongside legendary figures like Gilman on the myriad rights that they argued women should defend as their enfranchisement seemed imminent. Both the group's approach to and use of the term *feminism* exemplify broader trends in this moment of the women's movement.[53]

Summarizing the ways in which the idea of feminism reflected both the growing breadth and limitations of the suffrage movement, *Harper's Weekly* contributor Winifred Harper Cooley wrote in this period: "All feminists are suffragists, but not all suffragists are feminists."[54] Cooley also noted that the issue of sexual expression was among the most divisive of issues debated by women's rights activists during this period, amounting to "a violent altercation going on continually, within the ranks of feminists in all countries." She continued: "The conservative women reformers think the solution is in hauling men up to the standard of virginal purity that has always been set for women. The other branch, claiming to have a broader knowledge of human nature, asserts that it is impossible and perhaps undesirable to expect asceticism from all men and women."[55]

In a letter to *Forum* magazine in 1915, a reader named Lottie Montgomery elaborated on the latter position and its growing relevance to the women's movement as a whole:

[Feminists want] an opportunity to express themselves sexually whenever they see fit without the interference and permission of the Church and State, and this neither constitutes promiscuity, nor yet polyandry, but an opportunity to live your own life in your own way and not to have to sacrifice your name, privacy, self-respect and income in order to gratify the sex instinct. . . . Whether we like to admit it or not, the fact remains that women today, from the mansion to the tenement, are acquiring sex experience outside of marriage, which account for the great mental strides they have made with the past two decades.[56]

While Montgomery's direct association of sexual liberation with women's liberation had its origins in first-wave feminist thought since at least Mary Wollstonecraft, not until suffrage had succeeded in organizing women in the increasingly sex-integrated public sphere would this notion become so prominent an issue. Moreover, the growing prominence of youthful suffragists—who had theatricalized and reenergized the movement and took for granted the freedoms that they enjoyed in the public sphere, surely pushed the issue. But such women's expressive sexuality often made their elders uncomfortable. (As the early suffragist and Hull House founder Jane Addams told the *Ladies' Home Journal* in 1915: "I confess I am some times taken aback at the modern young woman; at the things she talks about and in her free and easy ways."[57]) Likely anticipating (indeed, with their youthful energy, perhaps spoiling for) the fight for women's rights to extend long past the date of their enfranchisement, the term *feminist* was increasingly conjured in the 1910s by younger suffragists to suggest the personal—and, particularly, the sexual—issues they felt merited discussion as part of the larger debates surrounding women's rights.

But the sexual discussion these feminists sought to initiate was hardly unique to the movement; rather, it echoed and amplified the expanding public discourse on sexuality and youth culture that we have seen since the fin de siècle. By 1913, William Marion Reedy famously declared that the American cultural clock had struck "sex o'clock," and *Current Opinion* magazine concurred with a laundry list of reasons why the country's "former reticence on matters of sex" had given way "to a frankness that would even startle Paris." Feminism was listed among the causes of this change—but, quite surprisingly, given positive credit for this role.

America's fascination with sex, *Current Opinion* opined, was "concomitant to the movement for the liberation of woman from the shackles of convention that will disappear when society has readjusted itself to the New Woman and the New Man[.]" While the article admitted that the country was divided on whether and to what degree it would accept this new pair, it concluded that all factions agreed on one matter: "Radicals and conservatives, Free-thinkers and Catholics, all seem to believe in solving the sex problem by education."[58] While the proliferation of popular journals like *Current Opinion* was one way in which the "correct" form of this sexual education might be debated, it was clear that even more accessible and novel forms of mass media need be employed—pamphlets, novels, theater, and of course the newest of the modern mass media, moving pictures.

That film would increasingly be singled out as an ideal medium for sex education in the United States was unsurprising considering its growing accessibility and popularity. Moreover, unlike any other medium in history, movies gave viewers simultaneous access to both the active and glamorous performer familiar from the stage, and the isolated, intimate, close-up framing of the same blown up larger than life—an impossible scale and point-of-view (even from the closest seats in the live theater), reserved historically for imagery of the ruling classes and the sacred.[59] The combination of these cinematic qualities, Eileen Bowser has argued, ironically meant that the screen actor "in absence, belonged to the spectator in a closer way than would ever be possible in reality."[60] Moreover, this intimate spectacle of the moving picture immediately lent the medium a sexualized aura. While cinema's evolution did not yield the close-up and its correspondingly deified stars until the mid-1910s, the display of familiarly sexualized female bodies from the theater was present from the dawn of popular film: the risqué shorts of the earliest kinetoscopes captured the titillating performances of exotic Middle Eastern "hootchy-kootchy dancers" as early as 1896, as well as those of the era's burlesque strippers and "models."[61] While at first these shorts were scorned as just another cheap diversion among many in the industrialized cityscape, Janet Staiger's research on the period demonstrates that myriad forces quickly realized that if such images could be narrativized, they might be used and defended as instructive in a cultural climate where such displays of sexuality in popular entertainment and the in-

creasingly heterosocial public settings of these very entertainments had come to be viewed as an inevitable part of modern life.[62]

Part of this positive spin on representations of female sexuality in the cinema came from the period's "white slavery" scare, which coincided with the rise of motion pictures. Investigations of the alleged phenomenon—in which scores of innocent young women were allegedly being forced into sexual slavery by pimps and madams—concluded that the problem was wildly exaggerated at best, and at worst an urban legend that had spiraled out of control. Regardless, it was also determined that educating young people—in particular, young women—to such *potential* dangers that lurked in the public sphere would do more good than harm, and that the film industry might be a powerful partner in teaching youth to recognize and avoid dangerous situations.[63] Even after the foundation of what would eventually become known as the National Board of Review, through which the movie industry reviewed its films for traces of "vulgarity," exceptions were made for films in which the plot and characters' sexual behaviors—bad as well as good—might be construed as instructions for what to expect and how to live in an increasingly sexualized modern world. Not only did this self-censorship by the movie industry help to (at least temporarily) curtail moralists' calls for government censorship of films, it also meant that filmmakers and the increasingly powerful studios with which they were associated were almost guaranteed to convince exhibitors that their films were appropriate to screen in theaters in both conservative and liberal states, urban centers and small towns, and even in international venues.[64] "Good" morals were also good business—especially when sexuality could be framed as educational.

In the same way that this new openness toward sexual representations would be reined in by the film industry to simultaneously serve the public good and the capitalist machine, so too would the New Woman herself. Staiger has argued that the cinematic embrace of feminist characters in this period was the result of filmmakers' and film audiences' realization that their sexual self-awareness might provide the public with useful ideas for thinking about options and imagining utopias for women, who both comprised an enormous share of the filmgoing public and were viewed as those who benefited the most from sex education.[65] As we shall see, this utopian potential of the New Woman was

capitalized upon by the scores of women directors, screenwriters, and even actresses who rushed into the film industry in its earliest years, and by the suffrage movement itself. As Shelley Stamp's work on women in early motion picture culture has demonstrated, silent films—made as they were in the years of the movement's greatest and most violent protests—rarely treated the suffrage movement positively. Nonetheless, she notes that suffrage organizations viewed both the medium and its audiences as potential agents of social change and created several films during the years in which nations around the Western world were debating women's enfranchisement, in the hopes of swaying popular opinion in favor of suffragists' goals.[66]

As we have seen, during this era suffragists recognized the power of the theatrical woman, as well as theatrical marketing. As film culture evolved out of early nickelodeon and vaudeville settings and into the "movie palaces" that would mark the medium's coming into its own, suffragists were quick to capitalize upon the educational and the propagandistic potential of motion pictures. Choosing to produce not documentaries, but melodramas like *Votes for Women* (1912), *Eighty Million Women Want—?* (1913), and *Your Girl and Mine* (1914), American suffrage organizations sought to use the persuasive new medium to construct positive images of the movement itself through the fictionalized and romantic young suffragist characters whose struggles comprised the core of the films. To connect their fictional, sympathetic feminist heroines with the real-life movement, these films incorporated cameos and even "introductions" by prominent real-life activists like Jane Addams, Emmeline Pankhurst, Dr. Anna Howard Shaw, and Harriot Stanton Blatch—indeed, many of these same women often appeared to lecture in person at screenings of these silent films in order to literally "give voice" to the situations and issues that the films addressed.[67]

It may seem odd that, at the most heated moment of the suffrage movement, commercial venues screening films would welcome not just its propagandistic films but actual representatives into their theaters. However, when one considers the educational thrust of the industry in this era and exhibitors' efforts to both educate and attract female audiences, this pairing makes considerably more sense. By the start of the twentieth century, women were already acknowledged and courted as powerful consumers: whether their dollars came from their growing

presence in the workforce or their more traditional role as housewives, women of various social strata were increasingly responsible for not just their households' shopping, but also their entertainment. Women not only had more money to spend and more freedom to spend it in the public sphere, but many also had—or at least were responsible for coordinating their families'—leisure time, both during and after traditional "work hours." Moreover, because women of many different backgrounds now felt comfortable with their various roles in the public sphere—whether part of their work, domestic, or social routines— women had the potential to effectively upclass movie theaters away from their origins as nighttime entertainment centers for working-class men in the same way that they had burlesque in the mid–nineteenth century. As such, movie exhibitors recognized women's appeal on many levels: they had the power to purchase tickets for themselves, their families, or their sweethearts; the time to fill theaters not only in the evenings and on weekends, but during daytime matinees; and the cachet to broaden the demographics of the moviegoing public in such a way as to make the once suspect entertainment seem wholesome and educational.[68] And, Stamp asserts, not only would films featuring broad and novel ranges of sympathetic female characters draw this important audience into movie theaters, suffrage features in particular—with their female heroines, melodramatic plots, and nationally known orators—could also "be promoted as respectable, 'high-class' offerings in the hopes of attracting middle-class female viewers, who promised exhibitors the cultural cachet they sought."[69]

Though exciting, such intersections of the progressive goals of the women's rights movement and the popular marketplace were hardly exploited solely to promote the political, social, and sexual liberation of the women courted by such alliances. Soon enough, Staiger notes, it became clear that "positive, regulated representations of the New Woman might well serve the developing consumer culture" as well as the educational bent of both suffragists and society at large, and during the 1910s women were represented onscreen and aggressively courted as film patrons for their effects beyond the box office. In Staiger's words, "the struggle over what the New Woman would mean was not just a question of gender debates. A New Woman was necessary for the new order. Women were necessary for the heterosocialized labor mar-

ket; women were needed as consumers in the exotic department stores; women were important in the expansion of consumption into the realm of pleasure and leisure."[70] Yet Staiger rightfully insists that the resulting proliferation of "instructive" films—presenting the already permeable boundaries of the New Woman morphing into new and multiple configurations—nonetheless meant that women "were seeing images and hearing much new talk about who they were or should or might be." As such, she continues, it is imperative that the "very heterogeneity of that talk cannot be dismissed."[71]

This heterogeneity extended to the industry's still photography as well as its motion pictures, as the pin-up—its utility to the entertainment industry having been proven and expanded in its decades-long use by actors in the theater—was quickly used in film promotion during this era. Because the actress was bound up in the sexual permissiveness, utopian potential, and "feminization" of the cinema in the late years of the suffrage movement, so too do we find these issues clearly reflected in the visual language of the pin-ups created to promote them.

4

CELEBRATING THE

"KIND OF GIRL WHO DOMINATES"

Film Fanzines and the Feminist Pin-Up

As Miriam Hansen has argued, "More than any other entertainment form, the cinema opened up a space—a social space as well as a perceptual, experiential horizon—in women's lives."[1] As we have seen, this space could exist and inspire because of the cinema's rise in the midst of dramatically changing perceptions of how women functioned in the increasingly heterosocial public sphere. Because of the fascination and power that these women held—both on the streets and on the screen, as producers and consumers of pop cultural imagery—as we have also seen, by the late 1910s, motion pictures became increasingly centered upon their stories and patronage. By the end of the 1920s, women would constitute between 75 and 83 percent of cinema audiences, leading a film industry magazine to assert in 1928: "It has become an established fact that women fans constitute the major percentage of patronage or at least cast the final vote in determining the majority patronage."[2] The importance of women in these early years of silent cinema helped in the shaping and proliferation of positive images of the New Woman on the screen. So too would changes in the way films themselves were watched.

The very earliest years of cinema were marked by audiences' interests in narrative, and actors were rarely mentioned in advertisements and production stills used to promote motion pictures; but this gave way by the early 1910s to a focus on the actors starring in the film. As Shelley Stamp has articulated this logic in cinema's evolution, the increasingly closer "camera positions favored during these years" as well as "new acting styles tailored to more intimate views . . . fostered repeat identification of the players" in the audience imagination.[3] This would lead to the subsequent establishment of what has loosely become referred to as the "star system" in the creation and promotion of movies.[4]

With this shift came the film industry's return to the promotional strategies of the stage in which the appeal of individual actors was cultivated and exploited by the studios producing the films—studios that would eventually be built around the stable of talent on which they staked their reputations with filmgoers. Because of this shift from script to star, the creation and circulation of performers via pin-up images became an important part of studios' larger promotional strategies.[5] Fans responded to and associated film stars with such portraiture immediately—as early as 1919, a *Photoplay* magazine article on fan letters determined (using a "sample analysis" of actress Dorothy Gish's fan mail) that over 90 percent of stars' studio mail consisted of requests for photographs.[6] The following year the magazine addressed this phenomenon, and specifically its appeal to female film fans, in a report on "girls' schools and high schools around Los Angeles and Hollywood . . . in the grip of a wave of 'picture collecting.'"[7]

But the popularity of pin-ups was recognized and exploited long before these fanzine features. By 1915, Paramount Studios' publicity department was boasting to exhibitors that pin-ups extended advertising dollars ordinarily spent on newspaper ads; they recognized that the immediacy of the images and the media upon which they were printed meant audiences' favorite stars could easily, lovingly be tucked "in a pocket or a purse, thus increasing chances of preservation and insuring a measure of permanency foreign to the herald."[8] Because of their role in the success of movie theaters (to whose success the studios' own were tied), regardless of the sex of the actor represented, most films and corresponding pin-up imagery were targeted primarily at women. Drawing upon the same sophisticated mass-reproduction techniques that al-

lowed the Gibson Girl's image to be inscribed on countless consumer objects and advertisements, movie-star pin-ups in the 1910s and 1920s took the form of everything from paper dolls to sheet music (fig. 42), printed on products from pillow-tops to powder tins (fig. 43), and they were furnished to theaters, stores, and film fan magazines as "advertising accessories" that promoted a studio's stars beyond the theatrical space itself. Such inexpensive items, distributed as either an advertised or a regular "gift" from an exhibitor or studio, helped cultivate loyal, frequent patronage in moviegoing audiences, who vied to obtain a complete set or series of images.[9] As Stamp notes, the period's pin-up images were printed on strategically chosen accoutrements related to the domestic sphere in general, and women's culture in particular, reflecting the larger cultivation of a "fan culture that chiefly targeted women . . . by providing souvenirs and tie-ins that froze photoplays in possessable, consumable moments through the dissemination of products . . . [that] insisted, rather forcefully, on the compatibility of domestic life and film culture."[10]

Much like the carte-de-visite pin-up in the early years of burlesque, most popular imagery of these early cinema actresses drew upon the novelty and desirability of their performing nontraditional sexual roles both on- and offscreen. While these increasingly diverse representations of the period's transgressive new female ideals were compiled, compared, and contrasted side-by-side in the albums and scrapbooks of fans who collected them in the manner of theatrical photos before them, cinematic pin-ups would be additionally used and admired in—and, for many fans, even derived from—the new, prepackaged "albums" that would soon replace them: film fan magazines. *Photoplay*, arguably the first true film fanzine, began publishing in 1912 and was dedicated to promoting the personalities and productions of cinematic celebrities. Because of its early success and longevity, it would build a formula for the fanzine that more or less remains the model for movie magazines to this day.[11] Its use of pin-up imagery from the first issue demonstrates how quickly the genre was incorporated into fan culture, and the kinds of pin-ups found in its pages over the next several decades track the genre's evolution—not just by documenting the changing strategies by which the sexualized woman of the "motion picture" was temporarily captured in the freeze-frame of the pin-up, but also by providing con-

42: Joan Crawford pin-up on sheet music cover for "I Loved You Then," from the MGM film *Our Dancing Daughters*, 1928 (Collection of the author)

below 43: Henry Clive pin-up illustration of Bebe Daniels on lid of 1920s powder tin

textualizing commentary alongside these images that both reflects and builds upon the filmic texts from which these performers' star images were built. (The fact that *Photoplay*'s representation of these women was framed by a staff in which roughly half its writers were female is significant as well.) As such, pin-ups as presented in fanzines like *Photoplay* around the late years of the woman's suffrage movement give us a clear sense of how the New Woman was constructed, evolved, received, and even emulated in a film culture much invested in feminist culture.

The Girl on the Cover and Her "Feminine Fans"

As Janet Staiger's research on the films of this period demonstrates, the overarching message that reverberated from the cinema made clear that "older versions of a good woman will no longer be acceptable, and the films insist upon the value of a new, independent, intelligent, and aggressive woman, even a *desiring* woman."[12] In the earliest years of *Photoplay*, this woman was constructed within the context of the "photoplays" (or film narratives) that the magazine summarized, which comprised the bulk of its content. This narrative-based promotion of the films it addressed (all, significantly, listed in the index according to the studio from which they originated as well as the films' titles) is perfectly in keeping with that moment's convention of cinematic advertising. But the fact that from the start the magazine's content began with neither a photoplay summary nor a "special article" but a pin-up "gallery of picture stars" reveals where the industry was rapidly headed. These first issues of *Photoplay* also incorporate articles and verse that more broadly reflect the already entrenched defense of films' educational potential, as well as industry efforts to stem government censorship of them using this same defense.[13]

These twin, interdependent messages of education and free expression reflected the period's larger progressive aims for motion pictures and would become a *Photoplay* tradition. Considering the period's simultaneous interdependent interest in stars and sexuality, it is unsurprising that pin-up portraiture would also become a staple of *Photoplay*. Indeed, the pin-up's very definition uncannily reflects Staiger's summary of sexual representation in the films they would promote in this era:

in both, "sexuality is not censored or repressed; it is studied. What is covered up—and then only visually—is only a part of that sexuality: the explicit physical act of copulation."[14] Relating as they did to both the sex appeal of the actors and the increasingly sexualized roles they played, the pin-ups first found only in its "gallery of picture stars" increasingly came to replace *Photoplay*'s narrative-relating stills as the fanzine, like the films and fan culture that it addressed, became increasingly star-centered. By the end of its first year in print, *Photoplay*'s pin-ups began replacing stills as illustrations for feature articles—which had themselves quickly expanded to include interviews with film actors that gave readers a "behind-the-scenes" look at filmmaking and their favorite stars. When published in isolation, pin-ups were soon accompanied by brief biographical or news captions relating to the star depicted that essentially made these images "features" unto themselves. While it would be several years before the magazine would abandon its original, primary purpose of providing what amounted to article-length adaptations of film "photoplays"—which editors would begin phasing out of the publication as early as 1917[15]—it seems clear that it was not the stories but their accompanying illustrations that most pleased *Photoplay*'s readership. Indeed, among the earliest letters published by the magazine, at the end of 1912, is one from a reader asking to subscribe to two issues a month "because I am saving the fine photos in them and pasting them into a scrap book."[16]

Soon, *Photoplay* capitalized upon the popularity of these "fine photos" by incorporating them into both the magazine's content and its cover design. By the March 1914 issue, *Photoplay* abandoned its use of film stills for its covers, replacing these with pin-up style photographs and illustrations of the actresses—and, until a strikingly unflattering illustration of D. W. Griffith made him the first man on its cover in 1916, only actresses—featured inside. (A few months after its first pin-up cover in 1914, the magazine subtly articulated the female focus of its new facade by creating a corresponding column titled "The Girl on the Cover," in which the subject's history, film career, and even experiences shooting the very cover photograph in question are chronicled by *Photoplay* writers.)[17] That same year, *Photoplay*'s advertising sections began including ads for "Pictures and Post Cards"—first, filled with promises of "beautiful women" and "life models," but within a year containing

ads for pin-up imagery of "your favorite Motion Picture Players" on everything from calendars to spoons.[18] In 1915 the magazine's expanding content grew to include celebrity "fashion features," which would become an important source of pin-up photography for *Photoplay*, in large part because it allowed the magazine to couch the frequently revealing clothing of its subjects in the guise of photo-reportage.[19] That same year, the magazine itself got itself into the pin-up business more directly, by advertising and selling reproductions of its pin-up cover illustrations—sold as "art prints"—to *Photoplay* readers. The following year, the magazine expanded its role as a pin-up distributor by binding and selling the imagery and corresponding biographies from its "gallery" section in a deluxe *Stars of the Photoplay* book, updated volumes of which would be published and sold by the magazine for decades.[20]

In the same issue as *Photoplay*'s first pin-up cover (of actress Norma Phillips) appears an article debating the merits of "Photoplays versus Personality," in which the very shift in audiences' and the film industry's focus from plot-driven to star-driven pictures that led to the magazine's embrace of the pin-up is addressed with surprising sophistication and insight.[21] In addition to the feature's thoughtful consideration of this complex shift in both the film industry and fan culture, its author also assumes a position that suggests the magazine's unique ability to mediate between the two—an industry "insider," but one that serves the fans rather than the industry itself. This type of feature speaks not only to the interesting relationship *Photoplay* sought to forge with its readers from the earliest years of its existence, but also to the magazine's address of its subjects—whether star or reader, male or female—as intelligent and discriminating.[22] These common qualities it subtly suggested its stars and readers shared, however, were tempered by the magazine's desire to appeal to the broad audiences that film itself enjoyed: audiences that, like the stars on the screen, were by the mid-1910s overwhelmingly female. The breadth of modern womanhood that the cinema presented in these years would increasingly become the focus of *Photoplay*'s content, as would its recognition of the special connection that female fans shared with their film idols—all of whom, the magazine insinuated, were invested one way or another in the principles of New Womanhood espoused by both the social and commercial forces that affected the period's filmmaking.

As such, as Jennifer Bean has succinctly stated, in the early years of *Photoplay* we begin to see the cinematic New Woman appearing "in multiple guises, alternately garbed as childish tomboy, *garçonne*, athletic star, enigmatic vamp, languid diva, working girl, kinetic flapper, and primitive exotic—all in various national, economic, and even chronological forms."[23] This proliferation of diverse, even divergent images of the period's New Woman—represented in the films narrativized by *Photoplay* and personified by the actresses upon whom the magazine reported—was frequently conjured by the magazine as symbolizing the appeal of both the films themselves and their largely female patrons. In essence, both were addressed as the magazine's subjects. A 1915 feature on the cinema's "feminine fans" exemplifies this strategy. This page-long, meandering piece meditates upon and connects the appeal of both the female film star and her female fan: "Women as fat as Pauline Bush, women as thin as Roscoe Arbuckle. Virginal-eyed Pickford women; cruel-lipped women a la Bara. . . . Pal women like Kathlyn, queen women like Nance O'Neill. Passionate Petrova-women, fascinating Billington-women, humorous Normand-women," and so on.[24] The piece articulates the circular style of pop-cultural identification we have examined since the Girl of the Period emerged to emulate the burlesque stars that, in turn, emulated them. However, *Photoplay* updates this relationship to reflect and celebrate the new proliferation of female identities that the movies borrowed from and contributed to popular culture since American films and feminism had struck "sex o'clock."

The piece also speaks to the period's new embrace of the contradictory nature of women on both the screen and the street, delighting as it does in bouncing back and forth between oppositional models of femininity both on the screen and in the audience, ultimately adding up to a constellation of different types of modern womanhood. This celebration of the contradictory modern woman was often noted not just between but *within* their cinematic counterparts. Indeed, precisely because of *Photoplay*'s conscious cultivation of its insider perspective, this strategy was frequently employed to underscore its female subjects' appeal, but also the magazine's ability to give its readers the real "scoop" on them, which was expressed through its interviews with and gossip about popular stars, as well as the imagery chosen to illustrate the same. Even as the magazine surely indulged studios and press agents in the

44: Mabel Normand on an early "swimsuit cover" of *Photoplay* magazine, August 1915

mythologizing of their actors, the magazine frequently went out of its way to de- (or re-) mythologize them as well. As different as the period's actresses and the roles that they played were, the one thing that connected most of *Photoplay*'s coverage on them was the magazine's constant—and, it seems, conscious—depiction of them as complex, contradictory women.

This paean to the magazine's "feminine fans" appears in the same issue as a *Photoplay* swimsuit cover (fig. 44)—the second ever for the magazine—depicting the silent-era superstar Mabel Normand posing before what the accompanying "Girl on the Cover" article suggests is the sunny Pacific Shore of southern California, where she made her wildly popular films for Keystone Studios. Today, the comediennes of Mack Sennett's Keystone films blur together as the anonymous "bathing beauties" of our collective cinematic memory, but in their own day they were each known by name and frequently stepped out of their ensemble comedies into star vehicles of their own. As in the case of still-renowned actresses Gloria Swanson, Annette Kellerman, and Marie Prevost, they often went on to enormous fame both within and outside of the studio.[25] Normand was Keystone's first breakout comedienne—and

a frequent foil for Charlie Chaplin—and in her heyday was one of the highest-paid actors in Hollywood.[26] True to form, both *Photoplay*'s pin-up cover and its accompanying article paint a portrait of Normand as a bundle of contradictions and a model of modern womanhood. While asserting that readers can "just take Mabel Normand at her screen value and . . . know her" as the "fearless" stuntwoman and comedic actress she was famed for being, the author also goes out of his way to construct her in a manner that contradicted her dominant, rough-and-tumble star image by simultaneously positing Normand as a model of "bewitching femininity"—which the pin-up imagery of the actress both on the cover and within the feature seem dedicated to supporting, even as they appear alongside more typical images of Normand from her films. Commenting approvingly on her high salary and informed opinions of the film industry, the author also includes an anecdote that suggests Normand is a soft-hearted Good Samaritan who spends altogether too much of her salary on charity for less-successful actresses.[27]

Photoplay's veritable canonization of Normand in this feature might appear less an embrace of the actress's contradictions than a press agent's dream article, its unabashed love for the actress undercutting the less apparent, thoroughly progressive manner by which its seamless fusion of her many contradictory personae (both on- and offscreen) is promoted as the core of her appeal. But the frequency with which the magazine applied this contradictory model of New Womanhood using both words and images—in features on subjects ranging from girlish waifs like Mary Pickford and Lillian Gish to womanly, romantic actresses like Olga Petrova and Alice Brady—demonstrates both the myriad configurations with which this strategy was applied and the corresponding proliferation of such complex feminine ideals in fan culture.[28] However, the feminist potential of this approach is perhaps most apparent in *Photoplay*'s representation of the period's screen "daredevils," with whom Normand was loosely associated. Like our collective memory of Sennett's comediennes, the phrase "Perils of Pauline" conjures images —of the shrieking, ring-curled girl tied to the tracks or thrown over the mustachioed villain's shoulder, crying out to be saved by the film's hero—that have little to do with the actual films from which this cliché evolved. In fact, *The Perils of Pauline* serials depicted their titular heroine, played by Pearl White, as a scrappy (and, occasionally, cross-dressing!)

New Woman actively engaged in solving mysteries, chases with villains, and dangerous espionage—where the heroine was more likely to save her disapproving fiancé than vice-versa.[29] The wildly popular female-daredevil genre of which White's films were a part—and which had fans and imitators both in the United States and abroad[30]—are from the perspective of the twenty-first century perhaps the clearest representation of New Womanhood in the period's film history, for what Stamp identifies as the characters' "taste for adventure that belie outmoded notions of demure 'ladylike' behavior and stay-at-home femininity. These young women lead independent lives, noticeably freed from familial obligations, marital bonds, and motherhood."[31] (Indeed, these adventures were so clearly associated with feminism in their *own* day that the North American Woman Suffrage Association commissioned daredevil-serial author Gibson Willets to write the screenplay for its propagandistic melodrama *Your Girl and Mine*.)[32]

Fanzines often implicated fans in their heroines' adventures, publishing "interactive" contests relating to such serials—allowing female readers to help plot these daredevils' adventures and "solve" their mysteries—as well as features relating to the real-life adventures of the actresses who starred in the films. Pin-up imagery was also used strategically in fanzines' construction of the daredevil as the clearly contradictory challenge to traditional femininity that she played on the screen, even as these images helped assuage any anxieties over the challenge itself. As Stamp argues, pin-ups in these fanzine features "reassured fans that stars retained their femininity even while performing feats of cinematic daring. But they also insistently marked the unaccustomed juxtaposition of feminine delicacy with might and brawn."[33] Such juxtapositions are clear in *Photoplay* features on film daredevils, such as a 1913 Pearl White interview in which the magazine typically parallels her off- and onscreen personae—in this case, revealing that in addition to the "perils" she faces in her unique workaday world, White "has a nifty little biplane all of her own, and flies all by herself quite regularly as a diversion from her strenuous studio labor." They add to this approving comment on her real-life daring another on its effect: "You know some people are just naturally bewitching, but when they add to this the setting of the inventions of man—no wonder they have admirers!"[34] Visually connecting the article's conflation of White's "natural" womanly appeal and subver-

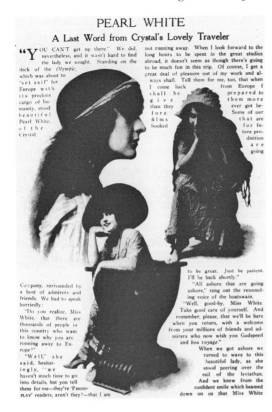

45: Pearl White pin-ups in article layout of October 1913 *Photoplay*

sively unladylike behavior is a trio of radically different, pin-up photographs of the actress that illustrate the article (fig. 45)—read clockwise from the upper left, White is depicted in a cameo-style profile wearing quasi-classical robes; crouching barefoot in an old-fashioned gingham "milkmaid" outfit, looking demurely up at the viewer; and seated with a saucy tilt and a beaming smile in an elaborate contemporary chair, wearing an ultrachic modern ensemble. The images read as if to suggest three ages of womanhood simultaneously embodied by and ending with White's model of contemporary New Womanhood, much like the article they accompany suggests that the actress's allure comes from her ability to fuse a timeless, essential femininity with what might seem to be its transgressive and consciously constructed opposite.

While White's feature illustrates with particular clarity this fanzine strategy of lauding the cinematic New Woman's ability to both pos-

sess and transgress traditional feminine roles, the article is only one of myriad examples. Indeed, White herself is today only the most familiar of what was in fact a much-imitated screen image of the New Woman, which *Photoplay*'s frequent and similarly constructed features on her many contemporaries in the daredevil-serial genre reveal. In an interview with Helen Holmes of the *Hazards of Helen* railroad-adventure serial, the author notes that Holmes "wears pretty gowns and is very proud of the fact that she can burst the sleeves of any of them by doubling up her biceps," and proceeds to recount the dramatic behind-the-scenes accounts of her dangerous stunts with which she regaled him during the course of their interview.[35] A feature on Lasky Studios' serial queen Anita King embellishes upon her onscreen daring with alleged real-life stories of her confronting (and being shot in the arm by) a group of Mexican bandits at her home in Mexico City and taking on Native Americans, "tramps," and timber-wolves while on a solo cross-country road trip, all of which is played against the fact that the author, Grace Kingsley, was welcomed to King's home by the actress looking "as delightfully helpless, as charmingly useless (clad in a foolishly ruffled heliotrope afternoon gown) as any masculine heart could desire."[36] In an interview with Kathlyn Williams—the star of "jungle drama" series *The Adventures of Kathlyn*—the actress and trainer asserts that wild animals "will often tolerate a woman and even like a woman when they will attack a man savagely," and proceeds to tell stories of her and fellow Selig Studio female daredevils' experiences with their frightened and even attacked male colleagues, where these women stepped in to save the day.[37]

All these stories are illustrated with spectacular stills of the actresses performing and sometimes directing the stunts for which they were famous. But these are juxtaposed with glamorous pin-up photographs of the women posing in stylish, and often abbreviated street clothing to represent them in offscreen moments. Such features demonstrate that, whereas film stills were frequently used to illustrate the professional output of the actor, pin-ups were used to illustrate their personal lives— although, interestingly, these images were frequently as varied as their screen roles. Even as *Photoplay* pin-ups became more and more daring in the amount of skin or silhouette that they revealed, these sexualized images were used simultaneously to defend and to illustrate their sub-

jects' behavior—presenting these women as healthy models of modern femininity. For example, in a 1917 article on the fame of the period's "Bathing Girl" in the movies, *Photoplay* celebrates this contemporary pin-up and defends her from critics by comparing the pinched and corseted "steel-engraving ladies" of *Godey's Ladies' Book* to the flesh-and-blood models in the pages of the magazine, concluding: "Though you see a lot more of her than anyone ever saw of her *grandmere*, she is just as modest and infinitely more beautiful."[38] The article's layout of actresses engaging in athletic frolics on the beach—swimming, playing beach ball, and even surfing—along with other women (and even young men!) afforded viewers a look at their favorite photoplayers in abbreviated outfits, and suggested that what more prudish or old-fashioned readers might consider "immodest" about either their dress or behavior in fact reflects the healthy new lifestyle of modern women.[39]

But the way in which these features highlight screen actresses' fusion of traditional femininity with transgressive activity is not limited to the discussion and representation of the physical manifestations of this fusion. As the decade worn on, film fanzines grew more and more explicit in suggesting that the complex character of these women's physicality reflected a formidable intellectual character as well. For example, the wide-ranging stunts of the "Many Sided Vivian Rich" are connected to her varied interests (from literature to horseback riding to automobiles), and Normand's high-energy performances are likened to her voracious reading of Oscar Wilde, George Bernard Shaw, and Henrik Ibsen—which she takes in "not like a sponge, but like an electric motor."[40] As suffrage became an increasingly inevitable prospect at the end of the decade, such insinuations were increasingly couched in terms of the period's feminist rhetoric. A telling passage in a 1914 *Photoplay* feature on Kathlyn Williams is typical of this new trend. Responding to the male interviewer's incredulity at her stated desire to move into directing films, Williams indignantly counters: "I believe that women would make as big a success directing as men, if given the right chances and opportunity. You know I produced two or three of my own photoplays, do you not?"[41] The fact that Williams's intelligence is framed by her ambitions and abilities beyond acting is unsurprising, considering the still prevalent (if perhaps incorrect) assumption that work behind the camera is ultimately more rewarding and intellectually rigorous than

that before it. Unsurprising, too, is Williams's confidence in both her and other women's potential to affect the film industry as more than just actresses. As we will see, while *Photoplay* largely focused upon women as performers, the magazine in the 1910s and 1920s also regularly included features on opportunities for women in other Hollywood careers that—like Williams's comments—were similarly framed by both their subjects and authors as positive strides made for women as a whole.

Already in its first few months of publication, the magazine included a feature on the career of Alice Blaché and her production company Solax Films, in which the director is held up as "a striking example of the modern woman in business who is doing a man's work . . . doing successfully what men are trying to do."[42] Similar profiles of directors such as Ida Mae Parks, Lois Weber, and Germaine Dulac followed.[43] By 1916, the magazine began publishing not only stories about, but pin-up portraits of such offscreen women—starting with a feature on the actress-director Cleo Madison, posed "at work" both in front of and behind the camera. (Asked by *Photoplay*'s male reporter whether she was scared to direct her first feature, Madison snaps: "Why should I be? . . . I had seen men with less brains than I have getting away with it, and so I knew that I could direct if they'd give me the opportunity.")[44] *Photoplay* features on not just such clearly glamorous actresses branching out behind the screen,[45] but also a wide spectrum of women in the movie industry, were published in the years bracketing the passage of the Nineteenth Amendment: ranging from articles on the industry's "Film's First Woman Executive" to the "clever women cutters" in studios' editing rooms to Hollywood's women costume designers and *modistes*.[46] In an effort to dispel "the theory that lady writers are sartorial freaks," in 1918 *Photoplay* published a pin-up pictorial featuring screenwriters and directors such as Frances Marion and Anita Loos, in which the women are praised not only for their talent and beauty, but for their ability to balance their professional success with husbands and children at home.[47] Even Hollywood secretaries—many of whom frankly discuss their lack of success in finding work in front of the camera—are profiled as "virtuosos of the remingtons," leading exciting professional lives working for studios, directors, and actors.[48] In all these pieces one finds a common message directed at women readers, stressing and encouraging the role of female agency in film culture, which is stated succinctly in the maga-

zine's 1922 feature on "Girl Picture Magnates": "So you see, sometimes dreams do come true—if you make them."[49]

"The Cause" in Service of the Industry:
Hollywood's Embrace of Suffrage

Such content demonstrates the surprising manner in which fanzines sold an image of womanhood that was at once subversive and status quo, constructing and glamorizing the upside-down world of both movies and the studios that made them—which, while presented as distinctly *different* from the workaday world in which fanzines presumed their audiences lived, was also presented as accessible to these same audiences. As Southern California's ample land and weather agreeable to outdoor shooting quickly made it the capital of the American film industry, fanzines like *Photoplay* built on this message of film culture in general by constructing Hollywood in particular as a sort of transgressive alternative society to established urban centers of the eastern and central United States—a "wild west" full of new opportunities for intelligent, enterprising women. *Photoplay* made this connection explicit in a feature on Pearl White, who is held up as just one example of the "pioneering spirit" of Hollywood's women: "The early years of the twentieth century brought to American women the same vast, almost fabulous chances that came to their grandfathers in the middle of the century preceding. What the expansion of the West and the great organization of industry opened up to many a young man, the motion picture spread before such young girls as were alert enough, and husky enough, and apt enough to take advantage of it."[50]

This sense of California's unique possibilities for women celebrated by *Photoplay* was surely aided by the fact that, just before the magazine's launch, the state had joined its western neighbors Wyoming and Washington in allowing women the vote—the first three states to grant universal suffrage to its citizens. Arguably, the western United States was still sparsely populated enough that enfranchisement was first implemented west of the Missouri either to reward or tempt women migrants, whose numbers were so lacking there. In any case, California's voting female population surely lent to the glow of a woman-friendly

aura around Hollywood.[51] *Photoplay* would add to this aura by featuring women in the movie industry who associated women's professional capability in the industry with their capability as citizens—much like their predecessors on the stage, linking the unique freedoms their lot enjoyed in their profession with those for which suffragists were fighting.

From the earliest years of the magazine, *Photoplay* addressed such associations with great ease, as in its amused report of an overheard conversation between actress Laura Oakley and director Harry Pollard in 1913: in response to Pollard's resigned comment upon women's voting rights in California, "I guess the time has come . . . for women to vote like men," Oakley quipped, "Decidedly, no . . . That's not the idea at all. We are going to vote a great deal better than men ever did."[52] A 1915 photo feature of actress Eugenie Besserer building her own bungalow in Los Angeles—"improving HER OWN Southern California property in her own way, via her own firm biceps and bronzed small fingers"—is captioned "Women's Rights—the Besserer Definition."[53] The following year, Cleo Madison's aforementioned, headstrong ideas about women's worthiness to direct are similarly framed by *Photoplay*, which suggests that "with the lovely but militant Cleo at their head, the suffragettes could capture the vote for their sex and smash down the opposition as easily as shooting fish in a bucket."[54] *Photoplay*'s sense of the affinities between women in the film industry and suffragists is even clearer in a 1918 feature on Anita Loos; while the successful screenwriter is lavished with praise for her intelligence and professional success, as well as admired for her youth and beauty (as illustrated with several pin-up photographs), reporter Julian Johnson does not contain his disapproval in discovering during the course of the interview that Loos "despis[ed] suffrage"—a view that he saw as simply "illogical and incompatible with her accomplishments."[55] While *Photoplay* occasionally felt comfortable asking a question like "can anyone so pretty be interested in a book on advanced feminism?" alongside a pin-up photo of actress Wanda Pettit doing just that, it would elsewhere answer its own question with statements such as: "Some cynic once remarked, 'Some women are beautiful, and some are suffragists.' Olive Tell stands a living, breathing, pink and white refutation of these words"—an assertion bolstered by the flattering pin-up photographs and illustrations of the actress accompanying the article. After answering a question about her favorite colors with

the pointed choice of "yellow and white"—the uniform colors of the suffrage movement—Tell describes the thrill of marching in a suffrage parade and defends her activism: "Why shouldn't we vote? Haven't we done everything that a man has done excepting perhaps actually fight in the war?"[56]

Tell's comments not only typify the easy associations between its subjects and suffrage that one finds in the early years of *Photoplay*, but also speak to the ways in which both suffrage and public support of the movement grew during World War I, as women in the United States and Europe were increasingly called upon to serve the war effort: first through traditional means, such as food conservation and membership in the Red Cross; and as worker shortages became more desperate as the casualty toll climbed, eventually through more direct military and professional contributions.[57] Although from the beginning the American magazine addressed the war's effect on foreign films and the global cultural climate, once the United States joined the fighting in Europe, *Photoplay* went out of its way to promote—from the monies gained by the "war tax" upon box office sales to the patriotic messages communicated in the period's films—the ways in which "the moving picture is fighting the Hun."[58] Naturally, its reportage on Hollywood celebrities followed suit and, focused as the movie industry remained upon its female stars, *Photoplay* delighted in sharing their myriad contributions to the war effort: activities ranging from Mary Pickford's morale-boosting visits to troops stationed stateside; to the "knitting craze" sweeping all ranks of Hollywood women as they created sweaters, mufflers, and socks for soldiers; to the details of actress Kathleen Clifford's life-threatening efforts for the Red Cross amid the fighting in Belgium.[59] (In addition to an honorary military rank, *Photoplay* reports that Clifford "brought back many trophies but she regards with greatest value a long scar on the forefinger of her left hand . . . made by a piece of shrapnel for which she was probing with her digit in the wounded shoulder of a Canadian fighter.")[60] Just as *Photoplay*'s stars were lauded for their contributions to the war effort, its female readership was approached to contribute as well, with both the Red Cross and the Student Nurse Reserve—the latter a part of the Woman's Committee of Council on National Defense led by Dr. Anna Howard Shaw—recruiting women in the magazine's pages throughout 1918.

Even after the war's end in 1919 and the ultimate victory of the American suffrage movement in 1920, *Photoplay* frequently addressed suffrage as a relevant and positive force in cinema's evolution. A feature on the female directors at Universal Studios frames their success in terms of suffrage, arguing that " 'The Cause' . . . gained its greatest victory when Universal City gave women a chance to become moving-picture directors." After weighing the concerns of both pro and antifeminist voices on how this influence would affect film history, author Frances Denton concludes: "And so, which is it to be? 'Man—the Slave,' or 'Woman—the Partner?' Everything points to 'Woman—the Partner.' "[61] If this optimistic evaluation had been true, perhaps women both on the screen and behind the camera in Hollywood today would enjoy as much power as they did in these early years of silent cinema. Alas, in the same way that the success of suffrage with the ratification of the Nineteenth Amendment led to the dissipation of its supporters and a subsequent decline in the momentum of feminist activism throughout the 1920s, so too would the cinema lose an important and politically charged point through which to address and flatter its female subjects in these years. However, also reflective of larger feminist trends in this period, women's earlier participation in suffrage and the war effort had taught them to recognize and articulate the ways in which they both contributed to and were oppressed by society—and, increasingly, as women tested their new political freedom, so too would they begin to realize its impact on and relationship to their personal lives as well.[62] In this way, we begin to see feminism's effects on film culture evolve—an evolution reflected in *Photoplay* as it heads into the 1920s, particularly as sexual expression in its myriad forms is more and more explicitly addressed as a feminist issue in its features and imagery.

Cinema fans' fascination with feminist sexuality hardly originated in the 1920s—as clearly evidenced by Theda Bara's articulation of the connections between the New Woman's political and sexual aims in chapter 3. However, Bara's meteoric rise to fame in the years before World War I—and spectacular fall during the war—does demonstrate the ways in which the period's changing view and gradual acceptance of both feminism and sexuality in these years is reflected in film culture. As evidenced in Bara's fanzine pin-ups at the height of her fame, promoting films like 1914's *A Fool There Was* (fig. 46), the actress was constructed in

46: Theda Bara pin-up promoting 1914 film *A Fool There Was* (Courtesy of British Film Institute)

their pages as on the screen as the darkest, if most potent representative of the New Woman's sexual power. And although the "vamp" archetype epitomized the worst kind of New Womanhood in the golden age of silent cinema, she was nonetheless symbolic of not just feminism's potential power to destroy the family and society, but also the ways in which it might positively introduce new ideas about both women's passion and men's frailty as gender roles fluctuated not independently, but in relation to one another.[63]

But, while Bara's popularity—like the vamp's in general—was tied to the dual potential of her power, this power was too extreme to allow for much openness in its characterization. For example, like many film fanzines *Photoplay* frequently reported upon Bara's homely background and contrasted it with the exotic, fictional history she was given by the studio system. But a 1915 interview with the actress finds writer Wallace Franklin simultaneously confirming and negating the actress's real self in an attempt to articulate the power (and dominance) of her fictional creation: "I prefer to disbelieve those stupid people who insist that Theda Bara's right name is Theodosia Goodman, and that she is by, or and from

Cincinnati . . . I wish to believe, I am going to believe, I do believe that
Allah is Allah, and that Bara is Bara; that the ivory angel of purgatory
is an Eastern Star [and] was born under the shadow of the Sphinx."[64]
In typically contradictory fanzine style, Franklin proceeds to dismantle
the very mythology he allegedly chooses to believe, announcing "that
Theda Bara is a home-buster only in working hours, and in other hours
is a gentle, slightly melancholy, even timid creature" who bursts into
tears when an awestruck child calls her "the Vampire" on the street. "Isn't
it strange?" Bara asks Franklin, "that I'm so in love with life and every-
body alive that I'm only able to incarnate myself on the screen as an
embodiment of hate and evil?"[65]

This "incarnation" would take over Bara's career, but while the very
potent sexuality that she embodied was embraced by cinema audiences
and reconfigured in the growing proliferation of New Woman roles
leading up to World War I, it resulted in an inevitable backlash. By the
time Fanny Brice lampooned Bara on the stage of the Ziegfeld Fol-
lies with her satirical performance of the song "I'm Bad" in 1917, it had
clearly begun in earnest. The following year, *Photoplay*'s Delight Evans
encountered Bara promoting her new film *Cleopatra* and was appalled
by what she determined was the actress's delusional inability to separate
her on- and offscreen identities. Asking her readers "Does Theda Bara
Believe Her Own Press Agent?" Evans sniffed: "She may have been born
Theodosia Goodman of Cincinnati, Ohio: but she forgot it long ago —
and her press-agent never did believe it."[66] The actress would attempt
to defend herself in a subsequent *Photoplay* feature — while still insisting
(alas, correctly), "To be good is to be forgotten. I'm going to be so bad
I'll always be remembered."[67] Increasingly sophisticated film audiences
had grown to see in Bara's sexualized star image an extremity that they
quickly ceased to recognize in modern women's sexuality.

However, audience racism as much as audience sophistication likely
led to the vamp's demise. While her exoticism was clearly a part of the
vamp's allure, it was also clearly a part of her villainy, reflecting the
larger American panic over the wave of new immigrants from South-
ern and Eastern Europe that had begun in the late nineteenth century,
with whose ranks cinematic vamps were associated.[68] (Bara was, indeed,
a child of this wave of immigrants, and grew up in a tight-knit commu-
nity of Polish and German Jews in the suburbs of Cincinnati.)[69] On the

rare occasions that this community was addressed in the context of the fanzine, it was as part of such publications' larger (and self-preserving) educational aims: immigrant populations in America as well as audiences abroad were generally discussed in *Photoplay* not on their own terms but rather as "students" of the American culture reflected in the films they watched—thus, constructing movies as "a factor in stimulating immigration and then acting as the most important means by which the newcomer can be Americanized."[70] After the war, *Photoplay* editor-in-chief James R. Quirk would come to the aid of immigrant populations both in the industry and in the audience with a full-page denouncement of Henry Ford's still-infamous anti-Semitic comments about the prominence of Jewish participants in the movie industry, and he warned readers against such racial slurs—whether they pertain to Jews, "negroes," or Eastern European immigrants.[71] But these gestures did nothing to bring these populations to either the screen or fanzine reportage. As such, while the vamp was among the first and only cinematic roles of the period that allowed women clearly marked as non-Anglo to be represented as a desirable pin-up, her appeal would be short-lived once her "darkness" (in both senses) eclipsed her glamour—particularly when both films and the movie press otherwise portrayed immigrant women as either asexual victims in need of protection and reformation, or refusing both as parasitical, sexualized villains who threatened to infect the country.[72]

This fear of non-Anglo sexuality is represented by a marked absence of the same in both the period's films and fanzines, as evidenced in the pages of *Photoplay*. Indeed, as would be Hollywood's wont for decades, in the earliest years of cinema non-Anglo characters were generally performed by white performers in some sort of racial "drag." Even when sympathetically portrayed by popular, attractive actresses— whether Ethel Barrymore's turn as an Egyptian woman in *The Call of Her People*; Norma Talmadge as both the doomed, modern "Butterfly" San San and her grown, biracial daughter Toy in *The Forbidden City*; or Florence Lawrence's series of "Jewish Pictures" aimed directly at this growing immigrant audience—these characters' sexuality was pointedly either nonexistent or tragic, in films that stressed either their cultures' segregation from or full assimilation into dominant Anglo-American cultures.[73] There were rare exceptions in *Photoplay*'s reporting

47: Actress Tsen Mei in first non-European pin-up in *Photoplay*, February 1919

on minority performers: notably, its frequent features on and imagery of the Japanese-American actress Tsuru Aoki and her very successful husband, actor Sessue Hayakawa,[74] and occasional references to the "Latin" appeal of Spanish American actors like Beatriz Michelena and Antonio Moreno and part-Colombian actress Bebe Daniels (see fig. 43).[75] In a rare and revealing passage from a 1916 interview with Hayakawa, the actor actually protests the stereotypical Asian villains that he became accustomed to playing in the United States, saying such "roles are not true to our Japanese nature. . . . They are false and give people a wrong idea of us."[76] In 1919, *Photoplay*'s first true non-Anglo pin-up appeared in the form of a beautiful photograph illustrating a feature on Chinese American actress Tsen Mei (fig. 47)—praised by writer Delight Evans as not only a great actress but, in typically breathless awe of the contradictions, also "college-bred, a professor of medicine, a musician and a mimic."[77] But this highly unusual image would be the only pin-up the

magazine published of the actress, and it would be nearly another decade before the rise of Anna May Wong's career led to a remotely similar acknowledgment of a non-Anglo actress's beauty and capability on the same terms as its white actresses. In an era when even Nita Naldi's Southern European roots would be casually addressed as contributing to her "bizarre Italian beauty," and black faces are notable in their complete absence from *Photoplay* features (save in the form of servants in the orbit of its feature subjects, white performers in blackface, and the children of the "Our Gang" serials), the exceedingly narrow racial standard of feminine appeal that paralleled the racism that dominated both the film industry and the American audiences to which they primarily catered are clear.[78]

"The Kind of Girl That Dominates": Sex and Power in Postsuffrage Pin-Ups

But though all these facts would lead to the demise of the vamp, not so representations of the sexual self-awareness she had helped introduce. Vamps like Bara would ultimately be victims to the very sexual openness that they helped usher into cultural history, particularly as sexual expression itself came to be presented in fan culture as nothing less than the inevitable next frontier for American feminists in the years following World War I and the ratification of the Nineteenth Amendment. As Stamp has noted in her study of fanzines' personal profiles in this period, features on professional women's domestic lives became more and more frequent, but often to spotlight feminist struggles in their personal lives and "show actresses embracing new feminine roles at home, eking out more egalitarian relationships with men, integrating motherhood with work, and redefining the home front."[79] Movie fans' fascination with these women's abilities to negotiate such new models of offscreen womanhood was likely aided by the period's increasing sense of propriety in discussing real women's sexuality and heterosexual relationships through the convenient figure of the war widow. Some of *Photoplay*'s earliest, frankest discussions on these issues come in features representing actresses carrying on after the death of their husbands in the war—where not only is their status as sexual beings as-

sumed, but their sexual potential and struggles as newly single women and mothers are addressed directly in interviews and indirectly through imagery juxtaposing sweet mother-and-child portraits with smoldering pin-ups.[80] However, the war widow is not constructed as an entirely tragic figure. For example, of her remarriage after the death of her famous professional and romantic partner Vernon Castle, dancer Irene Castle says with surprising ebullience: "The theory that everyone should be married twice may be a true one. For the first marriage is an experiment. Its errors and maladjustments teach us how to be happy in the second."[81]

These sympathetic features on Hollywood war widows would help to further open up fanzine discourse surrounding the "proper" expression and coexistence of both sexuality and professional ambition, including formerly taboo subjects like divorce and single motherhood. Actress Louise Huff discusses marriage to her second husband—whom she began dating in college—in terms not unlike Castle's, and introduces her school-age daughter, whom we are led to assume she had as a teenaged girl during her first marriage, which ended in divorce.[82] Screen vamp Barbara LaMarr discusses and defends her decision to adopt a son and raise him as a single mother through the lens of her disillusionment with men: "They call me a vampire on the screen. Sometimes in life I have been called something very like that . . . but the only thing I've found in this world that's at all satisfactory to love is a baby."[83] Most interestingly, Alice Brady talks about her struggles with not just raising a young son after her divorce, but her own lack of maternal instincts, telling *Photoplay*: "One thing the baby has taught me: that story-book motherhood either doesn't really exist or I am terribly different."[84]

But such melodramatic domestic profiles often ran alongside jubilant ones that related to these women's professional and sexual independence both within and outside of the home. Indeed, Alice Brady's stated struggles with motherhood can be viewed parallel to the magazine's frequent and approving articles on her ongoing struggles for independence—not just from her ex-husband and her family's film studio, but in the characters she subsequently played under her new contract with Select Pictures—where a striking photo of a lingerie-clad Brady by the renowned pin-up portraitist Alfred Cheney Johnston might be accompanied by the caption, "Her screen heroines, like the real Alice,

are leading ladies with minds of their own."[85] Increasingly, such independence was linked not just to these women's sexual appeal, but their sexual freedom, as more and more women in *Photoplay* discussed their choice to play the field rather than settle down—such as actress Lillian Walker, who asks "Marriage? Certainly not . . . But why should I give up my independence?" She continues, coyly, "Oh, of course, I've been in love hundreds of times . . . but I've always managed to save myself just in time."[86] Although willing to poke fun at her reputation in the movie press as a fickle single woman linked to handsome bachelor after handsome bachelor, actress Constance Talmadge nonetheless protests the fact that the "whole world seems bent on forcing marriage into my cranium, and just to be stubborn I don't expect I'll ever get married— at least not for a long, long time."[87] Such articles suggest the period's growing tendencies to associate the sexualized woman with the thinking woman, both on- and offscreen, in increasingly direct ways—upending old-fashioned beliefs and prejudices alluded to by another *Photoplay* pin-up, actress Katherine MacDonald: "Isn't it true that if a girl or woman is considered beautiful that everyone immediately concludes that she hasn't anything *inside* her head? It seems to be traditional that a beautiful woman doesn't need to be clever. Of course it is wonderful to be thought beautiful, but gracious, one doesn't like to be elected an idiot on that account!"[88]

The period's features and accompanying pin-ups further demonstrate a broadening perspective on both how the sexualized young woman in the movie industry might also be intelligent and capable and how intelligent and capable older women in the industry might be sexualized. In 1920, for example, novelist and screenwriter Mary Roberts Rinehart is held up by *Photoplay* as "feminist and suffragette . . . a beautiful example of how a busy woman can keep busy and keep her good looks." A mother of three grown sons, Rinehart herself discusses women's work in the domestic sphere as well as the public sphere—interestingly, privileging her work in the latter when she argues that "housework isn't any harder than writing several thousand words a day, keeping a large house in working order, and attending to three grown-up sons."[89] Similarly, although director Ida May Parks discusses her life as "a wife and mother of a twelve-year-old," she also asserts that these experiences have led her to believe that there is "no reason why there should not be many more

women directors . . . [and] that women should have an aim outside a husband."[90] Matronly midlife writer Elinor Glyn enjoyed a second act to her career as a fin de siècle novelist when she began writing romantic screenplays featuring blatantly sexual modern heroines, and—regardless of her pointed disapproval of marriage for "creative women," frequently reported upon by *Photoplay*—was not only held up as a glamorous role model to young women in Hollywood but, as the 1920s wore on, became nothing short of a lifestyle guru to actresses in her circle.[91]

With such new models of womanhood performing in, writing, and directing the period's films, it is unsurprising that they and their female fans would yearn to see the same represented in film—which would lead to the abandonment of sexualized extremes like the vamp, and to the over-the-top reconstructions of modern womanhood from waifs to daredevils. And, entering the 1920s, *Photoplay* finds both actresses and audiences speaking out in the magazine in favor of "real" women on the screen, defined in its pages by actress Ethel Clayton as "neither the very good nor the very bad women, but the vast multitude of human beings who come somewhere between." Asserting the appeal of the real, Clayton continues: "Women fascinate me—women who are struggling with their problems wherever they may be and climbing upward, either in married life, in girl life, or in the vast business of making a living."[92] Shortly afterward, in a commissioned critique, feminist novelist and screenwriter Alice Duer Miller compared and contrasted life in the film industry with life in the movies that it made, and concluded that screen life possessed a "naïve regard for the realities of life," especially when considering the tremendously interesting, complex culture in which films are made.[93] Immediately upon *Photoplay*'s introduction of a regular letters column in 1922, its female readers would frequently use the forum to concur, such as an exemplary fan letter asserting, "The world needs Amazon, pioneer women; women of strength, character, mental, physical and moral. And we can only make them so by portraying them in our literature and on our screen. . . . We are surfeited on beautiful, downtrodden, spineless heroines. We want sincerity and truth."[94]

Unsurprisingly, this new demand for "sincerity and truth" began at the start of American involvement in World War I, when real women began quite visibly proving their abilities to transcend more workaday, but infinitely more relatable boundaries than those over which their on-

screen film heroines leapt. The homefront woman's appeal was noted by Jesse L. Lasky, vice president of the Famous Players-Lasky (later Paramount), who advised director Cecil B. DeMille and scenarist Jeanie Macpherson to "write something typically American . . . that would portray a girl in the sort of role that the feminists in this country are now interested . . . the kind of girl that dominates . . . who jumps in and does a man's work."[95] This would result in the legendary DeMille sex comedy *Old Wives for New*, which spawned a still-renowned trilogy of films (and countless copycat versions) built around couples negotiating the perils of modern marriage and divorce in this era. The films would launch the career of Gloria Swanson, who played variations on the day's sophisticated, sexually liberated young woman in each one. In such films and their corresponding promotional pin-ups Swanson forged the star image that would follow her entire career: that of an intelligent, ambitious, worldly-wise, but still virtuous woman. While Swanson's characters enjoyed freedoms and a lifestyle far beyond the reach of the real women who admired these films, they were embraced by female audiences who recognized in them a new and distinctly modern type of womanhood to which they both related and aspired. As Sumiko Higashi's work on DeMille's sex comedies has demonstrated, this association was problematic for the frequently materialistic undertones with which the director infused the films. But, while his women's conspicuous consumption "reinforced the objectification of women subject to the male gaze . . . the new woman was looking in narcissistic rapture at her own reflection."[96] And, as Gaylyn Studlar suggests, the "rapture" in which these characters were held by female fans who associated with them had an empowering potential beyond their films' materialism:

> [These] women did not go to the movies or read fan magazines merely to "possess" the luxurious furnishings or the clothes or the stars that might be displayed. They went for an experience, one whose terms of fascination could be altered by the extratextual process. As a consequence, it is unlikely that the complex activity of the female spectator or the fan magazine reader of the 1920s can be fully explained by a model of consumerism . . . that depends on a binarism in which women can only either possess or comprehend.[97]

The *Photoplay* article "Old Lives for New" exemplifies both in title and in content the feminist subtexts that women read into these increasingly familiar screen roles, in this case focusing not on Swanson, but on her costar in *Old Wives For New*, Florence Vidor. Using the female characters of this DeMille film as a way into Vidor's similar offscreen existence, writer Joan Jordan posits that, like these characters, "Florence Vidor demonstrates that the New Woman may do justice to both a home and a career." In the course of the article, discussing both her career and marriage to her childhood sweetheart, director King Vidor, the actress advises *Photoplay* readers: "Today I believe absolutely that a woman who has a definite talent, a real, deep, undeniable craving for a certain form of self-expression does more for her family by answering that call and working out her happiness than denying it. I feel that such a woman need not be deprived of her home life any more than a man." [98] This confidence that women could "have it all" in both their professional and personal lives permeated post–World War I popular culture, giving rise to screen characters reflecting this sensibility.

DeMille's heroines gave way to what *Photoplay* addressed in 1919 as the "Vampette," who has "all the experience of her tall, willowy big sister — only she doesn't work at it," and whose comparative realism and goodness not only stood in stark contrast to the stylized evil of the vamp, but whose sexual expressiveness was similarly viewed as a natural and positive facet of her personality. [99] The "vampette" was used in this piece as synonymous with the "flapper" — a term that would eventually eclipse it in history, but whose simultaneous relationship to and distance from the vamp that preceded her is rarely addressed. The flapper archetype was defined, appropriately, through her contradictions just four years earlier by H. L. Mencken in *Smart Set* magazine. Though he was no supporter of political women — as he proved, ironically, in his vitriolic attacks on suffragists in his book *In Defense of Women* — Mencken identified in the flapper's New Womanhood the same drive toward a "holistic" feminism, linking political and sexual freedoms, as we begin to see both in the women's movement and on the screen in the mid-to-late teens:

> This Flapper, to tell the truth, is far, far, far from a simpleton. . . . The age she lives in is one of knowledge. She herself is educated. She is privy to dark secrets. The world bears to her no aspect of mystery. She has been taught

how to take care of herself. . . . She has read Christobel Pankhurst and Ellen Key, and is inclined to think that there must be something in this new doctrine of free motherhood. She is opposed to the double standard of morality, and favors a law prohibiting it. . . . She plans to read Havelock Ellis during this coming summer. . . . She is youth, she is hope, she is romance—she is wisdom![100]

As Staiger notes, Mencken's flapper, like her cinematic counterpart, "is not the 'whore' or the 'madonna' so typically described as image for pre–World War I filmic woman. . . . She was at once an independent wage-earner, making her own way in the world, and a beautiful, romantic girl, seeking marital fulfillment."[101] And, while many feminist historians have held up the figure of the flapper as symbolic of women's waning interest in political feminism postsuffrage, it is just as easy to view the flapper as instead symbolic of both the internalization of feminist thought and its application in women's day-to-day lives in this same period.[102] Indeed, as Lori Landay's work on the flapper in film history reveals, though like "other Jazz Age discourses of the paradoxical new woman that juxtaposed feminist and consumerist ideals," the flapper also clearly signaled to viewers in this period "that the connections between insides and outsides, between the emotions and the body, are in flux for women" in ways that suggest "what bodies—and especially female bodies—can do in order to suspend the social laws in everyday life."[103] Naturally, what Landay calls the "kinaesthetic" appeal of the flapper is visible not only on the screen, but in pin-ups of the 1920s that find ways to use the genre to create an iconic form of the nonstop motion that in films represented her intelligence, curiosity, confidence, and ambition.

One of the earliest film flappers, Bebe Daniels, had first come to fame as the childlike object of Harold Lloyd's affections in several of his comedies of the 1910s, but after she announced her determination to "le[ave] comedy forever," could be found in films and fanzines of the 1920s "creating a new role—that of a good little bad girl."[104] The magazine published daring pin-up photographs of Daniels in form-fitting fashions, with hems that would creep up past the knees as the decade wore on, accompanied by articles on Daniels's outrageous offscreen exploits—indeed, the actress scored a publicity coup when she was arrested for speeding in conservative Orange County. *Photoplay* turned

the story into the satirical photo essay "56½ Miles Per Hour," in which the actress comically reenacts the details of her alleged "prison diaries" written during her ten days in jail. The diary, in which Daniels describes her family's mortification over her imprisonment—most of them, she writes, were "not equipped with the shock absorber of a sense of humor"—also finds the actress reveling in her flouting of more than just the *social* laws of which Landay speaks.[105] This publicity stunt successfully marked Daniels's break from the girlish comedy roles of her youth, typifying the actress's daring throughout the course of her decades-long career, as she posed for promotional pin-ups in jaunty driving ensembles behind the wheel of late-model cars.

Daniels, like fellow flapper Marie Prevost, would as her career went on also become defined by her constantly fluctuating hair color—brunette to blonde and back again—which reveals yet another evolution in women's sexual self-expression that the flapper represents in pop-cultural history: the conscious cultivation and presentation of beauty as a site of both artifice and agency. As Kathy Peiss's research on the cosmetics industry shows, its explosive growth during the post–World War I era was the result of the "already existing tensions in the relationship between appearance and female identity" we have been discussing, exploited by a commercial "beauty culture [that] popularized the democratic and anxiety-inducing idea that beauty could be achieved by all women—if only they used the correct products."[106] While Peiss acknowledges the industry's manipulation of women's "anxieties" through this promise, so too does she acknowledge the ways in which it encouraged women to associate its "democratic" potential with the same new breadth and familiarity of beauty that they saw in the cinema—constituting yet another manner in which women might both seize their sense of agency and represent the same in terms of its sexual self-expression. When fanzines not only kept track of, but celebrated the new, constantly fluctuating, artificially obtained and easily discarded looks of flappers like Daniels and Prevost,[107] Peiss contends that they suggested social "identities that had once been fundamental to women's consciousness, fixed in parentage, class position, conventions of respectability, and sexual codes" might in fact be constructed at will: " 'Lady' and 'hussy' were no longer moral poles of womanhood but rather 'types'

and 'moods' defined largely by external signs," as easily taken off as put on.[108]

Studio pin-ups of actresses such as Colleen Moore and Clara Bow reflect both the power and the feminist potential of the flapper in their representation of all these ideas. Their pin-ups also reflect the extent to which Hollywood studios themselves by the end of the 1920s became actively involved in the construction and promotion of these actresses's star images according to their contradictory appeal to film audiences. A 1929 pin-up of Moore created by First National studios to promote her film *Synthetic Sin* exemplifies how pin-up promotion had evolved by this period. This photograph would, like many studio portraits of the actress, be used for press purposes as well as in the creation of promotional souvenirs for fans. In the case of this particular press print of the image, the reverse of the 8″ x 10″ photo is backed by a prepackaged caption written by the studio and meant to "guide" the reportage of the movie press for which it was created. The caption clearly reflects the same contradictions of the photograph, in which the sweet-faced Moore is frozen mid-dance, one hand lifting up her already abbreviated, knee-skimming black lace dress, the other waving at the viewer, to whom she appears to be speaking through her smile: " 'Hey!' 'Hey!' Sings out Colleen Moore in the fast-stepping role she portrays in 'Synthetic Sin,' her newest First National picture. . . . Miss Moore is said to have the opportunity of her career in this new picture which mingles delightful comedy moments with melodrama which is as startling to the star in her role of innocence as it will be to the audience."[109]

The caption speaks to both what is seen on the image it backs and in the film it promotes, in which Moore stars as a virtuous small-town actress who migrates to the big city in hopes that complete immersion in the "synthetic sins" to be found there will make her a better performer. She reaches the movie's end with her virtue intact, but not for lack of trying. The actress's star image, the pin-up and press caption, and the film's plot revolve around one another in a telling manner: while the studio promotes Moore through its suggestion of the offscreen "sinning" for which she is known in fan culture and for which the film is titled, her "startling" performance as an innocent is nonetheless presented as appropriate, even though the irony was not meant to be lost

on her audiences. The relevance of her contradictory appeal certainly wasn't lost on Moore herself, who late in her life would articulate the barriers that the flapper broke down: "You see, we were coming out of the Victorian era and in my pictures I danced the Charleston, I smoked in public, and I drank cocktails. Nice girls didn't do that before."[110] These multiple meanings of what it meant to be a "nice girl" in the modern world were not only an established part of her appeal, but in this pin-up pointedly constructed by a studio that recognized the value of these meanings to the fans at whom this image and its accompanying caption are clearly aimed.

Moore's contemporary Clara Bow is probably the most famous of the film flappers, in large part because of her star-making turn in the 1927 film *It*, derived from a novella by Elinor Glyn published that same year. From the title on, *It* attempted to define and represent the indefinable and contradictory appeal of Bow's generation: they simply had "it," and although their appeal could take myriad forms, one knew "it" when one saw it. The film documents the phenomenon it seeks to address through Bow's flapper character: as Landay argues in her interpretation of the film, Bow is posited as the modern woman in motion—striding wildly through scenes, across classes, and up ladders both professional and social.[111] As such, it is perhaps unsurprising to see the promotion department of the powerful Paramount Studios invested in constructing pin-up images where Bow's "kinaesthetics" are depicted on many levels simultaneously. Typical of the flapper's appeal, Bow's charismatic sexuality was represented as natural, but its presentation was not. (As *Photoplay* once quipped in an interview with the star: "Clara Bow's hair is red and so are her fingernails. Neither hue is nature's.")[112] And Paramount pin-ups of the actress revel in such contradictions: whether the actress is depicted lounging about the house in lingerie or sparring in a boxing ring, she engages the viewer with her beaming gaze and mugs with a reckless abandon that underscores the fact that these portraits are as self-consciously constructed as her beauty. One promotional pin-up from the late 1920s (fig. 48) gets to the heart of how these images project and exaggerate her confident, sporty glamour: Bow poses—arms akimbo, head thrown back, and smiling triumphantly—framed by a patio from which she steps into the outdoors, wearing a revealing bathing suit with matching high-heels and bathing cap, a pair of roller-skates dangling

from a strap flung casually over her shoulder. Relating as she did to real young women in the post–World War I era, the ostentatious accumulation of attributes in this image reflects the flapper's desire and confidence in her ability to "have it all" but does so by consciously constructing iconic pin-ups that underscore the fact that "having it all" means "*doing it all*"—and, whether these actions are performed for the camera or in the workaday world, that such a woman's self-awareness and strategic agency is the key to both her success and her appeal.

The promise of the flapper in her myriad manifestations lay not just in her ability to continue the reinscription of popular ideals of the sexualized woman with the assertiveness, confidence, and capability we have seen in feminist pin-ups since the mid–nineteenth century, but also in her unique efforts to add the expression of sexual desire to the mix. From Mencken's introduction of the flapper in the mid-1910s to her most famous manifestations in the films of the 1920s, a key element in these women's appeal was not just their sexual agency, but the fact that this agency was rooted in a genuine and even informed desire of her

own—she was eminently desirable because also *desiring* her activities and successes, both within and beyond the sexual realm. As Landay has argued, the active and always moving figure of the flapper in popular culture was highly symbolic—of not just the "look," or style, with which we associate the flapper to this day, but of *a look*, or gaze, that worked to convey her emotions and desires. This "kinaesthetic gaze"—leveled forcefully at the viewer or, in motion pictures, transferring her point-of-view to the viewer as the camera cuts from her gaze to zoom in and fix upon its targets—represented the presence and purpose of women's desire and was an integral part of the flapper's feminist appeal.[113] One might argue that, in the empowering potential of both the narratives constructed for and direct address of readers in the fanzine, one also finds a similar gaze encouraged in female film fans of the period.

Gaylyn Studlar's research on fanzines in the 1920s suggests as much: her own readings of *Photoplay* in this period reveal a collusion between the magazine and its readers that embraced and flaunted the cultural perspective that, by "actively seeking sexual pleasure, American women of the 1920s were widely believed to be usurping a male prerogative more powerful and precious than the vote."[114] These facts led to the movie palace's transformation into what one theater manager churlishly called the "Valentino Traps" of the decade, increasingly focused upon not only steamy, woman-centered romances, but the rise of male sex-symbols whose main purpose seemed to be inflaming and basking in the passions of their female audiences. As early as 1921, *Photoplay* was reporting upon the ardor and prominence of the actively desiring female fan when it identified and gently satirized "The Masher, [who writes] her star-love that she knows by his close-ups their souls are in harmony."[115] Naturally, all these trends converged in the fanzine in the rise of the male pin-up. While glamour portraits of male actors appeared in *Photoplay* from its first year of publication, and many men in the film industry contributed their own ideas about modern romance to the discourse led by their female colleagues,[116] except for an occasional "physique" photograph of leading men in revealing athletic clothes,[117] it would not be until the 1920s that a sexualized male pin-up in the mold of their female contemporaries would emerge and proliferate.

Rudolph Valentino's images in *Photoplay* begin the magazine's male pin-up tradition in earnest soon after his star-making turn in the 1921

film *The Sheik*. Beginning with his extremely abbreviated "Hindu god" costume reproduced to promote his film *The Young Rajah* in 1922, and followed a few months later by what would become a stream of dramatically lit beefcake photos of the actor flexing his muscles wearing nothing but abbreviated trunks and sneakers, Valentino's imagery kicks off the decade's acknowledgment and celebration of heterosexual female desire.[118] (Underscoring the broad appeal of such images to the magazine's readership, as well as the period's rapidly changing ideas about the appropriate role of sexual desire in women's lives, it is interesting to note that in the same issue as Valentino's *Young Rajah* image, one mother approvingly reports in the *Photoplay* letters column, "my four-year-old daughter is cutting out [Valentino's] pictures.")[119] Over the next decade, similarly constructed images of male stars ranging from emerging young stars like Gary Cooper to established, older actors like Douglas Fairbanks Sr. would increasingly be created by the studios and circulated both in the movie press and as fan memorabilia. As early as 1923, *Photoplay* informed its female readership: "Our brawny, nuxated he-stars may scorn the title of matinee idol in public, but in the privacy of their own home-breweries they know that without the seal of the matinee-maid they'd be pack with the plough, the cuspidors or the notions. It's the woman who pays and pays and pays for the upkeep of the Hollywood beaux."[120] These beaux were not, *Photoplay* asserted, all in front of the cameras: a 1922 pictorial reproduced prints of glamorous portraits of eight men in the film industry—from studio electricians to cameramen to business managers—with movie-star good looks that "might easily 'get over' on the silversheet."[121]

"Beauty and Brains": Living the Dream

Perhaps men as well as women—whether in their film roles or in the "wild west" of the real Hollywood workplace—were even in this age of shifting morals and gender roles allowed particular license in their negotiation of new sexual ideals: like the performers who went before them for decades, their job revolved around the fantastic upside-down world of entertainment, effectively problematizing the real-world change they might have affected. But because after World War I movies and fan

culture increasingly encouraged audiences to see performers on- and offscreen as reflections of reality, it is interesting to note the dissolving distinctions between film stars and film fans during this period in fanzine history—particularly in the ways that the conveniently anonymous "struggling actress" who occupied a space between the two was addressed during this time. From the earliest years of *Photoplay*, these women were drawn upon in fanzine fiction by staff writers who used invented characters based on struggling actress "types" to address the more subversive (and salacious) behaviors associated with the stars, but which went largely unspoken in the magazine's features on real actors.[122] But by the early 1920s, *Photoplay* began publishing features on the subject that, while still sensationalistic, framed such stories as nonfiction reportage, with photographs of unnamed actresses rather than fantasy illustrations used to illuminate the articles.

A particularly good example of this can be found in the 1921 article "Oh! Hollywood" by Mary Winship, which summarizes the appeal of not just Hollywood's female stars, but the ordinary career girl in the film industry: "She's as seductive as any Parisienne but, as it were, she's a country girl gone wrong. A sophisticated milkmaid. A Follies beauty in a gingham gown . . . with a hoe in one hand and an absinthe frappe in the other."[123] While this exceedingly contradictory image of the film actress is perfectly in line with *Photoplay*'s construction of the same from its origins, what sets this piece apart is its frank discussion of sexuality in the world these unnamed women inhabit, along with its implicit feminist defense of the same. Winship writes,

> [Hollywood's women are] odd, frank, sex-ful creatures. Worldly wise, cynical, well able to look after themselves, but supreme good fellows. They have no particular philosophy of life except to succeed in the movies at any price—and have a good time. . . . There is of course a great deal of "sex" in Hollywood. The freedom between men and women is very great. . . . Women can—and do—what they like. They work, play, love, and draw their pay checks on exactly the same basis as men.[124]

Is it any wonder that young women would find not just "rapture" at her image reflected in the cinema, but long to take part in what—from even the perspective of the twenty-first century—sounds like the feminist utopia of Hollywood? Naturally, the vision Winship presents—con-

trary to her blasé tone — is every bit as mythical and self-serving as most of the images of womanhood sold to women in both the movies and the fanzines that reported upon them. Yet one cannot blame women — before the myth of Hollywood was as embedded and oft-refuted as it is from our jaded perspective today — for believing the dream in these early years of the film industry. Trumped-up though its egalitarianism may have been, in the first half of the twentieth century the film industry was nonetheless, as succinctly stated in *Photoplay* by actress Alice Brady, "the one field of big reward for a woman. It is almost the one field where she can be individual, where she need not warp herself to circumstance even if she lacks in strength."[125] And — particularly in the years before the monopolistic consolidations of Hollywood's myriad early independent studios — women did enjoy a great power there that their fans surely found tremendously inspirational.

Considering its core audience, it is unsurprising that *Photoplay* would consistently address its female readership's personal connections to female stars, and the professional ambitions that would lead many to wish to join them in the film industry. While *Photoplay*'s first reader contest to exploit such desires was, interestingly, its "Amateur Scenario Contest" of 1914 — a screenwriting competition that would continue (and continue to be won by women) over several decades[126] — it was the magazine's first star search in 1915 that would spark the imagination of its readers and reveal where most of their dreams lay. Undoubtedly seduced by both the glamour of the film actress and the magazine's consistent, primary focus upon the same, it is nonetheless important to note that the magazine's first competition for actresses was — befitting its construction of the female stars it profiled — titled the "Beauty and Brains" contest. The competition was directed at contestants with no previous acting experience, whose ranks were organized into and winners were chosen from six regional divisions in North America (five in the United States, one in Canada). From these divisions, two contestants from each U.S. division and one from Canada were flown to New York City and given modeling and acting lessons at the World Film Corporation studios, and *Photoplay* promised its ten finalists that those who "pass the final photographic and acting requirements . . . will be given contracts as World Film actresses for a period of not less than one year, at a regular salary."[127]

Over the next seven months, the magazine's breathless reportage of the contest's progression included stories and photographs submitted by the very different kinds of women, from many different backgrounds, that were among the over 10,000 entries submitted—in several cases, in direct reference to the magazine's circular style of referencing stars and their fans, juxtaposing contestant photographs in full-page reproductions next to small images of the celebrities they resemble.[128] Interestingly, *Photoplay* was adamant that contestants submit not snapshots, but formal, methodically constructed images of themselves in the style of the magazine's celebrity pin-ups. While this requirement might seem odd considering the magazine's insistence that only amateurs would qualify, when one also considers that by 1915 both the cinematic pin-up and the fanzine were firmly embedded in the period's fan culture, the fact that the young women who comprised their primary audience would feel confident about creating pin-up self-portraits for such a contest, this stipulation makes more sense. Indeed, because many of the "movie palaces" built in the movie industry's efforts to attract precisely such female audiences featured "Photo-Machines" that allowed filmgoers to photograph themselves at the very theaters that catered to their fantasies and narcissism, many women likely didn't need to commission a studio photographer to create these pin-ups at all—as seen in industry advertisements for these machines that, significantly, featured young women capturing their own images with these early versions of the "photo booth" (fig. 49). Interpreting the sense of agency that such machines offered female film fans, Stamp writes:

> [She] no longer sits facing the screen watching the patterns on its surface, but poses before a blank field waiting to be transformed into an image herself. Reversing the very process of projection itself, she renders herself the object of the camera's gaze, while the oval screen in front of which she sits echoes the mirror so frequently evoked in representations of the female viewer, more absorbed in her own image than in anything that could be presented on the screen.[129]

Granted, the pure (rather than productive) narcissism of such activities was undoubtedly the primary appeal of such self-portraiture for many young women. However, when such activities and imagery are read in the context of not only women's productive use of the same in

49: Advertisement for a "Photo-Machine" in January 1914 *Motion Picture News*

contests like *Photoplay*'s, but the notion that—as implied in the maga-
zine's features and directly stipulated in the contest's title—women's
success in the glamorous field to which they aspired was as dependent on
brains as on beauty, it is easy to understand how these women's activity
might be tied to the more politically charged, but equally valid profes-
sional aspirations of the period's feminists. Indeed, no less a vocal femi-
nist than actress Lillian Russell was a judge for this very contest, and she
would remind applicants in the pages of *Photoplay*: "If it were a merely
physical beauty competition there would be nothing new or momen-
tous about it. But the requirement which links unusual mentality with
pulchritude is very promising, because the winners will bring to their
new calling qualities of mind as well as charm of person."[130] The final-
ists' "chaperone," muckraking reporter Sophie Irene Loeb, concurred:
"A beauty without brains is like a wax flower in a glass case. A brainless
beauty is the most tiresome thing in the world. Especially is this true
of the woman who would appear in films. Your beauty cannot possibly
carry you through unless your brain acts—acts with intelligence. . . .
Therefore, if you will use your brain every minute, your beauty will
take care of itself."[131]

In 1916 the winners of *Photoplay*'s "Beauty and Brains" competition were announced from the entrants whose ranks had been featured, scrutinized, and celebrated by the magazine's writers, competition judges, and letter-writing readers alike for seven months in the magazine's pages.[132] Regardless of the magazine's breathless reports on the wildly diverse appeal of the entrants in issues leading up to its announcement of the finalists, and the variety of classes and backgrounds from which the finalists came, the last women standing were striking in their conformity to traditional, Eurocentric ideals of modern beauty: aged between 19 and 23, standing between 5′2″ and 5′6″, and (editorial rhapsodies over the "exotic" finalists of Irish and Scottish descent aside) all white and, presumably, Christian.[133] (Although, interestingly, *Photoplay* also reported on letters from Japanese women who protested the "regional" limits of the contest, as well as male fans whose legions wrote in protest of the women-only competition.)[134] For all the limitations of the contest and its choice of "worthy" young women, one cannot deny its relevance in the context of the period's growing acceptance of not just the sexual woman and the thinking woman, but the notion that one might acceptably be both, as represented in the fanzine's construction of the cinematic actress. And, as the contest was relaunched and revised in the post–World War I years (fig. 50), we see in the pin-up self-portraits that *Photoplay*'s female readership would continue to construct the same growing sense of confidence, agency, and quirky individuality as one finds in their reflections in the period's screen stars.[135]

Alas, these developments are limited, too, by the decades-old inference that—whether embraced or vilified—such subversive models of modern femininity are permitted when in the form of the actress. And, as much as fanzine culture would attempt to construct offscreen women in Hollywood as glamorous and independent, it was the actress—both in the pages of fanzines like *Photoplay* and in the hearts of their female fans—who would still embody and be emulated as the ultimate symbol of women's professional and sexual freedom in the 1910s and 1920s, almost to the exclusion of all other models. However, as women's power within the workforce and their realization of the same grew during and after World War I, film fanzines' overt references to not just their readers' relationship to actresses and the film industry, but the power of such relationships to project into the world beyond became more ex-

50: Homemade pin-ups sent to *Photoplay*, published in August 1922

plicit. Exemplifying this suggestion is an adoring 1919 piece in *Photoplay* directed at "A Young Girl Going to a Photoplay," which expands earlier explorations of the circular influence of female moviegoers and their film idols to directly address the ways in which this influence affects and is affected by women's broader ambitions:

> If it were not for you the photoplay would not exist. . . . Any photoplay which calls up that frank, healthy laugh of yours; one which makes you want to do something worth while in the world; one which plants the seed of ambition in your receptive mind; one which touches your sympathies and makes you feel kind toward people; one which bares to you the tenderness and strength, the helplessness and power of a real man's love—photoplays like these are more than mere entertainment. They will actually help you in realizing the vital and splendid womanhood which lies at the end of every American girl's rainbow of youth.[136]

While such messages were typically implied in the period's features on the vast abilities and potential of Hollywood women, this piece demonstrates how these same qualities could be attributed to workaday women, how directly such messages were addressed at the magazine's women readers, and how clearly women were encouraged to follow their cinematic idols' audacious lead not just into the movies, but into the immediate world that these fans inhabited. But women's acting on the very potential that this piece encourages would reach its apex in the 1920s, only to be thwarted by and then actively discouraged during the Great Depression. However, the same unfortunate event that would bring the United States out of its depression—involvement in the Second World War—would result in a revival and incredible expansion of the same professional demands that the United States had made of women during the previous world war. And, as we will see, with the genre's revival and proper christening as "pin-up" during World War II, it would once again be summoned to represent the "dominating" young woman who had emerged and triumphed in popular culture between World War I and the Depression. But this time around, her appeal (as well as her paycheck) would depend not on the box office, but on the bomber plant.

5

NEW FRONTIERS

Sex, Women, and World War II

Although the image by which we still associate the genre developed in Hollywood in the 1910s, the pin-up in the context and construct most widely recognized today was developed in the United States during the Second World War, epitomized by *Esquire* magazine's "Varga Girl" illustrations (see plate 1), painted by Peruvian-born Alberto Vargas y Chavez. The genre itself was given its name during this time, as U.S. soldiers overseas began pinning images of women from magazines and snapshots onto their barrack walls, footlockers, plane cockpits, and even foxholes. Whether ripped from or kept neatly tucked between the pages of *Esquire*, Vargas's illustrations captured the American imagination during World War II. During Vargas's years at the magazine, his pin-ups drew upon both established cinematic ideals of femininity and new ideals for ordinary women on the American home front. This juxtaposition of fantasy and reality in Vargas's work reflected American propaganda campaigns that encouraged women to emulate and men to idolize female types normally vilified during peacetime and actively discouraged during the depression—powerful, productive women in professions and the military, whose beauty and bravery resulted in large part from their very entrance into these spheres.

However, the home front woman's sudden comfort with playing the sex symbol wasn't the result of her patriotism alone. With women's entry en masse to the workforce came firsthand experience with collective, productive, and economic power that generations of men had taken for granted. Perhaps more important, it meant for more women than ever meeting and dealing with men in a role that was neither domestic nor submissive. While this fact certainly resulted in scorn and condescension from many men, the governmental support of women's new roles in the public sphere would undercut such individual disdain and also mean that new kinds of friendships and romance were encouraged and formed between heterosexual couples. The promise of these new kinds of romances resulted in a new kind of sexual ideal in which the independence, self-esteem, and ambition that the nation sought to groom in female workers spilled over into their sexual identities as well.

On the one hand, Vargas's pin-ups made explicit the fact that these home-front women's desirability was due to the capacity for sexual agency that developed with their explosive and socially sanctioned entry to the American workforce. On the other, as fantasy hybrids of real women, Vargas's illustrated characters were able to push the envelope of sexual audacity even further. As such, the Varga Girls represented and helped popularize a remarkably self-aware and aggressive female sexuality that had in previous generations been viewed as the domain of very particular women—the demimondaine, the suffragist, the film star—but without a real woman's fear of character defamation. And those figures! Vargas's ridiculous figures were as crisply focused as a photograph yet as impossibly proportioned as the women in Pablo Picasso's *Demoiselles de Avignon*. The Varga Girl's strange ideal clarifies how, like the government-shaped ideal of home-front womanhood, this World War II pin-up was an ambitious composite of contradictory feminine ideals that, once embodied, presented a new and monstrous beauty. In this period, Vargas's pin-ups became ubiquitous icons for the genre itself—so much so that any illustrated pin-up girl would come to be widely referred to as a Varga Girl, a common generalization that continues to this day.

As we will see, the feminine ideals of World War II womanhood, as embodied by the Varga Girl, not only reflected the fashions in heterosexual male desire, but were in many ways synonymous with the femi-

nist sensibilities of the home-front woman. As the war instigated dras-
tic changes in gender dynamics in both the public and private spheres,
the Varga Girl came to serve as an icon for the many ways in which
new, wartime ideals of women's sexuality related to such changes. As the
images/identities of this type of woman became increasingly familiar
to the broader population of women whose generation inspired them,
more women in the "real world" began imitating and finding subversive
pleasures through her look and attitude. However, whereas the feminist
pin-up in previous generations generally represented an alternative to
dominant, traditional ideals of womanhood, cultural forces leading up
to and during World War II recognized in the pin-up's associations with
defiantly modern womanhood an ideal to exploit in a culture desper-
ate for a consuming and a producing model of New Womanhood. As a
result of society's need for "womanpower" during the war, the pin-up
in this era would represent the nontraditional and self-aware sexualized
female as both a tantalizing and a wholesome ideal, developed through
and sanctioned by radically new roles for women in the public sphere. In
this environment, the Varga Girl was constructed and received as a sort
of modern war goddess, inspired by and inspirational toward women
whose roles were shifting in American popular culture and society dur-
ing World War II. As such, the Varga Girl can be read as an icon for this
powerful, if fleeting, moment in American history.

"Girls with an Air of Self-Assuredness and Determination"

Both Vargas and the women of World War II were indebted to the
proliferation and popular acceptance of the professional, sexually self-
expressive woman that Hollywood had been glamorizing since the First
World War. However—as the studio system coalesced in the 1920s from
a constellation of independent production companies into an industry
run by a handful of enormous studios helmed by exceedingly powerful
male executives—we find that while audiences in the years between the
wars were still dominated by women drawn to films led by female stars,
fewer and fewer women were producing, directing, or writing these
films. A 1931 *Photoplay* feature on Gloria Swanson—the last of the in-
dependent actress/producer holdouts from the silent era—typifies the

ambivalence with which this situation was met by both the movie press and, presumably, film fans. Chronicling "The Troubles of Gloria," reporter Ruth Biery alternately celebrates and chastises Swanson's stubbornness in demanding control over her films—lauding her nerve and successes, even as both are blamed for Swanson's financial and romantic failures. Biery asks readers to look upon Swanson's example and "ask yourself if you envy this woman who has more responsibilities and worries than any individual in pictures."[1]

This cautionary tale reflects the general tone of fanzines after the Great Depression began in 1929, and the ominous tenor of the American economic situation was echoed in *Photoplay*'s approach to professional issues relating to stars and fans alike. In this context, working women's failures were frequently paralleled to those of the nation as a whole, just as their triumphs over adversity were drawn upon for their messages of hope. To achieve such messages, articles often also drew upon familiar stories of female strength, intelligence, and resourcefulness, as clearly evidenced in the 1930 series on the "Amazing Stories of the Early Hardships and Privations" of popular actresses such as Mary Pickford, Gloria Swanson, Clara Bow, and Norma Shearer. The series asked: Was it "Beauty, Brains, or Luck" that led to their success? (Reflecting the magazine's perspective on the matter since the 1910s, each month's story inevitably came down without reservation on the side of brains.)[2] These successes were relevant, since the movie industry was one of the few to weather—indeed, thrive in the midst of—the Depression.[3]

Joan Crawford, for example, became the era's icon for the steely self-reliance and ambition of the Depression-era actress largely because of how fanzine discourse seized upon her real-life (and still-infamous) battles for success in Hollywood. Her struggles were held up against those of *Photoplay*'s readership when the magazine assured them that Crawford has "taken hard knocks. She's been broke and miserable, as many worthwhile people have been."[4] The magazine proudly reports that Norma Shearer—whose popularity, like Crawford's own, exploded in the Depression after years of climbing the industry ladder in the silent era—pursued her career even after D. W. Griffith tells her "I'm sorry, my child, but you'll never photograph"; the actress defiantly set out to prove him wrong, changing her life with what Shearer herself calls "determination and a methodical mind" until the next generation of pro-

ducers understood her potential. She tells *Photoplay* readers: "I know I'd
do it all over again if I had to. Sometimes I even miss the struggle."[5]
Married to MGM studio head Irving Thalberg, fanzines took great plea-
sure in both suggesting their romance may have been part of the same
career calculation for which they frequently lauded the actress and in
poking gentle fun at the ways Shearer's controlling nature was disrupted
by marriage and motherhood. For example, in one *Photoplay* feature, the
actress's pregnancy is dealt with as something she veritably conquered:
"For the first time in her life she was not completely mistress of the cir-
cumstances. . . . Norma Shearer, able to bend every person's will to her
own, had become merely a woman." Alas, we are reassured: "The new
attitude didn't last long. She has returned to her own cool, classic self.
And why not? Norma, the indomitable, triumphed over whatever whim
nature might have had."[6] Lest we doubt that Shearer's hard work has
allowed her to transcend "mere" womanhood, the piece juxtaposes an
image of "the raw material"—homely photos of the actress starting out
in 1923—side-by-side with one of a brand-new series of photos taken
of the actress by pin-up photographer George Hurrell, reflecting how
"her own spiritual force turned her into [this] sleek, gorgeous girl."[7]

Hurrell's pin-ups of Shearer speak not only to what would become
their long collaborative relationship, but also to an oft-told story of
Hollywood history in which the genre figures prominently—and in
which we find the pin-up's value acknowledged and exploited by one of
the period's most successful actresses, toward one of the period's most
feminist films. Upon discovering that MGM had purchased the rights to
the recent best-selling Ursula Parrott novel *Ex-Wife*—a literary embel-
lishment upon precisely the kind of "modern marriage" themes that
Swanson's romantic comedies with De Mille had far more tamely ap-
proached earlier—Shearer began a campaign to convince her husband
to offer her the role. Thalberg refused, squeamish over his wife's step-
ping into the role of a divorced graphic artist who spends the bulk of
the screenplay on what feminist film critic Molly Haskell would later
approvingly call "a man-tasting spree."[8] Drawing upon the calculating
creativity for which she was known, Shearer commissioned the rela-
tively unknown Hurrell to shoot her in a series of drop-dead-glam pin-
ups in hopes of changing Thalberg's mind. Hurrell had rapidly begun to
emerge as a portraitist to watch, because his photo set-up imitated the

dramatic, flattering theatrical lighting of film sets, and he had perfected the art of airbrushing facial flaws from view. His sparse, yet striking portraits would help develop new formal ideals for pin-up portraiture in the 1930s that amplified the sexual iconicity of the genre and its subjects—whether male or female.[9] (Indeed, it was the popular male pin-up actor Ramon Novarro who referred Hurrell's services to Shearer.) Hurrell's photos of Shearer, in which the actress wears a loosely wrapped robe and levels her smoky gaze at the viewer as she basks in the photographer's tenebrist lighting, sufficiently convinced Thalberg of Shearer's potential to play the independent, sexually curious lead in what would become the classic 1930 film *The Divorcee*.[10]

The film is still referenced as not only a turning point in Shearer's career—transforming her from a big-hearted, virginal ingenue to a dangerous playgirl whose goodness, amazingly, carried over from the actress's original star image—but as a turning point in Hollywood's representation of the sexualized woman. In it, Shearer's character, heartbroken after learning of her husband's infidelity, decides to divorce him, determined to challenge age-old double standards and experience sexual freedom herself. (She theatrically informs him of her decision—"You're the only man in the world my door is closed to!"—before embarking on said man-tasting spree.) MGM advertised the film with a question to its audiences: "If the world permits the husband to philander, why not the wife?" and audiences flocked to the film hoping to find an answer. *The Divorcee* was a runaway hit, Shearer won the year's Oscar for best actress, and this success led to a boom in filmmaking—as well a new breed of film heroine—that made a woman of the previous decade's "good little bad girl."

The following year, *Photoplay* reporter Katherine Albert summarized the break that Shearer's heroine in *The Divorcee*, and the imitators she spawned, had made with the past:

> For years the nice girl had her day. Her screen path was clear. She must neither drink, nor smoke. She must be chaste, nay almost prudish. She must be kind to old ladies, children and stray cats. Her clothes must be new but not gaudy. But now—whoops—the new brigade. . . . Nowadays the heroine goes right out and gets her man and does with him as she wills. Nobody minds, and the fans seem to like it.[11]

The "new brigade" was comprised of a generation of actresses still admired today for the unabashed sexuality, professional ambition, and wit that they both possessed and projected in their screen roles: Katharine Hepburn, Marlene Dietrich, Jean Harlow, and Barbara Stanwyck. These actresses were older and even more worldly-wise than the flappers before them, and in an era when much of the country was unemployed — and women were actively discouraged from working outside the home, lest they take a position needed by their "forgotten men"[12] — the women they portrayed enjoyed both the same sexual rights and the same professional aims as their male counterparts, employed as artists, journalists, athletes, even gangsters.[13] But it was Shearer's precedent in *The Divorcee* that was given credit for ushering in this bold new era. As the fanzine *Motion Picture Magazine* put her influence both on- and offscreen: "Norma Shearer has killed our grandmothers . . . She has killed what they stood for. She has murdered the old-time Good Woman. She has cremated the myth that men will never marry 'that kind of woman.' She has abolished 'that kind of woman.' There remain — free souls."[14] The change was instigated by neither a screen test nor a film, but a pin-up.

Shearer's MGM "stable-mate" and professional rival Joan Crawford was herself renowned for using pin-up photography to promote her own career — a fact actively promoted in an interesting series of pin-up images of the actress circulated by the studio in 1939. The images were part of MGM's promotion of the 1939 ensemble film (also starring Shearer) *The Women* and batched together as a prepackaged fanzine fashion feature titled "A Still-Life History of Joan Crawford." Each image features Crawford at a different moment in her career, striking alluring poses and wearing simple but glamorous ensembles, with a verso caption promoting the film, the occasional designer, and Crawford herself. Typical to much Depression-era fanzine chatter, Crawford's struggles and successes are addressed in the images' succession and the accompanying captions on the reverse of each image — but are framed by the very pin-ups with which they are paired. The caption accompanying the most contemporary photo in the series (fig. 51) speaks directly to the relevance of the pin-up in studio promotion that we have been exploring. But it also, significantly, speaks with equal directness to the conscious control and manipulation that women took for granted in their use of the genre: "From the fashion poses, the bathing suit art, the holiday pictures, and

51: MGM pin-up
from *A Still-Life History
of Joan Crawford*, 1939
(University of California,
Los Angeles, Special
Collections Library)

the 'gag art' in which every newcomer to films finds herself involved,
Joan Crawford learned some of her most valuable screen lessons. 'These
days, lots of girls seem to think such posing is a waste of time and that
it isn't helping their acting career. Well, I made it help mine,' says Joan,
who personally selected the following examples to prove her point."[15]

While it is entirely possible that both the quote and the curato-
rial duties were those of MGM's publicists rather than the actress her-
self (though, from what we know today about the actress through her
adopted daughter's memoirs, both the tone and the sentiment cer-
tainly sound Crawfordesque), the message emanating from the entire
series was important regardless. It demonstrates the concerted efforts of
the film industry and movie press to respond to fans' fascination with
the ambitious, successful, take-charge woman—onscreen and off—that
emerged in and had matured since the early years of the star system.
(Even Mary Pickford, whose popularity had for decades been based on
her girlish sweetness, underwent a 1930s fanzine makeover to under-
score her past as "a shrewd, calculating producer who divided her time
between playing emotional scenes and paying off electricians, confer-
ring with writers, interviewing prospective actors for casts.")[16] Such fea-

tures demonstrate how frankly women spoke about and presented their ambitions in the period's popular culture. As films grew more risqué in their manner of showing the sexuality of this contemporary woman, so did the fanzines become more casual in addressing this fact and willing to tailor its pin-ups to follow suit. Typical *Photoplay* features from the early 1930s include references to Jean Harlow as "That Hotsy Totsy Platinum-Haired Baby Doll Who Knocks Over Ben Lyon in the Early Sequences of *Hell's Angels* by Appearing Clothed Almost Entirely in the Armor of Girlish Purity,"[17] and fashion features in the form of "A Movie 'Undie' Parade," in which actresses (led by none other than Crawford) model "feminine fripperies" consisting of bra-and-panty sets.[18]

Considering the period's sexual openness, it is perhaps unsurprising that studios were increasingly willing to take chances on representing new sexualities in its growing array of cinematic femininity. While both Greta Garbo and Marlene Dietrich began their careers in the 1920s, it was not coincidentally in the early 1930s that the "exotic" and ambiguously sexual actresses broke through to stardom. On one hand, fanzines' representation of these actresses as complex, contradictory creatures reflects a decades-old strategy. Juxtaposing the "two Greta Garbos" with a juxtaposition of two different pin-up portraits of the actress, *Photoplay*'s Katherine Albert compares and contrasts: "At the left is a plain girl, with simple tastes, who lives her own life and minds her own business. She likes children, and funny stories, and is timid in a crowd. At the right is the other Garbo—glittering, mysterious, exotic. The Greta of the screen whose allure is so powerful a magnet that she is talked about by millions of fans."[19] And after Marlene Dietrich's American debut in *Morocco*, Albert finds with "that long face with the shadowed cheeks, that deep, throaty voice, Marlene is almost nothing like her physically in real life. Her face is round, her nose turns up, she smiles."[20] On the other hand—as this same profile of Dietrich reveals—fanzines became surprisingly adept at framing this new generation of actresses' appeal in subversive new ways that matched their occasionally blurry sexual orientation: Albert tantalizingly recounts a scene in which starstruck Dietrich vies to meet her "screen crush" Joan Crawford at their mutual manicurist's office—"broken-hearted" when Crawford skips her scheduled appointment—and the actress confessing her frustrated attempts to "find with the women [in Hollywood] warmth and understanding."[21]

Introduced as she was to the American public as the French drag per-
former Amy Jolly in her first Hollywood film *Morocco*—in which she
flirts with (and, famously, romantically kisses) men and women alike—
Dietrich's contradictions seem couched in coded language suggestive
of the same bisexuality she projected onscreen and off. The studio pin-
up imagery created in the early 1930s to accompany Paramount's sen-
sational promotion of Dietrich as the studio's answer to MGM's "Divine
Garbo" reflects the same taboo-breaking sensibility of her audacious
American film debut. Two Paramount pin-ups from the era (figs. 52 and
53) are particularly useful in observing this strategy in action. In one,
Dietrich poses with the same ensemble and butch swagger of her drag
performances in *Morocco*, studied in the queer cabarets of Weimar Re-
public Berlin and the lesbian clubs of Paris's Montmartre district.[22] Diet-
rich looks lustily down at the viewer through hooded eyes. An unlit
cigarette dangles from her lip and, in a flirtatious gesture of "gentle-
manly" chivalry, she offers one to the viewer from the case in her hands.
While Dietrich's face is her unmistakably glamorous own, it is notable
that her hair is casually waved away from her face in a boyish bob, and
her face applied—shaded without prominent eye shadow or lipstick—
in the flattening, angular manner of masculine theatrical makeup. In
the other, Dietrich is styled in a spectacularly feminine fashion: glittery
shadow winks from her eyelids, her trademark cheekbones are flushed
with blusher, and her deeply colored lips parted seductively. Her face is
framed by a shimmering blonde halo, quite obviously achieved by top-
ping her still-bobbed hair (which peeks out at the sides) with a long, fat,
braided fall meticulously wrapped around her head. Peering out at us
from behind a gauzy fan, Dietrich is here the painstakingly constructed
picture of femininity.

The pair is striking in its similarity to the extremes that bracket Adah
Isaac Menken's pin-up explorations of gender construction nearly sixty
years earlier. But, created as they were in a cinematic era that projected
its entertainment, imagery, and discursive culture to audiences of un-
precedented number, and during which film producers vied with one
another for ever-more-shocking constructs of subversive female sexu-
ality, these images reflect the inroads that representations of even queer
sexualities made into mainstream culture during this time. As part of
her makeover in the period, even "America's Sweetheart" Pickford tried

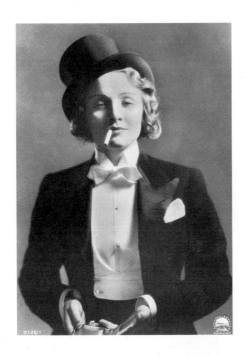

52: Paramount pin-up of
Marlene Dietrich, ca. 1930
(Collection of the author)

below **53**: Paramount pin-
up of Marlene Dietrich,
ca. 1932 (Collection of the
author)

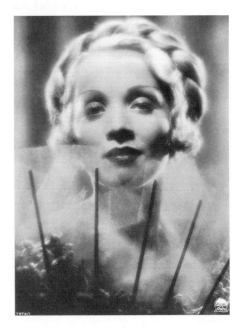

to capitalize on the gender-bending craze with her own characteriza-
tion of a French drag performer (the year following Dietrich's own)
in the romantic comedy *Kiki*.[23] The ease with which sex and sexuality
were blurred in film culture of the period extended to men as well as
women—for example, while Gary Cooper played an undeniably manly,
womanizing Foreign Legion officer opposite Dietrich in *Morocco*, in that
same film he also responds to Dietrich's swaggering drag performance
by girlishly tucking the boutonniere she tosses him behind his ear as
he gazes up at her with batting eyelashes. The leveling quality of such
cinematic gender play in the period is beautifully reflected in an an-
drogynous pair of colored pin-up notebook covers from the period,
marketed toward school-age film fans: one depicting Cooper, the other
Dietrich's rival Greta Garbo (plates 2 and 3). In Garbo's image, the actress
is depicted with the tomboyish flair for which she was known offscreen,
wearing a tight, jaunty beret and a sharp, man-tailored blouse and coat,
smiling confidently with her head slightly thrown back. Cooper, on
the other hand, while clothed in a clearly modern and masculine coat
and tie, looks slightly up and away from the viewer, his eyes heavy
and narrowed as he gazes through his long lashes in a conventionally
feminine expression of seduction. Further underscoring the subtle an-
drogyny of each pin-up's pose is the fact that, in tinting these black-
and-white studio photographs, the notebooks' manufacturer has "made
up" each actor's face with no gender differentiation—both stars appear
to sport the same eye makeup, heavy blush, and bright red lipstick.

In addition to the period's suggestion of the beauty and pleasures to
be found in new sexualities, we also see occasional efforts to similarly
insinuate broader racial models into the period's feminine ideals. Diet-
rich's costar in the 1932 film *Shanghai Express*, Anna May Wong, would
be among the first non-Caucasian actresses to be actively sold by Holly-
wood as a sex symbol. Her first fanzine appearances began in 1923, when
her breakthrough performance in the film *The Toll of the Sea* received
rave reviews. (Indeed, *Photoplay* singled out the actress's performance
in that film as its "best portrayal of the month.")[24] The following year,
Photoplay began publishing gorgeous, sophisticated pin-ups of the actress
alongside Anglo beauties in its "gallery" section. But with the expand-
ing sense of what constitutes an acceptable feminine sexuality in the
1930s, Wong's career truly blossomed—and although (as we see in her

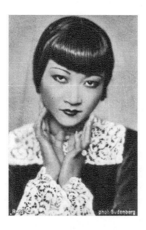

54: Cigarette card
with Paramount pin-up
of Anna May Wong,
ca. 1932 (Collection of
the author)

performance as Dietrich's maid in *Shanghai Express*) Wong found it diffi-
cult to obtain roles that did not pigeonhole the actress as either a servant
or an "exotic," in pin-up imagery (fig. 54) the actress was allowed to
construct a sexualized image on the same terms as her white contempo-
raries. Similarly, the period's Hispanic actresses used the pin-up genre's
iconic visual language as a rare site through which to transcend the often
demeaning roles by which their screen performances were limited. In
fact—as proven when *Photoplay* declared that the pin-ups of Mexican
actress Dolores del Rio earned her the title of "The Best Figure in Holly-
wood"—the streamlined, iconic sexuality of the pin-up genre often al-
lowed women of Asia, Latin America, and Southern and Eastern Europe
to not just compete with but dominate over their Anglo contemporaries
in ways that their frequently stereotypical film roles did not.[25]

It was in this atmosphere that Peruvian-born Alberto Vargas's career
began and the Varga Girl began to coalesce. A self-taught painter, Var-
gas's only art training came from a childhood apprenticeship with his
photographer father, where he had been taught to manipulate an air-
brush—which would eventually become his "brush" of choice as a
watercolorist. After Vargas was shipped to private boarding schools in
Paris and Zurich to complete his liberal arts education, his interest in a
career as an artist grew. In these cities, Vargas was exposed to the aca-
demic work of neoclassicist Jean-Auguste-Dominique Ingres and to the
popular continental illustrators Alphonse Mucha and Raphael Kirchner
(of the popular magazine *La Vie Parisienne*), whose styles he emulated

in his own paintings. After graduation and on his way to a photography apprenticeship in London, twenty-year-old Vargas was detained in New York City in 1916, his ship rerouted because of the ongoing battles of World War I. Of this soon-to-be permanent layover in the United States, Vargas wrote of his first encounter with audacious American womanhood in this age of late suffrage, which became his motive for staying behind once his ship sailed on: "From every building came torrents of girls . . . I had never seen anything like it. Hundreds of girls with an air of self-assuredness and determination that said: 'Here I am, how do you like me?' This certainly was not the Spanish, Swiss, or French girl."[26]

After his surprising move to the United States (and cut off by his family, livid that he was abandoning the family studio), Vargas supported himself doing commercial work in the fashion industry, which eventually led to a position with theatrical impresario Florenz Ziegfeld —himself a self-proclaimed "glorifier of the American Girl"—where Vargas joined his hero Kirchner as one of the Ziegfeld Follies' portraitists. Here, the artist was responsible for painting the Follies' actresses for theater displays, as well as for reproduction in magazines and sheet music covers. Combining Ingres's fantastical idealization of the feminine figure, Mucha's and Kirchner's deification of theatrical women, and the ideal of the smart and social New Woman he'd first confronted on the streets of New York City, Vargas sought to create an icon of twentieth-century femininity that fit the emergence of what he saw as the uniquely sophisticated and independent American woman developing in the wake of WWI. By the early 1930s, Vargas was accepting commissions from Paramount, Twentieth-Century Fox and Warner Brothers, eventually relocating to Hollywood where he worked as both a portraitist and set designer. Naturally, his style of representing this type of modern womanhood was well suited to the star images of up-and-coming Depression-era actresses like Dietrich, Garbo, and del Rio—all of whom Vargas painted.

Typical of both Vargas's style and how well it jibed with the period's film heroine is his image of Barbara Stanwyck created for posters promoting the 1933 film *Ladies They Talk About*. Stanwyck plays the film's protagonist, lady gangster and bank robber Nan Taylor, in a film built around Nan's efforts to break out of San Quentin to exact revenge upon

a handsome preacher to whom she confesses her crimes and who sub-sequently turns her in for them. In the meantime, the film dwells on the "ladies" of its title: Nan and her fellow convicts of different races, ages, backgrounds, and even sexual orientation. Vargas chooses to de-pict Stanwyck as neither punished nor repentant in the prison denims she wears through the bulk of the movie but rather decked out in her glamorous gun-moll finery—a silky, two-toned wrap dress and fur stole sliding off her shoulders as she leans toward the viewer, arms folded over her crossed legs. The combined look of menace and seduction per-fectly fits her character's alternating efforts to kill and make love to the antagonistic reformer who sent her away. Both the film's and Vargas's depictions of Stanwyck's character exemplify the complexities allowed the sexualized woman in this period of popular culture.

Such daring would come to an end soon after its explosion on the scene—ironically, in large part due to the same progressive spirit that led to it. In 1933—emboldened by the period's sense of civic responsi-bility and activism furthered by the political efforts of the new president Franklin D. Roosevelt, and capitalizing upon the peaking sense of help-lessness that Americans felt over the lingering Depression—American protests of the movie industry set into motion a response that would grind the feminist promise of the period's film culture to a halt. In this year, economic problems within the movie industry led to not only layoffs and salary cuts but panic as both urban censorship boards and the newly formed Catholic Legion of Decency openly campaigned against American studios, each of whose films seemed dedicated to out-sensationalizing the last in the movie industry's efforts to compete for audiences' dwindling dollars. In their search for an industry solution to assuage moralists' fears, as well as ensure that films would not be blocked by the local censorship boards of lucrative urban centers, studios sought to instigate the reevaluation and enforcement of the 1930 "Hays Code."

Will Hays, head of the Motion Picture Producers and Distributors of America (which became popularly known as the Hays Office), had been appointed in 1922 to this role by representatives of the film indus-try to serve as the "czar of the cinema" in the industry's ongoing efforts to convince exhibitors of the moral value of its films—a position ini-tially viewed with disdain by film fans themselves. (Indeed, as part of its early crusade against censorship, *Photoplay* addressed his appointment

skeptically the year after its announcement, protesting that his position and actions offend "the intelligence of the missions of photoplay patrons.")[27] Hays collaborated with several studio-production heads to arrive in early 1930 at a code of ethics—whose stamp of approval their films would bear—to see that "no picture shall be produced which will lower the moral standards of those who see it." The resulting Motion Picture Production Code (generally referred to as the Hays Code) was generally paid lip service until Joseph Breen—a Roman Catholic (and openly anti-Semitic) employee of the Hays Office who had served as a Hollywood "mole" to the Legion of Decency—was appointed head of Hays's Production Code Administration (PCA) in 1934, formed that year for the express purpose of enforcing the code in films released by the major studios. While Breen's appointment had been meant to placate the rallying Catholic protestors—where some local dioceses informed the faithful that attending condemned movies was a mortal sin—and censorship boards in the nation's all-important urban centers, he took his position within both the Hollywood studio system and America's Catholic community seriously and began pressuring studios into strictly enforcing the Code's myriad and vague guidelines to a one (which the PCA would continue to do into the 1960s), in order to ensure their safe passage into theaters across the nation. Unsurprisingly, particular prejudice was immediately aimed at sexually frank films with central female characters—from the comedies of Mae West to the melodramas of Greta Garbo—which were either bowdlerized in the editing room, kept from production until the script met Breen's approval, or in some cases pulled out of circulation altogether.[28]

However, these efforts did not succeed through one man's zeal alone—the same culture that had championed the ever-more-daring women of pre-Code Hollywood held startlingly antifeminist perspectives on women in the workaday world. While audiences may have thrilled to wisecracking working women on the screen, they were less likely to tolerate their presence in the professions—especially as the Depression wore on. While more American women in the 1930s worked outside of the home than ever before, their presence was looked upon with great disdain, as demonstrated by the findings of the period's pioneering cultural anthropologists Robert S. and Helen Merrel Lynd. The Lynds' research suggested that as more women worked to supplement family

incomes—leading to a corresponding confusion of traditional gender roles when women were clearly needed to work for more than "pin money"—a cultural sensibility emerged to demand of women a kind of penance in the form of a return to traditionally feminine dress and emphasis on homemaking.[29] While the job growth ushered in by the New Deal created some tremendous opportunities for women in the late 1930s, overt and covert discrimination against women continued as even the government officially perpetuated wage differences for men and women and the sex stereotyping of positions.[30] Even in the upside-down world of the film fanzine, one finds the period's antifeminist voices around the edges. In a spectacular *Photoplay* tirade by the divorced author Cal York—ironically, the screenwriter of one of Norma Shearer's most daring pre-Code films, *Strangers May Kiss*—the writer complains about living single and supporting herself, emphatically stating: "I am not a feminist. In fact, I resent the feminists—they are the ones who started all this. I wonder if they realized what they were letting us all in for. We don't want this freedom. We only work when we are forced, by pressure, to do so."[31]

<div align="center">

Anonymously Yours:

Esquire and the Rise of the Illustrated Pin-Up

</div>

Even as the professional woman was increasingly met with scorn, the unrepentantly sexual woman proved far too tantalizing for popular culture to part with. Whereas the former fought for recognition, the latter would continue to thrive and grow—albeit in new and sneaky modes. Granted, the PCA's power was such that in the films of the next three decades, repent the sexual woman would—indeed, Breen's wrath was so feared that not only film characters onscreen but the real women who played them were careful not to draw the ire of the PCA. As such, studios and fanzines alike paid meticulous attention to the language—and, of course, the imagery—through which it constructed their stars' images after 1933. But fans remained fascinated by the sexual audacity of their screen stars, and while the studios and even the stars themselves had to pay careful attention to the specifics of sexual representation post-Code, the appeal of pre-Code sexuality was so fantastic that it should come

as no surprise that—in much the same way that shortly after her birth the New Woman would in turn beget the fantasy Gibson Girl—such transgressive personae would be hybridized into fantasy types in fanzine illustration. Artists like Enoch Bolles and George Quintana were among the glamour illustrators who would make their careers creating daring fantasy starlets for film fanzines in the post-Code era. These imaginary women appealed to the moviegoing public's already frenzied interests in sexual transgression, but their anonymity allowed them to stand in for—indeed, go further than—the real women who had inspired them.

The foundation of *Esquire* magazine on the brink of these changes would help further the rise of the illustrated pin-up girl, in large part by returning her to the larger cultural context from which she first emerged in the nineteenth century. *Esquire* was inspired by the boom of the men's clothing trade that began the decade; originally intended for distribution primarily through male clothiers, it was first modeled upon the ladies' fashion journals of the nineteenth century and the early twentieth. However, popular demand for the innovative "men's magazine" was so great that 95,000 copies of the premier issue in 1933 were recalled from stores and redistributed to newsstands.[32] *Esquire* soon sought to cultivate a reputation as not just a fashion leader, but a literary and cultural leader as well. The magazine published essays and fiction by F. Scott Fitzgerald, John Dos Passos, and Ernest Hemingway and provided its readership with erudite articles on contemporary art, music, films, and American politics. The magazine's most popular features, however, were its "girlie" cartoons. Unlike similar features that had been popular in tabloids like *The National Police Gazette* since the previous century, *Esquire*'s subjects were, like the Gibson Girls, the glamorous, white, upperclass women of the American *nouveau riche*. However, Gibson's comparatively modest young ladies of the Eastern seaboard were players in urbane excursions or drawing-room morality tales. *Esquire*'s women were, like the "wild west" female stars of the pre-Code movie fanzine, represented in various states of undress and often humorous, modern sexual situations. The cartoons were part of *Esquire*'s appeal: combining cultural sophistication and bawdy humor with what one critic succinctly defined as "a heavy load of excellence with a fine streak of vulgarity."[33]

Illustrators E. Simms Campbell, Alex Raymond, and Howard Baer

helped construct the modern ideal of the *Esquire* woman in the magazine's one-panel comics. However, the most famous artist of the magazine's early years was George Petty. His wildly popular "Petty Girls" were primped and sporty cuties that began life as part of the constellation of girlie cartoons; they were accompanied by gag caption one-liners, generally quoting their naive reactions to the ogling viewers ("Oh, you *would*, would you?"), or pouting responses to sugar daddies ("I want to keep the ring for *sentimental* reasons!"), who presumably sat at the other end of the ever-present phone receiver held in a well-manicured hand. In December 1939, however, the Petty Girls moved from the one-page, single-panel comic narrative format to a fold-out centerfold of their own. In these, all narrative indicators (save the gag line) were reduced to the point that the Petty Girls eventually occupied a blank, white space, where her physique, costume (or lack thereof), and expression were literally the sole focus of the image. (Eventually, the Petty Girls' telephone receiver, abbreviated clothing, and even shoes were rendered in gestural sketch marks, drawing all the more attention to their meticulously painted flesh.) Rarely addressing the always presumed male viewer with her gaze and toothily grinning for his approval on the rare occasion that she did, though she began as a gold-digging, sex-crazed actress of the pre-Code mold, by 1940 the Petty Girl was well-established as a naïf whose only real talent, much less profession, involved looking delicious while charming men out of their money.

As Petty's popularity increased with *Esquire* readers, and his outside advertising commissions skyrocketed, so too did his monetary demands from the magazine. By 1940, *Esquire* actively sought a comparable replacement for the artist, which they found in Alberto Vargas. By then, Vargas had been blacklisted by Hollywood studios for taking part in unionized walkouts and began working for *Esquire* in 1940 as the replacement for Petty that the magazine had sought to groom. The artist—desperate for commercial work, unfamiliar with publishing issues such as reproduction and ownership rights, and starving along with scores of other workers in the last years of the Depression—accepted the magazine's $75 weekly salary. In this arrangement, the artist would produce pin-up imagery on demand, which the magazine would own outright: a fraction of the $1500 that Petty would receive per image by 1941, an agreement in which Petty also retained ownership of and re-

production rights to his work. *Esquire* then dubbed the artist "Varga"—
citing reasons ranging from a wish to distance the artist from "fascist-
leaning" Brazilian President Getulio Vargas to publisher David Smart's
claim that the name simply sounded more "euphonious"—a name that
the magazine, not the artist, would own.[34] As one could well imagine,
in the long run these terms would prove disastrous to Vargas's career and
legacy, but in the meantime the artist was thrilled to be filling the shoes
of the legendary George Petty.

Vargas's first fantasy pin-up appeared as a gatefold in the October
1940 issue (plate 1), in which the pressure for the artist to live up to the
precedent set by Petty was apparent. The telephone scenario and an ac-
companying gold-digger verse of this first Varga Girl were perfectly in
keeping with Petty's style. However, the dramatic, lingerie-clad figure
striking an artfully foreshortened pose was a complete departure from
Petty's cheery naïfs. The subtly colored and shadowed blonde lounged
languidly with a slightly bemused expression that contrasted Stack's ex-
clamatory verse about the woman at hand falling for the previous eve-
ning's disastrous date only after the girlfriend on the other line informs
her of said date's silver mines. ("AS RICH AS THAT? He surely doesn't
show it . . . MY GOD! I've been in love and didn't know it!")[35] Thankfully,
by Vargas's third *Esquire* pin-up he had completely shrugged off the bag-
gage of the Petty prototype and returned to the glamour-goddess style
of his earlier portraiture. Defying the full-body format that *Esquire*'s
centerfold was devised to accommodate, the January 1941 Varga Girl
(fig. 55) was a head-and-shoulders rendering of a meticulously coiffed
masquerader in a strapless feather bodice. ("Your bodice, oh, my god-
dess / Proves that you and love have wings!") Following the style of
this centerfold, Vargas's women, poses, and compositions began more
closely resembling the strong, sexual icons he painted in the pre-Code
era than the comical nude with a narrative that had by then marked *Es-
quire*'s illustrated women. Two months after the 1940 introduction of the
Varga Girl, *Esquire* confidently published the first Vargas calendar, with
a unique new pin-up girl for every month. The magazine previewed
the calendar's images in the December 1940 issue, and in one fell swoop
doubled Vargas's annual output for the magazine. This debut Vargas cal-
endar (as would the seven that followed it) made history by becoming
the best-selling calendar of any kind worldwide in the year it was re-

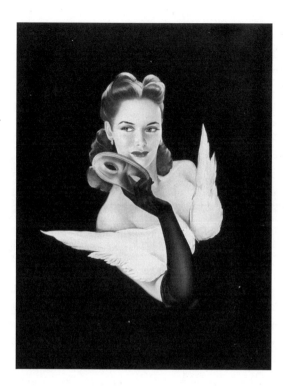

55: Alberto Vargas, watercolor painting published as an *Esquire* centerfold, January 1941 (The Spencer Museum of Art, The University of Kansas, Gift of Esquire, Inc.)

leased. Eventually, *Esquire* would commission Varga Girl playing cards, notepads, and print series from the artist, all of which propelled the girls' images far beyond the magazine's pages.[36]

Shortly after her debut in *Esquire*, the *New Yorker*'s "Talk of the Town" addressed the Varga Girl's decidedly unladylike exhibitionism with the now-famous quip that Vargas "could make a girl look nude if she were rolled up in a rug." The same column made note of the manner in which his women were "faultless in limb and shaping, curved with strange magics."[37] In fact, Vargas's freakishly "faultless" women uncannily mirrored the *Odalisques* of his hero, Ingres. Like Ingres's career-long disfigurement of the human figure in the name of sensual pleasure (his famous *Grande Odalisque* prominently featured three extra vertebrae in her seductively exposed back), Vargas embellished freely upon his renderings of the female body in order to exaggerate their sensuality.[38] The Varga Girls' impossibly long legs ran derriere-lessly into their waists; their ample breasts spread irrationally far across their chests; their doll-

like and fetishistically detailed feet teetered on pumps rendered with equally lavish attention; and even eighteenth-century period drag clung to their bodies like the wet *peploi* of Hellenistic marble goddesses. Adding to the Varga Girls' unsettling perfection was Vargas's airbrush technique. With the controlled paint-sprays of the tool, Vargas held enormous control over the subtleties that the artist chose to heighten their look. With the same instrument used not only to whisk away Joan Crawford's freckles in George Hurrell's studio, but also to paint the flawlessly gleaming finishes of American roadsters and coupes, Vargas conjured up lemon-meringue blondes with bodies just as steely and dangerous as anything rolling off the assembly lines in Detroit. In contrast, Vargas meticulously rendered details such as eyes, lips, feet, and hands with extra-fine sable brushes that lifted the subjects' gazes, gestures, costumes, and accessories forcefully off the page. All the action took place in a surreal void that seemed the result of the women's refusal to accept anything on the page that might detract from the viewer's undivided attention to their person. In fact, the Varga Girls didn't seem to like company of any kind: during Vargas's six-year association with *Esquire*, they appeared only once as a duo, once as a trio, and once with a man. Engaging the viewers with their forward, even predatory gazes and beckoning gestures while distancing them with the shimmering solidity of their impossible figures and spectral surroundings, they aimed to entice but not necessarily to invite.

Interestingly enough, Vargas's fantastical women were supposedly modeled after life studies of his wife, former stage performer (and Gloria Swanson look-alike) Anna Mae Clift, and Jeanne Dean, a young model whom he had discovered while she worked as a teenaged movie "usherette."[39] While the figural studies of Clift and Dean do explain why Vargas's figures seemed to generally come in two flavors—either tall and athletically toned like the former, or petite and curvaceous like the latter—his composite style in fashioning each pin-up guaranteed that they would be chimerical. As we will see, the Varga Girl's dependence upon shifting ideals of beauty and womanhood from popular culture guaranteed that she would change along with the American women who first inspired the artist.

Regardless of the magazine's months of breathless, anticipatory Vargas propaganda, such differences were certainly not appreciated by all of

Esquire's readers, who were used to thinking about the Petty Girl as *the* Esquire girl. The first letter on the subject was immediate—and typical of complaints to follow—from one Richard J. Langston, who wrote in the December 1940 issue:

> We (the readers) have missed the shapely Petty Girl, but her absence is not nearly so disappointing as your giving us a substitute such as this one. She is good, yes, and shapely too, but she is not what we have been wanting—and getting. . . . Miss Varga looks far more hardened and callous than the inviting, yet more reserved, Betty Petty. . . . The Varga Girl is desirable in her own sort of way, but she, unlike Papa Petty's creation, is not as likely to be taken out in public.
>
> Women's beauty is—and should be—judged from the standpoint of that which would make her most desirable to men. We want a female who is a lady in the daytime and a woman at night. . . . [Petty's] women have their emphasis in such a manner as to make one take them in the belief that such women really exist—and they do.[40]

Langston's comments reflected many letters from Petty fans, for whom the Varga Girl reflected a decadence and sexual self-awareness absent in the Petty Girl.

Others, however, saw in these same "hardened and callous" qualities a sophistication and complexity that they cheered. In response to several male subscribers' anti-Vargas letters, one female reader wrote to defend the new artist's women over Petty's. Her comments about the Vargas vs. Petty debate speak not only to the different appeal of each illustrator, but also more subtly to a desire for men like Langston to approach women's sexuality as a part of their whole being—a manner that she apparently felt Vargas had over Petty. This reader, "A. K. V." of Dallas, spoke directly to Langston's above comments when she wrote, "My colleagues (female) and myself have decided that a Varga girl (if such could breathe) would be at least understandable, while a Petty wench is something you view with lifted eyebrow and censor your thoughts. . . . [Langston's comment,] 'we want a female who is a lady in the daytime and a woman at night,' simply slayed [sic] me, as I did not know there was such a vast chasm between night and day."[41]

Apparently, the Varga Girl struck a chord with female readers like A. K. V., for whom this particular pin-up represented a more believ-

able image of female sexuality. Letters such as this represent an *Esquire* audience that historians rarely take account of: its large female readership. The "dialogue" between readers like Langston and A. K. V. signaled more than friction in the change from the Petty to the Varga era in *Esquire*. It foreshadows another, broader dialogue in American society that would soon occur when both female sexual ideals and women's role in constructing them went through a dramatic makeover after the United States joined World War II in December 1941. As a magazine geared toward men, but read extensively by women as well, *Esquire* provides us with an interesting perspective on feminine ideals during World War II. On the one hand, *Esquire* served as a pointedly contemporary voice for presumably heterosexual males; it represented a site in which men could speak among themselves about world affairs, popular culture, and women. On the other hand, the magazine itself acknowledged and publicized the fact that a large number of its subscriptions were read by women who "peeked in" to this male world because they found some kind of pleasure and identification there. As the war instigated drastic changes in gender dynamics in both the public and private spheres, the Varga Girl came to serve as an icon for the new, wartime ideals of women's sexuality.

War Goddess: From Pin-Up to Bombshell

Within a year of their first appearance in *Esquire*, the Varga Girls began to find their own identity. The magazine dropped the Petty-esque gagline jabs at the gatefold girls and replaced them with the adulatory verse of Phil Stack, constructing the girls as women to be worshipped, not ridiculed. As early as April 1941—eight months before the bombing of Pearl Harbor—Vargas's pin-ups and Stack's text came to not only praise the Varga Girls' beauty and underscore their sexuality, but also to give them a "voice" as a patriotic ideal for American womanhood. Between 1942 and 1945, nearly every gatefold and most calendar captions would address the war in some way, and gatefolds like "Yours to Command" (fig. 56), "Victory Song," and "Peace, It's Wonderful!" represented women in military garb and insignias with correspondingly patriotic poems. In contrast, the military women of George Petty—still

56: Alberto Vargas, watercolor painting published as an *Esquire* centerfold, October 1941 (The Spencer Museum of Art, The University of Kansas, Gift of Esquire, Inc.)

contributing the occasional pin-up to the magazine — were predictably represented as charmingly gullible girls playing dress-up in masculine drag. In a July 1941 centerfold the Petty Girl — on all fours and talking to a ragdoll, wearing just the jacket and hat of a Navy officer — tells the doll childishly, "So take my advice and just bet your shirt" when dealing with military men.[42] Varga Girls, however, were sexualized yet pointedly active women usurping and clothed in the accoutrements of male power, learning drills and semaphore. The first real "recruit" was a Women's Army Auxiliary Corps (WAAC) member in the 1943 calendar, who announced as she paused before her new uniform: "I'm off to join the WAACs / and serve the country that I love / until the Axis cracks!"[43] Later, Vargas represented a member of the Navy Women Accepted for Volunteer Emergency Service (WAVE) mid-push-up in the 1944 calendar, proclaiming: "I'm going to join the Navy WAVES / and help the war to halt / and also show my navy beau / that I am worth my salt!"

Suffice it to say that many male soldiers in World War II took just as strong a liking to the Varga Girls as the girls had to military drag.

The military demand for Vargas's pin-ups eventually became such that from 1942 to 1946 *Esquire* printed 9 million copies of the magazine—without advertisements and free of charge—and sent them to American troops stationed overseas and in domestic bases. In addition to the magazine, Varga Girl calendars circulated widely, and *Esquire* eventually commissioned extra Varga Girl pin-ups exclusively for reproduction on the back covers of its free "Military Editions." Swept up in the context of the "good fight," the Varga Girls were no longer the monthly centerfold that spiced up reading at the prewar study or breakfast table, but a liaison to the home front and a metaphor for the American girl. Bob Hope summed up the Varga Girls' overwhelmingly strong connection with American GIs when he proclaimed: "Our American troops are ready to fight at the drop of an *Esquire*."[44]

Nowhere was the Varga Girls' role in this capacity more prevalent than in their exhibition and appropriation by the American troops. Addressing the "travels" of the Varga Girl in a 1944 editor's note, *Esquire*'s editor-in-chief Arnold Gingrich reminded readers that "there's no doubt which pages cover more territory than the rest of the magazine put together."[45] Letters from GIs poured into *Esquire*, detailing the ways in which Varga Girls accompanied U.S. soldiers overseas. They hung alongside photos of friends, mom, and F. D. R. in the barracks and officers' quarters alike, graced the inside walls of tanks and planes, and even shared foxhole spaces with young soldiers. In an image that stresses the almost religious iconicity of the World War II pin-up, one Marine Corps photo sent to *Esquire* shows the August 1943 Vargas centerfold unrolled on the deck of a landing barge and meditated upon by Marines approaching the Japanese-held South Pacific island of Tarawa (Gilbert Islands), which burns ominously before them (fig. 57).[46] More than just a diversion, in the words of one soldier, these women provided "the background to danger."[47]

Significantly, the most common and most recognized appropriation of the Varga Girls was in the nose art of World War II bombers. Considering the talismanic quality of the Varga Girl for many soldiers, it should come as no surprise that they were often reproduced for good luck on these planes. Moreover, the Varga Girls' hypersexual physique and prosaic innuendo shaped them into creatures whose sexuality tended to be more than a little fearsome. Although there was the occasional "girl next

57: Marines approaching the island of Tarawa with the
August 1943 *Esquire* centerfold in hand (Library of
Congress, Prints and Photographs Division)

door" type—caught in mundane domestic acts of yard work or dressing, looking on in a moment of dreamy repose—in image and prose, the Varga Girls were remarkably aggressive about their sexual desires and prowess. The centerfold of February 1941 reclines in orgasmic abandon, recalling "that tiny inn we sought when night would fall / The candlelight . . . the wine . . . and you and I." The racy November 1942 centerfold is a ranch hand rocking back on her satiny dressing-room ottoman—wielding a riding crop with a devious grin—while the text cheerily informs viewers that with such women accustomed to taking over men's work during the war, "I bet she wears the pants forevermore!" The August 1943 calendar girl stretches luxuriously, aware that "All the men who pass me by / Just look at me . . . and swelter!" And the shockingly saucy Miss July in the 1944 calendar throws a knowing look at the viewer in the midst of a highly suggestive yoga pose to say: "I'm learning some commando tricks / for keeping fit, they're dandy/ and when you men come home again / they're apt to come in handy!"[48] Whether through their abbreviated choice of gown or randy honeymoon behavior, even Vargas's annual June brides hardly seemed virginal.

Such wartime Varga Girls were painted on Army bombers named in honor of the ladies represented—often taken directly from the titles of Stack's poems that accompanied the pin-ups. Archival images of World War II bomber art include dozens of bombers on which Varga Girls appeared, menacingly dubbed "The Dark Angel," "Double Trouble," and "War Goddess" (fig. 58). One bomber pilot wrote *Esquire* to testify that "the Varga beauty stenciled onto his bomber made a German pilot come within gun range for a better look."[49] A specially designed Varga Girl created by the artist for a U.S. bomber squadron is a wild-eyed, scarlet-clothed blonde that coaxed allied missiles—seeming to spring forth from beneath her skirt—toward their targets. Even the Women's Airforce Service Pilots (wasps) had a pin-up mascot painted on the noses of their planes in the form of a curvy sprite, Fifinella, designed specifically for the wasps by Walt Disney. As historians Elaine Tyler May and Despina Kakoudaki have noted, to parallel the pin-up's overt sexuality with the generally male-identified implements of destruction (and liberation), female sexuality represented in such a manner would have to be associated with danger and strength. As such, bomber art pin-ups further underscore the power with which modern women so represented be-

58: B-24 bomber with *Esquire* October 1944 calendar pin-up on nose (United States Air Force Museum)

came invested during World War II.[50] Like Miss August headed toward Tarawa, the use of contemporary pin-ups as bomber-nose mascots—to serve as a sort of troop "protectress"—demonstrated how the genre's use by the military could symbolically reverse the traditional roles of male/protector, female/protected.

Victory Girls: Women, Work, and Sexuality

Of course, American soldiers were aware that it was not fantasy women helping to win the war. As demonstrated by a 1944 war effort poster by Cy Hungerford (fig. 59), Varga Girls weren't the only kind of pin-up girl admired in the military. Standing before Rosie the Riveter—the icon for the female home-front war worker—a sailor, a soldier, and an airman give a thumbs-up salute to "Their *real* pin-up girl."[51] As the pool of male workers drained from the American labor force to the military overseas, the government campaign of which Hungerford's poster was a part forcefully promoted the notion that it was not only necessary but also fashionable, and even sexy for women to enter the workforce. Contrary to the privileging of white, male workers during the Depression, with America's entry into World War II the new economy was desperate for *any* workers to fill the void left by men leaving the home front. President Franklin D. Roosevelt's 1942 Columbus Day speech directly addressed

59: Cy Hungerford, *Their Real Pin-Up Girl*, Office of War Information poster, 1944 (Library of Congress, Prints and Photographs Division)

the fact that traditional biases would not be tolerated in the wartime workforce: "In some communities employers dislike to hire women. In others they are reluctant to hire Negroes. We can no longer afford to indulge such prejudice."[52] As a result, women and people of color on the home front were soon asked to learn to perform roles that years, even months earlier had been deemed beyond their physical and intellectual capabilities. Hungerford's simple propaganda poster was part of the visual culture that would help instigate the dramatic shift in American attitudes that would occur during World War II, during which 60 percent of the country's women would find themselves working outside the home before the war's end in September 1945.[53]

Hungerford's work reflects the influence of the American government's "womanpower" campaign, through which groups like the War Manpower Commission and the Office of War Information sought to make war jobs appear both patriotic and glamorous to women. In such campaigns the government recruited the News, Motion Picture,

Graphics, Magazine, and Radio bureaus in influencing the industries they monitored to depict women in industry and the military as models of patriotism, wholesomeness, and even romance.[54] However, these campaigns often pointedly glorified the American housewife, praising homemaking as either a current or future "profession" for women, urging women to maintain their prewar housekeeping and childrearing duties. These campaigns also overtly stressed the notion of "the duration" to the women that they were recruiting. Women were constantly reminded that soldiers would expect their jobs back upon their return. For those with notions of working up in their professions, a glass ceiling often kept women from becoming too useful or comfortable in home-front positions they attained. On the one hand, these strategies helped the national objection to wives working outside the home plummet from 80 percent during the Great Depression to 13 percent by 1942.[55] On the other hand, the phenomenon of what historian Leila Rupp calls "the housewife-turned-factory-worker came into the limelight," reminding women of their "real" domestic identity at the same time it encouraged them to work outside the home.[56] Such mixed messages that women were given pertaining to their wartime role on the home front represent an ominous shadow that followed all women's gains in the public sphere during this era.

However, it can also be argued that the contradictions resulting from the country's conflation of women's traditional and nontraditional roles ultimately encouraged women to reconcile qualities of both within themselves in different ways than the "housewife-turned-factory-worker." In fact, particularly for young and single women, it seemed that this contradiction represented a delicious manner through which they could reshape their personal balance of propriety and progressiveness. Their experiments in self-reinvention were not limited to their roles as workers. As they encountered both difficulties and successes in their entry to the newly integrated public sphere, women also discovered the power and problems that their sexuality posed in relations with their male counterparts. Naturally, once on their own in sex-integrated workplaces, there was ample opportunity for women to be sexually harassed and exploited by male colleagues and superiors. As aircraft worker Stella Vanderlindel Always put it, male supervisors often demanded, "Either you 'came across' or else."[57] Simultaneously,

women were themselves often blamed for the "distraction" they posed in the workplace and forbidden from wearing sweaters or form-fitting clothing.[58]

Oral histories prove that many women nonetheless dealt with issues of sexual harassment and double standards with the same wit and determination that they did other workplace obstacles, often with the help of both female and male colleagues. The machinist and self-described "tomboy" Phyllis Kenney Skinner threatened one male worker with a punch and swung a piece of machinery at another when their flirtations became unwelcome. "I wasn't that type of girl to begin with. Very shy, and I was raised very strictly. . . . I said, 'This is to let any of you know that I'm not that type of person.' And from then on, I was Miss Kenney."[59] One welder, Julie Raymond Elliot, was taught by a male supervisor to fend off unwanted advances by striking an arc with her welding gun, creating a painful flash for the unprepared aggressor.[60] Librarian Josephine Carson recalled how women escaped their boss's groping by a system of coded warnings from woman to woman, devised to inform those working alone in the stacks of the perpetrator's approach.[61] Many other women discovered the power in such organization; some groups even collaborated in "reverse discrimination," learning that when "men were faced with catcalls, whistles, and sexual aggression by women, their own misbehavior stopped."[62]

Through such scenarios, both positive and negative, women of unprecedented numbers and different classes were for the first time forced to confront and address the issues that their own sexuality posed in the public sphere. While surely frightening for many, it also encouraged others to explore the pleasures of their newfound sexual awareness and confidence. With a professional reason to escape the confines of the home, as well as to move from rural to urban areas, young women had space to reinvent themselves and explore their sexuality outside of marriage and without parental supervision. Their generation had unprecedented personal and economic freedoms, and opportunities to meet single men on a relatively level professional field. Moreover, these women witnessed birth control's first steps into the mainstream with the formation of the Planned Parenthood Federation of America in 1942.[63] Kay Hearn, who was then a college student, remembered that the difference between a girl's sexual life before and during the war seemed

immediate and dramatic: "All of a sudden, you were just a play girl. . . . We'd party as much as we could."[64] Writer Sean Elder's mother confessed that patriotism alone didn't send her to enlist in the Marines: "It was something to do and it was exciting. And besides, there were men around."[65] *Premarital Dating Behavior*, Winston Ehrmann's 1959 study of the World War II era, included stories of young women who approached sex with "a feeling of high adventure," as well as young men recalling the extent to which working girls were "on the make." In the heady environment of World War II, one young man matter-of-factly asserted: "The times were conducive for this sort of thing."[66] John D'Emilio and Estelle Freedman note that while it was the issue of prostitution that worried moralists during World War I, "by the 1940s, it was the behavior of 'amateur girls'" that was cause for concern. They cite the period's proliferation of new and not necessarily derogatory names for these sexually adventurous women — "khaki-wackies, victory girls, and good-time Charlottes" — as evidence of the extent to which women's sexual agency was both widely expressed and accepted during wartime.[67]

Regardless of moralists' fears, the establishment of the United Service Organization (USO) showed the extent to which even the government sanctioned young people's mingling and romancing for "the duration." Founded in 1941 at President Roosevelt's request, the USO recruited young women to entertain male troops through morale-boosting performances overseas and in homefront facilities for soldiers on leave — serving homemade food, sponsoring dances, and planning outings — where older women served as temporary moms and young women served as temporary sweethearts.[68] Although the organization did everything it could to keep the festivities chaste, young women easily figured out ways to skirt the rules. Catherine Ott would spend her weekends home from college at the Rhode Island USO canteen run by her mother and rendezvous with young soldiers after hours. She noted, "You weren't supposed to leave the building with men, so we would leave alone and meet them around the corner. There [were] always ways of getting around things like that."[69] In this environment, where sexually active young ladies were no longer necessarily "tramps," but "victory girls," women constructed new and positive ways of publicly expressing and representing their sexual agency.

Unmediated by many of the traditional influences that kept women's

sexuality tied exclusively to their roles as wives or mothers, women were able to relate their sexuality to their own desires and pleasure in much the same way they might relate their jobs to the same. Ultimately, the necessary sexual awareness taught or developed in the public sphere not only served to make women more protective and controlling of their sexuality, it also encouraged them to construct a feminine ideal that reconciled traditional elements of beauty and glamour with new attributes of strength, independence, and bravery.[70] As an icon for the active, desiring, and desirable woman, the pin-up girl fit the bill as a template through which these women might represent their reinvented selves. Like Frances Benjamin Johnston's appropriation of the romantic Gibson Girl as a model of New Womanhood at the turn of the century, it seems that many women during World War II saw the familiar visage of the Varga Girl not as an unattainable fantasy of the heterosexual male imagination, but as something they could both associate with and aspire toward.[71]

Joanne Meyerowitz's analysis of the pin-up genre's female audiences asserts that the wartime signification of the pin-up as a dangerous feminine force was part of their appeal to women viewers, and cites the *Esquire v. Frank C. Walker, Postmaster General* case as exemplary of this fact. In 1943, *Esquire*'s second-class mailing privileges were revoked due to what the postmaster general decreed was the Varga Girls' legally pornographic ("obscene, lewd, and lascivious character") status.[72] Contesting the postmaster's decision, both *Esquire* and the U.S. government called a series of female witnesses to testify as to their perspectives on the pin-ups' "decency." While the women testifying were varied on their perspectives on the propriety and ubiquity of such brazen displays of female sexuality in popular culture, Meyerowitz notes that in all of their court testimonies—both in favor of and against the features—the Varga Girls were viewed as "active subjects luring men, not as victims of the male gaze."[73] Not coincidentally, this was during an era in which women were—arguably, for the first time in American history—encouraged by both political and cultural forces to develop an awareness of their roles as professional, economic, and sexual agents.

In images like Hungerford's, directed at female factory workers, we see the artist using the subject of the pin-up to appeal to this type of woman who, if she did not already see herself as a pin-up-styled sub-

ject of some man's admiration, was certainly being encouraged to do so by forces ranging from Hollywood to the White House. In fact, pin-up artists were commissioned by the armed forces for the precise purpose of using their talents of flattering and glamorizing women toward the recruitment of women. This tactic was not new; during World War I, Charles Dana Gibson led the Division of Pictorial Publicity, where he and other popular artists created recruitment posters for the war. Gibson and fellow pin-up artist Howard Chandler Christy (creator of the Gibson Girl's main competitor, the Christy Girl) each used the female figures they were famous for in home-front propaganda.[74] However, Gibson reinvented his formerly feisty girls as modest "house managers" soldiering in the kitchen, and the Christy Girl was put not toward enlisting her fellow young women, but for the recruitment of young men. During World War I young women had, ironically, been asked—to paraphrase the famous illustration reproduced in fanzines like *Photoplay* as part of the Red Cross's recruitment efforts—to transgress traditional norms of femininity by approaching their war work as "the world's mother." During World War II, rather than tempering either the professional capability or the charismatic sexuality of modern women in the period's recruitment illustrations, the same bold and glamorous types seen in *Esquire* were used to recruit women for war jobs, the military, and medical professions (fig. 60). The first Coast Guard SPAR (taken from their motto, *Semper Paratus*, or "always ready") to leave *Esquire*'s home base of Chicago was rewarded with a pin-up portrait by Vargas. Even George Petty was commissioned to create a (hardly heroic but certainly enthusiastic) Navy WAVE for the corps' recruitment efforts.

Rejected by the draft, legendary calendar artist Al Buell served the country by glamorizing military women for Brown and Bigelow's calendars. His military recruitment poster, *They're All Tops* (fig. 61), is the quintessential example of the pin-up put to work for the war. Surrounded by the hats of six different military corps, a glamorous young redhead muses over her choice of the many professions that she is implored—and, by implication, qualified—to join. In images such as these, young women were not only encouraged to follow active, "masculine" paths in the public sphere but reminded of their choices among these paths in what must have felt like an abundance of subversive opportunities. The distribution of this particular image also gives us a sense of

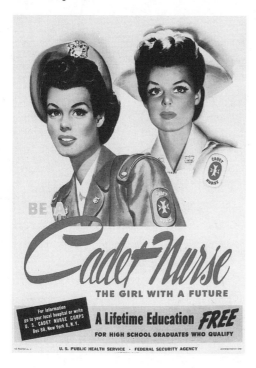

60: Cadet Nurse Corps recruitment poster, Office of War Information, 1944 (Courtesy of the United States Naval Historical Foundation)

broad appeal of these images to both women and men; in addition to serving as a recruitment image for women, Brown and Bigelow used the image for promotional pin-up calendars that traditionally male-oriented businesses (such as barber shops and garages) ordered from the company and gave away to customers.[75] These posters used the pin-up for all her seductiveness, sass, and self-assurance—the same qualities she possessed in magazines like *Esquire* but wrapped in slightly more fabric and aimed at both men and women. Through propagandistic uses such as these, still subversively tinted with the naughtiness with which the genre was born, during World War II the pin-up would come to serve as an increasingly acceptable ideal for women's sexual self-expression.

Contrary to contemporary assumptions that the Varga Girl (and *Esquire* magazine) was enjoyed by an exclusively male audience, we find her presence in such contexts where she would not only have been highly visible to women, but there as the result of what one can assume was her already existing popularity with a female audience. By the start of the war, women were certainly familiar with her; in the very same

61: Al Buell, *They're All Tops!*, recruitment illustration, 1944
(Art from the Archives of Brown and Bigelow)

issue as the first Varga Girl, an *Esquire* reader-poll appeared that indicated
nearly three-quarters of the "gentlemen's magazine" subscriptions were
in fact read by women, for whom the magazine's illustrations were the
number-one attraction.[76] During the war, advertisers courted *Esquire's*
female readership, frequently targeting women in ads that encouraged
them to purchase consumer items both for themselves and the men
for whom they presumably shopped.[77] *Esquire's* editors followed suit by
occasionally publishing women's fashion features that complemented
theme-based men's features. In fact, if one reads the magazine's let-
ters section, "The Sound and the Fury," throughout the 1940s, women's
letters were frequently published—many written solely to remind the
male editors and readers that the magazine had a broad audience that
included women whose presence should be considered in features, car-
toons, and advertisements. (As writer Marion W. Scholten put it: "You

can be a Ph.D. or a bum and enjoy *Esquire*. And whether people know it or not you can be a twenty-year-old minister's daughter at that and still appreciate it. [I'm one.]")[78]

The Varga Girls were interesting enough to *Esquire*'s female audience that reportedly one-fourth of Vargas's fan mail was from women—who wrote not just in support of his work, or for advice on how they could emulate the Varga Girls' style, but also asking how they could get into a career as pin-up illustrators.[79] Vargas's papers at the Smithsonian Institution's National Archives of American Art even include letters from a thirteen-year-old aspiring artist, whose drawings she included and asked him to contemplate and critique.[80] One magazine introduced an Indiana "Varga Club," in their report on Midwestern "sub-deb clubs" for high school girls.[81] Varga Girls taken from *Esquire*'s centerfolds and calendars were used for home-front War Bond ads aimed at women (imploring them, in a sneaky double-entendre, to give "Something for the Boys") as well as a Varga Girl ad campaign for Jergens cosmetics. In fact, Jergens not only encouraged women to "Be his Pin-up Girl" but did so by associating real-life, Caucasian makeup colors with particular Varga "types"—with signed testimonials by Vargas and packaged in a special compact designed by the artist. The homefront-girl-as-Varga-Girl theme was realized perhaps most vividly in the 1943 film *DuBarry Was a Lady*, in which Vargas's pin-ups came to life during the musical number "I Love an Esquire Girl"—effectively reversing the post-Code trend of hiding real women's sexual audacity through a safely anonymous pin-up by turning these illustrated pin-ups into real, live women.[82]

Through calendars, magazines, and films, the Varga Girl contributed to the growing visibility of the pin-up genre beyond the realm of privileged male viewing, and where it was embraced as part of the consciousness and culture of American women. Even the male appropriation of pin-ups for barracks and bombers—viewed then as now as nearly requisite for the planes—perhaps unwittingly removed the genre further from the realm of privileged male viewing. As the proliferation of popular publications circulated between the battleground and the home front, the pin-up in its new contexts contributed to American women's sense of its possibilities as an icon of their sexual selves. (An interesting example of not only the acceptance of popular pin-up imagery during the period, but the exchange of pin-up imagery from the home front to

soldiers overseas and back is the case of St. Louis Weather Bureau worker Virginia Tredinnick Denmark, who was surprised to begin receiving letters of admiration from an Air Force Weather Squadron in Africa. Apparently, one of the soldiers' mothers had mailed the squadron photographs of home-front women at work published in a local newspaper, which the men subsequently turned into pin-ups.)[83] In a work that unquestionably reflects the home-front understanding and acceptance of the pin-up by the end of World War II, in 1944 Twentieth-Century Fox produced the Betty Grable feature *Pin-Up Girl*. In it, Grable's USO showgirl character, Lorry Jones, contends with the "pressures" of turning all the soldiers she entertains into groveling fools. To boost morale, she hands out her pin-up portrait to soldiers who visit the canteen—a reproduction of Grable's famous, real-life pin-up for Fox Studios that had by then become the number-one promotional photo of any actress during World War II and had propelled the then–bit player to stardom.

In the film's world, the photo does much the same, gaining her a slot in the lineup at Washington, D.C.'s ritzy Club Diplomacy. Lorry Jones eventually adopts a bookish alter ego to escape discovery by her sailor boyfriend at her day job in his office as a Navy stenographer, for fear that he will not love her if he knows she is an ordinary war worker. However, by the end of the film, Grable "transforms" from Lorry Jones into Lorelei Lee before her sailor's eyes, to prove that she can be both "Lorries" at once. She immediately launches into the patriotic closing number, telling an updated tale of "The Merry Widow" (apparently in reference to Franz Lehár's light 1905 opera of the same name) who, like Lorry herself:

Packed her pretties away
Wears a uniform every day
Now the little lady
has no time for dancing
Does her job with great devotion
She's a cinch for big promotion
And they say she does her duties very, very well.

This final song fades into a lengthy, military-influenced finale, where Grable seems to divide herself before our very eyes into an all-woman corps performing drills—and exposing the similarities between military

and Busby Berkeley spectacles—led by Grable herself barking orders in a stern, drill-sergeant style. The message of *Pin-Up Girl* is clear: the World War II pin-up girl is a powerful force, with an overwhelming effect on men that can be channeled toward good or selfish ends, depending on the woman's motives.[84]

In all these World War II constructions of the pin-up ideal, women so represented were almost invariably depicted as sexually aggressive and self-aware, engaging the viewer with a direct gaze that underscored the figure's confidence. Moreover, as women surely knew from their by now decades-long familiarity with the constructed nature of the genre, the pin-up could serve as a vehicle of self-expression and even self-promotion for a contemporary woman. As such, by World War II the pin-up genre would provide a model through which contemporary women on the home front could construct themselves: at once both conventionally feminine and subversively aware of her own power for sexual agency. Like Betty Grable magically reproducing into an entire army of real women of different shapes and sizes, the pin-up morphed and proliferated at what must have surely seemed like an exponential rate. By literally turning themselves into pin-ups through self-portraiture relating not to the exceptional figure of the actress or activist but to the ordinary home-front woman—the workaday gal— they also found a method for supplanting their images (and new identity) overseas in place of the "fantasy" pin-ups appropriated by soldiers.

Say "Cheesecake": Homemade Pin-Ups of Homefront Pleasures

Eventually, as Robert Westbrook notes in his essay on the role of the pin-up in World War II, the genre became popular enough as a mode for home-front women's self-portraiture that homemade pin-ups circulated overseas as widely as published imagery.[85] In his analysis, Westbrook rightfully attests to the fact that pin-ups were part of the national construction of women as "icons of obligation." However, his assertion that women's sexual exhibitionism was part of their patriotic obligation—presenting themselves as "the sort of women their men would be proud to protect"—takes into account neither the talismanic appropria-

tion of pin-ups by male soldiers nor the apparent and subversive pleasure that women seemed to take in their own pin-up imagery.[86] Examples of homemade cheesecake from the World War II era shows women displaying a sense of humor, fun, and creativity that calls into question the uncomfortable "obligatory" origins that Westbrook claims for these images and, in turn, female sexuality of the era. Studying pin-up snapshots from both private and archival collections, one finds that many of these snapshots feature women in dress clothes, posing modestly but with an expression of sass or sentimentality. In one of these (fig. 62a), a young brunette sits on a small stone bridge, smiling happily, seemingly amused over her own audacity at both posing for a cheesecake photo and hiking up her full skirt for the occasion. Like many others, this image is just risqué enough to blur the boundary between portrait and pinup. But the photo's dedication on its reverse, revealing that its intended recipient was "a swell soldier" (fig. 62b), demands that we recognize it as a pin-up. A look at World War II pin-ups from various collections of vernacular photography include similar examples: young women of all shapes and backgrounds posing for the camera with a knowing look, saucy strut, or comical wiggle, in backdrops and activities both conventional and surprising (fig. 63). Many of these are also personalized, inscribed with lines like "Eileen '44," "Mostly Legs," and "Glamour Cut-Ups," and likely intended for display in a footlocker or barracks wall.

Not all homemade pin-ups, however, were destined for a heterosexual male recipient. Like the recruitment pin-up, much home-front cheesecake appears to have been created for the delectation and amusement of exclusively female audiences. Among the pin-up-styled snapshots taken from the back of a 1944 WASP yearbook, for example, one shows a flyer posing in a provocative portrait/parody of the hard-living, trouble-seeking, pistol-packing WASP stereotype. Sitting in a sideways three-quarter pose, wearing a blouse tied up under her breasts and thigh-baring shorts, a petite WASP glares at the viewer through slit eyes and casually fingers a pistol at her side, the cigarette dangling out the side of her mouth completing her menacing expression. This hilarious but undeniably sexy image represents an important moment in the continuum of the pin-up; like Lydia Thompson's self-parody in the form of her Victorian "Girl of the Period," the WASP both mocks and flaunts the trans-

top **62**: Photographer unknown, home-front pin-up, ca.
1944 (Collection of John Low Banning and Low, Ltd.
Kensington, Md.)

63: Photographer unknown, home-front pin-up, ca. 1943
(Collection of Michael Hoffmann and Tracy Floreani)

gressive behavior stereotyping her profession via a carefully constructed photograph. Although highly sexually charged, the image is also a lark, reproduced for the pleasure of her female classmates.[87]

Another example of women dabbling in the pin-up for their own fun and delectation (fig. 64) is found in a collection of snapshots featuring a group of frolicking young women who appear to be picnicking together, taken shortly after the war's end.[88] One of these shows the women gleefully posing in casual summer clothing, lined up and kicking in the style of a chorus. On what is obviously the same excursion, these same women also took a series of more pensive, pin-up style photos of one another at the site (e.g., fig. 65). Whether these photos were intended for each other or male admirers, the "session" proves that the very staging, as well as appreciation, of the pin-up seemed to be a pleasurable part of women's culture by the end of the war—and a genre in which a male audience was not necessarily prerequisite for its creation or circulation. However, if and when these images were destined for the admiration and display of men, they appear to be an extension of the pleasure that women received from exploring and flaunting their sexuality in a public manner.

Despite their impossible proportions, the Varga Girls were part of the dialogue that gave women a language for such sexual self-expression. As fictional icons of female allure and American productivity, upon them could be projected either the image of any woman or ideals of every woman—and women were both comfortable and flattered by the comparison. One audacious female *Esquire* reader went so far as to send a pin-up self-portrait along with a letter to the magazine, inviting readers to compare the day's "flesh and bone competition [to the] Esquire beauties."[89] Her confidence was warranted; as the Varga Girls helped shape the style and popular visibility of the pin-up genre for these amateur female subjects, the era also saw the Varga Girl shaped by her "real" counterparts in the public sphere. The Varga Girl had long associated herself with both the war movement and trends in contemporary female issues and identity. As we've seen, by 1946 the Varga Girls had joined the WAVES, the WAACS, and the War Bond effort. Phil Stack's verse on the September 1942 Varga Girl gatefold, "Miss America," deals point-blank with women's labor, making the claim that as home-front

above **64**: Photographer unknown, group portrait, 1947 (Collection of John Low Banning and Low, Ltd. Kensington, Md.)

65: Photographer unknown, pin-up from above group outing, 1947 (Collection of John Low Banning and Low, Ltd. Kensington, Md.)

women are symbolic of America, so is the Varga Girl a symbol of home-
front women:

> This lovely creation has earned a vacation
> for she is a symbol today
> Of all the career girls, those deadly sincere girls
> who fight for the old USA.
> She's taken dictation with speed and elation
> From men who are running the show
> And gotten out orders that stream from our borders
> to cover poor Adolf with woe.[90]

The Varga Girls' anonymity provided another opening for women as
well as men to identify the pin-ups with real women. As Vargas himself
would explain his popular creation's appeal, "she is a composite picture
of all American girls. Each boy sees in one of my girls a little some-
thing of his own sweetheart back home, so he pins up a Varga girl and
says, 'My girl looks something like that.'"[91] Vargas's obvious (and ironic,
for an Hispanic immigrant) racial generalization of American woman-
hood aside, it is worth pointing out the extent to which many soldiers
did in fact identify the surreal Varga Girl with the very real women in
their lives. One group of soldiers wrote *Esquire* with a story of celebrat-
ing Independence Day overseas by creating a Varga Girl shrine: the men
named a pin-up after each of the battalion's nurses and toasted them
with cake, Chinese vodka, and fireworks—their celebration fashioning
the pin-ups as icons of both America in general and of specific female
camp members.[92] World War II pilot Robert Swanson's commission of a
Varga Girl pin-up on his B-25 (fig. 66) was even more typical in its asso-
ciation of the *Esquire* ladies with real-life women on the home front. Just
weeks after meeting Jerre Vaught in Shreveport, Louisiana, while sta-
tioned at the army training base there, Swanson left for the Mediterra-
nean Theater and took with him a pin-up photo of his new sweetheart.
Signed, "I love you, your 'Paper Doll'" (in reference to the Johnny Black
song of the period, made popular by the Mills Brothers). Vaught's image
complemented the constant letters that the young couple sent back and
forth during a courtship that took place almost entirely by mail. When
time came to select a mascot for his plane, Swanson chose the December
1943 "aviator" Varga Girl popular with many pilots. In honor of Jerre,

66: Robert Swanson and his B-25, "The Paper Doll," 1944 (Courtesy of Robert H. Swanson)

however, Swanson requested that the soldier painting the work turn the blonde Varga Girl into a brunette and named her the "Paper Doll"— effectively transforming the fantasy pin-up into an appropriate stand-in for his real-life love back home.[93]

In examples such as these, we find that the pin-up provided a model through which women could construct themselves as icons of contemporary womanhood—extraordinary in their ordinariness. Through the genre, women were representing themselves as aware of their own power and potential for agency on levels both personal and political. Furthermore, it can be argued that the Varga Girls' modern, self-aware, and ubiquitous performance of female sexuality would seem the perfect stance to emulate for a nation of young women looking to assert their newfound sexual confidence and prowess. The pin-up provided

an outlet through which women might assert that their unconventional sexuality could coexist with conventional ideals of professionalism, patriotism, decency, and desirability—in other words, suggesting that a woman's sexuality could be expressed as part of her whole being. Through pin-up self-portraiture, home-front women also found a method for supplanting their images—and modern identity—overseas in place of the fantasy pin-ups appropriated by American soldiers. Perhaps more important, the feminist drive to shape, express, and represent a new sense of sexual agency was not only realized in these women's interest in and appropriation of the pin-up; the period's images provided later generations with icons representative of this fleeting moment in which such women's freedom to exercise their ability, sexuality, and potential was encouraged by society at large.

6

New Roles and Readings in the Postwar Era

The beloved Leonard Bernstein musical *On the Town*—with stage and film incarnations created during and after World War II, respectively— reflects both the deep ambivalence surrounding the changes in women's professional and personal lives during the war, and how rapidly this ambivalence switched to disdain after the war's end. Hinged as its plot was upon a pin-up girl, it also reflects the ways in which the genre's meanings during these years reflected these same issues. The play on which the film was based—the script and lyrics for both written by the famed team of Betty Comden and Adolph Green—debuted in 1944, inspired by sunnier stereotypes of the World War II sailor on twenty-four-hour shore leave and the exciting, modern young women they could expect to encounter upon their return to the home front. *On the Town's* plot revolves around three sailors from the American South and Midwest—Gabey, Chip, and Ozzie—whose sightseeing tour of New York City turns into a mad search for "Miss Turnstiles for June," Ivy Smith, after Gabey discovers her pin-up plastered around the city's subway system. Miss Turnstiles was based on the real New York transit authority's monthly crowning of a Miss Subways from among the subway's female passengers beginning in May 1941. The gimmick was likely inspired

by the monthly Alberto Vargas calendar girls that *Esquire* debuted with such outrageous success that same year and, as we see in *On the Town*, by 1944 Miss Subways would similarly construct the pin-up as symbolic of the homefront woman's dazzling complexity. Simultaneously homemaker and society girl, scholar and worker, dainty and athletic —descriptions represented in the film by an elaborate dance number in which Ivy performs each contradictory pair in seamless sequence— Gabey dreamily sighs before an image of Miss Turnstiles: "What a girl— she can do *everything*!"

The sailors' pursuit of Ivy sets the first act of *On the Town* in motion, and the ensuing chase leads them to discover the dream girl's real-life counterparts: the fast-talking cabbie Hildy, who volunteers to help the sailors in her own pursuit of the reticent Chip; and the anthropologist Claire, whose path the group crosses in their search of the city's museums. As different as are the working-class Hildy and upper-class Claire, they have much in common: both young women are attractive, but not strikingly so; kind, but not gullible; pursuing traditionally male careers; and clearly comfortable encountering and bantering with men, on equal footing, in the public sphere. This comfort, in fact, leads to one more thing these young women have in common: both are presented and celebrated as very aware of and willing to act upon their own sexual desires. Hildy, for example, spends the bulk of the first act pressing the reluctant Chip to "ditch these guys and come up to my place"—her ardor in the film version underscored by the casting of Frank Sinatra as her object of desire. (Sinatra famously enjoyed similar attention from the scores of female fans who took advantage of the period's sexual openness to express their love for him in a legendarily public manner at his wartime concerts.) While Hildy's job gives her convenient access to such young men, Claire's anthropological studies derive from efforts to get over her own man-chasing by studying them "objectively"—an effort toward chastity we immediately discover is half-hearted as she makes a play for Ozzie. (In the 1949 film version, introduced to Claire in the American Museum of Natural History and having just watched Claire dip Ozzie back into a passionate kiss minutes after their first encounter, Hildy quips: "Dr. Kinsey, I presume?" in witty reference to the landmark publication of Alfred Kinsey's shockingly frank publication on his findings concerning *Sexual Behavior in the Human Male* the year before.)

While both characters' nymphomania is played for laughs, it is also a part of their charm for both the audience and the sailors that they are clearly meant to win over. Like many home-front women, they may be hot to trot, but they are also healthy, savvy, and productive—good girls who are also looking for a good time. The pair spend the bulk of the second act getting the hapless, out-of-town sailors out of trouble in the big city and, once the elusive Ivy Smith is found, shielding their new girlfriend from embarrassment as cracks in the surface of the idealized pin-up girl start to appear.

The gradual crumbling of Ivy's facade, however, reveals the ambivalence beneath the period's propagandistic celebration of "woman-power" in its myriad forms during World War II. While Ivy puts up an admirable fight to present herself to the world as the multitalented superwoman that her pin-ups suggest, we soon discover that New York's sophisticated Miss Turnstiles is, in fact, just another struggling small-town gal—from Gabey's own hometown of Meadowville, Indiana, no less—looking for her big break on the stage while she pays the bills as a cootch dancer—complete with Little Egypt get-up—on Coney Island. On the one hand, as Hildy's and Claire's response to her situation demonstrates, we are meant to sympathize and perhaps even disagree with the fact that Ivy should feel pressured to present herself according to an ideal for fear that the "real girl" will let her pursuer down when she doesn't measure up. On the other hand, in an inversion of the strategy and moral of Betty Grable's *Pin-Up Girl*, Ivy's breakdown upon her full disclosure to the sailors near the film's end, while making clear that her charade was unnecessary—Gabey, of course, only loves her *more* for this new humility—also suggests that the ideal it represented was not just unattainable but, ultimately, undesirable. Indeed, once it is insinuated that, having found her true purpose as Gabey's girl, she give up this crazy career business and return to their beloved Meadowville to await his return, *On the Town*'s once-elusive Miss Turnstiles truly becomes its heroine—discovering not only her destiny, but the meaning of "the duration." Unsurprisingly, when the film was made in the postwar era, it was precisely this aspect of Ivy's folly and this romanticization of her recapitulation that was underscored. While the 1949 film still reveled in the sexual voracity of Hildy and Claire, it couldn't help but make cheap shots at the public lives that led them to come into contact with their

romantic counterparts: after the boys discover that their boyish cabbie Hildy is, indeed, a woman ("He's a girl!"), gobsmacked Chip asks her a question that many postwar men felt entitled to ask women who, like Hildy, refused to develop a case of amnesia about what she had learned of both her potential and her pleasure during World War II: "Whaddya doin' . . .?!? *The war's over!*"[1]

Postwar Repression Begets the Postwar Pin-Up

At the end of the Second World War, and with the return of men from overseas, the home-front climate changed dramatically in terms of national ideals of female identity that had been so thoroughly transformed during wartime. The nation that had rallied feverishly for women to question their traditional stations in the domestic realm during the war soon demanded with equal ferocity that it was now just as much their patriotic duty to return to their homes—and their supposed prewar contentment there—as it had been to rush into the labor force during the war. The concept of "the duration," which had been used in coaxing women into the work force, took on an entirely new meaning as it was now applied to mass layoffs of women to make way for male laborers. The same government that had launched propagandistic efforts to call upon women's patriotic duty to serve the nation as "production soldiers" now used such tactics to return women to the home. Similarly, images of women in popular culture reflected the postwar American interest in idealizing a less aggressive, thoroughly nostalgic construction of the contemporary woman, fit to cultural demands for a return to more conventional gender roles.[2]

Pamela Robertson articulates this rejection of the World War II woman in popular culture as plainly reflective of the larger "backlash against professional women coincident with the return of American GIs after the war and the need to reassert masculine authority in the workplace after the unprecedented wartime employment of women."[3] Thus began the 1950s era of the "eternal virgin" and "dizzy blonde bombshell," in which popular culture reinscribed the ideal female according to nothing short of a Victorian duality: desirable either for her asexuality and domestic potential or for her naive, yet overt, sexuality. As such,

the postwar United States constructed "the ideal American woman as [either] a dependent and happy homemaker . . . [or] sex object, kept childlike by a permanently arrested development."[4] Whether reflected in the Doris Day/Marilyn Monroe binary that dominated Hollywood pin-ups during these years, or the illustrated pin-ups of postwar artists like Art Frahm—who virtually single-handedly invented the postwar "Oops-I-dropped-my-panties!" genre by representing the myriad situations in which modern women's underwear waistband could conceivably snap and send her panties dropping to her ankles in public—women's sexual simplicity, and even humiliation, was suddenly sexy.

At *Esquire*, the shift from the wartime to postwar pin-up reflects such wider trends in American culture. First, the magazine lost the artist whose women personified the transgressive wartime woman on her way out of fashion. *Esquire*'s legal troubles with Vargas had begun at the cusp of the war's end; when the artist attempted to renegotiate his contract with the magazine, he proceeded to lose his job as well as his rights to his name at and work for *Esquire*. As a result of his departure from the magazine in 1947, the transition from the Varga Girl to the Esquire Girl coincidentally occurred in the shift from wartime to the postwar era—making the change in the magazine's pin-ups all the more dramatic in their adherence to postwar ideals of femininity. Fritz Willis, Al Moore, and Joe De Mers were among the new pin-up illustrators who eschewed the working woman and sexual dynamo for the bobby-soxer and cuddly coed. The one career woman represented among these pinups created immediately after the war was chided in the accompanying text to "shake off the phony blessedness of her solitary way in favor of the more savory satisfactions which only come from sharing."[5] As journalist Susan Faludi would later write of this "undeclared war against American women," in the postwar era the independent woman of World War II, who had flaunted her political, social, and sexual agency, was viewed as an outdated construction that "provoked and sustained the antifeminist furor [of the 1950s, and] . . . heightened cultural fantasies of the compliant homebody and playmate."[6] This new playmate that emerged capitalized on both the dearth of openly transgressive female models in the 1950s and the era's willingness to (re)construct women's sexuality in a simplistic, one-dimensional manner.

With the renewed focus on morality and maternity that accompa-

nied many women's postwar retreat to the home—similar to the "cult of true womanhood" among upper- and middle-class women in the Victorian era—came a resurgence of the "ladies club." These groups aimed female activism at societal disruptions of "moral order," under which they felt young women's access to and influence by pin-ups fell.[7] Due to such groups' protests against the display of pin-ups in media viewed by women and children, many popular publications (such as early pin-up pioneers, *Esquire* and *Life*) deemphasized or altogether eliminated their pin-up features in the postwar era.[8] To fill the void left by the disappearance of images of the sexualized female in broader popular culture, former *Esquire* employee Hugh Hefner molded an era-appropriate pin-up—the Playmate—in his new magazine, *Playboy*. Here, Hefner sought to reclaim both the genre and women's sexuality for a privileged male gaze.

Unlike *Esquire*'s cultivation of a female readership in the 1930s and 1940s, from its first issue in 1953, *Playboy*'s founder emphatically stressed the magazine's interest in catering exclusively to a male audience. In the first issue's publisher's statement, articulating the magazine's "philosophy," while Hefner invited the readership of men "between the ages of 18 and 80," he churlishly added: "We want to make it very clear from the start, we aren't a 'family magazine.' If you're somebody's sister, wife or mother-in-law and picked us up by mistake, please pass us along to the man in your life and get back to the *Ladies' Home Companion*."[9] Hefner promised that the magazine would "form a pleasure-primer styled to the masculine taste," and he delivered with articles on politics, sports, and entertainment; pages of party jokes; and photo-spreads and centerfolds of nude models, drawn from what Hefner dubbed his stable of Playmates. *Playboy* Playmates' allure was by design distinct from the aggressive, self-referential sexuality of their World War II prototypes. Instead of idealizing contemporary womanhood as complex and independent, Hefner believed that the Playmate should rather reflect the compliant and accessible "girl next door . . . [with] a 'seduction-is-immanent' look" that addressed not the subject's but the male viewer's sexual desire. In other words, as Russell Miller writes in a biography of Hefner, countering the transgressive nature of the pin-up as constructed and popularized during World War II (and the threat to gender stability that she posed in the postwar era), "the attraction of the Playmate was the

absence of threat. . . . there was nothing to be feared from seducing them."[10] Ironically, in 1959 Hefner succeeded in hiring the man whose very different pin-ups first gave Hefner the inspiration to create his own—Alberto Vargas. However, in keeping with the Playmate template, Vargas's women from his *Playboy* years lost the style, aggression, and the clothes of his *Esquire* pin-ups. Now nude and accompanied by gag-caption one-liners in the style of *Esquire*'s Petty Girls, Vargas's *Playboy* illustrations generally lacked the references to women's culture and clear reverence for his subjects that had made his World War II work subversive. Indeed, in the rare instances that these women directly addressed the viewer, it was usually from an explicit position of sexual and professional subservience—referring to the always-assumed-male viewer as "sir" or "Mister"—that made quite clear that the easy sexuality of *Playboy*'s women was in no way connected to their power or complexity.

However, the *Playboy* "philosophy" involving the cultivation of a space for the sole enjoyment of men did not keep away female readers, nor did it do so in a culture where women were completely satisfied in their roles of "homebody and playmate."[11] The publication of Betty Friedan's *The Feminine Mystique* in 1963 was groundbreaking in its analysis and critique of both the postwar relegation of women to roles of infantilized subservience to men and women's compliance to such a cultural mandate. By the end of the decade, Friedan's voice was one of many instigating a widespread questioning of the submissive postwar ideal, giving rise to what would become feminism's second wave, led by the "Baby Boom" daughters of World War II war brides. Leila Rupp reminds us that the strides made by these women's mothers during World War II had been considerable, even if the changes they enacted "were in a larger sense superficial, because they were meant by the government, and understood by the public, to be temporary."[12] Moreover, the frequently homosocial environs of both the home-front workplace and the military had meant that while the culture at large had actively encouraged the bold new heterosexual romances formed during the war, there were—at first, clandestine, and later, increasingly open—lesbian romances formed during this same period of sexual frankness.[13] After the war, many women longed to find a space to discover and articulate their sexuality; in the margins of repressive postwar America, one

finds that the pin-up continued to inspire women to do so in progres-
sive ways.

<div align="center">

A Tale of Two Betties:

Circumventing the *Feminine Mystique*

</div>

Although the revolutionary changes swept in by the women's libera-
tion movement of the 1960s often read as if they happened overnight,
they in fact came after a quiet but significant period of postwar revolt
and resistance inspired by the growing labor and civil rights movements
of the time. In 1952, for example, journalist Betty Goldstein wrote a
pamphlet titled UE *Fights for Women Workers*, which addressed women's
involvement in the labor union, the United Electrical, Radio and Ma-
chine Workers of America. The pamphlet would be among the earliest
consciousness-raising documents of the burgeoning second wave of the
women's movement, instigating many left-wing women in the United
States to reinvestigate the efforts of earlier women's rights and suffrage
advocates—a search that led many to see the logic in applying similar
strategies to the ongoing gender discrimination that had become par-
ticularly apparent in the postwar years.[14] Eleven years later, published
under her married name, Betty Friedan, Goldstein's *The Feminine Mys-
tique* would break further ground. In it, she analyzed and critiqued the
relegation of women to roles of subservience to men, and women's
widespread compliance to such a cultural mandate, after the end of
World War II. Among the origins of this sea change in male-female
power relations Friedan cited the postwar infantilization of women,
which she argued had begun with men's own during the war. Scarred by
their horrific experiences in battle, she reminded readers: "In the fox-
holes, GI's had pinned up pictures of Betty Grable, but the songs they
asked to hear were lullabies."[15]

As such, Friedan argues that at the war's end "the American spirit fell
into a strange sleep; men as well as women, scared liberals, disillusioned
radicals, conservatives bewildered and frustrated by change—the whole
nation stopped growing up. All of us went back into the warm bright-
ness of home, the way it was when we were children and slept peacefully
upstairs while our parents read, or played bridge in the living room, or

rocked on the front porch in the summer evening in our hometowns."[16] Friedan argued that, desperate for security and eager to return to a nostalgic version of home, hearth, and nation, men and women alike were happy to conform to an imaginary approximation of what life had been before the war. For women this involved the belief in what she dubbed a "feminine mystique," which demanded postwar women be "young and frivolous, almost childlike; fluffy and feminine; passive; gaily content in a world of bedroom and kitchen, sex, babies, and home."[17] With science, society, and pop culture alike all threatening women with a life of unhappiness should they not comply, the "mystique spelled out a choice — love, home, children, or other goals and purposes in life."[18]

In the pin-up genre, we see the mystique played out not only in the emergence of the Playmate, but even in the desperate reconfiguration of prewar pin-up heroines to conform to new standards of femininity. As we have seen, Hollywood pin-up constructions of idealized womanhood since the 1910s had comfortably conflated traditional standards of physical beauty with unconventional elements of intelligence and sexual self-awareness. In the postwar era, these same pluralistic constructions of women (and, incidentally, the women whose star images were formed characterizing them) spelled "box-office poison." Among the greatest victims of this turnaround in female ideals was Joan Crawford, whose star image as a tough, working-class heroine during the Depression and World War II was clearly incompatible with postwar models. Ironically, Crawford's own scrappy reaction to her star's fall was to ambitiously instigate a comeback as a happy homemaker and "bachelor mother" to her two adopted children at the end of the war.[19] Publicity photos of the "real" Joan Crawford tending to the home in 1946 (fig. 67) are every bit as staged as her 1939 "Still Life History" discussed in chapter 5. But rather than openly asserting the pin-up's relevance in "making" her career as she had in the previous pictorial, this time Crawford's agenda was to *covertly* construct a new star image as a homebody in the mold of the young women whose personae abided by the rules of the feminine mystique.[20]

However, historian Joanne Meyerowitz disputes Friedan's sweeping generalization of women's postwar experiences as controlled by the mystique. Introducing a volume of women's "alternative histories" of the 1950s, Meyerowitz argues: "With *The Feminine Mystique*, Friedan

67: Joan Crawford, MGM promotional still, 1946

gave a name and voice to housewives' discontent, but she also homogenized American women and simplified postwar ideology; she reinforced the stereotype that portrayed all postwar women as middle-class, domestic, and suburban, and she caricatured the popular ideology that she said had suppressed them. . . . More generally, it seems, postwar culture was not as inextricably tied to the domestic ideal as Betty Friedan and some historians have implied."[21] This critique appropriately calls into question the limited feminist analyses of popular culture in the postwar era—largely informed by Friedan—that deny the existence of strong, complex constructions of women during this period; analyses which, incidentally, tend to dominate our current understanding of it.

Indeed, Daniel Horowitz's recent biography of Friedan herself bolsters Meyerowitz's analysis. Horowitz reminds us that Friedan was, like many women, a victim of the mystique—a wife and mother of three who, by her own account, had given up a fellowship and jobs for fear of not conforming to period ideals. However, he also reveals the little-known fact that she was during this same period also a labor activist and

freelance journalist whose work openly critiqued male prejudice and discrimination. In other words, Friedan may have created a "persona of the suburban housewife [that] enabled her to talk about alienation and discrimination," but she herself found routes to circumvent the allegedly totalitarian mystique of which she wrote.[22] Similarly, looking at the history of the pin-up genre, the "nonthreatening" postwar pin-up ideal of *Playboy* may have been the period's most visible, imitated, and desirable model of femininity, but constructions of women within and around the genre during this era were not entirely limited to the standard set by the magazine. Meyerowitz's further analysis of the period shows that, while the Playmate constructed for exclusively male viewership was by far the best-known manifestation of the pin-up in the postwar era, constructs of the dominant, sexually self-sufficient pin-up disappeared neither from the genre, nor from the visibility of female audiences.

To a certain extent, Meyerowitz's research on women's views of pin-ups during this era affirms Friedan's findings. The independent and sexual woman, who had been embraced by women and men alike in World War II popular culture, was largely rejected through the renewed "maternalist" identity of many postwar women. Not only had female protests succeeded in removing pin-ups from popular family and literary magazines, but many wrote in to postwar "gentlemen's magazines" to voice their disapproval of the genre's lingering presence on the cultural landscape. However, Meyerowitz also notes that there certainly existed women openly supportive of pin-ups, for whom the imagery served as an arousing and celebratory reflection of their own sexuality.[23] In her analysis of letters to *Playboy* magazine written specifically in reference to its pin-ups, from its first issue in 1953 through the end of 1959, Meyerowitz found that four-fifths of the commentary written by women was in praise of the magazine.[24] While acknowledging that editorial selection of such letters should be taken into account (in perhaps privileging such positive responses), she also notes that the supportive comments revealed poignant insights about the beliefs of women who appreciated pin-up imagery in a culture where men and women alike sought to keep the genre from female audiences.

These letters expressed frustration over the stigma attached to openly sexual women who both posed for and read the magazine; complaints

over the comparatively "whipped-cream pap" of postwar women's magazines; and "pity" for female critics who opposed what the writers felt was the pin-up's celebration of female sexuality. Overall, Meyerowitz concluded that such postwar female pin-up admirers, like *Esquire*'s female readers during World War II, "insisted on their right to appreciate a magazine aimed explicitly at men . . . rejected a double-standard in which men enjoyed sexual titillation while women feigned sexual innocence . . . [and] thereby asserted their right to inclusion in what they saw as sexual fun."[25] It seems, then, that although *Playboy* certainly set the standard for the postwar ideal of the submissive, simplistic pin-up for an exclusive male audience, there remained a very different kind of woman interested in the genre even after their own access to the pin-up diminished.

Indeed, *Playboy* frequently addressed and even celebrated the presence of these women in postwar culture—particularly after Kinsey's follow-up to his study of men's sexuality, his groundbreaking 1953 publication *Sexual Behavior in the Human Female*, contradicting long-held assumptions about women's sexual practices, became widely read.[26] Alas, the magazine regularly drew upon such potentially enlightening ideas in a typically mixed manner—in features as in pin-ups, constructing contemporary women's sexual pleasure and freedoms as reality, but always in the context of how this both affected and should be exploited by men. The 1955 article "Don't Hate Yourself in the Morning" exemplifies this strategy: *Playboy* writer Jules Archer conjures (and, naturally, outrageously oversimplifies) Kinsey's findings with the goal of reassuring male readers confronted with reluctant sexual partners not to "feel like heels if, after a roll in the hay, the woman weeps inconsolably or tragically views herself as damaged beyond repair. The unvarnished truth in most cases is that the lady is willing, but wants to go on record as protesting and regretting."[27] The article concludes in an even more outrageous as well as contradictory manner: with a checklist of reminders for randy young bachelors that, on the one hand, suggest that men finally get over the double standard ("You may have made a non-virgin out of a virgin, but that alone can't make a bum out of an intrinsically nice girl"); but on the other hand reaffirm equally conventional, gendered notions of "proper" sexual roles and self-expression ("when you think that you're seducing her, she's probably seducing you," and "If she be-

comes pregnant, she secretly wanted to in the first place").[28] Yet, in a testament to the intelligence and perception of *Playboy*'s female reader-ship, subsequent issues' "Dear Playboy" letters included smart, satirical complaints against the piece by women who felt that Archer's piece was rife with clichés and generalizations that not only did Kinsey's research a disservice but, in the words of one, quite simply revealed that the au-thor's "knowledge of women is sadly lacking."[29] Such dialogues make clear that while women readers likely found solace in *Playboy*'s willing-ness to address and embrace sexuality with such candor, that this com-fort was undercut by the magazine's tendency to frame this sexuality in the same casual misogyny that bred the very repression against which *Playboy* alleged to fight.

But even as *Playboy* and its imitators dominated the pin-up genre in American popular culture of the postwar era, images of the confident, sexually aggressive female popularized during the Second World War flourished in counterculture "specialty" pin-up publications. Among these specialties were *Focus*, *Fantastique*, *High Heels*, and the now legend-ary *Bizarre* magazine. Founded in 1946 by writer, photographer, and illustrator John "Willie" Coutts, the magazine was targeted at both male and female audiences interested in what one writer dubbed "socially ac-ceptable masochism."[30] *Bizarre*'s primary focus was the representation of sexually dominant women—or "dominatrixes"—in the sadomasoch-istic tradition, but updated in the image of World War II glamour pin-ups. In fact, the magazine often reproduced vintage promotional studio pin-ups of the 1940s alongside its contemporary s-m imagery. Many of the magazine's original photographs were of Coutts's wife, Holly Anna Faram, herself a leather and bondage enthusiast. In the early years of the magazine, Coutts also served as its primary illustra-tor. His Vargas-inspired pin-ups had outrageous figures in tight-laced fetish gear. (Considering the surreal proportions and brazen sexuality of the Varga Girls, it should come as no surprise that they themselves were often the subjects of such fetish fantasies. A World War II–era Vargas cal-endar in the Kinsey Institute collection shows how one Vargas fan, likely a soldier, painstakingly modified the women's fashions to include fetish boots and chains.) Whereas Hefner asserted, "*Playboy* is not interested in the mysterious, difficult woman, the femme fatale, who wears elegant underwear, with lace" (adding that such women are "sad, and somehow

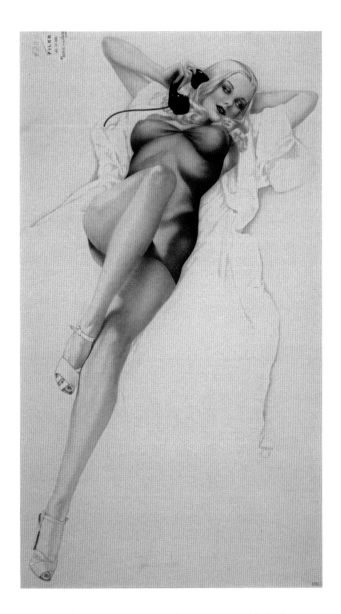

Plate 1: Alberto Vargas, watercolor painting published as
the first Esquire "Varga Girl," October 1940 centerfold
(The Spencer Museum of Art, The University of Kansas,
gift of Esquire, Inc.)

Plate 2: Notebook cover with MGM promotional pin-up of Greta Garbo, ca. 1933 (Collection of the author)

below **Plate 3**: Notebook cover with MGM promotional pin-up of Gary Cooper, ca. 1933 (Collection of the author)

Plate 4: Pauline Boty, *It's a Man's World I*, 1963
(Courtesy of Pauline Boty Estate/Whitford Fine Art)

Plate 5: Pauline Boty, *It's a Man's World II*, 1963–65
(Courtesy of Pauline Boty Estate/Whitford Fine Art)

Plate 6: Cindy Sherman, *Untitled #93*, 1981
(Courtesy of the artist and Metro Pictures)

Plate 7: August 2003 pin-up from *J. D.'s Lesbian Calendar* (Photo: Cass Bird)

Plate 8: Lisa Yuskavage, *Day*, 1999–2000
(Courtesy of Marianne Boesky Gallery)

Plate 9: Lisa Yuskavage, *Night*, 1999–2000
(Courtesy of Marianne Boesky Gallery)

mentally filthy"), *Bizarre* countered Playmates' wholesomeness and accessibility by idealizing the commanding and sexually aggressive (read: "difficult") woman in its pin-ups.[31]

While *Bizarre*'s circulation, among the largest of such specialty magazines, was limited to 5,000 copies per issue, the specialty genre to which it belonged launched the careers of Coutts as well as New York photographers Irving and Paula Klaw. By the early 1950s, the pin-ups of this brother-and-sister team were crossing over from such specialty magazines into the mainstream, published in widely circulated publications where the photos were reproduced as well as advertised, with sets sold by the thousands to individual purchasers. The Klaws' dominatrix themes were of particular interest to publisher Robert Harrison, whose enormously popular men's magazines—such as *Wink, Titter, Beauty Parade*, and *Eyeful*—pointedly offered an alternative to Hefner's Playmates in their presentation of what writer Gay Talese dubbed "high-heeled heroines with whips and frowning faces . . . offering punishment for pleasure."[32]

While the Klaws deserve credit for generally promoting the sexually aggressive pin-up in the postwar era, they are today far more famous for launching the career of pin-up model Bettie Page, among the first women to gain national renown for her work in the genre alone. In the early 1950s, Page had posed as a dominatrix figure in fetish magazines such as *Bizarre* (fig. 68), starred in what is today generally referred to as bondage-and-domination (B-D) pin-ups and film loops made in the Klaws' Movie Star News studio, and served as a regular model for pin-up features in Harrison's publications. However, Page just as frequently posed in more traditional "cheesecake" garb and comical situations, and even as the submissive "bottom" in the Klaws' (always all-female and fully-clothed) mock S-M scenes—but with the same self-possessed, melodramatic flair that she brought to her dominatrix sessions. Page's unique style gained such crossover popularity among pin-up aficionados in the 1950s that by 1955, Page was hailed on national television as "Miss Pin-Up Girl of the World," had magazines dedicated solely to her pin-ups, and, with a now-legendary photograph taken by female pin-up photographer Bunny Yeager, landed the year's Christmas centerfold in *Playboy*.[33] (Hugh Hefner apparently found the model's unique style powerful enough to not only waive the all-unknowns policy he

above **68**: Bettie
Page on the cover
of *Bizarre* magazine
no. 14, 1954

69: Irving and
Paula Klaw, Bettie
Page photograph,
Movie Star News,
ca. 1954

initiated after the magazine's first centerfold—a vintage '40s Marilyn Monroe nude—but also suppress his stated distaste for the "difficult" woman.)[34]

However, Page's most relevant contribution to the pin-up genre was not her successful crossover appeal as a dominating woman in the era of the demure Playmate. Her brazen, over-the-top poses and pointedly lighthearted approach to performing as a pin-up served to expose the very construction of the genre, revealing both its artificiality and performative nature, as well as its potential as an expressive medium for the woman so represented. A great performer as well as a great beauty, Page's pin-up celebrity came from her ability to shift gears within a spectrum of extreme sexual roles. Her B-D photographs for the Klaws are excellent cases in point. Unlike much B-D imagery, and the culture in general—where certain individuals gain reputations as either "tops" or "bottoms"—we find Page switch-hitting, alternating between delivering and receiving the blows from session to session. In each case, however, she takes on the role with hammy gusto—whether wincing with pain and indignation as the paddled party, or snarling with cartoonish rage as the paddler. Even in the Klaws' more extreme, intricately constructed bondage scenarios, Page's participation and performativity shine through as she manages absolutely comical body language through ominous looking binding and ball-gags (fig. 69).[35] Not only does such imagery expose the control and playfulness that Page exerted in her pinups, to this day such imagery is held up by many S-M and B-D practitioners as exemplary of their belief in role-playing and consent.

In her popularity and her successful oscillation between vamp and virgin, Page helped maintain the presence of the complex, pluralistic pinup in an era that vigorously sought to use the genre to communicate far more binary—and therefore stable—constructions of female sexuality. At once a celebration and parody of the genre itself, Page's destabilization of the pin-up throughout her brief but unbelievably prolific career would later provide one of the most imitated models for feminist appropriations of the genre.[36] Her visibility and popularity as a transgressive alternative to the pointedly nonthreatening Playmate was instrumental in the pin-up genre's breaking from the postwar Playmate archetype in the following decades.

Black Beauty vs. Miss Fine Brown Frame:
Politicizing the Pin-Up in *Ebony* Magazine

One needn't comb through underground "girlie magazines" to find pro-
gressive models of female sexuality not only represented but analyzed in
1950s popular culture. With the rise of the civil rights movement after
the end of World War II, popular magazines like *Ebony* published pin-up
imagery that openly addressed the political potential of the sexualized
woman when constructed specifically to present thoughtful alternatives
to the status quo. As feminist intellectuals like Friedan took stock of the
reversal of women's fortunes in the years after their accumulated suc-
cesses had led to a postwar backlash, African Americans analyzed their
related situation. The black community's protestation of the discrimi-
nation that it felt immediately after World War II would be addressed by
the Truman Committee on Civil Rights appointed in 1946, instigating
a dialogue between community organizations and the government that
gave way to civil rights legislation over the next two decades.[37] Because
the civil rights movement was fueled by a range of activists from the
grass roots to the upper echelons of American politics, much like the
women's liberation movement that it would inspire, progressives within
the movement looked to popular culture as both a perpetuator of nega-
tive messages and a possible tool against the same. It was with this sen-
sibility that *Ebony* magazine, modeled after *Life*, was founded in 1945.

From *Ebony*'s first issue—significantly, hitting the newsstands just
months after V-Day—publisher John H. Johnson made clear his intent
for the magazine to serve as a popular alternative to the more estab-
lished and literary magazine he had founded three years earlier, *Negro
Digest*. In its inaugural publisher's statement, *Ebony* informed its readers:
"You can get all hot and bothered about the race question (and don't
think we don't) but not enough is said about all the swell things we
Negroes can do and accomplish. *Ebony* will try to mirror the happier
side of Negro life—the positive, everyday achievements from Harlem
to Hollywood."[38] As regularly addressed in the magazine's features, this
upbeat approach was born of the same professional progress for black
Americans that women had enjoyed through their participation in both
the Works Progress Administration (wPA) and the war effort. But *Ebony*

associate editor Allan Morrison—formerly the sole black writer on the staff of the military journal *Stars and Stripes*—conceded how quickly these hopes were dashed when he wrote in 1947: "Few if any of the colored heroes expected to find a completely new America when they came back to their homes. . . . But the majority had hopes that things would be better, that there would be more opportunities for their people and less hate in the land. To a man they admit such hopes were premature."[39] When not only was the promise of the war effort denied, but the progress that led to it actually reversed, *Ebony* immediately became comfortable tempering its celebration of the successes of the black community with protests concerning the limitations that often kept its members from achieving their full potential.[40]

Considering the contributions of both African American men and women to activism since the abolitionist movement, it is unsurprising that *Ebony* focused upon the stories of both sexes; indeed, many of its early stories have a decidedly feminist tone because of precisely this history. In its first decade of publication the magazine celebrated working black women from doctors to dancers, lawyers to "lady boxers."[41] In these features *Ebony*'s writers carefully and clearly addressed sex as well as race discrimination, noting that even black professional women of the upper classes find "sex [a] bigger barrier than color" and bond with white women who "get a taste of what being colored is like" when they enter traditionally male professions.[42] Indeed, in one feature on "Women Leaders" in black history, the magazine lauds "Negro women [who] have been in the forefront of agitation throughout the country for women's rights . . . [and] struck telling blows for feminism, but reminded white women that 'free and equal' should include Negroes, too."[43] Even women's postwar return to the home was analyzed and politicized by *Ebony* editors, who argued for black women's interest in homemaking as a choice they earned when they demonstrated their abilities alongside men and white women working outside of domestic service during World War II—in the words of the magazine, effectively empowering African American women to say "Goodbye Mammy, Hello Mom." Comparing the comfortable postwar suburban lives of white GIs' families with hardworking yet still struggling black families, its editors argue: "Nobody wants to tie a woman to her hearthstone with hackneyed phrases and ideas about where her place is. But every family

should be able to live on the income of one breadwinner. And every woman should be able to choose whether she wants to devote her days to her children and her home or to a career girl's job."[44]

Considering *Ebony*'s enlightened postwar approach to sex in its pages, its enlightened approach to sexuality is perhaps unsurprising—indeed, from its earliest issues the magazine demonstrates a striking interest in analyzing and politicizing sexuality in ways that not only reflect its larger aims but also look forward to feminist strategies in the 1960s. For example, taking stock of developments since the war's end in the photo essay "One Year after V-Day," *Ebony*'s editors outline not only the professional and political "successes and defeats" of African Americans, but the romantic ones as well, when it remembers August 11, 1945 as the day "when white sailors kissed Negro girls in packed downtown New York and got caught in the act by *Pix* photog Jacob Lotman."[45] We find a similar effort to draw upon the leveling quality of romance and beauty clearly articulated in its publisher's statement of May 1946:

> Beauty is skin-deep—and that goes for brown as well as white skin. You'd never think it, though, to look at the billboards, magazines, and pinup posters of America. Cheesecake (photographers' jive talk for sex-appeal pictures) is all white. But the Petty girl notwithstanding, Negro girls are beautiful too. And despite the fact that Miss America contests hand out "for whites only" signs, there are thousands of Negro girls lovely enough to compete with the best of white American pulchritude.[46]

The desire to prove this point would lead to *Ebony*'s use of female pin-up imagery from its inaugural issue—including illustrated pin-ups by African American *Esquire* artist E. Simms Campbell—and a pin-up on the cover of its second (fig. 70). Indeed, because of the new presence and appreciation of non-Anglo actresses during the Great Depression and World War II—during which time actresses like Anna May Wong and Dolores del Rio, as well as African American performers like Josephine Baker and Lena Horne, became as admired for their pin-ups as their films—black pin-up girls were frequently championed in the magazine's pages as noteworthy success stories. While the magazine's pin-up subjects tended to be entertainers—such as the groundbreaking Horne (the first African American actor to obtain a long-term studio contract in Hollywood, and the subject of *Ebony*'s first full-color

70: Hilda Simms on the cover of *Ebony* no. 2, December 1945

cover) and jazz musicians such as Hazel Smith and Dorothy Donegan — the magazine also went out of its way to feature glamorous, sexualized imagery of black women from a range of backgrounds and professions. Dress designer Marva Louis, teenaged piano prodigy Philippa Schuyler, and Barbara Gonzales, the first black graduate of Sarah Lawrence College, typify the range of featured pin-up subjects from the early years of *Ebony*, out to prove "Negro pulchritude ranks high despite lily white standards."[47] Indeed, its pictorial on Gonzales, "Glamour Is Global," essentially demythologizes not only white beauty but the genre itself by hiring a pin-up photographer to shoot this exceptional unknown specifically to demonstrate that, when applied "to a naturally beautiful Negro girl, the glamour process produces results no less appealing and exotic than when the subject is white. Photographically the same effect is created — the end result being a sexually-attractive, tastefully-cosmetized young lady whose curves and features are calculated to quicken the pulse and heighten the desire of a normal male."[48]

Letters in subsequent months not only thank *Ebony* for publishing pin-ups to offer to those who "need proof that Negroes can be pin-up girls as well as men with letters after their names," but offer suggestions for and even homemade pin-ups of other "Black Beauties" to include in future issues.[49]

But *Ebony*'s pin-up features—again, like the magazine's broader tone—weren't simply celebratory. Indeed, particularly when involving subjects from the field of entertainment, many were careful to temper its celebratory aim with a sense of the subjects' struggles. While we have seen this strategy in action in fanzine pin-ups since at least the Depression, in the case of *Ebony*'s postwar pin-ups, it is used less to bring the star "closer" to readers by sharing in their problems so much as to instill a sense of outrage in the readers over the limits with which even the black community's greatest success stories must live. *Ebony*'s first pin-up cover girl, stage actress Hilda Simms, is a case in point. The accompanying feature goes out of its way—in a manner similar to early fanzines' constructions of the actress—to reveal that, although she is a handsome actress known for playing earthy, sexy roles, Simms is in real life "a well-read, intellectual young lady with a coming novel up her sleeve" whose "New York home is lined with books and interesting art pieces which she collects."[50] However, the feature's focus on her success on Broadway in the groundbreaking, all-black drama *Anna Lucasta* concludes with the magazine's piece "'*Anna*' Cast Draws High Profits, Gets Low Wages," which notes that in addition to the dearth of dignified roles for them, the "sepia stars" of even this enlightened Broadway hit earned lower wages than their white counterparts.[51]

In the feature accompanying its first cover of Lena Horne, *Ebony* proudly informs readers that the "thousands of requests that come to Metro-Goldwyn-Mayer for her pictures are by no means confined to Negro men. . . . Her photos can be found plastered up on barracks walls and company messes the world around."[52] Horne is also photographed on the MGM lot pointedly interacting with both her white colleagues and African American workers on the set—all of whom are introduced by name and occupation. But *Ebony* is sure to include Horne's recounting of a Jim Crow incident during the war in which Horne was refused service by a white waitress in an airport on her way to a southern USO performance, after which the waitress's son ran out from washing dishes

in the kitchen to ask the actress to autograph the menu—underscoring the indignities that even the country's most successful black actor must suffer in an undeniably racist world. Indeed, in its history of the recently closed Cotton Club's "chorines," while the feature juxtaposes period pin-ups of its female performers with contemporary images of these same women at work in new jobs that range from artists' models to dental technicians, *Ebony* also uses the club's history to underscore the ways in which the black community itself had internalized the racism with which it lived by reminding readers that until 1932 the club hired only women whose complexions were "nothing darker than a light olive tint."[53]

However, the very political awareness with which *Ebony*'s staff contextualized its pin-ups reflected an equally aware readership with a plethora of different ideas about the propriety of sexuality as a subject of black activism. No sooner than letters celebrating *Ebony*'s pin-ups started pouring in did criticism of the same begin, both subtly and overtly politicized, ranging from complaints about editors' choices of light-skinned women for its cover to concerns about what one reader called the "prideless" practice of promoting the magazine with the bodies of "almost naked" black women.[54] This dialogue would play out both in the magazine's letters section and in subsequent issues' pin-up features, such as that accompanying the daring cover of dancer (and former WPA writer) Katherine Dunham who, while stating that "she dislikes leg-shots like *Ebony*'s cover [of her] this month," asserts inside the magazine: "The only thing sexy about my [dance] reviews are the dirty minds of those customers who come to seek sex."[55] Even the magazine's discussion of the science of African American sexuality was debated by its readership after, in its December 1948 issue, *Ebony* published the story of a young black woman who participated in what would become Kinsey's 1953 study of women's sexuality; for months afterward the magazine's editors aired complaints and kudos from readers over its airing of the subject.[56]

But by far the most heated dialogue over the proper expression of sexuality in this forum emerged from a puff piece on the winner of a promotional stunt in the form of a "Miss Fine Brown Frame" beauty contest in 1947. The nationwide contest—inspired by a hit song by the Buddy Johnson Orchestra—yielded a winner in the "frame" of Evelyn

Sanders, whom the magazine celebrated as the "darkest girl in the contest," chosen by the audience after protesting the judges' choice of a "light-skinned Dixie belle." While the magazine published the story as an example of everyday activism—with the contest audience letting the "judging board know that, for once, white standards of beauty would not be forced upon them"—for months readers wrote in with their objections to what they found to be the objectification of black womanhood in the both the contest and the article's accompanying pin-ups of the winner.[57] Typical of the pro-pin-up writers was the reader asserting that the "poses of Miss Fine Brown Frame are wonderful examples of the flower of Negro womanhood." Another writer conjured a spiritual defense of such images: "There is beauty in all the handiwork of God, and it shows a lack of intelligence for the creatures to be ashamed of the work of the Creator."[58] Yet another asked "Why can't we have the body beautiful when we have beautiful bodies to display just as our white brothers do," only to answer his own question: "Until we can forget that old pride and shame that has been instilled in us, we will always have dissenters."[59]

But dissent many readers did, finding it "unfortunate that the girl placed so little value on her body as to allow it to be displayed in such a manner and photographed from angles which were calculated to appeal to those craving sexual excitement."[60] As another writer noted, when such imagery could conceivably bolster "the impression many people have of Negroes as morally inferior," *Ebony* tread a dangerous line in its inclusion of pin-ups.[61] More typically, another reader noted the hypocrisy of the magazine's pointed refusal to publish ads for racist novelty gifts and liquor ads as part of its larger political aims in light of its willingness to publish revealing photographs of its women. ("I for one would rather look at a raw whiskey ad than the expose of Miss Fine Brown Frame's buttocks!") The sentiment of the letter's author, Daphne A. Grigsby, was summarized in a telling manner: "Why copy all of the vices of the white man? Or has virtue become extinct for the Negro also?"[62]

While *Ebony* would continue to publish pin-ups in its pages—and readers would continue to voice both their support of and disdain for the same—the "Miss Fine Brown Frame" debacle illuminates the contours of arguments concerning the problematic nature of positing sexual

expression as an activist statement—one that would dog not only the postwar civil rights movement but also the women's liberation movement on the horizon.

<div align="center">

Avant-Garde and Kitsch:

The Pin-Up, the Art World, and the Swinging '60s

</div>

In the postwar subculture of gallery arts, the pin-up was an equally contentious icon. Those interested in radically redefining postwar models of both art and gender leveled new challenges at each, challenges in which popular imagery like the pin-up became politically charged in this subculture in much the same way as it would in black activist culture. By the end of World War II, the work of critic Clement Greenberg had unquestionably established the paradigms of early-twentieth-century modernism, as well as the formalist ideals against which postwar artists would begin to rebel in the late 1950s. In his 1939 essay "Avant-Garde and Kitsch," Greenberg sought to defend a theory of superior contemporary art that promoted works rejecting the sentimental or propagandistic qualities of popular culture—antiprogressive qualities that threatened to corrupt avant-garde art, reflecting and even leading to political totalitarianism.[63] His criticism after 1945 had become inseparable from his defense of artists working in New York in the 1940s and 1950s— dubbed the New York School, or Abstract Expressionists—in whose work Greenberg located a logical, superior formal lineage of art through the work of Manet to Cézanne to the Cubists. He thus tracked the history of modernist art from Paris across the ocean to the United States. In the United States, Greenberg argued, modernist developments were allowed to expand without the strong, corrupting influence of European-based dada and surrealism—each of which Greenberg felt possessed an impulse toward narrative and figuration that essentially represented a devolution in his paradigm of modernism's development.[64] Greenberg synthesized and expanded his paradigms of avant-garde art in the 1961 essay "Modernist Painting." Here, he constructed a history of painting from the Renaissance to the 1950s. In this history he posited abstract expressionist painting as the latest progression in a continuum of "genuine" modernist art that Greenberg purported began with Edouard

Manet's break from realism and the impressionists' subsequent search for a self-critical process of art production.[65]

Interestingly enough, Greenberg's "Modernist Painting" was written precisely at a point in which new art developments had formed to pose challenges to his unquestionable continuum of art history's "natural" development. By the time the essay was published, artists such as Robert Rauschenberg and Jasper Johns had applied their education in abstract expressionism toward works that little resembled Greenberg's model of its purely visual essence; Andy Warhol and the British Independent Group were creating works that directly appropriated the kitschy pop-cultural icons against which Greenberg defined art itself; and artists' collectives such as the Judson Dance Theatre, Fluxus, and the Situationist International mixed and merged art media and performance with flagrant disregard for Greenberg's paradigms. His theory of a linear and elite history of art—or "mainstream"—would be rejected by these artists in favor of an altogether different mainstream: one that, like progressives in the civil rights movement, looked to common rather than elite culture for inspiration.

Sally Banes argues that at this time such artists looked to pop culture and the human body—inseparable from the period's ideas of common culture—as logical antidotes to modernism's Cartesian, antifigurative, and cerebral ideals of art. In her study of the body's relevance to this emerging generation of avant-garde artists, Banes contends:

> The confidence of post–World War II America created an intrepid social body in the Sixties. It also created an oppositional avant-garde, proposing even more outrageous bodies, reveling in an increased somatic consciousness of the here and now. . . . The body in the Fifties and early Sixties mainstream culture was almost always controlled and covered up. . . . The avant-garde arts produced a new image—unruly, festively promiscuous, candid, and confident—that by the late Sixties had become the cultural norm.[66]

This avant-garde did not believe in a philosophical split between the mind and body but rather theorized the potential of what Banes calls an "effervescent" and intelligent body. Within an artistic community that had frequently denigrated women precisely because of their historical association with the physical and sensual, a new space was suddenly created for women to participate beyond that of the previous

generation, where women generally had been viewed "as an appendage to the male intellectual or artist."[67] As articulated recently by historian David Allyn, female participation in these "happenings" also reflected the ideal of "participatory democracy" for which many such performances, and those who instigated them, stood.[68] Although they generally participated in a manner traditionally viewed as "feminine"—as dancers, actors, or choreographers—women like Yvonne Rainer and Carolee Schneemann were given room to present themselves not simply as bodily, but as *thinking* bodies. Banes notes that Rainer's highly disciplined, modernist-inspired choreography would be spiked with "strippers' bump-and-grind routines" and the assumption of "erotic poses from Indian temple sculpture."[69] In Schneemann's 1968 *Naked Action Lecture*, literally performing the title, the artist posited the possibility of conflating the roles of artist and art historian, performer and intellectual into the role of "art istorian." Directly addressing the period's desire to abolish hierarchies between the mind and body, male and female, past and present, art and life, she asked her audience, "Can an artist be an art istorian? Can an art istorian be a naked woman? Does a woman have intellectual authority? Can she have public authority while naked and speaking?"[70] Naturally, each question was answered through the commanding performance itself. In presenting works and raising issues like these, women were viewed as significant contributors to the art, performances, and happenings that were becoming increasingly important to the creative communities from which the pop art movement would emerge.

That these women's work would shift from the margins to an increasingly central role in avant-garde art practice should not be surprising considering the value that their generation placed on the media and genres of so-called low culture—readymades and reproductions, spectacle and burlesque—as an alternative to modernism's sense of Art-with-a-capital-A. Contrary to the aesthetic and moral values that Greenberg had previously placed on a masculine, artistic elite and its specialized audience, in the 1960s artists placed great faith in the value of folk and popular arts as a means of communicating beyond an elite community and letting the "real" world back into the art world. Banes articulates the artists' feeling that if "folk art's material is daily life, then the everyday objects of the [artist's] urban village were said to consti-

tute a new landscape—made of the objects of commercial consumer culture—to recycle."[71] With a twin interest in the physical and the marginal, avant-garde circles in the 1960s allowed women and their work to slowly gain headway. In this environment, the pin-up—feminine, physical, and marginalized—rose not simply as a popular icon, but as a symbol rife with meaning and ready for recycling in the contemporary art world.

One could argue that—like much of its work derived from popular imagery and objects—the avant-garde's embrace of the pin-up in the postwar era had origins in the very quirks of the dada and surrealist movements of the early twentieth century that Greenberg found so problematic. In a 1972 study of the pin-up's history and relevance to pop, Thomas Hess noted that the pin-up's easy availability as a puzzle piece for the increasingly popular collage medium had resulted in its earliest appropriation by these artists in the late 1910s and 1920s.[72] As discussed in previous chapters, by the start of the twentieth century the pin-up—particularly the cinematic pin-up—represented the last word in contemporary fashion and femininity. Interested in nothing so much as the madness of modernity, the pin-up had often been appropriated by both dada and surrealist artists as an antidote to the classicized nudes that linked even Pablo Picasso's female forms to the past. Hannah Höch's dada collage "portraits" of young women, such as *Beautiful Girl* and her lesbian tribute to Dietrich's star image in *Marlene*, manipulated pin-up imagery cut from popular magazines into works that present a range of feminist meanings: from critiquing pop culture's destructive commodification of femininity in the former to lauding its celebration of sexual subversives in the latter.[73] In a more literal use of the genre, Man Ray's 1933 photograph of surrealist artist Meret Oppenheim, *Erotique-voilée* (fig. 71), depicts Oppenheim nude and assuming a pin-up's position of dreamy repose, but smeared with ink and at work on a printing press—layering "veils" of intelligence, action, and activity atop the blatant eroticism of her body. Even gender is layered upon the body here, as the eye follows her slim, feminine form down to the suggestively placed printing-press handle that jarringly adds a prosthetic "penis" to the artist's body. Reproduced—like a perverse Gibson or Petty Girl—in the surrealist magazine *Minotaure*, one might say that Oppenheim was in fact the first true pin-up of the avant-garde.[74]

71: Man Ray, *Erotique Voilée*, 1933 (© 2005 Man Ray Trust/Artists Rights Society [ARS], New York/ ADAGP, Paris)

But, as Hess argues, the popular pin-up had by the end of the 1950s become increasingly pornographic, and as "the cultural underpinnings of the image gave way and almost overnight, it seems in retrospect, the pinup was no longer a living icon, but a bit of memorabilia—a vestige from the past." In light of the era's growing interest in addressing sexuality as a natural, as opposed to perverse element of human existence—inspired, in no small part, by Kinsey's postwar research—the genre evolved to construct female sexuality in a less covert and artificial manner than it had traditionally. Moreover, in this age of sexual repression, publishers recognized the loophole couching provocative imagery in scientific or journalistic pretexts provided them, and they increasingly began creating and selling pin-ups under such guises—giving way to the "nudist," "physique," and "artist's studies" magazines of the postwar era.[75] In their attempts to cater to these various demands for "naturalism" in sexual imagery, mainstream pin-up publications began showing pubic hair and even provocative "action" poses in their pin-

up imagery, and by the early 1970s, newer magazines like *Penthouse* and *Hustler* pointedly did away with all airbrushing and "touch-up" work on its photographic pin-ups.[76]

However, with these efforts to naturalize pin-up sexuality came a trend toward what Mark Gabor breaks down to "more shedding, more spreading" in the genre.[77] Crossing the line—in legal as well as formal definition—between what constitutes pin-up versus pornography, in this era of the pin-up's evolution the genre's meanings became increasingly problematic. On the one hand, the pin-up increasingly signified what it always had to those who a generation earlier had tried the Varga Girl on obscenity charges: the shamelessness and vulgarity of the desiring woman. On the other hand, as mainstream cheesecake magazines became increasingly daring in the amount of "pink" they showed, traditionally constructed pin-ups in the style of Hollywood portraiture and the Varga Girl—defined as much by what she kept on as what she took off—came be viewed as a nostalgic relic of another, more innocent but more glamorous era. However, whether the pin-up was viewed as a sleazy modern *vagina dentate* or an innocent reminder of femininity past, as we will see in the work of pop artists, by the 1960s all pin-ups would have one common association in the minds of an increasingly media-conscious and savvy public: their relationship to modern commerce.

David McCarthy's recent writing on the pin-up genre asserts that it was only during this time, and with this twin nostalgic and commercial significance, that the pin-up would gain enough currency as an icon that pop artists could begin appropriating the genre as such. Ironically, the pin-up had to become ubiquitous to the point of invisibility, and then supplanted by ever more explicit versions of itself, before the avant-garde and youth culture could once again imbue the genre with modern meaning. However, once appropriated as a symbol of the "effervescent" female body postwar artists sought to reclaim, the pin-up for this generation would, McCarthy contends, serve to openly "unite several highly charged issues, such as nationalism, consumerism, and the body in a fashion that made them both easily understandable and seductively engaging. . . . Identified with mass culture, implicated in advertising, and associated with contemporary American sexuality, the pinup was a ready-made art form that carried considerable social freight."[78] Additionally, as international pop artists began a project of "American-

izing" both art and the female nude, painting women in the vernacular pin-up tradition served as a simultaneous imitation and repudiation of the classical nude—underscoring the uneasy fact that, as Independent Group artist Richard Hamilton put it: "It is the *Playboy* 'Playmate of the month' pull-out pin-up which provides us with the closest contemporary equivalent of the odalisque in painting."[79] Of course, both the figurative and narrative appeal of the genre—which had not been lost on Greenberg, who had listed "calendar girls" among other objects of scorn in "Avant-Garde and Kitsch"—surely made the pin-ups all the more interesting to young artists seeking to escape from the formal and conceptual limitations of Greenbergian modernism. To Robert Rosenblum, artists' appropriation of the pin-up in this period represented nothing less than a "new kind of insolent vulgarity that might thoroughly dispose of the lofty moral pretensions and ivory-tower elitism of so much New York painting of the '50s."[80]

Perhaps because they came to the modern American genre as fascinated outsiders, European artists seemed particularly aware of the pin-up's power in commerce and culture alike. Indeed, French film critic Andre Bazin's 1946 essay "Entomology of the Pin-Up" represented the first critical treatment of the genre in the context of the Americanization of postwar European culture: "Rapidly perfected, like the jeep, among those things specifically stipulated for modern American military sociology, she is a perfectly harmonized product of given racial, geographic, social, and religious influences. . . . Sprung from the accidental sociological situation of the war, it is nothing more than chewing gum for the imagination. Manufactured on the assembly line, standardized by Varga, sterilized by censorship."[81] Considering this sophisticated understanding of her exotic appeal, it should be perhaps unsurprising that European artists were the first in the larger pop movement to begin to appropriate the genre in their work. Independent Group artist Eduardo Paolozzi began utilizing pin-ups as early as 1947, where the pin-up girl was put to use as symbolic of the American culture that had infiltrated Europe while the country rose to prominence as European nations picked up the pieces after World War II. As shown in works like Paolozzi's *I Was a Rich Man's Plaything*, the pin-up had the sheen of excess and exoticism. Here, an illustrated pin-up, taken directly from the American pulp tabloid for which she was designed, is displayed along-

side racy headlines that include the piece's title. The tabloid-style cover is collaged atop an English poster graphic celebrating U.S. bombers stationed there during the war, as well as remnants of an ad for the ultimate American import—Coca-Cola.[82]

In works like these, we see how quickly after World War II's end the pin-up's association with American power and prosperity led her to appear to Europeans, in Hess's estimation, as "an otherworldly figure—unusually dangerous or attractive."[83] The pin-up also seemed particularly connected to youth culture, a symbol of postwar youths' fixation on American culture as a way of articulating their difference from their parents' "old world" values. The pin-up was an extension of the big cars, B movies, and rock-and-roll that inspired movements like art's *nouveau realisme* and cinema's French and Italian new waves. Nowhere is this fact more apparent (or hilarious) than in Federico Fellini's 1962 contribution to the short film collection *Boccaccio 70*, titled *The Temptation of Dr. Antonio*. In it, an eight-story-high Anita Ekberg steps out of a sexy pin-up billboard—appropriately enough for the busty Ekberg, advertising milk (fig. 72)—to terrorize a government censor, the puritanical Dr. Antonio, who has tried to use his influence to remove the offensive ad from his neighborhood. The pin-up—lounging gracefully in the midst of oppressive, concrete apartment blocks in the then-fashionable "brutalist" style of modernist architect Le Corbusier—is clearly set up as a luscious, powerful foil to the barren, imposing urban environs in which she is placed. Apparently fed up by the war waged against her by the bureaucrat, the pin-up comes to life and—in the manner of King Kong, or the antagonist of the 1958 B movie *Attack of the 50 Foot Woman*—kidnaps the tiny Dr. Antonio. Clutching him to her chest while he beats at her enormous breasts in protest, she carries him around Rome like a naughty infant until he admits defeat. As in many of Fellini's films, the all-powerful young woman is contrasted with the impotence of the moralistic old man, but presented here in a fantastic, cartoonish fashion for which the exaggerated and playful nature of the pin-up is perfectly suited.[84]

Meantime, Robert Rauschenberg was among the first postwar artists in America to appropriate the pin-up in his work, incorporating a cheesecake photo of a peroxide blonde into an untitled "combine" painting of 1955. The work was created as a companion piece to Rausch-

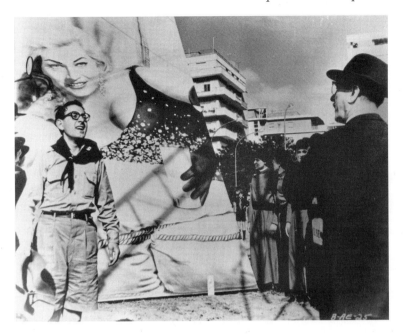

72: Still from Federico Fellini's *Temptation of Dr. Antonio*, 1962
(Courtesy British Film Institute)

enberg's better-known *Odalisque* begun that same year. The two share
both female pin-up photographs and imagery of roosters, meant to re-
spectively allude to the female and male sexes in a comical updating of
the subject-audience relationship inherent in the art historical odalisque
tradition.[85] Considering his interest at this time in visually juxtaposing
the popular, the political, and the avant-garde in his combines, the pin-
up's appearance as a frequent character in these vast cultural mosaics is no
surprise. Nor is its appearance in the work of Andy Warhol, for whom
the image of the pin-up took on an almost religious iconicity. His *Gold
Marilyn* of 1962 floats like a Byzantine Madonna on a backdrop of shin-
ing metallic paint, and his enormous *Elvis* paintings from the following
year underscore the ways in which the rock-and-roll idol's pin-ups both
deified and feminized the singer as an object of teenage (and, in Warhol's
case, queer) worship and lust.

But Tom Wesselmann and Mel Ramos are perhaps the most renowned
pin-up painters of American pop, and their respective oeuvres consist

of little outside of female nudes posed in the style of this vernacular tradition. Yet, although their oeuvres are often lumped together for this fact, the differences in their work and use of the pin-up are striking. In fact, their work reminds us of how, in the hands of pop artists, subtleties in appropriation of similar imagery may yield surprisingly different results. Wesselmann's *Great American Nude* series, begun in 1961, painted highly reduced, flattened pin-up silhouettes into painted and collaged interiors. The faceless figures in his works are no more human than the still lifes at their bedside or posters on their walls. As McCarthy points out in his analysis of Wesselmann's *Great American Nude #26*, "Like the cake and Coca-Cola, the Great American Nude is sweet, easily available, quickly consumed, and just as quickly disposed of."[86] Interestingly, however, as the series wore on what would seem to be a critique of the pin-up-as-commodity would be revealed as something quite different as the nudes evolved into ever more artful (but no less heatedly sexual) abstractions. In these later works, as her presence is exposed as a mere trope for Wesselmann's formal experimentation, the pin-up's role as an object seems tied not to her commodification in culture at large, but to her inhumanity in the artist's own eyes. At first glance, Wesselmann's pin-ups seem a humorous protest, but delving into the series makes disturbingly clear how unaware the artist seemed of the joke.

Ironically, Mel Ramos's pin-ups of the same period use commercial and art clichés with such subtle inversions of what is depicted—and with such a seemingly straight face—that in many cases they underscore the power of female sexuality to transcend the marketing purposes it is put toward. Ramos's pin-ups evolved out of a series of "superhero" paintings, in which the artist invented superheroines such as *Roma: Empress of the Ancient World* and *Fantomah: Daughter of the Pharaohs*, as female counterparts to his renditions of real comic-book heroes such as Batman, the Phantom, and the Flash. Combining the naturalistic draftsmanship of popular illustration with the sensuous painterly effects of his professor and California pop contemporary Wayne Thiebaud, Ramos's pin-ups seemed daring and dangerous as well as seductive. Stepping out from the confines of their cover-art templates, his figures seemed more real and far more important than the cookie-cutter stories one imagined they might accompany. Even in the comical canvases of his later career, his juxtaposition of pin-up nudes and larger-than-life logos from

the advertising world (fig. 73) are similarly jarring for their interest in putting the pin-up (literally and figuratively) *before* the product, effectively reminding the viewer which of the two is the true source of power drawn upon to make the sale.

But it arguably took the British pop artist Pauline Boty to make clear the real-life danger that contemporary women's sexuality posed, in her painting *Scandal 63*. Boty was a painter, actor, and activist associated with the Independent Group and herself something of a pin-up for London's avant-garde. This particular painting centered around a portrait of her London contemporary Christine Keeler: a beautiful, young, working-class woman whose affairs with English Tory party leaders (as well as a Soviet naval attaché) exposed not only a sex ring within the conservative party, but acts of international espionage, in a debacle that would become known as the Profumo Affair.[87] Nude save for a strategically placed Arne Jacobson chair (a pose appropriated from a popular photograph of Keeler by Lewis Morley), she seems to size up the viewer from beneath several unflattering mug shots of the men she helped bring down. Unlike the pathetic or disgraceful character described by many journalists, Boty's image of Keeler presents not a dizzy street urchin lured by powerful men into a life of debauchery but, as McCarthy notes, a sharp and ambitious woman "coolly surveying anyone confident enough to meet her gaze."[88] Boty's work served as a subtle reminder of the surprising realms in which the sexualized woman exerted a powerful influence in contemporary culture. Painting the piece in the same year that the scandal broke, Boty was surely among many young English women who reveled in the daily reports of Keeler's turning the tables on hypocritical figures of patriarchal authority and class oppression.

But, this treatment of the pin-up as an erotic tormentor also had a dark side in the popular imagination of the period. Antonio Saura's imaginative 1959 portrait of Brigitte Bardot (fig. 74) gives us a sense of the fear and violence with which even bohemian circles often met the forcefully sexual woman emerging in this period. Having exploded on the international scene three years earlier via her lusty performance in . . . *And God Created Woman*, Bardot immediately became emblematic of the moody, free-living woman associated with arty countercultural groups from the Greenwich Village avant-garde to the French New Wave. The popularity of her voracious, even dangerous sexu-

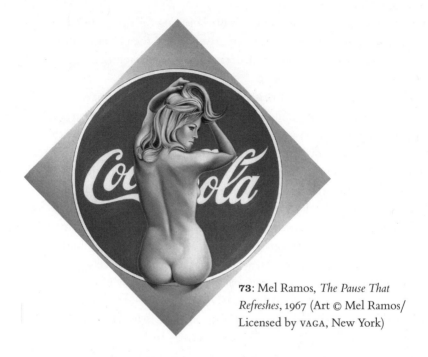

73: Mel Ramos, *The Pause That Refreshes*, 1967 (Art © Mel Ramos/ Licensed by VAGA, New York)

74: Antonio Saura, *Brigitte Bardot*, 1959 (Collection of Juan March Foundation, © 2005 Artists' Rights Society [ARS], New York/ADAGP, Paris)

ality heralded what would become the triumph of such postwar rebels against the Doris/Marilyn binary; in the 1960s, Bardot's success would inspire an entire generation of imitators, from Catherine Deneuve to Jane Fonda. Like many works in the portrait series from which it comes, Saura's *Brigitte Bardot* is clearly indebted to Willem de Kooning's then-new *Woman* series. But unlike de Kooning's comparatively sweet handling of the quintessential postwar pin-up, Marilyn Monroe—all smiles, colorful curves, and windblown locks—Saura's nearly nine-foot, grisaille torso of Bardot is the murderous, shrieking doppelganger of Fellini's playful giantess. Saura's Bardot reveals an anxiety about a new kind of woman—complex, tempestuous, unruly—who appeared to be taking over feminine ideals recently dominated by Friedan's mystique. Saura was right to be concerned: bombshell Bardot was a very small sample of changes on the horizon as the youth culture she represented became increasingly politicized, and women demanded their freedom to interpret as well as create . . . woman.

7

OUR BODIES/OURSELVES

Pin-Ups in the Wake of Women's Liberation

In the 1960s and 1970s, the pressure building on the lid that had been placed on women's progress in the postwar era exploded as women in unprecedented numbers began questioning their limited roles in society. As such, the pin-up genre in these decades would embody the changing ideals of womanhood that such discourse brought about.[1] As Richard Kallan and Robert Brooks note in their analysis of pin-up imagery in the 1960s and 1970s: "Society increased the premium it placed on certain values—notably, the virtues of individuality and political activism," and the identity of the pin-up followed suit.[2] Eventually, Hollywood films of the period—such as *Kitten with a Whip, Bonnie and Clyde*, and *Barbarella*—spawned pin-up stars that drew upon the dangerous, unpredictable, and even villainous allure of American actresses like Ann-Margret, Faye Dunaway, and Jane Fonda (herself an antiwar and feminist activist offscreen), whose appeal reflected that of European predecessors like Brigitte Bardot.[3] The Billboard charts reflected this new feminine ideal, as sassy pop hits like Nancy Sinatra's "These Boots Are Made for Walkin'" and Aretha Franklin's "R-E-S-P-E-C-T" topped the music charts. Even the small screen had its own version of the tough,

independent heroine in television's *The Avengers*. The show's sexy female lead, Emma Peel (played by British actress Dame Diana Rigg), not only fought crime in the same skin-tight leather dominatrix gear fetishized in "underground" pin-ups but did so as a weapons, intelligence, and martial arts specialist.[4] Significantly, as fashion historian Valerie Steele points out in her analysis of such 1960s heroines, the commercial world was forced to recognize that "the image of a woman who is both strong and sexy obviously appeals to many women (as well as men)."[5] These pin-ups' appeal to both sexes allowed such idealized images of the aggressive, sexually dominant woman in popular culture to once again cross over into the realm of female visibility and acceptance in ways that had gone out of fashion in the 1950s.

Such gradual challenging of the postwar, Playmate-styled pin-up would even lead to changes in *Playboy* itself. As Kallan and Brooks noted, with the political and cultural changes of the 1960s came a shift in what it was that even the "girl next door" celebrated by the magazine would come to represent in the United States. Thus, they argue, "If the Playmate were still to symbolize the all-American ideal, her personality would need to adapt accordingly."[6] In the 1960s, the individuality of each Playmate—outlined in the self-penned "Playmate profiles" that accompanied the magazine's monthly feature centerfold—was not only stressed but constructed so as to underscore the women's involvement with a politically active "new generation" of women. In this period, *Playboy* actually led the way among pin-up publications by integrating women of different races in its pages. After more than a decade of exclusively white pin-ups, in 1964 the magazine included its first Asian Playmate, actress China Lee, and the following year Jennifer Jackson became *Playboy*'s first African American pin-up—even illustrator Alberto Vargas concocted fantasy pin-ups of different races than the Anglo Amazons for which he was renowned. As activism became status quo in the 1960s, the magazine kept up with the cultural trend by featuring Playmates who expressed interests in the counterculture, social reform, and civil rights issues. Granted, *Playboy* molded these activist statements to suit the all-important pleasure and comfort of its male audience. Exemplifying the extremes to which the magazine would go to temper the jagged edges of activist women is a particularly disturbing caption

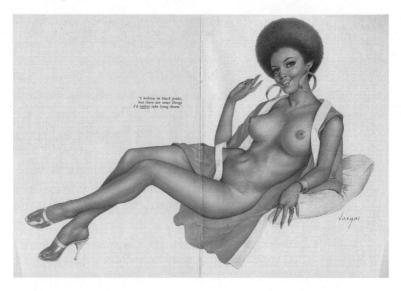

75: Alberto Vargas, September 1970 *Playboy* centerfold

accompanying an otherwise gorgeous, 1970 Vargas pin-up (fig. 75) — in the mold of no less a radical beauty than Angela Y. Davis, at that moment wanted by the FBI — which states, "I believe in black pride, but there are some things I'd *rather* take lying down."[7]

However, up-and-coming pin-up magazines aimed at younger, hipper audiences — such as the newly founded "swing scene" magazine *Penthouse* — occasionally drew upon the dangerous political appeal of not just countercultural activism in general, but feminism in particular by focusing on and giving voice to women from the burgeoning "women's liberation" movement. *Penthouse* occasionally featured "Pets" like 1971 pin-up (and philosophy student) Josee Troyat — posed naked except for a bullet-studded, leather artillery belt in her featured centerfold — who asserts in her profile: "Liberation for women is what I am doing now — posing like this for *Penthouse*. It would have never been possible in my mother's youth. She would have been condemned rather than admired, for showing off all her beauty."[8] Although naive at best — particularly in an era of far more explicitly politicized outlets for activism — Troyat's view of her own feminist infiltration of the pin-up genre demonstrates how we will find the genre evolve in the 1960s and 1970s to visually

represent women's growing desire to celebrate and politicize their own sexuality.

Troyat's conflation of the women's movement and sexual freedom is reflective of another large cultural trend that feminism's evolution in the period helped inspire: the sexual revolution. As Alison Assiter and Avedon Carol noted in their analysis of the relationship between the two:

> If there was one thing that saved [feminism], it was that sexuality as a whole, both in its more "respectable" forms and in the vernacular, had entered the public discourse to such an extent that, for the first time in modern history, women had access to its imagery and its language. . . . As people became used to the idea of women participating in that problematic area of discussion, we were more and more often permitted to be true contributors to the lore of sexuality.[9]

As women gained access to the pin-up genre in the 1970s—in the midst of both increased public permissiveness of open sexual discourse and feminism's challenge to sexual double standards for women—its potential as a tool through which women could express a sense of sexual freedom and aggression became more explicit than in the past.

In response to increased demand from heterosexual women's interest in sexual imagery, *Cosmopolitan* magazine published its first male nude pin-up in 1972—entirely selling out the issue—and in the same year Playboy Enterprises published its first issue of *Playgirl*. Simultaneously, as we have seen, women working within artists' communities became increasingly interested in establishing a feminine voice in their artwork—a voice that would eventually evolve to become a feminist voice. For all these reasons, many feminist artists would look for inspiration to pop-cultural conventions of representing women's sexuality in order to explore what Lucy Lippard would call the "subtle abyss that separates men's use of women for sexual titillation from women's use of women to expose that insult."[10] As this heady time ushered in the sexual revolution of the 1970s, many women would not only explore but call into question the limits of their own sexual freedom: in particular, to what extent such "freedoms"—and their reflections in visual culture—could perhaps be oppressive in a society still dominated by patriarchal systems.

Scrutinizing Sex in the Women's Liberation Movement

The women's liberation movement—responsible for instigating a "second wave" of feminism in Western culture after the post–World War II lull in gender activism—emerged out of the labor, civil rights, and antiwar movements of the postwar era. In each of these movements, the tremendous numbers of participating women found opportunities both to apply themselves to fulfilling work outside of the professional sphere in which they had been discouraged from fully participating and also to learn about and fight against the very systems of oppression that had brought about this situation in the first place. Participating in groups such as the Student Nonviolent Coordinating Committee (SNCC) and the Students for a Democratic Society (SDS), American women of different races and classes learned to recognize discrimination and gradually awakened to the sense that they themselves were discriminated against—as much within the activist communities they served as without.[11] Not surprisingly, women's sexuality and sexual desirability were drawn upon constantly as both resources for the movement and easy methods of brushing off their intellectual contributions. Civil rights activist Stokely Carmichael's infamous 1964 statement on women's role in the movement—"The position of women in SNCC is prone"—was a cruel comment on how many women had felt their contributions were ignored and their sexual submission expected by male activists of all stripes.[12] Relating her own experience of the SNCC in this era, lesbian author and activist Amber Hollibaugh wrote: "Part of the 'new world' we were building was men and women together; you were free with your body unrepressed—basically you had to sleep with anyone who asked you. Otherwise, you were called frigid, peculiar, or got kicked out of the movement."[13] Reflecting the counterculture's patriarchal, dismissive attitude toward the role of women in general and feminism in particular was a 1967 cartoon (fig. 76) in the SDS newspaper *New Left Notes*, published next to the statements and demands of the Women's Liberation Workshop from that year's group conference.[14] The cartoon's open mockery of one of the earliest period efforts to organize women as an oppressed group reflected a much larger problem of the period's leftist politics: men's unwillingness to recognize the hypocrisy of male domi-

We want our
Rights
&
We want them
NOW!

WLF

76: Antifeminist cartoon
from *New Left Notes*, 1967

nance in activist groups that sought to end inequality and war.[15] With such lack of support from their male counterparts, and the inspiration of earlier feminist publications like Friedan's *Feminine Mystique*, many became interested in reevaluating notions of feminist identity proposed by earlier feminist thinkers. "Slowly," Hollibaugh wrote, "many women, leftists and socialists, came to the realization that we had to leave the Left to create a women's movement."[16]

Identifying their activism as a "second wave" of feminism—which, in turn, not only named but allowed them to simultaneously associate with and dissociate themselves from the sprawling "first wave" that preceded them—this generation of women who rose in the late 1960s and early 1970s would tangle in a highly intellectual fashion with the many issues that feminist writing and activism had brought to light in previous decades, as well as add ideas unique to their own generation.[17] Among such issues, the analysis and protest of sexism in visual culture was of the utmost importance. Published in her 1974 study of misogyny in pornography, *Woman Hating*, Andrea Dworkin's "Beauty Hurts" diagram exemplifies the anger expressed and agitprop strategies used by many radical feminists, for whom popular images of the sexualized female represented a constant, painful reminder of women's sexual oppression. The image breaks down the sexualized female body by way of the containment, adornment, and manipulation imposed upon it in the name

of heterosexual desirability.[18] The stylized woman—whose resemblance to a shooting gallery human "target" underscores her victimhood— is effectively reduced to nothing more than the total of her painfully primped physical parts.[19] By the 1970s, such views of the pin-up were hardly in the minority: even *Playboy* pin-up photographer Bunny Yeager reflected upon the era with distaste:

> Glamour photography was more explicit than ever. . . . I found it distaste-
> ful to compete any more to please this out-of-control market. Photos of
> women in men's magazines were not longer beautiful for me to look at. I
> didn't want to do that kind of photography. It was demeaning to women.
> The loveliness of a woman's body was gone and in its place was a type of cold
> clinical photography that only concentrated on the female sexual organs.[20]

Such perspectives would lead to feminist discourse through which the historical oppression of women could be viewed as simultaneously re-flected in and enforced by such images. Among the earliest and most in-fluential of these analyses was Laura Mulvey's 1975 essay "Visual Pleasure and Narrative Cinema." In it, Mulvey used a Freudian, psychoanalytical reading of films from Hollywood's "golden age" to locate the systems through which women are "fetishized" and therefore "objectified" in narrative cinema. She proposed that a destructive "male gaze" is assumed by both male and (through what Mulvey calls "psychic transvestism") female viewers of such films. By a simultaneous physical distance from the objects on the screen and imaginative identification with the male hero, these viewers participate in the objectification of the film's female characters, whose sexuality becomes a spectacle. Mulvey's theories on the male gaze reflected and bolstered John Berger's relatively contem-porary, Marxist art-historical analysis of female imagery. Berger's *Ways of Seeing* had recently proposed that patriarchal Western culture had in-extricably bound the act of "seeing" to male privilege and the image of women to passive scrutiny; or, as simplified by Berger, "men act and women appear." In this economy of vision, "A woman must continu-ally watch herself. . . . From earliest childhood she has been taught and persuaded to survey herself continually. And so she comes to consider the surveyed and surveyor within her as the two constituent yet always distinct elements of her identity as a woman."[21]

Mulvey's Freudian approach to this view, as it could be applied to certain narrative structures of cinema, became highly influential among feminist thinkers beyond its original application. For many, the principle of the active male gaze perpetually at work on images of women became a method through which feminists could uncover systems of oppression in the popular imagery through which both men and women define their own identities.[22] Amid the questions raised by such theories about representations of women, the most widely criticized imagery became that which emphasized female sexuality. When placed upon openly sexualized representations of women, the ubiquitous male gaze rendered the possibility of sexual imagery to assert the "subjectivity" of women so represented not only problematic, but practically impossible.

As such, it should not be surprising that much feminist art reflecting this theory treated traditional media and genres that depicted female sexuality with critical retorts, or pointedly eliminated the female body altogether. Such perspectives also came to dominate second-wave feminist theory and activism as the decade wore on, and would later become identified as part of the larger program of what was called "cultural feminism"—a philosophy equating women's liberation with the development of a female counterculture to supersede the dominant patriarchal culture.[23] Dworkin began what in the 1980s would become a highly influential theory of pornography wherein the "sexually explicit subordination of women through pictures and/or words" constituted both a criminal act of rape and an infringement of women's civil rights.[24] Her work reflected that of fellow radical feminists like the Cell 16 collective and Ti-Grace Atkinson, who debated whether sex acts (heterosexual, lesbian, and otherwise) in a culture that demanded the compulsory sexual compliance of women formed the foundation of women's oppression.[25] Later women's collectives such as Women Against Pornography put such philosophies into action, presenting multimedia performances and lectures in which pin-up images from men's magazines and popular advertising were presented and deconstructed from a new, antiporn feminist perspective that demonstrated the manner in which such imagery served to subjugate women to men's sexual desires.[26]

In the wake of the popular feminist movement and, later, gaze theory, women's gallery arts of the 1960s and 1970s find the pin-up often ap-

propriated toward similar ends. As Eleanor Antin would later say of this period of awakening: "Suddenly pop didn't look so friendly anymore."[27] Interestingly, the pop artist Pauline Boty anticipated this perspective in her work the same year as her celebratory view of the pin-up in *Scandal 63*. Begun in 1963—the same year that *The Feminine Mystique* debuted—Boty's diptych *It's a Man's World* (plates 4 and 5) pointedly depicts the pin-up as iconic not of women's sexual revenge, but of women's sexual subservience. The first panel juxtaposes portraits of male heroes from the twentieth century as a mosaic against a backdrop of Renaissance palaces and fighter jets. From Vladimir Lenin and Jack Kennedy to Mohammed Ali and the Beatles, Boty depicts a range of men whose identities combine strength, intellect, creativity, wisdom, and romance. (The only woman who infiltrates this masculine landscape is the blur of an adoring, Chanel-bedecked Jackie Kennedy, who accompanies JFK in their doomed Dallas motorcade.) The second panel presents a contrasting image of women's worth meant to underscore the relative dearth of similar roles for women in the culture created by their male counterparts. Centrally balanced by a standing female form cropped above the neck and below the knees, this painting's feminine mosaic presents a group of nameless pin-up nudes, obviously derived from men's magazines such as *Playboy*. Superimposing these portraits atop a tranquil landscape, the work underscores women's historical associations with "nature" rather than the realm of "culture" so obviously dominated by the men in the first panel. Illustrating Mulvey's and Berger's concepts before the fact, the work also asserts that in the "man's world" of the title, women are valued (and encouraged to value themselves) solely for the sexual pleasure men derive from their beauty and bodies. A radically different look at contemporary female sexuality than *Scandal 63*, the diptych bookends the spectrum of meanings that it would possess in works throughout Boty's short life.[28] As Helena Reckitt has argued, Boty's work often explored how the " 'permissiveness' of the swinging '60s scene, in which Boty was a fashionable figure, offered the promise that bodily pleasure could be liberating. These paintings[, however,] are a critical portrayal of the spaces of male power which continued to ensure that this promise was denied."[29]

Mixed Messages: Feminist Artists
Interpret and Represent Feminist Sexuality

The different meanings of such works also look forward to an equally large spectrum of feminist artworks that would succeed them. On the one hand, the women's liberation movement questioned conventional beauty standards, patriarchal notions of sexual health, and even women's ability to explore and enjoy sexuality in a world where gender inequalities not only proliferated in society but were often internalized by women themselves. On the other hand, it also instigated the publication of books like *Our Bodies, Ourselves* and Anne Koedt's and Dr. Betty Dodson's respective research on female orgasm and masturbation, in which feminists asserted that sexual liberation could not be separated from the struggle for women's liberation.[30] Jane Gallop explained her own "double transformation" during this period: "The disaffected, romantic, passive young woman I had been gained access simultaneously to real learning and to an active sexuality. One achievement cannot be separated from the other. . . . Feminism made me feel sexy and smart; feminism felt smart and sexy."[31] Ann Snitow felt much the same, writing of her early years in women's liberation, "Oppressed and depressed before the movement; I found sexual power unthinkable, the privilege of a very few women. Now angry and awake, I felt for the first time what the active eroticism of men might be like."[32] Ellen Willis offered her own view on why she associated feminist politics with feminist sexuality, stating: "I was angry because I'd always been rejected by men for being too smart, too intelligent. I *wanted* to be a sex object."[33] Developing alongside women's liberation was also the safety and accessibility of oral contraceptives; the Food and Drug Association's approval of Enovid in 1960 steadily increased women's access to the Pill, giving them unprecedented freedoms from unwanted pregnancy should they choose to experiment sexually.[34] As Deirdre English recalled: "The sexism was there, but women were actually having more sexual experience of different kinds and enjoying it. Women were having more sex that was not procreational, and claiming the right to it as well as paying a lower social and emotional cost."[35] For these women, the sexual revolution that

followed women's liberation opened up new freedoms for feminists to not only critique but also enjoy their sex lives.

Crucial texts from the earliest years of the movement bear this out. Kate Millet's 1970 book *Sexual Politics* may have taken male-penned erotica to task for its sexism, but she also called for "a fully realized sexual revolution . . . [to] end traditional sexual inhibitions and taboos . . . [as well as] the negative aura with which sexual activity has generally been surrounded." She continued, "The goal of revolution would be a permissive single standard of sexual freedom, and one uncorrupted by the crass and exploitative economic bases of traditional sexual alliances."[36] That same year, Shulamith Firestone's *The Dialectic of Sex* asserted that "in our new [feminist] society, humanity could finally revert to its natural polymorphous sexuality—all forms of sexuality would be allowed and indulged."[37] Erica Jong's writing, most notably her best-selling 1973 novel *Fear of Flying*, attempted to represent this feminist ideal. The book offered women the concept of the "zipless fuck" and presented an outrageous and smart sexual subject who was also a desirable sexual object, seeking pleasure for its own sake and on her own terms, and seeking out male partners turned on by the prospect of such a new heroine.[38] Jong's Isadora Wing was "a thinking woman who also had a sexual life," and her creation proved popular enough that the book sold 6 million copies in the United States alone.[39] Susan Rubin Suleiman would later praise Jong's work for its radical "reversal of roles *and* of language, in which the docile or bestial but always silent, objectified woman of male pornographic fiction suddenly usurps both the pornographer's language and his way of looking at the opposite sex."[40]

Other feminists made their desire to be seen as a sexual being known by participating in sex radical collectives. A notable example is Germaine Greer, whose 1971 book *The Female Eunuch* was one of the first feminist bestsellers. Greer organized the Sexual Egalitarian and Libertarian Fraternity (SELF) and edited and contributed to the eponymous magazines of the Oz and Suck collectives, which espoused and lived a philosophy of sexual and intellectual libertinism. The appropriation and manipulation of a postwar pin-up in the style of illustrator Peter Driben (fig. 77) for a cover of *Oz* magazine—turning a typical 1950s naïf into a vibrator-toting, blunt-smoking feminist who (as per Greer's advice in *The Female Eunuch*) appears to have been recently inspecting

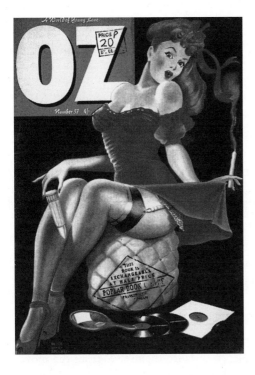

77: Pin-Up cover of
Oz magazine no. 37,
September 1971

her own genitalia in the mirror at her feet—gives one a sense of both
the pop art and women's lib strategies that the group employed. Greer
herself even posed as a funky feminist pin-up for *Suck*—although the
issue in which the image appeared would instigate the beginning of
the end of her association with the group: Greer protested that there
were no comparable images of male contributors in what had been
proposed as a pictorial of the entire editorial collective.[41] Even Andrea
Dworkin, in *Woman Hating*, discussed collective magazines such as *Oz*
and *Suck* as reflective of "our own [counterculture's] turned-on, liber-
ated time and space," with feminist value despite their frequently overt
sexism. Singling out Greer's contributions, Dworkin celebrated "her at-
tempt to bring women into closer touch with unaltered female sexu-
ality and place that sexuality clearly, unapologetically, within the realm
of humanity: women, not as objects, but as human beings, truly a revo-
lutionary concept."[42] These many and varied perspectives on the repre-
sentation of female sexuality would emerge as women negotiated the
truths among these positions and strove toward the creation of a new,

feminist language of sexual desire. But where, then, would old dialects be salvaged or destroyed as this new vocabulary was built? And who would determine its rules of grammar?

One strategy frequently applied in this resurgence of feminist activism is that of a radical break from the past, which would reflect the boundless sense of freedom for which participants like Phyllis Chesler felt the movement was fighting: "Like the goddess Athena, newly hatched from her father Zeus's brow, we, too, wanted to experience ourselves as motherless daughters. . . . When we stepped out onto the stage of history, we did so primarily as motherless daughters/sisters/sibling rivals. Psychologically, we committed matricide," rejecting the postwar construct of motherhood in the form of the women who raised the young women leading the movement—mothers viewed simultaneously as victims and perpetuators of the "feminine mystique"—to reinvent themselves as radicals within the new women's movement.[43] In the rush toward reinvention, as Astrid Henry recently argued in her history of feminism's intergenerational tensions, many of these women would reject not only their biological mothers, but their philosophical mothers as well.[44] Eager, for example, to distance themselves from the movement's liberal origins in Friedan's 1963 *The Feminine Mystique*, radical North American feminists not only broke away from Friedan's National Organization for Women (NOW) to found their own groups, but began documenting their own groups' activities in a conscious effort to revise the in-progress history of the women's liberation movement: hence publications such as Firestone's and Koedt's anthology *Notes from the First Year*, published in 1968, and followed by three subsequent "years" in an effort to assert that *their* timeline tracked the movement's "growth accurately, [and would] in time become a historical record."[45] However, even this effort at rehistoricizing the movement acknowledged historical predecessors—indeed, the *Notes* anthologies tracked the lineage of their project to first-wave documents like Elizabeth Cady Stanton's and Susan B. Anthony's *Revolution*—even as it cherry-picked them from the first wave rather than their predecessors in the second. As Henry notes, "while feminists of the late 1960s stressed the importance of affiliating with feminists of the past, it was only by disconnecting themselves from women in their immediate present—their older feminist contemporaries, such as Friedan, as well as their mothers and their mothers'

generation of women—that they were able to construct their identification with feminism."[46] Regardless, this effort to recuperate the individuals and ideas of the past as legacy for them to draw upon helped the women's liberation movement to not only define themselves but to view themselves as part of feminism's historical continuum.

In much the same way that many women sought to reclaim women's histories (or "herstories") in the name of feminism, so too would many artists seek to reclaim the representation of women. Inspired, too, by the fierceness and unflinching attitudes of writers like Jong and Greer, many women found the reclamation of their bodies and sexuality a liberating act. As such, many feminist artists began creating works with what art historian Joanna Frueh has dubbed a "cunt-positive" attitude—often with a literal focus on women's genitalia.[47] This interest in reclaiming the cunt often had a dual purpose. First, in art's history the elimination of female genitalia has often been viewed as the one basic quality that allowed the female nude to distinguish itself from pornography—or, at the very least, distinguished the "naked" from the "nude."[48] This fact proved an enticing challenge to many women, for whom vaginal imagery represented a radical grenade to launch at the art world. Second, vaginal imagery provided a literal reminder of the one shared quality—or "essence"—that bound all women together.

Judy Chicago's term for work focusing on the cunt, "central-core imagery," reminds us of this unifying, feminist spin that often accompanied explicit body art of the period. Chicago's *Pasadena Lifesavers* series of 1969–1970 would evolve into ever more explicit drawings and paintings, culminating in the "central-core" ceramic plates that festooned the table of her monumental 1979 work *The Dinner Party*. Her students in the Fresno State College Feminist Art Program were also inspired by the concept of cunt positivity and created works ranging from Faith Wilding's delicate *Flesh Petals* to the creation of a hilarious *Cunt Cheerleader* squad. In Europe, the performance artist Valie Export prowled the aisles of porno theaters in a pair of crotchless blue jeans (which she dubbed "Action Pants") while wielding a fake Uzi, tormenting their all-male audiences in a 1969 piece called *Genital Panic*. Carolee Schneemann's 1975 performance *Interior Space* presented the artist reading a protest poem she had penned from a ten-foot scroll: a delicately folded document that she slowly unraveled from within her vagina as she read. That same

year, Kate Millett offered feminist "erotica" in the form of spectacular, close-up photographs of women's genitalia, cheekily reproduced in the stereoscopic manner of Victorian pornography. In light of such radical, defiant expressions of feminist sexuality, is it any wonder that the primped and powdered pin-up seemed tame by comparison?

However, for a few feminist artists in these heady days, the pin-up maintained an untarnished, if subtle edge carried with her since the earliest days of the genre. Unlike the more explicit body art of the period, the pin-up was still deemed "suitable for display." As pop artists had proven, its ubiquity made subtle, politicized appropriations all the more radical when they entered mass culture beneath the radar that monitored and censored transgressive messages. Also, unlike the "essentialism" that cunt art suggested united women, the pin-up's sense of control and masquerade instead suggested something quite different. Borrowing from the 1949 text of a frequently claimed first-wave predecessor, Simone de Beauvoir, the idea that "one is not born, but rather becomes, a woman," many women's art in feminism's second wave would seek to explore not the essence but the *construction* of womanhood.[49] As Diana Fuss astutely notes, differences in the essentialist and constructionist positions ultimately boil down to proponents of each positioning the female body differently: "For the essentialist, the body occupies a pure, pre-social and discursive space. The body is 'real,' accessible and transparent; it is always *there* and directly interpretable through the senses. For the constructionist, the body is never simply there, rather it is composed of a network of effects continually subject to sociopolitical determination."[50] Although it would not become a fully articulated theory until well into the 1980s, much art of the women's liberation movement exhibits an interest in the performance of gender that would eventually articulate itself fully as constructionism. Among these early constructionist documents, we find feminist artists appropriating the pin-up for precisely the qualities that made it so seemingly "tame": its humor, its potential to transform the sitters, and its mass reproducibility.

A hilarious collaborative poster from 1970 by Judy Chicago's first class at Fresno State College's Feminist Art Program (fig. 78) presents what may be the first true pin-up of feminism's second wave. The work was part of a series of role-playing "costume images" in which students and teachers alike restaged and reclaimed feminine stereotypes such as the

bride, whore, and lady.[51] Contrary to contemporary assumptions about the work of Chicago and her students—which is generally believed to toe an essentialist line—such works were part of the program's much larger project of constructionist explorations of female identity that would eventually culminate in installations and performances at their *Womanhouse* in 1971–72.[52] The works in this role-playing series reflect the theatricality and sass of their predecessors on the stage and screen, as well as the do-it-yourself ethos of homemade World War II pin-ups. Created specifically to promote a 1970 exhibition of the program's work at the Richmond Art Center in Richmond, California, the *California Girls* image is a clever bait-and-switch piece, which at first glance presents a carefully-arranged group of bikini-clad beauty pageant participants striking classic cheesecake poses for appreciative fans. (In fact, many of the posters were signed by the women in character—"Miss North Hollywood" or "Miss San Francisco"—and adorned with lipstick prints.) A closer look, however, shows these pin-ups are far from the day's glamorous norm: although some are slim and conventionally attractive, most the women's figures venture beyond the perfect hourglass standard; most have long, unstyled hair and many have unshaven underarms and wear no makeup; those wearing makeup have slathered it on in comical, over-the-top imitation of beauty-queen style; others wear long wool socks and work boots. These pin-ups are obviously a put-on.

The genre was ripe for appropriation by feminist artists on a variety of levels. Not only were pop art pin-ups a ubiquitous icon of the art world, in both popular culture and the gallery scene, the women's liberationist was often seen positively in the context of a youth culture that valued dissent and strength. Peter Blake's pin-ups of the period took the form of not only film stars, but circus performers and female wrestlers. The latter served as the subject of one of his most famous pin-up prints, a 1968 piece representing the fictional wrestler *Babe Rainbow* (fig. 79)—whose flamboyant profession was not only apparent in her theatrical costume, but documented in an accompanying pamphlet that gives an account of the character as a twenty-three-year-old who had already broken her nose in the ring.[53] Sigmar Polke's *3 Girls* of 1970 makes the eroticism of feminist strength literal, depicting three contemporary, topless female predators, each of whom triumphantly rests a high-heeled foot on top of a writhing, protesting man who serves as

above **78**: Collective work by Miss Chicago and the California Girls, 1970 (Photo: Dori Atlantis, Anti-copyright, 1970)

79: Peter Blake, *Babe Rainbow*, 1968 (Art © Artists Rights Society [ARS], New York/DACS, London)

the human equivalent of a hunting trophy—these women have literally caught and conquered The Man. Moreover, the alleged "bra-burning" protests surrounding the Miss America contest of 1968 were still a fairly fresh media coup for women's liberation.[54] New too were chauvinistic countercultural critiques such as the *New Left Notes'* "women's rights" cartoon. In *Miss Chicago*, the Fresno artists are obviously critiquing the concept of the beauty queen. However, considering the period's anti-feminist sentiment reflected in the *New Left* cartoon, one cannot help but assume these women knew that the double-edge of sexual oppression cut another way: women were harpies when they downplayed their desirability, shallow and brainless when they didn't.

Faith Wilding explained that the work was meant as "a humorous jibe at the California girl image."[55] Yet, echoing Ellen Willis's desire to use feminism to inspire new ideals of desirability, Wilding has also asserted that such collaborations sought to represent beauty and sexuality in "different, more assertive ways."[56] According to Cheryl Zurlingen, another one of the program's students, the intent behind such images was not limited to mocking or deconstructing sexual representations of women; fighting for sexual pleasure was very much a part of their fight against sexism. Zurlingen wrote: "We began discussing our sex lives very openly in C-R [consciousness-raising meetings]. . . . We learned that as long as we could not demand that our sexual needs be met, we could also not make demands that other needs in our lives be met."[57] Viewed in this light, *Miss Chicago and the California Girls'*s bikini-clad women of different shapes and sizes, conventionally and unconventionally beautiful, deserve to be viewed as part of the movement's drive for pleasure as well as critique. The women obviously take a subversive delight in their own sexual pride, audacity, and exhibitionism—a delight that is all too frequently forgotten when looking back at the movement's history.

Another significant appropriation of the pin-up from this era was in the *Eleanora Antinova* series begun by conceptual artist Eleanor Antin between 1973 and 1974. These pin-ups came from the conflation of two characters she introduced in performance-based pieces, a single character that she would continue to develop for the next fifteen years. Over this time, her early characters "The Ballerina" and "The Black Movie Star" fused into the increasingly complicated "Eleanora Antinova."[58] In her earliest manifestation, the Ballerina was a character in two paral-

lel projects: several sets of photographs and an accompanying videotape
both titled *Caught in the Act*. In the former, the artist is presented in
a series of still photographs, posed gracefully in complicated choreo-
graphed moments that reflect performance cartes de visite of the pre-
vious century. The latter, essentially a video documenting the making
of the stills, serves to underscore the trickery that went into the art-
ist's masterful construction of the Ballerina's moves; in it, we see Antin
struggling to hold the positions, stumbling and falling, and using props
to maintain the illusion of the poses.[59] Calling to mind not only the
formal subject matter but the same conscious construction and promo-
tion of idealized femininity of nineteenth-century carte-de-visite pin-
ups, the series finds the feminist artist drawing on this history of female
determination and identity-building.

Even more striking similarities to her burlesque predecessors can be
found in the directions that this character grew in the years to follow.
In 1979, the Ballerina resurfaced with a much more extensive history in
*Before the Revolution: A Ballet Designed, Costumed, Painted, Choreographed,
Written, and Performed by the Celebrated Black Ballerina of Diaghilev's Bal-
lets Russes, Eleanora Antinova*. The olive-skinned, Jewish American Antin
would continuously perform this character in dark-hued makeup, not
only in stage performances like *Before the Revolution*, but also in lec-
tures and a biography sharing her "recollections" with the real Diaghilev
Ballet and in three weeks of daily life in *Being Antinova*. Yet, although
she reveled in her status as the first and only black ballerina of Diaghi-
lev's troupe, the details of Antinova's struggles connected the charac-
ter not to the elevated world of modern dance but, as Lisa E. Bloom
notes, to the tradition of Little Egypt in the "vaudeville theater, [roles]
in which Jewish women as well as black women were seen as exotic
and erotic spectacles."[60] As such, Antinova used her performances and
image to work both within and against the prejudiced world of "legiti-
mate theater." And if her light-skinned, part-Jewish, part-black woman
of the theater and letters already resembled a twentieth-century Adah
Isaacs Menken, the fake "archival" pin-ups of "Antinova's Great Roles"
of the past (figs. 80 and 81) only added a more direct parallel to this
great pretender of the burlesque era. As art historian Howard Fox wrote
of Antin's character, "Hybrid, impure, and unruly, Antinova's art em-
bodies the aesthetics of synthesis, of montage. If radical modernism

80: Eleanor Antin, Eleanor Antinova in "The Prisoner of Persia," from *Recollections of My Life with Diaghilev* (Courtesy of Ronald Feldman, New York)

below **81**: Eleanor Antin, Eleanor Antinova in "Pocahontas," from *Recollections of My Life with Diaghilev* (Courtesy of Ronald Feldman, New York)

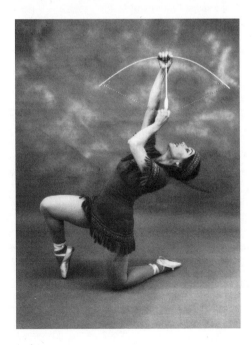

strove for an empirical truth and a unity of form and content, Antinova's art is steeped in an anxious commingling of total, blind idealism and hard-boiled irony. Indeed, Antinova's history was patently fictitious, her character decidedly faux."[61]

Like the similarly complex lives and careers of those women before her, the pin-up's ability to construct and "prove" these personae into being served as a useful tool. Antin's contemporary feminist twist was to use these roles to act out adventurous identities without the danger—to seize the excitement and schizophrenia but reject the victimization of these historical women's lives. As the artist put it:

> My personae, my historical fictions, are actually all the lives that I'm not going to live because I *chose* not to. I certainly don't want to be regretful when I'm an old woman, but do I really want to go live in Marrakesh and walk around the markets and pick up market women to sleep with, like Jane Bowles? I mean, it's very interesting to have your jealous love poison you slowly, but do I really want this? No! . . . But in my art I can enjoy a delicious feeling of removal and being at the same time.[62]

"Beware of Fascist Feminism": The Problems of Politicizing Sexual Expression

However, if such work hinted at the subversive potential of the feminist pin-up, in the years that followed few feminists saw either the humor or the pleasure in such forays into the genre. In the same year that *Woman Hating* was first published, outrage surrounding the publication of feminist sculptor Lynda Benglis's pin-up self-portrait in the November 1974 issue of *Artforum* demonstrated the extent to which the very possibility of a feminist pin-up eluded many established feminist thinkers in the art world. The photograph was a veritable punk updating of Meret Oppenheim's *Minotaure* portrait from forty years earlier. Naked and glistening with baby oil rather than printer's ink, sporting an androgynous hairdo and cat-eye sunglasses, Benglis poses with one hand on her hip and another holding an enormous pink dildo outward from her pubic area. After the magazine refused to publish it accompanying a feature article on the artist by Robert Pincus-Witten, Benglis paid *Artforum* $3,000 (almost a quarter of her annual income at the time) to reproduce the image

in the same issue as part of a two-page advertisement for an upcoming New York show at the Paula Cooper Gallery.[63]

The image had originally been created as part of a series of "sexual mockeries" in the style of the Feminist Art Program's earlier costume images, where the artist established herself as both sexual subject and sexual object, simultaneously taking pleasure in and critiquing the roles she played.[64] Benglis's lifelong interests in drag, performance, and the Mardi Gras traditions of her hometown, New Orleans, led to her own self-aware experiments with sexualized masquerade, initially to overcome her learned behavior and neuroses. In this way, the artist asserts, the series confronted "the sexual self-consciousness I wanted to shed, and the only way I knew how to get rid of it was to mock it."[65] Months before the pin-up ad was published, the April issue of *Artforum* carried a different ad for a Benglis exhibition that presented the artist in what she called her "macharina" pose: wearing man-tailored clothes and aviator sunglasses, leaning in studied bull-dagger style on a vintage Porsche.[66] For the exhibition's invitation, however, she purposely constructed an image of the macharina's opposite in a photograph taken by Annie Leibovitz. In this, Benglis poses—naked except for the jeans around her ankles—in what the artist called a comical updating of the classic World War II pin-up "à la Betty Grable."[67] The artist created the Paula Cooper ad as yet another facet of this identity play, but as a character *between* the two previous images. Benglis recently clarified this intention, stating: "I realized I needed another image that alluded to the idea of the artist being self-motivated, particularly the feminine side of the artist—in other words, she directs herself, she's not directed by someone else. What was missing [in the Leibovitz image] was the mocking of both sexes. Therefore, [in the *Artforum* ad] I used the dildo. For me it wasn't a dildo, it was a symbol of male power, and alluded to the male myth."[68]

Befitting the wide range of meanings the pin-up had acquired since the late 1950s, Benglis's *Artforum* pin-up ad served several complex purposes. Like the beauty queens of *Miss Chicago and the California Girls*, Benglis's pin-up began as a therapeutic project that, having empowered the artist, presents the self-aware, sexualized woman as a kind of wolf in sheep's clothing. As the artist herself would later say, "What I did . . . was pretty myself up and still act tough," making quite literal both the sexual and the gendered expressions of what art historian Susan Krane has

identified as the artist's "dual nature."[69] Benglis also recognized that the gesture of publishing this outrageous work would ridicule the double standard of the "art-star system," where male artists were encouraged to "hype" themselves, but women were accused of vanity and shallowness when following this same rule.[70] Finally, like the body art and cultural investigations of many of her contemporaries, the work was intended to explore the intersections between art and kitsch, erotica and pornography, to ultimately "question what vulgarity is."[71]

The magazine's response seemed to definitively answer this question. Several *Artforum* associate editors were horrified enough by the advertisement image that in the following issue they published a lengthy objection to its inclusion.[72] Ironically misreading Benglis's sexual mockery as a "shabby mockery" of the women's liberation movement, the letter's tone was typical of much feminist scholarship and criticism uncomfortable with both the "effervescent" body and its popular expression. Signed by associate editors Lawrence Alloway, Max Kozloff, Joseph Masheck, Rosalind Krauss, and Annette Michelson, the letter alleged that the image "exists as an object of extreme vulgarity, brutalizing ourselves and, we think, our readers."[73] In *The Feminist Art Journal* Cindy Nemser went further, suggesting that Benglis's ad was not simply an exploitation of female sexuality but symbolic of the artist's "case of sexual nostalgia" and "desperate seeking after masculine attention." Not recognizing the project as worthy of her "serious" sculpture, Nemser lamented, "It is sad to think that Benglis has so little confidence in her art that she had to resort to kinky cheesecake to push herself over the top."[74] These critical responses made clear that in the early 1970s few within the art community saw either the strategy or humor in this kind of feminist appropriation of popular sexual imagery. It seemed that the double standard that Benglis sought to critique would in turn be used to critique this effort. Indeed, the lack of comment that followed a similarly staged ad by Benglis's lover and collaborator Robert Morris that same year—a pin-up parody of "butch" masculinity created in dialogue with Benglis's own parodies—reminds us of the ways in which even well-intended feminist voices silenced women's sexual self-expression while men's was taken for granted.[75] As critic Lucy Lippard would conclude: "The uproar that this [*Artforum*] image created proved conclusively that there are still things women may not do."[76]

At the same time that Benglis's *Artforum* ad was confronted by both sexual and creative double standards in the art world, Hannah Wilke's work was being met in much the same way. Like Benglis, Wilke first gained renown as a minimalist sculptor; indeed, her vulvic terra-cotta sculpture of the 1960s has been discussed as the first explicit vaginal imagery to come out of the earliest stirrings of the women's liberation movement.[77] Also like Benglis, by 1970 her feminist-inspired work had branched out into body art and sexual self-portraiture, begun in response to her mother's mastectomy. As beautifully stated by Joanna Frueh: "As Wilke's mother was losing her body, Wilke wore her mother's wounds. She also needed to affirm the presence of her own body, as alive and female, as the site of imposed cultural meaning, and as the source for new ones."[78] Among the best known of these early body works was the merging of her minimalist sculpture and own body in *S.O.S.— Starification Object Series*, begun in 1974. In this piece, the artist created tiny vulvic sculptures—in the style of her then-signature ceramic and laundry-lint pieces—out of chewing gum, which she then stuck to her body in patterns resembling tribal scarification. Covering her body in these tiny icons of feminist "essentialism," she paradoxically then photographed herself in various states of undress, striking sultry pin-up poses that suggested a variety of constructed female identities—a self-made star who flaunts her beautiful, yet strangely scarred personae. In addition to the work's subtle juxtaposition of both essentialist and constructionist theory, like much of her later work *S.O.S.* would additionally explore intersections of pain and pleasure, succinctly stated by Lippard as exposing both "the scars and triumphs accumulated by a woman as physically beautiful as society demands."[79]

However, even this champion of feminist body art seemed suspicious of the messages Wilke's work ultimately sent out. Calling Wilke a "glamour girl," Lippard cited the artist's "confusion of her roles as beautiful woman and artist, as flirt and feminist," as giving rise to the sense that it is "a little too good to be true when she flaunts her body in parody of the role she actually plays in real life."[80] However, Wilke was hardly "confused" about how such unwillingness to accept the (female) artist's sexuality/body as equal and equivalent to her intellect/mind led to such criticism. Indeed, some of her most compelling and nuanced work of the 1970s would forcefully draw attention to this issue by putting the

pin-up's radical potential into effect. Less than two years after Benglis's *Artforum* debacle, Wilke quietly dealt with her own art-press protest in the work *Art News Revised*. The work was a response to an image of the artist taken for a 1976 *Art News* article on the subject of artists in their studios, in which the constantly topless Wilke (who preferred to work this way, even while working and installing exhibitions) was asked to put a shirt on to pose next to her vulvic *Ponder-r-rosa* wall sculptures for the accompanying photo. Although Wilke obliged them, she parried with an almost identical image in which the artist reshot the *Art News* image as a self-portrait, but posing in true "studio mode"—topless and with her worn jeans comfortably unbuttoned around her belly. In both image and title, *Art News Revisited* makes clear Wilke's protest of the journal's unwillingness to acknowledge the artist's sexuality. As art historian Amelia Jones recently noted of the power of this reclamation of her image/body: "Wilke unveils her body/self among her works to instantiate herself as both their 'subject' and a parodic imitation of woman as conventional 'object' of artistic practice. . . . In doing so, she collapses the incompatibility between the functions male/artist/subject and female/object."[81]

The following year, Hannah Wilke would again rebelliously conjure the pin-up in her 1976 poster self-portrait, *Marxism and Art: Beware of Fascist Feminism* (fig. 82). Addressing the ways in which purposeful sexual outrageousness by artists like her was met with scorn in the name of feminism, the work denounced the "fascism" with which she felt certain thinkers had influenced both the art world and women's movement.[82] This poster is the most direct protest of the artistic double standards that Wilke and Benglis were fighting in their careers. As Wilke herself put it, the work sought to expose the fact that "female nudity painted by men gets documented and when women create this ideology as their own it gets obliterated."[83] The work also confronted the unspoken fact that, as Wilke had learned in her career, "beauty does make people mistrust you."[84] With this in mind, Frueh has suggested that the poster has yet another layer of meaning, where the title also alludes to the "marks-ism" of both the "starification objects" on her person and the internal wounds resulting from "correct thinking and aesthetics."[85] That Wilke would choose these seductive and confrontational pin-up poses to protest limits on women's artistic expression is not surprising:

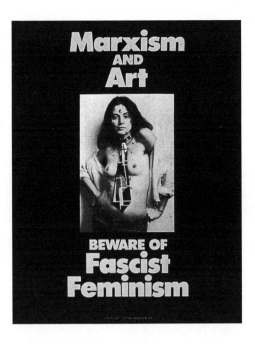

82: Hannah Wilke, *Marxism and Art: Beware of Fascist Feminism*, 1974–77 (Art © Marsie, Emanuelle, Damon, and Andrew Scharlatt, courtesy of Ronald Feldman Fine Arts, New York)

below **83**: Hannah Wilke, *Arlene Hannah Butter*, 1954 (Art © Marsie, Emanuelle, Damon, and Andrew Scharlatt, courtesy of Ronald Feldman Fine Arts, New York)

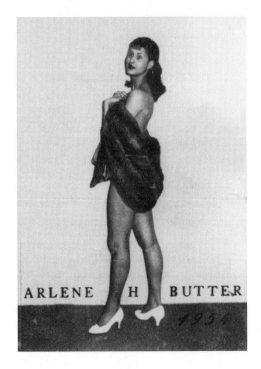

her earliest artworks consisted of pin-up self-portraits that she took of herself as a fourteen-year-old (fig. 83).[86] During this time, Wilke claimed she "was made to feel like shit for looking at myself in the mirror," as if (as her contemporaries Berger and Mulvey asserted) her beauty was something cultivated for the pleasure of others but not herself. It also intimates the ways in which society both disdains the self-consciously sexual woman and deems her sexual self-expression incompatible with her intellect. This patriarchal notion of the sexual woman as an unthinking woman, unwittingly reflected in much of the period's feminist thought on sexualized imagery, is plain in the comments of a longtime friend of Wilke's, who said of her earliest impressions of the artist: "I never thought of her as arty. She was too pretty."[87] These and other appropriations of the pin-up not only railed against the stereotype of the sexualized woman as an object incapable of subjectivity but also claimed looking and self-assessment as a defiant act—or, as theorized recently by Jones, "radical narcissism."[88]

<div style="text-align:center">

Pinned Up, but Not Pinned Down:
Feminism and Postmodernism

</div>

Alas, one woman's radical narcissism is another's . . . well, narcissism. In a 1975 interview Luce Irigaray ironically noted of the times that "what is most strictly forbidden to women today is that they should attempt to express their own pleasure."[89] On the one hand, Irigaray's words spoke to the failure of the sexual revolution, the promise of which had ultimately yielded to the patriarchal norms it had sought to overturn—replacing the revolutionary aspect of encouraging women's sexual freedom with a new way of phrasing the same old cultural demand for women's sexual availability to men. On the other, her observation just as easily applied to the feminist movement itself. By the mid-1970s the subject of pleasure in the women's movement had quickly evolved from a major rallying point to an issue better swept under the rug in favor of putting more "serious" issues to the fore. In this way, feminism was both following the general tone of the times and attempting to defend itself against the same. As America, and eventually much of the industrial world, slid into

an economic crisis that would last into the 1980s, the sexual revolution and those it most clearly affected would be looked upon as both scapegoats and diversions. As David Allyn wrote in his study of the period, "It was far easier to blame movies, television, pornography, homosexuals, and feminists for America's problems than it was to restore the nation's economic vitality."[90]

Tied as they were—for better or for worse—to the sexual revolution, many feminists began distancing themselves from the same in the wake of this backlash. However, politics and public relations weren't the only reasons for such distancing measures. In many ways, this was an unfortunate but logical expression of feminism's tortured relationship with sexuality in a world where sexuality itself remained the most consistent and tangible site of most women's oppression; as a result, it had become the single most contentious site of division among feminists. In 1977, Adrienne Rich summarized the state of feminist thought: the "body has been made so problematic for women that it has often seemed easier to shrug it off and travel as a disembodied spirit."[91] As Rich knew, this was as true for lesbian feminists as for heterosexuals, because the "proper" sexual positioning of the women's movement had been a site of tremendous debate and division. Were lesbians a perverted "Lesbian Menace" to the movement (as Betty Friedan infamously referred to them), or were they feminism's only true women-identified women? Were heterosexual feminists on the frontlines of negotiating the period's shifting gender roles, or were they sleeping with the enemy? "Despite its militancy," Amber Hollibaugh would later reflect, "the women's movement was terrified of sexuality."[92] As such, feminist attempts to represent the embodied spirit, in particular those appropriating popular genres such as the pin-up, were generally met with disdain, if not vilified or pitied, by feminist critics. Exemplifying this very tendency articulated by Rich, in the same year Audrey Flack directly confronted the pin-up in her painting *Marilyn (Vanitas)*, which symbolizes the victimization of sexualized women through the tragic life of quintessential postwar pin-up Marilyn Monroe. Here, Monroe's life is allegorically represented through the Dutch Baroque *vanitas* genre, which represents imagery of vanity and frivolity in association with immorality and death. Rather than celebrating Monroe's sex-goddess per-

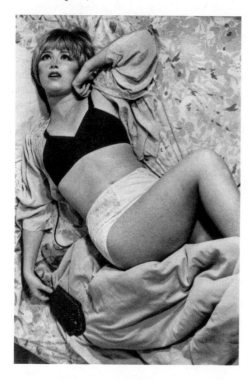

84: Cindy Sherman,
Untitled #6, 1977
(Courtesy of the artist
and Metro Pictures)

sona as a construction of the actress herself, the work is a lamentation for
Norma Jean Baker, a naive victim of the beauty myths embodied by her
creation—a mythology ultimately responsible for killing them both.[93]

But at precisely the moment that Flack's mournful homage to Mon-
roe was completed, her younger contemporary Cindy Sherman em-
barked on a very different meditation upon the Hollywood pin-up—
one that reflected an emergent discourse in both feminism and the art
world that would problematize the period's permitted paradigms of
sexual expression in each. Begun in 1977, Sherman's *Untitled Film Stills*
(e.g, fig. 84) consisted of black-and-white self-portraits depicting the
artist in a variety of elaborate costumes, playing the same exaggerated
feminine "types" from classic, postwar Hollywood cinema for which
Monroe was iconic. However, instead of directly appropriating these
roles from the imagery of others, she rather confiscated the symbolic
constructions of women that popular culture often promotes, creating
eerily familiar but entirely original characters and scenarios. Inspired by

the earlier performance documentation of artists such as Antin, these works were meant to serve not as straight portraits but documents of the artist's staged situations—in her studio and public sites—for her characters to inhabit.[94] Using costume and makeup transformations, the artist rendered herself virtually unrecognizable from photo to photo and, imitating conventional setups of cinematic blocking, depicted the artist/character at hand in ambiguous situations seemingly lifted from an ongoing narrative. Although technically unremarkable—indeed, Sherman failed her first photography course at SUNY Buffalo for her inability to master technical processes—these unconventional self-portraits were created at a moment during which identity, sexuality, and spectatorship were coming to the fore as the primary subjects of not only new feminist thought, but emerging concepts of postmodernism.

Fredric Jameson's groundbreaking 1982 essay "Postmodernism and Consumer Society" represents one of the most influential, early scholarly attempts to locate a sense of unity within (or "periodize") our contemporary, "postmodern" era of art history. In it, Jameson asserts that the primary differences between the modern and subsequent postmodern eras—the latter emerging amid the anti-Cartesian rumblings of the "effervescent body" in culture since the late 1950s—may be found in each period's construction of history, culture, and self. He contended that modernist historians such as Clement Greenberg established "oppositional" and highly individualized moments toward shaping and defining different periods within a linear historical continuum. Postmodernism, on the other hand, possesses a different historical sensibility that rejects the singularity of and boundaries between individuals, genres, and even time itself. Postmodern thinkers instigated the "erosion of the older distinction between high culture and so-called mass or popular culture . . . [and] the fragmentation of time into a series of perpetual presents," seeking transitions, fluidity, and affinities between people and periods.[95] This ideal of fragmentation led to what Jameson argued as some of postmodernism's few, if fuzzy unifying qualities: pastiche, a sense of expressive "schizophrenia," and the freedom that comes with the notion that a singular, masterful modernist "author"—originator of new and period-shattering ideas—does not exist. Philosopher and art critic Arthur Danto would later address how this affected art history in particular: whereas modernist critics like Greenberg and many of the

abstract-expressionist painters he championed "celebrate[d] a repudia-
tion of the past" through which they constructed a radical new lineage
and identity for themselves, postmodernists have "no brief against the
art of the past, no sense that the past is something from which liberation
must be won, no sense even that it is at all different as art from modern
art generally. It is part of what defines contemporary art that the art of
the past is available for such use as artists care to give it."[96]

Craig Owens would theorize the ways in which, for artists, the strate-
gies of allegory and appropriation went hand in hand with this frag-
mentation of history and the self. Allegory, in its most traditional usage,
is the presentation of a subject or narrative using symbolic language that
requires interpretation. From its definition, Owens claimed, allegory
and appropriation have a necessarily symbiotic relationship in art: "Alle-
gorical imagery is appropriated imagery; the allegorist does not invent
images but confiscates them. He [*sic*] lays claim to the culturally signifi-
cant, poses as its interpreter. . . . He does not restore an original meaning
that may have been lost or obscured. . . . Rather, he adds another mean-
ing to the image."[97] Owens asserted that this "allegorical impulse" was
repressed in Greenbergian modernist work and reemerged in postmod-
ern art as a result and critique of its earlier repression—a critique that
had evolved in ever more complex ways since the rise of the effervescent
body and the reevaluation of popular culture in the late 1950s.

Significantly, Owens also posited that, because "historically consigned
to the spheres of nonproductive or reproductive labor, [and] thereby
situated outside the society of male producers," women's history of look-
ing in on cultural production gave them a particular edge over men in a
sophisticated understanding and analysis of both allegorical and appro-
priated imagery. Unlike men, they were historically viewed as incapable
(and thereby expected to express themselves outside) of true originality
and mastery, a fact that might make women uniquely qualified not only
to speak in the fragmented languages of postmodernism, but to articu-
late the possibility of a fragmented self. For these reasons, Owens viewed
Sherman's self-portraiture as exemplary of all these postmodern prac-
tices. Citing Douglas Crimp's assertion that Sherman effectively ques-
tions the cinematic concept of auteurism, which "equates the known ar-
tifice of the actress in front of the camera with the supposed authenticity
of the [male] director behind it,"[98] Owens argued that Sherman's work

went further, addressing and denying the broader "masculine desire to fix the woman in a stable and stabilizing identity."[99]

Although many of Sherman's images were meticulously constructed environments where the figure's surroundings and the suggested narrative were key, several of the ambiguous scenes appeared much closer to pin-ups of the past than to a larger storyboard—unsurprising considering Sherman's drive to destabilize the subject's sexuality, a goal toward which the pin-up's historical ability to present an ambiguous feminine sexual identity is well suited. As she learned from Antin, the frozen pose of the "still" is a very different construct than the more revealing continuity of action—easier to stage and easier to fake—and as such the posed quality of several of the *Film Stills* resemble promotional pin-ups more than the narrative-revealing film still tradition. Even the series' 8 x 10″ black-and-white glossy medium—with no text, captions, or logos— imitates the standard size, commercial stock, and ambiguous scenario of Hollywood and "glamour" pin-ups.

The best examples of the pin-up style within the *Film Stills* series are two of its earliest images, *Untitled #2* and *Untitled #6*, both shot in 1977. In each of these, the artist is scantily clad and made up with heavy cosmetics and a light-blonde pageboy wig to resemble a late-1950s or early-1960s ingénue. Both images present the subject in an ironic pose of studied nonchalance. In *Untitled #2*, although the viewer appears to have caught the subject unawares, again the portrait-ready formality of her self-study in a bathroom mirror and the fixed arrangement of her "slipping" towel are clues to the subject's control over the scenario. In *Untitled #6* (fig. 84) the sense of the subject's dreamy repose, lying on a rumpled bed with a hand mirror at her side, is undercut by the angularity and stiffness of her artfully arranged limbs. Each character's gaze is concentrated away from the eye of the camera/viewer, but the fact that both of these pin-ups is or has been actively musing over her own visage reminds us not only of the self-awareness of her characters' feminine masquerade, but ultimately of the artist's own. As Hal Foster has noted, in these images "Sherman points to the gap between imagined and actual body-images that yawns within each of us, the gap of (mis)recognition that we attempt to fill with fashion models and entertainment images every day and every night of our lives."[100] Yet in addition to the sense of yearning, in the excessive narcissism of each scenario there is an un-

deniable sense of pleasure that the characters seem to take in their own
sensual image—as, one senses, Sherman feels in her using these char-
acters to shed any inhibitions and play with her own sexual identity—
regardless of the success with which they may or may not live up to the
stereotypical ideals they mimic.

Sherman's appropriation of the pin-up became even more literal in
one of the first series to follow the *Untitled Film Stills*, the ambitious self-
portraiture of her *Untitled Centerfolds*. The 1981 series was conceived as
a portfolio that had been commissioned of the artist by *Artforum* maga-
zine. Perhaps seeing an opportunity in the magazine's square size—
which opened up for an unusually wide, two-page spread—*Centerfolds*
were both a continuation of and departure from *Film Stills*: like Sher-
man's previous works, each depicts the artist playing different feminine
characters, but that was where the resemblance with her earlier series
ended. The 2' x 4' slick color photographs imitated the proportions and
horizontality of the classic fold-out pin-up and depicted extremely con-
temporary and arguably ordinary women, shot in sharp focus with little
or no background details. Also unlike her earlier self-portraits, these
works were almost all shot from above, with the subject claustropho-
bically cropped in such a way that limbs are out of the frame. Unlike
the coy and controlled sexuality of *Film Stills*, the *Centerfolds* were cold
and disturbing—imitating the clinical focus and crops of pornogra-
phy rather than the "whole woman" approach of most pin-up imagery.
Here, allowing the subjects' sexuality to become the subject rather than
the subtext, Sherman completely overturned assumptions about both
the pin-up genre and her own work to date. The subjects' expressions
of disorientation and rumpled wardrobe were markedly different from
the primly put-together women of the film stills, resulting in character
studies that one critic called "embarrassingly intimate."[101]

In this clever inversion of subject and genre, Sherman now used the
pin-up to draw attention not to her subjects' mastery of their sexu-
ality, but rather to their sexual vulnerability. In *Untitled Centerfold #87*,
the subject is a disheveled young tomboy in a wrinkled blue pullover
with the waist of her underpants haphazardly peeking above the waist
of her jeans, lying on a painted wood floor and clutching a knit af-
ghan like a security blanket. *Untitled Centerfold #93* (plate 6) depicts
a thrashed-looking blonde—eye makeup smudged and running, hair

stringy and tangled—limply pulling a black bed sheet over her body and staring toward a bright, raking light before her with a look of dejection. The intimacy of the vantage point and crops, the theatrically interrogative lighting, and the fearful or void expressions on each character suggested an air of sexual danger, but no sexual thrill—in the case of *Untitled Centerfold #93*, the image even hinted at rape. *Centerfolds* demonstrated Sherman's willingness to depict the dark side of the same sexually charged narratives and sexualized women of her earlier series, while still claiming control and ownership over the proceedings. Regardless, in a stunning return to its inability to recognize such critical subtleties in Lynda Benglis's self-portraiture almost twenty years earlier, *Artforum* rejected the series for its ambivalent display of these disturbing sexual identities.[102]

Both series' use of pin-up conventions reflected the contradictions and complexities of the prosex feminist and postmodern theories coalescing at the time they were created, even though (as *Artforum*'s reaction to the *Centerfolds* demonstrates) popular ideas about feminism had not necessarily caught up. Regardless, Sherman was certainly a woman of her time: growing up at precisely the moment that feminism's second wave exploded on the cultural scene, she sought to capture the rapid changes in sexual ideals that women her age had grown up with, from postwar prudishness to the sexual revolution. Of her impetus to explore the stereotypes many of her contemporaries hoped to banish to history's dustbin, Sherman said, "[As a child] I had these role models—women in films—and you would wear pointed bras and girdles and sleep with curlers in your hair. Then in college everything had to be natural—no makeup, no bras, no hair dyeing. So I had a love-hate relationship to the makeup and all the accoutrements of beauty because you were not supposed to like them. But I still like it and get pleasure from it."[103]

By acting simultaneously as spectator (of the classic roles that inspired her) and actor/director (who reinvents the roles), Sherman expanded the possibilities of both for women—in the *Film Stills* and *Centerfolds* series, she is *both* spectacle and subject, accepting *both* pleasure and danger in her sexualized scenarios. In a manner simultaneously articulated by postmodern theorists, Sherman's work succeeded on all these counts by her familiarity with and mastery of fragmentation, allegory, and appro-

priation unique to those marginalized by modernist ideals. As Owens succinctly summarized the tactic, "The subject poses as an object *in order to be a subject.*"[104] He would also defend Sherman's use of the pin-up to achieve this end: "Sherman abandoned the film-still format for that of the centerfold, opening herself to charges that she was an accomplice in her own objectification, reinforcing the image of the woman bound by the frame. This may be true; but while Sherman may pose as a pin-up, still she cannot be pinned down."[105]

Pleasure and Danger: The "Sex Wars"

To paraphrase Rosalind Krauss's influential analysis of Sherman's *Film Stills*, the artist was one of the earliest contemporary artists to encourage viewers to "look under the hood" of popular images of women, rather than buying wholesale into the mythology they represented to *either* the culture industry or its feminist critics.[106] But Sherman's early work was rare for the nuanced, ambivalent way with which it approached the possibility of a feminist sexuality simultaneously derived from and critical of popular culture. Indeed, while issues of pleasure and sexual expression were largely passed over in favor of more palatably political ones by the feminist majority, there simultaneously rose one group within the movement with a great interest in tackling these issues: antipornography feminists. Continuing their estimable legacy from the earliest days of the women's movement, radical feminist thinkers such as Andrea Dworkin developed ever more sophisticated ways not only of calling attention to sexism in pop culture, but for arguing that this very culture may be responsible for the persistence of sexism itself.

Such views reached perhaps their most radical height in the early 1980s with the writings and political activism of Dworkin and feminist law professor Catharine MacKinnon, both of whom contended that popular imagery that "objectified" women served as the basis for women's oppression. Zeroing in on the sexual objectification of women in pornography, Dworkin asserted,

> The oppression of women occurs through sexual subordination. It is the use of sex as the medium of oppression that makes the subordination of

women so distinct from racism or prejudice against a group based on reli-
gion or national origin. . . . In the subordination of women, inequality itself
is sexualized: made into the experience of sexual pleasure, essential to sexual
desire. Pornography is the material means of sexualizing inequality; and that
is why pornography is a central practice in the subordination of women.[107]

Drawing upon Dworkin's evaluation of pornography's power struc-
tures, MacKinnon set about constructing a new legal definition of and
case against pornography. Using a combination of personal accounts,
and legal and feminist theory, MacKinnon's and Dworkin's work—both
individually and in collaboration—espoused the notion that all sexual
imagery of women is not only demeaning to, but arguably constitutes
a literal assault on women. In a model law begun by MacKinnon and
Dworkin in 1983, "pornography" was argued as best defined for feminist
purposes not according to the Supreme Court's criminal definition of
obscenity (that which appeals to the "prurient interest" of its viewers
and is found "patently offensive" in light of "community standards"),
but more broadly as the "sexually explicit subordination of women
through pictures and/or words," constituting instead an infringement of
women's civil rights.[108] As MacKinnon articulated the difference, "Ob-
scenity, in this light, is a moral idea; an idea about judgments of good
and bad. Pornography, by contrast, is a political practice, a practice of
power and powerlessness."[109] Further, as both Dworkin and MacKin-
non construct the physical act of heterosexual intercourse as reflective
of the unbalanced power relations in a sexist society, any imagery that
is potentially sexually stimulating to men constitutes an active and op-
pressive threat to all women.[110] As such, according to MacKinnon and
Dworkin's theories, sexual imagery itself constitutes a form of sexual
violence that not only depicts but causes such violence—a perspective
summarized in Robin Morgan's now-famous slogan, "Pornography is
the theory, rape is the practice."[111]

Ironically, popular media and politicians began embracing this
broadly defined antiporn feminist perspective—as both the only femi-
nist perspective and one conveniently serviceable to Reagan-era anti-
obscenity efforts[112]—at precisely the moment that this perspective was
being reinvestigated and refuted by both academics and activists within
the movement.[113] With the reality of such antiporn theory looming in

the form of proposed laws, many feminists came to question the extent to which such theories could prove harmful to women if enacted and enforced. Although their proposed ordinance included an exception for "erotica," the fact that this safety valve is referred to in only one sentence, where it is defined vaguely as "sexually explicit materials premised on equality,"[114] the broad net with which Dworkin and MacKinnon identified nuanced and subjective ideas like "pornography" and "subordination" made the issue of sexuality once again a hot-button issue. By the end of the 1980s, increasing numbers of feminist scholars, artists, and activists would come to see the logic of exploring the issue of sexual expression in their work when losing that freedom became a very real possibility. Exposing the intellectual, personal, and creative problems with which the period's antiporn activism threatened women's sexual identities and self-expression, a new wave of feminist thought approached the subject with a sense of purpose and urgency. The potentially damaging legal ramifications of antipornography activism—both in theory and their subsequent, temporarily successful applications—are too complex and tangential to be addressed properly here.[115] However, for the purposes of this study, I would like to dwell on several critical responses to antiporn activism that would affect feminist visual culture of the period, proving highly influential in the evolution of the women's movement.

At precisely the moment that Sherman was at work on her groundbreaking *Film Stills*—and still very much in the margins of both the established art world and feminist community—Audre Lorde presented her now-legendary 1978 essay "Uses of the Erotic: The Erotic as Power" at the Fourth Berkshire Conference on the History of Women.[116] Lorde's essay was one of the first crucial texts to instigate substantial change within the women's movement in ways that related to the role of sexuality in feminist culture. In it, she identified and warned of the period's "false belief that only by the suppression of the erotic within our lives and consciousness can women be truly strong," and defended the possibility of the erotic to offer "a well of replenishing and provocative force to the woman who does not fear its revelation, nor succumb to the belief that sensation is enough."[117] Lorde's reclamation of the erotic —while contrasted against pornography as "its opposite"—would embolden women within the movement who had felt both intimidated

by the prominence of antiporn voices and selfish in their demands for pleasure as a feminist issue, giving way to a new era of feminist thinkers responding to Lorde's call for "women brave enough to risk sharing the erotic's electrical charge without having to look away, and without distorting the enormously powerful and creative nature of that exchange."[118]

That same year, Angela Carter would similarly challenge the period's feminist aversion to sexual expression by arguing against the very divide between the erotic and pornographic that still marked the work of even progressive, prosex feminists such as Lorde. Carter's revolutionary feminist reading of the life and writing of the Marquis de Sade in *The Sadeian Woman and the Ideology of Pornography* made the powerful argument that, rather than simply enslave women within a labyrinth of eternal sexual inequality, pornography might also be used to free women from their sexual inhibitions by giving them a sense of their power. Using Sade as a model and Freudian psychoanalysis as an interpretive tool, Carter articulated the potential of a "moral pornographer" who dares flesh out not just the sexual acts but the sexual character and motivations of his subjects in ways that reveal the ugly truths of sexuality in a corrupt and patriarchal society, while simultaneously suggesting that women can master and subvert them. As such, Carter argues, Sade "put pornography in the service of women or, perhaps, allowed it to be invaded by an ideology not inimical to women."[119]

She notes that Sade's women embrace all forms of pleasure fearlessly and without apology; they reject social and legal definitions of the female body as maternal and frigid, or pay horrible prices for buying into such clichés; they actively construct their bodies and sexual selves (through methods ranging from simple self-determination to the bodily incorporation of sexual toys) rather than believe in corporeal limitations; and, ultimately, they are allowed to play out and conquer Freudian masculine neuroses like the Oedipal complex and fetishism, which Freud himself deemed women too sexually unformed to be affected by. Quoting Sade himself, she encourages her readers with his promise that, through curiosity about, an understanding of, and experimentation with their own sexuality: "Charming sex, you will be free: just as men do, you shall enjoy all the pleasures that Nature makes your duty,

do not withhold yourselves from one. Must the more divine half of mankind be kept in chains by the others? Ah, break those bonds: nature wills it."[120]

Reflecting Carter's unique feminist appropriation of Freudian psychoanalysis, academic feminists of the period used the gaze theory of fellow Freudian Laura Mulvey as yet another strategy for articulating the feminist potential of sexual expression. Interestingly, Mulvey's theories were of great interest to many antiporn feminists who used (if oversimplified) her extremely specific construction of the male gaze and its objectification of women as a catchall concept for men looking at women. As such, many feminist critiques of Mulvey's work — even among those who championed it — questioned the ways in which its influence in feminist scholarship had evolved to deny the notion of female agency in viewing and interpreting sexual imagery. (As the work of cultural historian Lorraine Gamman has addressed, most subsequent "models of the gaze have produced some very one-dimensional accounts of viewing relations.")[121] However, as scholars Kegan Doyle and Dany Lacombe remind us in their research on this period of feminist history, gaze theory also represented "a more sophisticated approach to sexist imagery than that of radical [antiporn] feminists . . . [;] it emphasized, at least potentially, the viewer's activity in the production of meaning in pornography. If the pornographic is produced via the mobilization and organization of specific 'pornographic' codes, it is possible for the viewer, once aware of this process, to reject, challenge, or even subvert those codes."[122] As such, Mulvey's approach actually opened a space for even her critics to theorize alternative "codes" to interpreting visual culture's effects and utility.

Prominent feminist scholars of this period who turned gaze theory against itself include Teresa de Lauretis, Mary Ann Doane, and Annette Kuhn, all of whom reinvestigated the same exaggerated feminine "types" from classic Hollywood cinema that Sherman had in her own work.[123] Part of their scholarship's strength was its articulation and centering of constructionist feminist thought, rejecting the essentialist base of most antiporn views of desire and sexuality. In arguing for the primacy of both social factors and individual agency in the construction of gender identity, these scholars' arguments stressed the fluidity and performance of gender, a traditionally binary structure (male/female,

gay/straight) that such scholars argue can potentially be reshaped and transgressed, thus denying both the "anatomy is destiny" arguments and the heterosexism at the center of arguments like Dworkin's and Mac-Kinnon's.

Pairing the scholarship of Mulvey with that of Freud's disciple Joan Riviere (1883–1962), Doane argued in 1982 for the potential of a female spectator who takes on the active self-consciousness of "masquerade" to counter the negative "psychic transvestism" Mulvey felt women viewers passively adopted. Doane proposed that the "effectivity of masquerade lies precisely in its potential to manufacture a distance from the image, to generate a problematic within which the image is manipulable, producible, and readable by the woman."[124] She argues that this opportunity presents itself not when women (either as spectator or spectacle) attempt to avoid femininity, but rather when femininity is depicted in excess, demonstrating the awareness of and mastery over clichés that might otherwise have the power to objectify. Similarly, Annette Kuhn explored the theme of "sexual disguise" in cinematic history, singling out examples in which "the masculine-feminine dualism becomes so prominent an issue that the very cultural stability proposed by the categories is rendered subject to challenge."[125] Indeed, among Kuhn's attempts to locate representations of women's sexual agency in visual culture, her essay "Lawless Seeing" addressed the potential of the pin-up as a slippery genre rife with multiple meanings and interpretations. Unlike conventional pornography, which tends to fragment and/or behead the female form to get to the explicit sexual "truths" of her body, she notes that the pin-up both depicts the " 'whole' woman" and is always contextualized: "In offering itself as both [constructed] spectacle and [essential] truth, the photograph suggests that the woman in the picture, rather than the image itself, is responsible for soliciting the spectator's gaze. In doing this, the photograph constructs her body as an object of scrutiny, suggesting at the same time that female sexuality is active, that women may invite sex."[126]

De Lauretis's work addressed two other key points of Mulvey's theory, narrative and visual pleasure, each of which Mulvey argued must be avoided by filmmakers with "passionate detachment" for a feminist cinematic tradition to emerge.[127] Writing in 1984, de Lauretis argued instead for "an interruption of the triple track by which narrative,

meaning, and pleasure are constructed from [the male] point of view. The most exciting work in cinema and in feminism today is not anti-narrative or anti-Oedipal; quite the opposite. It is narrative and Oedipal with a vengeance, for it seeks to stress the duplicity of that scenario and the specific contradiction of the female subject in it."[128] In the midst of all these broadening perspectives of just what does and does not constitute pornography and "the gaze," asserting the complexity of individual interpretations and appropriations of sexualized imagery of women in visual culture, such feminist scholarship defended a space in which images may construct women as sexual subjects regardless of the patriarchal societal framework in which they are created.

One of the earliest efforts to organize this expanding chorus of voices heralding a new philosophy of feminist sexual agency was Barnard College's 1982 conference "The Scholar and the Feminist: Towards a Politics of Sexuality." The conference, and the subsequent publication of the writing and images presented there, encompassed a spectrum of feminist positions on the role of sexuality that existed between prosex and antiporn thinkers in the women's movement.[129] It also helped initiate a broader feminist investigation of how women's sexual expression had been fought not only by patriarchal systems, but by feminism itself. (Indeed, regardless of its inclusion of antiporn voices, Women Against Pornography picketed the conference. In addition to a two-page leaflet distributed by the group, in July of that year WAP's allies at *off our backs* magazine gave agitated—and arguably libelous—accounts of both the sessions and the sexual lives of individual participants that remains something of a black mark on late feminist history.)[130] The following year, the collection *Powers of Desire: The Politics of Sexuality* was published in an effort to, similarly, prove and expand the breadth of such perspectives in the feminist movement. At the same time, the Vancouver-based group Feminists Against Censorship organized around many of the same issues, with the aim of continuing and expanding the debate. The group organized art exhibitions, public forums, and anticensorship events but also "urged women to directly challenge mainstream pornography through the development of an 'alternative' sex-positive feminist pornography."[131] In 1985 FAC member Varda Burstyn edited and published *Women Against Censorship*, a collection of essays and scholarship relating to their cause.[132]

In her introduction to *Pleasure and Danger*, the landmark publication that came from the Barnard conference, the conference coordinator Carole Vance forcefully articulated a view shared and fought for by many of these feminist thinkers in the 1980s:

> Feminism should encourage women to resist not only coercion and victimization, but also sexual ignorance, deprivation and fear of difference. . . . Feminism must also insist that women are sexual subjects, sexual actors, sexual agents; that our histories are complex and instructive; that our experience is not a blank, nor a mere repetition of what has been said about us, and that the pleasure we have experienced is as much a guide to future action as the brutality. . . . It is not enough to move women from danger and oppression Feminism must increase women's pleasure and joy, not just decrease our misery.[133]

Vance's words reflected those of the growing number of feminists at the start of the decade, to whom the activism of antiporn feminism represented a threat to personal liberties, the evolution of feminist thought, and the plurality of feminism itself. In the anthology *Sex and Single Girls: Straight and Queer Women on Sexuality*, Lee Damsky reflected upon the ensuing "sex wars" within this period of the women's movement, and their relevance to feminism's evolution thereafter: "In retrospect, the sex wars can be seen as a struggle over what the relationship between the personal and the political could be"—through not just the investigation of "the utter resistance of sexual desire to external political or social agendas," but the fact that the period's "feminist examination of sexuality included personal experiences of sex by women of diverse backgrounds and sexual interests" even as it "also seriously addressed the questions of women's sexual oppression."[134]

Needless to say, things did not appear so rosy to feminists in the trenches. Documenting the journey of the women's movement in a presentation delivered to several different women's groups at the height of the sex wars, Ann Snitow was alarmed to find the movement had turned so sharply "away from insisting on the power of self-definition—think of the [lesbian] Lavender Menace, or the early celebration of the vibrator, or the new heterosexual imperative that one should demand from men exactly what one wanted sexually—to an emphasis on how women are victimized, how all heterosexual sex is, to some degree,

forced sex, how rape and assault are the central facts of women's sexual life and central metaphors for women's situation in general."[135] On the one hand, this shift from liberation to victimization was a distressing development for feminists who wanted to increase women's pleasure as well as fight women's oppression. On the other hand, this shift itself provided these same women with an opportunity to think more broadly about the many *feminisms* that comprised feminism. As Snitow herself continued, "We are faced now with the task of exploring the various strands of the ideological web we've been weaving all along, discovering and facing the contradictions that are inevitable in a movement as rich, as broadly based as our own."[136]

As the decade wore on, not only would like-minded feminists accept this challenge, but their efforts would instigate an even broader base for the movement as feminism evolved toward the turn of the century. As we will see, the expansive approaches to feminist practice that emerged would give way to a breadth that, by the early 1990s, led many to ponder whether a "third wave" of feminism had been born of this very expansion—a new wave that would rediscover the pin-up, which now had an explicitly feminist history to be excavated and built upon.

8

FROM WOMYN TO GRRRLS

The Postmodern Feminist Pin-Up

Artist and former sex worker Annie Sprinkle is among the most visible feminists whose work and activism grew out of the sex wars of the 1980s, and she stands as a symbol of precisely the growth-by-division that the movement would experience in this period. Sprinkle "came out" as a feminist as part of the Carnival Knowledge collective—begun in 1981 to counter the recently formed Christian lobbying group the Moral Majority—which in the wake of the period's debates around sexuality extended its anticensorship and reproductive rights activism to include support of feminist and queer sexual expression, which its members were dismayed to find under attack from *both* the feminist Left and the Christian Right. As seen in Sprinkle's *Anatomy of a Pin-Up Photo* (fig. 85), the pin-up in this period would be conjured as a method of playfully promoting the goals of activists fighting for the recognition of sexual self-expression as a progressive issue.

The work engages in a respectful, but still cheeky dialogue with the period's antiporn discourse—in this case, that specifically promoted by Andrea Dworkin and represented in her 1974 *Beauty Hurts* pin-up. Sprinkle's image nearly replicates Dworkin's earlier deconstruction of the sexualized female body—in this case, the artist's own—but to a

85: Annie Sprinkle, *Anatomy of a Pin-Up*, 1991
(Photo: Zorro, courtesy of the artist)

very different end. In a similarly cartoonish fashion, Sprinkle breaks down her own (clever, comical, and unsuccessful) body manipulation toward attaining a conventional pin-up girl allure. However, Sprinkle's lighthearted approach to these endeavors, as well as the way she asserts her control of and pleasure from them, contrasts sharply with Dworkin's evocation of the pain and humiliation the same represent to her. Dworkin's image exposes the fact that popular culture often represents women according to patriarchal myths that have controlled and oppressed women through their sexuality. Sprinkle's image, however, offers a very different response to such myths. *Anatomy of a Pin-Up Photo* suggests that when women are given the opportunity to take control of, deconstruct, and find pleasure in the representation and performance of their sexual representation, they may ultimately expose the very mythology with which women's sexuality and beauty are associated—indeed, to such feminist thinkers, others' judgment of and desire to eradicate them is itself oppressive.

Sprinkle's image was part of a larger feminist response to the dominance of antiporn voices in the women's movement, led by activists who as the 1980s wore on would argue that the same sexualized imagery fought against by feminists like Dworkin represented to other feminists a liberating and necessary language for self-expression. After the second wave of the women's movement had helped break down barriers to women's access to popular sexual imagery—historically dominated, in consumption as in creation, by men—many women felt finally free to study and converse in its vocabulary and resented the limitations they felt antipornography dogma placed on both the practice and the representation of their sexuality. As such, the pin-up would be rediscovered and recontextualized in the rapidly changing and expanding feminist discourse that emerged in the 1980s—a decade when issues of sexuality were addressed with particular urgency. This was due in large part to the antifeminist backlash of the decade's conservative politics in the United States and Europe, as well as allegiances formed between conservatives and antipornography feminists in this period, in support of legislation that would alter women's rights in order to protect them from "sexual subordination." When faced with the very real possibility of feminist theory being applied in a way that many felt would limit, rather than expand, women's freedom and equality, a new movement in late-second-

wave feminism rose to reconsider the potential of sexual self-expression in their lives.

The ideas of this movement reflected the period's broader interest in exploring the seductive and slippery concept of postmodernism, in which plurality and constructionism were championed over singularity and essentialism. The resulting articulation and acceptance of many feminist sexualities were part of broader cultural efforts to articulate and embrace the increasing eclecticism and scope of culture that had been steadily growing since early efforts to question modernist principles in the late 1950s. Postmodern theory gave language and license to feminist artists exploring imagery of the sexualized woman in ways different than their predecessors used. With postmodernism's willful blurring of the distinctions between traditionally oppositional boundaries such as high and low culture, the playful experiments with popular imagery feminist artists toyed with in the 1960s and early 1970s would not only grow exponentially but also take on increasingly layered and referential meanings. Moreover—fueled by the AIDS crisis that would politicize and galvanize the gay community—scholarship and activism by the gay and lesbian communities began to both merge and gain visibility as the 1980s wore on, encouraging even broader ways of viewing gender and sexuality.

All of these new voices and perspectives influenced the evolution of feminist thought profoundly in the postmodern era. As such, in the last twenty-five years feminist thought on sexuality and its expression has grown to embrace the notion that women's sexual pleasure and fantasy is beyond dogma, while more women have come to place this idea squarely at the center of their feminist politics. As we will see, the pin-up has served as a tantalizingly loaded icon for artists to use in both activism and artwork of this period, which grew to recognize the power of sexual self-expression in an era marked by the primacy of plurality. The era's complex, often ironic perspectives on sex and femininity would transform feminism significantly enough to give way to an emerging new wave in its history, with a new generation of feminists born and raised in the midst of a contentious and expansive women's movement. The fact of the pin-up's associations with internal struggle in the movement would mean that the unprecedented prominence of such sexualized imagery in the work of contemporary activists and artists comes from

a sense of their difference from previous feminists as well as a respect for their legacy. This ambivalent approach to feminist history marks our present, third wave of the movement but also frustrates efforts of those both within and outside of the movement to identify or even recognize feminist art and activism today.

"This Bridge": Sex and Pluralism in 1980s Feminism

As addressed in chapter 7, the sex wars of the 1980s are frequently blamed or credited for the period's splintering of the feminist movement into the clear and contentious factions with which we are still living today. Naturally, sex was not the lone catalyst of this change; like decades of activists past, this splintering was the broader effect of a feminist culture divided by both changes ushered into the movement by its own activism and the varying generational experiences that activism brought about. However, the splintering that occurred in feminism's second wave was unique because the changes ushered in during this era were so dramatic and rapid as to transform culture before the movement had time to recuperate, reflect, and regroup. As a result, second-wave activism gave way to an era in which a generation of young people growing up at its start was able to enjoy the benefits for which second-wave activists fought at precisely the same time that conservatives opposed to the same gained enough power—both political and cultural—to manufacture a broad, antifeminist backlash. As such, Nancy Whittier writes, the 1980s "drove a generational wedge between the women who had organized feminist groups and protests during the 1960s and 1970s and their younger counterparts, who came of age in an era that was simultaneously more hostile to feminism and less restrictive of women."[1] Moreover, as we have also seen, whereas the feminist culture of the second wave developed not just at a relatively rapid pace but at a certain distance from the crest of first-wave activism, women coming to the movement after the mid-1970s necessarily confronted a formidable, preexisting movement whose tensions new members exacerbated.

While the divisiveness that we will track in this chapter would lead to a diversity that arguably led to the resiliency of the women's movement, this very diversity would—as we have seen in similar growth within

the first wave—also lead to a breadth of approaches to and individuals in the movement that made it difficult for more established feminists to acknowledge those that did not resemble them in age, politics, or even style. (A still-raging debate between what Devoney Looser calls the "purebreds vs. mangy strays," in which the most recently emergent young feminists are pitted against whichever generation feels it represents the last "pure" bloodline.)[2] Worse, however, than the polarization of feminists in our particular era—unbound by a single, unifying issue in the way that the first wave had been unified by suffrage—was the ensuing lack of communication and recognition among the movement's various factions that led to misrecognition of and even blindness toward "unfamiliar" feminisms. As early as 1983, a young feminist activist recounted in *Ms.* magazine a conversation in which an older feminist wondered aloud why there were no young women in the movement: "The wondering gives me the sense of watching my own funeral—struck dumb—and unable to tell my mourners that I am still very much alive."[3] The result of such exchanges—both one-on-one and collectively—would mean that in this decade not only would debates within the movement become more heated, but because they felt unwelcomed or unrecognized within it, many would-be feminists would begin to ignore the movement altogether.

Others, however, battled not just for space within but for recognition from the feminist establishment. As the 1980s wore on and the breadth of approaches ushered in by the second wave became inescapable, feminists began articulating their various positions in such a way as to argue that, as postmodernists were attempting to name and define the emergence of a new cultural era out of modernism, so too might feminism be experiencing a shift both born of and challenging the era that preceded it. And though on the surface the rumblings of a third wave of feminism spinning off of the second appear generational, they were in fact the result of much more complicated and longstanding divisions within the movement.[4] Indeed, while the term "third wave" is frequently credited to writer and activist Rebecca Walker in 1992—and, as such, popularly used in reference to the feminists of Generation X, from which she comes—it was in fact used much earlier and in a significantly different context in the 1980s, as part of a campaign by feminists of color to be recognized as part of the movement's expanding discourse. As early as 1970,

we find Frances Beale articulating the marginalization of black women in both the civil rights and feminism movement in her essay "Double Jeopardy: To Be Black and Female," and as the 1970s wore on prominent activists and authors such as Florynce Kennedy, Michelle Wallace, and Toni Morrison would further efforts to challenge the movement's Eurocentrism.[5] At the decade's end, Audre Lorde's "Uses of the Erotic: The Erotic as Power" paralleled the period's feminist fear of the erotic to a fear of the non-Anglo other—fears, she argued, that were "shared by women who continue to operate under an exclusively european-american [*sic*] male tradition."[6] But it would take until the 1980s for Lorde and her colleagues at Kitchen Table: Women of Color Press to not only force the white hegemony of the organized feminist movement to confront its own racism, but help define and name an emergent third wave of the movement.

The press was founded in 1981 by Lorde, Cherríe Moraga, and Barbara Smith to publish writing by feminists whose voices had been marginalized or ignored by the women's movement. Kitchen Table's now-legendary anthology, *This Bridge Called My Back: Writings by Radical Women of Color*, had first been published by Persephone Press in 1981 and quickly went out of print. After Persephone ceased operations, the book's editors had both enough faith in its message and optimism for the pluralism of burgeoning postmodern discourse for Kitchen Table to retrieve control of and reprint the book. In the foreword to the second edition, Moraga wrote optimistically of the differences between conceiving the book in 1979 and reprinting it in 1983, suggesting that feminism was growing receptive to the words of contributor Donna Kate Rushin: "Stretch or drown / Evolve or die."[7] The message and influence of Kitchen Table's reprint of *This Bridge Called My Back*—along with *Home Girls: A Black Feminist Anthology*, edited by Smith and published shortly thereafter—would force academics and activists alike to acknowledge and see beyond the (witting or unwitting) Eurocentricity of the feminist establishment. The success of these collections ushered in a new wave of feminist discourse both by and about women of color that helped rejuvenate feminist theory and encourage women of different races and classes to consider their relationship to a women's movement many assumed spoke only to and for Anglo women of the upper classes.[8]

In response to these changes, Kitchen Table began (but would ulti-
mately never publish) an anthology titled *The Third Wave: Feminist Per-
spectives on Racism*, which represented the first coordinated effort to
use the term "third wave" in the feminist movement—significantly,
to mark not an age-based shift, but a philosophical one based on the
period's larger investigation and critique of the movement. This emer-
gent wave theorized by Kitchen Table can be viewed in the broader
context of postmodernism, where there was a parallel effort to articu-
late the period's break with what came before, as contemporaries like
Fredric Jameson and Craig Owens were calling for a cultural "reaudi-
tion of the oppositional voices of black and ethnic cultures" alongside
those from "women's or gay liberation"—all of which were growing
increasingly prominent in and pertinent to postmodern thought.[9] Chi-
cana theorist Chela Sandoval would later articulate this cultural moment
as one marked by the revelation that not only feminists, but in particu-
lar feminists of color had "long understood [the postmodern notion]
that one's race, culture, or class often denies comfortable and easy access
to either category, [and] that the interactions between social categories
produce other genders within the social hierarchy."[10] Or—as simply
stated at the start of *This Bridge Called My Back*—"We learned to live with
these contradictions. This is the root of our radicalism."[11] As such, many
postmodern progressives realized that the "bridge-building" for which
feminists of color provided a model needed to extend to other issues
of difference within the movement. As succinctly stated by Dorothy
Allison: "If we could hope for this across the barriers of color and class,
why not across sexuality and gender? And if the writers in *Bridge* could
make themselves vulnerable while still insisting on a shared vision of
feminism, I believed that I had a responsibility to do the same."[12]

However, while feminism—as a movement whose second-wave roots
lay in Leftist critiques of both racial and class inequality—took seriously
the challenges of their working-class and non-Anglo sisters, the issues
of sexuality and gender to which feminists like Allison leapt as parallels
were much tougher sells. The subject of sexual orientation—whether
as an identity or a practice—was long a touchy one within the move-
ment, polarizing because of the inevitable individuality (as opposed to
collectivity) of the positions it asked women to take. However, when
the AIDS epidemic of the 1980s created an international panic over the

"gay plague," both gay men and lesbians responded with an unprece-
dented unification of their traditionally separate communities that led
not only to highly effective activist counterattack—against both the
lack of cultural support for finding a cure and the homophobia that led
to this lack—but also to an exchange of resources and knowledge that
would lead to new thought about sexuality as an activist issue in the
feminist community.[13] This approach was led by the postmodern re-
thinking of collective identity brought about by the constellation of
new allegiances forged within AIDS activism. As Nancy Whittier's study
of these allegiances makes clear, suddenly lesbian feminists accustomed
to no small amount of homogeneity in their particular feminist circles
were working alongside "lesbians and gay men from various racial and
ethnic groups and classes, as well as bisexuals, transsexuals or 'transgen-
derists,' and those who participate in sexual practices defined as deviant,
such as sadomasochism," resulting in a firsthand experience of collective
identity that needed to embrace diversity to be effective.[14]

Embracing, in turn, the historically derogatory term "queer" as an
identity binding these disparate and even contentious communities
gradually discovering common ground amid their differences, a new
mode of sexual/cultural identity developed to make the same demands
for plurality in gay politics as were the feminists fighting for sexual
self-expression in the sex wars. As Rosemary Hennessy would later at-
tempt to define it, queer culture and theory represented "a gesture of
rebellion against the pressure to be invisible or apologetically abnor-
mal . . . an in-your-face rejection of the proper response to heteronor-
mativity, a version of acting up."[15] Astrid Henry has succinctly sum-
marized both its relevance to and legacy in postmodern culture, where
the "messiness" of the term queer was embraced as "its power—its in-
ability to be defined."[16] Like their postmodern contemporaries in cul-
tural studies and feminist activism, queer theorists were increasingly
interested in constructionism and sexual agency and worked to re-
fute the strictly heterosexist construction of both sexuality and the
gendered nature of spectatorship into oppositional, binary structures:
male/active/master/oppressor versus female/passive/servant/victim.[17]
Indeed, for many queer thinkers, "straight-identified" individuals were
welcome for both their support in fighting heterosexism and the poten-
tial sexual openness of their fantasies and behaviors.

These effects of the AIDS crisis would have a profound effect not only on feminist activism and theory but on feminist imagery. As critic and curator Joyce Fernandez articulated this effect, AIDS "forced the gay community to consider its representation within mainstream culture and to acknowledge the political power commanded by that representation." As such, women who identified with queer culture, in an effort to claim images of their own sexuality, looked for inspiration to "gay male culture and produced images of a so-called sexual fringe . . . that refuse, or at least attempt to refuse, assimilation by mainstream culture."[18] The flip side of this strategy was the queer appropriation of mainstream culture's imagery for "assimilation" by the fringe. The pin-up would be conjured for these ends by artists drawing on its familiarity, its popularity, its ambiguity and—amid their own debates between contentious feminist factions—its relevance in countering the stability of the sexual object with the possibility of a sexual subject. As a sexualized image that has historically straddled the line between public and private sexuality, the pin-up represented to many queer artists the first "outing" of their sexuality. Queer artists like photographer Elizabeth Stephens, caught in her childhood "intently studying a pin-up" in her father's machine shop, "wanted the power and freedom to enjoy my own glossy babe-of-the-month." She continued: "There was something about their all-American mix of seduction and repression that both melted me and made me want to take them on a wild ride."[19]

Nowhere was the queer feminist pin-up more clearly sent on a "wild ride" than in the groundbreaking lesbian magazine *On Our Backs*. Founded in 1984, Nan Kinney, Debi Sundahl, and Susie Bright started *On Our Backs* (a taunting play on the title of the virulently antiporn feminist news journal *off our backs*) as an inspired combination of historic lesbian journals by collectives such as the Daughters of Bilitis—which frequently published photographs of its butch-femme couples but avoided explicit discussion of lesbian sexual practices—and campy, lurid, lesbian-themed pulp fiction of the postwar era—which drew upon and exaggerated popular stereotypes of lesbians but was often written and read by women as an outlet for erotic fantasy. The unabashedly sexy *On Our Backs* featured articles on women's health and feminist activism, as well as fiction and photo essays encompassing a wide range of lesbian sex practices and politics. With contributing writers such as

Dorothy Allison and Joan Nestle, and photographers like Tee Corinne and Honey Lee Cottrell, *On Our Backs* hilariously subverted *Playboy*'s concept of a "pleasure primer for masculine tastes" to live up to its own slogan: "Entertainment for the adventurous lesbian."[20]

On Our Backs' sassy critique of antiporn feminism was in many ways part of a larger, increasingly visible critique of what many in the queer community felt had become a rigid dogmatism in both antiporn feminist and lesbian activism where sex was concerned. As Gayle Rubin lamented in 1981, "now [lesbian] sex has to occur in a certain way for it to be good. And the only legitimate sex is very limited. It's not focused on orgasm, it's very gentle, and it takes place in the context of a long-term, caring relationship. It's the missionary position of the women's movement."[21] It was also, as Allison would write, a perspective that didn't reflect most women's varied and complex sex lives: "I argued that there was a gap between their theory and my reality—that there were lots of lesbians who fucked around, read pornography, voted Republican (a few anyway), and didn't give a damn about the National Organization for Women. . . . Real lesbians are not theoretical constructs."[22] In line with the ideas of burgeoning queer theorists, *On Our Backs* explored how the unruliness of sexuality problematizes antiporn constructs by actively demonstrating the fluidity of desire and power as well as gender—often with an ironic sense of humor.

Pin-up photography played heavily into the magazine's content, but always with a subversive edge—the first *On Our Backs* centerfold was called "Bull Dyker of the Month," and the s-m–influenced imagery was often modeled on the hammy, camp style of vintage Bettie Page pin-ups. A good example of such strategies can be found in its fifth anniversary issue, in which magazine founder and contributor Susie Bright posed for a particularly hilarious pin-up by the photographer Phyllis Christopher (fig. 86). The image was part of a larger pin-up pictorial called "A Day in the Life of *On Our Backs*," spoofing the notion that these lesbian sex radicals (real women with jobs, families, and the same, myriad responsibilities of most adults) actually lived the journal's fantastic scenarios 24/7. Here, as in Page's classic bondage imagery, Bright shouts in mock protest while bound spread-eagle to a bed frame. The new twist to Bright's sexual persona, however, is that unlike the original (who would have been dressed in appropriately seductive lingerie or bond-

86: Phyllis Christopher, Susie Bright in *On Our Backs*
fifth anniversary issue, 1989 (Courtesy of the artist,
© Phyllis Christopher)

age gear), the postmodern feminist version finds the subject wearing a T-shirt (promoting the butch lesbian folksinger Phranc) over a pair of cigarette pants, and instead of beautifully arranged makeup and hair Bright wears a facial mask and curlers.

Both sexy and comical bits of suggestive detail abound. Bright's boudoir mules and a Hitachi Magic Wand vibrator lying on the bed imply the subject has been making use of the *Hustler* magazine and Marilyn Monroe pin-up paper-doll book lying beside her. A closer look, however, also finds a copy of *The Village Voice, The World of Pooh*, a *Mary Poppins* songbook, and—in direct reference to Dworkin and MacKinnon's teaming with Republican legislators on this very study—the 1986 *Attorney General's Commission on Pornography's Final Report*. (Bright was on record declaring of the Meese report: "I masturbated to that report until I just about passed out—it's the filthiest thing around! And they know it!")[23] Surrounding the subject is not a dungeon torture chamber, but an ordinary domestic bedroom, where Bright is surrounded by what appears to be her eclectic morning reading. Indeed, as Bright herself has said of the image's ironic narrative, "that photo was supposed to be the way I typically wake up in the morning."[24] Packing its pin-ups with contradictions and ironic humor, *On Our Backs* demonstrated how the genre's theatricality afforded single images like this one an array of politicized meanings, and its lead was followed by groups like the Canadian collective Kiss and Tell, and the English lesbian magazine *Quim*.[25]

In the same year that *On Our Backs* was launched, the Carnival Knowledge collective organized a multimedia exhibition and conference at the Franklin Furnace, titled *The Second Coming*, to serve as "an erotic carnival providing a new definition of pornography, one not demeaning to women, men, and children."[26] While the group's members were largely straight, prosex feminist activists, the show's embrace of sexual diversity reflected the influence of queer theory upon feminism's evolution in this period. The 1984 show was also a landmark feminist collaboration with sex workers, who worked with the group on its objects, installations, and performances—all of which explored the place of sexual self-expression in these women's feminist politics. The exhibition's "Deep Inside Porn Stars" panel discussion brought publishers, porn stars, and performance artists (and combinations thereof) together to talk about the place of eroticism, sexual orientation, and feminism in their various

works and professions. In a portrait of the panel's participants by photographer Dona Ann McAdams, the spirit of the 1970–71 Fresno "class portrait" pin-up was resurrected, in this case with the panel participants provocatively posed topless behind placards identifying each woman's role in the talk. (Reflecting the point of the session—to assert that "porn star" and "feminist" are not mutually exclusive roles—the placards do not necessarily correspond with what position/profession society might stereotype each woman based on her career.)[27] In her review of the show, Arlene Raven—a pioneering activist since the start of the second wave—struggled with what *The Second Coming* meant in the context of feminism's ongoing evolution, bringing together and problematizing as it did the distinctions between feminist and porn star, gay and straight, and concluded: "Beginning to build alliances between women surviving in such different milieus as those who created *The Second Coming* is neither sexy nor comfortable. . . . But only by accommodating differences now will we be able to survive long enough to finally, maybe, reach the point at which we can fight oppression instead of each other; take and use any image as our own."[28]

This drive to "take and use any image as our own" was further explored with the 1986 publication of *Caught Looking: Feminism, Pornography, and Censorship*. Published by the Feminist Anti-Censorship Taskforce (FACT)—one of the several groups formed to organize feminist activists in an effort to counter what they viewed as the outsized visibility and influence of antiporn groups in the movement—the book was intended "as a guide for further activism against the state's efforts, and the efforts of others, to control, suppress, determine, moralize about, or censor women's expression and exploration of [their sexuality]."[29] *Caught Looking* featured the erotic imagery and self-portraiture of *On Our Backs* veterans Corinne and Cottrell and emerging feminist artists and sex workers Sprinkle and Veronica Vera (fresh from their recent participation in *The Second Coming*), as well as imagery culled from pornographic magazines, pin-ups, and advertisements. The book's imagery and essays underscored the complex links between feminist sexual expression and popular visual culture, questioning the notion that such imagery intrinsically objectifies women. *Caught Looking*'s juxtaposition of contemporary feminist work and the wildly varied historical images that inspired it (selected by FACT's designers mostly from members' pri-

vate collections) was revelatory in its suggestion of the direct affinities between sexualized imagery from feminist culture and popular culture. The book was a bedroom-baring exposé of its activists' desires, which attempted to answer the question that had for years been silently pondered by women confused by antiporn feminists' insistence on the inherent difference between erotica and pornography—a question succinctly posed by writer Joanna Russ: "If erotica was different from porn, why didn't [they] give examples of erotica that got *them* excited?"[30]

Also important was the fact that, reflecting the period's new impetus toward plurality across the women's movement, the imagery of *Caught Looking* followed neither a straight nor a lesbian trajectory, nor did it look like FACT's largely Anglo membership. Rather, the imagery was pointedly queer and multicultural: imagery was culled from sources (whose sexual images ranged from "vanilla" to hard-core B-D/S-M) aimed at straight men and women, lesbians and gay men, and transgendered individuals; fashion and glamour photography; nineteenth-century cartes de visite; blue movie film stills; and even medical illustrations. The imagery included men and women (both together and alone) of African, Hispanic, and Asian descent in the same range of activities and poses as the book's Caucasian subjects. Clarifying the journal's creative ideal of an open "omnisexuality" was a pieced-together pin-up at its center, compiled of women and men of ambiguous racial makeup and from different eras, engaged in a spectacular act of autoeroticism. As Deborah Bright would later say about the relevance of this publication: "By showing such a wide-ranging selection of porn, *Caught Looking* sought to both demystify it and to demonstrate that it wasn't the instrumentally misogynistic product anti-porn feminists described. Rather, it catered to an array of nuanced fantasies and desires, utterly disrespectful of gender conventions."[31]

<div style="text-align:center">

The "Feminist Postmodern":
Third Wave Moves from Margin to Center

</div>

The influence of these developments upon women's use and interpretation of sexualized imagery during the 1980s cannot be overestimated. Writers and artists working in that idiom subsequently had more op-

portunities, contexts, and communities in which to disseminate and discuss their work. As new feminist theory spread—as per the title of bell hooks's influential book of the period—"from margin to center," so the ideas therein would begin to pierce mainstream culture in such a way that the notion of a third-wave break from the feminism that came before it became palpable and popular. Indeed, the success of these postmodern feminist statements to not just analyze but influence popular culture in the early 1980s is easily witnessed in the rise of the decade's ultimate, unavoidable icon, Madonna. Madonna's breakthrough album *Like a Virgin* was released in 1984 and was denounced by many second-wave feminists as symbolic of the Reagan era's antifeminist backlash—and with submissive songs like the title track, as well as the notorious paean to materialism, "Material Girl," who could blame them? Madonna would, however, gradually be recognized and embraced by many within the movement as a symbol of the shifting practices of feminist culture in the postmodern era, taking feminist thought into uncharted territory.

Although theoretically making her name as a singer, it was Madonna's popular (or populist?) variation of performance art and self-portraiture—videos, concerts, interviews, films, and of course pin-ups—that would make her a celebrity. But it is important to remember that before she became a pop phenomenon, Madonna was part of the same burgeoning Lower East Side art scene in Manhattan of the late 1970s and early 1980s that would bring artists like Cindy Sherman to the attention of the art world.[32] Like Sherman, Madonna grew up in an era of repression and came of age in the midst of the feminism's second wave (with which she has openly identified), and in the work of both women we see similar forms of identity construction and ironic subversions of feminine stereotypes. (Indeed, subtly speaking to the underlying affinity between the two "artists" is Madonna's recent individual sponsorship of the Museum of Modern Art's 1997 traveling retrospective of Sherman's *Untitled Film Stills*.) However, as she is several years younger than Sherman, Madonna's own star turn would take place after—rather than at the start of—the explosion of prosex feminist theory and the rise of queer culture in the late 1970s and early 1980s. As such, her mainstream breakthrough in their wake would use aspects of both in a more explicit and self-consciously campy fashion, with a sense of comfort that almost seemed to take such radical discourse and activism for granted—an ex-

aggerated, never earnest, and definitely postmodern pose that media historian Angela McRobbie has called "ironic femininity."[33]

Moreover, Madonna seemed to take Sherman's postmodern feminism to new levels. First, Madonna embraced queer culture, which produced her most adoring audience, as well as a direct source of inspiration that Sherman's work (even the artist's 1989–90 *History Portraits* that found her in period drag) never so openly acknowledged. Second, she also openly paid homage to black and Latin American culture in her appropriation of disco and dance sounds, hip-hop street gear and dance moves (often, as in her "vogueing" phase, from subcultures within these subcultures)—acknowledgments of race and racial difference that only rarely permeated Sherman's pictorial universe. Finally, whereas in interviews (presumably, as in life) Sherman made clear distinctions between her "real," everyday self and the characters she created for her photographs, Madonna made no such distinctions between her star image and her self, and her model encouraged others to similarly construct and control their lives according to their own fantasies. As cultural historian Andrew Ross would later write, Madonna seemed to live and share an outrageous new world "in which the unqueer, unlike the undead, do not haunt with menace, and where picaresque adventures in the flesh trade are conducted with safe passage across a landscape lavished with neon proclaiming, 'This is Dangerous. Try It.' "[34]

Indeed, it was her ability to speak to and inspire imitators across gender, race, class, and sexual preference that make the queer world she continues to inhabit subversive. As she is no great beauty—with her gap-toothed smile and plain features—fans and detractors alike acknowledge that every ounce of Madonna's allure comes from sheer will and hard work. Promotional pin-up imagery of Madonna tracks her carefully scouted, up-to-the-minute fashions, from the "outerwear underwear" of her early career to her Kabbalah-inspired styles of late; heavily and expertly applied makeup giving way to more natural looks; a head of hair constantly fluctuating between long and cropped, blonde and brunette, often with the obvious help of outrageous wigs and extensions; and her soft, curvy figure giving way to a muscular, gym- and yoga-sculpted body, which has twice bounced back after healthy (and publicly flaunted) pregnancy weight gain. Again, she invites viewers to marvel at her exploits while suggesting that they, too, may choose to

"try it" without shame or fear—and certainly without the DNA of a Teutonic Amazonian supermodel. Even Madonna critic bell hooks—who famously called Madonna a modern-day Shirley Temple to black pop culture's Bojangles[35]—would admit, "what some of us [black women] like about her is the way she deconstructs the myth of 'natural' white girl beauty by exposing the extent to which it can be and is usually artificially constructed and maintained. She mocks the conventional racist defined beauty ideal even as she strives to embody it."[36]

And it *is* a marginalized audience to whom Madonna always seems to speak: from the start of her career, it was women and gay men, not straight men, who responded to her flirtations, leading to a slavish following whose imitation of her ever-changing style would help bring the term "wannabe" into the English language. As sexologist Carol Queen has written of Madonna's audiences,

> Straight men aren't the audience Madonna aims to address; no wonder so many of them don't like her. They'd be glad to fork over money if they felt she was *looking* at them, maybe even that she was styling herself with their particular gaze in mind. Ironically, though, the woman whose supposed pandering to men outraged so many feminists is really dressing up and performing for a mirror, and here again her queer and camp sensibilities get in the way of her being a traditional male's traditional object of traditional desire.[37]

Because of the effortlessness with which she embodies the notion of what might be safely addressed as postmodern feminism, Madonna may be both the perfect coda to the 1980s and the perfect entrée toward our present moment in feminist history. In their effort to track and define the far-reaching and contradictory ideals of contemporary feminism, Jennifer Baumgardner's and Amy Richards's *Manifesta* significantly begins its list of "what the Third Wave grew up with" with the debut of *Like a Virgin*. They argue that for many young women who came of age in the formative years of this era, to discover Madonna was to effectively discover their own feminist identity via her simple (but outrageous) message: "Be what you want to be, then be something else that you want to be."[38] Cathy Schwichtenberg elaborates on the discursive and activist potential of this model. In "Madonna's Postmodern Feminism," Schwichtenberg argues that "Madonna's shifting persona and stylisti-

cally seductive aesthetic are all hallmarks of a postmodern commodity culture where modernist notions of authenticity surrender to postmodern fabrication . . . [leading feminists] to entertain multiple styles, surfaces, sexualities, and identities [that] may move us from the margin to the center in coalitional acts of resistance and disruption."[39] Paula Kamen concurs: "She made female sexuality an object of public discussion, as something separate and distinct from male sexuality, and introduced themes reflecting women's sexual diversity."[40] Andrew Ross brilliantly (and hilariously) parallels Madonna's relationship to third-wave feminism to "what environmentalists call a charismatic mega-fauna: a highly visible, and lovable, species, like the whale or spotted owl, in whose sympathetic name entire ecosystems can be protected and safeguarded through public patronage."[41] And, it is true: the woman that *Time* magazine denigrated as a "sweaty pinup girl come to life" has, ironically, come to serve as an icon for third-wave feminism in much the same way that Gloria Steinem or Angela Y. Davis have for the second wave.[42]

Madonna—forty-seven years old at the publication of this book—embodies both the contradictions of feminism's third wave and the impossibility of nailing down a "birth date" for the same. Her work—like that of contemporaries such as Sherman, Sprinkle, Bright, and Christopher—informed both feminist and popular culture in ways that molded the younger women with whom our present era is most closely associated. Generally identified as the women of Generation X, born in the 1960s and 1970s, these women grew up in the midst of tremendous shifts in feminist practice. For these women, previous generations' radical readings of media imagery would be inherited as a veritable second language—as evidenced in the media and genre savvy of Madonna. Yet, though the feminists who came of age in the third wave have an outrageous array of and access to media that their mothers could have hardly imagined—photocopy machines, personal computers, and the Internet—they nonetheless instinctively recognize its propagandistic value in ways similar to their predecessors. Popular media are viewed as unavoidable and strategic; as Germaine Greer recently asserted, like their foremothers, younger feminists today know the value of "cheap publishing and mass propaganda . . . [which] insists upon communication, accessibility, and immediate, tangible relevance to the everyday

lives of women."[43] But unlike the many second-wave women who were saddled with the "feminine mystique" on their road to feminist consciousness, both women and men growing up in the years afterward were raised in a culture saturated with the influence of the women's movement: the frank and sympathetic novels of feminist writer Judy Blume; celebrities ranging from *That Girl* Marlo Thomas to All-Pro defensive lineman Rosie Greer guiding them toward the notion that "You and me are free to be . . . you and me" in the wildly popular 1970s television special, record, and book of the same name; and powerful and ingenious (if jiggly) television heroines like *Charlie's Angels* and *Wonder Woman*. As teenagers, whereas some took advantage of new equal-opportunity laws, like the U.S. federal Title IX, which affected their school programs, many others discovered underground or "alternative" art and music communities—rock, punk, and later indie rock artists and performers—where women were increasingly likely to be visible participants.[44] As young adults they entered professions and institutions of higher education shaped by decades of recent and wildly diverse feminist theory, often taught as part of the newly ubiquitous women's studies programs now part of university curricula across the Western world.

This generation entered the 1990s as the embodiment of the "feminist postmodern" for which Susan Rubin Suleiman called at the decade's start, when she argued "for the recognition of both differences and joint allegiances between male avant-gardes and contemporary feminists, as well as for the recognition of multiple differences between and among women. . . . In short, I argue for complication and fine distinctions over simple oppositions, for internal divisions and double allegiances, even at the expense of disorder and certain clutter."[45] However, as Nancy Whittier has noted, while in this era "women happily entered formerly male colleges and universities, pursued previously male-dominated careers," there came a false but growing sense among women that they were both "unhindered by any remaining limits" and that those who "persisted in calling attention to sexism or raising feminist issues . . . were needlessly fighting old battles."[46] Developing affection for the term *postfeminist*—as if women had somehow moved beyond or rejected the need for, or even existence of feminism—mass media in the United States and Europe latched on to this evolution in feminist thought as if it were a revolution of young women rejecting the term. In reality, as evidenced in

the more nuanced studies of today's feminist culture that will be discussed here, there is not only a greater embrace of feminist issues among young women today than there might at first glance appear, but also an unprecedented sense of entitlement to the rights for which their predecessors fought.

Granted, the identification and visibility of a third wave emerged only after the dramatic splintering of feminism in the 1980s led to a subsequent disunity that, while thriving as an interpretive practice in the academy, resulted in a relative lull in organized activism. However, in Rebecca Walker's 1992 *Ms.* magazine essay "Becoming the Third Wave" —inspired by the wounds inflicted upon the American women's movement in the wake of the Clarence Thomas hearings—feminists across issues and generations felt a rallying cry. Walker's article is often credited for articulating the need for a third wave of feminism not only to battle the antifeminist climate ushered in and nurtured in a world led by three consecutive Republican administrations in the United States—which by 1992 stood alone as the First World's superpower—but to resuscitate feminism itself. Rejecting the popular media buzzword *postfeminist*, Walker declared "I am not a postfeminism feminist. I am the Third Wave."[47] The daughter of the writer Alice Walker—whose own writing and activism were informed by and tremendously influential to both the second wave of the movement and the feminists of color who sought to instigate and articulate a third wave out of it—Rebecca Walker's declaration and person would come to symbolize a resurgence, but also a "break" within feminism in the 1990s. As literary scholar Astrid Henry has argued, Rebecca Walker's specification is telling: choosing to pointedly frame her feminism in the context of a "third wave" seemed to indicate that whereas "Alice could use feminism as a way to move beyond her own mother, the only way that Rebecca [could] remain a feminist and yet distinguish herself from her mother is to try to chart new territory *within* feminism."[48]

As such, while the term appropriated by Walker had roots going back nearly a decade—reflecting the movement's postmodern move toward criticism of and definition against preceding feminist practices —Walker's identification as a third-wave feminist and call for young women to reenergize the movement by joining her would indelibly mark the third wave not as a cultural shift in feminist history, but as

a generational one. As Nancy Whittier notes in her study of "feminist generations," these shifts have occurred across the movement's history, as incoming activists seek "to alter the meaning of 'feminist,' while earlier cohorts retain their own definition of feminism and feel alienated, confused, or disapproving as the new movement promotes a changed collective identity."[49] However, as compellingly argued by Henry, there is nonetheless an unusually vehement sense among feminists today that they both connect to and disavow the feminisms that came before them. There is also tremendous meaning behind both older and younger women's tendency to see the third wave as a generation rather than an era; for while "the notion that a cohesive generational unit is itself always a fiction . . . [and] the recent focus on generations should not lead us to believe that all forms of feminist conflict are, in truth, generational, neither should we treat as irrelevant the apparent persistent need to describe this conflict in generational terms."[50]

Unsurprisingly, one of the many things both binding and separating these generations within contemporary feminism is the issue of sexuality. As we have seen since the start of the women's movement, younger women — in the prime of their childbearing years and likely to sexually experiment, not to mention appreciated as sexual beings by culture at large for both reasons — have historically embraced sexual expression as a feminist issue after their older contemporaries have grown either weary of or timid about the subject. Coming of age in the wake of both the second wave and the sexual revolution, young women today approach their sexuality and its representation with an unprecedented sense of confidence born of their unprecedented privileges. As Kamen notes: "On the one hand, we now have a 'sexualized marketplace,' the result of society's greater openness about sex. Sexualized pictures are everywhere, used to sell every product possible, but in a market still dominated by male tastes and defining female sexuality as what is attractive to men. On the other hand, women now have more control over their sex lives because of their access to sex education, erotica, and information about their bodies."[51] As a result, younger feminists tend to feel far less cause for immediate suspicion about what pop culture is "telling" them about their sexuality, as well as empowered to manipulate those messages to suit their purposes.

In addition to different messages about femininity and sexuality,

younger feminists today also witnessed many different versions of what feminism itself could be, a fact addressed by Leslie Heywood and Jennifer Drake in their introduction to a recent collection of third-wave essays. They note that younger women today "grew up with equity feminism, [and] got gender feminism in college, along with poststructuralism." However, as a result of the expanding feminist discourse they grew up taking for granted, Heywood and Drake also note that the third wave subsequently took it upon themselves to "work on a feminism that strategically combines elements of these feminisms, along with black feminism, women-of-color-feminism, working-class-feminism, pro-sex feminism, and so on."[52] This postmodern plurality is also reflected in the tremendous influence on contemporary feminism of postmodern theorists such as Judith Butler and Donna Haraway, each of whose work on identity construction was born of the heady climate of the movement in the 1980s. Butler's constructionist work on the instability of gender (an identity not necessarily tied to one's biological sex) argues that once feminists understand themselves as possessing a "culturally constructed body," perhaps they might usher in a world in which all humanity might be "liberated, neither to its 'natural' past, nor to its original pleasures but to an open future of cultural possibilities."[53] Likewise, Haraway has argued for the potential of constructionism by conjuring the ultimate postmodern creature: the cyborg. "A creature in a post-gender world," Haraway writes, "it has no truck with bisexuality, pre-oedipal symbiosis, unalienated labor, or other seductions to organic wholeness through a final appropriation of all powers of the parts into a higher unity." Comprised of women and men struggling together in the present, but unified by a future-minded effort to organize humanity through the genderless logic and vocabulary of technology, Haraway's "Cyborg Manifesto" proposes a feminist movement that stands "for *pleasure* in the confusion of boundaries and for *responsibility* in their construction."[54]

Because of such influential expansion and pluralism in feminist thought, it is unsurprising that younger feminists tend to feel their sex has much to explore and celebrate, rather than simply get angry about. As designer and design historian Liz McQuiston has noted in her exploration of feminist graphic art, *From Suffragettes to She-Devils*, contemporary artists tend not to dwell on earlier feminists' trials, but rather

on their *"celebrations*—of heroines and activities both past and present—
[that] not only brought a sense of continuity with past struggles, but
also encouraged a new vision of creativity and culture in the present."[55]
Moreover, younger feminists seem to recognize in their optimism about
and mastery of popular imagery an opportunity to expand the reper-
toire of celebratory images with which to work. They are also spurred
on by theorists like Haraway, for whom feminism's "power to survive"
might be found "not on the basis of original innocence, but on the basis
of seizing the tools to mark the world that marked them as other . . . re-
coding communication and intelligence to subvert command and con-
trol."[56] In other words, by looking to theory and popular visual lan-
guages that might underscore female power and plurality—as opposed
to oppression and unity—younger women who identify with feminism
today have found tools for self-expression and a place for themselves in
the continuum of feminist evolution.

In the gallery arts, we see from the start of the 1990s layered and sub-
versive appropriations of the pin-up that reflect this evolution. These
artists' work echoed and amplified many strategies of feminist pin-ups
that preceded them in the 1980s, but with a subtlety or ambivalence con-
siderably different than the still strident appropriations of the previous
decade. Marlene McCarty's 1992 matchbook pin-ups (fig. 87) from her
Hearth (Feurerstelle) installation are exemplary of such third-wave strate-
gies visible in the art world at the decade's start. As the artist has said
of the works: "Matches interested me as a small, transportable medium
that traveled through many hands. . . . I saw matches as message packets
which never really returned to the original donor but continued to
travel through various social spheres." Her use of pin-ups, however,
came after the artist began perusing the licensed images available for
purchase by matchbook manufacturers and was surprised to find vin-
tage pin-up images among the "candlelight dinner" and "flower photos."
Puzzled by the absurdity of these charged images amid otherwise be-
nign ones, McCarty felt compelled "to do something just as absurd to
'liberate' them."[57] She chose to reproduce the pin-ups as-is but, rather
than advertise phone sex or escort services—the purpose that such pro-
vocative matchbooks ordinarily serve—she instead inscribed the "ad"
portion as if it were a voice-caption for the pin-up herself, declaring:
"I got a CLIT so big I don't need a DICK."[58] Visitors to the exhibition

87: Marlene McCarty,
*Matchbooks from Hearth
(Feuerstelle)*, 1992
(Courtesy of the artist)

88: Shonagh Adelman,
Yvanna from *Playgirls*
series, 1998 (Courtesy of
the artist)

were encouraged to take the matchbooks home, and presumably, cir-
culate them outside of the gallery space, where their antagonistic but
sexually provocative text was meant to give pause to users accustomed
to such free matchbooks advertising services aimed at men's pleasure.[59]

The following year, Lutz Bacher "liberated" her own prefab pin-ups
in the *Playboys* series. Like McCarty's work cultivated from but con-
ceptually twisting preexisting sources, Bacher's series consists of images
derived directly from Alberto Vargas's *Playboy*-era pin-ups. As we have
seen, created with the magazine's generally sexist editorial philosophies
in mind, the original works were accompanied by airheaded, comical
one-liners that speak to the women's submission to the male viewer/
lover. In addition to Bacher's seemingly baffling choice of images to
appropriate, the works' meaning shifts when one learns that they were
not in fact painted by Bacher, but by a commercial illustrator hired by
the artist. Unlike the originals—painted in watercolor on paper and
with an obsession for the surface details of the figures' faces and bodies
—Bacher's works were painted flatly with shiny acrylic on canvas to
undercut any sense of the originals' illusory, tactile sensuality. The series
finds a feminist artist choosing to steal images by a male artist, and then
hiring a male artist to do the work, which she subsequently claims as
her own, serving as a meditation on not only the commercialization
of sexuality but the issues of "authorship" and gender—and changes
in the same since the Vargas pieces were first published (between 1957
and 1978). Pointing to this convergence of facts, Elizabeth Hess noted
Bacher's obvious affection for the originals while simultaneously striv-
ing to free "the girls from their *Playboy* balls and chains." The result is
"a paradigmatic heterosexual fantasy that has been annihilated by the
feminist movement," reminding us that though the original has been
effectively killed, it awaits "necrophilic attention."[60]

Bacher's cultural necrophilia represents a strategy shared by many
third-wave artists who—unlike previous generations of feminists for
whom the pin-up represented the very real and oppressive sexual and
aesthetic demands made of women before the second wave—view the
pin-up as an outdated, if loaded, icon of the past. As such, by the end of
the decade one finds third-wave artists working not to "annihilate" the
fantasy that artists like McCarty and Bacher sought to conjure (before
demolishing) so much as to problematize the supposedly stable mean-

ings behind that fantasy—thus creating a much more ambivalent femi-
nist pin-up. Shonagh Adelman's 1998 *Playgirls* (fig. 88) series is a case in
point. The series finds the artist operating in a mode similar to Bacher's,
but rather than undercutting the heterosexual male fantasy that the illus-
trated pin-up represents, Adelman is instead appropriating that fantasy
on behalf of queer culture. A feminist philosopher as well as an artist,
Adelman creates writing, art, and curatorial projects in which the sexu-
alized woman in popular culture is a recurrent theme; earlier projects
like *Teledonna* (1992) and *Skindeep* (1993) explored ways in which com-
mercially produced erotic imagery of lesbians created for men often
inspires and can be manipulated to reflect lesbian desire even as the pic-
tures maintain their appeal to straight male viewers.[61] Her *Playgirls* con-
tinued this exploration, insinuating the presence of the desiring female
spectator among the pin-up's audiences. However, this series addition-
ally sought to address the grotesque nature of the pin-up—and both the
feminist and antifeminist potential of this fact.

Dividing extreme bodies of women appropriated from comics, fash-
ion photography, and cheesecake illustration into thirds, Adelman re-
produces and reassembles the source imagery into seamlessly merged,
tripartite pin-up paintings based on the surrealist "exquisite corpse"
drawing game. Head-and-bust studies in ink on gessoed plastic and in-
tricately decorated fabric calves and feet are cut to form and mounted
flush against the wall in imitation of wall graffiti and decoupage, respec-
tively. These upper and lower extremities are then intersected by tra-
ditionally mounted, oil-on-linen canvases, which comprise the figures'
midsections. The silhouettes and contours of Adelman's monumental
women, like the game that inspired them, merge seamlessly into one
another. The radically different media and dimensionality of each com-
ponent, however, also assures that the viewer's desire to fully incorpo-
rate them into a single, natural whole will be thwarted. Once lured by
the familiarity and technical mastery of these luscious pin-ups, one must
simultaneously confront the monstrous nature of their size, aggressive
presence, and confrontational superiority. In yet another contradiction,
the individual works' titles—*Faye, Sadie, Gabrielle*—breathe life and add
an unsettling sweetness to these prefab creatures. As such, Adelman's
playgirls are deceptively accessible.

As we see in works like *Yvanna*, her talent as both a draftsperson

and painter beckons viewers to appreciate the works' adept imitations
of popular iconography and sensual human forms, fabric textures and
backdrops from nature. However, once lured into the technical mas-
tery of these luscious pin-ups, one must simultaneously confront the
monstrous nature of their size, aggressive presence, and cut-and-paste
construction. In *Yvanna*, the head of a film noir villainess looks into
the distance, cigarette dangling from her lower lip, while her soft-focus
midsection, clothed in a sweet, filmy sundress, leans with her back
against a Barbie-pink wall in a pose of either seduction or passivity—
depending, of course, on whether you believe the expression or the
sundress. On the one hand, as Adelman writes of her aversion to plas-
tic surgery victims like the infamously enhanced Jocelyne "Bride of"
Wildenstein, "this series of hybrid creatures, among other things, in-
vokes the extent to which the technological revolution has enabled
real Frankenstein spectacles." On the other, she asserts that the works
also suggest "that a little tampering can turn any old super-model into
a super-heroine," by literally embodying the sexual/identity ideal of
Donna Haraway's paeans to the pleasurably pieced-together cyborg.[62]

That same year, Renée Cox's interest in the "super-heroine" led her
to an even more direct source in her own series of pin-up self portraits,
Rajé: A Superhero (The Beginning of a Bold New Era). The series came about
after the artist discovered an early 1970s Wonder Woman comic that
briefly introduced the heroine's twin sister from Amazonia—revealed
to be a powerful black warrior named Nubia. On the one hand disap-
pointed to find the character disappear almost immediately from subse-
quent issues, on the other appalled that the comic would draw so literally
and stereotypically upon feminism's "dark side," the artist decided to res-
urrect and recuperate Nubia in a contemporary, quasi-autobiographical
form: she crossed the classically inspired black Amazon with a fierce
Brooklyn homegirl to create Cox's alter-ego, Rajé.[63] Dressed like a per-
sonification of the Jamaican tricolor, Rajé's superhero costume includes
the popular, "ghetto-fabulous" accoutrements of hip-hop divas: a swirl-
ing, dreadlocked updo, chunky platinum jewelry, and patent leather,
thigh-high boots. Cox's series of self-portraits suggest Rajé's adventures
in the single-frame and sexualized format of the pin-up—here vowing
vengeance before the burning crosses of the Ku Klux Klan, there poised

seductively in the Statue of Liberty's crown while keeping watch over the world (fig. 89).

In the series, Cox invests the fantasy pin-up with the power to battle racism and sexism in the real world.[64] Cox herself has discussed her interest in using such work toward "flippin' the script"—appropriating iconic images traditionally associated with whiteness or oppression and giving them black faces and positive meanings. Her choice of imagery associated with American pop culture is strategic and, she argues, internationally relevant since, as we have seen in the pin-up's global importation after World War II, "the U.S. is the prime exporter of [stereotyped] images in the world."[65] It also exposes an unsettling fact of the pin-up's history by underscoring the genre's almost exclusive association—up to the present day—with white sexuality. The resulting revision of these images both underscores these images' inherent power and undermines their traditionally oppressive or exclusive meanings— new meanings that relate to Cox's interest in both power and pleasure, and of course the ambivalence that marks much feminist art in the movement's third wave. As photographer and critic Carla Williams wrote of the series, Cox leads viewers toward a vision of "black people at ease with their sexuality and the display of their skin . . . repositioning power in the black female body and making that power active rather than metaphoric."[66]

More recently, Cox has revisited the pin-up and her ambivalence toward the genre in a far more complex and personal series of images from her 2001 *American Family* exhibition. The series—which in an interview Cox herself comically subtitled the "diary of a mad housewife"— deals with issues of "female fantasy and desire and how that ties into family."[67] The images show Cox, a Jamaican American child raised Roman Catholic, a black activist married to a white man, and a feminist artist raising two biracial sons, working through such contradictions in her life with bittersweet humor and pleasure. The pin-up is conjured as a cathartic method of working through sexual repression in works like *The Good Little Catholic Girl* and *Holy Communion*. In each of these works, Cox sandwiches portraits taken of the artist as a young girl with recent self-portraits in which Cox seems to console her awkward and camera-shy young self with images of herself as a fierce and boldly

89: Renée Cox, *Chillin' with Liberty*, 1998 (© Renée Cox,
Courtesy of Robert Miller Gallery, New York)

sexual woman. A particularly touching work from the series shows the pin-up doubled on several levels: *Mother* pairs a 1940s pin-up photograph of Cox's mother—posing in a bathing suit on an urban rooftop—with a contemporary image of the artist, who wears a far more provocative variation of her mother's two-piece. Both women engage the camera head-on with an upright, frontal pose, suggesting the source of the artist's beauty and confidence. However, the artist's seductive swagger and knowing look differ subtly but significantly from her mother's relative rigidity and offhand smile, suggesting as well the self-awareness and audacity that Cox—indeed, her whole generation of women—has developed because of but does not necessarily share with the woman who raised her.

Riot, Never Quiet:
Putting the Growl in the Pin-Up Grrrl

As varied as their perspectives on feminist history may be—and whether or not they embrace the term *feminist*—all women born since the early 1960s have in common the fact that came to consciousness in a world where a formidable feminist institution always existed. As recent scholarship on the culture of emerging feminists has shown, this has proven to be both a blessing and a curse for the women's movement—a fact that art and popular culture reflect. Comparing her studies of magazines aimed at young women in the 1970s to those at the end of the twentieth century, Angela McRobbie argues that today's journals' casual willingness to deal frankly with issues of sexual health, lesbianism, and self-sufficiency clearly reflected her "own [generation's] political effectiveness as feminists."[68] In Paula Kamen's recent, extraordinary study of "young women remaking the sexual revolution," *Her Way*, she applies this conclusion to the myriad and even contentious factions of feminist thought today—from conservatives in the "neo-virgin" movement to the liberal and sexually voracious "superrats." Kamen argues that these women's personal and professional lives stem directly from the fact that "the once radical values of the women's movement for more equality and education and those of the sexual revolution for sexual permission have

now become fully absorbed into the mainstream's consciousness."[69] In their study of third-wave history and attitudes in *Manifesta*, Baumgardner and Richards—like Kamen, themselves born into this era—note that this fact is readily apparent everywhere: "Today, the feminist movement has such a firm and organic toehold in women's lives that walking down the street (talking back to street harassers), sitting in our offices (refusing to make the coffee), nursing the baby (defying people who quail at the sight), or watching TV shows (*Xena! Buffy!*) can all contain feminism in action."[70] So how, exactly, did *Time* magazine's June 1998 cover justify its announcement's of feminism's death?

Granted, as Erica Jong noted shortly thereafter, between 1969 and 1998, *Time* alone had declared feminism's demise at least 119 times, and the mass media have never embraced the women's movement except to use it against itself.[71] However, this popular "invisibility" of feminism's third wave is not due to a media conspiracy alone. (Although both the cover article, penned by journalist Ginia Bellafante, and Baumgardner's and Richards's published critique of it give one the sense that it was lazily researched at best and pointedly antifeminist at worst.)[72] Indeed, a large part of women's feminist identity in the third wave is the fact of their living feminist lives without necessarily identifying with the "f-word." McRobbie sympathizes with this drive for women to "prove that they can do without feminism as a political movement while enjoying the rewards of its success in culture and in everyday life."[73] This is especially the case when older feminists continue the unfortunate tradition of failing not only to embrace but even to recognize younger women's ideas and issues into a feminist establishment whose goals they have become accustomed to determining—a problem to which much of Baumgardner's and Richards's *Manifesta* is dedicated, articulating the ways in which feminists of late have often pushed younger women away by "deny[ing] that they could benefit from younger feminists' knowledge and experience." As a result, many "young women eager to join the movement find themselves repeatedly cast aside, and so jump ship."[74]

But, as we've seen in feminist culture since the 1980s, those who stay are just as likely to remain invisible within the movement as without. Asked about the work of young feminists for Bellafante's article, the pioneering second-wave writer Susan Brownmiller's dismissal is sadly typical when she says, "These are not movement people. I don't know whom

they're speaking for." The notion that young feminists might be speaking for themselves, in ways different from their elders', goes unexamined.[75] And, in the time-honored tradition of feminists past, in the same piece Betty Friedan latches onto the perceived hypersexuality of young activists, snapping "All the sex stuff is stupid. The real problems have to do with women's lives and how you put together work and family," as if sex is something that affects neither (an idea that her own classic feminist text, *The Feminine Mystique*, itself negated some thirty-five years earlier).[76] Granted, because of their complex and contradictory relationship to the women's movement, younger women's typically postmodern approach to feminism—with its self-conscious sensitivity to plurality and identity leading to perhaps too many subtleties and factions to be defined by anything but its willful eclecticism—does make it difficult to pin down in the ways that second-wave activists had attempted. However, rather than bolstering *Time*'s call for feminism's demise-by-diaspora, the range of feminist identities and ideas that affect contemporary feminism mean that, unlike the urgency and newness of second-wave activism, young women today often simply take for granted the activist statements in their work as well as the potential of activism beyond traditional paradigms. And the fact that there are those among them who identify as the third wave of the women's movement—pointedly rejecting the "postfeminist" tag—asserts the continued relevance of the movement's history in their lives and work. For all these reasons, the youngest women of feminism's third wave continue to claim the pin-up for feminist purposes—often reflecting the irreverence, humor, drama, and identity play of predecessors from Adah Isaacs Menken to Annie Sprinkle.

The third wave's most visibly organized incarnation to date—the brief but fiery riot grrrl movement of the 1990s—not only sketches out the contours of feminist youth culture today but gives us a sense of how the pin-up has become to the youngest of contemporary feminists a kind of visual shorthand for their era. Riot grrrl (spelled thus to suggest the growl in each girl) was a movement founded by teenage and twentysomething women, based on the concept of a grass-roots feminist infiltration of pop culture.[77] The movement particularly thrived in Olympia, Washington, and Washington, D.C, although local members and "chapters" eventually sprung up throughout North America

and Europe, where their most visible activism was felt in concerts and conventions that included music, art, "libraries," workshops, and panel discussions—a tradition that has since been finely honed into annual, international "Ladyfest" conferences and concerts independently co-ordinated by regional feminist groups since 2000.[78]

One of the movement's leaders, Kathleen Hanna, a writer, musician, and former sex worker, asserted that riot grrrl was born of the same sense of frustration, hopelessness, and invisibility that contemporaries like Rebecca Walker felt in the years leading up to the Clarence Thomas hearings; indeed, Hanna's own feminist "click" came as the result of yet another death-of-feminism story, this time a 1990 *Newsweek* report. Angered by both the ubiquity and falsehood of this story as perpetuated by the mass media, Hanna was among those who felt an urgency "to go get a bullhorn and tell everyone [otherwise], because what about all of these fourteen-year-old girls all over the country who believe that it's over? What if they believe that it's already happened?"[79] However, whereas Walker chose the venerable pages and readers of second-wave *Ms.* magazine for her own third-wave declaration, riot grrrl articulated its "feminist issues and politics to the average girl in a downright explicit and thrilling format."[80] Although hardly exclusive to young women alone—indeed, born of punk-rock college students like Hanna discovering parallels between their pop idols and feminist figures through women's-history and gender-studies courses—riot grrrl's roots in youthful activist and independent music scenes resulted in an attitude and population that skewed young. In an inversion of traditional, organized demonstrations, riot grrrl instead promoted local, covert actions, where one woman gleaned support and knowledge from a sprawling collective, then acted locally by papering a neighborhood with agitprop posters, starting a band, or establishing a Web site—activities viewed as male-dominated, in which riot grrrl felt women had always participated but where their contributions had been overlooked. This do-it-yourself approach to feminist activism was aided by the sense of agency that the youngest women of the third wave took for granted in their upbringing—not just as makers but as consumers of cultural meaning—fulfilling what Hanna argued was the need for not only artists "who are unwilling to commodify themselves, [but also] audiences who will actively participate instead of just consuming."[81]

90: Cover of *riot grrrl* zine, July 1991

The small, cheaply photocopied zine (as in magazine, or fanzine) was the primary medium through which riot grrrl expressed itself and connected participants with one another (fig. 90), blurring the line between maker and consumer that riot grrrl sought to erase. Like the 1980s indie-rock, antinukes, and of course prosex feminist circles in which they originated, the zines and art of riot grrrls often focused upon recycled and recontextualized imagery taken directly from mass culture—often from commercial sources marketed toward young girls—resulting in a visual culture in which Guerrilla Girls posters, girl-band flyers, MTV hip-hop divas, and Calvin Klein ads live in peaceful coexistence. As a movement aimed at and dependent on very young women, riot grrrl's dominant interest in popular culture significantly tapped into what Baumgardner and Richards define as "girlie" signifiers, which were both a prominent and a denigrated part of their feminist upbringing. "Girlie encompasses the tabooed symbols of women's feminine enculturation—Barbie dolls, makeup, fashion magazines, high heels—and says using them isn't shorthand for 'we've been duped.'"[82] Or, as articu-

lated in one "Riot Grrrl Manifesto," girlie poses helped young women say: "We are angry at a society that tells us girl = dumb, girl = bad, girl = weak."[83]

"The appeal of that word is no fluke," wrote *Village Voice* author Joy Press as riot grrrl evolved into what she referred to as its "softcore" sister, "girl power," in the late 1990s:

> *Girl* reserves the right to think about clothes and makeup but she still expects to be taken seriously. *Girl* isn't afraid to be obnoxious or snarly for fear she'll be seen as unfeminine. *Girl* wants a boyfriend but values her female friendships more. *Girl* knows she's as good as a guy, but she's proud to be girly and to wield her girl power. . . . fierce and feminine, *girl* is a mess of contradictions and conflicts, sure. But when you get right down to it, she expects a lot from the world.[84]

While frustrating to older feminists for what appears to be its infantilization of women, the pointed girliness of young women's feminist culture today—celebrating but politicizing the games, fashions, and icons of contemporary youth culture—is in fact a strategy for drawing attention to and championing the ideas of a generation that feels it has been either ignored or denigrated by its feminist elders precisely because of its relative youth. Interestingly, younger feminists' appeal to youth is also a recruitment strategy born of the same frustrations that older feminists have with what they perceive as younger women's lack of interest in feminist activism. As Press recognizes, while it is perceived that many young feminists promote "feel-good feminism, with all the struggle and critique removed . . . [it] could be argued that, in this mediagenic age, being stylized and diluted is a fair price for being disseminated throughout wider culture."[85] Ultimately, as argued by Marcelle Karp, editor of the still-in-publication, now-glossy zine *Bust: The Voice of the New Girl Order*, "Let [women] get up on MTV or in the movies and remarket feminism and call it girl power. Put that out there, let the girls soak it up and think about what girl power *really* means."[86]

Because it is the realm of popular culture in which they have found both their reflections and role models—and where the genre's influence significantly affects the representation of these icons—it is unsurprising that the pin-up genre is so frequently conjured in these young feminists' artwork. Inscribed with slogans or juxtaposed with seemingly contra-

91: Técha Noble, Geekgirl
.com mascot, 1999 (Courtesy
of the artist)

dictory imagery, from zines on out the "girlie pictures" of the pin-up
genre have become symbolic of the "grrrl-style revolution," as a way
for younger feminists to continue to simultaneously associate with and
disavow the feminist culture that preceded them. From *Bust* and *Minx*
magazines, to the *Geekgirl* (fig. 91) and *Fat Girl* Web sites, to records by
Candye Kane and Seven Year Bitch, one is hard-pressed to find a project
by young feminists today without finding a pin-up as its mascot. Like
the genre's long history in feminist hands, in all cases the pin-up is ma-
nipulated in ways that upend expectations of the genre—whether rep-
resenting women of a different race, body type, background, or even
gender than typically represented in the pin-up's popular history. A par-
ticularly good example of the latter can be found in the "lesbian pin-up
calendar" published by the riot grrrl record label Mr. Lady, which fea-
tured the naturally-mustachioed, boyish member of Hanna's most re-
cent band Le Tigre, J. D. Samson (plate 7), striking provocative poses
in stereotypical "masculine" roles from Hollywood and porn history—
lifeguard, handyman, pool boy, farmhand.

However, these young women add a new twist to their own appro-
priations: while recognizing the inadequacy of the pin-up to effectively
represent women's complex experiences and vast potential, they also
recognize and admit the appeal of the very sexualized imagery that they
seek to upend—a recognition that allows the youngest feminists today

to approach the subject of pleasure without the sense of guilt or urgency with which even their immediate predecessors were so frequently tormented. As such, young feminists approach the pin-up with a simultaneous dose of criticism and affection that seems to have emerged as a defining trait of the third wave itself—its typically postmodern refusal to accept either/or, and reservation of the right to claim both/and— which is often misunderstood and even criticized by feminists who earlier sought to demolish rather than reclaim such traditional feminine roles in work where the political statements were generally clear and direct. In the gallery arts as well as popular graphics, such layered and subversive appropriations among younger feminists have proliferated. These artists similarly explore both the pleasures and dangers of the pin-up, often in highly articulate ways that agitprop riot grrrl graphics often only hint at—indeed, some of the most talked-about and studied contemporary women artists are also those in whose oeuvre we find the pin-up conjured as a highly charged catalyst to such discourse.

Los Angeles–based artist Alma López recently used the pin-up toward such ends—as a sign of both tradition and rebellion, within both feminist history in general and Latin American culture in particular. Her 1999 digital print *Our Lady* transforms the sacred sixteenth-century Mexican icon of the Virgen de Guadalupe into a contemporary, sexually empowered Chicana held up not by a cherubic angel, but by another bold female. Utilizing performance artist Raquel Salinas and activist Raquel Gutierrez as the figures of La Virgen and the angel, respectively, López sought to create an image of this popular religious icon "expressing the multiplicities of [Chicanas'] lived realities"[87]—specifically, "from my own worldview as a Chicana Lesbian"[88]—rather than the antiquated ideal of the suffering and submissive mother. She also wished for her work to engage with the history of the feminist movement—particularly earlier appropriations of La Virgen by 1970s artists like Yolanda López and Ester Hernández. A brief look at the progression of Virgenes gives us a sense not only of the importance of this religious icon in Mexican cultural life, but of the evolution of feminist thought. Yolanda López's 1978 *Guadalupe Triptich*, exemplary of early second-wave ideals, depicts La Virgen as a maquiladora, a grandmother, a marathon runner (the artist herself) trampling the angel who had supported her. Ester Hernández's *La Ofrenda II*, painted in 1988, demonstrates perspectives

that emerged in third-wave feminist practices of the 1980s, which would most directly influence Alma López's generation; here, La Virgen is now a tattoo inscribed on the body of a Chicana punk rocker, sexily (but modestly) exposing her naked back to the viewer. Alma López's work—like that of many of her contemporaries—would continue its audacious appropriation and celebration of her culture's feminist icon, while dealing directly and primarily with the issue either ignored or implied in the earlier images: sexuality.

López cites her interest in exploring the icon's unmentionable sexuality as stemming from writer Sandra Cisneros's essay on the subject, "Guadalupe the Sex Goddess."[89] Indeed, she is depicted here as just that: a heavenly creature stepping out from behind her heavy robe (ordinarily covered in stars, but here patterned in a pre-Columbian relief) to show her worshippers what lies beneath—a fantasy Cisneros's essay ponders at length. López offers one idea: a sassy bikini made of the roses that she gave to the indigenous Juan Diego, which would transform into an image of La Virgen on the shirt in which he carried them—proof of her connection to indigenous people, resulting in her induction into the pantheon of Catholic icons. However, unlike that familiar Virgen—depicted shrugging shyly, with arms outreached and beckoning or hands together in the submissive pose of prayer—La Virgen of *Our Lady* stands with her hands on her hips, imperiously looking down upon her viewer. Reminding us that "churches, in Mexico and Europe and the United States, house images of nude male angels and most prominently, a Crucifixion practically naked except for a loincloth," López's Chicana pin-up incorporates the corporeal in a way that makes a bid for women's equality within the sexist, homophobic communities (both religious and secular) in which she and many other Hispanic women are raised.[90] But López does so using—with great affection—both the pin-up and the icon: imagery from the same sexist cultures that she seeks to critique.

Wanda Ewing's 2004 series *Black as Pitch/Hot as Hell* appropriates the pin-up toward similar, if less serious ends (fig. 92). The compositions and poses of Ewing's series of enormous self-portraits are derived from the pin-ups of postwar illustrators like Peter Driben, whose outrageous, impossible bodies and costumes the artist found simultaneously repulsive, progressive, and comical. Ewing transformed the kitschy source imagery—in whose full figures and theatrical fashion sense Ewing reads

92: Wanda Ewing,
Image from *Black as
Pitch/Hot as Hell*, 2004
(Courtesy of the artist)

parallels to the ideals of contemporary hip-hop culture—into highly in-
timidating, larger-than-life paintings on panel. Cutting around the fig-
ures' contours so that the pin-ups literally hover above the raw surface of
the wood, and painted in striking, graphic *grisaille*, the artist's images are
one-part comic-book character, one-part religious icon. While inspired
by earlier third-wave appropriations of the pin-up by Renée Cox—who,
like Ewing, sought to insinuate a black, feminist beauty into the lily-
white repertoire of pop-cultural imagery—Ewing's silly, sexy, and even
self-deprecating take on the subject is entirely devoid of the anger and
melancholy of Cox's self-portraiture. Photographer Nicole Cawlfield
shares a similar affection for such postwar imagery that many in the
second wave had perhaps hoped their daughters would grow to revile.
However, like Ewing, she does not gravitate toward such subjects un-
critically. Cawlfield's ongoing series, the ironically titled *Thin-Up Girls*,
begun in 2003, is comprised of a series of voluptuous women of vari-
ous ages, dressed and posed in the style of vintage pin-ups from the
1950s. But, whereas the source material to which Cawlfield is drawn
mocks women's vanity and struggles toward weight loss even as it de-
mands both of them, her "thin-ups" flaunt their full figures—and both
the eating habits and disinterest in exercise with which they cultivated
them—to demonstrate instead the degree to which her subjects refuse
to connect their beauty to a number on a scale.

Expensive makeup cannot hide
the bruises
on this "blushing" bride!

93: Peregrine Honig, *Bruiser*, 2001 (Courtesy of the artist)

Even more pointed in her feminist critique is Peregrine Honig, who
in her recent pin-up paintings (fig. 93) uses the genre to address not
women's beauty, but rather the ugly realities that lurk beneath women's
desirable facades. Honig approaches the pin-up with great interest in its
power to depict feminist sexuality but, like López's reading of La Vir-
gen, she also acknowledges the ways in which the genre has been used
to manipulate women into submission rather than inspire them to grasp
their power. As such, Honig presents a view of the genre that is both
enamored and embarrassed, slipping shocking critiques and surprising
bodies into her pin-ups. A student and fan of pin-up history, Honig
nonetheless sees in them a dark side of women's sexual and professional

lives. Media-savvy, she also recognizes that "contemporary issues are much more captivating when the victim is portrayed as a modelesque woman."[91] Works from her 2001–2 series of pin-ups inspired by World War II–era *Esquire* illustration show a convergence of the artist's interests. Using the verse style of Alberto Vargas's Varga Girl pin-ups, and cleverly appropriating the signature style of George Petty, Honig fashioned works like *Bruiser* and *Ruby Ribbons*, which give a sense of her bait-and-switch style. *Bruiser* presents what seems at first glance a vintage glamour girl caught off-guard after bathing, but on closer inspection is actually a young bride who has been freshly battered by her husband — a fact that the accompanying verse confirms. The Petty-inspired phone at her feet is here not a connection to her sugar daddy, but very likely a lifeline that she may have attempted to use before caught and frightened by her attacker — a role that Honig forces the viewer to play in this disturbing scenario. *Ruby Ribbons* suggests a far more subtle and complicated scene of sexual degradation, in which she paints a painfully thin stripper on her knees, seemingly edging toward a club audience for more dollar bills to hang from her garter. Although the image is a familiar one that the artist derived from fashion photography, the accompanying verse indicates a dark narrative that, interestingly, links the glamorous world of modeling to the shadier one of stripping: the frequent drug addictions of its female professionals.[92]

Another contemporary third-wave artist to draw on the dark side of the pin-up's sexuality is the painter Lisa Yuskavage. But whereas both Honig and Yuskavage use the genre for its potential to unsettle, Yuskavage's pin-ups are less pointedly political and far more personal. She herself has claimed to be drawn to the genre because it conjures feelings about her own sexuality that she has always been "uncomfortable with and embarrassed by"[93] — and painting, she argues, is the "ultimate transference object."[94] Since 1995, Yuskavage's work has toyed with a perverse juxtaposition of art history and trash culture perhaps befitting the dramatically shifting environment of a working-class girl raised in Philadelphia who, through her remarkable gifts as a painter and intellectual, went on to graduate study at Yale. In interviews she insightfully speaks of Jacopo Pontormo, Georges Bataille, and Margaret Keane's sad-eyed "Keane Kids" with equal affection. Yet rather than suggesting affinities between these worlds, in her seamless, Old Master–inspired style she in-

stead underscores the tensions and violence between them. Similarly, she seeks ways to depict such contradictions and tensions within oneself—particularly women, the display of whose sexualized bodies may be one of the few things shared across cultural divides.

Recent works like *Day* and *Night* (plates 8 and 9) show us these tensions in play. In poses allegedly derived from vintage 1970s *Penthouse* images but painted with a remarkable mastery of light and form that reflect her study of Vermeer and Fragonard, Yuskavage presents us with familiar clichés from the pin-up's history: in this case, the girl-next-door spied on unaware while undressing. However, gone are the bubbly or dreamy personalities of the *Penthouse* "pets," replaced here by a thick sense of anxiety reflected in the exaggerated vulgarity of the models—where every hip curve and bobbed nose is inflated and angled—as well as in the sense of melancholy their poses and expressions reflect. Although each woman at first appears to be admiring herself, a closer look indicates that they are scrutinizing their bodies with a combined sense of awe and disapproval. The dramatic lighting and thick atmosphere that Yuskavage expertly renders only add to the tension that feels bloated rather than explosive. Her pin-ups neither critique nor celebrate the genre, but as Robin Rice observed, seem instead to ask "a series of questions: Who are these divas of desire? How far do you have to go to be one? Exactly when does a *Penthouse* Pet turn into a sideshow freak?"[95] Rather than cheerleading for the confident dominatrix in every feminist, Yuskavage's work reminds us of the internalized shame that many have for their own sexuality when it fails to measure up to its alleged reflection in popular culture—as well as how we both compound and confront that shame by compulsively returning to those images in movies, television, and fashion magazines. Like many of her contemporaries, a sense of pleasure permeates her appropriation of these pin-ups, but hers is a pleasure shot through with longing and guilt.

Yuskavage has herself spoken of this tortured ambivalence that she (and most) women inevitably feels in our sexualized surroundings—part playground, part marketplace: "I think, 'good for her!', 'I hate her guts,' 'I wish I was her,' and 'how come I'm not more like that?'"[96] Rather than taking sides, Yuskavage presents but does not judge these contradictions. This choice is a luxury afforded the third wave by their second-wave predecessors: a confident and complicated recognition of the ways

in which women relate to and express their sexual selves—as well as their classed, raced, and even gendered selves—not only because of the political and personal freedoms that the second wave ushered into the women's movement, but because of the plurality of this same legacy. Yuskavage's works are also a challenge to traditional second-wave politics in their refusal to comfortably offer a conclusive intention along an easily read "feminist" line. Yet the inconclusive work of Yuskavage leads one to some interesting conclusions about both our present moment of feminism and its relationship to art history.

CONCLUSION/COMMENCEMENT

Writing on a 1996 exhibition of Lisa Yuskavage's work, Sydney Pokorny
located in it a provocation for dialogue typical of much feminist work
since the 1980s: "These paintings ask, for instance, why women art-
ists can't express an ambiguous relationship to their own and to other
women's bodies. Why is it that for a woman artist to be considered ac-
ceptably feminist she must paint fleshy mounds of femaleness not as
menacing she-devils but as loving representatives of some great goddess
figure? Why shouldn't she be able, instead, to examine the construction
of desire and the erotic in less than utopian ways?"[1] Why, indeed?

Both Pokorny's supportive critique of Yuskavage's work and her de-
fense of the questions that it raises are rare. More typically, criticism
of younger women artists like Yuskavage reflects the art press's limited
knowledge of feminist history, as well as the broader lack of under-
standing with which these artists' attitudes toward art and sexuality are
frequently met in culture at large. Such antipathy is perhaps best sum-
marized by the recent backlash against such artists, whose complex, am-
bivalent address of both sexuality and popular culture has been the sub-
ject of much negative criticism in the last five years. These artists have
recently been dubbed "Bad Girls" in the art press on the basis of a series
of feminist art exhibitions of the same name, launched in 1993 (and
before most of the artists thus labeled were brought to the media's at-

tention). One of the U.S. curators associated the show's title with con-
temporary feminist artists who are "irreverent, anti-ideological, non-
doctrinaire, non-didactic, unpolemical and thoroughly unladylike," and
the catalog suggested a "lineage" of feminists in popular culture ranging
from Annie Oakley to Chaka Khan.[2] Although the initial exhibitions—
Bad Girls East, in New York City, and *Bad Girls West*, in Los Angeles—
were popular enough with feminist artists and curators to have spawned
several regional spin-offs in both the United States and England, the
shows were near-uniformly pummeled by the art press.[3] In the years
since, the exhibitions' title has stuck for third-wave artists whose work
has subsequently tapped into the same "anti-ideological" and "unlady-
like" vein that the *Bad Girls* shows mined. Similar to *Time* magazine
writer Ginia Bellafante's short-sighted comparison of feminism past and
present, the most vocal analyses are misinformed at best (and hypocriti-
cal at worst) about the work of these young artists in the continuum of
feminist art history. Particularly surly and vitriolic attacks of this work
have come from other women, whose headlines and attention-grabbing
introductions give readers an immediate sense of where their affinities
lie: "This isn't exactly what Betty Friedan had in mind."[4] "What's so
good about being bad?"[5] "Q: How many Bad Girls does it take to screw
in a light bulb? A: One, and she really wants to get screwed!"[6]

As we have seen, younger artists' preoccupation and comfort with ad-
dressing sexual issues is a large part of many critics' dismissal of their
work. However, the criticism also reflects a newer and perhaps more
pervasive issue: the legacy of feminism's second wave. Barbara Pollack's
negative assessment of the third-wave work she refers to as part of the
"Bad Girl" generation articulates this grievance: "Many wish they would
give a nod to Mary Kelly or Sylvia Sleigh or Faith Wilding or Adrian
Piper—all of whom created remarkably similar works 25 years ago."[7]
This analysis of younger feminist artists' work may be frequently true,
but Pollack does not stop to wonder where the paeans to feminists past
were in the work of these same artists, none of whom invented the
women's movement from scratch. From Pollack's list, only Wilding—an
artist whose participation in the Fresno Feminist Art Program and Los
Angeles Woman's Building guaranteed her a foundation in women's his-
tory—directly acknowledged the influence of her predecessors consis-
tently in her work. Yet even when addressing history, as Astrid Henry's

research reminds us, by generally reaching far back in history to choose first-wave predecessors for celebration, rather than older, living feminists in their midst, second-wave feminists did not choose "to confront an established feminist generation in their immediate present. The first wave of feminism was long since 'dead' by the time they emerged on the political scene. They could thus identify with feminists of the previous century without really having to contend with them."[8] Naturally, neither the "motherless" sensibilities nor selective historicity of these artists who came to feminist consciousness during the second wave diminished the feminist meanings in their work—indeed, many argued at the time that this approach was necessary for the very resuscitation of the women's movement that they initiated. Why, then, would many of these same women feel that an explicit recognition of their own work be such a crucial one in the work of their successors?

Ironically, younger feminists familiar with, and even seeking to celebrate, the work of their predecessors run into as much criticism as those who do not directly acknowledge their influence. For example, in organizing *Sexual Politics: Judy Chicago's Dinner Party in Feminist Art History* —an exhibition conceived as an intergenerational rediscovery of this monumental (and then homeless) second-wave work[9]—Amelia Jones was shocked at the widespread antagonism that she encountered. Rather than excitement or support for her attempt to unify different feminist perspectives and generations through reminiscences and new analyses of Chicago's piece, she instead found resistance from older feminists who both refused to participate in "what they perceive[d] as the heroicization of Chicago" and were angry at the hubris of a younger scholar attempting to add to the history of "their" work.[10] The experience led to a rude awakening: "It was made clear to me that certain kinds of revisionist thinking were not welcome and that, as someone who did not actively participate in earlier periods of the feminist art movement, my attempts at intervening in what I perceived to be rather reified narratives of feminist art history were viewed antagonistically by at least some of the women who had been active in the 1970s."[11]

This intergenerational tension was also documented by Amy Richards and Jennifer Baumgardner in *Manifesta*, where they describe the chaos that ensued at a 1999 reading of second-wave feminist classics by young feminists, which the pair organized to celebrate International Women's

Day. What was intended as an intergenerational love-in went awry for much the same reason as had the *Sexual Politics* exhibition. When Elizabeth Wurtzel took the stage to read one of her favorite pieces by the second-wave maverick Kate Millett (a passage from the rare, out-of-print *Flying*), Wurtzel responded to what she felt were rude shouts for her to read louder by sarcastically comforting the shouters to not worry about their inability to hear her, since she wasn't reading from Millett's best work. Although perhaps a true statement—as many women in attendance would concur after the event—it was taken as a slight by several older feminists, including Millett herself, who stormed the stage and demanded to read the book herself. As Richards and Baumgardner wrote of the event, it's "not that older women didn't agree with Elizabeth; it was her tone that they found offensive"—a typical and unproductive example of the movement's current tensions in which, as with Jones's *Sexual Politics* show, young feminists feel that they cannot win the ear or respect of the older feminists, even when they wish to pay homage to their legacy.[12] As Jones herself put this problem, these critics prove themselves "somewhat hypocritical in their simultaneous desire to regulate discourse while self-proclaiming their own marginality and alignment with the oppressed and the excluded."[13]

Thankfully, such intergenerational tensions do not apply to feminists across the board, and certainly not so in the art world. Many prominent, established feminists have gone out of their way to express their support for the work and ideas of their progeny, even when these young women push the envelope in terms of their representations of both feminist history and sexuality. In 1998 I interviewed the legendary feminist artist Joyce Kozloff—whose work is counted among the pioneers of second-wave feminism—about her *Pornament* series' influence on younger feminist artists, and the conversation naturally came around to the then-emerging "Bad Girl backlash." Kozloff lamented her contemporaries' public attacks on artists like Yuskavage, photographer Sam Taylor-Wood, installation artist Kara Walker, and painter Cecily Brown, all of whom were just then coming to prominence in the New York art world—an arena Kozloff knew well as a formidable figure in it since the earliest days of the popular women's movement. Singling out the imposing burlesque pin-ups of the painter (and her former student) Veronica Cross as exemplary of fierce new feminist work, Kozloff said

she felt a responsibility to remind her contemporaries: "Isn't that what we wanted? I mean, there are the mothers and the grandmothers and the daughters, and aren't we nurturing them? Do we want them to be exactly like us?"[14] Similarly, in an article on the so-called Bad Girl phenomenon, Kozloff's contemporary Chicago asserted: "I think it's great that these women have internalized the freedom that the women in my generation had to fight for."[15] Not surprisingly, art historian Linda Nochlin has also defended these artists, finding the aggressive sexuality of their work as indicative of "feistiness," "a sign of energy and unconventionality," and a reflection of feminism's success that in "a postmodern world like ours, badness is acceptable in women . . . [whereas] in the 1970s it was deeply unacceptable."[16]

Nancy Spector, curator of contemporary art at the Guggenheim, is among the few feminists in the art world to point out the underlying double standard of third-wave artists' critics. She laments the fact that women "using their bodies and owning their sexuality have always been perceived as bad or dangerous. It has always been coded as body art when men do it and women's art when men do it." Whereas women's actions are viewed as loaded, men's "actions, however outrageous, have generally been discussed in neutral terms."[17] Performance artist Carolee Schneemann gets to the heart of what the "Bad Girls" tag truly represents: a label invented and used not by the artists themselves, but by the art press in order to oversimplify our present and complex moment in feminist art history. Schneemann—herself no stranger to criticism from both within and outside of the movement for her sexually frank work—dismisses the term itself as "the commodification of a much tougher, stronger transformation that has occurred in the culture" of feminism.[18] For the younger artists whose appropriations of the pin-up I have attempted to articulate here, this kind of support represents a welcome recognition of the ways in which they have built on their predecessors' ideas.

Amelia Jones—in her contribution to the nine views on contemporary art and feminism published in the October 2003 issue of *Artforum*—weighed in on the relevance of this recognition as it applies to not only feminism's future, but feminism's past, when she argued that if "we ignore works that have been determined (by feminists) to exemplify 'bad' feminist practices, then we are in danger of getting very confused

about the complexity of past decades' feminist debates."[19] Contributing to this same *Artforum* discussion, Nochlin voiced her own frustrations over this very "confusion" when she reminded her readers that, although second-wave activists were all "for justice, equity, and a fair shake for women artists, critics, and academics, our views were extremely varied, and we were often at odds with one another" and lamented the tendency for recent histories to pin down a unified trajectory for the second wave in such a way that a culture "that seemed open and dynamic [is] now pinned down and displayed like butterflies in a case."[20] By way of conclusion to these *Artforum* perspectives, Peggy Phelan spoke to both the openness of which Nochlin wrote and its legacy for subsequent generations of feminists. Her piece articulates the ways in which our contemporary art world was shaped both by second-wave challenges to patriarchal, heterosexist accounts of history, and by the anxiety of documenting its own history as postmodern artists and art historians simultaneously came to acknowledge the limits of doing just that. Phelan reiterates the degree to which the resulting ambivalence—as she puts it, "in the fullest sense of that term"—was the product of the increasingly self-critical, multicultural, and relativist postmodern culture ushered in by second-wave inquiry.[21] Indeed, as Phelan asserts, the ambivalence of the third wave is not just a logical progression of second-wave thought, but today a necessary worldview: "In these days of hideous fundamentalism, the capacity to acknowledge ambivalence is revolutionary."[22]

Yet, while all these scholars fight for the recognition of emerging feminist voices by their more established elders, it is important to remember that the lack of recognition that plagues the movement works both ways. Faith Wilding—a creative pioneer at the start of feminism's second wave whose recent work on "cyberfeminism" finds her continuously contributing new theory in our contemporary third wave—rightfully criticizes the ways in which young women's "repudiation of historical feminism is problematic" because it tends to throw out "the baby with the bathwater and aligns itself uneasily with popular fears, stereotypes, and misconceptions about feminism."[23] One cannot forget that many younger artists' uses of the pin-up are rooted not in a drive toward feminist continuity, but in an antagonism born of the desire to build their own feminist identity far from the institution constructed by their mothers. (As put by an exasperated third-wave painter, Cecily Brown:

"My generation was born feminists. We don't have to keep proving it.")[24] This stance—as I have outlined by tracing the tensions going back to the nineteenth century—is itself another consistent one in feminist history. As even the iconic second-wave leader Gloria Steinem recently said of her own feminist beginnings to interviewer (and riot grrrl leader) Kathleen Hanna in the third-wave zine *Bust*: "I knew less about the suffragists than you know about the second wave, [and] I did the same thing of positioning myself in opposition to them, because I had heard that they were these puritanical, sexless bluestocking folks. . . . I'm sure I made feminists older than I feel uneasy as I wandered around in the '70s in miniskirts and boots with a button that said 'Cunt Power.'"[25]

With this in mind I would like to return to Katy Deepwell's appropriation of Donna Haraway's pesky *mixotricha paradoxa* parasite as a hopeful model for feminism's future—one whose possibilities have hopefully presented themselves over and over again in this book. When first approaching the study of a "feminist pin-up," I felt certain that the contemporary artists whose work led me to the topic would in turn lead me toward the theme of rebellion in the contemporary feminist movement, and that the genre would provide me with a useful icon symbolic of the third wave's difference from previous eras in the women's movement. I found instead that the truth of feminism's present and history is far more complex, as are the present and history of the genre that I decided upon as the focal point of this cross-generational study. As I hope to have shown through the pin-up's feminist history, this drive to survive and reproduce has consistently led the movement to evolve according to each moment in which it has found itself. However, as the pin-up's evolution through these same moments has proven, both sexuality and pop culture have remained among those few issues too important to move past, but too complex to resolve conclusively. Having arrived at our present day through this 150-odd-year journey, I feel that the influence and lived familiarity of postmodern philosophy present early-twenty-first-century feminism with a unique opportunity.

Postmodernism's idealization of plurality has provided the women's movement with a manner of embracing its own multiplicitous history and the troublesome nature of sexuality therein without abandoning its activist nature—provided, however, that young feminists are willing to both refute the popular stereotypes of the movement and engage

respectfully with the ideas of our predecessors, so that feminism's "re-production by division" does not simply prove divisive. As articulated by the feminist historian Ednie Kaeh Garrison, we have come to accept that "the simultaneous confidence and uncertainty about what consti-tutes feminism doesn't have to be conceptualized as a 'problem.' Rather, it is a consequence of the proliferation of feminisms."[26] In this way, the pin-up serves simultaneously as a technique for exploring Haraway's call "for *pleasure* in the confusion of boundaries and for *responsibility* in their construction" and as a case-study in feminism's long history of doing precisely that.

Although it consistently reflects changing ideals of womanhood, the history of the pin-up genre has maintained the aura of feminist "awar-ishness" with which its early subjects imbued the genre at its origins. I believe that this history of depicting and marking as desirable a contra-dictory and willful sexual identity (wittingly or unwittingly) leads con-temporary feminist thinkers to their explorations of the genre today. Like Ali Smith's portrait of Janeane Garofalo, performance artist Ann Magnuson's recent work "Revenge of the Vargas Pin-Up Girl" (fig. 94) references the long shadow that the pin-up casts over feminist culture.[27] It is also a useful work with which to conclude this history of the femi-nist pin up.

In "Revenge," the artist poses in the guise of an elegant World War II Varga Girl but turns the artist's airbrush gun—the medium through which Vargas created his fantasy women—back onto the world. Mag-nuson has associated her appropriation of the pin-up with the same bait-and-switch subversion as the riot grrrl movement, saying: "Women's sexuality has been shunned; there's so much shame attached to being sexual. But then, why should frat boys be the only ones who get to ap-preciate a curvy figure? When the pin-up is allowed to speak (and has something to say), it changes the landscape."[28] But Magnuson's assertion that the tools of the pin-up's male creator, in the hands of its dangerous spawn, can be easily turned against its creator's or viewer's potentially oppressive motives also serves as a metaphor for all of the feminist pin-up imagery we've seen here. In this way, the pin-up's ultimate "revenge" lies in the fact that, although it may have been created as a tantalizing but unreal object for the delectation of heterosexual men, the pin-up would

94: Ann Magnuson, *Revenge of the Vargas Pin-Up Girl* from *I Have a Sex Book, Too!* 1992 (Photo: Len Prince) (Courtesy of the artist)

also find ways to reject this role to reflect and encourage the erotic self-awareness and self-expression of real women. An industrial revolution Lilith, like Adam's first and fiercely independent mate in Hebrew myth the pin-up grrrl reminds viewers that the hand that creates does not necessarily control—and that there are great pleasures to be found in exploring this contradiction.

NOTES

Introduction: Defining/Defending the "Feminist Pin-Up"

1 Nochlin, "Offbeat and Naked."
2 Linda Nochlin's lecture, "The Newd in Art," and our conversation took place at the Los Angeles County Museum of Art (11 January 2000). Many thanks to Dr. Nochlin for taking the time to discuss the subject both during and beyond the lecture's question-and-answer period.
3 Frueh, *Monster/Beauty*, 11.
4 Ali Smith, e-mail to author, 27 July 2000.
5 Frueh, *Erotic Faculties*, 4.
6 hooks, *Feminist Theory*, 150.
7 Linker, *Love for Sale*, 17.
8 Kruger, "No Progress in Pleasure," 210.
9 As portraiture ranging from Hollywood pin-ups of male matinee idols to sexually charged imagery of male sports stars to gay "beefcake" shots attest, the male pin-up has a history almost as long as that of women. However, since the sexual display of oneself for popular consumption has been historically associated with women, male pin-ups are often saddled with the negative association of "feminization." See Meyerowitz, "Women, Cheesecake, and Borderline Material"; and Gabor, *The Pin-Up*, 162–73 and 251–54.

10 Gabor, *The Pin-Up*, 32–35.

11 See Finch, "Two of a Kind."

12 See Wharton, *The Age of Innocence*, 42–43. I'd like to thank historian Angel Kwolek-Folland for pointing out the class-based subtext of Wharton's commentary.

13 Solomon-Godeau, "The Other Side of Venus," 115.

14 Ibid.

15 Ibid., 131.

16 See Solomon-Godeau's notes in "The Legs of the Countess," 94.

17 For excellent synopses of cultural and legal definitions of pornography, see Kendrick, *The Secret Museum*, and L. Williams, *Hard Core*.

18 Finch, "Two of a Kind," 94.

19 Ibid.

20 Meyerowitz, "Women, Cheesecake, and Borderline Material," 10.

21 J. Butler, *Bodies That Matter*, 121–40. See also Butler's broader argument for drag and sexual subversion in *Gender Trouble*.

22 In addition to my position as a self-identified feminist—which leads me to take issue with the ubiquity of critical readings of the pin-up as a given rather than a question—my position as a student of art history demands that I call into question such an interpretive given toward what is essentially a representational genre. (Were one to say that all still-life paintings are moralizing, or all Dutch interiors emblematic, would such a blanket statement—no matter how frequently true in the case of these genres—go unchallenged?)

23 McNair, *Mediated Sex*, 145. McNair also uses this analysis in his take on "bad girl" feminist art, which was created in response to men's appropriation of pornographic imagery in the "bad boy" neo-expressionist art of the 1980s and 1990s. The term *bad girl* derives from the series of feminist art exhibitions of the same name, which were launched in the United States and England in 1993, and is discussed at length in chapter 8. Loosely defined, one of the U.S. curators associates the collective term as referring to feminist artists who are "irreverent, anti-ideological, non-doctrinaire, non-didactic, unpolemical and thoroughly unladylike" (Tanner, *Bad Girls*, 10).

24 Lord, "Pornutopia," 41. Rebecca Schneider also provides an excellent and extremely thorough theory of feminist appropriations of explicit sexual imagery in *The Explicit Body in Performance*.

25 Taking Susie Bright's cue, I feel that—while pornography is inevitably defined by each individual beholder—as long as individuals are being legally prosecuted as "pornographers," imagery, objects, and cinema that

meet local and/or national standards of pornography need to be recognized as such. See Bright, *Sexwise*, 76–79.

26 Dimen, "Politically Correct? Politically Incorrect?" 140.

27 Ibid.

28 See Haraway, "Otherworldly Conversations."

29 Deepwell, editorial statement.

30 Frueh, *Erotic Faculties*, 4.

31 Ibid., 28–29.

32 Frueh, *Monster/Beauty*, 204.

33 Haraway, "A Cyborg Manifesto," 150.

34 Roof, "Generational Difficulties," 72.

35 Gallop, *The Daughter's Seduction*, 93.

36 A. Henry, *Not My Mother's Sister*, 4.

37 Ibid.

38 Ibid.

39 Elam, "Sisters Are Doing It for Themselves," 63.

40 Whittier, *Feminist Generations*, 18.

41 Elam, "Sisters Are Doing It for Themselves," 56.

42 Whittier, *Feminist Generations*, 15.

43 A. Henry, *Not My Mother's Sister*, 23.

1. Representing "Awarishness"

1 Dudden, *Women in the American Theatre*, 1.

2 Ibid., 184.

3 Cited from a newspaper transcription of Lydia Thompson's "Girl of the Period" monologue in Allen, *Horrible Prettiness*, 18.

4 D'Emilio and Freeman, *Intimate Matters*, 70.

5 See Allen, *Horrible Prettiness*, 63–65; Banner, *American Beauty*; and Solomon-Godeau, "The Legs of the Countess," 95–108.

6 See Baker, "Introduction," *Votes for Women*, 15.

7 Welter, "The Cult of True Womanhood, 1820–1860."

8 See Parker, "The Case for Reform Antecedents."

9 T. Davis, *Actresses as Working Women*, 69.

10 See Howarth-Loomes, *Victorian Photography*; McCauley, *A. A. E. Disdéri*; and Linkman, *The Victorians*.

11 McCauley, *A. A. E. Disdéri*, 30.

12 Ibid., 23.

13 Quoted in Younger, "Cartes de Visite," 20.

14 "Cartes de Visite," 266–69. Note the anonymous author's use of "both

classes" (presumably "above" and "below" the bourgeoisie), implying a middle-class reader and carte de visite collector.

15 McCauley, *A. A. E. Disdéri*, 54.

16 Catering to an all-male clientele, cigar shops tended to carry almost exclusively photographs of pin-ups and even more risque imagery. This tradition would lead to the phenomenon of carte de visite pin-ups being circulated in cigarette packs as a promotional tool, and the genre would become known as the "cigarette card" later in the nineteenth century. See d'Emilio and Freeman, *Intimate Matters*, 130–31; and Gabor, *The Pin-Up*, 53–56.

17 The Toy and Miniature Museum of Kansas City contains in its collection examples of such "doll's albums," as does the renowned, private French "fashion doll" collection of Michael Canadas and David Robinson.

18 See Buse, "The Stage Remains." In this passage, I borrow the term and concept of "upclassing" from Luc Boltanski's and Jean-Claude Chamboredon's discussion of the identity of professional photographers, but the same issues of upward mobility can be attributed to the subjects and collectors of the carte de visite at this period. See Boltanski and Chamboredon, "Professional Men or Men of Quality."

19 See Banner, *American Beauty*, 45–65. Banner describes the ubiquitous "steel-engraving lady" of the period's fashion plates, whose bell-like proportions were both emulated by bourgeois women and rebelled against by burlesque performers, as the nineteenth-century physical ideal for women. McCauley also asserts that Eugénie's "fashion plate" poses were motivated by more than sheer aesthetics: "Eugénie, as the female head of state, was expected to embody the virtues of Second Empire womanhood while pushing French made fashion and fabrics" (*A. A. E. Disdéri*, 64–68).

20 See Dan Younger's analysis of this phenomenon in "Cartes-de-visite," 1–5, 21–24.

21 For a thorough study of the burlesque tradition and the complex and shifting roles of women within the genre, see Allen, *Horrible Prettiness*. Allen's work succinctly defines, and has highly informed my reading of the meanings of, early burlesque theater and its implications on the residual imagery that the theatrical genre produced.

22 See McCauley, *A. A. E. Disdéri*, 36–41, and Solomon-Godeau, "Legs of the Countess," 99–102.

23 Allen, *Horrible Prettiness*, 21.

24 Jean-Jacques Rousseau, *Lettre à d'Alembert sur les spectacles* (Paris: Hachette, 1896), 136, quoted in Roberts, *Disruptive Acts*, 54.

25 Solomon-Godeau, "The Other Side of Venus," 21.

26 Allen, *Horrible Prettiness*, 49.

27 Parker, "The Case for Reform Antecedents," 29.

28 Ibid.

29 Ibid., 30.

30 For a recent analysis of Truth's contribution to the abolitionist and early suffrage movements, see Painter, "Voices of Suffrage."

31 Cited in Dudden, *Women in the American Theatre*, 143.

32 For detailed accounts of Menken's performance and success in the role of Mazeppa, see Dudden, *Women in the American Theatre*, 157–64; Allen, *Horrible Prettiness*, 96–101; Lewis, *Queen of the Plaza*; and Mankowitz, *Mazeppa*.

33 Clemens, "The Menken," 6.

34 See T. Davis, *Actresses as Working Women*, 105–36.

35 Allen, *Horrible Prettiness*, 15–16.

36 Clemens, "Mark Twain's Travels with Mr. Brown," 85.

37 Quoted in Freedley, "The Black Crook and the White Faun," 14.

38 Quoted in Allen, *Horrible Prettiness*, 112.

39 Logan, *Apropos of Women and Theatres*, 135.

40 Taken from a newspaper transcription of Thompson's "Girl of the Period" monologue cited in Allen, *Horrible Prettiness*, 18.

41 Logan, *Apropos of Women and Theatres*, 117.

42 Menken's promotional photographs span from her teenaged years in 1859 to shortly before her surprising and early death (possibly of tuberculosis, peritonitis, or cancer) in 1868.

43 See Allen, *Horrible Prettiness*, 66–70.

44 See McCauley, *A. A. E. Disdéri*, 85–94.

45 Logan, *Apropos of Women and Theatres*, 115.

46 In her fascinating and exhaustively researched book *Performing Menken*, Renée Sentilles wades through the contradictory archival and biographical histories available for Menken yet is perpetually stymied in her attempts to nail down the actress's "true" racial or sexual history. However, Sentilles proposes that Menken was likely Louisiana Creole—making sense of Menken's contemporaries' references to her status as an "octoroon"—with one-eighth African American blood—by nineteenth-century standards. In documenting Menken's "American odyssey," she also elaborates on tales of Menken's run-ins with both Union and Confederate forces as she performed throughout the country during the Civil War. Although Sentilles feels that Menken's documented "romances" with other female performers and writers fall more under the rubric of

what d'Emilio and Freedman refer to as Victorian, nonphysical "romantic friendships," at least one contemporary scholar explicitly identifies Menken as bisexual. See Barnes-McLain, "Bohemian on Horseback."

47 See Dudden, *Women in the American Theatre*, 159; and Logan, *Before the Footlights and Behind the Scenes*, 56.

48 Interestingly enough, these same kinds of outfits were worn by the period's female acrobats and bodybuilders, most famously by the biracial strength performer "Miss Lala," depicted by impressionist painter Edgar Degas in his work *Miss Lala at the Circus Fernando*. See J. Todd, "Bring on the Amazons."

49 See Ben Bassham's description of Menken's and Sarony's arrangement in *The Theatrical Photographs of Napoleon Sarony*, 11.

50 The characters and dates from many theatrical cartes de visite, as well as the photographers that took them, are often speculative, since frequently these photos were circulated with none of this information imprinted anywhere on the carte. In fact, one sees identical poses frequently printed with information that claims the image represents characters from different plays. Moreover, actresses of the nineteenth century often reprised popular characters or plays many times over the course of their careers, making attempts to precisely date undated cartes according to certain performances extremely difficult. In this chapter, I have used photographers' names and photographs' dates and characters only when attribution has been ascertained by archival and/or published evidence.

51 In *Performing Menken*, Sentilles argues that this image was probably created for a limited circle of Menken's closest friends. However, its appearance in archives such as the Harvard Theatre and New York Public Library's Billy Rose Theatre Collections—in multiples and, in New York, in what is believed to be a fan's theatrical scrapbook—leads one to believe that the image was more widely circulated.

52 Allen, *Horrible Prettiness*, 70.

53 Cited in Mankowitz, *Mazeppa*, 11.

54 Cited in ibid., 172. Menken died in her early-to-mid-thirties—alas, her constantly shifting self-invention often included the year of her birth—of what biographers believe was either cancer or an infection brought on by a kick delivered by her steed during a performance of *Mazeppa*.

55 See ibid., 20–26, 80–83; Fuller, *Swinburne*, 163; and Sentilles, *Performing Menken*.

56 Previous biographers identified the woman with Menken as George Sand, who was also supposedly the godmother of Menken's illegitimate son. However, Sentilles effectively refutes both these claims, consider-

ing a comparison of the woman in the photo with images of Sand easily prove that they are not the same woman. Moreover, though they surely knew one another from Parisian literary and theatrical circles, there is no documentation proving any close friendship between the two.

57 Sentilles, *Performing Menken*.

58 Ibid, 232.

59 Burnham, "Stage Degeneracy," 34, cited in Allen, *Horrible Prettiness*, 8.

60 Linton, "The Girl of the Period," 25, 28. Not surprisingly, Linton was also a prominent antisuffrage essayist whose criticism frequently railed against both actresses and suffragettes. (Many early women's rights activists were indeed both.) See Tickner, *The Spectacle of Women*, for more information on Linton's literary run-ins with British suffragists.

61 In Allen, *Horrible Prettiness*, 140. Also see Gay, *The Bourgeois Experience*, 210–12, for further information on the Linton article and its influence in British and American society.

62 Banner, *American Beauty*, 28–30.

63 Linton, "Girl of the Period," 28.

64 Cited in Allen, *Horrible Prettiness*, 20.

65 Anonymous, "The Literature of the Lash: What the Chicago Press Has to Say of the Chicago Cowhiding" (1870), Lydia Thompson Clipping File, Harvard Theatre Collection.

66 Dudden, *Women in American Theatre*, 167.

67 Howells, "The New Taste in Theatricals," 642–43.

68 Logan, *Apropos of Women and Theatres*, 57–61.

69 Of the subject, Logan wrote: "The inevitable small boy, with ill-kept nose, came to visit me in every town, and took away several dozen of cartes de visite. But pray mark the mode of procedure of the inevitable small boy with ill-kept nose! In a fiendishly exultant manner, he rushes up to an inoffensive spectator, and, thrusting the picture under the visual organs of the aforesaid, cries out, in a shrill voice: 'Have Olive Logan, sir? Street dress and costume. *Do* take Olive Logan, sir. *Only twenty-five cents!*.' . . . Is it extraordinary that, under these circumstances, I immediately stopped the sale of my photographs?" (*Before the Footlights and behind the Scenes*, 241).

70 On Logan's later cartes and "Best-Dressed" distinction, see "The Best Dressed Woman in the World: Olive Logan," unlabeled period clipping from Olive Logan clipping file, Harvard University Theatre Collection; and Dudden, *Women in American Theatre*, 176–77.

71 Logan, *Apropos of Women and Theatre*, p. 114.

72 Cited in Younger, "Cartes de Visite," 11.

73 Solomon-Godeau, "The Legs of the Countess," 102–3.

74 Allen, *Horrible Prettiness*, 77–78.

75 See Banner, *American Beauty*, 86–127; and Clayson, *Painted Love*.

76 Allen, *Horrible Prettiness*, 148.

77 Ibid, 132.

78 For an excellent analysis of Mae West's old-school approach to burlesque theater and its feminist potential, see Robertson, *Guilty Pleasures*, 24–53.

79 See Linkman, *The Victorians*, 74–76 and 86–99.

80 See Gabor, *The Pin-Up*, 35–41 and 50–56.

81 Sanger, *An Autobiography*, 37.

2. New Women for the New Century

1 Ives, *The Dream City*.

2 For excellent accounts of the attractions and profits at the World's Columbian Exposition, see Muccigrosso, "Satisfying Popular Tastes," 154–78; and Bolotin and Laing, *The Chicago World's Fair of 1893*, 127–39.

3 See Birch, *The Woman behind the Lens*, 32–33.

4 Lovell, "Picturing 'A City for a Single Summer,'" 40–41.

5 Ibid., 51.

6 Ives, *The Dream City*.

7 Elizabeth Kendall discusses the "Salome factories" that began cranking out Little Egypt types by the hundreds for the vaudeville circuit in *Where She Danced*.

8 See Carlton, *Looking for Little Egypt*.

9 See Matthews, *The Rise of the New Woman*, 33–34; Muccigrosso, *Celebrating the New World*; and Bolotin and Laing, *The Chicago World's Fair of 1893*.

10 See Lovell, "Picturing 'A City for a Single Summer,'" 40–52.

11 See Weimann, *The Fair Women*.

12 The sculpture was finally accepted by architect Stanford White—who had first commissioned the work for his Madison Square Garden in New York—for his Agricultural Building, in large part to protest the prudery of the exposition's planners. For an excellent account of the Diana debacle, see Muccigrosso, *Celebrating the New World*, 99–102.

13 Ives, *The Dream City*.

14 See Pollock, *Mary Cassatt*; *Mary Cassatt, Modern Woman* (catalog); Carr and Webster, "Mary Cassatt and Mary Fairchild MacMonnies"; and Mathews, *Mary Cassatt*.

15 See Broude, "Mary Cassatt."

16 Quoted in Mathews, *Cassatt and Her Circle*, 238.

17 Broude, "Mary Cassatt," 42, 36.

18 Lecture reproduced in E. Stanton, Anthony, and Gage, *History of Woman Suffrage*, 2:353–55; quoted in Painter, "Voices of Suffrage," 51.

19 Gage, "Indian Citizenship," quoted in Sneider, "Woman Suffrage in Congress," 82.

20 Matthews, *The Rise of the New Woman*, 27.

21 See Painter, "Voices of Suffrage," 42–55.

22 See Matthews, *The Rise of the New Woman*, 6–7.

23 Stanton and Blatch, *Elizabeth Cady Stanton*, 338.

24 E. Todd, *The New Woman Revised*, 24.

25 Banta, *Imaging American Women*, 32.

26 Grand, "The New Aspect of the Woman Question," 142.

27 For contemporary scholarship concerning the emergence and definition of the New Woman, see Heilmann, *New Woman Strategies* and *Feminist Forerunners*; Todd, *The New Woman Revised*; DuBois and Gordon, "Seeking Ecstasy on the Battlefield"; Rupp, "Feminism and the Sexual Revolution,"; Tickner, *The Spectacle of Women*; and Smith-Rosenberg, "The New Woman As Androgyne," *Disorderly Conduct*.

28 Ouida (Marie Louise de la Ramée), "The New Woman."

29 See Richardson and Willis, "Introduction," 25.

30 Ouida (Marie Louise de la Ramée), "The New Woman," 154.

31 D'Emilio and Freeman, *Intimate Matters*, 189 and 194.

32 For an extensive study of the growth of and popular responses to women's clubs and labor unions, see Marks, *Bicycles, Bangs, and Bloomers*, chapters 2 and 4. Elaine Showalter also discusses the relevance of the period's "Clubland" and workforce in *Sexual Anarchy*, chapter 1; and see Peiss, *Cheap Amusements*, chapters 1–3.

33 D'Emilio and Freeman, *Intimate Matters*, 194.

34 See ibid., 222–35; Showalter, *Sexual Anarchy*, 46; and Matthews, *The Rise of the New Woman*, 96–125.

35 See Burdett, *Olive Schreiner and the Progress of Feminism*; Stokes, *Eleanor Marx*; and Woodhull, *A Victoria Woodhull Reader*.

36 Matthews, *The Rise of the New Woman*, 22.

37 Grand, "The New Aspect of the Woman Question," 141–42.

38 *Punch*, 12 May 1894, 225, quoted in Marks, *Bicycles, Bangs, and Bloomers*, 81.

39 For a thorough discussion of the differences between and different popular interpretations of homosexual communities in the mid– and late nineteenth century, see Dijkstra, *Idols of Perversity*; and D'Emilio and Freeman, *Intimate Matters*, chapters 6–10.

40 Showalter, *Sexual Anarchy*, 39.

41 Schreiner, *Women and Labor*, 252–53.

42 Marks, *Bicycles, Bangs, and Bloomers*, 18–19, 108.

43 Ibid., 191.

44 Quoted from 1945 *Time* magazine clipping in Banta, *Imaging American Women*, 213.

45 C. Gibson, "Her First Appearance in This New Costume," *Life*, 1893, reprinted in *Drawings by Charles Dana Gibson*.

46 Gibson, "A Modern Daniel," *Life*, 1894, reprinted in *Drawings by Charles Dana Gibson*.

47 The "coming age" series was compiled that same year in the volume *Pictures of People*.

48 Banta, *Imaging American Women*, 215–16.

49 Much of Marks's *Bicycles, Bangs, and Bloomers* is dedicated to excellent analyses of the differences between American and British approaches to the New Woman, as is the introduction to Richardson and Willis, *The New Woman in Fiction and in Fact*, 53.

50 *Punch*, 28 April 1894.

51 *Punch*, 8 September 1894.

52 C. Gibson, "In Days to Come, Churches May Be Fuller."

53 R. Davis, "The Origin of a Type of the American Girl," 8.

54 See Meyer, *America's Great Illustrators*, 8; and Reed, *The Illustrator in America*, 24.

55 See "The Face of Romance and the Face of Reality," 8.

56 C. Gibson, *The Education of Mr. Pipp*.

57 Kitch, *The Girl on the Magazine Cover*, 44.

58 See Todd's excellent analysis of Gibson's antifeminist tendencies against John Sloan's profeminist imagery in *The New Woman Revised*, 8, 19–30.

59 Willis, " 'Heaven Defend Me from Political or Highly-Educated Women!' " 53.

60 Bridges, "Charles Dana Gibson."

61 Banta, *Imaging American Women*, 214.

62 Bridges, "Charles Dana Gibson."

63 R. Davis, *About Paris*.

64 R. Davis, "The Origin of a Type of the American Girl," 8.

65 Bundles, *On Her Own Ground*, 62–63.

66 See C. Gibson, *Sketches in Egypt*.

67 Quoted in W. Gilman, *The Best of Charles Dana Gibson*, ix.

68 Cited in Ardis, *New Women, New Novels*, 4.

69 Richardson and Willis, *The New Woman in Fiction and in Fact*, 24.

70 See Dow, *Wise Women*; McQuiston, *Suffragettes to She-Devils*; and Tickner, *The Spectacle of Women*.

71 Gilman, *Women and Economics*, 148; quoted in Banner, *American Beauty*, 156.

72 In Bettina Birch's recent biography of Johnston, she discusses correspondence in which the photographer was consulted about and asked for photographs of work by certain poster artists from her collection. See *The Woman behind the Lens*, 18–19.

73 See Banta's discussion of the image in the context of the "golden age of the poster," *Imaging American Women*, 29–30.

74 Richardson and Willis, *The New Woman in Fiction and in Fact*, 24.

75 Frances Benjamin Johnston, undated, handwritten note, verso William Mills Thompson handbill (CAI Thompson, no. 1), Prints and Drawings Division, Library of Congress, Washington, D.C.

76 For accounts of both Johnston's studio parties and her bohemian clique "The Push," see Birch, *The Woman behind the Lens*, 26–29.

77 See Johnston's images of Thompson in the Frances Benjamin Johnston Collection (Lot 11735), Prints and Drawings Division, Library of Congress, Washington, D.C.

78 Johnston frequently joked in letters to friends about her fondness of cocktails—a particularly clever play on this fact is also found in a fake "enlistment record" she filled out after a stint photographing sailors about Admiral George Dewey's ship, where she granted herself "5's" (the highest mark) on all counts except sobriety, where she admitted a "4.9"—and allotments for cigarettes appear in her bills from her twenties forward. See Birch, *The Woman behind the Lens*, 36–37, 143–44.

79 See *Frances B. Johnston* for an early, influential interpretation of the role of race relations upon Johnston's imagery at these institutions.

80 Birch summarizes and reads the contradictory elements of Johnston's feminism in *The Woman behind the Lens*, 143–47.

81 Details of the commission and subsequent lawsuit were published only in "Alice Berry Was Taken En Deshabille," and Birch notes that both the scandal and lawsuit disappeared with curious speed; see Birch, *The Woman behind the Lens*, 30–31.

82 See Brough, *Princess Alice*, 98–116.

83 Quoted in ibid., 151.

84 Ticknor, "The Steel-Engraving Lady and the Gibson Girl," 106.

85 Ibid., 106–7.

86 Ibid.

87 Ibid., 108.

3. The Return of Theatrical Feminism

1 Cassini, *Never a Dull Moment*, 204.

2 Ibid.

3 Statistics cited in Auster, *Actresses and Suffragists*, 31.

4 Ibid., 123–37.

5 Fyles, "Our Ethel"; quoted in Auster, *Actresses and Suffragists*, 124.

6 See Auster, *Actresses and Suffragists*, chapter 7.

7 See Ledger, "Ibsen, the New Woman, and the Actress."

8 See Aston, "The 'New Woman' at Manchester's Gaiety Theatre."

9 See Auster, *Actresses and Suffragists*, chapter 5; Gates, *Elizabeth Robins*; and Marshall, *Actresses on the Victorian Stage*, 140–45.

10 See Auster, *Actresses and Suffragists*, chapter 7.

11 I. Gibson, "Just Two Girls"; cited in Auster, *Actresses and Suffragists*, 133.

12 Marshall, *Actresses on the Victorian Stage*, 114.

13 See Glenn, *Female Spectacle*, 13; and Auster, *Actresses and Suffragists*, 37.

14 Marshall, *Actresses on the Victorian Stage*, 114.

15 In *Actresses on the Victorian Stage*, Marshall relates this "submission" to the period's fascination with Galatea myths.

16 Shaw, "Two Plays," 147; quoted in Marshall, *Actresses on the Victorian Stage*, 149.

17 Shaw, "Duse and Bernhardt," 150; quoted in Marshall, *Actresses on the Victorian Stage*, 149.

18 Quoted in Laurence Senelick, "Chekhov's Response to Bernhardt," 173.

19 James, *The Tragic Muse*; quoted in Glenn, *Female Spectacle*, 7.

20 Glenn, *Female Spectacle*, 23.

21 See Gold and Fizdale, *The Divine Sarah*, 309–10.

22 Vicinus, "Turn-of-the-Century Male Impersonation," 198.

23 Nora, "Sur Hamlet"; quoted in Mary Louise Roberts, *Disruptive Acts*, 177.

24 See Abbott, *Notable Women in History*.

25 Fair, "Bernhardt"; quoted in Glenn, *Female Spectacle*, 31.

26 *New York World*, 22 March 1896; quoted in Glenn, *Female Spectacle*, 31.

27 Roberts, *Disruptive Acts*, 51.

28 See Verhagen, "The Poster in *Fin-de-Siècle* Paris."

29 See G. Harris, "Yvette Guilbert," 115–33.

30 See McPherson, *The Modern Portrait in Nineteenth-Century France*, chapter 3.

31 Skinner, *Madame Sarah*, xii; cited in Roberts, *Disruptive Acts*, 171.

32 Melandri has historically been credited as the author of this image, but Carol Ockman claims that the photograph has been deattributed—alas, with no further information or citations regarding this claim. See Ockman, "Women, Icons, and Power," 108.

33 See Gold and Fitzdale, *The Divine Sarah*, 113–14.

34 See Roberts, *Disruptive Acts*, chapter 6; McPherson, *The Modern Portrait in Nineteenth-Century France*, chapter 3; Andre, "Queer Monsters"; and Bergman-Carton, "Negotiating the Categories."

35 Roberts, *Disruptive Acts*, 178–79.

36 Marshall, *Actresses on the Victorian Stage*, 95.

37 See Tickner, *The Spectacle of Women*; and Cott, *The Grounding of Modern Feminism*: 13–40.

38 Quoted in Cott, *The Grounding of Modern Feminism*, 37.

39 Glenn, *Female Spectacle*, 3.

40 Quoted in DuBois, "Working Class Women, Class Relations, and Suffrage Militance," 241.

41 See DuBois, "Working Class Women, Class Relations, and Suffrage Militance."

42 Blatch, "Why Suffragists Will Parade on Saturday"; quoted in Glenn, *Female Spectacle*, 132.

43 Glenn, *Female Spectacle*, 134.

44 See Lunardini, *From Equal Suffrage to Equal Rights*.

45 Glenn, *Female Spectacle*, 142.

46 Tickner, *The Spectacle of Women*, 151.

47 Zangwill, "Actress Versus Suffraget," 1248; quoted in Auster, *Actresses and Suffragists*, 86.

48 See Glenn, *Female Spectacle*, 135–36.

49 See Holledge, *Innocent Flowers*, 50–63, 73–101.

50 Auster, *Actresses and Suffragists*, 109–10.

51 Greeley-Smith, " 'Woman Must Choose to Love or Be Loved' "; quoted in Staiger, *Bad Women*, 160.

52 See Matthews, *The Rise of the New Woman*, 104–5; Schwarz, Peiss, and Simmons, " 'We Were a Little Band of Willfull Women' "; and Cott, *The Grounding of Modern Feminism*, 12–13.

53 The Heterodoxy group also put together a veritable pin-up album as a Christmas gift to cofounder Marie Jenney Howe in 1920. While time does not permit me to address the album, Schwarz, Peiss, and Simmons do it justice in their photo essay " 'We Were a Little Band of Willfull Women.' "

54 Cooley, "The Younger Suffragists," 7.

55 Winifred Harper Cooley, quoted in Foxcroft, "Suffrage, a Step Toward Feminism," n.p.

56 Lottie Montgomery, quoted in ibid.

57 Quoted in Matthews, *The Rise of the New Woman*, 116.

58 "Sex o'Clock in America," 113–14; quoted in Staiger, *Bad Women*, 17.

59 See Richard Dyer's well-known discussion of the role of the close-up in the appeal of cinema in *Stars*, 16–19.

60 Bowser, *The Transformation of Cinema*, 107.

61 See Staiger, *Bad Women*, 57–58.

62 See ibid.

63 See Stamp, *Movie-Struck Girls*, chapter 2; and Staiger, *Bad Women*, 44–52.

64 See Rosenbloom, "Progressive Reform, Censorship, and the Motion Picture Industry," as well as Staiger's excellent history and analysis of the National Board and the New Woman in *Bad Women*, chapter 4.

65 Staiger, *Bad Women*, 26.

66 In addition to Stamp's discussion of suffrage films in *Movie-Struck Girls*, see her parallel discussion of birth-control films during this period in "Taking Precautions."

67 See Stamp's excellent history and analyses of suffragist-produced films in *Movie-Struck Girls*, chapter 4.

68 See Stamp, *Movie-Struck Girls*; Peiss, *Cheap Amusements*; and May, *Screening Out the Past*.

69 Stamp, *Movie-Struck Girls*, 176.

70 Staiger, *Bad Women*, 13, 179.

71 Ibid., 182.

4. Celebrating the "Kind of Girl Who Dominates"

1 Hansen, *Babel and Babylon*, 117.

2 Period figures and 1928 *Exhibitors Herald/Moving Picture World* quotation from Studlar, "The Perils of Pleasure?," 263.

3 Stamp, *Movie-Struck Girls*, 141.

4 See Richard deCordova's definition and extensive discussion of the "picture personality" in *Picture Personalities*.

5 See Bowers, "Souvenir Postcards and the Development of the Star System."

6 Robbins, "Dear Dorothy."

7 "Plays and Players," 107.

8 *Paramount Progress*, 11 November 1915, 7–8; quoted in Stamp, *Movie-Struck Girls*, 22.

9 See Stamp, *Movie-Struck Girls*, 21, 123–24; and Bowers, "Souvenir Post-cards and the Development of the Star System."

10 Stamp, *Movie-Struck Girls*, 22.

11 By "true" fanzine, I mean to say the first fanzine explicitly created for the film fan. While the shorter-lived movie magazine *Motion Picture Story Magazine* was founded the year before *Photoplay*, it might be argued the earlier magazine began, like many early film journals, as an "industry" journal.

12 Staiger, *Bad Women*, xvi.

13 See, for example, Starr, "The World before Your Eyes"; and Armstrong, "A Censored Censor."

14 Staiger, *Bad Women*, 7.

15 At this time, "photoplays" were mostly replaced by film reviews by staff critics and, in 1921, photo essays using stills and short captions to illustrate the plot. By the mid-1920s, the magazine had done away with the photoplay altogether.

16 "What They Think about It," 128. Unsurprisingly, the editors determine in their response to the reader that this is "not half a bad idea," and suggest perhaps "this plan of his will be adopted by a lot more of you who may care to start scrap books of your own."

17 See the first-ever such feature, Condon, "The Girl on the Cover."

18 See "Classified Advertisements," *Photoplay*, July 1914, 7, and December 1914, 5.

19 See, for example, "Camera Queens as Playtime Mermaids"; and "When She Swims."

20 *Photoplay* advertisement, November 1915, 178; *Photoplay* advertisement, May 1916, 178.

21 Johnson Briscoe, "Photoplays versus Personality."

22 For further analyses of this "insider" tone of the period's fanzines, see Morey, "So Real as to Seem Like Life Itself"; and Studlar, "The Perils of Pleasure?" 263–97.

23 Bean, "Introduction," *A Feminist Reader in Early Cinema*, 14.

24 "Fashions in Feminine Fans," 87.

25 See, for example, Cohn, "The 'Follies' of the Screen."

26 See Howe, "Why They Get Their Fabulous Salaries," 118.

27 James R. Quirk, "The Girl on the Cover."

28 See, for example, "Florence Lawrence," 105. Here, the actress asserts: "I was a tomboy and I still am. Just when I try to be dignified and seri-

ous, down comes my hair." She proceeds to reveal that she was once the leader of her neighborhood gang in Buffalo, who "had all the boys in my crowd scared to death because I was the champion rough-and-tumble fighter." Examples of such constructions of all these actresses are found in Delight Evans, "The Girl on the Cover (Lillian Gish)"; Howe, "A Misunderstood Woman (Alla Nazimova)"; and Albert, "What Garbo Thinks of Hollywood."

29 Excellent analyses of the female-daredevil genre may be found in Stamp, *Movie-Struck Girls*, chapter 3; and Singer, "Female Power and the Serial-Queen Melodrama."

30 See, for example, K. Butler, "Irma Vep, Vamp in the City"; and Dalle Vecchio, "Femininity in Flight."

31 Stamp, *Movie-Struck Girls*, 125–26.

32 See ibid., 182.

33 Ibid., 146.

34 "Pearl White," 47.

35 Burden, "The Girl Who Keeps a Railroad."

36 Kingsley, "All-Around Anita," 143.

37 K. Williams, "Kathlyn's Own Story."

38 "The 1917-Model Bathing Girl," 71.

39 Ibid.

40 Bagg, "Many Sided Vivian Rich"; and Bartlett, "Would You Ever Suspect It?" 45.

41 R. Willis, "Kathlyn the Intrepid," 44.

42 Levine, "In the Moving Picture World," 38.

43 See, for example, "Male (Vamp) and Female (Director)"; and "Lois Weber's Rival."

44 W. Henry, "Cleo, the Craftswoman," 111.

45 See, for example, articles on perennial *Photoplay* favorite Olga Petrova: "Petrova Practices Pouring for the Photographer"; Van Buren, "Petrova the Working-Girl"; and "We Take Our Hats Off To—."

46 See, for example, "The Film's First Woman Executive"; Starr, "Putting It Together"; Rogers-St. Johns, "From the Skin Out."

47 "Here Are Ladies!"

48 Hutchinson, "A Stenographer's Chance in Pictures."

49 Jordan, "Girl Picture Magnates."

50 Johnson, "The Girl on the Cover," *Photoplay* (April 1920): 57.

51 See Edwards, "Pioneers at the Polls."

52 "How Women Will Vote," 90.

53 "Women's Rights—the Besserer Definition," 63.

54 W. Henry, "Cleo, the Craftswoman," 109.

55 Johnson, "The Soubrette of Satire," 148.

56 Underhill, "Olive Tells Her Secrets," 43.

57 For a recent history of the effects of World War I upon the suffrage movement, see Matthews, *The Rise of the New Woman*, chapter 5.

58 See, for example, Parsons, "Propaganda!"

59 See, for example, "Quick, Watson, the Needles!"; and Owen, "Eileen from the Emerald Isle."

60 K. Owen, "Colonel Kathleen," 20.

61 Denton, "Lights! Camera! Quiet! Ready! Shoot!"

62 See Cott, *The Grounding of Modern Feminism*, chapters 3–5.

63 See Staiger, *Bad Women*, 161.

64 Franklin, "Purgatory's Ivory Angel," 69.

65 Ibid., 70–72.

66 Evans, "Does Theda Bara Believe Her Own Press Agent?"

67 A. Smith, "The Confessions of Theda Bara," 58.

68 Bram Dijkstra addresses the larger cultural meanings of the vamp—including Bara and early screen actresses—in this era of history in *Evil Sisters*.

69 Bara's roots as Theodosia Goodman are addressed extensively in Golden, *Vamp*.

70 Watson, "Making Americans by Movies," 42.

71 Quirk, "Oh Henry!" 44.

72 See Diane Negra's discussion of the twin political and sexual meanings of the vamp in this era, in "Immigrant Stardom and Imperial America."

73 See *Photoplay*, December 1912, 8; Darnell, "Studio Chat from the Inside"; Priest, "The Call of Her People"; and Billings, "Unto the Third Generation."

74 See "Photoplayers Gallery."

75 See Johnson, "Impressions"; and Jordan, "A Belle of Bogota," 46.

76 Kingsley, "That Splash of Saffron," 139.

77 D. Evans, "A New China Doll," 41.

78 "Rotogravure," *Photoplay*, December 1922, 25. For an example of the rare appearance of black "characters" in the magazine, see its one-panel comics such as that in *Photoplay*, January 1915, 166.

79 Stamp, *Movie-Struck Girls*, 147.

80 See, for example, D. Allison, "Team Work"; and Rogers-St. Johns, "A Cross in the Garden."

81 Castle, "How to Be Happily Married," 109.

82 Shannon, "Dante Was Wrong."

83 La Marr, "Why I Adopted a Baby," 30–31.

84 F. Smith, "Sex Appeal, Babies, and Alice Brady," 21.

85 *Photoplay*, April 1918, 18.

86 Briscoe, "Why Film Favorites Forsook the Footlights: Interviews with Lillian Walker and William Wadsworth," *Photoplay* (August 1914): 104.

87 Rogers-St. Johns, "Matrimony and Meringue," 80.

88 Regis, "Beauty: Her Great Handicap," 33.

89 D. Evans, "The Mother of the Sub-Deb," 74–75.

90 "Male (Vamp) and Female (Director)," 45.

91 See, for example, "What They Think about Marriage."

92 Rogers-St. Johns, "A Cross in the Garden," 49.

93 Miller, "Author in Wonderland," 128.

94 "Brickbats and Bouquets," *Photoplay*, February 1923, 8.

95 Letters from the Jesse Lasky 1917 folder, Lasky Co./Famous Players-Lasky, DeMille Archives, Brigham Young University; quoted in Sumiko Higashi, "The New Woman and Consumer Culture," 301.

96 Higashi, "The New Woman and Consumer Culture," 322.

97 Studlar, "The Perils of Pleasure?" 292.

98 Jordan, "Old Lives for New," 45–46.

99 McGaffey, "Introducing the 'Vampette.'"

100 Mencken, "The Flapper," 1–2; quoted in Staiger, *Bad Women*, 2–3.

101 Staiger, *Bad Women*, 3, 53.

102 An excellent and recent analysis of the problems that the flapper poses in feminist cultural history can be found in Kitch, *The Girl on the Magazine Cover*, chapter 6.

103 Landay, "The Flapper Film," 225, 243.

104 "Rotogravure," *Photoplay*, October 1920, 60.

105 Daniels, "56½ Miles an Hour."

106 Peiss, "Making Up, Making Over," 323–24.

107 A particularly telling example of this fanzine strategy is found in a *Screenland* magazine cover story (from September 1928) in which readers were invited to look at pin-ups of Marie Prevost as both a blonde and a brunette, then asked to vote for which "look" they preferred on her. More telling of the flapper's explicitly sexualized appeal to both female and male fans is the grand prize: voters would be entered in a drawing to win the lingerie that Prevost wore in the photographs.

108 Peiss, "Making Up, Making Over," 311.

109 Undated First National Studios photo, verso caption, private collection.

110 Quoted in Landay, "The Flapper Film," 227.

111 See Landay, "The Flapper Film," 237–43.

112 Woodward, "That Awful 'IT'!" 39.

113 See Landay, "The Flapper Film," 237–43.

114 Studlar, "The Perils of Pleasure?" 275–76.

115 Anthony, "Movie Fan-atics," *Photoplay* (June 1921): 40.

116 See, for example, Dexter, "Women I Have Loved"; Rogers-St. Johns, "The Confessions of a Male Vampire" and "What Does Marriage Mean?"

117 See, for example, the photos accompanying the article by actor Francis X. Bushman, "How I Keep My Strength," 60.

118 "Plays and Players," *Photoplay*, November 1922, 88; and "Plays and Players," *Photoplay*, April 1923, 68.

119 "Brickbats and Bouquets," *Photoplay*, April 1923, 7.

120 Howe, "What Are Matinee Idols Made Of?" 41.

121 "All Handsome Lads in Pictures Are Not in Front of the Camera," 36.

122 Anne Morey presents an interpretation of this *Photoplay* tradition—as well as its general policy of avoiding salacious stories on stars during this time—through the work of one staff writer in "So Real as to Seem Like Life Itself."

123 Winship, "Oh, Hollywood!" 20.

124 Ibid., 112.

125 F. Smith, "Sex Appeal, Babies, and Alice Brady," 21.

126 See, for example, "The $250 Prize Awarded"; "The Winners of the Contest"; "$2,000 Prize Won by Girl From Philadelphia."

127 "The 'Beauty and Brains' Contest," *Photoplay*, October 1915, 27.

128 See, for example, "Doubles."

129 Stamp, *Movie-Struck Girls*, 36–37.

130 "The 'Beauty and Brains' Contest," *Photoplay*, January 1916, 50.

131 "A-a-a-ll Aboard for Star-land!" 51.

132 See the entry tallies published in " 'Beauty and Brains Contest,' " *Photoplay*, June 1916, 101; and "The Winners."

133 See the winners' profiles in "Here Are the Winners!"

134 "The 'Beauty and Brains' Contest," *Photoplay*, January 1916, 50; " 'Beauty and Brains Contest,' " *Photoplay*, May 1916, 87.

135 "Just Before the Contest Closes," 44–45.

136 "To a Young Girl Going to a Photoplay," 23.

5. New Frontiers

1 Biery, "The Troubles of Gloria," 45.
2 See, for example, the first piece in the series: Fletcher, "Beauty, Brains, or Luck?"
3 In one such feature, *Photoplay* reports that when a motion picture actress "steps out," she can afford to treat her down-at-the-heels male suitors: "Hollywood girls want to save a man's money. Even the vamps are sheep in wolves' clothing." (The article even includes a "tally sheet" of costs for one couple's evening's entertainment to prove these women's generosity!) See Busby, "A Vamp Steps Out," 58.
4 "The Girl on the Cover," *Photoplay*, March 1932, 10.
5 "The Girl on the Cover," *Photoplay*, April 1930, 6.
6 Albert, "How Norma Shearer Got What She Wanted," 51.
7 Ibid.
8 Haskell, "Pre-Code Women."
9 See Viera, *Hurrell's Hollywood Portraits*.
10 See Mick LaSalle's account of Shearer's use of the pin-up in her campaign to win the lead in *The Divorcee* in *Complicated Women*, 66–68.
11 Albert, "Charm? No! No! You Must Have Glamour," 38–39.
12 See Cott, *The Grounding of Modern Feminism*, 141–42 and 224–39; and Scharf and Jensen, *Decades of Discontent*.
13 See LaSalle's lively discussion of the myriad working women in early 1930s films in *Complicated Women*, chapters 4–7.
14 Quoted in LaSalle, *Complicated Women*, 6.
15 "A Still Life History of Joan Crawford," MGM Pictures (1940), UCLA Special Collections Library, Los Angeles. It could be argued that the studio caption may have been written by a publicist, as opposed to being a direct quote from Crawford. However, the actress's reputation for demanding control over her photos and film roles—as evidenced in both George Hurrell's memoirs and, more notoriously, those of her adopted daughter, Christina—seems to indicate that the quote is certainly not out of character and quite easily may have been Crawford's own.
16 Albert, "Mary Pickford Denies All!" 60.
17 Hall, "Hell's Angel," 69.
18 "And Now Something New."
19 Albert, "What Garbo Thinks of Hollywood," 65.
20 Albert, "She Threatens Garbo's Throne," 60.
21 Ibid., 140.

22 See Dietrich's daughter Maria Riva's candid discussion of her mother's lifelong ties to the queer circles in which she ran—both in Europe and the United States—in *Marlene Dietrich*.

23 See the discussion and promotional stills of Pickford's role in "Mary Makes One, Too!" 67.

24 "The Shadow Stage," 63.

25 Fletcher, "Who Has the Best Figure in Hollywood—And Why?"

26 Vargas and Austin, *Vargas*, 11.

27 "More Bunk Ad Nauseam," 27.

28 While the history of the Hays Code is far too complex to be given proper treatment here, for a succinct history of Joseph Breen's enforcement of the Hays Code after 1933, see Black, *Hollywood Censored*, chapters 6–8; and LaSalle, *Complicated Women*, chapter 9.

29 See R. and H. Lynd, *Middletown in Transition*, chapter 4.

30 See Lois Scharf, " 'The Forgotten Woman,' " 243–60.

31 York, "Should Women Work?" 45.

32 See Gabor, *The Pin-Up*, 76–77.

33 Merrill, *Esky*, 2.

34 See "The Varga Girl," 56; Merrill, *Esky*, 81–86; and Austin, *Petty*, 66–81. Smart's financial motives on changing Vargas's name are bolstered by an internal file from the magazine's 1946–47 court battle with Vargas over ownership of the name "Varga." In an affadavit from 24 April 1946, Smart writes that the magazine "decided to use him and develop him, not under his own name Vargas, but under a name which we could conceive and own ourselves." *Esquire* Varga archive, University of Kansas, Spencer Museum of Art, Department of Prints and Drawings.

35 The first Varga Girl's caption (October 1940), titled "Love at Second Sight," reads:

> Irene, I just called to let you know
> That I am signing off that guy from Butte
> Though his intentions may be pure as snow
> The way that cowboy rhumbas isn't cute!
> He says it's pretty lonely in New York
> And here is one for Ripley to endorse—
> The other night when we were at the Stork
> He called up home and asked about his horse!
>
> What's that you say . . . for me to hold on tight?
> Speak louder, this connection isn't clear . . .
> Oh, boy! You're sure that Winchell has it right?

SIX SILVER MINES! How interesting, my dear!
AS RICH AS THAT? He surely doesn't show it . . .
MY GOD! I've been in love and didn't know it!

36 See Martignette and Meisel, *The Great American Pin-Up*, 34.
37 "Talk of the Town," *New Yorker*, 11 January, 1941; cited in Merrill, *Esky*, 90.
38 Here, I borrow Carol Ockman's analysis of Ingres's female figures, as well as her feminist reading of the visual pleasure to be gained in them. See *Ingres' Eroticized Bodies*.
39 See Vargas and Austin, *Vargas*.
40 "The Sound and the Fury," *Esquire*, December 1940, 12.
41 "The Sound and the Fury," *Esquire*, February 1941, 10.
42 Unknown staff writer, *Esquire*, July 1941, centerfold.
43 Stack, *Esquire Calendar*, December 1941.
44 Cited in Merrill, *Esky*, 2.
45 Gingrich, "Legends of Esky's Travels," 29.
46 Photo published in *Esquire*, August 1945, 19, and full description of image from files at Library of Congress Prints and Photographs Collection, Lot 972.
47 Letter from Ensign Connell R. Miller, "The Sound and the Fury," *Esquire*, April 1944, 33.
48 Stack, *Esquire Calendar*, February 1944.
49 Gingrich, "Legends of Esky's Travels," 29.
50 See May, *Homeward Bound*, 69–70; and Despina Kakoudaki's excellent interpretation of this "sublime merger" between woman and machine in her essay "Pinup."
51 There is an interesting discourse surrounding the issue of Rosie the Riveter as a pin-up, which I unfortunately do not have the space to address in this study. See Dabakis, "Gendered Labor."
52 Cited in Gluck, *Rosie the Riveter Revisited*, 10.
53 Statistics cited in Peter Filene, *Him/Her/Self*, 163.
54 See Rupp, *Mobilizing Women for the War*, 137–66; and Honey, *Creating Rosie the Riveter*, 25–52.
55 Filene, *Him/Her/Self*, 163.
56 Rupp, *Mobilizing Women for the War*, 143.
57 N. Wise and C. Wise, *A Mouthful of Rivets*, 103.
58 Filene, *Him/Her/Self*, 163.
59 Wise and Wise, *A Mouthful of Rivets*, 99.
60 Ibid., 92–93.
61 *What Did You Do in the War, Grandma?*

62 Weatherford, *American Women and World War II*, 146–48.

63 See D'Emilio and Freedman, *Intimate Matters*, 248–49.

64 *What Did You Do in the War, Grandma?*

65 Elder, "The Sappiest Generation."

66 Ehrmann, *Premarital Dating Behavior*, cited in D'Emilio and Freedman, *Intimate Matters*, 260–61.

67 D'Emilio and Freedman, *Intimate Matters*, 260–61.

68 See Andrews, *Over Here, Over There*; and Coffey, *Always Home*.

69 *What Did You Do in the War, Grandma?*

70 For my phrasing of this phenomenon, I am indebted to Jana Frederick-Collins's paper " 'He Kept Pressing Me for Details!' "

71 See Meyerowitz, "Women, Cheesecake, and Borderline Material."

72 District Court of the United States for the District of Columbia, *Esquire v. Frank C. Walker, Postmaster General, Transcript of Proceedings before Post Office Department*, Civil No. 22722, National Archives, Post Office Department Records, Record Group 28, 46, cited and interpreted in Meyerowitz, "Women, Cheesecake and Borderline Material," 15–18; and Merrill, *Esky*, 103–23.

73 Meyerowitz, "Women, Cheesecake and Borderline Material," 17.

74 See Rawls, *Wake Up, America!*

75 I thank Brown and Bigelow archivist Teresa Roussin for her information on the history and distribution of this particular image.

76 See "Don't Look Now," 171.

77 Advertisers such as Pepsodent ("Now I've got *3 Times* the Confidence in my Man-Power"), Keepsake Jewelers, and the Arrow Shirt Company ("Ladies, come on this Christmas Gift Tour") ran ads addressed specifically at women in the "gentlemen's magazine" during World War II.

78 "The Sound and the Fury," *Esquire*, July 1945, 26.

79 See Merrill, *Esky*, 89–90.

80 See Alberto Vargas Letters: 1914–1982, reel 4059, National Archives of American Art, Smithsonian Institution.

81 "Sub-Deb Clubs: The Midwest Is Full of Them," unnamed/undated magazine clipping, *Esquire* Varga archive, University of Kansas, Spencer Museum of Art, Department of Prints and Drawings.

82 Ralph Freed, Lew Brown, and Roger Edens, "I Love an Esquire Girl," from the film *DuBarry Was a Lady*.

83 Kaye O'Brien and Gary Grice, *Women in the Weather Bureau During WWII*.

84 Meyerowitz, "Women, Cheesecake and Borderline Material," 17–18.

85 Westbrook, "I Want a Girl," 606.

86 Ibid., 605.

87 Many thanks to Lynn Rideout for sharing with me the images from the WASP class book of her mother, Patricia Houran, as well as stories from her mother's service days.

88 All the photos are inscribed on verso, "Echo Lake 5/30/47."

89 Anonymous, "The Sound and the Fury," *Esquire*, August 1943, 10. A month and a half later, Lieutenant Reddington Hanser wrote the magazine to say: "Though my liking for the Varga wenches is supreme, I would not replace the chassis on page ten for a Varga dame. It is too bad you could not provide a larger of such photo [*sic*] so that we, who appreciate shapely forms, could pin up" ("The Sound and the Fury," *Esquire*, October 1943), 10.

90 Phil Stack, first verse, "Miss America," *Esquire* gatefold, September 1942.

91 Lively, "Famous Varga Girl Creator and Wife Visiting in City."

92 Letter from Murray Benson, Capt. M.C., "The Sound and the Fury," *Esquire*, October 1944, 34.

93 Jerre and Robert were married upon his return from the Mediterranean Theater—where the Paper Doll flew in thirty-seven missions—and remained together for fifty-one years. Information taken from a letter to the author by Robert Swanson, dated 2 February 1998. I thank Mr. Swanson for sharing his stories and photographs with me.

6. Pop Goes the Pin-Up

1 See Bernstein, *On the Town*; and the film version, *On the Town*.

2 See May, *Homeward Bound*; Gatlin, *American Women since 1945*; and Meyerowitz, *Not June Cleaver*.

3 Robertson, *Guilty Pleasures*, 89.

4 Ibid., 97.

5 Anonymous, text accompanying "Ritual" pin-up, *Esquire*, April 1947, 52.

6 Faludi, *Backlash*, 53.

7 Meyerowitz, "Women, Cheesecake, and Borderline Material," 21–23.

8 See Gabor, *The Pin-Up*, 78; and R. Miller, *Bunny*, 27.

9 Hugh Hefner, publisher's statement, *Playboy*, December 1953.

10 Miller, *Bunny*, 49–52.

11 See Meyerowitz's discussion of *Playboy*'s female readership in "Women, Cheesecake, and Borderline Materials," 21–26.

12 Rupp, *Mobilizing Women for the War*, 138.

13 See Bérubé, "Marching to a Different Drummer," 88–99.

14 See Horowitz, *Betty Friedan*, and Horowitz's earlier, abbreviated treatment of the subject in "Rethinking Betty Friedan."

15 Friedan, *The Feminine Mystique*, 182.

16 Ibid., 86.

17 Ibid., 36.

18 Ibid., 183.

19 For a brilliant analysis of this comeback, see Robertson, *Guilty Pleasures*, 94–95. For a firsthand account of the disaster that was Crawford's "bachelor mother" campaign, see Crawford, *Mommie Dearest*.

20 See May, *Homeward Bound*, 64.

21 Meyerowitz, *Not June Cleaver*, 3, 8.

22 Horowitz, Rethinking Betty Friedan, 28.

23 See Meyerowitz, "Women, Cheesecake, and Borderline Material," 21–26.

24 Ibid., 21.

25 Ibid., 21–22.

26 See Kinsey et al., *Sexual Behavior in the Human Female*.

27 Archer, "Don't Hate Yourself in the Morning," 21.

28 Ibid., 48.

29 "Dear Playboy," *Playboy*, December 1955, 4.

30 See Kroll, *The Complete Reprint of John Willie's Bizarre*; and Vale and Juno, *Modern Primitives*, 6–36.

31 "I'm in the Center of the World!" 56.

32 Essex and Swanson, *Bettie Page*, 103.

33 One of Page's most famous collaborators, photographer Bunny Yeager, also exemplified the role of the subversive postwar pin-up—serving as both artist and model. Yeager had begun her career as a professional photographer at more or less the same time that she had begun her modeling career; she claimed that if she could shoot her own "model book," she could more effectively promote herself. As such, her earliest pin-up photos were self-portraits taken with either her camera's self-timer or a creatively placed shutter cord. In addition to the renowned "Santa" centerfold, Yeager shot some of Page's best-known cheesecake photographs during Page's occasional trips to Miami in 1954 and 1955. See Yeager, *Bunny's Honeys*.

34 Essex and Swanson, *Bettie Page*, 10, 179–80.

35 Such extreme B-D photos were part of the Klaws' lucrative made-to-order business, wherein the studio actually created images catered specifically to certain clients' requests. See R. Foster, *The Real Bettie Page*, chapter 7.

36 See Essex and Swanson, *Bettie Page*; and Burton, "I Was a Teenaged Betty," 71.
37 See M. Gardner, *Harry Truman and Civil Rights*.
38 "Backstage," *Ebony*, November 1945, 1.
39 A. Morrison, "What Price Heroism?" 11.
40 See, for example, the different approaches between the features "How to Write a Book in the Army" and "History Is Made in Flight."
41 See, for example, "Lady Boxer," 30.
42 "Lady Lawyers," 19.
43 "Women Leaders," 22.
44 "Goodbye Mammy, Hello, Mom," 36.
45 "One Year after V-Day," 40.
46 "Backstage," *Ebony*, May 1946, 4.
47 "Glamour Is Global," 19.
48 Ibid.
49 "Letters and Pictures to the Editor," *Ebony*, November 1946, 4.
50 "A Date with Anna," 21.
51 "'Anna' Cast Draws High Profits, Gets Low Wages," 23.
52 "Cover: Lena Horne," 1.
53 "Cotton Club Girls," 36.
54 See, for example, "Letters and Pictures to the Editor," *Ebony*, May 1947, 3. While most letters were from ordinary readers, no less a reader than G. James Fleming, secretary of the Race Relations Committee of the Quaker American Friends Service Committee, wrote in to say: "I am sure there are many of your readers who will appreciate a fully-dressed woman on the front page for a change." See "Letters and Pictures to the Editor," *Ebony*, December 1946, 51.
55 "Cover: Katherine Dunham," 3.
56 See, for example, the heated and varying perspectives in "Letters and Pictures to the Editor," *Ebony*, February 1949, 5; and "Letters and Pictures to the Editor," *Ebony*, April 1949, 5–8.
57 "Miss Fine Brown Frame," 47.
58 "Letters to the Editor," *Ebony*, March 1948, 9.
59 "Letters to the Editor," *Ebony*, August 1947, 6.
60 Ibid., 4.
61 Ibid., 6.
62 Ibid., 4.
63 See Greenberg, "Avant-Garde and Kitsch."
64 For an extensive analysis of the relationship between Greenbergian mod-

ernism and contemporary styles that were excluded from its history, see J. Harris, "Modernism and Culture in the USA."

65 See Greenberg, "Modernist Painting."

66 Banes, *Greenwich Village 1963*, 232–33.

67 Ibid., 72.

68 See Allyn, *Make Love, Not War*, 130–34.

69 Banes, *Greenwich Village 1963*, 97, 216.

70 Schneemann, *More than Meat Joy*, 180. Schneemann's use of "art *istorian*" relates to one who is simultaneously an artist, an art historian, and one who refutes the notion of a masculinist "*history*."

71 Banes, *Greenwich Village 1963*, 94.

72 See T. Hess, "Pinup and Icon."

73 See Lavin, "Androgyny and Spectatorship."

74 Significantly, as noted by Mary Ann Caws in "Ladies Shot and Painted," Oppenheim's "penis" was effectively lopped off in *Minotaure*'s reproduction—resulting in a far less dangerous vision of the "veiled erotic."

75 See Hooven, *Beefcake*, 18–103; Gabor, *The Pin-Up*, 132; and Essex and Swanson, *Bettie Page*, 129–30. Even relatively straightforward s-m/b-d magazines like *Bizarre* attempted to counter questions of the propriety of its imagery before the fact by peppering the magazine's many bondage images with illustrations of tip-toeing thieves and warning captions such as: "Don't let this happen to you! Learn jiu jitsu, the art of self defense." Inexplicably, it must have seemed to Coutts that such warnings might serve as something of a safety valve should the magazine's moral fiber be challenged.

76 See Gabor, *The Pin-Up*, 78–80; and Lord, "Pornutopia."

77 Gabor, *The Pin-Up*, 78.

78 McCarthy, *The Nude in American Art*, 83.

79 Hamilton, "For the Finest Art, Try Pop," 727.

80 Rosenblum, *Mel Ramos*, 4.

81 Bazin, "Entomology of the Pin-Up Girl," 158, 161.

82 See McCarthy, *Pop Art*, 46–49.

83 T. Hess, "Pinup and Icon," 236–37.

84 See Holland, "*8½* and Me."

85 See the catalog *Robert Rauschenberg*, 87–88.

86 McCarthy, *The Nude in American Art*, 96.

87 See Denning, *The Denning Report*.

88 McCarthy, *Pop Art*, 39.

7. Our Bodies/Ourselves

1 See Gabor, *The Pin-Up*, 79–80; and Kallan and Brooks, "The Playmate of the Month."

2 Kallan and Brooks, "The Playmate of the Month," 333.

3 See Gabor, *The Pin-Up*, 79–80; and Wortley, *Pin-Up's Progress*, 107–29.

4 See Steele, *Fetish*, 107–29; and Wortley, *Pin-Up's Progress*, 107–8.

5 Steele, *Fetish*, 34.

6 Kallan and Brooks, "The Playmate of the Month," 333.

7 Alberto Vargas centerfold illustration, *Playboy*, September 1970.

8 "Liberty Belle," 45.

9 Assiter and Carol, *Bad Girls and Dirty Pictures*, 3.

10 Lucy Lippard, "The Pains and Pleasures of Rebirth"; reproduced in Lippard, *The Pink Glass Swan*, 102.

11 Some excellent, relatively recent surveys addressing the rise of the women's liberation movement include Baxandall and Gordon, *Dear Sisters*; Echols, *Daring to Be Bad*; and Cott, *The Grounding of Modern Feminism*.

12 Quoted in S. Evans, *Personal Politics*, 87.

13 Hollibaugh, *My Dangerous Desires*, 106.

14 Two years later, an SDS chapter continued its open sexism by advising readers in a brochure: "The system is like a woman; you've got to fuck it to make it change." See Echols, *Daring to Be Bad*, 38–45, for an overview of the conference, panel, and *New Left Notes'* dismissive response.

15 bell hooks later offered an interesting analysis of how—in this era of the struggle to end dominance—such sexual domination might be viewed as a strategically used bonding device between activist men. "Accepting these sexual metaphors forged a bond between oppressed black men and their white male oppressors. They shared the patriarchal belief that revolutionary struggle was really about the erect phallus, the ability of men to establish political dominance that could correspond to sexual dominance" (*Yearning*, 58).

16 Hollibaugh, *My Dangerous Desires*, 109.

17 Astrid Henry documents and analyzes the earliest uses of the term—first by Marsha Wienman Lear in a 1968 *New York Times Magazine* on the burgeoning movement, and shortly (and more famously) thereafter by Shulamith Firestone and Germaine Greer—in *Not My Mother's Sister*, 58–60.

18 Dworkin, *Woman Hating*, 117.

19 The image's punch-line—"Q: Why haven't women made great works of art? A: Because they are great works of art"—is a reference to Linda

Nochlin's 1971 essay "Why Have There Been No Great Women Artists?"
See Dworkin, *Woman Hating*, 117.

20 Yeager, *Bunny's Honeys*, 16.

21 Berger, *Ways of Seeing*, 46–7.

22 Through Michel Foucault's and Roland Barthes's theories on constructions of "authorship," and the active subject/passive object in literary and cultural power relationships, feminist writers and artists found yet another manner of articulating the ways in which images of women both reflected and lent themselves to objectifying constructions of female sexuality within patriarchal systems. See Foucault, "What Is an Author?" and *The History of Sexuality: Vol. I.*

23 See Echols, "The Taming of the Id."

24 These concepts are perhaps best articulated in Dworkin's *Pornography*, 199–224, and "Against the Male Flood," 25.

25 See the collected writings of Cell 16 members published in *No More Fun and Games: A Journal of Women's Liberation* (1968–73); and Atkinson, "Lesbianism and Feminism," in *Amazon Odyssey*.

26 For first-person accounts of WAP's porn "slide shows" of the period, see Webster, "Pornography and Pleasure," in *Caught Looking*, 30; and D'Emilio, *Making Trouble*, 202–15.

27 Fox, "A Dialogue with Eleanor Antin," 206–7.

28 Pauline Boty died in 1966 at the age of twenty-eight.

29 Reckitt, "Works: Too Much," 94.

30 See Boston Women's Health Collective, *Our Bodies, Ourselves*; Koedt, "The Myth of the Vaginal Orgasm"; and Dodson, *Liberating Masturbation*.

31 Gallop, *Feminist Accused of Sexual Harassment*, 5–6.

32 Snitow, "Pages from a Gender Diary," 219.

33 From interview with David Allyn in *Make Love, Not War*, 106.

34 See Allyn, *Make Love, Not War*, 33–34.

35 English, Rubin, and Hollibaugh, "Talking Sex," 121.

36 Millett, *Sexual Politics*, 62.

37 Firestone, *The Dialectic of Sex*, 209.

38 See Jong, *Fear of Flying*.

39 Quote and statistics in Allyn, *Make Love, Not War*, 267.

40 Suleiman, *Subversive Intent*, 121.

41 For a more in-depth discussion of Greer's complex relationship to *Suck*, see C. Wallace, *Germaine Greer*, 204–15.

42 Dworkin, *Woman Hating*, 75, 81.

43 Chesler, *Letters to a Young Feminist*, 55.

44 See A. Henry, *Not My Mother's Sister*, 52–87.

45 Firestone and Koedt, *Notes from the Second Year*, 2; cited and analyzed in
 A. Henry, *Not My Mother's Sister*, 74–75.

46 A. Henry, *Not My Mother's Sister*, 72.

47 Frueh, "The Body through Women's Eyes," 192.

48 See Kenneth Clark's canonical treatment of the distinction in *The Nude*.

49 Beauvoir, *The Second Sex*, 267.

50 Fuss, *Essentially Speaking*, 5.

51 Student Dori Atlantis shot the photographs. See Wilding, "The Feminist
 Art Programs at Fresno and CalArts," 38.

52 In her unpublished work "Welcome to the (Deconstructed) Dollhouse:
 Revisiting *Womanhouse*," Temma Balducci explores the constructionist
 experiments of the Feminist Art Program with great thoroughness and
 wit. Many thanks to Temma for sharing her work and resources with me,
 as well as for opening my eyes to the nuances and visionary qualities of
 the *Womanhouse* project.

53 See Weitman, *Pop Impressions*, 99.

54 Unfortunately, the media turned the hair curlers and *Vogue* issues tossed
 into the "Freedom Trashcan" into the antifeminist slur "bra-burner," even
 though no such garments were burned.

55 Wilding, *By Our Own Hands*, 8.

56 Wilding, "The Feminist Art Programs at Fresno and CalArts," 35.

57 Zurilgen, "Becoming Conscious," 8; cited in Wilding, "The Feminist Art
 Programs at Fresno and CalArts," 5. Chicago herself concurred, writing
 in her autobiography that teaching in the Fresno Feminist Art Program
 taught her that "the real concern of the women's lives revolved around
 their sexual anxieties," and as such "discussing sex illuminated the entire
 personality problems of the women in the class" (*Beyond the Flower*, 79).

58 Although Eleanora Antinova is often addressed as a development of "The
 Ballerina," in Antin's 1999 Los Angeles County Museum of Art retro-
 spective, Howard Fox notes that the issues surrounding Antinova's black-
 ness originated in the soon-retired "Black Movie Star" of 1974. See Fox,
 Eleanor Antin, 72.

59 Ibid., 72–77.

60 See Bloom, "Rewriting the Script," 184.

61 Fox, *Eleanor Antin*, 131.

62 Fox, *Eleanor Antin*, 211–12.

63 See Susan Krane's excellent, thorough discussion of the *Artforum* article
 and advertisement in *Lynda Benglis*, 33–46.

64 See "Interview: Linda [*sic*] Benglis"; quoted in Krane, *Lynda Benglis*, 40.

65 Interview with Ned Rifkin in Gumpert, Rifkin, and Tucker, *Early Work*, 14; quoted in Krane, *Lynda Benglis*, 41.

66 Krane, *Lynda Benglis*, 39–40.

67 "Interview: Linda [*sic*] Benglis"; cited in Krane, *Lynda Benglis*, 41. Although her more suggestive ad pin-up was rejected, *Artforum* chose to reproduce Liebowitz's photograph among the illustrations in Pincus-Witten's article. See Pincus-Witten, "Lynda Benglis," 54–59.

68 Huberty, "Intensity of Form and Surface," 32.

69 Quoted in Krane, *Lynda Benglis*, 36.

70 From Ballatore, "Lynda Benglis' Humanism," 6; also quoted in Krane, *Lynda Benglis*, 42.

71 Pincus-Witten, "Lynda Benglis," 55.

72 The letter was published in *Artforum* in December 1974. Only West Coast editor Peter Plagens—who contributed a hysterical, satirical letter to the same letters section as the other letters' apology—contributed anything resembling a defense of Benglis. The complexities of the fiasco surrounding Benglis's ad are too great for me to properly discuss in the context of this article; Amelia Jones addresses the debacle at length in "Postfeminism, Feminist Pleasures, and Embodied Theories of Art," 33–36.

73 Alloway et al., "Letter to the Editor," 9.

74 Nemser, "Lynda Benglis," 7.

75 See Amelia Jones's excellent analyses of both Benglis's and Morris's images and their respective receptions in *Body Art*, 114–16.

76 Lippard, *The Pink Glass Swan*, 105.

77 See Joanna Frueh's analysis of this issue in "Hannah Wilke," 15.

78 Ibid., 44.

79 Lippard, *The Pink Glass Swan*, 108.

80 Ibid., 103.

81 Amelia Jones, *Body Art*, 155.

82 See Frueh, "Hannah Wilke," 41–49.

83 Quoted in Siegel, "Hannah Wilke: Censoring the Muse?" 47.

84 Quoted in Frueh, "Hannah Wilke," 52.

85 Ibid., 47.

86 Cited in ibid., 63.

87 Rower, "Fresh Dirt."

88 See Jones, *Body Art*, 152–95.

89 Irigaray, "The Power of Discourse," 77.

90 David Allyn, *Make Love, Not War*, 273.

91 Rich, *Of Woman Born*, 77.

92 Hollibaugh, *My Dangerous Desires*, 109.

93 Joanna Frueh presents a different interpretation of the work in her essay "The Body through Women's Eyes."

94 See Cruz, "Twenty Years of Cindy Sherman."

95 Jameson, "Postmodernism and Consumer Society," 112, 125.

96 Danto, *After the Pale of History*, 5.

97 Owens, *Beyond Recognition*, 54.

98 Crimp, "Appropriating Appropriation," 34.

99 Owens, "The Discourse of Others," 183.

100 Foster, "Obscene, Abject, Traumatic," 110–11.

101 Grundberg, "Cindy Sherman."

102 The parallels between Benglis's and Sherman's *Artforum* controversies are noted by Amanda Cruz in "Twenty Years of Cindy Sherman," 6–7.

103 Maria Lind, "Retracing the Steps of Cindy Sherman: Retaining the Element of Chance" (1995) (from artist's files at Metro Pictures).

104 The emphasis is Owens's (*Beyond Recognition*, 215).

105 Owens, "The Discourse of Others," 75.

106 See Krauss, "Cindy Sherman: Untitled," 28.

107 Dworkin, "Against the Male Flood" 25.

108 *Miller v. California*, 413 U.S. 15 (1973); MacKinnon, "Pornography, Civil Rights, and Speech," *Harvard Civil Rights-Civil Liberties Law Review* 20, no. 1 (Winter 1985); and Andrea Dworkin, "Against the Male Flood," 25. The model ordinance was passed and then vetoed or overturned in both Minneapolis and Indianapolis, and was later used by conservative senator Arlen Specter in drafting federal antipornography legislation. The influence of their model would reach its apex when Dworkin was famously called to testify at Attorney General Edwin Meese's Commission on Pornography, begun in the spring of 1985.

109 MacKinnon, "Pornography, Civil Rights, and Speech," 465.

110 See Dworkin, *Pornography*, *Woman Hating*, and "Against the Male Flood"; MacKinnon, "Pornography, Civil Rights, and Speech" and "Not a Moral Issue"; and Wilson, "Interview with Andrea Dworkin,"

111 R. Morgan, "Theory and Practice," 139.

112 Most notably, Dworkin's testimony during the Attorney General's (Meese) Commission on Pornography on January 22, 1986, in New York City. See U.S. Department of Justice, *Attorney General's Commission on Pornography Final Report*.

113 See Duggan, Hunter, and Vance, "False Promises."

114 MacKinnon, "Pornography, Civil Rights, and Speech," 466.

115 Many feminist scholars far more articulate in legal issues than I have bril-

liantly addressed the subject. Of particular use to me in my research are Duggan, Hunter, and Vance, "False Promises"; Cornell, *The Imaginary Domain*; and Strossen, *Defending Pornography*.

116 The conference presentation, held at Mount Holyoke College, took place on 25 August 1978. The paper was later published as part of Lorde's well-known collection of essays and poetry, *Sister Outsider*.

117 Lorde, *Sister Outsider*, 53–54.

118 Ibid, 59.

119 Carter, *The Sadeian Woman and the Ideology of Pornography*, 37.

120 Sade quoted by Carter, *The Sadeian Woman*, 37.

121 Gamman and Evans, "The Gaze Revisited," 14. See also Gamman and Marshment, *The Female Gaze*.

122 Doyle and Lacombe, "Porn Power," 191–2.

123 See, for example, Doane, "Film and the Masquerade"; Kuhn, *The Power of the Image*; and de Lauretis, *Alice Doesn't*.

124 Doane, "Film and the Masquerade," 86.

125 Kuhn, *The Power of the Image*, 48.

126 Ibid., 37–38, 43.

127 Mulvey, "Visual Pleasure and Narrative Cinema," 373.

128 De Lauretis, *Alice Doesn't*, 157.

129 The resulting publication was the book, *Pleasure and Danger*, edited by Carole S. Vance.

130 See Vance's account of the protests in her recent introduction to the third edition of *Pleasure and Danger*. See also Dorothy Allison's personal account of being a target of the Barnard attacks in *Skin*, 101–19.

131 Doyle and Lacombe, "Porn Power," 192–94, 200.

132 See Burstyn, *Women against Censorship*.

133 Vance, *Pleasure and Danger*, 2nd ed., 24.

134 Damsky, *Sex and Single Girls*, xvi.

135 Snitow, "Retrenchment versus Transformation," 110.

136 Ibid.

8. From Womyn to Grrrls

1 Whittier, *Feminist Generations*, 3.

2 Looser, "Introduction 2: Gen X Feminist? Youthism, Careerism, and the Third Wave," in Looser and Kaplan, *Generations*, 36–37.

3 Salvatore, "A Classic Case of Sensory Overload," 43–44.

4 Chroniclers of the third wave are indebted to the recent research of

Astrid Henry for unearthing this first reference to "third wave" in her book *Not My Mother's Sister.*

5 See, for example, M. Wallace, *Black Macho and the Myth of the Superwoman*; T. Morrison, "What the Black Woman Thinks about Women's Lib"; and Bunch and Myron, *Class and Feminism.*

6 The conference presentation, held at Mount Holyoke College, took place on 25 August 1978. The paper was later published as part of Lorde's well-known collection of essays and poetry, *Sister Outsider.*

7 See Moraga and Anzaldua, *This Bridge Called My Back*, iv, xxii.

8 Among the most influential writing to emerge from this period is Aptheker, *Woman's Legacy*; B. Smith, *Home Girls*; and hooks, *Ain't I a Woman?* and *Feminist Theory.*

9 Jameson, *The Political Unconscious*, 84; the same passage is cited by Craig Owens in "The Discourse of Others," 62.

10 Sandoval, "The Theory and Method of Oppositional Consciousness in the Postmodern World," 4–5.

11 Moraga and Anzaldua, *This Bridge Called My Back*, 5.

12 D. Allison, *Skin*, 115.

13 See Whittier, *Feminist Generations*, 169–90; and Patten, "The Thrill Is Gone."

14 Whittier, *Feminist Generations*, 174.

15 Hennessy, "Queer Theory," 967.

16 A. Henry, *Not My Mother's Sister*, 129.

17 I borrow the use of the term *binary* in reference to gendered notions of sexuality from Judith Butler's groundbreaking book *Gender Trouble*. For an excellent breakdown of the problems and utility of binarisms in queer culture, see Walters, "From Here to Queer," 830–69.

18 Fernandez, "Sex into Sexuality," 37–38.

19 Stephens, "Looking-Class Heroes," 281, 284.

20 See Nagle, "The First Ladies of Feminist Porn," 156–66; and Andrea Juno, "Interview with Susie Bright."

21 English, Hollibaugh, and Rubin, "Talking Sex," 121.

22 D. Allison, "Conceptual Lesbianism," in *Skin*, 141.

23 Juno, "Interview with Susie Bright," 209.

24 Susie Bright, e-mail to author, 19 July 2002.

25 See Boffin and Fraser, *Stolen Glances*; and Kiss and Tell, *Her Tongue on My Theory.*

26 Quoted in Raven, "Star Studded," 175.

27 See Carnival Knowledge papers (1981–85), Franklin Furnace Archive, New York City. Thanks to Franklin Furnace founder and director Martha

Wilson for her generosity with both the archive's resources and her own time recounting her experiences as the gallery's director during the Carnival Knowledge happenings.

28 Raven, "Star Studded," 181.

29 Ellis, O'Dair, and Tallmer, "Introduction," 8.

30 Russ, *Magic Mommas*, 59.

31 D. Bright, "Introduction," 8.

32 When the *New York Times* recently revisited its fashion photography archives, it discovered Amy Arbus's photographs of Madonna among the photographer's 1980s images of East Village hipsters. See Trebay, "The Age of Street Fashion."

33 See McRobbie, "New Sexualities in Magazines," in *In the Culture Society*, 46–61.

34 Ross, "This Bridge Called My Pussy," 47.

35 See bell hooks's critiques of Madonna's racial politics, "Madonna: Plantation Mistress or Soul Sister?" in *Black Looks*, 157–64, and "Power to the Pussy."

36 hooks, "Madonna," 159.

37 Queen, "Talking About *Sex*," in Frank and Smith, *Madonnarama*, 147.

38 Baumgardner and Richards, *Manifesta*, 31.

39 Schwichtenberg, "Madonna's Postmodern Feminism," 130, 141.

40 Kamen, *Her Way*, 31.

41 Ross, "This Bridge Called My Pussy," 52.

42 Cocks, "Big Girls Don't Cry," 74.

43 Greer, "Foreword," 7.

44 For firsthand accounts of this phenomenon for third-wave feminists, see Buszek, "Oh! Dogma (Up Yours!)"; and Powers, *Weird Like Us*.

45 Suleiman, *Subversive Intent*, xvii.

46 Whittier, *Feminist Generations*, 3.

47 Walker, "Becoming the Third Wave," 41.

48 A. Henry, *Not My Mother's Sister*, 178.

49 Whittier, *Feminist Generations*, 224.

50 A. Henry, *Not My Mother's Sister*, 6, 11–12.

51 Kamen, *Her Way*, 180.

52 Heywood and Drake, *Third Wave Agenda*, 3.

53 J. Butler, *Gender Trouble*, 93.

54 Haraway, "A Cyborg Manifesto," 150. For an excellent discussion of Haraway's influence on riot grrrl thought, see Garrison, "U.S. Feminism—Grrrl Style!"

55 McQuiston, *Suffragettes to She-Devils*, 90.

56 Haraway, "A Cyborg Manifesto," 175.

57 Marlene McCarty, e-mail to author, 25 July 2002.

58 McCarty shared with me a hilarious story of how difficult it was to get her chosen text printed: "The manufacturer was in Texas. I sent in my text to be applied to the matchbook. A few days later I got a callback from a lady with a very heavy southern drawl. '. . . ummm, Miss, my manager says we can't reproduce THAT word.' I knew she was referring to CLIT but I wanted her to say it, so I asked her, 'What word did [you] mean?' She said, 'Ummm, the fourth word.' She wouldn't say it. I asked her about DICK. She said 'That word's okay.'"

59 See McQuiston, *Suffragettes to She-Devils*, 162, 168.

60 E. Hess, "Gallery of the Dolls," 91.

61 See "Talking Cock" and *Shonagh Adelman*.

62 Adelman, *Artist's Statement*.

63 Cox's perspective is drawn from a telephone interview with the author, November 1998. See also Gibbons, "Rajé Rules."

64 See Gibbons, "Rajé Rules."

65 Cox, "Renée Cox Speaks Out."

66 C. Williams, "Playing Nature and Culture."

67 Renée Cox quoted in S. Williams, "Wonder Woman at the Brooklyn Museum," 43; and Henderson, "Sex Sells."

68 See McRobbie, "*Jackie* Magazine: Romantic Individualism and the Teenage Girl," in *Feminism and Youth Culture*, and *In the Culture Society*, 47.

69 Kamen, *Her Way*, 17.

70 Baumgardner and Richards, *Manifesta*, 15.

71 See the brief history of mass media's address of feminism in ibid., 93.

72 See Bellafante, "Feminism"; and Baumgardner and Richards, "Feminists Want to Know: Is the Media Dead?" in *Manifesta*, 87–125.

73 McRobbie, *In the Culture Society*, 56.

74 Baumgardner and Richards, *Manifesta*, 223.

75 Quoted in Bellafante, "Feminism."

76 Ibid.

77 Naturally, the best way into the riot grrrl movement is through grassroots zines such as *I [Heart] Amy Carter*, *Girl Power*, *Rockgirl*, *Pucker Up*, *Rollerderby*, and *Mons of Venus*—difficult to find in their original photocopied format, but slowly being compiled in third-wave feminist anthologies such as Green and Taormino, *The Girl's Guide to Taking Over the World*; and Baldauf and Weingartner, *Lips, Tits, Hits, Power?*. Mass media articles from the period offer perspectives on the subject; see Chideya,

Rossi, and Hannah, "Revolution, Girl Style"; Spencer, "Grrrls Only"; and France, "Grrrls at War."

78 Information on Ladyfest, as well as an archive of past conventions, can be found at www.ladyfest.org.

79 Quoted in Baumgardner and Richards, *Manifesta*, 93.

80 K. Allison and Nadim, "You're Really Good . . . for a Girl," 7.

81 Hanna, "On Not Playing Dead," 123.

82 Baumgardner and Richards, *Manifesta*, 136.

83 "Riot Grrrl Manifesto," *Bikini Kill* no. 2 (1991): 44; also quoted in Carlip, *Girl Power*, 31–60.

84 Joy Press, "Notes on Girl Power," 60.

85 Ibid., 61.

86 Ibid.

87 López, "Artist's Statement," Alma Lopez.net. Online. http://www.alma lopez.net/artist.html. (2001) 30 July 2002.

88 Quoted in Calvo, "Impassioned Icons."

89 See López, "Artist's Statement," and Cisneros, "Guadalupe the Sex Goddess."

90 López, "Artist's Statement." It bears noting that when the work was exhibited at the Museum of International Folk Art in Santa Fe, New Mexico, from 25 February 2001 through 28 October 2001, it became the subject of a protest coordinated by the Santa Fe archdiocese.

91 Honig, "Artist's Statement."

92 The text from these images are as follows: Bruiser: "Expensive makeup cannot hide/ the bruises on this blushing bride!"; Ruby Ribbons: " 'Lucy' dances without clothes/ to 'thread her needles'/ and 'powder her nose'!"

93 Yuskavage, "Interview," 27.

94 Rice, "Lisa Yuskavage."

95 Ibid.

96 Yuskavage, "Interview," 28.

Conclusion/Commencement

1 Pokorny, "Lisa Yuskavage," 89.

2 Tanner, *Bad Girls*, 10.

3 See Jan Avgikos, et al., "Bad Girl Blues"; Canning, "Bad Girls, Part 2"; Heartney, "Bad Girls"; A. Morgan, "Bad Girls, Part 1"; and M. Morgan, "Bad Girls West," 81.

4 Solomon, "Art Girls Just Wanna Have Fun."

5 Falkenstein, "What's So Good about Being Bad?"

6 Pollack, "Babe Power."

7 Ibid., 10.

8 A. Henry, *Not My Mother's Sister*, 38.

9 Chicago's work was very recently purchased by the Brooklyn Museum of Art. See Lord, "The Table Is Set."

10 Jones, "Sexual Politics," 25. The note from which this quote comes includes a list of the artists who boycotted the exhibition.

11 Quoted in Schor, "Contemporary Feminism," 15.

12 Richards and Baumgardner, *Manifesta*, 220–23.

13 Quoted in Schor, "Contemporary Feminism," 15.

14 Joyce Kozloff, personal interview with author, New York City, November 1998.

15 Quoted in Falkenstein, "What's So Good about Being Bad?" 159.

16 Quoted in ibid.

17 Quoted in ibid., 161.

18 Quoted in Pollack, "Babe Power," 8.

19 Jones, "Feminism and Art," 143.

20 Nochlin, "Feminism and Art: Nine Views," 141.

21 Phelan, "Feminism and Art: Nine Views," 148–49.

22 Ibid.

23 Wilding, "Where Is the Feminism in Cyberfeminism?" 397.

24 Quoted in Hayt, "The Artist Is a Glamour Puss."

25 Quoted in Hex, "Fierce, Funny, Feminists," 56.

26 Garrison, "U.S. Feminism—Grrrl Style!" 149.

27 These pin-ups first appeared as part of Magnuson, "I Have a Sex Book, Too!"

28 Ann Magnuson, telephone conversation with author, spring 1997.

BIBLIOGRAPHY

"A-a-a-ll Aboard for Star-land!" *Photoplay*, September 1916, 51–54+.

Abbott, Willis J. *Notable Women in History: The Lives of Women Who in All Ages, in All Lands, and in All Womanly Occupations Have Won Fame and Put Their Imprint on the World's History*. Philadelphia: J.C. Winston, 1913.

Abel, Richard, ed. *Silent Film*. New Brunswick, N.J.: Rutgers University Press, 1996.

Adelman, Shonagh. *Artist's Statement*: Corpus Delecti = *Body of Evidence*. New York: Linda Kirkland Gallery, 1999.

Albert, Katherine. "Charm? No! No! You Must Have Glamour." *Photoplay*, September 1931, 38–39, 119.

———. "How Norma Shearer Got What She Wanted." *Photoplay*, May 1931, 50–51.

———. "Mary Pickford Denies All!" *Photoplay*, January 1931, 60.

———. "She Threatens Garbo's Throne." *Photoplay*, December 1930, 60, 161.

———. "What Garbo Thinks of Hollywood." *Photoplay*, August 1930, 65–66+.

"Alice Berry Was Taken En Deshabille," *New York Morning Telegraph*, 5 February 1898.

"All Handsome Lads in Pictures Are Not in Front of the Camera." *Photoplay*, November 1922, 36–37.

Allen, Robert C. *Horrible Prettiness: Burlesque and American Culture*. Chapel Hill: University of North Carolina Press, 1991.

Allison, Dorothy. *Skin: Talking about Sex, Class, and Literature*. Ithaca, N.Y.: Firebrand Books, 1994.

———. "Team Work." *Photoplay*, March 1919, 67–69.

Allison, Kirsty, and Tahani Nadim, "You're Really Good . . . for a Girl." *Make*, December 2000–February 2001, 7.

Alloway, Lawrence, Max Kozloff, Joseph Masheck, Rosalind Krauss, and Annette Michelson, "Letter to the Editor." *Artforum*, December 1974, 9.

Allyn, David. *Make Love, Not War: The Sexual Revolution, an Unfettered History*. New York: Routledge, 2001.

"And Now Something New—A Movie 'Undie' Parade." *Photoplay*, August 1930, 86–87.

Anderson, Karen. *Wartime Women: Sex Roles, Family Relations, and the Status of Women During World War II*. Westport: Greenwood Press, 1981.

Andre, Laura. "Queer Monsters: Sarah Bernhardt and the Performance of Identity." MA thesis, University of North Carolina, Chapel Hill, 1997.

Andrews, Maxine. *Over Here, Over There: The Andrews Sisters and the USO Stars in World War II*. New York: Kensington, 1993.

" 'Anna' Cast Draws High Profits, Gets Low Wages." *Ebony*, December 1945, 23.

Anthony, Norman. "Movie Fan-atics." *Photoplay*, June 1921, 40.

Aptheker, Bettina. *Woman's Legacy: Essays on Races, Sex, and Class in American History*. Amherst: University of Massachusetts Press, 1982.

Archer, Jules. "Don't Hate Yourself in the Morning: You Weren't the Only One Having Fun." *Playboy*, August 1955, 21.

Ardis, Ann. *New Women, New Novels: Feminism and Early Modernism*. New Brunswick, N.J.: Rutgers University Press, 1990.

Armstrong, R. D. "A Censored Censor." *Photoplay*, February 1912, 51.

Assiter, Alison. *Pornography, Feminism, and the Individual*. Winchester: Pluto Press, 1983.

Assiter, Alison, and Avedon Carol, eds. *Bad Girls and Dirty Pictures: The Challenge to Reclaim Feminism*. Boulder, Colo.: Pluto Press, 1993.

Aston, Elaine. "The 'New Woman' at Manchester's Gaiety Theatre." In *The New Woman and Her Sisters: Feminism and Theatre, 1850–1914*, edited by Vivien Gardner and Susan Rutherford. Ann Arbor: University of Michigan Press, 1992.

Atkinson, Ti-Grace. *Amazon Odyssey*. New York: Links, 1974.

Auster, Albert. *Actresses and Suffragists: Women in the American Theater, 1890–1920*. New York: Praeger, 1984.

Austin, Reid. *Petty: The Classic Pin-Up Art of George Petty*. New York: Gramercy Books, 1997.

Avgikos, Jan, Benjamin Weissman, and Michael Corris. "Bad Girl Blues [Exhibits in New York, Los Angeles and London]." *Artforum International*, May 1994, 86–89+.

Bad Girls. Catalog, New Museum of Contemporary Art, New York. Cambridge: MIT Press, 1994.

Bagg, Helen. "Many Sided Vivian Rich." *Photoplay*, November 1914, 51–54.

Baker, Jean H., ed. *Votes for Women: The Struggle for Suffrage Revisited*. New York: Oxford University Press, 2002.

Baldauf, Anette, and Katharina Weingartner, eds. *Lips, Tits, Hits, Power? Popkultur und Feminismus*. Wien: Folio Books, 1998.

Ballatore, Sandy. "Lynda Benglis' Humanism." *Art Week*, 22 May 1976, 6.

Banes, Sally. *Greenwich Village 1963: Avant-Garde Performance and the Effervescent Body*. Durham, N.C.: Duke University Press, 1993.

Banner, Lois. *American Beauty*. New York: Alfred A. Knopf, 1983.

Banta, Martha. *Imaging American Women: Idea and Ideals in Cultural History*. New York: Columbia University Press, 1987.

Barnes-McLain, Noreen. "Bohemian on Horseback: Adah Isaacs Menken." In *Passing Performances: Queer Readings of Leading Players in American Theatre History*, edited by Robert Schanke and Kim Marra. Ann Arbor: University of Michigan Press, 1998.

Bartlett, Randolph. "Would You Ever Suspect It?" *Photoplay*, August 1918, 43–45.

Bassham, Ben L. *The Theatrical Photographs of Napoleon Sarony*. Kent, Ohio: Kent State University Press, 1978.

Baumgardner, Jennifer, and Amy Richards. *Manifesta: Young Women, Feminism, and the Future*. New York: Farrar, Straus and Giroux, 2000.

Baxandall, Rosalyn, and Linda Gordon, eds. *Dear Sisters: Dispatches from the Women's Liberation Movement*. New York: Basic Books, 2000.

Bazin, Andre. "Entomology of the Pin-Up Girl." In *What Is Cinema? Vol. II*. Berkeley: University of California, 1971. First published in *Ecran Français*, 17 December 1946.

Beale, Frances. "Double Jeopardy: To Be Black and Female." In *Sisterhood Is Powerful: An Anthology of Writings from the Women's Liberation Movement*, edited by Robin Morgan. New York: Random House, 1970.

Bean, Jennifer, and Diane Negra, eds. *A Feminist Reader in Early Cinema*. Durham, N.C.: Duke University Press, 2002.

Beauvoir, Simone de. *The Second Sex*. Translated by H. M. Parshley. New York: Vintage Books, 1989.

Bellafante, Ginia. "Feminism: It's All about Me!" *Time*, 29 June 1998.

Berger, John. *Ways of Seeing*. London: Penguin Books, 1972.

Bergman-Carton, Janis. "Negotiating the Categories: Sarah Bernhardt and the Possibilities of Jewishness." *Art Journal* (Summer 1996): 55–63.

Bernstein, Leonard, Betty Comden and Adolph Green. *On the Town: A Musical Comedy in Two Acts*. New York: Boosey and Hawkes, 1977.

Bérubé, Allan. "Marching to a Different Drummer: Lesbian and Gay GIs in World War II." In *Powers of Desire: The Politics of Sexuality*, edited by Ann Snitow, Christine Stansell, and Sharon Thompson. New York: Monthly Review Press, 1983.

Betterton, Rosemary, ed. *Looking On: Images of Femininity in the Visual Arts and Media*. London: Pandora Books, 1987.

Biery, Ruth. "The Troubles of Gloria." *Photoplay*, June 1931, 45+.

Billings, August E. "Unto the Third Generation." *Photoplay*, February 1914, 120–30.

Birch, Bettina. *The Woman behind the Lens: The Life and Work of Frances Benjamin Johnston, 1864–1952*. Charlottesville: University Press of Virginia, 2000.

Black, Gregory. *Hollywood Censored: Morality Codes, Catholics, and the Movies*. Cambridge: Cambridge University Press, 1994.

Blatch, Harriot Stanton. "Why Suffragists Will Parade on Saturday." *New York Tribune*, 3 May 1912.

Bloom, Lisa E. "Rewriting the Script: Eleanor Antin's Feminist Art." In *Eleanor Antin*, edited by Howard N. Fox. Los Angeles: Los Angeles County Museum of Art Fellows of Contemporary Art, 1999.

Boffin, Tessa, and Jean Fraser, eds. *Stolen Glances: Lesbians Take Photographs*. London: Pandora, 1991.

Bolotin, Norman, and Christine Laing, *The Chicago World's Fair of 1893: The World's Columbian Exposition*. Washington, D.C.: Preservation, 1992.

Boltanski, Luc, and Jean-Claude Chamboredon. "Professional Men or Men of Quality: Professional Photographers." In *Photography: A Middle-Brow Art*, edited by Pierre Bourdieu. Cambridge: Parity, 1990.

Boston Women's Health Book Collective. *Our Bodies, Ourselves: Women and Their Bodies*. Boston: Boston Women's Health Book Collective, 1970.

Bourdieu, Pierre. ed. *Photography: A Middle-brow Art*. Cambridge: Parity Press, 1990.

Bowers, Q. David. "Souvenir Postcards and the Development of the Star System, 1912–14." *Film History* 3, no. 1 (1989): 39–45.

Bowser, Eileen. *The Transformation of Cinema, 1907–1915*. Vol. 2 of *History of American Cinema*. New York: Charles Scribner's Sons, 1990.

Breasdale, Kenon. "In Spite of Women: *Esquire* magazine and the construction of the male consumer." *Signs* 20, no. 1. Autumn 1994, 1–22.

Bridges, Robert. "Charles Dana Gibson." *Collier's Weekly*, 15 October 1904.

Bright, Deborah. "Introduction: Pictures, Perverts, and Politics." In *The Pas-

sionate Camera: Photography and Bodies of Desire, edited by Bright. New York: Routledge, 1998.

Bright, Susie. *Sexwise*. San Francisco: Cleis, 1995.

———. *Sexual Reality: A Virtual Sex World Reader*. San Francisco: Cleis Press, 1992.

———. *Sexual State of the Union*. New York: Simon and Schuster, 1997.

Briscoe, Johnson. "Photoplays versus Personality: How the Identity of the Players Is Fast Becoming Known." *Photoplay*, March 1914, 39–47.

Briscoe, "Why Film Favorites Forsook the Footlights: Interviews with Lillian Walker and William Wadsworth." *Photoplay*, August 1914, 103–11.

Broude, Norma. "Mary Cassatt: Modern Woman or the Cult of True Womanhood?" *Woman's Art Journal* 21, no. 2 (2000–2001): 36–43.

Broude, Norma and Mary Garrard, eds. *The Power of Feminist Art*. New York: Abrams, 1994.

Brough, James. *Princess Alice: A Biography of Alice Roosevelt Longworth*. Boston: Little, Brown and Co., 1975.

Bunch, Charlotte, and Nancy Myron, eds. *Class and Feminism: A Collection of Essays from the Furies*. Baltimore: Diana, 1974.

Bundles, A'Lelia. *On Her Own Ground: The Life and Times of Madam C. J. Walker*. New York: Scribner, 2001.

Burden, Alan. "The Girl Who Keeps a Railroad." *Photoplay*, July 1915, 89–95.

Burdett, Carolyn. *Olive Schreiner and the Progress of Feminism: Evolution, Gender, Empire*. New York: Palgrave, 2001.

Burnham, Charles. "Stage Degeneracy: An Old Cry." *Theatre Magazine*, 26 July 1917, 34.

Burston, Paul and Colin Richardson, eds. *A Queer Romance: Lesbians, Gay Men and Popular Culture*. New York: Routledge, 1995.

Burstyn, Varda, ed. *Women against Censorship*. Vancouver: Douglas and McIntyre, 1985.

Burton, Bonnie. "I Was a Teenaged Betty." *Atomic Books Catalog*, Spring 1996.

Busby, Marquis. "A Vamp Steps Out." *Photoplay*, April 1930, 58+.

Buse, Peter. "The Stage Remains: Theater Criticism and the Photographic Archive." *Journal of Dramatic Theory and Criticism* 12, no. 1 (1997): 77–96.

Bushman, Francis X. "How I Keep My Strength." *Photoplay*, June 1915, 59–62.

Buszek, Maria Elena. "Oh! Dogma (Up Yours!)" *Thirdspace: A Third Wave Feminist Journal* 1, no. 1 (2001), http://www.thirdspace.ca.

Butler, Judith. *Bodies That Matter: On the Discursive Limits of "Sex."* London: Routledge, 1993.

———. "The Body You Want: Liz Kotz interviews Judith Butler." *Artforum* 31, no. 3. November 1992, 82–89.

———. *Gender Trouble: Feminism and the Subversion of Identity*. New York: Routledge, Chapman, and Hall, 1990.

Butler, Kristine. "Irma Vep, Vamp in the City: Mapping the Criminal Feminine in Early French Serials." In *A Feminist Reader in Early Cinema*, edited by Jennifer Bean and Diane Negra. Durham, N.C.: Duke University Press, 2002.

Calvo, Luz. "Impassioned Icons: Alma Lopez and Queer Chicana Visual Desire." http://www.csupomona.edu/plin/ews410/virgin_guadalupe.html.

"Camera Queens as Playtime Mermaids." *Photoplay*, July 1915, 112–13.

Canning, Sue. "Bad Girls, Part 2." *Art Papers*, July–August 1994, 41–42.

Carlip, Hillary. *Girl Power*. New York: Warner Books, 1995.

Carlton, Donna. *Looking for Little Egypt*. Bloomington, Ind.: IDD Books, 1994.

Carol, Avedon. *Nudes, Prudes, and Attitudes: Pornography and censorship*. New Clarion Press, 1994.

Carr, Carolyn Kindner, and Sally Webster, "Mary Cassatt and Mary Fairchild MacMonnies: The Search for their 1893 Murals." *American Art* 8 (1994): 52–69.

Carter, Angela. *The Sadeian Woman and the Ideology of Pornography*. New York: Pantheon Books, 1978.

"Cartes de Visite." *American Journal of Photography*, 15 November 1861, 266–69.

Cassini, Marguerite de. *Never a Dull Moment*. New York: Harper and Brothers, 1956.

Castle, Irene. "How to Be Happily Married, as Told to Ada Patterson." *Photoplay*, June 1921, 42–43.

Caws, Mary Ann. "Ladies Shot and Painted: Female Embodiment in Surrealist Art." In *The Female Body in Western Culture*, edited by Susan R. Suleiman. Cambridge, Mass.: Harvard University Press, 1986.

Chesler, Phyllis. *Letters to a Young Feminist*. New York: Four Walls Eight Windows, 1997.

Chicago, Judy. *Beyond the Flower: My Life as a Woman Artist*, 2nd ed. New York: Penguin, 1993.

Chideya, Farai, Melissa Rossi, and Dogen Hannah, "Generations: Revolution, Girl Style." *Newsweek*, 23 November 1992, 84.

Cisneros, Sandra. "Guadalupe the Sex Goddess." In *Goddess of the Americas/La Diosa de las Americas*, edited by Ana Castillo. New York: Putnam, 1996.

Clark, Kenneth. *The Nude: A Study in Ideal Form*. Princeton, N.J.: Princeton University Press, 1972.

Clayson, Hollis. *Painted Love: Prostitution in French Art of the Impressionist Era*. New Haven, Conn.: Yale University Press, 1991.

Clemens, Samuel L. "Mark Twain's Travels with Mr. Brown." *San Francisco Alta*

California (1867). In *Mark Twain's Travels with Mr. Brown*, edited by Franklin Walter and G. Ezra Dane. New York: Alfred A. Knopf, 1940.

―――. "The Menken―Written Especially for the Gentlemen." *Territorial Enterprise* (13 September 1863). In *Mark Twain's San Francisco*, edited by Bernard Taper. New York: McGraw Hill, 1967.

Cocks, J. "Big Girls Don't Cry," *Time*, 4 March 1985, 74.

Coffey, Frank. *Always Home: Fifty years of the USO— The Official Photographic History*. Washington: Brassey's Books, 1991.

Cohn, Alfred A. "The 'Follies' of the Screen." *Photoplay*, June 1917, 84–90.

Condon, Mabel. "The Girl on the Cover." *Photoplay*, August 1914, 53–57.

Cooley, Winifred Harper. "The Younger Suffragists." *Harper's Weekly*, 27 September 1913, 7–8.

Cornell, Drucilla, ed. *Feminism and Pornography*. Oxford: Oxford University Press, 2000.

―――. *The Imaginary Domain: Abortion, Pornography, and Sexual Harassment*. New York: Routledge, 1995.

Cossman, Brenda, Shannon Bell, Lise Gotell, and Becki L. Ross. *Bad Attitude/s on Trial: Pornography, Feminism, and the Butler Decision*. Toronto: University of Toronto Press, 1997.

Cott, Nancy F. *The Grounding of Modern Feminism*. New Haven, Conn.: Yale University Press, 1987.

"Cotton Club Girls." *Ebony*, April 1949, 34–38.

"Cover: Katherine Dunham." *Ebony*, January 1947, 3.

"Cover: Lena Horne." *Ebony*, March 1946, 1.

Cox, Renée. "Renée Cox Speaks Out: An Interview by Aïda Mashaka Croal." Africana Online, 27 February 2001. http://africana.com/DailyArticles/index_20010227.htm.

Crawford, Christina. *Mommie Dearest*. New York: Penguin, 1997.

Crimp, Douglas. "Appropriating Appropriation." In *Image Scavengers*, edited by Paula Marincola. Philadelphia: Philadelphia Institute of Contemporary Art, 1982.

Cruz, Amanda. "Twenty Years of Cindy Sherman." In *Cindy Sherman: A Retrospective*, edited by Cruz and Elizabeth A. T. Smith. New York: Thames and Hudson, 1997.

Curry, Jane Kathleen. *Nineteenth-Century American Women Theater Managers*. Westport, Conn.: Greenwood, 1994.

Dabakis, Melissa. "Gendered Labor: Norman Rockwell's *Rosie the Riveter* and the Discourses of Wartime Womanhood." In *Gender and American History since 1890*, edited by Barbara Melosh. London: Routledge, 1993.

Dalle Vecchio, Angela. "Femininity in Flight: Androgyny and Gynandry in

Early Silent Italian Cinema." In *A Feminist Reader in Early Cinema*, edited by Jennifer Bean and Diane Negra. Durham, N.C.: Duke University Press, 2002.

Damsky, Lee, ed. *Sex and Single Girls: Straight and Queer Women on Sexuality*. Seattle: Seal, 2000.

Daniels, Bebe. "56½ Miles an Hour." *Photoplay*, July 1921, 52–54+.

Danto, Arthur. *After the Pale of History: Contemporary Art and the Pale of History*. Princeton, N.J.: Princeton University Press, 1997, 5.

Darnell, Jean. "Studio Chat from the Inside." *Photoplay*, January 1914, 106–13.

"A Date with Anna." *Ebony*, December 1945, 21.

Davis, Fred. *Fashion, Culture and Identity*. Chicago: University of Chicago Press, 1992.

Davis, Richard Harding. *About Paris*. New York: Harper and Brothers Publishers, 1895.

———. "The Origin of a Type of the American Girl." *Quarterly Illustrator*, January 1895, 8.

Davis, Tracy C. *Actresses as Working Women: Their Social Identity in Victorian Culture*. London: Routledge, 1991.

Day, Gary, and Clive Bloom, eds. *Perspectives on Pornography: Sexuality in Film and Literature*. New York: St. Martin's Press, 1988.

deCordova, Richard. *Picture Personalities: The Emergence of the Star System in America*. Chicago: University of Illinois Press, 1990.

Deepwell, Katy, ed. *New Feminist Art Criticism and Critical Strategies*. Manchester: Manchester University Press, 1995.

———. Editorial Statement. *n.paradoxa: international feminist art journal*.

De Grazia, Victoria, with Ellen Furlough. *The Sex of Things: Gender and Consumption in Historical Perspective*. Berkeley: University of California Press, 1996.

Delano, Page Dougherty. "Making Up for War: Sexuality and Citizenship in Wartime Culture." *Feminist Studies* 26, no. 1 (2000): 33–68.

De Lauretis, Teresa. *Alice Doesn't: Feminism, Semiotics, Cinema*. Bloomington: Indiana University Press, 1984.

———, ed. *Feminist Studies/Critical Studies*. Bloomington: Indiana University Press, 1986.

D'Emilio, John. *Making Trouble: Essays on Gay History, Politics, and the University*. New York: Routledge, 1992.

———, and Estelle B. Freeman. *Intimate Matters: A History of Sexuality in America*. New York: Harper and Row, 1988.

Denning, Alfred Thompson. *Lord Denning's Report: The Profumo Affair*. London: Trafalgar Square, 1963.

Denton, Frances. "Lights! Camera! Quiet! Ready! Shoot!" *Photoplay*, February 1918, 48–50.

Derry, Linda Kay. "Pin-Up Art: Interpreting the Dynamics of Style." MA thesis, College of William and Mary, 1982.

Dexter, Elliott. "Women I Have Loved." *Photoplay*, May 1918, 18–21+.

Dick, Bernard F. *The Star-Spangled Screen: The American World War II Film.* Lexington: University Press of Kentucky, 1985.

Dicker, Rory, and Alison Piepmeier, eds. *Catching a Wave: Reclaiming Feminism for the Twenty-First Century.* Boston: Northeastern University Press, 2003.

Dijkstra, Bram. *Evil Sisters: The Threat of Female Sexuality and the Cult of Manhood.* New York: Alfred A. Knopf, 1996.

———. *Idols of Perversity: Fantasies of Feminine Evil in Fin-de-Siècle Culture.* New York: Oxford University Press, 1986.

Dimen, Muriel. "Politically Correct? Politically Incorrect?" In *Pleasure and Danger: Exploring Female Sexuality*, 3rd ed., edited by Carole Vance. New York: Pandora, 1989.

Doane, Mary Ann. "Film and the Masquerade: Theorizing the Female Spectator." *Screen* 23 (1982): 78–87.

Dodson, Dr. Betty. *Liberating Masturbation: A Meditation on Self Love.* New York: Bodysex Designs, 1974.

"Don't Look Now . . . But There's a Woman Reading over Your Shoulder." *Esquire*, October 1940, 171.

"Doubles: 'Just Girls' Who Mirror the Faces of Celebrities." *Photoplay*, December 1915, 91–98.

Douglas, Ann. *The Feminization of American Culture.* New York: Anchor, 1988.

Dow, Bonnie, ed. *Wise Women: Cartoons of the Woman Suffrage Movement.* Athens, Ga.: Hill Street, 2002.

Doyle, Kegan, and Dany Lacombe, "Porn Power: Sex, Violence, and the Meaning of Images in 1980s Feminism." In *Bad Girls/Good Girls: Women, Sex, and Power in the Nineties*, edited by Nan Bauer Maglin. New Brunswick, N.J.: Rutgers University Press, 1996.

DuBarry Was a Lady. Metro-Goldwyn-Mayer Films, Los Angeles, 1943.

DuBois, Ellen Carol, and Linda Gordon, "Seeking Ecstasy on the Battlefield: Danger and Pleasure in Nineteenth-Century Feminist Sexual Thought." In *Pleasure and Danger: Exploring Female Sexuality*, 3rd ed., edited by Carole S. Vance. London: Pandora, 1989.

DuBois, Ellen Carol. "Working Class Women, Class Relations, and Suffrage Militance: Harriot Stanton Blatch and the New York Woman Suffrage Movement, 1894–1909" in *Unequal Sisters: A Multicultural Reader in U.S.*

Women's History, edited by Vicki Ruiz and Ellen Carol DuBois. New York: Routledge, 1994.

Dudden, Faye E. *Woman in the American Theatre: Actresses and Audiences, 1790–1870*. New Haven, Conn.: Yale University Press, 1994.

Duggan, Lisa, Nan Hunter, and Carole S. Vance, "False Promises: Feminist Antipornography Legislation in the U.S." In *Women against Censorship*, edited by Varda Burstyn. Vancouver: Douglas and McIntyre, 1985.

Duncan, Carol. "The MoMA's Hot Mamas." *Art Journal* (Summer 1989): 17–18.

Dworkin, Andrea. *Pornography: Men Possessing Women*. New York: Pedigree Books, 1981.

———. *Woman Hating*. New York: Dutton, 1974.

Echols, Alice. *Daring to Be Bad: Radical Feminism in America, 1967–1975*. Minneapolis: University of Minnesota Press, 1989.

———. "The Taming of the Id." In *Pleasure and Danger: Exploring Female Sexuality*, 3rd ed., edited by Carole S. Vance. London: Pandora, 1992.

Edsforth, Ronald, and Larry Bennett, eds. *Popular Culture and Political Change in Modern America*. Albany: State University of New York Press, 1991.

Edwards, Rebecca. "Pioneers at the Polls: Woman Suffrage in the West." In *Votes for Women: The Struggle for Suffrage Revisited*, edited by Jean H. Baker. Oxford: Oxford University Press, 2002.

Ehrmann, Winston. *Premarital Dating Behavior*. New York: Henry Holt, 1959.

Elam, Diane. "Sisters Are Doing It for Themselves." In *Generations: Academic Feminists in Dialogue*, edited by Devoney Looser and E. Ann Kaplan. Minneapolis: University of Minneapolis Press, 1997.

Elder, Sean. "The Sappiest Generation: My Cantankerous Father and My Own Better Judgment Won't Let Me Get Sentimental about WWII Veterans." *Salon Magazine*, 31 July 2000. http://www.salon.com/books/feature/2000/07/31/generation/index.html.

Ellis, Kate, Barbara O'Dair, and Abby Tallmer, "Introduction." In *Caught Looking*, edited by the FACT Book Committee. East Haven, Conn.: LongRiver Books.

English, Dierdre, Gayle Rubin, and Amber Hollibaugh, "Talking Sex." In Hollibaugh, *My Dangerous Desires: A Queer Girl Dreaming Her Way Home*. Durham, N.C.: Duke University Press, 2000. First published in *Socialist Review*, no. 58 (1981), 40–52.

Essex, Daren, and James L. Swanson, *Bettie Page*. Los Angeles: General Publishing Group, 1996.

Evans, Delight. "Does Theda Bara Believe Her Own Press Agent?" *Photoplay*, May 1918, 62–63+.

————. "The Girl on the Cover (Lillian Gish)." *Photoplay*, December 1921, 39–40+.

————. "The Mother of the Sub-Deb." *Photoplay*, January 1920, 74–75+.

————. "A New China Doll." *Photoplay*, February 1919, 41.

Evans, Sara. *Personal Politics: The Roots of Women's Liberation in the Civil Rights Movement and the New Left*. New York: Vintage Books, 1979.

"The Face of Romance and the Face of Reality." *New York World*, 16 August 1895, 8.

Falkenstein, Michelle. "What's So Good about Being Bad?" *Artnews*, November 1999, 159–63.

Faludi, Susan. *Backlash: The Undeclared War against American Women*. New York: Crown Publishers, 1992.

"Fashions in Feminine Fans." *Photoplay*, August 1915, 87.

"Feminism and Art: Nine Views." *Artforum*, October 2003, 140–49.

Feminist Anti-Censorship Taskforce (FACT) Book Committee, eds. *Caught Looking: Feminism, Pornography, and Censorship*. New York: Linco Printing, Inc., 1986.

Fernandez, Joyce. "Sex into Sexuality: A Feminist Agenda for the '90s." *Art Journal* (Summer 1991): 35–37.

Filene, Peter. *Him or Her/Self: Sex Roles in Modern America*. Baltimore: Johns Hopkins University Press, 1986.

"The Film's First Woman Executive." *Photoplay*, December 1921, 94.

Finch, Casey. "Two of a Kind." *Artforum*, February 1992, 91–94.

Firestone, Shulamith. *The Dialectic of Sex*. New York: Morrow Books, 1970.

Firestone, Shulamith, and Anne Koedt. *Notes from the Second Year: Women's Liberation*. New York: New York Radical Women, 1969.

Fishburn, Katherine. *Women in Popular Culture: A Reference Guide*. Westport, Conn.: Greenwood, 1982.

Fletcher, Adele Whitely. "Beauty, Brains, or Luck?" *Photoplay*, August 1930, 40–41+.

————. "Who Has the Best Figure in Hollywood—and Why?" *Photoplay*, March 1931, 34–36+.

"Florence Lawrence." *Photoplay*, November 1912, 105.

Foster, Hal. "Obscene, Abject, Traumatic." *October* 78 (1996): 110–11.

————, ed. *The Anti-Aesthetic: Essays on Postmodern Culture*. Seattle: Bay, 1983.

Foster, Richard. *The Real Bettie Page: The Truth about the Queen of the Pinups*. Seacaucus, N.J.: Birch Lane, 1998.

Foucault, Michel. "What Is an Author?" In *Textual Strategies: Perspectives in Post-Structuralist Criticism*, edited by Josué V. Harari. Ithaca, N.Y.: Cornell University Press, 1979.

————. *The History of Sexuality: Vol. I.* New York: Random House, 1978.

Fox, Howard N. "A Dialogue with Eleanor Antin." In *Eleanor Antin*, edited by Fox. Los Angeles: Los Angeles County Museum of Art Fellows of Contemporary Art, 1999

Foxcroft, Lily Rice. "Suffrage, A Step toward Feminism." In *Anti-Suffrage Essays by Massachusetts Women*. Boston: Forum Publishers of Boston, 1916.

France, Kim. "Grrrls at War." *Rolling Stone*. July 1993, 23–24.

Frank, Lisa, and Paul Smith, eds. *Madonnarama: Essays on Sex and Popular Culture*. San Francisco: Cleis, 1993.

Franklin, Wallace. "Purgatory's Ivory Angel." *Photoplay*, September 1915, 69–72.

Fraser, Laura. "Nasty Girls." *Mother Jones*, February–March 1990, 32–35.

Frederick-Collins, Jana. " 'He Kept Pressing Me for Details!': A Critical Cultural Analysis of Domestic Narratives in Post-WWII Pin-Up Advertising Calendars." Paper presented to the Commission on the Status of Women at the Association for Education in Journalism and Mass Communication, 1994.

Freedley, George. "The Black Crook and the White Faun." *Dance Index* 4 (1945): 14.

Freedman, Estelle. *No Turning Back: The History of Feminism and the Future of Women*. New York: Ballantine Books, 2002.

Friedan, Betty. *The Feminine Mystique*. New York: Dell, 1983.

Frueh, Joanna. "The Body through Women's Eyes." In *The Power of Feminist Art*, edited by Norma Broude and Mary Garrard. New York: Abrams, 1994.

————. *Erotic Faculties*. Berkeley: University of California Press, 1997.

————. "Hannah Wilke." In *Hannah Wilke: A Retrospective*, edited by Thomas H. Kochheiser. Columbia, Mo.: University of Missouri Press, 1989.

————. *Monster/Beauty: Building the Body of Love*. Berkeley: University of California Press, 2000.

Frueh, Joanna, Laurie Fierstein, and Judith Stein, eds. *Picturing the Modern Amazon*. New York: New Museum of Contemporary Art, 1999.

Frueh, Joanna, Cassandra Langer, and Arlene Raven, eds. *New Feminist Art Criticism: Art, Identity, Action*. New York: HarperCollins, 1994.

Fuller, Jean Overton. *Swinburne: A Biography*. New York: Schocken Books, 1971.

Fuss, Diana. *Essentially Speaking: Feminism, Nature, and Difference*. New York: Routledge, 1989.

Fyles, Vanderhyden. "Our Ethel." *Gunters*, October 1906, unpaginated.

Gabor, Mark. *The Pin-Up: A Modest History*. London: Pan, 1982.

Gage, Matilda Joslyn. "Indian Citizenship." *National Citizen and Ballot Box*, May 1878.

Gallop, Jane. *The Daughter's Seduction: Feminism and Psychoanalysis*. Ithaca, N.Y.: Cornell University Press, 1982.

———. *Feminist Accused of Sexual Harassment*. Durham, N.C.: Duke University Press, 1997.

———, and Caroline Evans, "The Gaze Revisited, or Reviewing Queer Viewing." In *A Queer Romance: Lesbians, Gay Men, and Popular Culture*, edited by Paul Burston and Colin Richardson. New York: Routledge, 1995.

Gamman, Lorraine, and Margaret Marshment, eds. *The Female Gaze: Women as Viewers of Popular Culture*. Seattle: Real Comet, 1989.

Gamman, Lorraine, and Marja Makinen. *Female Fetishism*. New York: New York University Press, 1995.

Garber, Marjorie. *Vested Interests: Cross-Dressing and Cultural Anxiety*. New York: HarperCollins, 1993.

Gardner, Michael R. *Harry Truman and Civil Rights: Moral Courage and Political Risks*. Carbondale: Southern Illinois University Press, 2002.

Gardner, Vivien, and Susan Rutherford, eds. *The New Woman and Her Sisters: Feminism and Theatre, 1850–1914*. Ann Arbor: University of Michigan Press, 1992.

Garrison, Ednie Kael. "U.S. Feminism—Grrrl Style! Youth (Sub)Cultures and the Technologies of the Third Wave." *Feminist Studies* 26, no. 1 (2000): 141–70.

Gates, Joanne E. *Elizabeth Robins, 1862–1952: Actress, Novelist, Feminist*. Tuscaloosa: University of Alabama Press, 1994.

Gatlin, Rochelle. *American Women since 1945*. Jackson: University of Mississippi Press, 1987.

Gay, Peter. *The Bourgeois Experience: Victoria to Freud*. Oxford: Oxford University Press, 1984.

Gibbons, Sean. "Rajé Rules: Renée Cox and the Revisionist Ideal." In *Rajé: A Superhero. The Beginning of a Bold New Era* (catalog). New York: Christine Rose Gallery, 1998.

Gibson, Charles Dana. *Drawings by Charles Dana Gibson*. New York: R. H. Russell, 1898.

———. *Pictures of People*. New York: R. H. Russell, 1896.

———. "In Days to Come, Churches May Be Fuller." *Life*, July 1896, 588–89.

———. *The Education of Mr. Pipp*. New York: R. H. Russell, 1899.

———. *Sketches in Egypt*. New York: Doubleday and McClure, 1899.

Gibson, Idah M'Glone. "Just Two Girls." *Toledo Blade*, 26 October 1904.

Gibson, Pamela Church, and Roma Gibson. *Dirty Looks: Women, Pornography, Power*. London: British Film Institute, 1993.

Gillis, Stacy, Gillian Howie, and Rebecca Munford, eds. *Third Wave Feminism: A Critical Exploration*. London: Palgrave Macmillan, 2004.

Gilman, Charlotte Perkins. *Women and Economics*, edited by Carl N. Degler. New York: Harper and Row, 1966.

Gilman, Woody. *The Best of Charles Dana Gibson*. New York: Bounty Books, 1969.

Gingrich, Arnold. "Legends of Esky's Travels." *Esquire*, June 1944, 29.

"Glamour Is Global." *Ebony*, July 1946, 19.

Glenn, Susan A. *Female Spectacle: The Theatrical Roots of Modern Feminism*. Cambridge, Mass.: Harvard University Press, 2000.

Gluck, Sherna Berger. *Rosie the Riveter Revisited: Women, the War, and Social Change*. Boston: Twayne, 1987.

Gold, Arthur, and Robert Fizdale, *The Divine Sarah: A Life of Sarah Bernhardt*. New York: Alfred A. Knopf, 1991.

Golden, Eve. *Vamp: The Rise and Fall of Theda Bara*. Vestal, N.Y.: Emprise, 1996.

"Goodbye Mammy, Hello, Mom." *Ebony*, March 1947, 36.

Grand, Sarah. "The New Aspect of the Woman Question." In *A New Woman Reader: Fiction, Articles, Drama of the 1890s*, edited by Carolyn Christensen Nelson. Orchard Park, N.Y.: Broadview, 2001. First published in *North American Review*, no. 158 (March 1894): 270–76.

Greeley-Smith, Nixola. "'Woman Must Choose to Love or Be Loved,' Says Vampire." *Peoria Journal*, 6 May 1915.

Green, Karen, and Tristan Taormino. *A Girl's Guide to Taking Over the World: Writings from the Girl 'Zine Revolution*. New York: St. Martin's, 1997.

Greenberg, Clement. "Avant-Garde and Kitsch." In *Art in Theory, 1900–1990: An Anthology of Changing Ideas*, edited by Charles Harrison and Paul Wood. Oxford: Blackwell, 1992. First published in *Partisan Review* 6, no. 5 (1939): 34–39.

———. "Modernist Painting." In *Art in Theory, 1900–1990: An Anthology of Changing Ideas*, edited by Charles Harrison and Paul Wood. Oxford: Blackwell, 1992. Originally published in *Arts Yearbook* 4 (1961): 109–16.

Greer, Germaine. *The Female Eunuch*. London: MacGibbon and Kee Ltd., 1970.

———. "Foreword." In *Suffragettes to She-Devils: The Graphics of Women's Liberation and Beyond*, by Liz McQuiston. San Francisco: Phaidon, 1997.

Grundberg, Andy. "Cindy Sherman: A Playful and Political Post-Modernist." *New York Times*, 22 November 1981.

Gumpert, Lynn, Ned Rifkin, and Marcia Tucker, eds. *Early Work*. New York: New Museum, 1982.

Hall, Leonard. "Hell's Angel." *Photoplay*, January 1930, 69.

Halttunen, Karen. *Confidence Men and Painted Women: A Study of Middle-Class Culture in America, 1830–1870*. New Haven, Conn.: Yale University Press, 1982.

Hamilton, Richard. "For the Finest Art, Try Pop." In *Art in Theory, 1900–1990: An Anthology of Changing Ideas*, edited by Charles Harrison and Paul Wood. Oxford: Blackwell, 1992. Originally published in *Gazette*, no. 1 (1961).

Hanna, Kathleen. "On Not Playing Dead." In *Stars Don't Stand Still in the Sky: Music and Myth*, edited by Karen Kelly and Evelyn McDonnell. New York: New York University Press, 1999.

Hansen, Miriam. *Babel and Babylon: Spectatorship in American Silent Film*. Cambridge, Mass.: Harvard University Press, 1991.

Haraway, Donna. "Otherworldly Conversations; Terran Topics; Local Terms." *Science as Culture* 3, no. 1 (1992): 64–98.

———. "A Cyborg Manifesto." In *Simians, Cyborgs, and Women: The Reinvention of Nature*. London: Routledge, 1991.

Harris, Geraldine. "Yvette Guilbert: *La Femme Moderne* on the British Stage." In *The New Woman and Her Sisters: Feminism and Theatre, 1850–1914*, edited by Vivien Gardner and Susan Rutherford. Ann Arbor: University of Michigan Press, 1992.

Harris, Jonathan. "Modernism and Culture in the USA, 1930–1960." In *Modernism in Dispute: Art since the Forties*, edited by Paul Wood. New Haven, Conn.: Yale University Press, 1993.

Hartmann, Susan M. *The Home Front and Beyond: American Women in the 1940's*. Boston: Twayne, 1982.

Haskell, Molly. "Pre-Code Women: Swaggering Sexuality Before the Mandated Blush." *New York Times*, 31 May 2001.

Hayt, Elizabeth. "The Artist Is a Glamour Puss." *New York Times*, 19 April 1999.

Heartney, Eleanor. "Bad Girls." *Art in America* 82 (1994): 134–35.

Heilmann, Ann. *New Woman Strategies: Sarah Grand, Olive Schreiner, Mona Caird*. Manchester: Manchester University Press, 2004.

Heilmann, Ann, ed. *Feminist Forerunners: New Womanism and Feminism in the Early Twentieth Century*. London: Pandora, 2003.

Henderson, Tina. "Sex Sells (and in This Case, It's All Good)." *Greenwich Village Gazette*, 7 December 2001. http://www.gvny.com/columns/henderson/henderson12-07-01.html.

Hennessy, Rosemary. "Queer Theory: A Review of the *differences* Special Issue and Wittig's *The Straight Mind*." *Signs: Journal of Women in Culture and Society* 18, no. 4 (1993): 967.

Henry, Astrid. *Not My Mother's Sister: Generational Conflict and Third-Wave Femi-
nism.* Bloomington: Indiana University Press, 2004.

Henry, William M. "Cleo, the Craftswoman." *Photoplay*, January 1916, 109–11.

"Here Are Ladies!" *Photoplay*, October 1920, 74.

"Here Are the Winners!" *Photoplay*, July 1916, 65–68.

Hess, Elizabeth. "Gallery of the Dolls: Lutz Bacher, Mira Schor." *Village Voice*,
19 October 1993, 91.

Hess, Thomas. "Pinup and Icon." *Art News Annual*, no. 38 (1972): 223–37.

Hex, Celina. "Fierce, Funny, Feminists." *Bust Magazine*, Winter 2000, 56.

Heywood, Leslie, and Jennifer Drake, eds. *Third Wave Agenda: Being Feminist,
Doing Feminism.* Minneapolis: University of Minnesota Press, 1997.

Higashi, Sumiko. "The New Woman and Consumer Culture: Cecil B. De-
Mille's Sex Comedies." In *A Feminist Reader in Early Cinema*, edited by
Jennifer Bean and Diane Negra. Durham, N.C.: Duke University Press,
2002.

Higonnet, Margaret Randolph, Jane Jenson, Sonya Mitchell and Margaret
Collins Weitz, eds. *Behind the Lines: Gender and the Two World Wars.* New
Haven, Conn.: Yale University Press, 1987.

"History Is Made in Flight." *Ebony*, February 1946, 44.

Holland, Norman. "*8½* and Me: The Thirty-Two Year Difference" in *Aging and
Identity: A Humanities Perspective*, edited by Sara Munson Deats and Lagretta
Tallent Lenker. Westport Conn.: Praeger, 1999.

Holledge, Julie. *Innocent Flowers: Women in the Edwardian Theater.* London:
Virago Press, 1981.

Hollibaugh, Amber. *My Dangerous Desires: A Queer Girl Dreaming Her Way
Home.* Durham, N.C.: Duke University Press, 2000.

Honey, Maureen. *Creating Rosie the Riveter: Class, Gender, and Propaganda during
World War II.* Amherst: University of Massachusetts Press, 1984.

Honig, Peregrine. "Artist's Statement." April 2002, photocopy.

hooks, bell. *Ain't I a Woman? Black Women and Feminism.* Boston: South End,
1981.

———. *Black Looks: Race and Representation.* Boston: South End, 1992.

———. *Feminist Theory: From Margin to Center.* Cambridge, Mass.: South End,
1984.

———. *Outlaw Culture: Resisting Representations.* New York: Routledge, 1994.

———. "Power to the Pussy: We Don't Wannabe Dicks in Drag." In *Madonna-
rama: Essays on Sex and Popular Culture*, edited by Lisa Frank and Paul Smith.
San Francisco: Cleis Press, 1993.

———. *Yearning: Race, Gender, and Cultural Politics.* Boston: South End, 1990.

Hooven, F. Valentine III. *Beefcake: The Muscle Magazines of America, 1950–1970.* Cologne: Taschen, 2002.

Horowitz, Daniel. *Betty Friedan and the Making of* The Feminine Mystique: *The American Left, the Cold War, and Modern Feminism.* Amherst: University of Massachusetts Press, 1998.

———. "Rethinking Betty Friedan and *The Feminine Mystique*: Labor Union Radicalism and Feminism in Cold War America." *American Quarterly* 48.1 (1996): 1–42.

"How to Write a Book in the Army." *Ebony*, December 1945, 26.

"How Women Will Vote." *Photoplay*, November 1913, 90.

Howarth-Loomes, B. E. C. *Victorian Photography: A Collector's Guide.* London: Ward Lock, 1974.

Howe, Herbert. "A Misunderstood Woman (Alla Nazimova)." *Photoplay*, April 1922, 119–20+.

———. "What Are Matinee Idols Made Of?" *Photoplay*, April 1923, 41.

———. "Why They Get Their Fabulous Salaries." *Photoplay*, August 1922, 48+.

Howells, William Dean. "The New Taste in Theatricals." *Atlantic Monthly*, May 1869, 462–63.

Huberty, Erica-Lynn. "Intensity of Form and Surface: An Interview with Lynda Benglis." *Sculpture* 19, no. 6 (2000): 32.

Hutchinson, Lois. "A Stenographer's Chance in Pictures." *Photoplay*, March 1923, 42–43+.

"I'm in the Center of the World!" Interview with Hugh Hefner. *Look*, January 1967, 56.

"Interview: Linda [*sic*] Benglis." *Ocular* 4, no. 2 (Summer 1979): 30–43.

Irigaray, Luce. "The Power of Discourse and the Subordination of the Feminine: An Interview." In *This Sex Which Is Not One.* Ithaca, N.Y.: Cornell University Press, 1985. First published as "Pouvoir du discours/subordination du féminin." *Dialectiques*, no. 8 (1975): 31–45.

Itzin, Catherine, ed. *Pornography, Women, Violence, and Civil Liberties.* New York: Oxford University Press, 1992.

Ives, Halsey C. *The Dream City: A Portfolio of Photographic Views of the World's Columbian Exposition.* St. Louis: N. D. Thompson, 1893–94. Online at *The Paul V. Galvin Digital History Collection—Illinois Institute of Technology*, http://columbus.gl.iit.edu/dreamcity/00024003.html.

James, Henry. *The Tragic Muse.* London: 1890.

Jameson, Fredric. *The Political Unconscious.* Ithaca, N.Y.: Cornell University Press, 1981.

———. "Postmodernism and Consumer Society." In *The Anti-Aesthetic: Essays*

on Postmodern Culture, edited by Hal Foster. Seattle: Bay, 1983. Originally presented at the Whitney Museum of American Art, Fall 1982.

Johnson, Julian. "The Girl on the Cover." *Photoplay*, April 1920, 57–58+.

———. "Impressions: Brief Brilliancies Regarding Players." *Photoplay*, June 1915, 49.

———. "The Soubrette of Satire." *Photoplay*, July 1917, 27–28+.

Johnston, Frances B. *The Hampton Album* (catalog). New York: Museum of Modern Art, 1966.

Jones, Amelia. *Body Art: Performing the Subject*. Minneapolis: University of Minnesota Press, 1998.

———. "Feminism and Art: Nine Views." *Artforum*, October 2003, 143.

———. "Postfeminism, Feminist Pleasures, and Embodied Theories of Art." In *New Feminist Art Criticism: Art, Identity, Action*, edited by Joanna Frueh, Cassandra Langer, and Arlene Raven. New York: HarperCollins, 1994.

———. "Sexual Politics: Feminist Strategies, Feminist Conflicts, Feminist Histories." In *Sexual Politics: Judy Chicago's Dinner Party in Feminist Art History*, edited by Jones. Berkeley: University of California Press, 1997.

Jong, Erica. *Fear of Flying*. New York: Holt, Reinhart, and Winston, 1974.

Jordan, Joan. "A Belle of Bogota." *Photoplay*, January 1921, 46.

———. "Girl Picture Magnates: Determined to Become Producers, They Did." *Photoplay*, August 1922, 23, 111.

———. "Old Lives for New." *Photoplay*, April 1921, 45–46.

Juno, Andrea. "Interview with Susie Bright." In *Angry Women*, edited by Andrea Juno and V. Vale. San Francisco: RE/Search, 1991.

Juno, Andrea, ed. *Angry Women in Rock, Vol. 1*. New York: Juno Books, 1996.

Juno, Andrea, and V. Vale, eds. *Angry Women*. San Francisco: RE/Search, 1991.

"Just Before the Contest Closes." *Photoplay*, August 1922, 44–45.

Kaite, Berkeley. *Pornography and Difference*. Bloomington: Indiana University Press, 1995.

Kakoudaki, Despina. "Pinup: The American Secret Weapon in World War II." In *Porn Studies*, edited by Linda Williams. Durham, N.C.: Duke University Press, 2004.

Kallan, Richard A., and Robert D. Brooks. "The Playmate of the Month: Naked but Nice." *Journal of Popular Culture* 8, no. 2 (1974): 328–35.

Kamen, Paula. *Her Way: Young Women Remake the Sexual Revolution*. New York: Broadway, 2000.

Karp, Marcelle and Debbie Stoller, eds. *The Bust Guide to the New Girl Order*. New York: Penguin Books, 1999.

Kemp, Sandra and Judith Squires, eds. *Feminisms*. Oxford: Oxford University Press, 1997.

Kendall, Elizabeth. *Where She Danced*. New York: Knopf, 1970.

Kendrick, Walter. *The Secret Museum: Pornography in Modern Culture*. New York: Viking, 1987.

Kingsbury, Martha. "The Femme Fatale and Her Sisters." *Art News Annual*, no. 38. 1972, 183–203.

Kingsley, Grace. "All-Around Anita." *Photoplay*, August 1916, 143–45.

———. "That Splash of Saffron." *Photoplay*, March 1916, 139–41.

Kinsey, Alfred C., Wardell B. Pomeroy, Clyde E. Martin and Paul H. Gebhard. *Sexual Behavior in the Human Female*. Philadelphia: W. B. Saunders, 1953.

Kipnis, Laura. *Bound and Gagged: Pornography and the Politics of Fantasy in America*. New York: Grove Press, 1996.

Kiss and Tell. *Her Tongue on My Theory: Images, Essays, and Fantasies*. Vancouver: Press Gang, 1994.

Kitch, Carolyn. *The Girl on the Magazine Cover: The Origins of Visual Stereotypes in American Mass Media*. Chapel Hill: University of North Carolina Press, 2001.

Koedt, Anne. "The Myth of the Vaginal Orgasm." In *Notes from the Second Year*. New York: New York Radical Women, 1969. Reprinted in *Dear Sisters: Dispatches from the Women's Liberation Movement*, edited by Rosalyn Baxandall and Linda Gordon. New York: Basic, 2000.

Kotz, Liz. "Erotics of the Image." *Art Papers* 18, no. 6. November/December 1994, 16–20.

———. "Sex with Strangers." *Artforum* 31, no. 1. September 1992, 83–85.

Krane, Susan. *Lynda Benglis: Dual Nature*. Atlanta: High Museum of Art, 1991.

Krauss, Rosalind. "Cindy Sherman: Untitled." In *Bachelors*. Cambridge, Mass.: MIT Press, 1999.

Kroll, Eric, ed. *The Complete Reprint of John Willie's Bizarre*. Cologne: Taschen, 1995.

Kruger, Barbara. "No Progress in Pleasure." In *Pleasure and Danger: Exploring Female Sexuality*, 3rd ed., edited by Carole S. Vance. London: Pandora, 1992.

Kuhn, Annette. *The Power of the Image: Essays on Representation and Sexuality*. London: Routledge and Kegan Paul, 1985.

Labanton, Viven and Dawn Lundy Martin, eds. *The Fire This Time: Young Activists and the New Feminism*. New York: Anchor Books, 2004.

"Lady Boxer: Husky Gloria Thompson has Won Seven Bouts, Calls Herself 'Chick Champ of the World.'" *Ebony*, March 1949, 30.

"Lady Lawyers: 70 Carry on Battle for Sex and Race Equality in Courts," *Ebony*, August 1947, 18–22.

La Marr, Barbara. "Why I Adopted a Baby." *Photoplay*, May 1923, 30–31.

Landay, Lori. "The Flapper Film: Comedy, Dance, and Jazz Age Kinaesthet-

ics." In *A Feminist Reader in Early Cinema*, edited by Jennifer Bean and Diane Negra. Durham, N.C.: Duke University Press, 2002.

LaSalle, Mick. *Complicated Women: Sex and Power in Pre-Code Hollywood*. New York: St. Martin's Press, 2000.

Lavin, Maud. "Androgyny and Spectatorship." In *Modern Art and Society*, edited by Maurice Berger. New York: HarperCollins, 1994.

Leblanc, Lauraine. *Pretty in Punk: Girls' Gender Resistance in a Boys' Subculture*. New Brunswick, N.J.: Rutgers University Press, 2000.

Lederer, Laura, ed. *Take Back the Night: Women on Pornography*. New York: Morrow, 1980.

Ledger, Sally. "Ibsen, the New Woman, and the Actress." In *The New Woman in Fiction and in Fact: Fin-de-Siècle Feminisms*, edited by Angelique Richardson and Chris Willis. London: Palgrave Macmillan, 2001.

Levine, H. Z. "In the Moving Picture World: Madame Alice Blaché, President of the Solax Company." *Photoplay*, June 1912, 37–38.

Lewis, Paul. *Queen of the Plaza: A Biography of Adah Isaacs Menken*. New York: Funk and Wagnalls, 1964.

"Liberty Belle." *Penthouse*, June 1971, 45.

Linden-Ward, Blanche and Carol Hurd Green. *American Women in the 1960s: Changing the Future*. New York: Twayne Publishers, 1993.

Linker, Kate. *Love for Sale: The Words and Pictures of Barbara Kruger*. New York: Harry N. Abrams, 1990.

Linkman, Audrey. *The Victorians: Photographic Portraits*. London: Tauris Parke, 1993.

Linton, E. Lynn. "The Girl of the Period." In *Modern Women and What Is Said of Them: A Series of Articles in the Saturday Review*. New York: J. S. Redfield, 1868.

Lippard, Lucy. "The Pains and Pleasures of Rebirth: Women's Body Art." *Art in America* 64, no. 3 (1976), 73–81.

———. *The Pink Glass Swan: Selected Feminist Essays on Art*. New York: New Press, 1995.

Lively, Cornelia. "Famous Varga Girl Creator and Wife Visiting in City." *Birmingham News*, 10 October 1945.

Logan, Olive. *Before the Footlights and behind the Scenes*. Philadelphia: Parmelee and Company, 1870.

———. *Apropos of Women and Theatres*. New York: Carleton, 1869.

"Lois Weber's Rival." *Photoplay*, February 1921, 92.

Looser, Devoney, and E. Ann Kaplan, eds. *Generations: Academic Feminists in Dialogue*. Minneapolis: University of Minneapolis Press, 1997.

López, Alma. "Artist's Statement." Alma Lopez.net, 2001. http://www
.almalopez.net/artist.html.

Lord, M. G. "Pornutopia: How Feminist Scholars Learned to Love Dirty Pictures." *Lingua Franca* 7, no. 4 (1997): 40–48.

———. "The Table Is Set, at Last, in a Home." *New York Times*, 8 September 2002.

Lorde, Audre. *Sister Outsider*. Freedom, Calif.: Crossing, 1984.

Lovell, Margaretta M. "Picturing 'A City for a Single Summer': Paintings at the World's Columbian Exposition." *Art Bulletin* 78 (March 1996): 40–55.

Lumpkin, Libby. "Virtue be Damned: A Modest Proposal for Feminism." *Art Issues*, no. 42. March/April 1996, 18–21.

Lunardini, Christine. *From Equal Suffrage to Equal Rights: Alice Paul and the National Woman's Party, 1910–1928*. New York: New York University Press, 1986.

Lynd, Robert S., and Helen Merrel Lynd. *Middletown in Transition: A Study in Cultural Conflicts*. New York: Harcourt, Brace, World, 1965.

MacKinnon, Catharine. "Not a Moral Issue." *Yale Law and Policy Review* 321 (1984), 2.

———. "Pornography, Civil Rights, and Speech." *Harvard Civil Rights–Civil Liberties Law Review* 20, no. 1 (1985), 20.

Maglin, Nan Bauer. ed. *Bad Girls/Good Girls: Women, Sex, and Power in the Nineties*. New Brunswick, N.J.: Rutgers University Press, 1996.

Magnuson, Ann. "I Have a Sex Book, Too!" *Paper Magazine*, October 1992, 20–22.

"Male (Vamp) and Female (Director)." *Photoplay*, May 1920, 44.

Mankowitz, Wolf. *Mazeppa: The Lives, Loves, and Legends of Adah Isaacs Menken*. New York: Stein and Day, 1982.

Marks, Patricia. *Bicycles, Bangs, and Bloomers: The New Woman in the Popular Press*. Lexington: University of Kentucky Press, 1990.

Marshall, Gail. *Actresses on the Victorian Stage: Feminine Performance and the Galatea Myth*. Cambridge: Cambridge University Press, 1998.

Martignette, Charles, and Louis K. Meisel. *The Great American Pin Up*. Cologne: Taschen, 1996.

Mary Cassatt, Modern Woman (catalog). New York: The Art Institute of Chicago with Harry N. Abrams, 1998.

"Mary Makes One, Too!" *Photoplay*, February 1931, 66–67.

Mason-John, Valerie. "The Bitter Debate." *Feminist Art News* 3, no. 8. 1991, 19–21.

Mathews, Nancy Mowl. *Mary Cassatt: A Life*. New York: Villard Books, 1994.

———, ed. *Cassatt and Her Circle: Selected Letters*. New York: Abbeville, 1984.

Matthews, Jean V. *The Rise of the New Woman: The Women's Movement in America, 1875–1930*. Chicago: Ivan R. Dee, 2003.

May, Elaine Tyler. *Homeward Bound: American Families in the Cold War Era*. New York: Basic Books, 1988.

May, Lary. *Screening Out the Past: The Birth of Mass Culture and the Motion Picture Industry*. New York: Oxford University Press, 1980.

McCarthy, David. *The Nude in American Art, 1950–1980*. Cambridge: Cambridge University Press, 1998.

———. *Pop Art*. Cambridge: Cambridge University Press, 2000.

McCauley, Elizabeth Anne. *A. A. E. Disdéri and the Carte de Visite Portrait Photograph*. New Haven, Conn.: Yale University Press, 1985.

McDonough, Yona Zeldis. "Confessions of a Female Pornographer." *Women Artist's News* 11, no. 5. Winter 1986/87, 16–17+.

McGaffey, Kenneth. "Introducing the 'Vampette,' " *Photoplay*, March 1919, 47.

McNair, Brian. *Mediated Sex: Pornography and Postmodern Culture*. London: Arnold, 1996.

———. *Striptease Culture: Sex, Media, and the Democratization of Desire*. London: Routledge, 2002.

McPherson, Heather. *The Modern Portrait in Nineteenth-Century France*. Cambridge: Cambridge University Press, 2001.

McQuiston, Liz. *Suffragettes to She-Devils: The Graphics of Women's Liberation and Beyond*. San Francisco: Phaidon, 1997.

McRobbie, Angela. *Feminism and Youth Culture*. New York: Routledge, 1991.

———. *In the Culture Society: Art, Fashion, and Popular Music*. London: Routledge, 1999.

———. *Postmodernism and Popular Culture*. New York: Routledge, 1994.

Melosh, Barbara, ed. *Gender and American History Since 1890*. London: Routledge, 1993.

Mencken, H. L. *In Defense of Women*. New York: Alfred A. Knopf, 1920.

———. "The Flapper." *Smart Set* 45 no. 2 (1915), 1–2.

Merrill, Hugh. *Esky: The Early Years at* Esquire. New Brunswick, N.J.: Rutgers University Press, 1995.

Meskimmon, Marsha. "The Monstrous and the Grotesque." *Make*, no. 72. October/November 1996, 6–11.

Meyer, Leisa D. *Creating G.I. Jane: Sexuality and Power in the Women's Army Corps During World War II*. New York: Columbia University Press, 1996.

Meyer, Susan. *America's Great Illustrators*. New York: Harry N. Abrams, 1978.

Meyerowitz, Joanne, ed. *Not June Cleaver: Women and Gender in Postwar America*. Philadelphia: Temple University Press, 1994.

———. "Women, Cheesecake, and Borderline Material: Responses to Girlie

Pictures in Mid-Twentieth-Century U.S." *Journal of Women's History* 8, no. 3 (1996): 9–35.

Miller, Alice Duer. "Author in Wonderland." *Photoplay*, October 1920, 37–39+.

Miller, Russell. *Bunny: The Real Story of Playboy*. New York: Plume, 1984.

Millett, Kate. *Sexual Politics*. Garden City, N.Y.: Doubleday Books, 1970.

"Miss Fine Brown Frame: Audience Insists Judges Pick Darkest Girl in Contest." *Ebony*, May 1947, 47.

Moraga, Cherrie, and Gloria Anzaldúa, eds. *This Bridge Called My Back: Writings by Radical Women of Color*. New York: Kitchen Table: Women of Color, 1981.

"More Bunk Ad Nauseam." *Photoplay*, March 1923, 27.

Morey, Anne. "So Real as to Seem Like Life Itself: The *Photoplay* Fiction of Adela Rogers St. Johns." In *A Feminist Reader in Early Cinema*, edited by Jennifer Bean and Diane Negra. Durham, N.C.: Duke University Press, 2002.

Morgan, Ann Barclay. "Bad Girls, Part 1." *Art Papers* 18 (1994): 41.

Morgan, Margaret. "Bad Girls West." *Art and Text*, no. 48 (1994): 81.

Morgan, Robin. "Theory and Practice: Pornography and Rape." In *Take Back the Night: Women on Pornography*, edited by Laura Lederer. New York: Morrow, 1980.

———, ed. *Sisterhood is Powerful: An Anthology of Writings from the Women's Liberation Movement*. New York: Random House, 1970.

Morrison, Allen. "What Price Heroism?" *Ebony*, January 1947, 11.

Morrison, Toni. "What the Black Woman Thinks about Women's Lib." *New York Times Magazine*. 22 August 1971.

Muccigrosso, Robert. *Celebrating the New World: Chicago's Columbian Exposition of 1893*. Chicago: Ivan R. Dee, 1993.

Mulvey, Laura. "Visual Pleasure and Narrative Cinema." *Screen* 16, no. 3 (1975): 6–18.

Murphy, Mary. "Subversive Pleasures: Painting's New Feminine Narrative." *New Art Examiner* 24, no. 6. March 1997, 14–20.

Nagle, Jill. "The First Ladies of Feminist Porn: A Conversation with Candida Royalle and Debi Sundahl." In *Whores and Other Feminists*, edited by Nagle. New York: Routledge, 1997.

Nead, Lynda. *The Female Nude: Art, Obscenity and Sexuality*. London: Routledge, 1992.

Needham, Gerald. "Manet, *Olympia*, and Pornographic Photography." *Art News Annual*, no. 38. 1972, 81–89.

Negra, Diane. "Immigrant Stardom and Imperial America: Pola Negri and the Problem of Typology." In *A Feminist Reader in Early Cinema*, edited by

Jennifer Bean and Diane Negra. Durham, N.C.: Duke University Press, 2002.

Nelson, Carolyn Christensen, ed. *A New Woman Reader: Fiction, Articles, Drama of the 1890s*. Orchard Park, NY: Broadview Press, 2001.

Nemser, Cindy. "Lynda Benglis—A Case of Sexual Nostalgia." *Feminist Art Journal* 3, no. 4 (1974–75): 7.

Newton, Esther. *Mother Camp: Female Impersonators in America*. Englewood Cliffs: Prentice-Hall, 1972.

"The 1917-Model Bathing Girl." *Photoplay*, July 1917, 71.

Nochlin, Linda. "Feminism and Art: Nine Views." *Artforum*, October 2003, 141.

———. "Offbeat and Naked." *Artnet*. 5 November 1999. http://www.artnet .com/magazine/features/nochlin/nochlin11-5-99.asp.

Nora, Elise. "Sur Hamlet." *La Fronde*, 4 July 1899.

Ockman, Carol. *Ingres' Eroticized Bodies: Retracing the Serpentine Line*. New Haven, Conn.: Yale University Press, 1995.

———. "Women, Icons, and Power." In *Self and History: A Tribute to Linda Nochlin*, ed. Aruna d'Souza. New York: Thatmes and Hudson, 2001.

O'Brien, Glenn. "Pink Thoughts." *Aperture* 122. Winter 1991, 62–79.

O'Brien, Kaye, and Gary Grice, eds. *Women in the Weather Bureau during World War II*. 1998. http://www.lib.noaa.gov/edocs/women.html.

On the Town. MGM Entertainment, 1949.

"One Year after V-Day." *Ebony*, September 1946, 40.

Ouida. (Marie Louise de la Ramée). "The New Woman." In *A New Woman Reader: Fiction, Articles, Drama of the 1890s*, edited by Carolyn Christensen Nelson. Orchard Park, N.Y.: Broadview, 2001. First published in *North American Review* 158 (1894): 610–19.

Owen, K. "Eileen from the Emerald Isle." *Photoplay*, February 1918, 77–78.

———. "Colonel Kathleen: Some Boy!" *Photoplay*, August 1917, 19–20.

Owens, Craig. *Beyond Recognition: Representation, Power, and Culture*. Berkeley: University of California Press, 1992.

———. "The Discourse of Others: Feminism and Postmodernism." In *The Anti-Aesthetic: Essays on Postmodern Culture*, edited by Hal Foster. Seattle: Bay, 1983.

Painter, Nell Irvin. "Voices of Suffrage: Sojourner Truth, Frances Watkins Harper, and the Struggle for Woman Suffrage." In *Votes for Women: The Struggle for Suffrage Revisited*, edited by Jean H. Baker. New York: Oxford University Press, 2002.

Parker, Alison M. "The Case for Reform Antecedents for the Woman's Rights Movement." In *Votes for Women: The Struggle for Suffrage Revisited*, edited by Jean H. Baker. New York: Oxford University Press, 2002.

Parsons, Louella. "Propaganda! How the Moving Picture is Fighting the Hun." *Photoplay*, September 1918, 43–45+.

Patten, Mary. "The Thrill Is Gone: An ACT UP Post-Mortem. Confessions of a Former AIDS Activist." In *The Passionate Camera: Photography and Bodies of Desire*, edited by Deborah Bright. New York: Routledge, 1998.

"Pearl White: A Last Word from Crystal's Lovely Traveler." *Photoplay*, October 1913, 46–47.

Peiss, Kathy. *Cheap Amusements: Working Women and Leisure in Turn-of-the-Century New York*. Philadelphia: Temple University Press, 1986.

———. "Making Up, Making Over: Cosmetics, Consumer Culture, and Women's Identity." In *The Sex of Things: Consumption in Historical Perspective*, edited by Victoria de Grazia with Ellen Furlough. Berkeley: University of California Press, 1996.

Peiss, Kathy and Christina Simmons, eds. *Passion and Power: Sexuality in History*. Philadelphia: Temple University Press, 1989.

Perkins Witt, Whitney. "Taking Back Pornography, Taking Back Sexuality: A case for feminist pornography." Bachelor's thesis. Law/Women's Studies), Hampshire College, 1993.

"Petrova Practices Pouring for the Photographer." *Photoplay*, January 1917, 43.

Phelan, Peggy. "Feminism and Art: Nine Views." *Artforum*, October 2003, 148–49.

"Photoplayers Gallery." *Photoplay*, October 1914, n.p.

Pincus-Witten, Robert. "Lynda Benglis: The Frozen Gesture." *Artforum*, November 1974, 54–59.

"Plays and Players." *Photoplay*, October 1920, 98–109.

Pokorny, Sydney. "Lisa Yuskavage: Boesky Gallery." *Artforum*, February 1997, 89.

Pollack, Barbara. "Babe Power." *Art Monthly*, no. 235 (2000): 7–10.

Pollock, Griselda. *Mary Cassatt: Painter of Modern Women*. London: Thames and Hudson, 1998.

Powers, Ann. *Weird Like Us: My Bohemian America*. New York: Simon and Schuster, 2000.

Press, Joy. "Notes on Girl Power: The Selling of Softcore Feminism." *Village Voice*, 23 September 1997, 59–61.

Priest, Janet. "The Call of Her People." *Photoplay*, July 1917, 37–45.

Queen, Carol. "Talking About Sex." In *Madonnarama: Essays on Sex and Popular Culture*, edited by Lisa Frank and Paul Smith. San Francisco: Cleis Press, 1993.

"Quick, Watson, the Needles!" *Photoplay*, February 1918, 24–25.

Quirk, James R. "Oh Henry!" *Photoplay*, June 1921, 44.

———. "The Girl on the Cover." *Photoplay*, August 1915, 39–41.

Robert Rauschenberg (catalog). Washington, D.C.: National Collection of Fine Arts, 1976.

Raven, Arlene. "Star Studded: Porn Stars Perform." In *Crossing Over: Feminism and Art of Social Concern*. Ann Arbor: UMI Research Press, 1988.

Rawls, Walton. *Wake Up, America! World War I and the American Poster*. New York: Abbeville, 1988.

Reckitt, Helena. "Works: Too Much." In *Art and Feminism*, edited by Reckitt. London: Phaidon, 2001.

Reed, Walt. *The Illustrator in America, 1900–1960s*. New York: Reinhold, 1966.

Regis, Julia. "Beauty: Her Great Handicap." *Photoplay*, June 1920, 32–33.

Rice, Robin. "Lisa Yuskavage, Hella Jongerius and Jurgen Bey, Mei-ling Hom: Silkworm Grind." *Philadephia City Paper*, http://www.citypaper.net/articles/121400/ae.art.lisa.shtml.

Rich, Adrienne. *Of Woman Born: Motherhood as Experience and Institution*. New York: Bantam Books, 1977.

Richardson, Angelique, and Chris Willis, eds. *The New Woman in Fiction and in Fact: Fin-de-Siècle Feminisms*. London: Palgrave Macmillan, 2001.

Riva, Maria. *Marlene Dietrich*. New York: Ballantine Books, 1992.

Robbins, Elmer M. "Dear Dorothy." *Photoplay*, May 1919, 70–72.

Roberts, Mary Louise. *Disruptive Acts: The New Woman in Fin-de-Siècle France*. Chicago: University of Chicago Press, 2002.

Robertson, Pamela. *Guilty Pleasures: Feminist Camp from Mae West to Madonna*. Durham, N.C.: Duke University Press, 1996.

Robinson, Hilary, ed. *Feminism-Art-Theory: An Anthology*. Oxford: Blackwell Publishers, 2001.

Rogers-St. Johns, Adela. "The Confessions of a Male Vampire." *Photoplay*, March 1919, 28–30.

———. "A Cross in the Garden." *Photoplay*, May 1919, 48–50+.

———. "From the Skin Out." *Photoplay*, May 1919, 32–35+.

———. "Matrimony and Meringue." *Photoplay*, July 1919, 80.

———. "What Does Marriage Mean? As Told by Cecil B. de Mille." *Photoplay*, October 1920, 28–31.

Roof, Judith. "Generational Difficulties; or, The Fear of a Barren History." In *Generations: Academic Feminists in Dialogue*, edited by Devoney Looser and E. Ann Kaplan. Minneapolis: University of Minneapolis Press, 1997.

Rosenbloom, Nancy J. "Progressive Reform, Censorship, and the Motion Picture Industry, 1909–1917." In *Popular Culture and Political Change in Modern America*, edited by Ronald Edsforth and Larry Bennett. Albany, N.Y.: State University of New York Press, 1991.

Rosenblum, Robert. *Mel Ramos: Pop Art Images*. Cologne: Taschen Books, 1997.

Ross, Andrew. "This Bridge Called My Pussy." In *Madonnarama: Essays on Sex and Popular Culture*, edited by Lisa Frank and Paul Smith. San Francisco: Cleis, 1993.

Rousseau, Jean-Jacques. *Lettre à d'Alembert sur les spectacles*. Paris: Hachette, 1896.

Rower, Ann. "Fresh Dirt." http://www.echonyc.com/meehan/Soil/Crust/rower.html.

Rupp, Leila J. "Feminism and the Sexual Revolution in the Early Twentieth Century." *Feminist Studies* (Summer 1989), 289–309.

———. *Mobilizing Women for the War: German and American Propaganda, 1939–1945*. Princeton, N.J.: Princeton University Press, 1978.

Russ, Joanna. *Magic Mommas, Trembling Sisters, Puritans, and Perverts: Feminist Essays*. Trumansburg, N.Y.: Crossing, 1985.

Russo, Mary. *The Female Grotesque*. New York: Routledge, 1995.

Salvatore, Diane. "A Classic Case of Sensory Overload." *Ms.*, April 1983, 43–44.

Sandoval, Chela. "U.S.–Third Word Feminism: The Theory and Method of Oppositional Consciousness in the Postmodern World." *Genders* (Spring 1991): 1–24.

Sanger, Margaret. *An Autobiography*. New York: Norton Books, 1938.

Schanke, Robert and Kim Marra, eds. *Passing Performances: Queer Readings of Leading Players in American Theatre History*. Ann Arbor: University of Michigan Press, 1998.

Scharf, Lois. " 'The Forgotten Woman': Working Women, the New Deal, and Women's Organizations." In *Decades of Discontent*, edited by Scharf and Joan M. Jensen. Westport, Conn.: Greenwood, 1983.

Scharf, Lois, and Joan M. Jensen, eds. *Decades of Discontent: The Women's Movement, 1920–1940*. Westport, Conn.: Greenwood, 1983.

Schneemann, Carolee. *More Than Meat Joy: Complete Performance Works and Selected Writings*. New Paltz, N.Y.: Documentext, 1979.

Schneider, Karen. "Re-Shooting World War II: Women, Narrative Authority, and Hollywood Cinema." *Genders* 21. 1995, 58–79.

Schneider, Rebecca. *The Explicit Body in Performance*. New York: Routledge, 1997.

Schor, Mira, ed. "Contemporary Feminism: Art Practice, Theory, and Activism—An Intergenerational Perspective." *Art Journal* (Winter 1999), 8–29.

Schreiner, Olive. *Women and Labor*. New York: Frederick Stokes, 1911; reprint, London: Virago, 1978.

Schwarz, Judith, Kathy Peiss, and Christina Simmons, "We Were a Little Band of Willfull Women: The Heterodoxy Club of Greenwich Village." In *Pas-*

sion and Power: Sexuality in History, edited by Kathy Peiss and Christina Simmons Philadelphia: Temple University Press, 1989.

Schwichtenberg, Cathy. "Madonna's Postmodern Feminism: Bringing the Margins to the Center." In *The Madonna Connection: Representational Politics, Subcultural Identities, and Cultural Theory*, edited by Schwichtenberg. Boulder, Colo.: Westview, 1993.

Scott, Joan Wallach. ed. *Feminism and History*. Oxford: Oxford University Press, 1996.

Segal, Lynne. *Why Feminism? Gender, Psychology, Politics*. New York: Columbia University Press, 1999.

Segal, Lynne and Mary McIntosh, eds. *Sex Exposed: Sexuality and the Pornography Debate*. New Brunswick: Rutgers University Press, 1993.

Senelick, Laurence. "Chekhov's Response to Bernhardt." In *Bernhardt and the Theatre of Her Time*, edited by Eric Salmon. Westport, Conn.: Greenwood, 1984.

Sentilles, Renée. *Performing Menken: Adah Isaacs Menken and the Birth of American Celebrity*. Cambridge: Cambridge University Press, 2003.

"The Shadow Stage." *Photoplay*, February 1923, 63.

Shannon, Betty. "Dante Was Wrong." *Photoplay*, August 1920, 30–31+.

Shonagh Adelman: Skindeep (catalog). Toronto: A Space, 1994.

Showalter, Elaine. *Sexual Anarchy: Gender and Culture at the Fin-de-Siècle*. New York: Viking, 1990.

Siegel, Judy. "Hannah Wilke: Censoring the Muse?" *Woman Artists News* (Winter 1986–87): 47.

Singer, Ben. "Female Power and the Serial-Queen Melodrama: The Etiology of an Anomaly." In *Silent Film*, edited by Richard Abel. New Brunswick, N.J.: Rutgers University Press, 1996.

Skinner, Cornelia Otis. *Madame Sarah*. Boston: Houghton-Mifflin, 1967.

Smith, Agnes. "The Confessions of Theda Bara." *Photoplay*, June 1920, 56–58.

Smith, Ali. *Laws of the Bandit Queens*. New York: Three Rivers, 2002.

Smith, Barbara, ed. *Home Girls: A Black Feminist Anthology*. New York: Kitchen Table: Women of Color, 1983.

Smith, Frederick James. "Sex Appeal, Babies, and Alice Brady." *Photoplay*, October 1922, 20–21.

Smith-Rosenberg, Caroll, ed. *Disorderly Conduct: Visions of Gender in Victorian America*. Oxford: Oxford University Press, 1986.

Sneider, Allison. "Woman Suffrage in Congress: American Expansion and the Politics of Federalism, 1870–1890." In *Votes for Women: The Struggle for Suffrage Revisited*, edited by Jean H. Baker. New York: Oxford University Press, 2002.

Snitow, Ann. "Pages from a Gender Diary: Basic Divisions in Feminism." *Dissent* 36, no. 2 (1989): 205–24.

———. "Retrenchment versus Transformation." In *Women against Censorship*, edited by Varda Burstyn. Vancouver: Douglas and McIntyre, 1985.

Snitow, Ann, Christine Stansell, and Sharon Thompson, eds. *Powers of Desire: The Politics of Sexuality*. New York: Monthly Review Press, 1983.

Solomon, Deborah. "Art Girls Just Wanna Have Fun." *New York Times Magazine*, 30 January 2000.

Solomon-Godeau, Abigail. "The Legs of the Countess." *October*, no. 39 (1986): 65–108.

———. "The Other Side of Venus: The Visual Economy of Feminine Display." In *The Sex of Things: Gender and Consumption in Historical Perspective*, edited by Victoria de Grazia with Ellen Furlough. Berkeley: University of California Press, 1996.

Sontag, Susan. "The Pornographic Imagination." *A Susan Sontag Reader*. New York: Farrar, Straus & Giroux, 1982.

Spencer, Lauren. "Grrrls Only." *Washington Post*, 3 January 1993.

Sprinkle, Annie [Ellen F. Steinberg]. *Post Porn Modernist*. Amsterdam: Art Unlimited, 1991.

Sprinkle, Annie and Katharine Gates. *Post-Modern Pin-Ups: Pleasure activist playing cards*. Richmond: Gates of Heck, Inc., 1995.

Stacey, Jackie. *Star Gazing: Hollywood Cinema and Female Spectatorship*. New York: Routledge, 1994.

Staiger, Janet. *Bad Women: Regulating Sexuality in Early American Cinema*. Minneapolis: University of Minnesota Press, 1995.

Stamp, Shelley. *Movie-Struck Girls: Women and Motion Picture Culture after the Nickelodeon*. Princeton, N.J.: Princeton University Press, 2000.

———. "Taking Precautions, or Regulating Early Birth Control Films." In *A Feminist Reader in Early Cinema*, edited by Jennifer Bean and Diane Negra. Durham, N.C.: Duke University Press, 2002.

Stanton, Elizabeth Cady, Susan B. Anthony, and Matilda Joslyn Gage, eds. *History of Woman Suffrage*, vols. 1 and 2. New York: Fowler and Wells, 1881.

Stanton, Theodore, and Harriot Stanton Blatch, eds. *Elizabeth Cady Stanton: As Revealed in Her Letters, Diary, and Reminiscences*. Vol. 2. New York: Harper and Bros., 1922.

Starr, Frederick. "The World before Your Eyes." *Photoplay*, February 1912, 9–10.

Starr, Helen. "Putting It Together." *Photoplay*, July 1918, 52–53.

Steele, Valerie. *Fetish: Fashion, Sex, and Power*. New York: Oxford University Press, 1996.

Stephens, Elizabeth. "Looking-Class Heroes." In *The Passionate Camera: Photography and Bodies of Desire*, edited by Deborah Bright. New York: Routledge, 1998.

Stokes, John, ed. *Eleanor Marx: Life, Work, Contacts*. Burlington, Vt.: Ashgate, 2000.

Strossen, Nadine. *Defending Pornography: Free Speech, Sex, and the Fight for Women's Rights*. New York: New York University Press, 2000.

Studlar, Gaylyn. "The Perils of Pleasure? Fan Magazine Discourse as Women's Commodified Culture in the 1920s." In *Silent Film*, edited by Richard Abel. New Brunswick, N.J.: Rutgers University Press, 1996.

Suleiman, Susan Rubin, ed. *The Female Body in Western Culture*. Cambridge, Mass.: Harvard University Press, 1986.

Suleiman, Susan Rubin. *Subversive Intent: Gender, Politics, and the Avant-Garde*. Cambridge: Harvard University Press, 1990.

Sullivan, Steve. *Va, va, voom!: Bombshells, pin-ups, sexpots, and glamour girls*. Los Angeles: General Publishing Group, 1995.

"Talking Cock: Lesbians and Aural Sex, Cynthia Wright Interviews Shonagh Adelman." *Fuse*, May–June 1994, 44–48.

Tamblyn, Christine. "No More Nice Girls: Recent Transgressive Feminist Art." *Art Journal*. Summer 1991, 53–57.

———. "The River of Swill: Feminist art, sexual codes, and censorship." *Afterimage* 18, no. 3. October 1990, 10–13.

Tasker, Yvonne. *Working Girls: Gender and Sexuality in Popular Cinema*. New York: Routledge, 1998.

Tickner, Lisa. *The Spectacle of Women: Imagery of the Suffrage Campaign, 1907–1914*. London: Chatto and Windus, 1987.

Ticknor, Caroline. "The Steel-Engraving Lady and the Gibson Girl." *Atlantic Monthly*, July 1901, 106.

"To a Young Girl Going to a Photoplay." *Photoplay*, February 1919, 23.

Todd, Ellen Wiley. *The New Woman Revised: Painting and Politics on Fourteenth Street*. Berkeley: University of California Press, 1993.

Todd, Jan. "Bring on the Amazons: An Evolutionary History." In *Picturing the Modern Amazon*, edited by Joanna Frueh, Laurie Fierstein, and Judith Stein. New York: New Museum of Contemporary Art, 1999.

Trebay, Guy. "The Age of Street Fashion." *New York Times*, 27 October 2002.

"The $250 Prize Awarded." *Photoplay*, August 1914, 153.

"$2,000 Prize Won by Girl from Philadelphia." *Photoplay*, December 1931, 68–69+.

Underhill, Harriette. "Olive Tells Her Secrets." *Photoplay*, February 1918, 43–44+.

U.S. Department of Justice, *Attorney General's Commission on Pornography Final Report*. Washington, D.C.: U.S. Government Printing Office, 1986.

Valant, Gary M. *Vintage Aircraft Nose Art*. Osceola: Motorbooks, International, 1987.

Vale, V., and Andrea Juno. *Modern Primitives*. San Francisco: RE/Search, 1989.

Van Buren, Raeburn. "Petrova the Working-Girl." *Photoplay*, June 1917, 54–55.

Vance, Carole S. "Feminist Fundamentalism—Women against images." *Art in America* 81, pt. 9. September 1993, 35–37.

———, "More Pleasure, More Danger: A Decade after the Barnard Conference." In *Pleasure and Danger: Exploring Female Sexuality*, 3rd ed., edited by Vance. London: Pandora, 1992.

———, ed. *Pleasure and Danger: Exploring Female Sexuality*. New York: Routledge, 1984.

"The Varga Girl." *Newsweek*, 23 September 1940, 56.

Vargas, Alberto, and Reid Austin, *Vargas*. New York: Harmony, 1978.

Verhagen, Marcus. "The Poster in *Fin-de-Siècle* Paris: 'That Mobile and Degenerate Art.'" In *Cinema and the Invention of Modern Life*, edited by Leo Charney and Vanessa R. Schwartz. Berkeley: University of California Press, 1995.

Vicinus, Martha. "Turn-of-the-Century Male Impersonation: Rewriting the Romance Plot." In *Sexualities in Victorian Britain*, edited by Andrew H. Miller and James Eli Adams. Bloomington: Indiana University Press, 1996.

Viera, Mark. *Hurrell's Hollywood Portraits: The Chapman Collection*. New York: Harry N. Abrams, 1997.

Walker, Rebecca. "Becoming the Third Wave." *Ms.*, January–February 1992, 41.

———, ed. *To Be Real: Telling the Truth and Changing the Face of Feminism*. New York: Anchor Books, 1995.

Wallace, Christine. *Germaine Greer: Untamed Shrew*. New York: Faber and Faber, 1998.

Wallace, Michele. *Black Macho and the Myth of the Superwoman*. New York: Dial, 1970.

Waller, Jane and Michael Vaughan-Rees. *Women in Wartime: The Role of Women's Magazines, 1939–1945*. London: Optima, 1987.

Wallis, Brian, ed. *Art After Modernism: Rethinking Representation*. New York: New Museum of Contemporary Art, 1984.

Walters, Suzanna Danuta. "From Here to Queer: Radical Feminism, Postmodernism, and the Lesbian Menace (Or, Why Can't a Woman Be More Like a Fag?)," *Signs: Journal of Women in Culture and Society* 21, no. 4 (1996): 830–69.

———. *Material Girls: Making Sense of Feminist Cultural Theory*. Berkeley: University of California Press, 1995.

Watson, Max. "Making Americans by Movies." *Photoplay*, May 1921, 42+.

Weatherford, Doris. *American Women and World War II*. New York: Facts on File, 1990.

Webster, Paula. "Pornography and Pleasure." In *Caught Looking*, edited by the FACT Book Committee. East Haven, Conn.: LongRiver Books.

Weimann, Jeanne M. *The Fair Women: The Story of the Woman's Building, World's Columbian Exposition, Chicago, 1893*. Chicago: Academy Chicago, 1981.

Weitman, Wendy, ed. *Pop Impressions: Europe/USA, Multiples from the Museum of Modern Art*. New York: Museum of Modern Art, 1999.

Welter, Barbara. "The Cult of True Womanhood, 1820–1860." *American Quarterly* 18, no. 2 (1966): 151–74.

Westbrook, Robert B. "I Want a Girl Just Like the Girl That Married Harry James: American Women and the Problem of Political Obligation in World War II." *American Quarterly* 2, no. 3 (1990): 587–614.

"We Take Our Hats Off To—." *Photoplay*, February 1921, 34.

Wharton, Edith. *The Age of Innocence*. New York: Scribner Paperback Editions, 1998.

What Did You Do in the War, Grandma? An Oral History of Rhode Island Women During WWII. http://www.stg.brown.edu/projects/WWII_Women/WarSparks.html.

"What They Think about It." *Photoplay*, December 1912, 128.

"What They Think about Marriage." *Photoplay*, April 1921, 20–22+.

"When She Swims." *Photoplay*, July 1916, 103–12.

Whittier, Nancy. *Feminist Generations: The Persistence of the Radical Women's Movement*. Philadelphia: Temple University Press, 1995.

Wilding, Faith. *By Our Own Hands: The Women Artists' Movement in Southern California, 1970–1976*. Santa Monica, Calif.: Double X, 1977.

———. "The Feminist Art Programs at Fresno and CalArts, 1970–1975." In *The Power of Feminist Art*, edited by Norma Broude and Mary Garrard. New York: Abrams, 1994.

———. "Where Is the Feminism in Cyberfeminism?" in *Feminism-Art-Theory: An Anthology*, edited by Hilary Robinson. Oxford: Blackwell, 2001. First published in *n.paradoxa* 2 (1998), 6–12.

Williams, Carla. "Playing Nature and Culture: Black Women Make Themselves." In *Soothsayers: She Who Speaks the Truth*. Catalog, Philadelphia: Painted Bride Art Center, 1999.

Williams, Kathlyn. "Kathlyn's Own Story." *Photoplay*, April 1914, 39–42.

Williams, Linda. *Hard Core: Power, Pleasure, and the "Frenzy of the Visible."* Berkeley: University of California Press, 1989.

Williams, Stacey. "Wonder Woman at the Brooklyn Museum: Aftermath." *International Review of African American Art* 17, no. 4 (2001): 43.

Willis, Chris. "'Heaven Defend Me from Political or Highly-Educated Women!': Packaging the New Woman for Mass Consumption." In *The New Woman in Fiction and in Fact: Fin-de-Siècle Feminisms*, edited by Angelique Richardson and Chris Willis. London: Palgrave Macmillan, 2001.

Wilson, Elizabeth. "Interview with Andrea Dworkin." In *Looking On: Images of Femininity in the Visual Arts and Media*, edited by Rosemary Betterton. London: Pandora Books, 1987.

"The Winners." *Photoplay*, July 1916, 11.

"The Winners of the Contest." *Photoplay*, January 1918, 103–4+.

Winship, Mary. "Oh, Hollywood!" *Photoplay*, May 1921, 20–22+.

Wise, Nancy Baker, and Christy Wise. *A Mouthful of Rivets: Women and Work in World War II*. San Francisco: Jossey-Bass Publications, 1994.

Wolverton, Terry. *Insurgent Muse: Life and Art at the Woman's Building*. San Francisco: City Lights Books, 2002.

"Women Leaders." *Ebony*, July 1949, 19–22.

"Women's Rights—the Besserer Definition." *Photoplay*, June 1915, 63.

Woodhull, Victoria. *A Victoria Woodhull Reader*, edited by Madeleine B. Stern. Weston, Mass.: M&S Press, 1974.

Woodward, Michael. "That Awful 'IT'!" *Photoplay*, July 1930, 39.

Wortley, Richard. *Pin-Up's Progress: An Illustrated History of the Immodest Art, 1870–1970*. London: Panther Books, 1972.

Yeager, Bunny. *Bunny's Honeys: Bunny Yeager, Queen of the Pin-Up Photographers*. Cologne: Benedikt Taschen, 1994.

York, Cal. "Should Women Work?" *Photoplay*, August 1931, 45+.

Younger, Dan. "Cartes de Visite: Precedents and Social Influences." *California Museum of Photography Bulletin* 6, no. 4 (1987): 20.

Yuskavage, Lisa. "Interview: Lisa Yuskavage Talks with Chuck Close." In *Lisa Yuskavage* (catalog). Santa Monica, Calif.: Smart Art, 1996.

Zegher, Catherine de, ed. *Inside the Visible: An Elliptical Traverse of Twentieth-Century Art In, Of, and From the Feminine*. Cambridge, Mass.: MIT Press, 1996.

Zurilgen, Cheryl. "Becoming Conscious." *Everywoman* 2, no. 7 (1971): 8.

INDEX

Abbott, Willis J., 123
Addams, Jane, 136, 139
Adelman, Shonagh, 335, 337–338
Albert, Katherine, 190, 193
Allen, Robert C., 36–37, 63–65
Allender, Nina, 100
Allison, Dorothy, 318, 321, 397 n.130
Alloway, Lawrence, 290
Allyn, David, 257, 295
Always, Stella Vanderlindel, 215
American Woman Suffrage Association
 (AWSA), 76–77
Anderson, Mary, 121
Ann-Margret, 268
Anthony, Susan B., 74, 76–77, 110, 280
Antin, Eleanor, 276, 285–288, 299
Aoki, Tsuru, 164
Arbuckle, Roscoe "Fatty," 149
Archer, Jules, 243–244
Arnold, Charles Dudley, 70–71
Assiter, Alison, 271
Atkinson, Ti-Grace, 275

Bacher, Lutz, 336
Baer, Howard, 202
Baker, Jean H., 30
Baker, Josephine (doctor), 135
Baker, Josephine (performer), 250

Banes, Sally, 256–257
Banner, Lois, 58
Banta, Martha, 79, 89, 96
Bara, Theda, 134, 149, 160–162, 165
Bardot, Brigitte, 265–267
Barney, Alice Pike, 110
Barnum, P. T., 44–45
Barrymore, Drew, 118
Barrymore, Ethel, 23, 117–120, 134, 153
Baumgardner, Jennifer, 328, 342, 345, 357–
 358
Bazin, André, 11, 261
Beale, Frances, 317
Bean, Jennifer, 149
Beauvoir, Simone de, 17, 282
Bellafante, Ginia, 342, 356
Benglis, Lynda, 288–292, 301
Berger, John, 274, 294
Berkeley, Busby, 224
Bernhardt, Sarah, 23, 62, 117, 120–129,
 133
Bernstein, Leonard, 233
Berry, Alice, 108–109
Besserer, Eugenie, 158
Betz, Stefanie van (Countess de Cassini),
 116–117
Biery, Ruth, 188
Bizarre magazine, 244–246, 391 n.75

Blaché, Alice, 156
Blackwell, Henry, 77
Blake, Peter, 283–284
Blatch, Harriot Stanton, 131–133, 139
Bloom, Lisa E., 286
Blume, Judy, 330
Bolles, Enoch, 202
Booth, Edwin, 49
Boty, Pauline, 265, 276
Bouguereau, Adolphe-William, 9–10
Bow, Clara, 173–175, 188
Bowser, Eileen, 137
Bradley, William H., 101
Brady, Alice, 151, 165–166, 179
Breen, Joseph, 200–201
Brice, Fanny, 162
Bright, Deborah, 325
Bright, Susie, 320–323, 329
British Blondes, 42, 53, 58, 60
Brooks, Robert, 268
Broude, Norma, 75–76
Brown and Bigelow, 219–220
Brown, Cecily, 358, 360–361
Brownmiller, Susan, 342
Buell, Al, 219–220
Burstyn, Varda, 308
Bush, Pauline, 149
Bust magazine, 346–347
Butler, Judith, 12, 333, 398 n.17

Caird, Mona, 90
Campbell, E. Simms, 202, 251
Carlton, Donna, 72
Carmichael, Stokely, 272
Carnival Knowledge, 323–324
Carol, Avedon, 271
Carqueville, William L., 101
Carson, Josephine, 216
Carter, Angela, 305–306
Cassatt, Mary, 75–76
Cassini, Marguerite (Countess de), 115–117
Castle, Irene, 166
Cawlfield, Nicole, 350
Caws, Mary Ann, 391 n.74
Chaplin, Charlie, 151
Chekhov, Anton, 122
Cheret, Jules, 124–126
Chesler, Phyllis, 280

Chicago, Judy, 7, 281–284, 357, 359, 394 n.57
Christopher, Phyllis, 321–322, 329
Christy, Howard Chandler, 219
Cisneros, Sandra, 349
Clare, Ada, 49
Clayton, Ethel, 168
Clifford, Kathleen, 159
Clift, Anna Mae, 206
Coast Guard SPARS, 219
Comden, Betty, 232
Commander, Lydia, 6
Cooley, Winifred Harper, 135
Cooper, Gary, 177, 196
Corinne, Tee, 321, 324
Cottrell, Honey Lee, 321, 324
Coutts, John "Willie," 244–245
Cox, Renée, 7, 338–341, 350
Crawford, Joan, 188, 191–193, 206, 240–241, 384 n.15
Crimp, Douglas, 298
Cross, Veronica, 358

Daguerre, Louis, 32
Damsky, Lee, 303
Daniels, Bebe, 164, 171–172
Danto, Arthur, 197–198
Davis, Angela Y., 270, 329
Davis, Richard Harding, 91, 97
Davis, Tracy C., 31
Day, Doris, 236, 267
Dean, Jeanne, 206
Deepwell, Katy, 14, 361
de Kooning, Willem, 267
De Lauretis, Teresa, 306–308
Del Rio, Dolores, 197–198, 250
DeMers, Joe, 236
D'Emilio, John, 30, 81, 217
DeMille, Cecil B., 169–170, 189
Deneuve, Catherine, 267
Denmark, Virginia Tredinnick, 223
Denton, Frances, 160
Dietrich, Marlene, 48, 191, 193–196, 198, 258, 385 n.22
Dijkstra, Bram, 381 n.68
Dimen, Muriel, 13
Disdéri, A. A. E., 32–33, 41
Disney, Walt, 212
Doane, Mary Ann, 306–307

Dodge, Mable, 135
Dodson, Dr. Betty, 277
Donegan, Dorothy, 251
Dos Passos, John, 202
Douglass, Frederick, 77
Doyle, Kegan, 306
Drake, Jennifer, 333
Drew, Louisa Lane, 118
Driben, Peter, 278, 349
Dudden, Faye E. 27–29, 60
Dudley, Russell, 14–15
Dulac, Germaine, 156
Dumas, Alexandre pére, 51
Dunaway, Faye, 268
Dunham, Katherine, 253
Durand, Marguerite, 123
Duse, Eleanora, 121–122
Dworkin, Andrea, 6, 273–275, 279, 302–
 304, 307, 311–313, 323

Ebony magazine, 248–255
Ehrmann, Winston, 217
Ekberg, Anita, 262–263
Elam, Diane, 20
Elder, Sean, 217
Elliot, Julie Raymond, 216
Ellis, Havelock, 81, 171
English, Dierdre, 277
Esquire magazine, 1–3, 185, 202–212, 218–
 222, 227–229, 236–238, 352, 385 n.34
Eugénie de Montijo (empress consort of
 France), 34–35, 51, 62
Evans, Delight, 162, 164
Ewing, Wanda, 349–350
Export, Valie, 281

Fairbanks, Douglas Sr., 177
Faludi, Susan, 236
Faram, Holly Anna, 244
Fellini, Federico, 263–264
Feminist Anti-Censorship Taskforce
 (FACT), 324–325
Feminists Against Censorship (FAC), 308
Fernandez, Joyce, 320
Finch, Casey, 9–11
Firestone, Shulamith, 17–18, 278, 280
Fitzgerald, F. Scott, 202
Flack, Audrey, 295–296
Flynn, Elizabeth Gurley, 135

Fonda, Jane, 267–268
Foster, Hal, 299
Fox, Howard, 286
Frahm, Art, 236
Franklin, Aretha, 268
Franklin, Wallace, 161–162
Freedman, Estelle B., 30, 81, 217
Fresno State College Feminist Art Pro-
 gram, 281–284, 289, 356
Friedan, Betty, 24–25, 238–242, 248, 273,
 280, 295, 343, 356
Frueh, Joanna, 3, 6–7, 14–16, 281, 291–292
Fuss, Diana, 282

Gabor, Mark, 8–9, 260
Gage, Matilda Joslyn, 77
Gallop, Jane, 19, 277
Gamman, Lorraine, 306
Garbo, Greta, 193, 196, 198, 200
Garofalo, Janeane, 3, 362
Garrison, Ednie Kaeh, 362
Gibson, Charles Dana, 22, 85–99, 104,
 118, 219
Gilman, Charlotte Perkins, 100, 130, 135
Gingrich, Arnold, 210
Gish, Dorothy, 143
Gish, Lillian, 151
Glenn, Susan A., 122, 131–133
Glyn, Elinor, 168, 174
Gonzales, Barbara, 251
Gould, J. J., 101
Grable, Betty, 223–224, 239, 289
Grand, Sarah, 76–79, 82–84, 117
Green, Adolph, 232
Greenberg, Clement, 255–258, 261, 297
Greer, Germaine, 278–279, 281, 329
Griffith, D. W., 147, 188
Grigsby, Daphne A., 254
Grimké, Angela, 38
Grimké, Sarah, 38
Guerilla Girls, 345
Guilbert, Yvette, 124
Gutierrez, Raquel, 248

Hamilton, Richard, 261
Hanna, Kathleen, 344, 347, 361
Hansen, Miriam, 142
Haraway, Donna, 14, 16, 333–334, 338, 361–
 362

Harlow, Jean, 191, 193
Harper, Frances Watkins, 77
Harrison, Robert, 245
Haskell, Molly, 189
Hayakawa, Sessue, 164
Hayden, Sophia, 72
Hays, Will, 199–200
Hearn, Kay, 216–217
Hefner, Hugh, 237–238, 244–245
Hemingway, Ernest, 202
Hennessy, Rosemary, 319
Henry, Astrid, 19–21, 280–281, 319, 331–332, 357, 397–398 n.4
Hepburn, Katharine, 191
Hernández, Ester, 348–349
Hess, Elizabeth, 336
Hess, Thomas, 258–259, 262
Heterodoxy, 135, 377 n.53
Hewitt, Mattie Edwards, 108
Heywood, Leslie, 333
Higashi, Sumiko, 169
Höch, Hannah, 258
Hollibaugh, Amber, 272–273, 295
Holmes, Helen, 154
Holmes, Oliver Wendell, Sr., 62–63
Honig, Peregrine, 351–352
hooks, bell, 7, 326, 328, 392 n.15
Hope, Bob, 210
Horne, Lena, 250–253
Howells, William Dean, 60
Huff, Louise, 166
Hugo, Victor, 128
Hungerford, Cyrus, 213–214
Hurrell, George, 189–190, 206
Hustler magazine, 260, 323

Ibsen, Henrik, 90, 114, 118–120, 129, 155
Ingres, Jean-Auguste-Dominique, 197–198, 205
Irigaray, Luce, 294
Ives, Halsey C., 70–71, 75

Jackson, Jennifer, 269
James, Henry, 56, 65, 122
Jameson, Fredric, 297, 318
Johns, Jasper, 256
Johnson, Alfred Cheney, 166
Johnson, Grace Nail, 135
Johnson, John H., 246

Johnson, Julian, 158
Johnston, Frances Benjamin, 22, 99–111, 114–117, 124, 218, 375 n.78
Jones, Amelia, 292, 357–360, 395 nn.72, 75
Jong, Erica, 278, 281, 342

Kakoudaki, Despina, 212
Kallan, Richard, 268
Kamen, Paula, 329, 341–342
Karp, Marcelle, 346
Keeler, Christine, 265
Keene, Laura, 36, 38–39
Kellerman, Annette, 150
Kelley, Abby, 38
Kelly, Mary, 356
Kennedy, Florynce, 317
Key, Ellen, 81, 171
King, Anita, 154
Kingsley, Grace, 154
Kinney, Nan, 320
Kinsey, Alfred, 233, 243–244, 253, 259
Kirchner, Raphael, 197–198
Kiss and Tell, 323
Kitch, Carolyn, 95
Klaw, Irving and Paula, 245–247
Knowlton, Josephine Gibson, 99
Koedt, Ann, 277, 280
Kozloff, Joyce, 358–359
Kozloff, Max, 290
Krane, Susan, 189
Krauss, Rosalind, 290, 302
Kruger, Barbara, 7
Kuhn, Annette, 306–307

Lacombe, Dany, 306
La Folette, Lola, 135
Landay, Lori, 23, 171–176
Langhorne, Irene, 93
La Marr, Barbara, 166
Lasky, Jesse L., 169
La Vie Parisienne, 67, 197
Lawrence, Florence, 163
Lee, China, 269
Liebovitz, Annie, 289
Life magazine, 85–89, 91–93, 95, 97, 237
Lind, Jenny, 44–46, 48, 62
Linker, Kate, 7
Linton, Eliza Lynn, 55–58, 65, 80
Lippard, Lucy, 271, 290–291

"Little Egypt," 69–73, 76, 98, 129, 234
Lloyd, Harold, 171
Loeb, Sophie Irene, 181
Logan, Olive, 42–43, 61–62, 117, 122, 371 n.69
Longworth, Alice Roosevelt, 109–110, 120
Loos, Anita, 156, 158
Looser, Devoney, 316
López, Alma, 348–349, 351
López, Yolanda, 349
Lord, M. G., 13
Lorde, Audre, 304–305, 317
Lotman, Jacob, 250
Louis, Marva, 251
Lovell, Margaretta, 70–71
Lynd, Robert S. and Helen Merrel, 200–201

MacDonald, Katherine, 167
MacKinnon, Catharine, 6, 302–304, 307, 323
MacMonnies, Mary Fairfield, 75
Macpherson, Jeanie, 169
Madison, Cleo, 156, 158
Madonna, 326–329
Magnuson, Ann, 362–364
Man Ray, 258–259
Marion, Frances, 156
Markham, Pauline, 53, 59, 62. *See also* British Blondes
Marks, Patricia, 84–85
Marshall, Gail, 121
Marx, Eleanor, 81–82
Masheck, Joseph, 290
Matthews, Jean V., 82
May, Elaine Tyler, 212
McAdams, Dona Ann, 324
McCarthy, David, 260, 264–265
McCarty, Marlene, 334–336, 400 n.57
McCauley, Elizabeth Anne, 32–33
McNair, Brian, 12
McQuiston, Liz, 333–334
McRobbie, Angela, 327, 341–342
Mei, Tsen, 164–165
Melandri, 128
Mencken, H. L., 170–171, 175
Menken, Adah Isaacs, 28, 40–42, 44–53, 61–62, 122, 124, 126–128, 194, 286, 343

Meyerowitz, Joanne, 11–12, 218, 240–241
Michelena, Beatriz, 164
Michelson, Annette, 290
Milholland, Inez, 135
Miller, Alice Duer, 168
Miller, Russell, 237–238
Millet, Kate, 278, 282, 358
Monroe, Marilyn, 236, 247, 267, 295–296
Montgomery, Lottie, 135–136
Moore, Al, 236
Moore, Colleen, 173–174
Moraga, Cherie, 317
Moreno, Antonio, 164
Morey, Anne, 383 n.122
Morgan, Robin, 303
Morley, Lewis, 265
Morris, Robert, 290
Morrison, Allan, 249
Morrison, Toni, 317
Mott, Lucretia, 37
Mucha, Alphonse, 124–126, 197–198
Mulvey, Laura, 6, 274–276, 294, 306–308

Naldi, Nita, 165
Napoleon III, 34
National Organization for Women (NOW), 280, 321
National Police Gazette, 62, 67, 101, 126, 202
National Woman Suffrage Assocation (NWSA), 76–77
Nemser, Cindy, 290
Nestle, Joan, 321
Nochlin, Linda, 1–4, 359–360, 392–393 n.19
Nora, Elise, 123
Normand, Mabel, 149–151, 155
North American Woman Suffrage Association (NAWSA), 77, 152
Novarro, Ramon, 190

Oakley, Laura, 158
Ockman, Carol, 377 n.32, 386 n.38
Office of War Information (OWI), 214–215
O'Neill, Nance, 149
On Our Backs magazine, 320–323
Oppenheim, Meret, 258–259, 288

Ott, Catherine, 217
Ouida (Marie Louise de la Ramée), 79–80, 82–83
Owens, Craig, 298–299, 302, 318
Oz magazine, 278–279

Page, Bettie, 245–247, 321
Palmer, Bertha Honoré, 74–75
Pankhurst, Christobel, 132, 171
Pankhurst, Emmeline, 132, 139
Paolozzi, Eduardo, 261–262
Parker, Alison M., 37–38
Parks, Ida Mae, 156, 167–168
Parrott, Ursula, 189
Paul, Alice, 132
Peiss, Kathy, 172–173
Penfield, Edward, 101
Penthouse magazine, 260, 270–271, 353
Petrova, Olga, 149, 151
Pettit, Wanda, 158
Petty, George, 203–204, 207–209, 219, 250, 352
Phelan, Peggy, 360
Phillips, Norma, 148
Photoplay magazine, 24, 143–184, 187–190, 193, 196–197, 199, 201, 219
Phranc, 322–323
Pickford, Mary, 149, 151, 159, 188, 192, 194–195
Pincus-Witten, Robert, 288
Piper, Adrian, 356
Plagens, Peter, 395 n.72
Planned Parenthood Federation of America, 216
Playboy magazine, 3, 237–238, 242–244, 246–247, 261, 269–271, 274, 321, 336
Playgirl magazine, 271
Pokorny, Sydney, 357
Pollack, Barbara, 356
Pollard, Harry, 158
Press, Joy, 346
Prevost, Marie, 150, 172, 382 n.107
Production Code Administration (PCA), 200–201

Queen, Carol, 328
Quim magazine, 323
Quintana, George, 202
Quirk, James R., 163

Rainer, Yvonne, 257
Ramos, Mel, 263–265
Rauh, Ida, 135
Rauschenberg, Robert, 256, 262–263
Raven, Arlene, 324
Raymond, Alex, 202
Reedy, William Marion, 136
Rice, Robin, 353
Rich, Adrienne, 295
Rich, Vivian, 155
Richards, Amy, 328, 342, 345, 357–358
Richardson, Angelique, 100, 103
Rigg, Diana, 269
Rinehart, Mary Roberts, 167
Riot grrrl, 343–346, 400 n.76
Ristori, Adelaide, 44–47, 53, 62
Riviere, Joan, 307
Roberts, Mary Louise, 123, 129
Robertson, Pamela, 235–236
Robins, Elizabeth, 119–120
Roof, Judith, 19
Roosevelt, Alice. *See* Longworth, Alice Roosevelt
Roosevelt, Franklin D., 199, 210, 213–214, 217
Rosenblum, Robert, 261
Rosie the Riveter, 213–214
Ross, Andrew, 327, 329
Rossetti, Dante Gabriel, 49
Rousseau, Jean-Jacques, 36
Rubin, Gayle, 321
Rupp, Leila, 215, 238
Rushkin, Donna Kate, 317
Russ, Joanna, 325
Russell, Lillian, 134, 181

Saint-Gaudens, Augustus, 74
Salinas, Raquel, 348
Salt 'n' Pepa, 6
Samson, J. D., 347
Sanders, Evelyn, 254
Sandoval, Chela, 318
Sanger, Margaret, 67–68
Sargent, John Singer, 110
Sarony, Napoleon, 46–47, 49–51, 61, 126
Saura, Antonio, 265–267
Schneemann, Carolee, 257, 281, 359
Scholten, Marion W., 221

Schreiner, Olive, 81–82, 84–85
Schulyer, Philippa, 251
Schwichtenberg, Cathy, 328–329
Sentilles, Reneé, 51, 369 n.36, 370 nn. 51, 56
Shaw, Dr. Anna Howard, 139, 159
Shaw, George Bernard, 122, 155
Shaw, Mary, 119–120, 135
Shearer, Norma, 188–191, 201
Sherman, Cindy, 7, 296–302, 306, 326–327, 329
Showalter, Elaine, 84
Simms, Hilda, 251–252
Sinatra, Frank, 233
Sinatra, Nancy, 268
Skinner, Phyllis Kenney, 216
Sleigh, Sylvia, 356
Smart, David, 204
Smith, Ali, 3–4, 362
Smith, Barbara, 317
Smith, Hazel, 251
Snitow, Ann, 277, 309–310
Solomon-Godeau, Abigail, 10–11, 36–37, 63
Spector, Nancy, 359
Sprinkle, Annie, 311, 324, 329, 343
Stack, Phil, 208, 227–229, 385–386
Staiger, Janet, 137–138, 140–141, 147, 171
Stamp, Shelley, 139–140, 143–144, 152, 165, 180
Stanton, Elizabeth Cady, 37, 74, 76–78, 280
Stanwyck, Barbara, 191, 198–199
Steele, Valerie, 269
Steinem, Gloria, 329, 361
Stephens, Elizabeth, 320
Stone, Lucy, 77
Storey, Wilbur F., 59–60
Student Nonviolent Coordinating Committee (SNCC), 272
Students for a Democratic Society (SDS), 272–273
Studlar, Gaylyn, 169, 176
Suck magazine, 279
Suleiman, Susan Rubin, 278, 330
Sundahl, Debi, 320
Swanson, Gloria, 150, 169–170, 187–189
Swanson, Jerre (Vaught), 229–230, 388 n.93

Swanson, Robert, 229–230, 388 n.93
Swinburne, Algernon Charles, 49, 51

Talese, Gay, 245
Talmadge, Constance, 167
Talmadge, Norma, 163
Tarbell, Ida, 109
Taylor-Wood, Sam, 358
Tell, Olive, 158–159
Terry, Ellen, 27–28, 121
Thalberg, Irving, 189–190
Thiebaud, Wayne, 264
Thompson, Lydia, 42–43, 53–61, 122, 225. *See also* British Blondes
Thompson, Mills, 102, 105–106
Tickner, Lisa, 133
Ticknor, Caroline, 112–114
Todd, Ellen Wiley, 78
Tolstoy, Leo, 90
Toulouse-Lautrec, Henri de, 124–125
Truman Committee on Civil Rights, 248
Truth, Sojourner, 38, 77
Twain, Mark, 40–41

United Service Organization (USO), 217, 252

Vance, Carole, 309, 397 n.129
Vargas, Alberto, 1–3, 24, 185–187, 197–199, 203–213, 219, 222, 229, 238, 244, 261, 269–270, 336, 352, 385 n.34
Vera, Veronica, 324
Vicinus, Martha, 123
Victoria I, 34, 45
Vidor, Florence, 170

Walker, Alice, 331
Walker, C. J., 97–98
Walker, Kara, 358
Walker, Lillian, 167
Walker, Rebecca, 316, 331–332, 344
Wallace, Michelle, 317
Walters, Suzanna Danuta, 398 n.17
War Manpower Commission, 214–215
Warhol, Andy, 256, 263
Weber, Lois, 156
Wells, Ida B., 74
Wesselmann, Tom, 263–264
West, Mae, 66, 200

Westbrook, Robert, 224–225
Wharton, Edith, 9–10
White, Pearl, 151–153, 157
Whitman, Walt, 49
Whitney, Helen Hay, 109
Whittier, Nancy, 20–21, 315, 319, 330, 332
Wilding, Faith, 281, 285, 356, 360
Wilke, Hannah, 291–294
Williams, Carla, 339
Williams, Fannie Barrier, 74
Williams, Kathlyn, 149, 154–156
Willis, Chris, 95, 100, 103
Willis, Ellen, 277, 285
Willis, Fritz, 236
Wilson, Martha, 398–399 n.27
Winship, Mary, 178–179
Wollstonecraft, Mary, 17, 48, 136
Women Accepted for Volunteer Emergency Service (Navy WAVES), 209, 219
Women Against Pornography (WAP), 275, 308

Women's Air-force Service Pilots (WASPs), 212, 225–226
Women's Army Auxiliary Corps (WAACs), 209
Wong, Anna May, 165, 196–197, 250
Woodhull, Victoria, 77, 81–82, 134
Works Progress Administration (WPA), 248, 253
World's Columbian Exposition (Chicago), 69–76
Wright, Frances, 48
Wurtzel, Elizabeth, 358

Yeager, Bunny, 254, 274, 389 n.33
York, Cal, 201
Yuskavage, Lisa, 7, 352–355, 358

Zangwill, Israel, 133
Ziegfeld, Florenz, 198
Zurlingen, Cheryl, 285

MARIA ELENA BUSZEK
is an assistant professor of art history at
the Kansas City Art Institute.

Library of Congress Cataloging-in-Publication Data
Buszek, Maria Elena
Pin-up grrrls : feminism, sexuality, popular culture /
Maria Elena Buszek.
p. cm.
Includes bibliographical references and index.
ISBN 0-8223-3734-7 (cloth : alk. paper)
ISBN 0-8223-3746-0 (pbk. : alk. paper)
1. Pinup art. 2. Women in art. 3. Feminism in art.
4. Feminism and art. I. Title: Pin-up girls. II. Title.
N7630.B87 2006
760'.04428—dc22 2005031756